Also by Nicholas Fox Weber

The Drawings of Josef Albers

Louisa Mathiasdottir: The Small Paintings (with Jed Perl and Deborah Rosenthal)

*The Woven and Graphic Art of Anni Albers (with Mary Jane Jacob
and Richard S. Field)*

Leland Bell

Warren Brandt

Josef Albers: A Retrospective

The Art of Babar

Patron Saints

Cleve Gray

Anni Albers

Balthus: A Biography

Marc Klionsky (with Elie Wiesel and John Russell)

Josef & Anni Albers / Designs for Living

The Clarks of Cooperstown

Le Corbusier: A Life

Anni Albers: Print Catalogue Raisonné (with Brenda Danilowitz)

The Bauhaus Group

THE BAUHAUS GROUP

Six Masters of Modernism

Nicholas Fox Weber

Alfred A. Knopf

NEW YORK

2009

This Is a Borzoi Book Published by Alfred A. Knopf

Copyright © 2009 by Nicholas Fox Weber

All rights reserved. Published in the United States by Alfred A. Knopf, a division of Random House, Inc., New York, and in Canada by Random House of Canada Limited, Toronto.

www.aaknopf.com

A portion of this work originally appeared in ARTnews.

Owing to limitations of space, all acknowledgments to reprint previously published material may be found at the end of the volume.

Knopf, Borzoi Books, and the colophon are registered trademarks of Random House, Inc.

Library of Congress Cataloging-in-Publication Data
Weber, Nicholas Fox, {date}
The Bauhaus group : six masters of modernism / by Nicholas Fox Weber.
p. cm.
"A Borzoi book."
Includes bibliographical references and index.
ISBN 978-0-307-26836-5 (alk. paper)
1. Bauhaus—Biography. 2. Artists—Germany—Biography. 3. Designers—Germany—Biography. 4. Avant-garde (Aesthetics)—Germany—History—20th century. I. Title.
N332.G33W483 2009
709.43'0904—dc22 2009028729

Manufactured in the United States of America

First Edition

For Charlotte

Contents

Illustrations

COLOR INSERT I

COLOR INSERT II

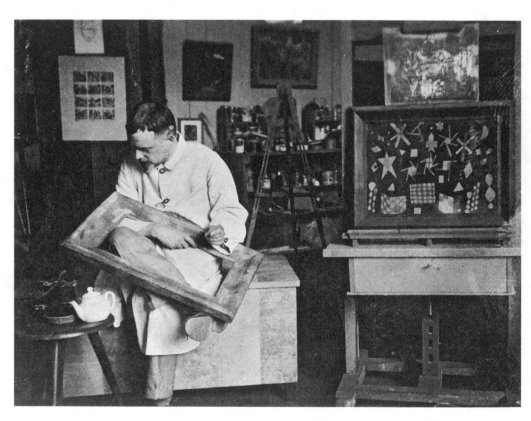

Paul Klee in his studio at the Weimar Bauhaus, 1924

Klee's Birthday Party

It was the fall of 1972, and I was driving Anni Albers down the Wilbur Cross Parkway from my family's printing company in Hartford, Connecticut, back to her and Josef's house in the New Haven suburb of Orange. The Alberses—she was seventy-four, he eighty-five—were the last two surviving members of the Bauhaus faculty. I had been introduced to them two years earlier, and was now working with Anni on a limited edition print in which she was making ingenious use of photo-offset technique that was generally applied to commercial lithography rather than abstract art.

Anni and I were in my two-seater hatchback car, an MGB-GT which the Alberses praised as an exemplar of the Bauhaus ideals of impeccable functioning and no wasted space. "We prefer good machinery to bad art," Josef had explained. But the torrential rain that afternoon was so intense that Anni was an anxious passenger. "Please pull over under that bridge until the downpour gets lighter," she requested in her German-accented English, the controlled politeness barely masking an inner desperation. "In Mexico, when we would go there in the thirties with friends in their Model A, we often had to pull over during storms," she added, to make it clear that she was not criticizing my driving.

The cascade of rain on the windshield was intensifying and the visibility was becoming dire as I stopped the car. Under one of the charming carved stone parkway bridges built by the WPA, Anni momentarily closed her eyes in relief. She was an adventurer—luring Josef from the Dessau Bauhaus to Tenerife for five weeks on a banana boat in the 1920s, getting them to Machu Picchu in the fifties—but she also was chronically anxious, which she directly attributed to the period in 1939 when she had to get her extended family out of Nazi Germany; her parents' ship docked in Veracruz, in Mexico, where she and Josef had to scramble to bribe one person after another before Anni's increasingly desperate mother and father finally managed to disembark. At twenty-four, I was soaking up Anni's life experiences as if they had been my own, and was enchanted by the consuming dedica-

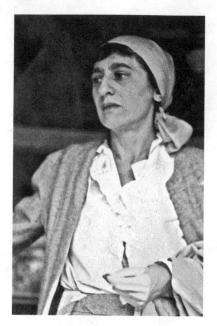

Josef Albers, photo of Anni Albers.
Anni disparaged her own looks; others
considered her a great beauty. This is one
of the many pictures Josef took of her
over the years.

tion she and Josef had to the making of art and by the way their work enabled them to withstand anything. Now, in the sports car under the bridge, the woman who had become director of the Bauhaus weaving workshop assured me that our journey had been worth its challenges because of her thrill at supervising the presswork of her latest prints, and the importance of her being there to oversee the mechanical adjustments that intensified the tonality of the gray ink.

I had switched the motor off. Anni turned to me and said with a smile, "You deserve a reward. I know you have been wanting to hear about Paul Klee for a long time." Since our first meeting, I had badgered her with questions when either she or Josef mentioned Klee, Kandinsky, or their other colleagues. Both the Alberses, however, were so focused on their current work and uninclined to nostalgia that I had not been able to elicit more than a few cursory remarks. "I will tell you something I have never told anyone before— about his fiftieth birthday."

It was 1929. Klee, Anni told me, was her "god at the time"; he was also her next-door neighbor in the row of five superb new masters' houses in the woods a short walk from the Dessau Bauhaus. Although the Swiss painter was, in her eyes, aloof and unapproachable—"like Saint Christopher carrying the weight of the world on his shoulders"—she admired him tremendously. She had even acquired one of his watercolors after being bowled over by an exhibition in which Klee tacked up his most recent work in a corridor of the Bauhaus when it was still in Weimar. The purchase had been a rare public admission of her family's wealth, which she normally concealed: she told me that she had been so embarrassed by the appearance in Weimar of two of her uncles in a Hispano-Suiza that she had begged them to drive off immediately. But though her ability to buy the painting conspicuously set her apart from the other students in difficult economic times, she still could not resist acquiring Klee's composition of arrows and abstract forms. Now, as her god approached his major birthday, Anni heard that three other students in the weaving workshop were hiring a small plane from the Junkers aircraft plant, not far away, so that they could have this mystical, otherworldly man's birthday presents descend to him from above. He was, they

had decided, beyond having gifts arrive on the earthly level where ordinary mortals live.

Klee's presents were to come down in a large package shaped like an angel. Anni fashioned its curled hair out of tiny, shimmering brass shavings. Other Bauhauslers made the gifts the angel would carry: a print from Lyonel Feininger, a lamp from Marianne Brandt, some small objects from the wood workshop.

Anni was not originally scheduled to be in the four-seater Junkers aircraft from which the angel would descend, but when she arrived at the airfield with her three friends, the pilot deemed her so light that he invited her to get on board. For all of them, it was their first flight. As the cold December air penetrated her coat and the pilot fooled with the young weavers by doing 360-degree turnabouts as they huddled together in the open cockpit, Anni became suddenly aware of new visual dimensions. She told me she had been living on one optical plane in her textiles and abstract gouaches. Now she was seeing from a very different vantage point, with the factor of time added in. She was too fascinated to be afraid.

She guided the pilot by identifying the house the Klees shared with the Kandinskys next door to her and Josef. Then he swooped the plane down and they released the gift. The angel's parachute didn't open fully, and it

Josef Albers's photo collage of Klee in his studio at the Dessau Bauhaus.
Albers's portrait photos were scarcely known until after his death in 1976.

landed with a bit of a crash, but Klee was pleased nonetheless. He would memorialize the unusual presents and their delivery in a painting that shows a cornucopia of gifts on the ground in good condition, even if the angel looks a bit the worse for wear (see color plate 1). James Thrall Soby, who owned the colorful canvas, told my wife and me that he thought it depicted "a woman passed out drunk at a cocktail party," with the golden brushwork Klee used for Anni's brass shavings representing the socialite's blond hair, but Anni's account revealed the actual facts.

Josef Albers was less impressed than Klee was. Later that afternoon he asked Anni if she had seen "the idiots flying around overhead." Anni smiled mischievously as she recalled this. "I told him I was one of them," she said with her usual tone of proud defiance.

The rain let up, and we resumed our drive. This was America in the hey-day of Pop Art, a time when the newspapers reported daily about what parties Andy Warhol and Baby Jane Holzer had gone to the night before; while that sort of current gossip held no interest for me, every morsel about Bauhaus life had a glow. Listening to Anni in her newly expansive mood as we headed home, I began to see that the geniuses of the Bauhaus lived with the creativity and flair of their work.

Yet at the same time that these painters, architects, and designers were having extraordinary impact and leading unusual lives, they were subject to the same needs and fears and longings as most human beings. As I spent more time with Josef, too, he made clear both the pleasures and the struggles of his colleagues, so that I had at least a tiny glimpse of their everyday realities as well as their exceptional lust for improving the seeable world. A reverence for the universe, a profound dedication to adding to its beauty— these were constant, but so were the inescapable realities of money and family and health.

ANNI ALBERS WAS SOMEONE who was not used to confiding in another person, possibly not even in Josef, and she clearly had a lot bottled up that she wanted to say. Although she seemed full of certainty, there was much that made her uncomfortable. Once our friendship helped assuage her own feeling of inadequacy, Anni described a slight that had stung her nearly a half century earlier, but that, until she told me about it, she had kept to herself.

Shortly after the Alberses had moved into one of Walter Gropius's splendid, flat-roofed masters' houses at the Dessau Bauhaus, Josef, who by then had a high rank on the faculty, told her that Ludwig Mies van der Rohe and Lilly Reich, Mies's mistress, would be coming for dinner. Eleven years her husband's junior, still a student in the weaving workshop, and not someone who was ever sure of herself socially, Anni wanted to do everything right.

By then she and Josef had been married for three years, but she still felt like a new bride who wanted to make the right impression on her husband's cohorts. Besides, Mies already had a reputation as one of Germany's most important architects, and both Alberses admired his work immensely.

Anni's mother had given her a butter curler. In the luxurious Berlin household in which Anni had grown up, family members never entered the kitchen, which was strictly reserved for staff, but when dinner was laid out on the heavy, carved Biedermeier table in the ornament-laden dining room, butter balls were part of the landscape, and Anni knew how they were made. Preparing for dinner that evening in Dessau, she carefully used the clever metal implement to scrape off paper-thin sheets of butter and form them into graceful, delicate forms resembling flower blossoms. It was the sort of process and manipulation of materials she prized, and which she often discussed in explaining her textile and printmaking work. Like weaving, the making of butter balls required the careful stretching and pulling of a simple substance with the correct tool, to achieve a transformation. The resemblance of the result to a flower was at odds with her usual concept of nonrepresentational design, but it amused her in this rare instance.

Mies and his imperious female companion arrived. They had not even

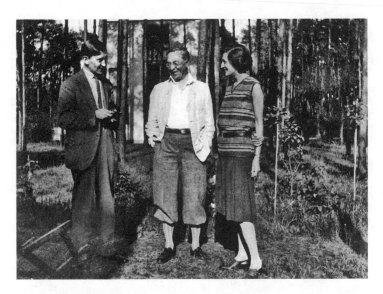

Josef and Anni Albers with Wassily Kandinsky on the grounds of the Dessau masters' houses, ca. 1928. After the Bauhaus moved to Dessau, the masters and their wives were thrilled to live in the new houses Walter Gropius had designed for them. Josef Albers and Wassily Kandinsky often took walks in the woods together.

removed their coats or uttered a word of greeting before Reich, glancing at the table, exclaimed, "Butter balls! Here at the Bauhaus! At the Bauhaus I should think you'd just have a good solid block of butter!"

It was a sting Anni Albers remembered word for word half a century later. But the significance of Lilly Reich's remark was not just its nastiness. The incident involving the form of butter on the dining room table exemplified the way that every detail of how we live, every aesthetic choice, affects the quality of daily human experience. That idea, as well as the significance of individual personalities, was, I was beginning to see, the crux of the Bauhaus.

The Bauhaus Group

Walter Gropius

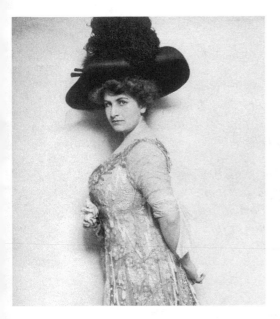

Alma Mahler, 1909

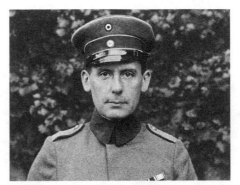

Walter Gropius, in the uniform of a cavalry officer, during World War I

The loveliest girl in Vienna
Was Alma, the smartest as well
Once you picked her up on your antenna
You'd never be free of her spell

Her lovers were many and varied
From the day she began her beguine
There were three famous ones whom she married
And God knows how many between

. .

The first one she married was Mahler
Whose buddies all knew him as Gustav

And each time he saw her he'd holler
"Ach, that is the fräulein I moost hav"

Their marriage, however, was murder
He'd scream to the heavens above
"I'm writing 'Das Lied von der Erde'
And she only wants to make love!"

. .

While married to Gus, she met Gropius
And soon she was swinging with Walter
Gus died, and her teardrops were copious
She cried all the way to the altar

But he would work late at the Bauhaus
And only come home now and then
She said, "What am I running, a chow house
It's time to change partners again"

. .

While married to Walt she'd met Werfel
And he too was caught in her net
He married her, but he was careful
'Cause Alma was no Bernadette

And that is the story of Alma
Who knew how to receive and to give
The body that reached her embalma
Was one that had known how to live

—TOM LEHRER, "ALMA," 1965

1

When thirty-six-year-old Walter Gropius conceived the Bauhaus, it was to provide the larger world with sensible designs in which form followed function, and ornament and fluff were eradicated. His private life was topsy-turvy, his personal relationships stormy. He intended to create a visual environment as simple and balanced as his emotional situation was tumultuous.

Gropius preached anonymity and a sense of service as the fundaments of his pioneering art school. In this community of workshops, students and masters would work hand in hand, as had the humble stonemasons and woodcarvers who built the Gothic cathedrals. Modesty and dedication to a shared purpose were to rule. Human conduct was to be as straightforward as the tubular steel and tough textile fibers that would now be utilized openly—exposed and celebrated, rather than concealed or adorned with a deceptiveness demanded by previous generations. Gropius's personal existence might be an imbroglio, but the setting and props of the society he envisioned would be built on precepts of grace and honesty.

Gropius's complex life was set in chic spas and glamorous metropolises far removed from the quiet and historic city of Weimar, where he was starting the Bauhaus. Gropius had long been a bon vivant and a womanizer, but never before had his cavorting caused him such trouble. Now his marriage to one of the most demanding femmes fatales of the twentieth century had him in turmoil. While promulgating the alliance of art and industry at the Bauhaus, the patrician architect was also dealing with the decline of his marriage to Alma Mahler. Mahler was as duplicitous as she was beguiling; Gropius had recently discovered that he was not, as he had previously believed, the father of his wife's newborn son.

The young artists for whom the first Bauhaus brochure, with Gropius's brief manifesto on the virtues and potentials of their labors, had been a summons to this radically different art school—and who now sat riveted as he confidently charted the future and mapped that new relationship between art and industry—had no idea that their smiling leader, declaring his mission with such assuredness, was distraught. But when the former Adolf Georg Walter Gropius—name trimming was a Bauhaus norm—arrived in Weimar in 1919, he was in the midst of the agonizing on-again, off-again phase that often precedes divorce.

Had the students known, they might have recognized that the way he handled his situation demonstrated the strength he would need to keep the Bauhaus going. One of the reasons he could start a new and extraordinary

school in a repressive milieu and then guide it to a position of lasting world-wide influence in spite of constant, merciless opposition, both from outside and from within, is that he was a master juggler who could manage complex, tortuous developments with unwavering mettle and calm. Anyone who could cope with Alma could run the Bauhaus. And she was just one of many challenges this steely, tenacious man had already faced squarely and survived.

BORN TO AN AFFLUENT Berlin family on May 18, 1883, "Walty" was christened in a Gothic-style church because his father deified the famed nineteenth-century neoclassical architect Karl Friedrich Schinkel, who was buried in the church cemetery. Walter Gropius, Sr., then thirty-three years old, was a mid-rank building official for the government; he dreamed that his new-born son would become an architect of Schinkel's skill and renown.

In earlier generations, the family had prospered in the field of silk weaving. Our Gropius's great-grandfather, whose business success enabled him to co-own a theater for the pleasure of it, had commissioned Schinkel to make its proscenium and stage curtains. In the next generation, Gropius's great-uncle was the successful architect Martin Gropius, internationally recognized for his work in Schinkel's style. Walter's father was an architect in the same vein, but minus the drive or consequent success; his son deemed him "withdrawn and timid . . . without sufficient self-reliance, so therefore he never penetrated to the first rank."[1] Walter Senior's failures as a designer of buildings had, by the time his namesake was born, reduced him to the rank of a minor municipal employee.

Walter Junior would compensate in spades for his father's professional setbacks, and more so for his father's bourgeois lifestyle. Walter Senior lived unadventurously in a long-term marriage to the daughter of a district councilor who descended from French Huguenots; the couple kept to a straight and narrow path from which they appear never to have strayed. Their son would help change the appearance of buildings worldwide and be a Don Juan.

In his childhood, however, Walty was timid. He got in trouble at school for speaking too little and answering questions too slowly. Shy to the point of being unsociable, he first gave a hint of his colorful future when, wearing a topcoat indoors, he passed his gymnasium examinations by reciting his own translation of Sappho's "Ode to Aphrodite," garnering great praise from his professors. His father toasted him with champagne at a celebration dinner at Kempinski's, Berlin's most fashionable restaurant.

Walty's family members included wealthy landowners, on whose vast estates—one of eleven thousand acres—he spent idyllic summer holidays.

But with all of his opportunities for pleasure, he was a dour and solitary adolescent. It is as if he were charging his batteries for the flair with which he would live as a man.

EVEN AS HE KEPT to himself, Walter Gropius, Jr., acceded to his father's goal and strategy for his future. To become an architect, the first step was Technical School in Munich, following which he became an apprentice for a large reputable firm. Then, at twenty-one, Gropius enlisted in the Fifteenth Hussar Regiment.

It was a digression from architecture, but it was also a deliberate step up in the German class system, which would have bearing on his architectural career. Gropius's relatives had money; they were not, however, aristocrats. A bourgeois surrounded by other young men whose titles and "von"s made him an outsider, he befriended another soldier who had a sense of not belonging: a Jewish doctor with the surname Lehman. A letter he wrote to his mother showed both an open-mindedness rare for his milieu and inherent prejudice. Gropius described Lehman as "a very nice person. Inexperienced, naïve, and clumsy, he is not at all ostentatious or profligate. I have not discovered any Jewish trait in him. He is the best-educated man in the regiment."[2] Gropius, however, was mainly determined to be at home with the upper echelon.

The reclusive adolescent began to transform himself into a worldly gentleman. He became an expert horseman, jumping more than a meter from a standstill; his commanding general applauded him. He was also developing an eye for the ladies, even if he did not yet act on it. On a Christmas furlough in Hamburg, close to where he was billeted, he attended a musical evening about which he wrote his father, "Very beautiful girls, but all cold Hanseatic blood."[3] As his connoisseurship of the opposite sex grew, he became eager to make a good impression and chalked up considerable expenses with the tailor and the shoemaker. The bills, along with his casino costs and charges at the saddler's, sparked tension with his parents. The Gropiuses came from comfortable families, but their own means were limited, and they considered their son a spendthrift.

Fortunately, the military had instilled its rigor as well as a fondness for pleasure, and when Gropius returned to Berlin to attend the Konigliche Technische Hochschule, he assumed an intense course load that required up to twelve hours a day in class. Rich relatives had him design buildings on their estates, and some family friends commissioned a house. His future seemed assured. And when he wasn't working, he was learning how to hunt, drink, and smoke, under the tutelage of a prosperous uncle.

Then Gropius inherited a windfall of money from a great-aunt. Once his

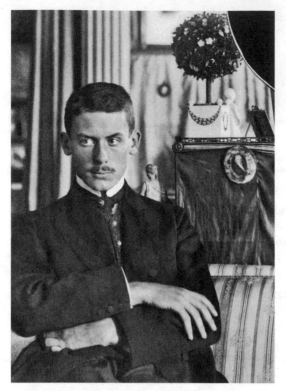

Walter Gropius, 1905, as a student at the Munich Technical School. He was determined to outdo his father in the same field.

financial situation changed, so did everything else in his life. Although he had nearly finished his program at the Hochschule, he dropped out without bothering to take the final examination. Gropius was beginning to evince the traits that would drive him, a decade later, to start up the radical art school in Weimar: a brave disregard for traditional education and its metrics, and an intrepidity that facilitated and required risks. Just when his contemporaries were settling down, Gropius took off for a year in Spain to "push forward from the beaten path into unknown regions, in order to know myself better."[4] With a male traveling companion of his own age, he swooned to Gregorian chants sung by the monks in a monastery near Burgos, feasted his eyes on Coca Castle—which, with its many pinnacles and towers, seemed like something from a fairy tale— devoured the wonders of Avila with its spectacular Roman ruins and eleventh-century cathedral, and furthered his studies of the opposite sex.

The women in Avila were in a league of their own, remarkable especially for their bold features, which to him overpowered what he now considered the inherent weakness of those "beautiful girls" he had previously admired in the north. But other categories of Spanish women interested him as well. Much as he liked the blond and blue-eyed Basques, he also admired those with jet-black hair, which contrasted so dramatically with their pale skin and deep crimson lips. His attraction to more than one type of woman at a time would be a central element of his life as the director of the Bauhaus.

WHILE HE WAS BECOMING increasingly aware of females his own age, Gropius was cementing his relationship to his mother. Manon Gropius was a woman of sharp opinions, and she doted on her son, for whom she had no end of ambi-

tion. She was eager to know what was happening in his life, and he let her in on a surprising amount. He wrote Manon that in Madrid he had donned his best clothes just because they made him feel worldly while he took evening strolls to admire the exquisite ladies. One night he met two Cuban women whom he decided were the most alluring females in all of Madrid; he found them "so ravishingly beautiful in figure and face that my breath stood still." One of them "was also intelligent and amiable, a rare combination." Although the twenty-four-year-old assured his mother that his heart was "not yet broken in two—so don't worry," it would be soon enough.[5] He would also break a few hearts himself, while navigating treacherous seas with Manon, whose reactions to his choices in women as well as to his architecture would always matter greatly to him.

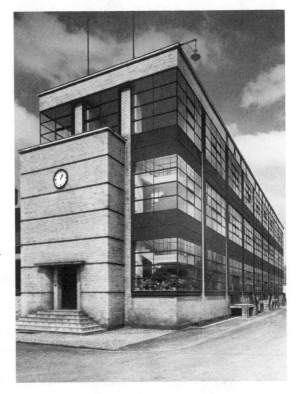

Entrance of the Fagus factory, designed by Gropius and Adolf Meyer in 1911. This remarkable building helped establish a new vocabulary of architectural forms and materials.

In Madrid, Gropius bought art he thought he could sell at a profit back in Germany, and he also enlarged his circle of influential acquaintances. Among them was Karl Ernst Osthaus, founder of the Folkwang Museum in Hagen, an avatar of modernism. Osthaus had the idea that Gropius should return to Berlin and work for the architect Peter Behrens. He wrote Behrens a letter recommending the young man; that turn of events changed Gropius's life.

In his AEG Turbine Factory (1908–9), Behrens introduced an unprecedented use of steel and glass into architecture. Young Gropius worked on the project and on Behrens's boldly modern factories for the Krupp empire in Germany's Ruhr region. He became excited by the possibilities of this new building style for industry, imagining its being used not just for manufacturing plants but also for prefabricated mass housing. Gropius suffered

all of the usual problems endemic to apprenticeship—Behrens was a notorious bully—but by the time he left Behrens's practice to start out on his own in 1910, he had a new aesthetic outlook. Mies van der Rohe and Le Corbusier would also apprentice in Behrens's office and have similar experiences: both the confrontation with authority and the transformative exposure to a fresh concept of architecture.

In his first year on his own, Gropius, with fellow architect Adolf Mayer, designed a factory for the Fagus shoe-last company. Behrens's style was clearly evident, but so, for the first time, was Gropius's magical touch. The Fagus factory is a crisp and handsome block that ennobles the idea of sheer simplicity. It used large rectangular panes of glass divided by trim steel mullions; the corners look as if a completely transparent wrapping has been stretched taut at right angles around an invisible support.

The building seems to be made of air and light as well as of steel and concrete and glass. In the glazed corner staircase, the passage of daylight through the ample windows onto the stairs is palpable, and the straightforward, efficient stairs sing out in their vigorous up-down movement. The bold entrance block is a tour de force. Comprising seven tough bands of bricks stacked one on top of another, their mass punctuated only by a modest overhang and a large circular clock that epitomize elegant understatement, the entryway blends classical simplicity with unprecedented forthrightness.

Twenty-seven-year-old Walter Gropius was developing ideas on how good design and the latest technology could benefit society at large. To spell out his program and try to put it into effect, in April 1910 he wrote a memorandum of twenty-eight typewritten pages, which he gave to a prominent Berlin industrialist, Emil Rathenau. The dream Gropius codified for Rathenau was a construction company that "sees as its aim the industrialization of the building of houses, in order to provide the indisputable benefits of industrial production methods, best materials and workmanship, and low cost." It would be an uphill battle to offer as much for the masses, since, he explained, "instead of good proportions and practical simplicity, pomposity and false romanticism have become the trend of our time."[6] Gropius decried as "unbearable" all that was "ostentatious" and "purely superficial," favoring instead "good material, solid workmanship, distinction, and simplicity." He imagined using uniform plans and components in a range of settings to assure large groups of people the chance to live in houses with "clear and open spatial arrangements," where construction would be based on "the selection and application of proven materials and reliable techniques," achieving "excellence, to be guaranteed for many years."[7] Salubrious living conditions, he insisted, should be available for people at every level of society.

2

While developing his idealistic agenda for re-forming the world around him, the handsome twenty-seven-year-old had moved from the solitary pleasures of horsemanship and gambling in his hussar's uniform to doing more than simply observe women. On June 4, 1910, at a sanatorium in the Tyrol, he encountered Alma Mahler for the first time. This fetching woman with a pouf of jet-black hair had a way of looking at him that was charged with electricity; Gropius had never before experienced anything like it.

The architect was at the sanatorium because, overworked, he was suffering from a cold that refused to abate. But ill health did not prevent the young man from falling instantly head over heels for Alma. Her husband, the renowned composer and conductor Gustav Mahler, was fifty-one years old to her thirty-one, and she was restless. Her young daughter's presence did not impede her availability.

Alma Schindler Mahler was a force to reckon with. Her appearance was more fascinating than classical; she had fiery eyes and a vibrant presence that many men found irresistible. Because of her partial deafness, she stood especially close to anyone speaking to her and carefully read the person's lips, a posture that many men regarded as a sexual invitation. Alma's early romantic liaisons had included theater director Max Burckhard and composer Alexander von Zemlinsky. She had married Gustav Mahler in 1902, when he was director of the Vienna Court Opera.

For Alma, an essential ingredient of male greatness was artistic creativity. As a child she deified her father, Emil Jakob Schindler, a landscape painter who did well enough with his art to bring up his family stylishly in a castle on the outskirts of Vienna, where he devoted almost as much energy to throwing lavish parties as to painting. Alma never recovered from the jolt of his sudden death when she was thirteen.

She had far less regard for her mother, Anna. When her younger sister Grete was put into an asylum following two suicide attempts, her mother said the reason for Grete's illness was that her father (who was not Schindler) had syphilis. Alma held Anna in contempt, and resented her all the more for marrying yet another former lover, the painter Carl Moll, soon after Schindler's death. Moll had been a student of Schindler's when he and Alma's mother first had an affair.

At least Moll, who was a major figure in the contemporary art scene in Vienna, attracted interesting people to the house. Young Alma gave her first kiss to the painter Gustav Klimt, whom she met when she was seventeen. Klimt had recently become president of the Secession, an artistic movement he had conceived with Moll and a third artist, Josef Engelhardt. Its goal was to break away from the traditional academic style that dominated the artistic establishment in Vienna. Alma was by nature attracted to rebellious groundbreakers who were in positions of power (Gropius would be a prime exemplar), and it's no surprise that the painter fell for her in return. Klimt deliberately confronted societal norms—he sported a fringe beard and wore voluminous monk's robes—and considered his colleague's teenage stepdaughter a perfect quarry. The slightly oversize features that made her face so riveting, her unabashed mischief, and her skill at singing Wagner with her mezzo-soprano voice enchanted him to the point of obsession.

When Alma's mother and Moll heard about her kissing the painter, who was more than twice her age, they tried to put an end to the relationship, to which Klimt responded with a letter saying that Alma was "everything a man can wish for in a woman, and in abundant measure."[8] Alexander von Zemlinsky, who was Alma's music teacher, was also obsessed with her. Although Alma considered him "a hideous gnome,"[9] a private rendition he gave her of *Tristan* led to passionate embraces.

Alma remained a virgin, but it was a struggle. Even at an early age, the future first lady of the Bauhaus confessed her sexual longings in her diary. While she would not allow Zemlinsky full intercourse, she wrote, "I madly desire his embraces, I shall never forget the feel of his hand deep in my innermost self like a torrent of flames! . . . Perfect bliss does exist! . . . I would like to kneel down before him and press my lips to his naked body, kiss everything, everything! Amen!" Although she would have been "in the seventh heaven" if she had allowed him to bring her to orgasm, she would not give him "the hour of happiness" he craved.[10] The reason was that she had met Gustav Mahler.

In February 1901, Alma, age twenty, saw the forty-one-year-old tyrant with famously unruly hair and unkempt clothing conduct the Vienna Philharmonic in *The Magic Flute*. While most young women were repulsed by Mahler, Alma, noting his "Lucifer face" and "glowing eyes," was completely thrilled.[11] Without knowing that his agonized expression was caused by his deep hemorrhoids and the onset of a rectal hemorrhage, she realized that he was someone of unequaled intensity and made it her mission to rescue him.

Later that year, a friend of Alma's, the journalist Berta Zuckerkandl, organized a meeting between Mahler and Alma. The two began a tempestuous courtship. At the start, Zemlinsky was still very much a player; as Wal-

ter Gropius would discover, initially to his advantage, Alma required the simultaneous presence of at least two ardent pursuers.

ALMA SCHINDLER AND GUSTAV MAHLER were married in March 1902. It was a small private ceremony, designed to keep the press at bay, for Mahler was already a Viennese celebrity. Alma agreed to give up her own wish to compose in order to support her husband's work, and while Mahler composed and conducted and toured, she practiced diplomacy on his behalf. When Mahler sulked silently at public dinners or stormed out in the middle of them, Alma smoothed the waters. Her striking looks helped distract people from Mahler's unpleasantness on his New York tour; the pianist Samuel Chotzinoff called her "the most beautiful woman I have ever seen"—a complete contrast to the husband who was enthralling in "the force of his genius," but, besides being awkward and homely, was given to fits of rage.[12]

The Mahlers soon had two daughters, and for a while all went well. Then, in 1907, the older girl died of diphtheria. Alma began to suffer from deep depressions. Her spirits further declined when, in a splendid concert hall in Paris, during the middle of the second movement of Mahler's Second Symphony, Claude Debussy—who had been Alma's dinner partner the night before—walked out conspicuously, as did the two other French composers, Paul Dukas and Gabriel Pierné, who were with him. They subsequently explained that the music was "too 'Schubertian,' . . . too Viennese, too Slavonic." Mahler was devastated. Alma had to pamper him to such an extent that she ended up exhausted. "I was really sick," she later explained, "utterly worn out by the perpetual motion necessitated by a giant engine such as Mahler's mind. I simply could not go on."[13] In the spring of 1910, the doctors recommended that she treat her severe melancholy by going to the resort spa of Tobelbad for a rest cure. This was where, in early June, she met Walter Gropius, in an encounter that revived her more effectively than anything the doctors had in mind.

ALMA HAD BEEN COMPLETELY dispirited when she and her little daughter, Anna, known as Gucki, arrived at the spa, in the duchy of Styria in the southern reaches of what was then the Austro-Hungarian Empire and is today Slovenia. Despite the beautiful location—a fir forest that blanketed a valley surrounded by mountain peaks—initially Alma showed no signs of rebounding. Neither the diet of lettuce and buttermilk, nor the walks in rain and wind that were supposed to bring her back to health, had any effect, and the baths in hot springs made her faint. Finally, the German doctor in charge of her care resorted to persuading her to dance and meet young men. "One was an extraordinarily handsome German who would have been

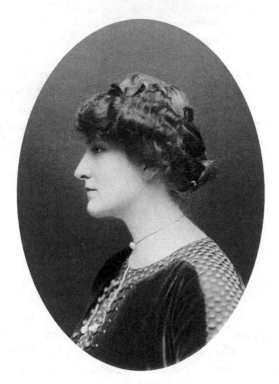

Alma Mahler at the time of her marriage to Gropius.
Her profile could have been on a Greek vase, but there
was nothing classical about her personality.

well cast as Walther von Stolzing in *Die Meistersinger,*" Alma later recalled.[14]
Gropius had what it took to bring her back to life.

In Gropius's arms on the dance floor, the forlorn patient felt her humor
change completely. The dashing young man, "handsome, fair-haired, clear-
eyed . . . the son of an eminently respectable Prussian bourgeois family,"
was her husband's opposite.[15] As they slowly glided around to the music of
the small orchestra, Alma learned that he had studied architecture with a
friend of her beloved father's; she considered it a magical connection.

Then Mrs. Mahler and Walter Gropius went for a walk in the moon-
light. They talked until dawn. The young architect's "aristocratic bearing,
unwavering gaze, and restrained demeanor" had their effect on the tor-
mented young mother.[16] In return, Alma's intensity and arresting looks
took Gropius by storm.

Gropius stretched his stay at Tobelbad to mid-July. Alma was convinced
that no man had ever made her as happy. Her mother, who had arrived at the
spa, sanctioned the affair and took care of Gucki so that the lovers could

spend entire nights together. When Mahler, who wrote regularly, became anxious over the dearth of mail from the woman he addressed as his "child-wife,"[17] his mother-in-law sent a letter reassuring him that all was well but that Alma was too fatigued to be in touch.

Mahler was then composing his Tenth Symphony in Toblach, a village in the Tyrol where he and Alma had a country house. Once Alma returned to him, she and Gropius began sending daily letters back and forth. The longer they were apart, the more fervently they expressed their love.

Alma relished having a lover and a husband at the same time. Mahler had become "more amorous than ever" since her return;[18] she attributed his increased ardor to the new allure she had acquired in Gropius's arms. The combination of the confident young lover and the tormented yet brilliant older husband was ideal.

THEN CAME ONE of the great slip-ups of all time. Walter Gropius put a love letter to Alma Mahler in an envelope that he addressed to "Herr Direktor Mahler."

When Gustav Mahler returned home from the concert hall one evening, the envelope was on the piano. As soon as he read the incriminating document, he handed it to his wife. He told her he was convinced the so-called mistake was deliberate on the part of the young architect. Mahler believed this was Gropius's way of asking him to release her, a ploy that enraged him almost as much as the affair itself. Alma was less certain; she didn't know "whether the youth had gone mad or had subconsciously wanted this letter opened by Mahler himself."[19]

Gropius's letter was full of explicit references to what was going on between him and Alma, and posed the question, "Did your husband not notice anything?"[20] Alma answered by writing Gropius that while Mahler had not previously detected the affair, everything had changed because of the misaddressed letter. She demanded that he write her an explanation for the catastrophe, letting her know whether it was a faux pas or by plan, and send it to her private post office box.

IN THE INCIDENT of the letter sent to Gustav Mahler may lie a clue to the real nature of the man who launched the great art school. Alma's biographer Françoise Giroud—who maintains, "One thing is certain; it was no accident"—asks, "Was it Mahler he was in love with, through Alma?"[21] Gropius's taste for women married to fascinating husbands would be borne out again at the Bauhaus.

Gropius himself never made any effort to explain what had happened. Meanwhile, in response to the crisis, the Mahlers grew closer. They took long walks on which they both wept, Alma telling all, Gustav blaming

himself for having made Alma forsake her own work. Alma let her husband know she now realized she could never leave him; ecstatic, the composer clung to her "every second of the day and night." Mahler took to writing her love letters; in one he described standing by her bedroom door "with longing" while he kissed her "little slippers a thousand times."[22] He also insisted on keeping the door between their adjoining rooms open at night just so that he could hear her breathe.

During the days, when Alma went to the forest hut where Mahler worked so that she could summon him for meals, she often found him lying on the floor, weeping in fear that he might lose her. But all signs pointed to the marriage lasting, especially when Alma's mother appeared on the scene to offer them both her support—even if she had abetted the secret liaison with Gropius.

Alma instructed Gropius that under no circumstances was he to come to Toblach. He was not, however, someone who followed instructions. With the resolve and determination that would mark his tenure at the Bauhaus, he showed up anyway. After wandering around town, he went to the Mahlers' house, where a guard dog chased him away. Alma inadvertently spotted him concealing himself under a bridge. She immediately told Mahler, who ferreted Gropius out of his hiding place and invited him to the house. The swashbuckling former hussar walked up the dark country lane with the bedraggled musical genius who was old enough to be his father. They said nothing to each other. Mahler then left Gropius and Alma alone in the parlor to work out things by themselves.

The lovers spoke only briefly before Gropius left the room and found Mahler, whom he asked to divorce his wife so that she would be free to marry him. When Mahler calmly asked Alma if this was what she wanted, she replied that her lover's proposal was out of the question and that she would stay with her husband. Mahler led Gropius down the lane up which he had guided him only an hour earlier, the darkness requiring him to carry a lantern. Again the two men walked in complete silence.

The next day, Alma went into Toblach to bid Gropius farewell at his small hotel and accompany him to the train. There is no way of knowing the precise conversation on the platform, but every time the train stopped on the way back to Berlin, Gropius dashed out to wire another telegram to Alma, begging her to reconsider.

THEN THE LYING BEGAN AGAIN. After assuring Mahler that she had renounced her lover completely, Alma continued to write to Gropius. When she and Mahler returned to Vienna, she sent the architect a letter explaining her predicament: "My remaining with him—in spite of all that has happened—means life to him—and my leaving—will be death to him. . . . Gustav is

like a sick, magnificent child. . . . Oh—when I think about it, my Walter, that I should be without your love for my whole life. Help me—I don't know what to do—what I have the right to."[23]

Alma's mother, Anna Moll, again became the lovers' accomplice, so that Gropius, rather than risk having another letter fall into the wrong hands, could now write via this indulgent lady. The pace of their correspondence picked up, and Alma invited Gropius to Vienna. They fell into each other's arms. The first meeting was followed by another, and another, always in secret. Alma studied her husband's schedule in order to organize trysts when he was in rehearsal or performing out of town, and she and Gropius invented brilliant pseudonyms to use when registering for their hotel rooms. Physically, Gropius was everything Mahler was not: trim, well toned, impeccably dressed without being a dandy. He was terrifically handsome; even if he considered his nose too large, his well-proportioned features were those of a classical marble sculpture. His sallow complexion and thick, dark, straight hair were striking, and he had made a wise decision to go clean-shaven after sporting a slightly foolish mustache during his army days (it would periodically reappear at the Bauhaus). His ears stuck out, but rather than detracting from his looks they only increased the impression that he was listening attentively. The perpetual look of mischief on his face made him all the more irresistible.

When Mahler went on a concert tour, leaving Alma at home, he barraged her as never before with telegrams and letters and sent a stream of presents and flowers. Alma thought he had stepped over the edge into madness. "The idolatrous love and worship which he shows me now can hardly be considered normal," she wrote Gropius.[24] Mahler became even more unbalanced when, after he returned to Alma in Vienna, he found himself repeatedly impotent.

The composer urgently sought a consultation with Sigmund Freud, and was upset to learn that Freud was on a family holiday in Leiden, in Holland. Alma's cousin Richard Nepallek, a well-established nerve specialist, persuaded the inventor of psychoanalysis to see Mahler even during this time away from work. Freud consented under the condition that Mahler come to him. The composer took off on the long journey to Leiden.

Following an initial fifty-minute session in Freud's hotel room, Freud and Mahler walked through the ancient city's narrow streets for four more hours. Freud later described the encounter to both Marie Bonaparte and Theodor Reik, which is why we know a surprising amount about it. The great doctor made Mahler aware that he often called Alma by her rarely used second name, Marie. This was only one letter different from Mahler's mother's name, Maria. And while the composer was looking for elements of his mother in his wife, Alma was seeking a replacement father. According to

Alma's account of the one-day treatment, Freud told Mahler, "I know your wife. She loved her father and can seek and love only his type. Your age, which you are afraid of, is just what attracts your wife. Don't worry about it." Alma thought Freud was completely "right. . . . I really was always searching for the short, stocky, wise, superior man I had known and loved in my father."[25]

The session with Freud succeeded in accomplishing one of its primary goals. Freud wrote Reik that Mahler's understanding of "his love requirements" had enabled him to overcome "the withdrawal of his libido."[26]

With Mahler transformed, Alma concluded that the lean and fit Gropius, four years her junior, had been her attempt to escape her natural attraction to her father's type, and to compensate for Mahler's sexual failings, which had now been cured. With that knowledge, she considered herself over her love affair and content in Toblach.

WALTER GROPIUS, HOWEVER, proved irresistible. Alma wrote asking him if he would support her having "a life of love" with him. While the revivified Mahler was composing with feverish zeal in their mountain retreat, Anna Moll helped Alma engineer a cover story so she could sneak off to Vienna to be with Gropius. Alma now had a theory that the affair was necessary for her health; she needed the intensity and frequency of her orgasms "for the heart and all the other organs."[27] She craved "not only the sensual lust, the lack of which has made me prematurely into a detached, resigned old woman, but also the continuous rest for my body."[28]

Time apart from Gropius was unbearable. When she returned to Toblach, Alma wrote him, "When will there be the time when you lie naked next to me at night, when nothing can separate us any more except sleep?" She signed this letter "Your wife."[29]

Two weeks later, she wrote "My Walter" that she wanted to bear his child. Again, she signed herself "Your wife."[30]

WHEN ALMA ASKED WALTER whether he shared her desire for them to have a child while she was still married to Gustav, knowing that eventually the day would come when they might, "secure and composed, sink smiling and forever, into each other's arms," he responded by return mail, "I see a younger, more beautiful life arise from the pain endured."[31]

He told her, "What we experience together is the highest, greatest thing that can happen to men's souls."[32] Gropius thought in extremes and envisioned apogees. To bow to the rules and regulations that most people considered inevitable and irrefutable was anathema to the man who would change forever the nature of art education and design. The same faith in a new and wonderful future that he conveyed to Alma Mahler would inspire

him to launch the Bauhaus. Conflict had to be overcome and battles won; in the relationship with his mistress, he developed the willpower and fortitude that he would need in Weimar.

But the obstacles did not go away. Gustav Mahler again fought to hold on to his wife. He was going to New York that fall to conduct the Metropolitan Opera, and he insisted that Alma and their daughter join him on the trip. Alma summoned Gropius to Munich, where Gustav was getting ready to conduct the premiere of his Eighth Symphony. The composer had dedicated the masterpiece to her, but she focused only on having every possible moment with Gropius before an ocean separated them.

The architect was equally avid. Day after day, he lurked impatiently at the entrance of his hotel, the Regina, waiting for Alma. The Mahlers were in another hotel nearby. Once Gustav left to rehearse, Alma rushed to the Regina, where they repaired to Gropius's room for the few hours she had free. Alma always timed the encounters so that when the perpetually suspicious Mahler arrived back at their hotel, she was there waiting for him as if she had never left.

The premiere of the Eighth Symphony was an unmitigated triumph. Mahler's only reaction to his success was to obsess over whether Alma was sufficiently pleased that her name was printed in the manuscript, while Alma obsessed over how much she wanted to have a child with Gropius.

The Mahlers would be sailing to America from Bordeaux toward the end of the third week of October. Alma was to take the Orient Express from Vienna to Paris four days ahead of Gustav. She instructed Gropius to get on the train in Munich, and to use the pseudonym Walter Grote when he bought his the ticket, in case the wary Gustav looked at the list of travelers. She would be waiting for him in the second sleeping car, in compartment number 13. When the train pulled into the station in Munich, Alma wore a veil so no one would recognize her through the train window. She sat nervously twisting a handkerchief inside her muff, hoping the encounter would come off without a hitch. When the compartment door slid open and Gropius appeared, she was in paradise. The bliss of that evening continued for four days in Paris; immediately afterward, Alma wrote Gropius, "Only a god could have made you. I want to take all your beauty into myself. Our two perfections together must create a demi-god."[33]

ONCE IN NEW YORK, Alma Mahler demanded from Walter Gropius the fidelity she had good reason to think he might not offer. Almost as soon as her ship had docked in America, she wrote him: "Don't squander your lovely youth, which belongs to me. . . . Keep yourself healthy for me. You know why."[34]

Alma's mother, still in Vienna, continued to encourage the affair. Anna Moll wrote Gropius that even though this was not the moment, she

believed that the love between him and her daughter would "last beyond everything." Frau Moll laid down the rules: "I have unlimited trust in you. . . . I am firmly convinced you like my child so much that you will do everything not to make her more unhappy."[35]

Alma was mentally living in two worlds simultaneously. Gustav Mahler was in good form; even as she longed for Gropius, she enjoyed an American Christmas with her brilliant husband and their child. It was bliss to look out of the ninth-floor window at the Savoy Plaza Hotel and watch the elderly father and their six-year-old daughter walk through Central Park cheerfully throwing snow at each other. Then, suddenly, everything changed. Mahler developed a high fever from tonsillitis. He conducted at Carnegie Hall in spite of it, but soon the composer was so weak from a streptococcal infection that his wife had to feed him with a spoon. They immediately returned to Paris to see a bacteriologist in whom they had more faith than the American doctors. In France, as Gustav Mahler further deteriorated from the endocarditis that resulted from the infection, his wife began to sign letters to Gropius "Your Bride." At the clinic where Mahler was being treated, in the Paris suburb of Neuilly, Alma wrote her lover from the room where she kept his picture hidden, imploring him to visit so she might feel his "warm, soft, dear hands."[36]

The Mahlers and their entourage returned to Vienna. On May 18, Mahler received an emergency application of radium bags. Then, as Alma later recalled, "There was a smile on his lips and twice he said 'Mozarte' "—an affectionate diminutive of the great composer's name.[37] Alma watched her husband use a finger to conduct Mozart on the quilt until he suddenly stopped, his hero's name still on his lips, and died at fifty-one. Alma noted what she considered an extraordinary coincidence: it was Walter Gropius's birthday.

A few days later, Gropius wrote Alma about Gustav Mahler's death. "As a human being he met me in such a noble way that the memory of those hours is inextinguishable in me."[38] That aplomb and tact would be crucial to Gropius's effectiveness as the leader of the Bauhaus.

GROPIUS WENT TO VIENNA, where he and Alma were reunited in his room at the Hotel Kummer. She told Gropius that during the time she was in New York, she and Mahler had had sex whenever he wanted. Gropius, who had remained faithful to Alma during their separation, was furious. He could not bear the idea that Alma had been making love with Mahler regularly during all those months when she was acting as his nurse. That she had betrayed him with the dying man to whom she was married did not lessen the sting.

The next day, Gropius wrote Alma a letter from the Kummer: "One

important question which you have to answer, please! When did you become his lover again for the first time? . . . My sense of chastity . . . is something overwhelming; my hair stands on end when I think of the unthinkable. I hate it for you and me, and I know that I shall remain faithful to you for years."[39] After he mailed the letter, he went back to Berlin—before she could answer.

As soon as Gropius arrived back in the German capital, he received a letter from Alma saying she was afraid she was pregnant and did not know what to do.

Mahler had been dead long enough that Gropius believed he was the father. He wrote her, "A feeling of shame is welling up in me . . . on account of my lack of mature precaution. . . . I . . . feel deeply saddened about myself."[40] Nonetheless, when Alma said she was coming to Berlin in September, he said he would not see her.

Then Alma discovered she was not pregnant after all. Liberated, she moved to Paris with her daughter. She begged Gropius to come to her.

This was one occasion when events so exhausted Walter Gropius that he could not function. He wrote Alma that the emotional turmoil of the previous month had left him too weak to travel; at the end of 1911 he checked into another sanatorium, the Weisser Hirsch, near Dresden. Informing his mother that "I know now how feeble I really am" and that he required a complete rest, he spent most of his time there walking in solitude.[41]

Alma Mahler continued to pursue Gropius for most of 1912. Feeling too

Oscar Kokoschka, The Tempest, *1913. Seeing this canvas in an exhibition, Gropius realized that his wife had another lover.*

wounded to respond, he left her letters unanswered until the end of the year, when he wrote her: "Everything has become basically different now. . . . I don't know what will happen; it doesn't depend on me. Everything is topsy-turvy, ice and sun, pearls and dirt, devils and angels."[42] That sense of life as the violent opposition of good and evil, with beauty vying to vanquish ugliness, would soon impel Walter Gropius to create and run the Bauhaus.

AT THE START OF 1913, Gropius went to the Berlin Secession exhibition. He was riveted by a painting by Oskar Kokoschka, who lived in Dresden. Kokoschka's previous work had left him cold, but this time one picture grabbed his attention. *The Tempest* showed a man and a woman being tossed around in a boat on a stormy sea. It took a moment before Gropius realized who the couple was. The woman was Alma, "lying calmly, trustfully clinging to" Kokoschka, "who, despotic of face, radiating energy, calms the mountainous waves."[43] That description was subsequently provided by Alma, who recounted how Gropius deduced from the canvas not just that she and Kokoschka were lovers, but also that, when he looked at its date, Gropius realized that the couple had begun their affair while she was still telling him that he was the love of her life.

When Alma later wrote about the impact of this moment on Gropius, she made no effort to conceal her excitement. She had met the tall, lean Kokoschka in the winter of 1912. The starving artist in torn shoes and a frayed suit captivated her immediately. He was "handsome . . . but disturbingly coarse. . . . His eyes were somewhat aslant, which gave them a wary impression; but the eyes as such were beautiful. The mouth was large, with the lower lip and chin protruding."[44] She had gone to him to have her portrait done, and he had interrupted his sketching to sweep her into his arms. The following day, she received a letter saying, "I want you to save me until I can really be the man who does not drag you down but lifts you up. . . . If you, as a woman, will strengthen and help me escape from the confusion of my mind, the beauty that we worship beyond our power to know will bless us both with happiness."[45] Alma's weakness for irregular-looking, emotionally overwrought men was even greater than her craving for the one who looked like a stage idol and was determined to exercise control.

After seeing that painting, Walter Gropius would wait more than a year before having any further communication with Alma Mahler. But he was far from through with her. Only when he was directing the Bauhaus would he grasp that her need to have tortured, brilliant lovers was chronic—and that he alone could not satisfy her.

3

It was in Gropius's nature to leap into treacherous territory with giant steps. In 1914, the Deutscher Werkbund—an organization of independent artists and craftspeople "determined to combat conservative trends in design, and to grapple with the impact of mechanical production on the arts"[46]—was staging a major exhibition in Cologne. Gropius, who was developing a knack for befriending influential people, prevailed upon the Werkbund secretary to persuade the exhibition planner to hire him to design several of its structures. For what he rightly sensed would be a turning point in the history of design, he moved to Cologne. The luxurious cabin he created for a train sleeping car was a highlight of the Werkbund show; it summed up the notion of stylish, up-to-date travel and delighted the public. The journey from Munich to Paris with Alma was probably in his thoughts as he conceived it.

The ambitious young architect made an even greater impact with a pavilion for displaying machines. Revolutionary in its mix of simplicity and bravado, this structure, one of the largest at the exhibition, had a façade that was like a perfectly drawn thick bracket encasing a wall of glass with the bracket's arms supporting an overarching roof, the profile of which was articulated in pure and simple white brick. A well-lit, unfettered, generous space, the building had both esprit and efficacy.

Alma Mahler heard about the Werkbund from Berta Zuckerkandl, the friend at whose house she had first met Gustav Mahler. Zuckerkandl had become a prominent journalist whom Alma considered an insider on the latest artistic developments. That May, telling Alma about the groundbreaking presentation of modernism, Zuckerkandl began to enthuse wildly about a young architect named Walter Gropius, saying he was the talk of the show. Zuckerkandl had no idea that the name would mean a thing to Alma. It was more than Alma could bear.

She sent Gropius a letter, which she signed "Alma Mahler (and nothing else anymore in this life)." She made no mention of Kokoschka. "I have a great desire to speak to you," Alma wrote Gropius. "Your image is dear and pure in me and people who have gone through so many beautiful and strange experiences should not lose each other."[47]

Alma beckoned her former lover to Vienna with an entreaty few men could have resisted: "I long for a will that would wisely guide me away from

what I've acquired, back to what is inborn. I know I could get there by myself, too, but I would so much like to thank someone for it!"[48]

THERE IS NO KNOWING whether Gropius was tempted to take the bait. The military conflagration that would soon evolve into a world war had begun. On August 5, Gropius reported to his regiment with the rank of sergeant major.

Within days, he was fighting against the French in the Vosges. He quickly demonstrated his leadership qualities, and in November he was promoted to lieutenant. Then, characteristically, Gropius plunged from intrepidness to anguish. In mid-December, a grenade exploded right in front of him. Although he was not injured, he fainted from shock. Shortly thereafter, his captain was killed before his eyes by a shot in the heart. By New Year's Day, nearly half of Gropius's regiment of 250 men had been lost. He was emotionally shattered.

"At night I got the screaming jeebies," he wrote his mother.[49] A military doctor sent him back from the front lines to a secure camp in the hope that he would begin to heal. But Gropius's insomnia became so debilitating that he had to be hospitalized in Strasbourg. Afterward, he required a convalescent leave back in Berlin.

A letter from Alma awaited him. The German newspapers had written about Gropius as a military hero, and she was desperate to see him. From his sickbed in Berlin, Gropius allowed that he might agree to meet up with her again. In February, she made the journey from Vienna to Berlin. Following their meeting, she wrote in her diary that he was "one of the most civilized men I knew, besides being one of the handsomest."[50]

The reunion lasted two weeks, best described by Alma: "Days were spent in tearful questions, nights in tearful answers."[51] Gropius hammered away about her betrayal of him for Kokoschka, but, finally, at their farewell dinner at Borchardt's Restaurant, the evening before he was to take a train to Hannover to return to the front, Alma knew she again had him in her clutches.

At the train station, during their final embrace, he pulled her onto the moving train. When Alma returned to Berlin the next day, after an unanticipated night in Hannover, it was clear that the woman who had signed her letters "Your wife" would get what she wanted.

GROPIUS'S COURAGE WAS RESTORED. That March, he again acquitted himself with valor on the battlefield by deliberately attracting fire from the French troops in order to determine their precise location. One bullet penetrated his fur cap, another the sole of his shoe; a third went through the right side of his

coat, a fourth through the left. His bravery won him the Bavarian Military Medal 3rd class with swords.

In spite of the heat of combat, he was writing to Alma every day, as she was to him. Again Alma thought she might be pregnant. Having said a year earlier she was and would always remain "Alma Mahler," she now signed a letter "Alma Gropius! Alma Gropius!" with the instruction "Do write this name in one of your letters." Alma proposed that he take a furlough so they could marry, while initially keeping it a secret. The prospect excited her unbearably: "I am glowing and cannot sleep."[52]

One reason to conceal the marriage was that Gropius's mother objected strenuously to the love affair. Having been essentially on her own in the world since the death of Walter Gropius, Sr., in 1911, Manon Gropius threatened that she would leave Berlin if her son did not put a halt to his relationship with a woman she considered tainted by scandal. Gropius would not be cowed, however. He had not acceded to Alma's wish for a secret marriage, but now he and Alma met with his mother and told her that they intended to wed.

His mother embodied the attitudes that he would devote his life to changing. Arguing with her, he demonstrated the iron will with which he would start the Bauhaus. Gropius explained to Manon that he had always challenged convention, while she embraced tradition. With her, he was not merely confronting conservatism and old-fashionedness, but also dealing with extreme belligerence and a lack of compassion he found intolerable. Walter Gropius relished the path to rightness, and nothing would stop him once he had made up his mind; he had the confidence that his viewpoint was the correct and humane one.

Gropius advised his mother to write the woman he intended to marry. That will to broker peace was one of the architect's most powerful traits, and he had what it took to get difficult people to comply. Manon sent a conciliatory letter. Still, Gropius and Alma married in a secret ceremony in Berlin on August 18, 1915, without telling his mother.

By now, Gropius was addressing Alma by her middle name, Maria. Supposedly this was because he wanted to differentiate himself from the men who called her Alma. But Maria, of course, was what Mahler had called her—the habit to which Freud had attached such significance. Gropius's real reason was very likely to identify himself further with the brilliant composer who had preceded him in Alma's bed.

The day after the clandestine wedding, the rich young widow wrote of her marriage to the handsome lieutenant: "My objective is clear—simply to make this man happy. I am unshakeable, calm, stimulated as never before." But Alma almost immediately became annoyed with him. She blamed

Gropius when he was forced to return to the front soon after their wedding; she saw no justification for his abandoning her to his family and the city of Berlin, both of which she disdained.

Even though Alma regarded her husband's military obligations as a personal insult, she dutifully accompanied him to a military equipment store on an exceptionally hot summer day so he could choose the leather for his riding boots. When he deliberated too long over the selection, however, Alma lost patience. Unable to tolerate the strong smell of the Russian leather in the heat, she rushed outside. She complained that "Gropius took his time," while she always bought things "quickly, unthinkingly, and not always wisely."[53] Waiting in the fresh air and contemplating this difference from her meticulous, design-obsessed husband, Alma bought a magazine from a peddler. In it was a poem by Franz Werfel, "Man Aware." It made an indelible impression on the woman who was anticipating her husband going off to war, and she noted the poet's name.

ONCE BACK AT THE FRONT, Gropius had even more on his plate than his marriage and his obligations as a soldier. That April, Henry van de Velde, the innovative architect who had created the Grand-Ducal Saxon School of Arts and Crafts in Weimar, a small and picturesque city in the bucolic region of Thuringia, had been forced to resign from his position as its director because he was Belgian. He asked Gropius to assume the post, writing, "You are, dear Herr Gropius, among those people whom I have always wished well and hoped the world would remember."[54] Initially, Gropius did not take the offer seriously. Then the grand duke shut down the school, not merely halting activities because of wartime, but decreeing, as van de Velde wrote Gropius in July, "that the Grand-Ducal School of Arts and Crafts cease to exist as of October 1." Van de Velde was shattered by the closing of this institution that had provided free design advice to industry and craftspeople. "Everything is so pitiful and sad that one could weep," the Belgian lamented.[55]

Gropius did not receive this letter until after he had returned to his military encampment following his wedding. By the time he read it, he had also heard from Fritz Mackensen, the director of the Grand-Ducal Saxon Academy of Fine Art in Weimar—a completely separate institution in the city that was a bastion of German culture. Mackensen asked Gropius to head an architecture program there. Mackensen believed that the demise of van de Velde's School of Arts and Crafts was not a bad thing. It had, Mackensen complained, a "feminine character," evident in its failure to advance the applied arts and its neglect of architecture.[56]

Gropius was captivated by Mackensen's proposition. He responded from his field headquarters that he would entertain the idea if he could dictate the terms. Architecture had to be a core subject, not a peripheral one, for it

was "all-encompassing. . . . I would be able to work well only according to my *own* ideas. The *absence of restrictions* must be an explicit condition."[57]

As soon as she got wind of this proposal, which would change her new husband's home base, Alma wrote Gropius that Mackensen was a liar and should not be trusted: "This position is not so grand. You should enter into it only if they give you all the authority you ask for in *writing*."[58] She advised Gropius to speak to the grand duke himself. The word "Bauhaus" did not yet exist, but the institution was under way.

4

The meeting that Alma wanted occurred in January 1916. The Grand Duke and Grand Duchess of Saxe-Weimar summoned Walter Gropius to Weimar from the Vosges, where he was billeted with his regiment that winter. The encounter that led to the creation of the Bauhaus could not have occurred in a setting less like the Bauhaus in style. Gropius was greeted at the gatehouse of the grand *schloss,* a spectacular baroque structure built in the seventeenth century. He was taken through vast galleries, up the magnificent and imposing grand staircase, and through one opulent salon after another before arriving in the grand duke's private chambers. The subsequent conversation went perfectly, and Gropius left feeling confident that he would be able to develop a teaching program with far-reaching ramifications. He had to return immediately to his battalion, but he wired Alma, ecstatic about all that would occur once the war was over.

Alma now loved the idea. "Your telegram of today puts a ray of happiness in my heart! Weimar! I would like that *best*! A small house there to begin, away from relatives and friends. . . . My God, that would be lovely. See that it gets done!"[59] She had little interest in the agenda of the school or of its possible global significance, but thrilled to the prospect of domestic life in the picturesque city where Goethe and Schiller had lived.

In his encampment on the western front, Gropius began to imagine his new institution. The grand duke's chief of staff, Freiherr von Fritsch, had asked him to identify the changes he would make to the Academy of Fine Art once it took over some of the functions of the former School of Arts and Crafts. Gropius's thinking on the subject reflected his circumstances of the moment. While formulating his program, he was dealing on a daily basis with the tools of warfare—guns, cannons, the straightforward architecture of military camps—and with a cross-section of German society. The army was still a hierarchy, but every level of citizenry was present in it, and neces-

sity ruled. Gropius wrote out for von Fritsch his guidelines for a collaboration of artist and craftsman that blurred the distinction between the two. He conjured an atmosphere of teamwork in which hardworking individuals with different areas of expertise would come up with effective as well as pleasing designs for objects and buildings, and in which mechanical methods would replace dependence on handwork. The latest technology would be applied to the realm of everyday living. In turn, Gropius envisioned that hard-nosed businessmen would be persuaded to endorse artistic creations. Worlds that had previously been considered separate—industry and artistic creativity—would be joined.

Gropius was promulgating the modernism he had discovered in Peter Behrens's office and advanced with his own Fagus factory and the Werkbund machine hall, in conjunction with the spirit of cooperation and mutual dependence he had acquired in the army. And he was applying to other realms the qualities of design and meticulous execution he experienced every time he cocked his rifle or loaded a bullet.

WALTER GROPIUS DID NOT EXPECT the grand duke to favor all of his ideas. The young architect knew it would require a lot of cajoling to get his patron, who viewed the world from an ornate desk and grand canopied bed in a palace, to do away with notions of traditional handwork. The idea of merging art and industry in the institution that bore the grand-ducal crest would not be readily accepted. But as he had demonstrated with Alma, Gropius knew when to be ardent and when to be reticent. A tactician par excellence, he recognized the language and tempo required to deal with officialdom if he was going to nurture the seeds of such a revolutionary institution in territory ruled by nostalgia for the golden days of the nineteenth century. Van de Velde and Mackensen had both known what they were doing when they tapped the courtly lieutenant to advance their cause.

When plans for the new art school were tabled while Gropius returned to the front lines and the grand duke and Von Fritsch devoted themselves to their work on behalf of the military effort, Gropius needed to apply his tactics in a different realm. Manon Gropius was irate when she learned of her son's clandestine marriage. Walter tried to make her understand that because Alma loathed being in the public eye, which it was no easy task for Gustav Mahler's widow to escape, the secrecy had been essential. Beyond that, as the lieutenant wrote his mother from the front, he and his wife both considered "conventions a . . . great evil."[60]

Manon Gropius finally bowed to her son's request that she accept the match and reach out to his wife. Alma, however, was less agreeable. She wrote Gropius, "This is the first letter from your mother which comes from the heart, though from a narrow-minded one. . . . She is very greedy for

power. . . . You go ahead writing her your good, brave letters. . . . Be all son!! As before, without telling her about your real life's aims. She is not capable of understanding any of them." Alma was determined, however, that Manon grasp what a step up Walter had made by marrying her: "Tell her that the doors of the whole world, which are open to the name Mahler, will fly shut to the totally unknown name, Gropius." After reminding her husband that Manon's own husband, Walter's father, had never advanced in his work beyond the level of thousands of other people, she boasted: "There was only one Gustav Mahler, and there is only one Alma."[61]

Even if the grand duke was unaware that she and Gropius were husband and wife, Alma knew that their love affair had long been the subject of gossip. She was proud that his involvement with her enhanced the image of Gropius's forcefulness. And she was determined that Gropius recognize the ordinariness of his own family compared to the aura he had gained by being linked to her. She goaded him not to "fall back into the Philistine allee," while letting him know that she admired his ability to rise above the level of his uninspired, uninspiring family.

Her taunts goaded him all the more to try to combat the old order. In the school he was imagining, he would meet the challenge of changing the daily details of millions of people. ~

WHILE GROPIUS DEVELOPED his ideas for the Bauhaus in an army camp, Alma went to Berlin. She refused to get in touch with her mother-in-law, but flew into a rage when Manon did not call on her at her hotel. The new Mrs. Gropius then insisted that her husband take a furlough to compensate her for her suffering by escorting her to an important party in Vienna.

He could not get permission; effective as Alma Mahler usually was, her demands had no impact on his commanding officers. But when Gropius was able to obtain leave to spend Christmas of 1915 with Alma in Vienna, their relationship was again idyllic. Alma and Gustav's daughter, Gucki, now adored Walter as if he were the father of her dreams. Afterward, once he was back at the front, he wrote his mother, "I don't know how I deserve so much love and joy." All that was still needed was for Manon to "feel what great soul lives in my beloved wife."[62]

What Walter Gropius next said to his mother about Alma revealed some of the same motives that prompted his creation of the Bauhaus: "I have only one great wish: that I may be able to live up to her expectations. . . . She will make of me everything possible with her steady longing for perfection."[63] He craved improvement of himself and the world.

The woman who longed for perfection was a torturer. Following their marvelous holiday together, she began writing him at field headquarters with descriptions of various men who found her irresistible. "That my

beauty makes such an impression on him, I didn't know," she reported about one admirer.[64] She played music for a second suitor, and welcomed visits from a third. Of course, she assured Gropius, she was faithful to him—though the others were trying hard to win her over.

WHILE DECLARING THAT HIS "one great wish" was to meet Alma's standards, Gropius had another burning desire as well. In his tent, he typed eight pages of ideas for the new educational institution that would work in tandem with German industry. He sent the report to the Grand-Ducal Saxon State Ministry. It warned that with machine production having substantially replaced handwork, the new mechanization brought with it "the threatening danger of superficiality." Gropius considered such inferior design an ominous threat to human well-being. The school he proposed would realize "technical and economic perfection" in tandem with "beauty of external form."[65]

Business leaders needed to listen to artists, Gropius advised the ministry. "For the artist possesses the ability to breathe soul into the lifeless product of the machine, and his creative powers continue to live within it as a living ferment. His collaboration is not a luxury, not a pleasing adjunct; it must become an indispensable component in the total output of modern industry."[66]

Through art publications and the occasional exhibitions he had seen in Berlin, Munich, and Vienna, Gropius had become alert to a handful of artists who had those "creative powers" in abundance. Besides pulsing with the "ability to breathe soul" that Gropius considered vital, the paintings of the Swiss artist Paul Klee were possessed of the purity and integrity Gropius craved in the realm of design. Gropius did not yet have the idea of summoning people of Klee's caliber to his proposed school, but at least he felt he was not alone in desiring a very different approach to visual experience.

Gropius recognized that the gap between technology and the artistic realms would not be easily bridged. What was required was a state-backed educational institution where students would be carefully selected according to "their previous training and their natural capabilities." These gifted individuals would then be guided by competent teachers in design studios. First they would receive practical training. They would then learn *organic design* (the italics were Gropius's way of emphasizing the idea) in lieu of "the old, discredited method, which was to stick unrelated frills on the existing forms of trade and industrial products."[67]

Gropius came from a world in which the esteem for decorum struck him as inherently false. He also felt buffeted around by his personal relations. In his educational program, he had jumped to surer territory. His ideals offered a transparency and truthfulness that were otherwise lacking in his life.

Gropius's imagined prototype for a great teacher at the new school would

have the power to guide the pupils to clarity and effectiveness: "False histor-
ical nostalgia can only blur modern artistic creation and impede artistic
originality. He has to direct the students to look ahead and strengthen their
confidence in their own nature and in the power of time, but without
neglecting the legacy of the art of past ages with false pretentiousness."[68]
That respect for the artistic wonders of the past was not to be confused with
a weak attachment to outmoded form. But what mattered most of all,
whether for students or teachers, was faith in oneself.

WALTER GROPIUS WAS IMAGINING a time when the everyday objects of human
existence would be clearly conceived, ornament-free, clean, and functional.
The most suitable substances would be employed; new manufacturing
methods would be put to work. Efficient and pleasing household objects
would bestow emotional benefits on their users. Convinced that design
rooted in ingenuity and clear thinking benefits all who encounter it, while
pretentious or illogically conceived objects do harm, he intended to replace
human confusion with satisfaction and a sense of rightness.

Pounding out his manifesto as cannons blasted within earshot, Gropius
concluded: "A school led in the above way could bring real support to the
trades and industry and would be able . . . to stimulate the industrial arts in
their entire scope, more so than their own production of exemplary pieces
would." As an exemplar of the noble collaboration he envisioned, he cited
the Bauhütte, medieval lodges in which people from every artistic disci-
pline—"architects, sculptors, and craftsmen of all grades—came together
in a homogeneous spirit and humbly contributed their independent work to
the common tasks resting upon them."[69]

That ideal of anonymity, of working toward a higher goal, would be
shared by all the true giants of the institution whose name would simply
replace "hütte" (huts) with "haus" (house). It is no wonder that those of the
true Bauhauslers who lived long enough would loathe with such vehemence
the careerism, and the confusion of celebrity with more important values,
that have come to dominate the art world.

5

For Walter Gropius's wife, however, celebrity was an essential issue—even
as she tried to escape it. In February 1916, Alma was pregnant—this
time for sure. Yet since most people did not know that she was married, she
was unwilling to reveal that she was expecting a child.

Alma and Walter were both thrilled by the prospect of a baby, but her insistence on secrecy, along with the discomforts of pregnancy, made the expectant mother extremely tense. For that reason, Gropius did not tell her that he had been in a plane that crashed on an observation mission. The pilot was killed, and although Gropius managed to limp away from the scene, it had been a close call.

Since it was not in his nature to ask for sympathy, his reticence came naturally; even if he had wanted it, he probably would have received little comfort from the volatile Alma. When Gropius wrote to inquire about progress on a porch he had designed for her house, she replied furiously. She blasted him for his failure to grasp the impossibility of getting workmen during wartime: "This thoughtlessness makes me wonder. *Such inconsiderateness!*"[70] Did he not realize how tiring anything to do with a construction project would be for her while she was pregnant? Was he that ignorant of her reality while he was out there on the front?

Alma scolded mercilessly. "And *you* want to carry out a practical profession while you have no idea how much you can demand of a person! And you want to be my support while you burden me carelessly with unnecessary tasks! . . . This has shocked me . . . because consideration is what I *demand* of you."[71] She snapped that perhaps he also wanted her to make alterations to the janitor's house.

Then the monstrous Alma made herself irresistible. In midsummer, she wrote Gropius the sort of thing that could not fail to fire up a man confined to a military camp. "I am very sensual, long always for unheard of things. Want to suck you in from all sides like a polyp. Stay true to me! . . . Pour your sweet stream into me, I am starving."[72]

Alma's physical appearance had evolved. A decade earlier, as Mahler's wife, she had been a bewitching young flirt whose unruly looks were part of what made her so compelling; now the vixen had become a refined goddess. A photograph of her in profile shows a visage that, firmed up with age, conformed to the rules of classical proportion, where forehead, nose, and the line from the bottom of the nose to the point of the chin are all equal, each a third of the total. Her nose was as straight as if it had been precisely drawn on a Greek vase, and her lips were perfectly proportioned. Alma's slightly bulbous jutting chin and sharply angled jaw might have been considered her one facial flaw, but they resembled the idealized types painted by the neoclassicists. Her long and narrow neck and her porcelain-like skin were in the same tradition. Her well-coiffed, thick, dark, wavy hair, turned and pinned in a soft chignon, was a crowning glory.

To be in love with this tantalizing woman while dealing with the horrors of the battlefield and dreaming of an art institution that would transform civilization was more than Walter Gropius could bear. German war casual-

ties mounted, and prospects for victory diminished as the British and French broke through along the Somme. Alma, meanwhile, kept taunting him, and she continued to bicker with his mother; the two women complained about one another to him, and he could do nothing about their problems. Walter Gropius began to descend into personal darkness.

DURING THE SAME SUMMER as the German defeat at Verdun, Gropius wrote his mother: "I am livid with rage, sitting here in chains through this mad war which kills any meaning of life. . . . My nerves are shattered and my mind darkened."[73] Such despair would be shared by many of the most creative people he would summon to the Bauhaus. Wassily Kandinsky and some of the others turned to visual experience as a lifeline in part because they felt that the outside world was beyond their control, incomprehensible, and deeply upsetting. The balance lacking in their surroundings, in their own minds and personal connections, had to be found elsewhere. The making of buildings and art could help them restore that lost sense of meaning.

For the architects and painters at the Bauhaus, cerebral doubt and uncertainty could be counteracted by the reassuring resistance of steel, the clarity of large sheer planes of glass. The muddiness created by governments could be tempered by the luster of polished chrome. The emotional anxieties generated by militarism and inflation formed a compost that nourished a passion for a stability derived from visual harmony. As Gropius's problems with one of the most tyrannical women of the twentieth century became insurmountable, his resolve to realize marvels in the aesthetic realm would only intensify.

During that gruesome August of 1916, while Gropius went back and forth between the battlefront and his field headquarters in the Vosges, Alma let him know that a married man was making her loneliness bearable. "His wife is in no way disturbing," she informed her husband, while explaining that "I must surround myself with serenity."[74] It was her pregnancy, she told Gropius, that justified her need for a man at her side. She relished every kick of their baby inside her and could not endure such a rich experience in solitude.

AT HOME, with her activities limited by her pregnancy, Alma was, in spite of her own peccadillos, jealous of her husband at the front. Gropius had a gig he loved to drive on his rare day off, and Alma often envied him galloping along in it. That he was in danger most of the rest of the time had no bearing for her. She thought he was using the gig to search for women. Then one day Gropius went out driving and the gig turned over just after he left the stables. Gropius was injured and the carriage shattered to bits; the horse ran

away. This time Gropius did not keep his injury from Alma. When she heard the news, she blamed herself for being a wicked sorceress.

Alma's impact on her lovers was certainly beyond the norm. Around this time, Oskar Kokoschka, who had been injured by a bayonet when serving with the Austrian army in Russia, returned from the front and learned of her marriage to Gropius. Shortly thereafter, Kokoschka commissioned a Munich dollmaker, Hermine Moos, to make a life-size doll of Alma. Kokoschka provided a drawing, also life-size, of his former mistress, and instructed Moos:

> I ask you to copy this most carefully and to transform it into reality. Pay special attention to the dimension of the head and neck, to the ribcage, the rump and the limbs. . . . Please permit my sense of touch to take pleasure in those places where layers of fat or muscle suddenly give way to a sinewy covering of skin. For the first layer (inside) please use fine, curly horsehair; you must buy an old sofa or something similar; have the horsehair disinfected. Then, over that, a layer of pouches stuffed with down, cottonwool for the seat and breasts. The point of all this for me is an experience which I must be able to embrace! Can the mouth be opened? Are there teeth and a tongue inside? I hope so.[75]

During the six months it took to make the doll, Kokoschka bought Parisian undergarments and clothing for it. Once it was completed, he painted it just as he had painted Alma's portrait, traveled in an open carriage with it, and bought opera tickets that allowed the doll to have the seat next to his. Finally, he gave a party at which the doll, exquisitely dressed by his maid, was present. "When dawn broke—I was quite drunk, as was everyone else—I beheaded it out in the garden and broke a bottle of red wine over its head."[76]

IN SEPTEMBER, Gropius was granted a furlough to coincide with Alma's due date. The baby, however, failed to appear during the seventeen days allotted. On October 6, he was back in the Vosges when he received a terse telegram announcing that a daughter had been born the previous day.

Gropius was devastated to be so far away. "My child has entered this world. I don't see it, I don't hear it," he lamented to his mother. He had no idea, either, that after ten months of pregnancy Alma had deliberately injured herself to make it appear that she was hemorrhaging so that the doctor would be willing to perform the delivery surgically. It was nonetheless an excruciatingly painful labor, following which Alma, upon learning she had given birth to a healthy girl, immediately cried out, "Now, I also want to have a boy."[77]

A week after the birth, a desperate Gropius still had no information

about how Alma and the baby were doing. On October 16, he wrote his mother, for whom the little girl had been named, "I wait with chattering teeth for what fate has in store for me, who is so miserably helpless."[78]

Alma did one of her turnarounds. She overcame her resentment at the infant's being female, and began to adore her and to experience great joy when nursing her. She also started to think favorably of her absent husband. Alma felt that Gropius was "immensely generous" when from the front he arranged for her to receive, as a gift in honor of their baby's birth, Edvard Munch's *Midnight Sun,* a picture she had long adored in the collection of a wealthy Viennese, Karl Reininghaus. But when Gropius was finally granted two days' leave to go to Vienna to see his baby for the first time, Alma greeted him with hostility. The excited father had taken an overnight train from France where the only available space for him was in the locomotive. He rushed home eagerly, only to have Alma recoil from "him, grimy, unshaven, his uniform and face blackened with railroad soot." That description is her own; she felt no need to mask her disgust. Deciding that her husband looked like "a murderer," Alma blocked his way to the swaddling table and prevented him from touching their baby; she only let him "glance at his child from a distance" — this is her proud account of the event — after he pleaded with her. When Gropius accused her of being "like a tigress," she acknowledged that "there was more to it than notions of hygiene."[79] The real problem was that their relationship was waning.

What Alma had wanted above all from the marriage was a child. Now that she had achieved her goal, and had come to accept the baby's not being a boy, she had little use for her husband. "I am no longer interested in his existence," she wrote in her diary. "And yet, I loved him once!" The soot was only one of many things that bothered her. Gropius had been given to fits of jealousy during his brief leaves; recalling how he hurled a fan by Kokoschka into the fireplace, Alma found his rage unforgivable. While she was pleased that Gucki, now thirteen, "loved Walter Gropius," Alma felt her own relationship with him was comparable to her older daughter's.[80] She was, she decided, like an adolescent who saw the man she loved only on rare occasions; the relationship was not that of a wife who lived with her husband. The reason for Gropius's absence was irrelevant.

Alma wrote of Gucki, "With Gropius she was really infatuated. What seemed to attract her in particular was his mustache; when he shaved that off he was suddenly much less beautiful in Gucki's eyes, and her romantic interest diminished."[81] Contemplating her loneliness with her husband off in the army, Alma realized that she felt just as fickle.

ALMA CONSIDERED their Christmas that year a disaster. Gropius jealously insisted that she give away Kokoschka's portrait of her as well as Kokoschka's

drawings and fans. By Gropius's account, on the other hand, he was welcomed warmly upon his return for the holidays and their daughter's christening. He was pleased at how well Alma had managed their separation with a frenzy of shopping, playing the piano, seeing friends, and going to the opera, and he passed a vacation of "the greatest inner harmony" with his wife, baby, and the stepdaughter who continued to adore him.

A similar approach to unpleasantness would mark his tenure at the Bauhaus. He was not naïve, but he deliberately dealt with conflict by acting as if things were better than they actually were and intentionally blinding himself to problems. He was conducting his marriage in the same way that he would direct the art school: by minimizing the impact of controversy.

ON THE MORNING that Gropius left to rejoin his regiment, when he and Alma said good-bye on the staircase outside the apartment that Alma had had with Mahler and still considered her home, she affected her "brightest smile to help him over the sad departure." But what was really on her mind was a concert that afternoon at which the Amsterdam Concertgebouw Orchestra was going to perform Mahler's *Song of the Earth*. When Gropius missed his train and rushed home, Alma was appalled when he rang the bell "violently" and "burst in." Her response was that "coming back is always a mistake."[82]

Franz Werfel, photographed by Carl Van Vechten in 1940. Alma was rarely content to have only one man at a time.

Later that afternoon, the architect walked in the deep snow alongside the carriage in which Alma and Gucki were being driven to the concert. As he plodded in sequence with the horses, he begged his wife to let him join them. Alma had no ticket for him, which was a convenient excuse, since she was adamant that Gropius not attend. A friend had introduced her to Franz Werfel, the poet whose work she had read when Gropius selected boot leather, and she knew he would be at the concert.

Gropius departed again that evening. When he reached the border, he sent Alma a telegram instructing her to "splinter the ice in your features." By Alma's account, the words, ironically, came from a poem by Werfel.

Werfel called on Alma in her box at the concert, and then accompanied

her and Gucki home. Alma wrote in her diary, "It had to happen. It was inevitable . . . that our lips would find each other and he would stammer words without rhyme or reason. . . . I can repent nothing. . . . I am out of my mind. And so is Werfel."[83]

In February, Gustav Klimt died, making Alma realize that she "had never stopped loving him" either.[84] Everything was happening at once. She would periodically take the baby Manon to Berlin, the nearest safe point to Gropius's encampment, so they could meet whenever he was granted leaves of two or three days, but she remained preoccupied by thoughts of Klimt and, again, Kokoschka. Franz Werfel, meanwhile, had her periodically visit him in Vienna at the Hotel Bristol, where he was correcting the proofs of *Day of Judgment.*

And, although she did not tell anyone, Alma was again pregnant.

6

Gropius next went home in March. He wrote his mother about his five-month-old daughter: "I am totally in love with her. . . . She is lying next to me and sings endless songs, like a twittering machine. She is a cheerful child and full of vivacity. And very pretty though she looks so very much like me. Alma nurses her almost completely and performs amazingly well, taking care of the child without any help and at the same time finding occasion for music and social life. I felt I was in paradise."[85]

Such domestic bliss was the ideal of the architect who would devise the Bauhaus curriculum and design its residences. His goal was to improve everyday surroundings, and his starting point was the wonder of life itself. The greatest artist he would lure to the Bauhaus, Paul Klee, would make a marvelous painting there titled *Twittering Machine,* of a device that could be cranked to make mechanical birds sing. Sheer joyfulness was at the core of the Bauhaus mentality.

WHATEVER GROPIUS DID, he was consumed by passion. In every realm—architecture, fatherhood, womanizing, his military service—he sought the pinnacle. He was stationed in Belgium, where he taught military communications in an abandoned castle; its gardens and terraces were set into the landscape so as to form "the most beautiful and grandest sight I have ever beheld."[86] When he was transferred to a peasant's house to direct activities related to military communications—including the training of dogs, signal throwers, and homing pigeons—he delighted in his clean room, how-

ever modest, and his independence from the usual army routine. Gropius felt that given the difficulties others faced at that time, he had no right to complain about anything. He attributed the dreadful food—"turnips and so-called liverwurst"—to "the indolence of the gentlemen around here and I shall change all that."[87] That will to eradicate the harm caused by the combination of laziness and excess in the past would peak when he created the Bauhaus.

For now, Gropius was running a school with a very specific purpose: teaching communications. The entire army was counting on him. From his mental darkness of the previous year, he was beginning to soar with faith in his own abilities and effectiveness. He was sent to Italy to instruct Austrian soldiers in the use of dogs to carry messages through crossfire. Gropius's success at that mission would win him, at the start of 1918, the Austrian King's and Queen's Military Merit Medal 3rd Class with War Decoration.

Meanwhile, by the end of 1917, in the cafés of Vienna and Berlin everyone was beginning to talk about Alma's romance with another cultural celebrity whose name was almost as glamorous as Gustav Mahler's. Only Alma's husband, living on turnips and training messenger dogs for the military, remained ignorant. Gropius spent another Christmas leave in Vienna thinking that his life was perfect, that relations with his wife and daughter and stepdaughter were flawless, and that Alma's sole wish was to move to Baden-Baden to be closer to him. He still had a couple of months of blissful ignorance ahead before he figured out what was going on between Alma and Franz Werfel. It was a piercing wound to his ego from which he would never fully recover.

Werfel had an allure with which Gropius could not compete. The Czech Jewish novelist and poet came from a rich family—his father was a successful glove merchant—and he was a close friend of Franz Kafka, with whom he had attended high school. Werfel, who spoke and wrote in German, had published his first book of poems in 1911, when he was twenty-one; his verse had instantly created a sensation, making him a major figure in the movement of poetic expressionism. Werfel's line "My only wish is to be related to you, O Man!" was on everyone's tongue. It had the intensity Alma found irresistible.

The higher the emotional pitch, the more enchanted Alma became. At the start of the war, Werfel had joined Martin Buber in a movement endorsing pacifism, and in 1915 he adapted Euripides's play *The Trojan Women* to emphasize the merits of peace and love in those treacherous times.

The intense cigar-smoking rebel pacifist who wrote that he wanted to be "dissolved by feeling," and who made Gropius seem laconic by comparison, was able to turn Alma's head and heart from her husband.

Werfel had none of Gropius's good looks. His irregular features, con-

torted in a downtrodden expression under a furrowed brow, defined angst. He was not as dashing and was from a less socially acceptable family; even if the Werfels had money and were assimilated, they would always be thought of as Jews. He was so outspoken in his pacifism that after the war he would be tried for high treason. All this only enhanced his allure for the volatile, capricious Alma.

Even before he knew about his wife's new liaison, Walter Gropius was descending into another period of emotional darkness, from which he would emerge only when he devoted his energies to the Bauhaus. Exhausted by a war that was heading toward a bitter defeat for Germany, he was longing to return to architecture, and to be recognized. He wrote Osthaus, "I'm crumbling inside. . . . I don't want to be buried alive and must therefore get mightily busy so that people see that I'm still here."[88] At the start of 1918, he sent his mother a letter from the war zone saying that his life had become "unbearable. I feel that I am mentally reduced and my nerves are getting worse."[89]

Like so many Germans at that time, Gropius latched on to a scapegoat for all that had befallen his nation: "The Jews, this poison which I begin to hate more and more, are destroying us. Social democracy, materialism, capitalism, profiteering—everything is their work and *we* are guilty that we have let them so dominate our world. They are the devil, the negative element."[90] In the same letter he told his mother that he had just learned that Alma was again pregnant. He did not yet know that his wife's Jewish lover was the father of the baby.

IN MAY, Gropius briefly cheered up: he believed that the Germans might prevail against the French after all. But then he was wounded in combat. Hospitalized, he again crashed from ebullience to bitterness. Now he deemed the war "insane . . . What a gloomy fate to have to sacrifice everything that makes life worthwhile for an ever more doubtful patriotic ideal!" His financial situation had become so dire as the result of years without any income beyond his meager military stipend that once he was released from the hospital he could not afford to buy a loaf of bread for his meager meals. The little he earned from the army he sent home to Alma, for he was determined that she not depend only on money inherited from Mahler to bring up their daughter. "My pride does not permit that my child be raised by money that another man has made," he wrote his mother. Nothing was going his way: his mother, contrary to his instructions, had given one of his suits to the janitor, although it might have been worth as much as four hundred marks. Alma's "touching noblesse" was the only thing that made his situation bearable.[91] He still had no clue about the truth of her pregnancy.

Then Gropius was recalled to the front lines. Between Soissons and

Rheims, he fought a battle in which a building collapsed on top of him, along with everyone else in his contingent. Miraculously, a flue penetrated the rubble near his head, allowing oxygen in; for three days, crushed by debris, he cried out, his voice weakening by the hour. Finally, some passing troops heard him. They pulled off the stones, chunks of plaster, and wood under which Gropius was pinned and took him to a field hospital. Of the many men who were buried alive, Gropius was the sole survivor.

While in the hospital, Gropius received a letter from the School of Arts and Crafts in Hamburg, asking him to teach there. He declined the invitation by making clear his greater intentions: "I cannot decide to say yes. I cannot imagine myself fitting into the existing curriculum. I am too self-willed for that and have had my own very definite ideas for a long time, very different from the existing ways, as to how architecture is to be taught. On this one cannot compromise and I see no other way but to continue my efforts to found a school program of my own."[92]

Lying in that makeshift hospital on the front, absorbing the shock that he was the only one still alive when so many friends and comrades had died at his side only days before, Walter Gropius now knew without a doubt what he had to do in Weimar.

7

On August 2, before dawn, Alma Mahler Gropius went into labor in her house in the countryside. The infant was going to be dangerously premature, and her own health was in danger.

Alma summoned Gropius, who had managed to get himself transferred to a military hospital near her. He rushed from his bed and fetched a gynecologist and a midwife. When they arrived at Alma's bedside, the doctor ascertained that the baby was in breech position and the delivery could not be performed at home. When Alma left the house, she had to be transported head down and bundled against an icy wind, while little Manon stood there as if to say good-bye forever. Gropius led his miserable wife and the doctor and midwife by carriage, cattle wagon, and train to a sanatorium.

A baby boy was born. But, as feared, there were complications. The baby had convulsions on his third day of life, and was too weak to nurse. Several days later, Gropius was awarded the Iron Cross 1st class, and with it came the exciting news that if he returned to the front he would have his own horse. To abandon Alma and the children was, however, out of the question. He let his superiors know he could not leave Vienna.

Two weeks after the birth, Gropius wrote his mother that throughout the long ordeal "I stood with admiration before Alma's bed. This control, this standing above it all, always thinking of others, not of herself. She has a great magnificent heart and it is no accident that people love her so much. She deserves it."[93]

Lieutenant Gropius had no idea that three days after the baby was born Franz Werfel had asked Alma, "Is it my child?" The following day, when Werfel saw the baby for the first time, he wrote in his diary, "I felt at once and distinctly that it belongs to my race. . . . The rhythm of its substance seems strongly Semitic."[94] He set to work on some verses he called "The Birth of the Son."

Then, on August 26, Gropius, who had managed to extend his leave, overheard a phone call. Alma was talking with Werfel in an endearing voice, addressing him with the familiar "Du," discussing what name should be given to the baby, and agreeing on Martin. This was the name of Gropius's famous great-uncle, but that was a red herring. Without letting Alma know he had heard anything, Gropius went to see Werfel later that same day.

Werfel was napping and did not hear the knock on the door. Gropius left his card and attached a note to it. He followed Mahler's example of a betrayed husband acting with dignity. He wrote Werfel, "I am here to love you with all the strength at my command. For the love of God, be careful with Alma. A disaster could happen. The excitement, the milk—suppose we lost the child."[95]

Werfel was unnerved by Gropius's generosity. He thought he might faint out of guilt at inflicting pain on someone of such noble feelings. He wrote Gropius to convey his deep thanks and admiration. Alma was overcome with remorse, especially when she considered how Gropius had taken care of her throughout the difficult delivery and its aftermath.

Shortly after Gropius wrote Werfel, his furlough came to an abrupt end. Germany's military situation had suddenly taken a turn for the worse. He immediately returned to the front, near the Marne. He was not there for long, however. At the end of September, Hindenburg and Ludendorff requested an armistice and accepted the defeat of Germany.

WALTER GROPIUS RETURNED to Berlin. From there he went to Vienna and proposed to Alma that they divorce—with the condition that he have custody of their daughter. He anticipated that he would be released from the military on November 18, 1918, the day he would be thirty-five and a half years old. Then he would be in a position to care for Manon. Alma could remain with Werfel to bring up Gucki and the infant Martin.

When Alma refused, Gropius tried a different tactic. On November 4, he

went to Werfel's hotel and persuaded the poet to go with him to call on Alma.

Facing her husband and her lover, Alma announced that they both had to leave her. Her plan was to go off alone with the children. Gropius "threw himself at his wife's feet, beat his breast, implored her to forgive him. . . . All he wanted was to keep her, nothing else."[96]

Alma then decided that she would break with Werfel and resume married life. Yet when Gropius returned to Berlin, she began to see Werfel every day, in spite of her repeated promises that she would not do so. Meanwhile, it was becoming clear that baby Martin's head was growing disproportionately fast and that he was showing early signs of mental retardation.

Martin's condition worsened. In January he had a cranial puncture, the prescribed treatment of the era, but it didn't help. The outside world was no less confusing than the child's health and Gropius's marriage. A leftist-backed revolution swept Berlin; a state of anarchy ensued when two of its leaders, Rosa Luxemburg and Karl Liebknecht, were murdered. On January 19, a prime minister and a temporary president were elected, but control of the government was up for grabs.

In March, little Martin, no longer able to live at home, was put into a clinic so that he could receive medical treatment full-time. Alma blamed herself for his illness, as if it had resulted directly from her personal conduct. Nevertheless, when Gropius went to Vienna a month later to see his wife and try to sort things out, she was too busy going to and giving soirées to engage in a serious discussion with him. He spent time with his daughter, who was now three years old, and his stepdaughter, and attended Alma's parties—at one of them, he met Johannes Itten, an eccentric painter who would become one of the key figures at the Bauhaus—but he did not settle any of the major issues confronting him.

After being gone for more than four years, it was nearly impossible for Gropius to rekindle his architectural practice in Berlin. Trying to find design projects, he imagined "something entirely different now, which I've been turning over in my head for many years—a Bauhütte!" Again he used the word for a medieval masons' lodge and imagined a similar idea of living and working communally "with a few like-minded artists."[97] The person to whom he breathed this was Karl Ernst Osthaus, one of the few people he knew who could be counted on to help in his effort to replace uncertainty with hope and clarity.

The milieu in which Gropius had been raised seemed increasingly alien. When his uncle Erich died around the same time that Luxemburg and Liebknecht were killed and Martin showed the first signs of illness, the war-shattered soldier felt completely estranged from his relatives at the funeral. He wrote his mother: "I was totally alone among them. They are . . . obsti-

nately prejudiced and full of arrogant political megalomania, without ever looking at their own faults. They see only what is coming down, but not what is growing up. They know nothing about the mental processes of humanity."[98] Gropius distinguished himself from what he considered the loathsome mentality of Germany's class of wealthy landowners: they were attached to an obsolete way of life, but he was different—interested in progress and determined to focus on what was good for the masses.

Appalled by the brutal killing of Luxemburg and Liebknecht, whom he considered rare for their idealism and tenacity, Gropius identified with their support of revolutionary goals—even if his were in the realm of building rather than politics. He became all the more fervent once he was elected chairman of the Arbeitsrat für Kunst, a group of artists and architects committed to "a total revolution of the spirit"; they sought to create "large People's Houses," high-rise housing structures in which it would be evident, in Gropius's words, that "the building is the immediate bearer of spiritual powers, creator of sensations."[99]

THE TIME HAD COME for Gropius to pursue the directorship in Weimar he had discussed before the war intervened. The grand duke had been deposed, but Freiherr von Fritsch had become Oberhofmarschall of the new government. On January 31, Gropius wrote him that he, too, was starting afresh. Using the oldest ploy in the book, even if it was true—that he had been offered another job but would rather take this one—he stated his case that the arts "must be freed from their isolation," and that, perhaps contradictorily, "a small town" with "the remains of an old tradition" was the place for an approach that would infiltrate all of society in a completely modern way.[100] Gropius assured von Fritsch that he was prepared to dedicate his life to this project.

Von Fritsch agreed to a meeting on February 28. Gropius used the occasion to propose combining the two Grand-Ducal Saxon institutions—the Academy of Fine Art and the School of Arts and Crafts—and making them into a single entity that would be "a working community of the collective artistic disciplines, which . . . should eventually be capable of producing everything related to *building:* architecture, sculpture, painting, furnishings, and handicrafts." New workshops would function alongside the existing master studios, and the school would be "in closest contact with the existing crafts and industries of the state."[101]

Von Fritsch fully supported Gropius's vision. Within a few weeks, he had secured official approval. On hearing that the authorities had agreed to his proposal, Gropius suggested that it be called the Staatliches Bauhaus in Weimar.

Plans zoomed along. The former School of Arts and Crafts, which had

served as a hospital during the war, would house the new institution. Henry van de Velde's handsome building would clearly make a splendid setting for the school. The north façade had floor-to-ceiling windows that allowed copious daylight to pour into the workshops and studios; what was almost a wall of glass wrapped around the roof cornice so that the top floor had sky-lights as well. The inside was generous in scale, and, while nothing in it was as streamlined or pure as Gropius's own architecture, every door pull and hinge betrayed an impressive eye for detail and a gracefulness.

Gropius was hired to start work as director on April 1, at a salary of ten thousand marks a year. Declining the title of professor—"I have decided to keep free of these ridiculous external things which no longer belong in our time," he wrote his mother—the architect set out to find other radical thinkers to join the old guard from the Academy of Fine Art as faculty members.[102]

8

Gropius's first faculty appointment was Lyonel Feininger, an American artist who had been living in Weimar. Feininger made a woodcut for the cover of a four-page leaflet that explained the aims of the new school. The image was an abstracted Gothic cathedral, its steeple a soaring triangle. The amorphous structure was surrounded by a flurry of lines and flashing stars that impart radiant energy. Gropius wrote a brief manifesto that was the sole text for the leaflet. Summarizing the ideals he had initially formu-lated in his military tent, he declared, "There is no essential difference between the artist and the craftsman." In writing as in speaking, Gropius exuded confidence. "When young people who take a joy in artistic creations once more begin their life's work by learning a trade, then the unproductive 'artist' will no longer be condemned to deficient artistry, for their skill will now be preserved for the crafts, in which they will be able to achieve artistic excellence."[103] Emphasizing the importance of technical capability, Gropius demystified what it meant to be a painter or a sculptor.

Nonetheless, Gropius voiced great faith in the potential achievement of artists once they had the necessary know-how. "In rare moments of inspira-tion, transcending the consciousness of his will, the grace of heaven may cause his work to blossom into art. But proficiency of craft is essential to every artist."[104]

To achieve that expertise, students would be offered instruction in a range of fields. Whether they were trained as apprentices, journeymen, or

junior masters, they would pay 180 marks per year—double for foreign students. The assumption, however, was that the Bauhaus would soon earn enough money for its designs to be able to waive these fees.

Students immediately flocked to Gropius's Berlin office. He decided to start classes as soon as possible. By the end of April, the school was up and running.

OTHER THAN ONE QUICK TRIP to Vienna Gropius had made early that spring before moving to Weimar, he saw nothing of his wife and the girls; he settled into his role as director of the Bauhaus in solitude. In spite of Alma's earlier enthusiasm for the idea of moving to Weimar, every time she planned a trip there from Vienna she subsequently canceled it. After exploding to a friend, "What! Vegetate in Weimar with Walter Gropius for the rest of my days?" she let her passport expire.[105]

Alma decided that she wanted neither Werfel nor Gropius, but Ko-

Lyonel Feininger, cover of the program for the Staatlichen Bauhaus Weimar, 1919. This modernized Gothic cathedral became a summons for students from all over.

koschka. She nevertheless went through the motions of renewing her passport so that, in theory, she could go to Weimar, and was glad to have done so when her financial situation changed dramatically after the American government seized Gustav Mahler's royalties in this postwar period because of his status as an alien. The loss of that income was so significant that Alma had to consider the possibility of living with her husband. In mid-May, she and Manon and Gucki finally made the journey to the Bauhaus. Taking the train from Vienna, they crossed the recently created Czechoslovakia before reaching Berlin and continuing on to Weimar.

SHORTLY AFTER ALMA ARRIVED in Weimar, the baby Martin died in the Vienna clinic where he had been placed three months earlier. Gropius, who was legally Martin's father, received the telegram announcing the baby's death. Spontaneously, he turned to Alma and burst out, "If only I had died

instead."[106] He then sent a telegram to inform Franz Werfel of his son's death.

Few people at the Bauhaus had any inkling of the tortures that their founding director, always upbeat in public, was suffering in private. On the surface, it was as if nothing had happened. For Alma it was the same. She was a hit in Weimar—at least with those people who did not find her too much to take. One of the professors at the former academy, Richard Klemm, gave a tea to present the Bauhaus director and his wife to the city's old guard, and also to welcome the new faculty. The renowned enchantress from Vienna offered a sharp contrast to the more traditional Weimar types. "All who saw Alma were charmed by her beauty and superior bearing," according to Lothar Schreyer, a painter from Dresden whose work mainly consisted of human figures reduced to abstract elements, with circles and crosses and stripes taking on the roles of body parts, and who was among the first people Gropius invited to teach.[107] Following the reception at Klemm's, Lyonel Feininger wrote his wife, Julia, his impressions of the Gropiuses as a couple: "In him and her we are facing two completely free, honest, exceptionally broad-minded human beings who don't accept inhibitions, characteristics of great rarity in this country."[108]

That, at least, is how the situation was represented by Reginald Isaacs, Gropius's late-life biographer, who was a friend of Gropius's at Harvard, where the Bauhaus director ended up after World War II. But there is another version to this history. Lyonel Feininger wrote Julia, who was in Berlin, on almost a daily basis that May. Unpublished letters in the Feininger Archive give a very different impression of Alma's impact. On May 20, Julia wrote Lyonel: "Say hi to Gropius and his dear, fat wife. Has the püppchen [a derogatory German term that translates to 'little doll'—said as if with a sneer] in the meantime given you her hand?" That same day, Lyonel wrote to Julia: "She [Mrs. Gropius] is visibly bored and is a very lively and spoiled Cosmopolitan who won't be able to navigate Weimar for long."[109]

On May 22, Julia referred to "Madame Gropius—always for herself!" She wrote Lyonel four days later: "But oh, if all men there have such beautiful wives, so big and impressive, and so whatever, how will I, a poor little plant, feel among them all? I'm really dreading that, I don't even dare. And you of all people, the most important and first one of all, will then have such a wallflower for a wife!"[110]

For Lyonel Feininger, the greatest hazard in Weimar was the cost of living. He wrote his wife, "I'm totally beside myself over my expenses for a tiny amount of food. . . . Life here really costs a lot of money. Just for myself I need more money than usually all of us together. . . . Food itself costs between 12 and 20 marks per day!"[111] In light of those hardships, Alma's worldliness was all the more grating. Julia understood his complaints,

replying, "I think you're completely right in your judgment about the Gropiuses. You know how much I admire and like him. Regarding her, I have the impression that she has too much of an aura and is too much of a *Grande Dame* to hold out in small Weimar for long. She needs more of a current around her. After our one meeting—please bear that in mind—I have the impression that she needs more width and breadth around her than depth. But she is generous and has a big heart, that I know for sure."[112]

THOSE RESIDENTS OF WEIMAR who were mired in tradition disapproved of Alma's scandalous love life the way that Gropius's mother did. And even though many of the Bauhaus students admired the licentiousness the townspeople deplored, like the Feiningers, they were put off by Alma's apparent sophistication. But in spite of the reactions she engendered in people and her initial reluctance to go to Weimar, once she was there, Alma's enthusiasm was palpable. Later she recalled her first impression of the Bauhaus: "There was a new artistic courage abroad in those days, a soaring, passionate faith."[113]

Whether people liked or disliked Alma, being married to the Madame Pompadour of the twentieth century heightened Gropius's stature. His wife contributed to the daunting reputation of the man who, with the courage that had recently won him military medals, was now attracting brilliant faculty members and capable, enthusiastic students to the school he had organized so rapidly. That he was married to a vixen of fantastic sexual capabilities, one who had famously used them on some of the great creative geniuses of the time, added to his luster. And Alma's renown was such that it immediately conferred a certain international importance on the Bauhaus.

AT THE START OF JUNE, there was a second party to welcome the Gropiuses. It was the first of many amusing festivities that would become an essential part of Bauhaus life. More relaxed than Richard Klemm's tea, this party took place in a large reception hall, decorated for the event in cubist designs. An imaginative covering over the chandelier, made of wire and paper, added dazzle and an exciting hint of danger, although the paper was a safe distance from the heat. The large central space was adorned in yellow and black, the alcove in gray, and the small stage in light blue. Most of the students wore costumes, and, as Lyonel Feininger wrote Julia, "there was a fantastic master of ceremonies . . . so innocent and nice and trusting."[114]

In spite of the high jinks, while Alma had coaxed her husband to move to Weimar by implying that she would happily settle there, she probably never actually believed she could flourish anywhere other than Vienna. Even Berlin had seemed like a backwater to her. Weimar, small and remote, was a nice place to visit, but only that.

Moreover, while Gropius was an idealist, Alma had little interest in the-

oretical issues or society at large. And to Alma, the unabashed romanticism of Mahler's music and the rigor of Gropius's architecture and theories paled before the dizzying force of Werfel and his poetry. Besides, Werfel was younger, and more totally devoted to her, than was Gropius.

Alma arrived in Weimar at the start of May, when the Bauhaus was a month old. She lasted only six weeks. In the middle of June, she told her husband that she was heading off to Franzenbad for a cure. Wherever she went, Manon and Gucki went, too. Rather than going to a spa, however, they returned to Vienna and an eagerly awaiting Franz Werfel.

After the "beautiful" weeks he had "savored" with his wife, daughter, and stepdaughter, Gropius felt "great emptiness" when they left. So he wrote his mother, whom he remained determined to prove wrong for her distrust of Alma.[115] He did, nonetheless, allow to his opinionated parent that his wife was mentally unstable. But rather than acknowledge a personality disorder, Gropius attributed Alma's problems to the conditions of life in postwar Germany and then the illness and death of her baby boy.

The architect's mother knew better. She warned her son in no uncertain terms that Alma, in spite of her promises to be back in Weimar at the end of July, would never set up house with her daughters at the Bauhaus.

For once, Gropius heeded his mother's advice. On July 12, he sent Alma Schindler Mahler Gropius a legal document enabling her to divorce him.

ALMA, OF COURSE, had to be the one to call the shots. She replied that she would give up neither her marriage nor her presence at the Bauhaus. In response to her letter, Gropius wrote his "Beloved" to say not only that their marriage must end but that there was no point in her continuing to make promises she would not keep. The cause for her lying was clear to him: "Your splendid nature has been made to disintegrate under Jewish persuasion which overestimates the word and its momentary truth. But you will return to your Aryan origin and then you will understand me and you will search for me in your memory."[116]

Organizing the Bauhaus, Gropius was calm and resolute, negotiating complex issues without ever seeming perturbed; in private, he unleashed his furies. He chastised his wife as if she were a nymphomaniac, for allowing each new passion to rule her because her "sexual fervor" made her blind to everything else. She had, he told her, no recognition that such feelings are short-lived. Moreover, she was a liar whose promises were "just words." All of this was part of her ultimate betrayal of Christian values with the Jewish Werfel: "Our bond has come to an end, and there is now only the bitter solution of divorce—because you cannot mock God."[117]

His riposte renewed Alma's desire for him. She responded by proposing that they could "live a life full of love and beauty" with her spending half

of every year with him and half with Werfel. In the summer of 1919, just as he was gearing up the Bauhaus for its first full year, Gropius wrestled with her proposal. He weighed its value primarily for his daughter and step-daughter, and then for himself. None of the colleagues with whom he was developing the various workshops, or the prospective teachers and students he was interviewing as the school began to grow, had a clue about his marital preoccupations.

After reflecting on his wife's proposition, Gropius became enraged. Proud as he was of his own rejection of tradition, he wrote "Almschi" to say, "I am hurt . . . don't do this to me, my beloved, to offer something that is a *half* measure."[118]

Divorce was the only option. He saw it as a clean break, a separation from the evils of the past, much as the Bauhaus was an answer to the decadence of existing German society. Gropius begged Alma to sign the necessary document. It was, he wrote, imperative "to clarify everything now; the sickness of our marriage demands an operation."[119]

The confidence that came with his new role as head of an institution that embodied everything he believed in gave him a courage he had previously lacked. He now declared, "Our marriage was never a real marriage; the woman was missing in it. For a short time you were a splendid lover for me, then you went away without being able to outlast and heal my war impairments with love and tenderness and trust. *That* would have been a marriage."[120] The blindness and illusions that had lingered in him only a couple of months earlier, before his mother set him straight, now gave way to perceptivity. Seeing the truth, he told the truth.

Gropius went on to inform his wife that he was not bitter and would never forget her kindness and brilliance. But the Bauhaus had made it possible for him to envision a new life. Besides, when he wrote Alma that "I long for a companion who loves me and my work," he already had someone in mind.[121]

ADDRESSING THE BAUHAUS STUDENT BODY in July 1919, Gropius referred to "these turbulent times." This moment, "a colossal catastrophe of world history," required "a transformation of the whole of life and the whole of inner man." Ostensibly, he was referring to the crisis of postwar Germany—inflation, and the changes within the national government—but in his thoughts he could have been focused equally on the issues revolving around Alma, their child, her other lovers, his other lovers, even the roles of their parents. The point was, as Gropius told the students, that "what we need is the courage to accept inner experience, then suddenly a new path will open for the artist."[122]

To lend harmony to human existence, Gropius envisioned aesthetic and

technical perfection on every level, from drinking glasses to public build-
ings. These advances, to be achieved by a community of artists working
together, would have far-reaching benefits. "This great total work of art,
this cathedral of the future, will then shine with its abundance of light into
the smallest objects of everyday life," Gropius declared of the Bauhaus. It
was essential for people to cooperate with one another and combine their
energies, enjoying mutual support rather than depleting their force through
the sort of rifts that were plaguing him in private. "We artists therefore
need the community of spirit as much as we need bread."[123]

Struggling to resolve his relationship with his only child and with the
woman who had dominated his thoughts, Gropius instructed the students
about the need to overcome "the scattered isolation of the individual."
Artistic integrity and faith in the power of honest design could provide a
true sense of community and a rich stability. Gropius's agenda was to
demonstrate, through the Bauhaus, "that for us artists the crafts will be our
salvation."[124]

<h1 style="text-align:center">9</h1>

A new German constitution was drafted that summer, and in August the
Weimar Republic was established. It gave the government a new seat, no
longer Berlin but Weimar, which had been a pilgrimage site for the intelli-
gentsia ever since Goethe moved there in the late eighteenth century. Lucas
Cranach, Johann Sebastian Bach, Martin Luther, Friedrich Schiller, and
Franz Liszt had all lived there. The great hope in a defeated and floundering
Germany was that the wisdom and creativity of these geniuses would per-
vade the nation's new incarnation.

The move of the governmental seat put the Bauhaus at the center of
things. For Gropius, it was a great moment. But just when he would gladly
have devoted all of his energies to the first full year of his increasingly
important institution, an entreaty came from Franz Werfel. It was mis-
guided, but Gropius still had to deal with it.

Having nearly died on the battlefield for Germany, Gropius was unlikely
to respond favorably to a man who had recently been tried for treason and
was his wife's lover besides. But Werfel naïvely described two blissful weeks
he had just spent with Alma and assured the man who, in spite of his
request for a divorce, was still Alma's husband that the idyll made him—
Gropius!—"especially close to my heart and before my eyes." He implored
Gropius to join him in helping their poor Alma, who was "torn apart by the

heavy conflict that tortures her." Because of their mutual devotion to "this wonderful woman, who was born only for divine purposes," Werfel maintained that no other man was as "dear and close" to him, and that they should go along with her idea of each spending six months of the year with her.[125]

Gropius did not answer the remarkable letter. Nor did he destroy it. Rather, he put it in a desk drawer.

WERFEL'S PROPOSITION came at the end of August, just as the Bauhaus's first full academic year was about to get under way. Alma beseeched Gropius to think of their nearly three-year-old daughter. She wrote, "I am looking forward to the time when you will want to see her again. But when do you want to see her?" The child was only a ploy; Gropius, after all, had sought full custody of her. The issue was that Alma was again pining for her husband. She now insisted that she would jump at the chance to make another trip to Weimar, however rugged the travel. She found Gropius's "dreadful silence" agonizing.[126]

Alma was suffering because this time the terms were his. She was jealous of Gropius's devotion to the institution that had become his cause in life, and she also knew that his charisma, handsome face, and firm soldier's body were irresistible to many women. By now she may also have suspected that he, too, had another lover.

Indeed, the tall, buxom Lily Hildebrandt—another dark-haired beauty, but one whose radiant calm and serenity made her Alma's opposite—had become his latest obsession. Unlike Alma, she was younger than he— thirty-one to his thirty-six—and completely admiring of what he was trying to achieve in starting up the Bauhaus.

Lily was married to the established art historian Hans Hildebrandt, with whom she lived in Stuttgart. This was another point in her favor. It meant that she might help with the pressing task of raising some money for the school. The need was desperate: many of the young students were living in virtual poverty, and Lily was eager to help.

While Alma was bemoaning the absence of communication from Gropius and using their daughter as bait, he was sending letters to Lily about how much he longed for her. A letter Lily wrote from Stuttgart that October made him "wild, my senses in tumult." He could resist his urge to rush to hold her only because their separation would be brief. He craved her unabashedly—and with an erotic intensity that made the missives Alma had once written him seem restrained by comparison. Illicitness again heightened the thrill. Gropius wrote her, "We shall both overcome this short period and kiss each other in our minds—and then—we shall rush into each other. Darling, my whole warmth will caress you. My hands

search for the sweet naked skin, the ravishing young limbs which are long-ing for me! . . . I want to inhale *your* fragrance! Put a flower between your lovely thighs when you are hot from thoughts of me and send it to me in a letter."[127]

The flower would not be necessary. The next day, he wrote again to say he had reserved rooms in two different hotels in Frankfurt for six days hence. In spite of the impecuniousness of the Bauhaus, these were establishments of the highest quality. The only thing Lily needed to do was to choose who would be booked in which one, since she knew the city better than he did.

In his office in Weimar, Gropius was pushing forward his agenda to forge ties between the Bauhaus workshops and German industry. He applied himself rigorously to the task of making the new school work on a shoe-string budget. At the same time, he was organizing the details of his tryst. The latest issue was his new mistress's proposal that they register as brother and sister in just one of the Frankfurt hotels. The idea, he let her know, "made me really laugh. Nobody will believe that your little nose belongs in the same family as my monster nose."[128]

Lily wanted reassurance that, even if they cheated on their spouses, she and Gropius would remain loyal to each other. She had reason to worry: Gropius's success as a Don Juan was growing. With his aristocratic good looks, he had more than the allure of being married to the infamous Alma. Adventurous and passionate, he was undaunted by anything, and as a result the school he had founded was achieving international renown.

WALTER GROPIUS DID NOT pretend to be unaware of his own appeal. But he reas-sured his mistress of his faithfulness to her, letting her know that three weeks after their Frankfurt idyll, at a big party at the Bauhaus, he had not even kissed anyone. For she had left him sexually exhausted. "It seems that I am at an age and in a state of mind which attract women. Many invite my advances. But that should not trouble you, on the contrary. After the deep saturation in Frankfurt, I am in an erotic-free phase and am completely absorbed by my mental work."[129]

His language, however, did not remain "erotic-free" for long. On Decem-ber 13, Gropius wrote Lily, "I would like to penetrate you with the sword of love." His staying powers—or else his imagination—were impressive: with that "sword of love . . . enveloped by your sweet body . . . we would stay this way for hours not knowing where the *I* ceases and the *you* begins."[130]

Gropius wrote this letter the day after a large public meeting at which authorities and prominent citizens in Weimar vehemently attacked the Bauhaus. He had, fortunately, felt equally potent as a speaker. He reported to Lily that he had been "sharp and witty" in a speech he gave responding to

the diatribes that accused the school of violating Weimar's classical tradition and personally demonized Gropius for his disregard of sacred artistic values. His discourse elicited "continuous endless applause. . . . I advance without compromise. . . . I had to summon all my strength and calmness to stop the assault of the howling mob."[131]

Gropius elaborated on these harrowing events not only to Lily, but also to Alma and to his mother. To his mother, he wrote, "I am proud of this fight." Having broken with the world of his childhood, he had "become a very primitive man." He told Manon he now spent most of his time with the students, took his meals in the canteen with them, and preferred this new life of "less hustle and more inner intensity" to the one he had been leading before the war, when he was gallivanting from one family estate to another.[132]

Most of the former soldiers who had endured four years on the front lines in one of history's most gruesome wars now craved only safety and calm. But it suited Walter Gropius to be at "the terrible vortex of dangers." At the start of February 1920, he wrote Lily from Weimar, "The mob agitates against me." He begged her to visit "so that I can feel again how it is to have a hot, loving heart beat against mine."[133] She had to do it immediately, since Alma was going to arrive some two weeks later.

At this tender moment in the Bauhaus's history, a "Citizens' Committee" published a pamphlet that exacerbated Gropius's problems. The committee was made up mostly of members of the right-wing National People's Party, backed by conservative landowners and industrialists who were against the new Weimar constitution and favored the restoration of monarchy. They commended Gropius's original Bauhaus manifesto for representing ideals they respected, but said those worthy goals remained an unrealized promise. This publication attacking the school became immensely popular, for it represented mainstream opinion.

The opposition to the new school and to Gropius specifically was scurrilous and mocking, making no allowance that the great educational experiment was not yet a year old. According to the pamphlet, "The dithyrambic ending of the inspiring call for new action, which precedes the program, still reminds one, in thought and tone, of 'Meister Heinrichs Wunderglockenspiel' in Gerhart Hauptmann's 'Sunken Bell.' " As for the comparison Gropius made between the Bauhaus and the Gothic cathedral: "Parallels to past ages, much as they flatter the ear, always bear many a concealed flaw." The Bauhaus was accused of being "an artistic dictatorship" linked inexorably to "the personality of its leader. . . . Such one-sidedness is a sin against the spirit of art." The students, who were seen as outsiders to their historic milieu, showed "little gratitude. They consciously act as foreigners, deliberately display their contempt of the old Weimar, and by their conspicuous conduct provoke the opposition of the most patient citizen."[134]

WHEN THE FURIOUS BURGHERS of Weimar were not at Gropius's throat, Alma was. Gropius's steely reserve, evinced in his ability to manage the difficult affairs of the Bauhaus and weather attacks others would have found insurmountable, was driving her off the deep end. She wrote him, "Your beautiful male hardness is a wall around you. I shall *not let you know* anything that may still interest you a little bit around me."[135] If he would love her, all would be different; otherwise, she would keep him ignorant of her and the children. She reiterated the threat time and again.

Gropius calmly urged her to stop the torture. His main concern was their child; he advised Alma to have the same priority. He had developed the persona that enabled him to nurture the Bauhaus in spite of a perpetual onslaught of problems. His unwavering resolve, the slight distance from which he governed, the tough shell he kept around himself—aided by his physical attractiveness—helped him to entice extraordinary faculty and students to the school, manage their many disputes, vanquish his enemies, and preserve financial stability and optimism. Most people would have buckled, their institutions going with them. The Bauhaus flourished.

10

Back in Vienna, Alma Gropius now periodically walked out on Franz Werfel, who desperately searched the city's streets for her. Alma was preoccupied with Gucki, who was anorexic—although the term was not yet in use—and bounced from romance to romance until she married at sixteen. Alma despaired of the match.

In March 1920, the troubled mother took Manon to Weimar, fulfilling an obligation to have her younger daughter near her father. Werfel's *Trojan Women* was opening in Vienna, and she would have liked to be there. Instead, she, Gropius, and Manon settled in at the Hotel Zum Elephanten. A short walk from the Bauhaus, it was the best hotel in the region. Arriving at the gracious hostelry on the largest cobblestoned square in the old part of town, the setting of Weimar's open-air markets, Mahler's widow must have been delighted to realize that Johann Sebastian Bach had lived next door for a decade slightly more than two centuries earlier, and that two of Bach's gifted sons had been born there. But living conditions were difficult even with Weimar exuding its charms. On March 13, there was a nationwide general strike; workers flooded the local streets, spitting at the government troops who tried to maintain order. Riots ensued, and many workers were killed; afterward, the corpses were dumped outside the walls

of the local cemetery, where they festered for days since there was no one to bury them.

In the midst of this, Alma, Manon, and Gropius moved to Gropius's new apartment. Many of the details fell to Alma, since Gropius was busy with the school. One of his main objectives was to launch a range of disciplines with dynamic, talented artists at the helm. He invited the sculptor Gerhard Marcks to start a pottery workshop, and asked Johannes Itten, the painter he had met at Alma's in Vienna, to teach a preliminary course, the "Vorkurs," in which students would explore the nature of form and experiment with paper, glass, and wood in order to acquire an understanding of the possibilities and limitations of each. This requisite foundation course in which every student learned about materials and techniques on a practical level in advance of attempting creative work was a cornerstone of Bauhaus education. Teaching it with flair and passion, Itten quickly became the most important member of the faculty other than Gropius himself.

Gropius also created workshops in carpentry, metalwork, ceramics, weaving, wall painting, and graphic art. Every student took the Vorkurs, but he or she also joined a workshop.

During this first growth spurt, Alma played a significant role at the Bauhaus. She admired the rapid progress her husband had made with the school; the vehement scorn heaped on him and the Bauhaus only added to their luster. She began to ingratiate herself with the school community.

In late spring, however, Alma again insisted the marriage was over. She and Manon returned to Berlin and Werfel. But Gropius now said he did not want a divorce after all, and went so far as to maintain that his wife was wrong to claim he ever had. Alma, too, changed her story. At times she insisted she wanted to leave Gropius and claimed that the marriage had ended long ago. But then she would declare that she could not be without him.

Gropius was anguished. He wrote his mother, "I cannot live without her. . . . Since she has decided to leave me with the child I shall carry the sign of disgrace with me forever and cannot look anybody freely in the eye." Yet there was still another woman in his life. While Gropius was bemoaning the end of things with Alma and relishing the start with Lily, he also had an affair with "an attractive young widow." We do not know her name; writing about the liaison in 1983, more than sixty years after the fact, Reginald Isaacs still felt an obligation to protect the woman's reputation. While quoting letters Gropius sent to her, Isaacs concealed the widow's identity. But we know what Gropius wrote her: "I am a wandering star. . . . I know no anchors no chains. . . . I am bound nowhere and to no one. Wherever I go I make others feel good and by doing this, I create *life*. I am a *sting,* and a dangerous instrument! I love LOVE, without any objective, its great ever-

lasting intenseness. You wanted me and I gave myself to you and it was wonderful and pure, two stars put together their sea of flames but: ask for nothing, do not expect anything!"[136]

After one Bauhaus evening when he feigned indifference to the "young widow" in public, Gropius wrote her explaining the need for secrecy. But their passion was too great to be abandoned. He concluded the letter, "I just drink your warmth and one day the sword will drive out of me again," and signed off as "Your shooting star."[137]

IN MAY, in the midst of Gropius's juggling act, Alma and Manon came back to the Bauhaus. Afterward, Gropius wrote Lily that Alma now knew about them. But the state of the marriage was such that this no longer posed a problem. "I would like to have you in my arms again to drink Lethe's oblivion. . . . Try to understand the earthquakes that shake my soul and be good and tender with me. . . . How is your husband? . . . Let me know it, tell me everything; be close to me and kiss me. I kiss your sanctuaries."[138]

In July 1920, those earthquakes intensified. Gropius had to defend the Bauhaus at government hearings and demonstrate the same resilience required by his love life. The school's finances were a shambles. The workshops still lacked the most rudimentary equipment. The effects of inflation were catastrophic; a copperplate printing press that would have cost four hundred marks before the war now would cost between thirty-four and thirty-eight thousand. Gropius proposed a budget that, given the budgets of other art schools, was more than reasonable. To convince the skeptical authorities that this was warranted, he stressed that internationally respected architects, as well as more than two hundred newspapers, had already voiced admiration for the new school.

Concurrently, he was negotiating his divorce from Alma. To effect it, he had to plead guilty to the charge of adultery. A scene was arranged in a hotel room. Witnesses were organized; detectives appeared. Everyone gave the necessary depositions. The process took a while, but on October 11, 1920, as the Bauhaus started its second full academic year, the marriage of Walter and Alma Gropius officially ended.

11

Gropius's optimism and tenacity, and his powers of persuasion, made the Bauhaus a magnet for eager students and brilliant faculty members. At the same time that he was overcoming fierce opposition and a very tough

financial situation nationwide, he was luring every great artist he wanted into the fold.

One of the first of the fine and original modern painters he pursued and conquered was Oskar Schlemmer. Schlemmer had invented a unique form of geometric figurative painting, and was an innovative ballet and theater designer. Gropius offered him an academic chair that had recently been vacated by one of the old art school professors who was unable to tolerate the onslaught of modernism at his institution. These high-echelon positions brought with them an annual salary of sixteen thousand marks. It was an irresistible offer to Schlemmer, who was further attracted because he knew that Gropius was making the same offer to Paul Klee.

By the end of November 1920, Schlemmer was at the Hotel Zum Elephanten; Gropius rightly figured that a hotel that met his wife's standards would be an effective lure. Schlemmer would soon become, with his diaries and letters, the secret historian of the Bauhaus. One of his first observations was that what counted for Gropius about the people he attracted to the school was that they be first-rate artists more than "devoted teachers."[139]

Gropius made Schlemmer feel that his coming to Weimar was so inevitable that once he was there he could not imagine having done otherwise. The energetic Bauhaus director organized Schlemmer's new existence the way he handled a military campaign: picking out a handsome quiet studio for him, advising that he should stay for a month and then come permanently in the spring of the upcoming year.

Still, Schlemmer had his doubts. He was about to be married, and was concerned about how his future bride would fare in Weimar. Schlemmer, while happy about his recent success with the dynamic and inventive *Triadic Ballet,* was trying to figure out his domestic arrangements. He craved privacy and isolation; indeed, one of the conditions on which Helena Tutein— always called Tut—had agreed to marry him was that they would live in the countryside.

Nonetheless, by March 1921, the recently married Schlemmers were living in a former courtier's house at the Belvedere Palace in Weimar. Oskar Schlemmer had decided to go to the Bauhaus after Gropius, at the end of 1920, had succeeded in negotiating for one of the most original and brilliant painters of the modern era, Paul Klee, to join the school's faculty. This was no small accomplishment—Klee was as obsessed with financial details as he was gifted artistically—but Gropius had found the means, on a shoestring budget, to get the forty-one-year-old Swiss, and his wife and young son, to Weimar.

NOT EVERYONE RESPONDED TO Gropius as positively as Schlemmer and Klee did. Shortly after its creation, the Bauhaus divided into two opposing camps.

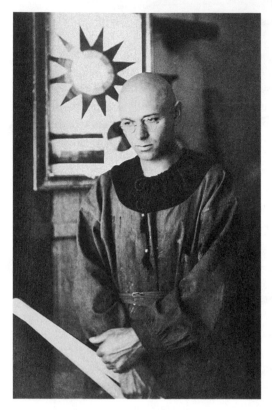

Johannes Itten, 1921. With his unusual clothing and practice of Mazdaist rituals, Itten had a very different persona from Gropius and Klee.

While Gropius was emphatic about the impact of the school's program on society at large, Johannes Itten and his followers were more focused on the development of the individual and on creativity regardless of its broader impact. In addition, most of this faction of students and faculty led by Itten adhered to the practice of Mazdaism—a way of life in accord with the teaching of Zoroaster, a Persian prophet born in 628 B.C. who viewed the universe as the cosmic struggle between *aša* (truth) and *druj* (lie). The goal of life was to sustain *aša* through good thoughts, words, and proscribed activities. Mazdaism required head shaving, the wearing of costumes, ritual baths, a vegetarian diet, and a range of other strictly regulated practices. Its adherents not only followed their many rules rigorously, but disapproved of anyone who did not.

Initially, Gropius extolled the health benefits of the new regime, while Alma was appalled. She had a sensitive gallbladder, and would not dare try "the obligatory diet of uncooked mush smothered in garlic" for fear of a bilious attack. Recoiling at the way "Bauhaus disciples [were] recognizable at a distance, by the garlic smell,"[140] she was also aware that when she first got to Weimar, Itten himself was suffering a bilious attack.

Alma felt that Itten—who was there, after all, because of her—had lost his flair. His current wife, the sister of his first (who had died), was "an utterly inhuman creature, who styled herself to resemble the Negro sculptures that were the rage at the Bauhaus in those days."[141] Gropius, however, unlike Alma, put aside his personal reactions to people and did his best to manage the conflict between Itten's followers and foes.

Nonetheless, the school developed an atmosphere of civil war. And Gropius was under attack because, while the Bauhaus was supposed to treat architecture as the ultimate art form, there was no architecture course. The

only architect on the faculty was Gropius himself—and he was too preoccupied with administrative matters, fund-raising, and his own work to teach.

Again sporting a bushy mustache, always impeccably dressed, Gropius was spending a lot of time on the road, giving lectures to explain and defend the school, and his travel schedule made it impossible to offer regular classes. Gropius also continued to practice architecture, and his client base was still in Berlin. With some of the new students serving as his apprentices, he designed a house for the lumber merchant Adolf Sommerfeld in Berlin-Steglitz in 1920–21. Surprisingly like a rustic country house, it would be faced with timbers from an old warship and utilize the boat's teak panels inside. The Bauhauslers made its windows, lighting fixtures, and furniture, giving hope to the idea that their work would be known well beyond the confines of Weimar. That house, in one of Berlin's finest residential neighborhoods, was a major step in spreading the gospel.

NO LONGER A VULNERABLE youth or volatile young man, at the Bauhaus Gropius faced issues head-on, appearing unfazed and resolute; he became disarmingly candid in his personal life as well. In the spring of 1921, he wrote Lily: "I wish I could feel just as passionately about you as I did a year ago and I am striving for it; one cannot force flames to rise out of oneself, but I know that it may happen again suddenly."[142] By then he had met Hans Hildebrandt, and the two men got along well. Lily had become active in the Circle of Friends of Bauhaus; the fiery love affair had now evolved into a professional relationship. In his role as school director, Gropius increasingly relegated all other issues to a secondary tier of importance.

Gropius needed that network of allies in which the Hildebrandts were key players, for he and Itten were increasingly at odds. A further wrinkle occurred when Theo van Doesburg—an innovative Dutch artist who had developed a rich and original form of abstract painting and, with Piet Mondrian and others, co-founded the movement they called "De Stijl"—moved to Weimar in 1921. Gropius liked Van Doesburg and his work sufficiently to invite him to his house, but not enough to ask him to join the faculty. Some of the Bauhaus students defected from the school to study with the De Stijl master, thus creating the feeling of yet another opposition force.

Gropius offered a dependability that was vital for many people. That same year, his stepdaughter, Gucki, left the man she had recently married. Rather than turn to her volatile mother, she fled to the stepfather she had adored ever since he had entered her life. For Gustav Mahler's daughter, Walter Gropius was the one person who offered hope, and Weimar, as it would for many other young people, became her refuge.

This was at just about the same time that another of the greatest painters of the era arrived at the fragile paradise Gropius had created. The Russian

Wassily Kandinsky, who had advanced abstract art to new heights, was at loose ends after returning to Germany, where he had previously lived, following exile in Moscow during the war. Kandinsky was in close touch with Klee, an old friend. By the start of 1921, Gropius had made arrangements for this pioneer of abstract art and his new young wife to come to Weimar Bauhaus.

IN FEBRUARY 1922, Gropius wrote an eight-page document about the problem of Itten's adherence to the idea of art for art's sake, and circulated it among the Bauhaus masters. Gropius blamed Itten's approach for the continuation of old-fashioned handwork and the production of one-of-a-kind pieces in the Bauhaus workshops. This contradicted his goal of working with industry. "The Bauhaus could become a haven for eccentrics if it were to lose contact with the work and working methods of the outside world. Its responsibility consists in educating people to recognize the basic nature of the world *in which they live* . . . to combine the creative activity of the individual with the broad practical work of the world!" Gropius did not mince words. He called the architecture and "arts and crafts" of the previous generation "a lie," a by-product of "the false and spastic effort 'to make Art.' "[143] He found these buildings and paintings disgusting for their lack of truthfulness.

The issues went even deeper, as most readers of the manifesto knew. Gropius's and Itten's personas corresponded to their beliefs. With his military bearing, immaculate grooming, and impeccable clothes, Gropius fit in perfectly with any group of distinguished people. Itten deliberately presented himself as a bohemian; his eccentric appearance was a declaration that artists were different from other people, and he delighted in shocking the bourgeoisie.

The issue would loom large for almost everyone at the Bauhaus, not only during its existence but afterward. The relation to the mainstream, the definition of one's self with regard to the rest of society, and the question of whether art should be consciously individualistic or have universal implications (these options were not necessarily contradictory), were matters everyone addressed. With Gropius and Itten as polar opposites, most of the faculty and students clearly identified with one or the other.

WHETHER OR NOT GROPIUS realized it, one of his truest allies in this time of internecine bitterness was his ex-wife. Alma had stayed in close touch with a number of the people she met in Weimar. She kept up those relationships on the rare occasions when she returned with Mutzi, as Manon was called, even if she did not stay with Gropius, and she assumed a major role behind the scenes. On July 3, she wrote a letter to Lyonel and Julia Feininger. It was not the normal missive of the period. Others would have addressed even

close acquaintances as "Herr" and "Frau"; Alma wrote to "Dear Beloved Friends." She used purple ink for her sprawling script, with the uppercase letters two centimeters high and the text more than a centimeter. Underlining certain points for emphasis, she gave the Feiningers vital advice:

> I haven't heard anything from you—not a thing—not even if you received my goodbye letter. But that's unimportant. Important is for me to know what you'll be doing during the summer and whether you'll be staying in Weimar. I have to know that!!! It's so reassuring to know that you're here in Weimar, at the Bauhaus, with Gropius. You can't, you can't leave him! Persevere. Take a long vacation, but stay with a cause that you helped establish. I'd be so happy if you came over to see me sometime!!! I send a thousand greetings to you both, your friend Alma Marie.[144]

Alma's warmth and her ability to connect with people had a powerful impact. And she knew how much Gropius needed her in this period when others treated him as a dangerous radical. In the fall of 1922, Carl Schlemmer—Oskar's brother and a master in the wall-painting workshop—spearheaded a rumor campaign about Gropius. Lily Hildebrandt had warned Gropius that Carl was against him, but it was Oskar Schlemmer who actually reported the extent of his brother's antipathy. Carl, Oskar told Gropius, had gathered every bit of gossip there was about the director and then gone on a campaign to spread it. Given Gropius's love life, there was no shortage of material.

When the personal slander didn't succeed in toppling Gropius, Carl wrote a pamphlet in which he called the Bauhaus a "Cathedral of Socialism." Knowing it would destroy the school, at least in its current form, if read by the right officials in the Weimar government, Carl published it when Gropius was away on vacation. When Gropius returned, he managed, just in time, to get hold of every possible copy of the offensive publication and keep it from circulating. But Carl Schlemmer had to leave the Bauhaus, and even Oskar, though beloved by Gropius and others, had an uncertain fate simply because he was the traitor's brother. Lily Hildebrandt urged Gropius to hire the painter Willi Baumeister to replace Oskar, but Gropius would have none of it. Baumeister, he said, was a second-rate artist by comparison.

It's little wonder that, even while he was still on holiday at the Baltic Sea at the start of September, a desperate Lyonel Feininger wrote Julia, "Tell me honestly how many people there are at the Bauhaus who really know what they want, or who are strong enough to produce something *on their own* through patient work?"[145]

During a visit she made in December 1922, Alma, who now returned to

Weimar with increased frequency, was appalled by the posters around town addressing "German men and women" and summoning them to assemblies to protest the "degenerates" and "cultural Bolsheviks" who were destroying Weimar's academy. Alma appreciated the irony of the accusation, given that the Kandinskys "had escaped from the real Bolsheviks" and that "Frau Kandinsky would literally faint at the sight of a red flag."[146] The atmosphere of the school was becoming more and more corrosive.

12

In 1923, Johannes Itten resigned. For Gropius, this was a victory and a great relief. By then he had met the artist László Moholy-Nagy, whom he brought to the school to replace his rival. That same year, Josef Albers, a little-known art teacher and printmaker from Westphalia, was the first student to complete his Bauhaus course. He became a "young master," and along with Moholy-Nagy and the painter Georg Muche began to teach the "Vorkurs." Gropius's power base was getting stronger.

During this period of internal change at the school, the Thuringian Legislative Assembly, known as the Landtag, insisted that Gropius organize a comprehensive exhibition to give evidence of what had been achieved in the four years since the Bauhaus had opened. He was against the idea, saying he needed more time if he was going to prove the success of his experiment, but the Landtag gave him no choice.

Once resigned to the necessity of the show, Gropius gave it his all. He wrote the authorities who had jurisdiction over any revisions to the former Academy of Fine Art to propose that he remodel its vestibule as the exhibition entrance. In this large, empty space, Gropius planned to install a rotating color wheel and a prism to illustrate color mixing and refraction. With Oskar Schlemmer in charge of execution, the old-fashioned light fixtures would be replaced with spheres and cubes, made of different types of glass— mirrored, frosted, milky, and opalescent—illuminated by colored lightbulbs. Gropius envisioned these radical changes as a diplomatic gesture that would "bridge the differences between the Academy and the Bauhaus by the interests we share" and would "demonstrate Goethe's ideas on the correlation of art and science."[147]

WALTER GROPIUS WENT ON the lecture circuit to raise money for the exhibition. On May 28, 1923, ten days after his fortieth birthday, he was in Hannover, giving his standard talk on "the unity of art, technology, and economy,"

when his eyes fell upon two sisters sitting in the front row. One of them had the same sort of looks with which the young Greta Garbo would later captivate film audiences. She had Garbo's thin lips, straight nose, large bright eyes, flawless skin, and piercing gaze. Gropius was bowled over; he felt he was giving his lecture to her alone, especially since, from the moment he began speaking, she stared at him with a visible attraction and responded as if his every word were changing her life.

A nephew of Gropius who lived in Hannover was able to tell him that the two sisters in the front row had the last name Frank; one was Ilse and the other Hertha. Gropius, however, had no way of identifying which was the one who had made him furious with himself for not having arranged to meet her after his lecture; he could not stop imagining how they would have spent the evening. His solution was to write a letter to both Frank sisters. He proposed a rendezvous when he passed through Hannover on his way home from Cologne a week later.

They agreed, and Gropius learned that the sister who had caught his eye was named Ilse. Twenty-six years old, she was the oldest of three girls whose parents had died years earlier. She worked in an avant-garde bookshop and was living with a man, both choices indicative of her fierce independence and strong willpower. Her lover was her cousin Hermann, whom she planned to marry that summer.

As usual, what someone else would have considered to be an insurmountable obstacle struck Gropius merely as a challenge. By June, Ilse Frank had become one more woman who succumbed to his charm. She wrote saying she knew how busy he was with the Bauhaus exhibition; regardless, she was desperate to be with him where he lived, and wanted him to know she would have four days off from the bookshop toward the end of the following week. He telegraphed back that she should spend all of them with him in Weimar.

FOLLOWING THOSE FOUR DAYS, Frank and Gropius began to organize further encounters. They also discussed marriage. She, however, had neither told Hermann about her lover nor canceled her wedding. The elaborate celebration planned for her aunt's house in Munich was only a few days away.

Gropius wrote her, "I am not a man who can wait! I storm through life and whoever cannot keep pace will remain by the wayside. I want to create with my spirit and with my body; yes—also with my body; and life is short and needs to be grasped." They had, he explained to Frank, "a holy bond" as a result of their "blessed nights" together. She needed to realize just how "hard and unrelenting" he was. His final entreaty was the same advice he gave students who were considering joining the Bauhaus: "Make a clean break, liberate yourself . . . I believe in you!"[148]

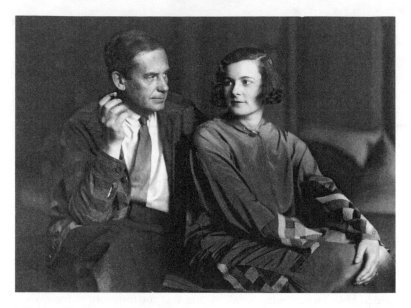

Walter and Ise Gropius shortly after their marriage on October 16, 1923. Following many tumultuous love affairs, the Bauhaus director briefly thought he had found stability.

Ilse followed his bidding. She advised Hermann, and put a halt to the fast-approaching marriage festivities. At the same time, she shortened her name. By dropping the "l" and becoming Ise, which had a more modern, streamlined ring, the future Mrs. Gropius took on a new persona.

Gropius was reinvigorated. He wrote Ise, "My great work is now saved by you; you gave wings to my feet."[149] With that energy, he would make the Bauhaus exhibition, and the week of events that coincided with its opening, one of the most remarkable cultural events of the 1920s.

WALTER GROPIUS gave the Bauhaus exhibition the central theme of "Art and Technics, a New Unity."

The young Herbert Bayer designed the boldly abstract announcement card that was the summons to the show. It utilized as few words as possible and was set in a new straightforward sans serif typeface. Alongside the text was a complete human profile—chin, mouth, nose, and forehead—made up of nothing more than three vertical rectangles and a single horizontal dash in a perfectly proportioned steplike arrangement. A square made the eye. Never before had a person's visage been evoked in such engineer-perfect shorthand. The announcement assured that even in advance of the actual show one anticipated something unprecedented. It declared the joy of inventiveness, as did the postcards Bayer—as well as Klee, Kandinsky, Feininger, and other artists, each in his own vibrant style—made with the basic infor-

mation and dates (see color plates 3 and 13). The excitement they generated was warranted. When the show opened on August 15, the former Weimar academy had been completely transformed.

Gropius had managed to find sufficient funding under nearly impossible conditions. Besides lecturing all over Germany, he had obtained support from family, friends, clients, and any businesspeople who had a few marks to spare. Money was so tight that the Bauhaus had had to let go of its janitors, but the masters' wives scrubbed the floors, and everything was sparkling clean.

Visitors were greeted by powerful graphics over the entrance door. The word "Ausstellung" ("Exhibition") was written vertically in bold, squared-off lettering, white on a solid black vertical rectangle, with a brilliant white band adja-

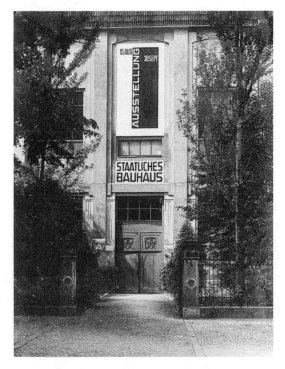

Entrance to the 1923 Bauhaus Exhibition. Herbert Bayer's graphics set the tone for the startling modernism of the show awaiting the public inside.

cent to it: all designed by Bayer. This was the beginning of his role as one of the most influential graphic artists of the twentieth century. In America, after World War II, Bayer would be hired by Walter Paepecke, who founded the Aspen Skiing Company and Aspen Institute in Colorado. There the Bauhaustrained artist would make posters promoting winter sports and become known all over the world. He also created many other well-known graphics and logos.

He would keep silent, however, about his work for the Nazi Party. In 1936, Bayer designed a brochure that extolled the glories of life in the Third Reich and of Hitler's impact, and that accompanied an exhibition for tourists visiting the Berlin Olympics. The brochure was conceived to advertise Hitler's achievements at a time when skepticism about the Third Reich was growing following Germany's invasion of the demilitarized Rhineland. Bayer's brochure included the Heinkel airplane factory, designed by Gropius's former associate Herbert Rimpl; the building combined Bauhaus modernism with references to traditional architecture in the cottagelike workers' houses. Throughout the brochure, Bayer linked the old and the

new to advertise Germany as a holiday destination. Later in life, when asked about it, Bayer would discuss only its use of duotone technique and other formal elements. Nevertheless, his involvement in Nazi propaganda would color many people's vision of the Bauhaus.

AFTER BEING WELCOMED by Bayer's signage, the public entered a vestibule filled with different colors of light and saw the extraordinary achievements of the four years since the school had opened its doors. The new art triumphed on every surface and in every open space. There wasn't a single alcove, staircase, or classroom that was not put to use to show murals, reliefs, and design work. Each workshop presented the products that had been developed there, and the classrooms were used to display theoretical studies and materials from the preliminary course.

The nearby State Museum of Weimar was turned over to an exhibition of Bauhaus painting and sculpture; it included many works that would eventually be ranked as masterpieces of modernism but that were at the time simply "faculty work." And a model house, the "Haus am Horn," had been constructed in the neighborhood where many faculty members lived. It had been built as an exemplar of Bauhaus style and was furnished entirely with products of the school's workshops.

The work on view throughout the main building and in the museum show extolled straight lines, right angles, and perfect circles, clean and pure, in a profusion never seen before. The geometric shapes glistened in chrome in lamps and tea balls and serving vessels, and pulsed in vibrant yellows and reds and blues in paintings so rhythmic as to seem audible. Oils and watercolors by Paul Klee presented his unique visions of birds and stars and other natural forms in abundance. Wassily Kandinsky's canvases combined intellectual rigor and spiritual mystery. The art was immensely varied, yet it was linked by its consuming energy, its look of faith, and its pioneering use of abstract form.

The display of the weaving workshop included some hangings that were the textile equivalent of oil paintings. These singular objects, mounted on the wall, serving no practical purpose, were revolutionary in their brazen simplicity. In addition, there were swatches of materials to be fabricated industrially and used as draperies, upholstery, and carpeting. Remarkable for their absence of floral or botanical subject matter, the new textiles celebrated raw materials. Twine, silk, hemp, and even metallic thread were interlaced in interesting ways, serving as the source of aesthetic delight as well as practical effectiveness.

The work on the wall that stood out above all the others was an austere, minimalist composition by the woman I came to know as Anni Albers. Annelise Fleischmann, as she was at the time, was a rich young woman—

her mother's family, the Ullsteins, were Europe's most prominent publishing family—who had arrived from Berlin the previous year. This quiet twenty-three-year-old, as socially timid as she was bold in her art, was not known to many people. She had not even wanted to join the weaving workshop and initially had hoped for carpentry or wall painting, thinking textiles to be "too sissy," the equivalent of needlepoint. But weaving was where most, although not all, women went, and Fleischmann suffered from a physical disability that, while she never acknowledged or discussed it, made certain Bauhaus tasks impossible for her. Now, even if working in thread was not her first choice, she had done something unprecedented. A few gray, black, and white rectangular blocks and bands made a bold new sort of visual art. Fleischmann's piece encouraged meditation; its gravity mixed with an evident lightness of touch gave it an intoxicating power associated more with music than with the visual arts. While most of the products of the weaving workshop were suitable for commercial production, advancing Gropius's goal of design for industry, this one-off suggested that craft and art could be the same thing. (See color plate 24.)

In the glass workshop, Josef Albers—the artist Fleischmann would ultimately marry—also revealed new possibilities for right angles and solid blocks of color. A young man from a very different background—she was Jewish; he was Catholic, the son of a carpenter/electrician/plumber/jack-of-all-trades in the smoky industrial Ruhr Valley—Albers, who was thirty-two when he arrived at the Bauhaus in 1920, and who until then had been a schoolteacher in his hometown, was so penniless that, in order to get funding to attend the Bauhaus, he had had to promise the regional teaching authorities back in Westphalia that he would return after his time in Weimar so that they could reap the direct benefits of what they had sponsored. At first, because Albers lacked sufficient funds for art supplies, he had spent a lot of time at the Weimar city dump hacking up bottle fragments and other detritus with a pickax to use in his glass assemblages. These vibrant and playful objects that were on view in the 1923 show gave spiritual power to junk; so did a carefully conceived, leaded stained-glass window in which checkerboard patterns counterbalanced large squares, pink rectangles sparkled with small white squares inside them, suggesting openings, and lattice patterns played against broad expanses of gray, purple, and deep red. In keeping with the tenets of the Bauhaus, Albers's work could be used in buildings—he had already done some large windows for Gropius's Sommerfeld House—but, like Fleischmann's weaving, it triumphed as pure art, as independent of practical purpose as a Renaissance Madonna.

There was also an exhibition of recent architecture being done all over the world. This included seven illustrations by the Swiss architect Le Corbusier showing his proposed city for three million inhabitants. This innova-

tive if shocking scheme, intended for Paris, represented a new form of urbanism that required razing entire neighborhoods in order to build skyscrapers that would be spaced around large open areas to allow access to the sky and would be linked by an efficient transportation system.

Like the displays in the school, the show of paintings at the Weimar Museum was evidence of a revolution. The work unabashedly celebrated beauty in places where it had not previously been recognized. Lyonel Feininger's cityscapes imbued tough urban forms—train viaducts, narrow streets, the spaces between anonymous warehouse buildings—with charm and lightness, refracting their shapes as if through a prism. Kandinsky's abstractions were orchestrated of pure circular forms orbiting around one another, straight lines flying off, and waves and zigzags moving to and fro, all in an intentional cacophony of colors; these unusual canvases exploded with energy: they were as powerful as atomic fusion and at the same time delicate and graceful. Klee's images of opera singers, underwater gardens, and purely imaginary architectural mélanges were somewhere between the known world and a dreamlike fantasy, deft and professional in execution while childlike in spirit. László Moholy-Nagy's precise paintings of overlapping geometric forms and his sculptures of shimmering nickel, steel, chrome, and copper all appeared to move at breakneck speed. Oskar Schlemmer's rendering of human forms, both painted and sculpted, reduced the body to a combination of abstract shapes, making it seem very much of the future while simultaneously imbuing it with the nobility and panache of the knights of ancient legends.

Not everything was of equal caliber, however. Even though Johannes Itten had recently left the Bauhaus, his work was a major element in this show; his paintings of awkwardly formed, robotic, puffed-up children, with the artist's name painted in large letters on a scrolling ribbon overhead (contradicting the Bauhaus ideal of artistic anonymity), were clumsy as well as cloying. Gerhardt Marcks's sculptures of mothers and babies, though sweet, lacked the artistic merit that would have been needed to make their sentimentality effective. Georg Muche's interior scenes were competent exercises in a late cubist style, but there was nothing exceptional about them; likewise, Lothar Schreyer's figures seemed to be the art of a follower rather than of a truly original talent. The Bauhaus tried to present itself as a community, but there was no way of getting around the reality that it had greater and lesser lights.

THE UNUSUAL OBJECTS MADE as studies for the Vorkurs resemble the products that would be commonplace in children's art classes seventy years later. But in the early 1920s, those who did not grasp their revolutionary intention considered them outrageous. There were towers of tin cans receding in size,

with metal bands and wires wrapped around them, and mixtures of straw, wood shavings, and brush. There were also patchwork collages of fabrics, wallpaper samples with buttons on them, and drawings that showed the structure of wood or demonstrated color mixing. These myriad objects were all evidence of a desire to look at the essence of things, to understand materials and optics, and to explore the nature of construction.

The carpentry workshop featured severely geometric children's toys cut out of wood and lacquered in bright colors. There was also a baby's cradle that prompted some of the good people of Weimar to accuse the Bauhaus of promoting child abuse. Made with two tubular steel wheel shapes joined at the bottom by a rod of the same material to create the base for two wooden planks, opening at angles and joined as if at the point of a triangle to form the baby's bed, this more than any other object would attract the ire of the Bauhaus's opponents, who did not make the claim of cruelty in jest. But most of the furniture, however unusual, inspired less controversy. Marcel Breuer and Eric Dieckmann had pared down the structure of beds, tables, and chairs so that they were as simple and honest as possible, without an iota of decoration. The same Josef Albers whose pieces were in the glass workshop had made a conference table and shelves in which smooth planks of contrasting woods were arranged rhythmically, imbuing the efficient and practical with an unprecedented jazziness.

The pottery workshop showed cocoa pots and canisters and coffee sets intended for mass production. Of timeless simplicity, these vessels offered proof that Bauhaus modernism had a leanness that, even in its novel expression, was connected directly to human need in a way that was universal and dated back to the birth of civilization.

The glistening, fantastically simple objects in the metal workshop were especially eye-catching. Dynamic lamps, ashtrays, and pitchers had been made by the innovative Marianne Brandt, one of the few women who had found a venue other than weaving. A desk lamp designed by K. Jucker and W. Wagenfeld featured a spherical glass base, a tubular glass shaft, a half globe of milk glass as its shade, and wiring contained in a silver tube inside the glass one. It represented a courageous new design approach, and although no one could have anticipated it, it would in time become a modern classic. From the versatile Josef Albers came fruit bowls made from nothing more than three wooden balls as the feet, a sphere of clear glass as the base, and a metal rim to keep the fruit in place. It was a rare use of frankly industrial forms for a domestic container.

The wall painting at the Bauhaus was another remarkable element of that 1923 show. From floor to ceiling there were spheres and rippling waves and bold sequences of smokestack-like columns. This decoration incorporated the utilitarian radiators as if they were design elements rather than some-

thing to be avoided. That acknowledgment of what a previous generation would have covered up embodied the spirit of the Bauhaus: honesty about what is needed in life, and the promulgation of the idea that anything can be made part of a total visual symphony. The hiding of reality and concealment of the functional that for centuries had been common practice in design for the middle and upper classes was toppled. And the need for gratuitous decoration referring to the natural world was made irrelevant by the rich possibilities of pure abstraction.

THE HAUS AM HORN was a square within a square. The large central square was the living room; almost one and a half times as high as the rest of the structure, it let light in through clerestory windows. The lower structure that enveloped it contained a well-equipped kitchen, a dining room, separate master bedrooms for the husband and wife, a room for the children, bathrooms, and storage spaces. The details put to the test the idea of incorporating into everyday living a lot of the breakthrough concepts on view in the Bauhaus exhibition. The cabinets, beds, desks, and chairs were all constructed without adornment. There was no window trim, and the radiators were exposed, as were the drainpipes. The message was one of total honesty, although to many viewers it also conveyed unforgiving coldness.

The Haus am Horn was designed by Georg Muche, but since Muche was

Haus am Horn, Weimar, 1923. Inside and out, this unusual dwelling embodied a new aesthetic.

a painter, not an architect, Gropius, as well as Adolf Meyer, had worked on many of the technical details. Gropius, as usual, was the one who articulated the objectives of the project for the general public. He declared that the Haus am Horn would provide "the greatest comfort with the greatest economy by the application of the best craftsmanship and the best distribution of space in form, size, and articulation."[150]

Gropius had also procured the financing—from Adolf Sommerfeld, the Berlin lumber merchant for whom he had built a very different sort of house a few years earlier. Sommerfeld's own house was sheathed in logs. While aspects of it bore the imprint of modernism, it fit in with the grand country-house style one expected for a rich man's private residence. The wealthy merchant would never have lived in anything like the Haus am Horn, which was made of steel and concrete. But he was the sort of patron willing to pay for work that had no connection to his personal taste.

The reigning force at Haus am Horn was practicality. Gropius declared, "In each room, function is important. . . . Each room has its definite character which suits its purpose."[151] The furniture and cabinetry, much of it made by Marcel Breuer, who was still a student, used unadorned planks and slabs of lemonwood and walnut, everything pared down and minimal, so that even the knobs were utterly plain and round, matched to the cabinets and drawers they were used to open. What might otherwise have seemed stark or antiseptic was animated by a rhythmic juxtaposition of forms and playfulness in the use of light and dark woods. Light fixtures designed by Moholy-Nagy and made in the metal workshop further energized the rooms. Even if the house looked like a barrack from the outside, the inside had an esprit and cheerfulness that made clear that Bauhaus design enhanced pleasure in everyday living.

Gropius's uphill battle to garner public approval for the school was beginning to pay off; the Landtag had done well to insist on the exhibition. Dr. Edwin Redslob, the national art director of Germany, made a public statement declaring that the Haus am Horn would have "far-reaching cultural and economic consequences." Redslob was the rare government official who had the foresight to see the worth of the Bauhaus at a time when so many of his colleagues perceived it as a threat. His endorsement was a lifeline. It helped the school retain its governmental support and a degree of financial security. It mattered greatly that this national figure commended this new domestic design, "which organically unites several small rooms around a large one," as "bringing about a complete change in form as well as in manner of living. . . . The plight in which we find ourselves as a nation necessitates our being the first of all nations to solve the new problem of building. These plans clearly go far toward blazing a new trail."[152]

THE EXHIBITION THAT GROPIUS had hoped to postpone managed, at least for a brief period, to enhance the luster of the Bauhaus nationally and even internationally. This was in part because of Bauhaus Week, a program of activities he organized that also began on August 15. Events included lectures by Gropius on the unity of art and industry, by Kandinsky on synthetic art, and by the Dutch architect J. J. P. Oud on recent advances in building design in Holland. Hindemith and Stravinsky both appeared in Weimar for performances of their work. That one lively week in summertime was euphoric from start to finish. There was a festival at which a fantastic array of paper lanterns were strung overhead, and a fireworks performance where the vibrant explosions were yet another form of impeccably crafted abstraction. A light show made incorporeal glows the essence of art. The Bauhaus jazz band performed its intensely animated music at a dance, and Oskar Schlemmer's *Triadic Ballet,* which he had developed more than a decade earlier, was given a stellar production. Those who saw it at the Bauhaus would never forget its mix of playfulness and profundity or its simultaneous activation of all the senses.

From the moment the ballet began, the extraordinary figures against brilliant abstract backdrops appeared to be working their way toward a dramatic climax. Wordless gestures, musical progression, and changes in scenery conveyed a feeling of expectation. Two males and one female danced twelve scenes in eighteen different costumes made of rigid, vibrantly colored papier-mâché. Sometimes encased in a metallic coating, the costumes gave the impression that the human body was composed of symmetrical geometric forms. The male outfits included one made of pointed ovoids like teardrops, another of puffy striped trousers formed like those of the Michelin tire man. The woman changed from a skirt like stacked soccer balls to one like an open Chinese parasol to a tutu that resembled a reversed champagne coupe. In the first act, these unusually shaped humanoids flounced around gaily in a burlesque against a lemon-yellow set. In act two, they became more deliberately organized, enacting a festive ritual in a setting that was entirely pink. Finally, in the third act, they performed on an all-black stage, becoming dreamlike characters of the night. The fantastic trio had taken the enraptured audience from a lively bounce to a consuming ambiguity and mysteriousness.

WHAT GROPIUS HAD MANAGED to achieve in just four years in Weimar becomes apparent in the 1936 autobiography of Igor Stravinsky. Rather than write a full account of his life to date, the forty-three-year-old composer deliberately recalled the few selected events that he considered the most significant of all his experiences. Stravinsky writes that he had been invited to Weimar in August 1923 as part of the program that accompanied the "very fine

exhibition" there.[153] His *Histoire du Soldat* was to be performed during Bauhaus Week; it had been previously presented on only one other occasion, in Frankfurt, at a concert of modern music organized a few months earlier by Paul Hindemith.

The journey Stravinsky and his future wife, Vera, endured to get to Weimar was harrowing—typical of what one could expect in Germany in those years. Although Stravinsky was married to his cousin, Katerina Nossenko, whom he had known ever since they were young children, he had recently met Vera de Bosset, who was married to the painter and stage designer Serge Sudeikin, and while Stravinsky makes no mention of Vera's presence on the trip (he remained married to Katerina until her death in 1939, only marrying Vera the following year), we know she was with him because of a reference to the journey to Weimar in her diary. On this first major outing together, the illicit couple started out from Paris on August 15 for Stravinsky's performance on August 19. He could only get train tickets to Griesheim, a village near Frankfurt that was on the demarcation line of the part of the Rhineland then controlled by the French, who had reoccupied the Ruhr and the Rhineland the previous January. The rail station in the village was manned by African soldiers, who faced Stravinsky with fixed bayonets. They told him that it was too late at night for him and Vera to reach Frankfurt itself, or even to get a phone call through, and that they would have to stay in the crowded waiting room.

Stravinsky, who was used to first-class hotels, immediately set out to look for any sort of hostelry where they would at least have a bed. The soldiers stopped him with the warning that he might be mistaken "for a vagrant" and shot. The composer had no choice but to stay squeezed between other people on a bench, "counting the hours till dawn."[154] At 7 a.m., a child guided him and Vera through soaking rain to the tram, which took them to Frankfurt's central station so they could continue to Weimar.

The trip was worth the effort. The way the members of the Bauhaus appreciated *Soldat* was one of the joys of the composer's life. Here were people for whom the marvelous energy and playfulness of that great work, its feeling of insouciance mixed with gravitas, corresponded completely with their own interests. Not only that, but Stravinsky met Ferruccio Busoni, a composer he greatly admired but who, Stravinsky had been told, was "an irreconcilable opponent of my music."[155] Stravinsky considered Busoni "a very great musician" and was therefore delighted when he and Vera sat with Busoni and his wife, Gerda, at the performance of *Soldat* at the National Theater in Weimar—Gropius had organized the most important concerts there—and observed Busoni enjoying *Soldat*. Both Busonis, Stravinsky would tell Ernest Ansermet, "wept hot tears . . . so moved were they by the performance."[156]

After the performance, Busoni, in spite of his fundamental opposition to work like Stravinsky's, commented, "One had become a child again. One forgot music and literature, one was simply moved. *There's* something which achieved its aim. But let us take care not to imitate it!"[157] Because Stravinsky had never before met Busoni, and would never do so again—the Italian composer died the following year—that experience became fixed in Stravinsky's memory as a key element of his visit to the Bauhaus.

The following night, the Stravinskys had dinner and spent the evening with Wassily and Nina Kandinsky, and with Hermann Scherchen, who had conducted *Soldat.* Sixteen years later, Scherchen's role in that performance would be held against him by the Nazis, but in 1923 the atmosphere was euphoric.

NOT EVERYONE APPROVED of the Bauhaus exhibition, the Haus am Horn, or the events of Bauhaus Week. The Bauhaus had its loyalists in high places, especially Redslob, but there was vehement opposition to it all over Germany. Newspaper headlines of the period included "The Collapse of Weimar Art," "Staatliche Rubbish," "Swindle-Propaganda," and "The Menace of Weimar."

The main issue was that an unknowing press and public assumed that because Gropius had started the school under a socialist regime—the Grand Duke of Saxe-Weimar had been politically to the left—the Bauhaus was a hotbed of radical politics. Since Gropius knew that ignorant observers would think as much, he had prohibited political activity there, but as the local government became increasingly rightist, the hatred mounted.

The situation became so bad that the school's business manager ended up writing Gropius that "the attitude shown by superior officials is malevolent, obtuse, and so inflexible as constantly to endanger the growth of the institution." He warned that the "open animosity" of the latest government was threatening the school's survival. Even in the artistic community, where one might have hoped for more enlighted attitudes, there were prominent people who saw no reason for the Bauhaus to exist. Karel Teige, a well-regarded critic and artist who was a leading figure in the Czech avant-garde, writing in *Stavba* (Building), the most important architectural periodical in Czechoslovakia, asked, "If Gropius wants his school to fight against dilettantism in the arts, . . . why does he suppose a knowledge of the crafts to be essential for industrial manufacture?" Teige was typical of many influential naysayers in his view that "craftsmanship and industry have a fundamentally different approach. . . . Today, the crafts are nothing but a luxury, supported by the bourgeoisie with their individualism and snobbery and their purely decorative point of view. Like any other art school, the Bauhaus is incapable of improving industrial production." Teige questioned every major premise of

Bauhaus education, declaring, "The architects at the Bauhaus propose to paint mural compositions on the walls of their rooms, but a wall is not a picture and a pictorial composition is no solution to the problems of space."[158]

On the other hand, the distinguished Swiss architecture historian Siegfried Giedion, in an article for the Zurich newspaper *Das Werk,* wrote — in September 1923, while the exhibition was still on though Bauhaus Week was over — "The Bauhaus at Weimar . . . is assured of respect. . . . It pursues with unusual energy the search for the new principles which will have to be found if ever the creative urge in humanity is to be reconciled with industrial methods of production." Giedion made his readers aware of the difficult situation of this noble cause: "The Bauhaus is conducting this search with scant support in an impoverished Germany, hampered by the cheap derision and malicious attacks of the reactionaries, and even by personal differences within its own group." He commended Gropius's institution for "reviving art" and tearing down "the barriers between individual arts" as well as recognizing and emphasizing "the common root of all the arts."[159] To those with open eyes and open minds, what was taking place in Weimar was a miracle.

13

During the final stages of preparation for the Bauhaus exhibition in early August, Ise Frank moved to Weimar to begin her life with Walter Gropius. The attack from Carl Schlemmer had had an impact, however. To avoid further opprobrium from the citizenry of Weimar, the Bauhaus's director did not want to be seen living with a woman to whom he was not married. The knowledge that Ise had just canceled her wedding to someone else on Gropius's behalf was scandalous enough. Ise Frank moved in with Paul and Lily Klee, whose reputations were beyond reproach.

Meanwhile, Lily Hildebrandt had announced her plan to come to town for the opening. Gropius had her stay in a summer resort some distance from the town center. They saw each other in public only at the last event of Bauhaus Week, the great masked ball on August 19, and no one else knew them behind their disguises. The following morning, Ise Frank and Walter Gropius snuck away for a vacation in Verona and Venice.

Ise and Walter were married on October 16, 1923, at a civil ceremony in Weimar. The witnesses were Wassily and Nina Kandinsky and Paul Klee. Shortly thereafter, they went to Paris, on what was in effect their honeymoon but was mainly a trip to visit Le Corbusier, who considered Gropius

one of his few colleagues of merit. The Swiss architect met them at Deux Magots, a café that was only a short walk from the small seventh-floor walkup apartment where he was living with his Monegasque girlfriend, Yvonne Gallis. The Gropiuses went with Le Corbusier to see the house he had recently built for Amédée Ozenfant, which had a large and well-lit painting studio as its core, and the Maison La Roche, a villa for a Swiss banker that was mainly intended to present the owner's collection of paintings by Braque, Picasso, Léger, Ozenfant, and Le Corbusier himself. These two groundbreaking exemplars of Le Corbusier's use of the latest technology in domestic habitation made a great impact on Gropius. Le Corbusier had a sense of visual rhythm that set him apart, but he shared Gropius's desire for the connection of art and industry, and for the importance of giving equal attention to every aspect of visual experience, from the design of ashtrays to the layout of closet interiors to the choice of one's shoes to the construction of building façades. What we see and touch affects how we feel and who we are.

IN WEIMAR, where Ise and Walter lived on Kaiserin Augustastrasse, they adhered to that goal of good design in every object within their sight. They had one particular possession that especially pleased them in its appearance and capability: a gramophone. They were the first Bauhauslers to own one. Guests would often listen with rapt attention, with Klee picking up a baton and conducting. Sometimes Klee would show up with his violin so that he could play alongside the machine that emitted recorded music.

The new Mrs. Gropius opened the house to the younger people at the Bauhaus as well as to the faculty. "The students had felt rebuffed by Alma, but were immensely attracted to the gracious Ise"—at least according to Gropius's biographer Reginald Isaacs, who was writing when Ise was still alive. She was, he says, as warm as her husband was optimistic, multiplying the effects of his positive energy. Ise delighted in quoting Gropius saying, "I am totally immune to disappointment because I do not see people and situations for what they are at the moment but for what they might become."[160]

There is, of course, no knowing what anyone was "really like," since a portrait always depends on the person giving it. Yet Anni Albers, my main living source for most of these people, while she could be a master of negative memory, also was incredibly perceptive. She saw Ise as a form of relief for Gropius, stable but slightly dull after Alma and his other women. Ise wasn't without her fire, however. What Isaacs leaves out of his book, and is not written in the many histories of the Bauhaus, is that when Gropius eventually resigned as director, one of his main motives was to get his wife away from Herbert Bayer, with whom she was having an affair.

Bayer was probably the Bauhaus's leading playboy. A photo Josef Albers

took of him shirtless makes clear that he was dashing, and whenever Anni thought back on him at the Bauhaus, she would roll her eyes and say, "Oh zatt Hehr-bert," maintaining that he was irresistible. Ise, on the other hand, was not, in Anni's eyes, a very nice person. When they were all living in the United States after World War II, the Alberses visited the Gropiuses at their house in Lincoln, Massachusetts. On one occasion, they were sitting in the living room when Ise's strand of pearls broke. Anni immediately got down on her knees and began to pick up individual pearls as they rolled away. Ise kept on talking as if nothing had happened. Finally, Anni looked up from the floor and asked, "Do you know how many pearls there were on the strand?" Ise replied that she had no idea, because these were not her good pearls. In the most condescending of voices, she informed Anni that if pearls are of true value, like the better strand she was not wearing that day, they have tiny knots between them so that this sort of spill would not happen.

The incident may seem trivial, but to Anni Albers it was immensely significant. As someone who had grown up wealthy, with more jewelry than she wanted, she knew about pearls, and as a textile artist, her understanding of knotting was better than Ise's. For Anni, the Bauhaus was the place where the most elemental aspect of putting beads or precious stones on a string, a practice almost as old as humankind, could be appreciated and understood for its true significance: the juxtaposition of the solid and the flexible, the wish for women of whatever financial circumstances to embellish themselves with something sparkling against the skin. When nothing else was available during World War II, Anni had made jewelry by stringing bobby pins, small metal washers, and grommets from a hardware store, and she had crafted clay beads by hand. By the time Ise derided her attempted helpfulness in the 1950s, thirty years after the two women first met, she at that moment represented the snobbery Anni associated with German class attitudes—precisely what the Bauhaus was meant to overturn. And she showed a lack of kindness, a will to make someone else feel bad: immensely significant for any human being, but especially for the wife of the director of the Bauhaus.

Nonetheless, it is probably true that Ise bolstered Gropius's optimism. The remarried Gropius was both happier and more settled than he had been before, and while he stayed friendly with Lily Hildebrandt, they ceased being lovers. For a brief period, Gropius confined himself to one woman only.

HE DID WELL TO concentrate his energies. The forces that had already begun to converge against the Bauhaus became even more ferocious when the Ordnungsbund (Coalition for Law and Order) came to power in 1923. This new

regime was hostile to the ideas of the Bauhaus and resented the incursion of nonconformists in the capital of the new republic. They quickly reduced government funding for the school, and high-ranking officials issued statements that the Bauhaus was riddled with Communists and that its students and faculty lived immorally. Some Bauhaus foes also charged that the school's precepts were destroying private enterprise.

On November 23, 1923, a Reichswehr soldier stormed into Gropius's office. He demanded to be taken immediately to Gropius and Ise's house on Kaiserin Augustastrasse. A search warrant had been issued, although the soldier did not have a clue about what they were hoping to find. Gropius looked on while seven men rifled through his belongings.

The following day, Gropius wrote a letter to the local military commandant. "I am ashamed of my country, Your Excellency," he declared. He insisted on an immediate inquiry and said he would report the incident to the minister of defense.[161] But he never received a satisfactory response and never knew what they were looking for.

While the Bauhaus workshops thrived—and Klee and Kandinsky, among the greatest painters in the world, worked peacefully in their studios—Gropius continued to have to do battle on a daily basis. By 1924, he was up against the German Völkische party after an election in the Thuringian parliament, the government body that had jurisdiction over Weimar and the Bauhaus, made these right-wing opponents of the school the majority.[162]

On March 24, while Ise was in a sanatorium because of an unidentifiable stomach ailment, Gropius wrote her that the newspapers in Jena and Berlin were reporting that this new government would not extend his teaching contract. This was a way of firing him, and the Bauhaus masters were going to meet to decide whether they would stay if it really happened. They were aware, however, that it was possibly a moot point; rumors were flying that the authorities hoped to dissolve the Bauhaus completely.

Gropius met with a government minister whom he described to Ise as resembling "a long dead clerk of the court . . . a dry bureaucrat without a personal opinion,"[163] but he could not get further information. Then some of the masters at the school, Klee and Kandinsky among them, wrote a letter to the minister of state to voice their unequivocal support of Gropius and also to say they would resign if he was no longer director.

The letter succeeded for a while in keeping the authorities from making Gropius the scapegoat for their general opposition to the Bauhaus. The Ministry of Culture, however, continued to campaign against the school. To fight for the preservation of his institution, Gropius wrote an article that appeared in the Weimar newspaper *Deutschland* on April 24, 1924. He responded specifically to statements from Völkische party officials challeng-

ing government support of the Bauhaus and questioning "the moral qualities of the Director."[164] Gropius enumerated the school's achievements. Of the 129 current Bauhaus students and the 526 who had been at the school since it opened in October 1919, a number had become apprentices in industry. While many students had had to leave for financial reasons, even the Bauhaus dropouts had become employed by German industry specifically because of the training they had received at the school. The director outlined the tremendous achievements that had been made in the realms of artistic development and education. He also defended the Bauhaus against attacks that pointed out that some of the other masters were not German. Gropius declared that this xenophobia was disgraceful and argued that the foreigners on the faculty did nothing but enrich German culture.

As for the critique concerning his own character: here Gropius said that these libelous attacks were the result of specious accusations made by disgruntled former employees of the school. He had, he wrote, initiated an official investigation into such attacks, with the Ministry of Education concluding that they were "unfounded" and "irresponsible . . . Retribution for these insults through public legal action is about to be concluded." Similarly, when his character was attacked the previous year, all accusations had been dismissed as unwarranted. This "ignorance and malicious slander of the most humiliating kind"[165] had to come to an end, the beleaguered director declared.

Few of the people around him were aware of it, but at this same time Gropius was again battling Alma. They had agreed that Mutzi would visit Weimar twice a year, but Alma was not keeping up her end of the deal. When Gropius wanted to see his child, he had to go to Vienna. This was problematic not only because the long journey kept him away from the Bauhaus for more time than he could afford, but also because Ise was unwilling to go there with him. Gropius's new wife was still insecure about his infamous ex.

When Gropius finally succeeded in getting a lecture invitation that covered the cost and justified the time of a trip to Vienna, he tried mightily to convince Ise to join him, but she refused, and he went alone. Ise's reluctance was well-founded: she would have been miserable to see the grip that Alma still had on her former husband. Gropius was overjoyed to be with the eight-year-old Mutzi, but Alma was determined to keep them from getting too close. Although Alma was completely committed to Franz Werfel, she was upset that Gropius had remarried. She hovered over the reunion in a way that made Gropius feel as if an evil spirit were present with him and his daughter.

Shortly after Gropius returned to Weimar, the "Yellow Brochure" appeared. It repeated the accusations that the Bauhaus was politically based,

essentially Bolshevist and anti-German. The authors of the popular document were all former Bauhauslers who had been dismissed, Carl Schlemmer among them. To counter the fervent anti-Bauhaus sentiment in Weimar, the students papered the town with posters supporting their school, and the masters rallied against the "Yellow Brochure" specifically. Gropius survived this latest attack, but the city that had provided such a fertile environment for the Bauhaus at its start was becoming so inhospitable to the school that the future was bleak.

14

Alma was making it hard for him to be with their daughter; the school he had conceived and nurtured was at risk of annihilation; his enemies were eager to give him the boot even if the institution survived. Although all of this was happening at the same time, Walter Gropius celebrated his forty-first birthday with élan. Ise wrote his mother about the festivities, which began on Sunday, May 18, and lasted eight days. He was "feted gloriously, spontaneously, radiantly," with the Bauhaus band playing jubilantly on several occasions.[166] The masters commemorated the birthday with a special portfolio, and the students showered him with gifts.

The hysteria outside was mounting, however. Militants wanted the Bauhaus shut down as if it were a den of vice. The rumors only grew nastier. At this time, a Circle of Friends was organized to help support the Bauhaus. The exhibition the previous year and Bauhaus Week had had an impact. The school's champions from the outside world included Albert Einstein, Igor Stravinsky, Marc Chagall, Oskar Kokoschka, Arnold Schoenberg, the architect Hendrik Berlage, Gropius's former boss Peter Behrens, and even his rival in love, Franz Werfel.

Alma promised that Mutzi could spend the summer in Weimar. But just before the scheduled trip, she reneged. Ise was furious that Gropius might make the trip to Vienna again. Wanting desperately to see his daughter, yet determined not to imperil his new marriage, he was torn. Gropius told Ise that he and Alma had never spent more than two weeks together and were "never really married." He assured Ise in a letter, "You are my first and only wife and I shall never want anyone else."[167]

Usually Gropius's persuasive powers triumphed, but not this time. Ise forbade the trip. Unlike Alma, she wanted all his energies focused on the Bauhaus, and she insisted that he could not be away at such a crucial time.

While an outpatient at a sanatorium in Cologne where she was in treatment for her stomach problems, she took it upon herself to advocate for the school. One of her converts was the city's mayor, Konrad Adenauer. Ise spent an hour and a half with him. By the end of their meeting, Adenauer had not only joined the Circle of Friends, but had also raised the idea of the school moving to his city, with Gropius assuming the role of city architect.

For the time being, the move didn't seem necessary, but Gropius was pleased when his wife found new donors and persuaded bankers to extend credit to the school. She also secured clients for the weaving workshop. Gropius not only declared her "a veritable magician" and "my good star," but began to address her as "My dearest Mrs. Bauhaus."[168]

THEN, IN SEPTEMBER 1924, the government of Thuringia decided to terminate the employment of all the Bauhaus masters. The reason given was that the Thuringian State Treasury had determined in an audit that the school was financially unstable. The government demanded that the school close its doors by April 1925.

Gropius argued before the Landtag. He gave the history of the embattled institution, pointing out that "the Bauhaus had to produce . . . everything from nothing." The workshops had to buy materials in uneconomically small quantities. Having started without capital, they lacked the competitive advantage of industries because they could not afford machines and tools essential for the manufacturing process. "The open hostility against the Bauhaus for political reasons, because of artistic intolerance or because of lack of understanding" had made it particularly difficult to develop the sort of ties necessary for a "solid business enterprise."[169]

His appeal fell on deaf ears. The new president of the Landtag, Richard Leutheusser, who was also the leader of the Völkische party in Thuringia, had no sympathy whatsoever for the Bauhaus. In September, Gropius and the other masters received notice that their employment was being terminated. With no one to pay faculty salaries, the school could not go on.

ISE GROPIUS REFUSED to accept the idea that the Bauhaus was closing. She continued to advocate for the school with her new friend Adenauer. This future world leader, known to be "incredibly rude and unpleasant if something did not interest him," was graciousness itself to "Mrs. Bauhaus."[170] Adenauer gave Ise introductions to well-known writers and prominent businesspeople in Düsseldorf. Those connections enabled her to drum up favorable publicity and lucrative outlets for Bauhaus products. Ise campaigned with influential people in the arts, both within and beyond Germany's borders, who responded by writing the Landtag in support of the school. Sympathetic

industrialists, some of whom had been brought into the fold by Ise, proposed turning the Bauhaus into a production company in order to keep it going.

The students also petitioned the government, but no amount of effort was sufficient to overcome right-wing opposition to the Bauhaus. German nationalism was beginning to steamroll, with more and more people insisting that the Bauhaus was too hospitable to individuals and trends from outside the country. This was not the first time that Walter Gropius had had to accept defeat after a long battle, and on December 29, he—along with eight other signatories, including Klee, Kandinsky, and Schlemmer—officially dissolved the Staatliche Bauhaus in Weimar.

15

In spite of all the internecine battles that had occurred in the five years of the Bauhaus's existence, a few individuals were determined to keep the school going. The benefits to a community of people with similar goals were vast.

The perspicacious Ludwig Grote, director of the Gemäldegalerie in Dessau, informed Fritz Hesse, Dessau's mayor, of the immeasurable significance of the Bauhaus, and suggested it might relocate there. The lively modern art school in Frankfurt am Main took a strong interest in incorporating the Bauhaus into its existing structure.

In the midst of all this turmoil, in late January 1925, Gropius took off with Ise for a four-week vacation. No one could even reach him. The isolation and complete change after years of struggle gave him the perspective he needed. By March, Gropius was among those investigating conditions in Dessau. In a short time "Das Bauhaus in Dessau" was official, with "direction: Walter Gropius" underneath the new name.

Located at the junction of the Elbe and Mulde rivers in the duchy of Anhal, Dessau was a small city surrounded by arid land. It lacked the charms and auspicious history of Weimar, but it did have an important theater built in the eighteenth century, and Wagner, Paganini, and Liszt had all performed there. The city had thrived during the industrial revolution and had a feeling of energy without being especially cosmopolitan. Now, by appointing Walter Gropius director of the existing School of Arts and Crafts and trade school, and folding the entire Bauhaus staff into those institutions, the Municipal Council was taking major steps to give Dessau a different aura. What they did out of civic loyalty saved the Bauhaus. The great

enterprise that had been stopped in its tracks in Weimar would be able to continue to provide innovative experiential education and to be a haven for some of the world's leading creative geniuses.

As usual, Gropius's iron will made all the difference. The Municipal Council had envisioned the Bauhaus in an ancillary role to the School of Arts and Crafts and the trade school already in operation. But, as his lovers and students knew, with Gropius it was all or nothing. He quickly persuaded council members to let him design new buildings for the Bauhaus, on a splendid site about two kilometers from the city center. As soon as he had their consent, Gropius opened a new architectural office in Dessau and began.

By the end of the summer, Gropius had completed working drawings for the new building. To achieve this, he employed some of his former students, among them Marcel Breuer. The building complex that emerged from their charette was marvelously functional, and of unprecedented appearance. A sparkling white, crisp amalgam of interlocking geometric forms, with a neatly tapered bridge and a flurry of balconies breaking up the strong masses, it was bold and refined at the same time, radiating power and optimism and a love of beauty.

The structure housed spacious workshops, a large auditorium, a dining hall, and residential facilities. By the time it opened in April 1926, it was the twentieth-century equivalent of a medieval village, a place for working and living in a community—even though the object of adulation was now art and design rather than the God for whom the Gothic cathedral had been built. The Dessau Bauhaus was a perfect marriage of function and style; it used industrial devices to achieve artistic grace and coupled high tech with poetry. Its glass walls were tensile light, its flat roof a statement of newness.

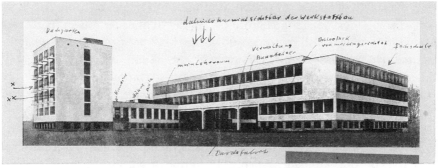

The Bauhaus in Dessau, built by Gropius, 1926, in a photo annotated by Josef Albers. The building separated the living accommodations from the work and community spaces, while linking them with a bridge.

Even today, the building is the symbol of all that was achieved within it. While he was designing it, Gropius carried on his campaign to reinvigorate the Bauhaus and to organize its students and faculty, but nothing was more effective as a gathering cry and an icon of the new faith, a representation of vigor, than this handsome shell with its impeccably clean, bold vertical lettering saying simply "Bauhaus."

AS BEFORE, Gropius was the school's main public spokesman, codifying its philosophy with serenity and assurance. Impressively resolute, as elegant in his verbal expression as in his architecture and his personal appearance, he reiterated that whether one was creating "a container, a chair, or a house— one must first of all study its nature; for it must serve its purpose perfectly, that is, it must fulfill its function usefully, be durable, economical, and beautiful."[171]

Gropius intended for the Dessau Bauhaus to improve life for the masses; even more than its Weimar predecessor, it was to penetrate society at every level, and to do so while emphasizing superior quality: "The Bauhaus fights against the cheap substitute, inferior workmanship, and the dilettantism of the handicrafts, for a new standard of quality work." The goal was "simplicity in multiplicity, economical utilization of space, material, time, and money."[172]

Gropius's ability to deal with difficult people was again called upon. Money was tight, in spite of the generosity of the Municipal Council, and he decided he had no choice but to ask senior faculty to give up 10 percent of their teaching salaries for the first year in the new location. Klee refused. Gropius, in turn, wrote an extremely measured response. He explained the harsh realities of the overall financial situation and of the antipathy toward Bauhaus modernism, and politely beseeched Klee to recognize the efforts that the mayor of Dessau and Gropius himself had made to ensure that Klee would enjoy ideal working conditions. As insistent as he was in matters of love, Gropius was willing to go down on his knees to beg for what he wanted. He wrote, "I simply cannot believe that you, dear Herr Klee, will desert me in this matter, and I cordially request you to support me."[173] In this instance, however, Gropius failed to persuade: neither Klee nor Kandinsky would agree to the cut.

In spite of the grim financial situation, Mayor Hesse provided land and funding for private houses for the Bauhaus masters. There was a forest of pine trees on Burgkuhnauer Allee, only a kilometer from the main Bauhaus building. It was a wonderfully bucolic setting, ideal for these artists who were as interested in the truths and tranquillity to be derived from nature as they were in modernism. Gropius immediately designed idyllic dwellings for the school's upper echelons.

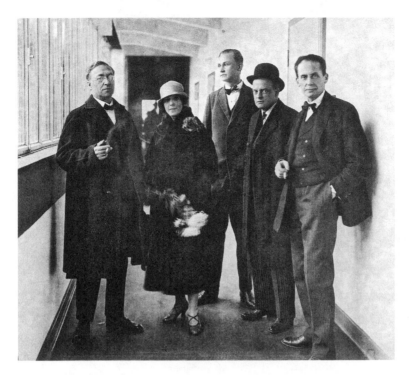

*Wassily and Nina Kandinsky, Georg Muche, Paul Klee, and Walter Gropius
at the Dessau Bauhaus, 1926. At first, the Bauhauslers had been skeptical
about moving to Dessau, but the new headquarters and masters' houses
soon provided them with exceptional working and living conditions.*

While the Bauhaus masters all belonged to the same purposeful brigade
and shared certain ideals and some beliefs, they still had their strong indi-
vidual preferences and quirks. Gropius, aided by Ise, set out to be as accom-
modating as possible with regard to their new houses. The masters' wives
had very specific requests. Tut Schlemmer wanted a gas stove, while Lily
Klee preferred one fueled by coal. Georg Muche's wife, the Norwegian
painter Erika Brandt, insisted on a new electric model. Nina Kandinsky,
ever nostalgic for her native Russia, wanted only a Kamin—a wood-
burning stove made of heavily ornamented black iron, which looked more
suitable for a cozy dacha than a contemporary kitchen. For themselves, Ise
and Walter Gropius picked streamlined furniture and objects from the
Bauhaus workshops, or designed their own suitably modern pieces, but
everyone else had tastes that had little to do with the school's program.

While their houses were under construction, the masters lived in what-
ever apartments they could rent. Neither the new building nor the resi-
dences were ready when the Bauhaus reopened in Dessau in October 1925.

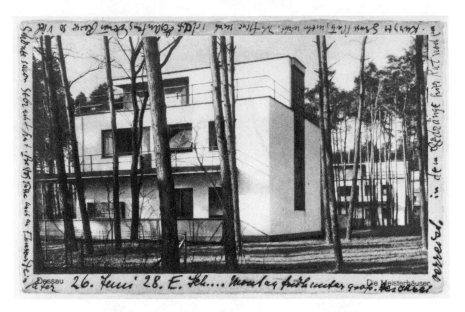

*Postcard sent by Lily, Felix, and Paul Klee in 1928. It shows a photo taken by Lucia
Moholy-Nagy of the masters' houses in Dessau, where the Klees and Kandinskys lived
in more idyllic working conditions than they had ever known before.*

The workshops and classrooms were located temporarily in a defunct textile
mill and an unheated building that had been a rope factory.

In these makeshift facilities, Gropius reiterated the institution's ideals
with his usual fervor, and reminded people of the links he was forging
between the workshops and German industry. Inconveniences were of sec-
ondary importance.

The pace was relentless that summer as he tried to whip the new build-
ing into shape and organize the reborn institution. In August, Ise, who was
pregnant, had an emergency appendectomy during which she lost her baby.
But Gropius could not afford to stop. He lectured wherever he thought he
could drum up support, while also working on his architectural projects and
promoting prefabricated housing. He now undertook the publication of a
series of Bauhaus books, for which he functioned as editor in chief. Pri-
vately, he was working on office buildings and an important project for the
great exhibition of modern housing that was scheduled to open in 1927 in
the Weissenhof section of Stuttgart. He was dealing nonstop with personnel
issues, too; when Georg Muche wanted to switch from being form master of
the weaving workshop to the architectural workshop and Gropius didn't
think he was up to the task, it was Gropius who had to make the decision
and enforce it diplomatically. Walter Gropius's ability to be architect, edu-
cator, and administrator at once was the backbone of the school.

16

On December 4, 1926, when the Dessau Bauhaus formally opened, Walter Gropius gave a speech that stirred his audience to a fervor. First he acknowledged that the Bauhaus had a troubled history. Its tenure in Weimar had been marred by confusion about what the school's intentions and functions were; the Bauhauslers themselves understood, but the outside world did not. Nevertheless, the masters and the students had demonstrated "unwavering determination."[174] Gropius's voice underscored the last two words.

He knew how to rally his listeners. Standing before the crowd at Dessau, handsome and confident as he always was in public, he explained that the Bauhaus had survived and was now being reborn because it had at its core "the purity of an idea" and a "common spiritual center" and because an entire community, comprising masters and students together, had worked together. "I would like to take this opportunity to thank them publicly and with all my heart," he declared with a warmth that stirred not only the recipients of those thanks, but also the many new converts to his cause.[175]

Gropius infused his listeners with a sense of their own worth and a faith that their purpose was lofty. This new building, he assured the more than one thousand guests—who included government ministers and artists and architects from all over Europe—was "for the creatively talented young people who some day will mold the face of our new world."[176] Everyone in the audience felt engaged in the phenomenal task.

WITH HIS GOAL of taking his new vision to the public at large, Gropius quickly was given an opportunity to prove himself. The government was funding a housing development in the Dessau suburb of Torten, and it was in effect the Bauhaus director's test case.

At Torten, Gropius organized living as if in a manufacturing plant. His goal was to apply the most rational approach conceivable to human needs. The settlement included a "building research section," which was intended to be the headquarters at which the reich could develop "a generous long-range master plan" for future construction nationwide.[177] The planners were to address the financing of housing, urban and rural development, and transportation all over the country. They were also to create central facilities that could provide electricity, water, and heating economically; to determine where decorative or kitchen gardens would be beneficial; and to provide

landscaping, standardize building types, revise construction ordinances, and study new materials as well as the latest methods of industrial production with an eye to their application for housing. Gropius believed that, with standardized building components and established working methods and tables of costs, it would be possible to calculate all expenses in advance. Such control of the finances of building would make it far easier for good design standards to proliferate.

Although the community of three hundred buildings, completed in 1928, looks more like a collection of barracks than what most people would want to call homes, it still allowed him to put his ideas to work.

A PHOTOGRAPH SNAPPED in 1927 shows Walter Gropius standing with Paul Klee and Béla Bartók in the roof garden of his house—the first in the row of masters' houses and the only single-family dwelling. The snapshot, meant only to record a happy encounter, makes clear the toll taken by all that the Bauhaus director had been doing. One can hardly believe that this is the same Walter Gropius who was the dashing lover of Ise in photos taken only three years earlier. He looks exhausted and worried; his pale face has aged two decades. While he is, as always, dressed and groomed with style, his jacket fits awkwardly and his bow tie is askew—surprising for someone usually so meticulous.

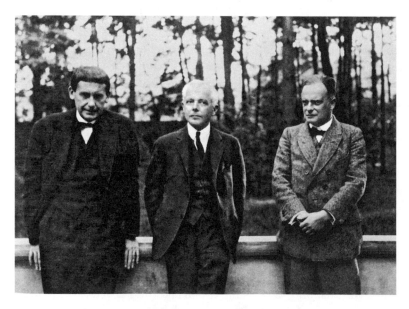

Walter Gropius with Paul Klee and Béla Bartók, Dessau, 1927. Gropius suddenly looked haggard; he lacked his usual dash and vigor. His greatest struggles at the Bauhaus had become financial.

A few days after the photo was shot, Gropius wrote to Kandinsky: "You are uninformed as to the superhuman burden I have to carry here, which is further significantly increased through the malfunctioning or the seclusion of some of the masters."[178] The bitterness was new. Feeling that he was giving more than he was getting, he was beginning to wear out.

GROPIUS'S FRUSTRATION began to turn to rage over an insult to Ise. Klee and Frau Lürs, the wife of a Dessau official, had both been invited to become directors of the Bauhaus Circle of Friends. At the same time, Ise Gropius was being eased out of that role by some of the other directors, who found Ise intrusive. Frau Lürs had organized a musical evening with Adolf Busch on violin, accompanied by Rudolf Serkin on piano, and Ise had proposed that the reception afterward be organized by Hinnerk Scheper, the head of the wall-painting workshop. Klee was annoyed. He considered Ise meddlesome and believed that, now that she was no longer a director of the Circle of Friends, she should not be involved. Klee said he would no longer have anything to do with the planning of the concert.

His main issue was with Ise's substandard musical taste. She had brought in a dance instructor from Berlin to teach the Charleston and other new steps to the young faculty. The lessons took place at Gropius's house, because that's where the only gramophone was. For Klee and Kandinsky, already appalled by what they considered Ise's frivolous taste in music, her intrusion into the social details of the Busch-Serkin concert was the last straw.

It seemed as if everyone at the Bauhaus was annoyed with everyone else. People accused one another of not doing enough for the institution, or of assuming too much power while taking on too few burdens.

In the summer of 1927, Walter and Ise Gropius got away from all the contentiousness for a holiday at his family's country house, followed by a trip to Copenhagen and rural Sweden. Gropius returned rejuvenated. The combination of beach time and lecturing to receptive audiences restored his hopes for the Bauhaus. But as soon as he was back, he faced demands from every direction. Teachers, students, journalists, Bauhaus guests, and prospective clients all wanted something from him. At the same time, he needed to travel continually to Berlin because of his private work.

Fritz Hesse, the Dessau mayor who had made everything possible, didn't like to see Gropius devoting time to anything other than the Bauhaus. Hesse's political party was losing support, and he was finding it increasingly difficult to get funding for the school. It irked him that Gropius was rarely in his office.

Hesse was also concerned about rumors of radical students organizing political meetings in the school canteen. With the director away more often than not, there was no one to address the problem. When Hesse told

Gropius that he wanted to see some major changes—the departure of Moholy-Nagy, whose work and personality were controversial; a reduction of the budget in many workshops; the closing of the printing workshop to cut costs—Gropius's only response was to volunteer that the salary owed him personally should go to the school instead. In spite of the offer of what would have been a major sacrifice, Hesse was not satisfied.

Ise was disliked by many of the Bauhaus faculty members and students, which only added to her husband's difficulties in Dessau. She was, however, helpful in his ongoing struggles with Alma. Alma would not permit eleven-year-old Mutzi to go to Dessau, as if the Bauhaus were a hotbed of danger, yet when Walter and Ise had tried to have his daughter join them on their summer holiday, Alma had prevented that as well. Meanwhile, Mutzi, who had been educated by private tutors and a governess, had no friends her own age. In the fall of 1927, she went to a boarding school in Geneva, but her trial enrollment lasted just a single night, after which she and Alma ended up on a mother-daughter holiday in Venice. When Alma finally consented to have Mutzi go to Dessau for a month, during a time when Gropius was swamped by his problems with Mayor Hesse and glimpsed his daughter only at meals and on weekends, Ise became involved and helped organize activities for her. Mutzi, who was developing an interest in the theater, attended rehearsals at the Bauhaus workshop, and "the children of masters dutifully called upon the director's daughter, but . . . she was still shy, and she found it difficult to communicate with the more unconventionally brought up children of the community."[179] Gropius's feeling that his child was an outsider exacerbated his feeling of being different from the world around him in the institution he had created less than a decade earlier.

THE ADMINISTRATIVE ISSUES INTENSIFIED, with no relief in sight. Marcel Breuer, who was creating extraordinary furniture, and whose chairs would eventually become staples of modern life, had arranged to have the steel pieces manufactured by a craftsman who was a fellow Hungarian. The Bauhaus administration, however, had already made an agreement with Meissner GmbH, a German manufacturer, to produce them. When Gropius insisted that was how it was going to be, Breuer became enraged and resigned from the Bauhaus faculty.

Gropius had by then begun to imagine finding someone to replace him as director. Breuer was one of the candidates. Even though the brilliant furniture designer rescinded his resignation, his erratic behavior disqualified him in Gropius's eyes. Looking outside the Bauhaus, he considered the architects Mart Stam and Hannes Meyer. Stam was not interested, but Meyer agreed to come to Dessau to head a new department of architecture. His specialty

was housing, specifically the way that individual residencies are affected by their surroundings: the impact of adjacent houses, of ambient smells, of outside noises, and of traffic.

In late 1927, shortly after Meyer arrived, a Dessau newspaper, the *Volksblatt,* accused Gropius of taking disproportionately large fees for the housing project in Torten. He wrote a rebuttal, which the editor would not print. On January 15, 1928, he wrote the publisher personally. "Why do you demand the voluntary renunciation of all financial gain only from me and not all others who participate in the construction work? This type of untoward and ridiculous demand can only result in regretting one's helpfulness."[180]

Since he had in fact relinquished a quarter of the fee to which he was entitled, Gropius was enraged to be accused of profiting from a social housing project. Beyond that, he had contributed more than 75 percent of his salary as Bauhaus director to the school's budget, which went unacknowledged in public.

On January 17, 1928, Gropius told a meeting of the Masters' Council that if the newspaper did not retract the charges, he would probably resign as director of the Bauhaus. Then the publisher replied to his letter with a postcard that said, "I am too busy to answer."[181]

The slight was unbearable. Worse still, after nearly a decade of daily anguish to finance the Bauhaus and keep it solvent, Gropius was tired of fighting an uphill battle that was only growing more difficult. An avant-garde theater director, Erwin Piscator—for whom Gropius, in 1927, had designed a fascinating total theater in the shape of a shell, with large interior units that could be rotated and raised or lowered (it was never built)—had ordered a great deal of furniture for his home in Berlin, but Piscator had gone bankrupt, owing the Bauhaus ten thousand marks.[182] There was not enough money to cover the next salary payments.

On February 4, 1928, Walter Gropius wrote a letter of resignation to Mayor Hesse. He recommended Hannes Meyer to succeed him.

THE EVENING AFTER WALTER GROPIUS'S letter of resignation was presented to the mayor by a magistrate of the court, the Bauhaus students were having a dance. Gropius felt he had no choice but to interrupt it with the announcement that he was leaving. It was as if he had told them someone they all loved had just died. The band refused to resume playing, and most of the students simply fell silent. Gropius again took the floor. He urged the students to enjoy themselves and continue dancing, but nothing could lift the pall.

One of the forlorn students, Fritz Kuhr, spontaneously made a speech. "For the sake of an idea we starved here in Dessau. You cannot leave now," Kuhr shouted. He expressed the fears of most everyone there that night.

Reactionaries would take over the Bauhaus; Hannes Meyer as director would be "a catastrophe."[183]

Gropius assured his acolytes that this was all for the best. But he could not resist trying to exact a certain sympathy as embattled martyr. He told the students that his successor would "not be hampered by all the personal difficulties" that had been thrust in his path over the preceding nine years. He had, he told them, been forced to use 90 percent of his time and energy "defensively."[184]

But then he put ideals above his own concerns. The Bauhaus had become, he said, "one of the leading members of the 'modern movement,' and I can serve the cause far better if I continue working for it in another part of the movement." Gropius insisted that the institution he had founded would be in a more desirable situation if he was out of the picture. He urged them "to work constructively and positively."[185]

The feeling on the dance floor that night was that Hannes Meyer had forced Gropius to quit, not that Gropius had anointed him. In the following days, when Meyer announced the ways he intended to reorganize the Bauhaus, and allowed that he had made these plans long before—having realized that the school clearly suffered from a "neurosis of inertia"—that sentiment only intensified.[186]

WHILE GROPIUS QUICKLY RELOCATED his architectural office in Berlin, he became possessed by the idea of traveling to the United States. When the city of Dessau agreed to reimburse him for the furniture he had built into the director's house, it looked as if he had the necessary funding for the trip. But the funds were slow in coming, and it took his old patron Adolf Sommerfeld, who wanted to learn about new construction methods being developed in America, to foot the bill. At the end of March 1928, Gropius and Ise, together with Renée Sommerfeld, Adolf's wife, sailed for New York.

In New York, they stayed at the Plaza Hotel. America made a mixed impression. The food was "unlovingly prepared; though the pastry makeup was tremendous, the quality of the chocolate was poor; the fruit was marvelous, but the waiter's service slow." At West Point, a dress parade was "informal in comparison with Germany." What they found more impressive was New York's Mount Sinai Hospital, where the nursing staff resembled "the famous Tiller Girls in beauty and manner"; the reference was to a dance troupe that performed in the Ziegfeld Follies and was famous for their "tap and kick" routine. By contrast, the nurses in Europe "came from less privileged and less educated classes."[187]

Gropius and Ise took the train to Washington, D.C., where he met with federal committees involved in building construction. The planning of America's capital struck him as "inadequate and inconsistent . . . with sepa-

rate standards for the political and social elite, for government employees and the middle class, and for negroes." Then the Gropiuses headed west on a tour that included Chicago and Los Angeles, but whose high points occurred in New Mexico and Arizona, especially on the Indian reservations; a visit with the Havasupai Indians was the "most beautiful day and greatest adventure in the United States."[188] They had no inkling that America would eventually become their home.

When he and Ise returned to Berlin seven weeks later, Gropius still had not received payment for the furniture in Dessau. On June 15, he wrote Mayor Hesse pressing for the transfer of five thousand marks to his account at the Municipal Savings Bank, saying he had "paid for the materials out of my own pocket and the city has taken them over," and that he was strapped because of what he

Walter Gropius in Arizona, 1928. One of the first things he did after leaving the school he had created was to travel to the United States for the first time.

had had to lay out to cover his moving expenses.[189] It was his last communication with a government official concerning the Bauhaus.

17

In 1934, Walter and Ise Gropius, aided by the London-based architect Maxwell Fry, moved to England. Many people felt that the reason Gropius was desperate to flee Berlin, abandoning a practice that had enjoyed considerable success after he left the Bauhaus, was not just to get away from Nazi Germany but to separate Ise from Herbert Bayer—the same desire that had motivated him when he had left the Bauhaus six years earlier.

In 1937, with Marcel Breuer, the Gropiuses moved to the United States so

Walter could teach at Harvard University's Graduate School of Design. He became an American citizen in 1944, and the following year founded The Architects' Collaborative, known as TAC. Until his death, at age eighty-six, in 1969, he would spread his architectural vision not just across the United States, but throughout the world, although sometimes the results, like New York's Pan Am Building, revealed hubris more than delicacy.

A younger architect at TAC described Gropius near the end of his life, when the Bauhaus founder, now in his eighties, was working on a gallery design in West Virginia:

> Gropius had an unusual degree of determination and energy for his age, which was amply demonstrated the day we presented the schematic design to the Building Committee at the Gallery. The design was well received and Gropius then suggested that we all get stakes and string and lay out the building addition to see how it would "fit" on the landscape. The members of the Building Committee were surprised. It was midday in midsummer with the temperatures in the humid 90s, a time of year and time of day when most West Virginians would prefer to remain in the shade. Nonetheless, we found ourselves out in the noonday sun hammering stakes and measuring, urged on all the while by the untiring elderly architect with fire in his eye.
>
> As a young associate at TAC, I was aware that Gropius did not always think of himself as an ordinary man who had to live by ordinary rules. He occasionally passed me on Route 2 on the way to work in his Nash Rambler, rather speedily I thought, his black french [*sic*] cap jauntily in place, and would disappear around the bend ahead of me in short order. He had loyalty to the Nash, not the most glamorous of cars, because Rambler had utilized the reclining front seats, the idea that he had originated in the design for the Adler car in Germany in the 1920s. But it was not until I began to travel with him for the Gallery that I became familiar with some unusual habits of his.
>
> Gropius had an unrestrained compulsion to be first. He needed to be first on and first off airplanes, and he was unable to wait his turn on line. He would simply barge in front of everyone else impervious to embarrassment. . . . On board, Gropius invariably caused a flurry by unsnapping his seatbelt at the first screech of tires during those terrifying seconds when the plane is touching down, and he would head for the door while we still hurtled at break neck speed down the runway. He was first at the door despite admonitions by the attendants to remain in his seat until the plane had reached a full stop.[190]

Walter Gropius always lived according to his own rules.

Paul Klee

1

Paul Klee specified the text for his tombstone:

I CANNOT BE GRASPED IN THE HERE AND NOW
FOR I LIVE JUST AS WELL WITH THE DEAD
AS WITH THE UNBORN
SOMEWHAT CLOSER TO THE HEART
OF CREATION THAN USUAL
BUT FAR FROM CLOSE ENOUGH[1]

By the time he arrived at the Weimar Bauhaus at the end of 1920, this totally original, free-spirited artist had demonstrated just how close to the heart of creation he was. A profusion of watercolors and oils in which plants burst into flower, and the seas and heavens explode into life before our eyes, are like moments of birth.

With his extraordinary mind occupying that realm in which life is generated, in his daily life Klee inhabited territory distant from the usual stage of human conduct. When Anni Albers, who was first his student and then his neighbor, said that Klee was like "St. Christopher carrying the weight of the world on his shoulders," it was both because he was in his own orbit and because he was preoccupied with his task of making art.

Will Grohmann, an astute art historian who often visited the Bauhaus, writes that the reticent Klee "held the world at arm's length."[2] Neither at meetings of Bauhaus masters nor on the rare occasions when he had ordinary conversations did he ever commit himself to strong opinions about how people should act.

The painter Jankel Adler describes what Klee looked like from afar:

I have often seen Klee's window from the street, with his pale oval face, like a large egg, and his open eyes pressed to the windowpane.

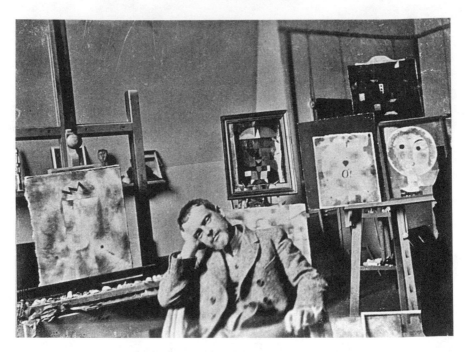

Paul Klee in his studio at the Weimar Bauhaus, 1922.
Klee worked on many paintings simultaneously.

From the street he looked like a spirit. Perhaps he was trying to deci-
pher the language of the branches across his windows.[3]

Adler gives a picture of Klee at work:

He used to gaze for a long time at his prepared canvas before he began
the drawing. . . . I have never seen a man who had such creative quiet.
It radiated from him as from the sun. His face was that of a man who
knows about day and night, sky and sea and air. He did not speak
about these things. He had no tongue to tell of them. Our language is
too little to say these things. And so he had to find a sign, a color, or
a form. . . . Klee, when beginning a picture, had the excitement of a
Columbus moving to the discovery of a new continent. He had a
frightened presentiment, just a vague sense of the right course. But
when the picture was fixed and still he saw that he had come the true
way, he was happy. Klee, too, set out to discover a new land.[4]

KLEE'S NATURE AND COMPORTMENT are evoked by Dostoyevsky's description of the
remarkable Prince Myshkin, hero of *The Idiot:* "For a long time he seemed

not to understand the turmoil that was seething around him, or rather, he understood completely and saw everything, but stood like a man isolated, not taking part in any of it, who, like the invisible man in a fairytale, has made his way into the room and was observing people who had nothing to do with him, but who interested him."[5]

This man of few words and consistently calm demeanor was often seen walking alone in Weimar, absorbing nature in solitude. If he separated himself from the quotidian lives of those around him, he responded deeply to the pulse of life within every bird or flower. The lusty appreciation and unguarded enthusiasm that emerged in his copious artistic production echo Myshkin's

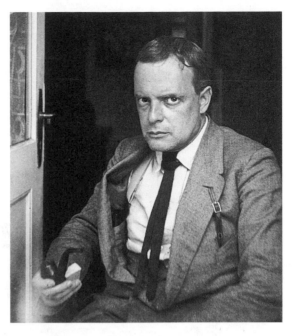

Photograph of Paul Klee taken by his son, Felix, at their house in Weimar on April 1, 1925. Most people found it hard to fathom what was going on in Klee's mind.

encomium for life: "You know, I cannot understand how one can walk past a tree and not be happy that one's seeing it? . . . How many things there are, at every step, so lovely that even the man at his wit's end will find them lovely! Look at a child, look at God's dawn, look at the grass growing, look into the eyes that look back at you and love you."[6]

For Klee, artistic creativity was steered by the same mysterious force by which the universe came into being and all life begins. One of his favorite words, in his teaching at the Bauhaus as in the texts he wrote when he was there, was "genesis." He lived at the miraculous moment of everything emerging for the first time.

2

Ernst Paul Klee was born on December 18, 1879, in a small village near Bern, the capital of Switzerland. His father, the son of an organist and from the same region of Germany as Bach, had intended to be a singer, but ended up a schoolmaster instead. Frustrated by not doing what he wanted, Hans Klee was notably edgy and sarcastic, which took a continuous toll on his son since he lived almost to the end of Paul's own life. Paul's mother, Ida Frick, a Swiss from Basel, had ancestors from southern France and, according to rumors, from North Africa; she was trained as a musician in the conservatory in Stuttgart, but never worked.

A few months following their son's birth, the family moved to Bern. Paul was an imaginative little boy, attracted by the bizarre; he would run to his mother "when the evil spirits that I had drawn (three to four years) suddenly acquired real presence." He also told his mother "that little devils had peeked in through the window."[7] Paul had an uncle who owned a restaurant, where the marble tabletops seemed full of grotesque faces and the veining of the stone assumed the forms of contorted figures, and he was so mesmerized that he made drawings of this lively world. At age three, he had a dream in which he saw what he believed to be the sexual organs of the family's maid, which consisted of four infantile penises arranged like a cow's udder; he never forgot the image.

It was normal at the time for little boys to wear skirts, but this was one little boy who was particularly eager that they look just right. Klee would remember, "I developed very early an aesthetic sensibility; while I was still wearing skirts I was made to put on underwear that was too long for me, so that even I could see the grey flannel with the wavy red trimmings. When the doorbell rang I hid to keep the visitor from seeing me in this state (two or three years)." Subsequently, he "was sorry I was not a girl myself so I could wear ravishing lace-trimmed panties (three to four years)."[8] Paul liked playing with his older sister's dolls at that same age.

He was even closer to his doting maternal grandmother, Anna Frick, than to his mother. Frau Frick gave him a box of brightly hued chalks, and he made lively, playful drawings of stick figures and animals, which, while typical of children's art, were remarkably controlled and articulate. Paul gave his grandmother most of these drawings, and she encouraged him to make art however he wanted. She also drew, and together they would pore over the luminous, commercially produced religious prints

that she considered great art. Paul marveled at the intensity of these reproductions.

Frau Frick's death devastated him. He subsequently wrote, "After my grandmother's death when I was five years old, the artist in me was orphaned."[9]

Mathilde Klee, the artist's sister, remembered: "My brother was left-handed, incidentally; except for his writing he did everything (including painting and drawing) with his left hand. One of our aunts thought 'this left-hand nonsense ought to be knocked out of him.' My grandmother flared up: 'Absolutely not! The child will use the hand that he feels he can use better.' "[10] His grandmother was his protector as well as his inspiration; she was also the source of a physical and emotional comfort he later described in his childhood recollections: "She used a particularly soft kind of toilet-paper on me, so-called silk paper!"[11]

THE CHILD WHO REGARDED the loss of his grandmother as his artistic orphanhood reacted to death in his own way. He was already aware of being different because he did not believe in God, while "other little boys were always saying, parrot like, that God was constantly watching us." When another child's grandmother died in their barrack-like apartment house, and the other boys in the building said that "she was now an angel, I wasn't the least convinced." He was equally matter-of-fact after Anna Frick died and he and other family members went to view her body in the hospital. Although he was not allowed to go close, Paul was aware that the corpse bore "no resemblance" to the woman he had adored. He learned "that the dead could terrify us," but he shed no tears, believing that crying was "reserved for adults."[12]

In grade school, Paul made imaginary advertisements for the school newspaper, showing things for sale, and signed them "Luap Elk"—his name spelled backward and shortened, with the "Ernst" dropped. He filled sketchbooks with vivid imagery that betrayed rare dexterity, and knew even then that he wanted to be a painter. But he was almost as obsessed with playing music as with drawing. His mother had had him start to learn violin at age seven. At ten he went with her to a performance of *Il Trovatore,* and the next year he joined the Bern Musical Orchestra.

After attending a ballet performance at age eleven or twelve, Klee was inspired to make some "pornographic drawings . . . a woman with a belly full of children"; another in which "a rather plump elf" bends down to pick up a strawberry and reveals his bottom as "the deep valley between swelling hills"; and one of a woman in an obscenely low-cut dress. Klee was "scared to death" when his mother found them and scolded him for being immoral. It was a time of setbacks; after he met a nine-year-old girl, "a delicate

beauty" named Helene, from Neuchâtel, and pulled her violently toward him and began kissing her, she fought him off and told him, "You're bad."[13]

FOR MOST PEOPLE, adolescence puts the brakes on the disinhibition of child-hood. Yet Klee never—either in his teenage years or later on—thought to conceal what was childlike, or possibly mad, in his character; he simply expressed his fervor in his art. A pencil drawing he made when he was sev-enteen reveals how overcome he was by trees on a riverbank. It was as if Klee lived inside nature, and the viewer joins the artist in being subsumed by a dense profusion of branches and leaves. The grass along the river's edge is thick and high, its lushness intensified by its reflection in the water.

We feel Klee's immense tenderness toward his subject; he draws like someone seduced. Still an adolescent, he rendered foliage with the emo-tional fervor with which certain nineteenth-century writers describe young love and evoke the torrents of springtime and of seasonal renewal. Even when he was the most influential teacher at the Bauhaus, Klee would not be so much a modernist or a theorist of any sort as a romantic and a naturalist.

Trees would be a recurring theme for the rest of the artist's life. He would draw gardens and forests, sometimes painting leaves abstractly with broad brushstrokes, on other occasions evoking branches by using a ruler to make schematic patterns of thin lines. The fealty to the riches of the cosmos that vividly imprinted itself on his consciousness when he was a child would only grow stronger. The advanced students at the Bauhaus who worked with him in his studio were given, as their first task, an assignment to draw trees.

3

In 1898, shortly before his nineteenth birthday, Klee moved to Munich to study art and to play violin in a string quintet.

He rented a room in the home of a doctor's widow, began playing music, and found someone to teach him figure drawing. But he quickly had differ-ent priorities from what he anticipated: "Life, of which I knew so little, attracted me more than anything else. . . . In short, I had first of all to become a man: art would follow inevitably. And, naturally, relations with women were part of it." He met a young woman whom he considered "free and fitted to introduce me to those mysteries around which the world, 'life,' for better or worse revolves." She was "a blonde, blue-eyed thing." He "car-ried a bag of apples for her," and when she offered him an apple, he assumed

he was on his way to experience "the Holy of Holies." In his diaries, Klee would tell the story of his pursuit, stage by stage, but also of his failure, leading him to feel that "I had some defect or other that kept me from being successful with women."[14] His main ambition was to make himself a proficient lover. "I hardly think about art. I only want to work at my personality."[15]

Nineteen-year-old Klee kept "a little 'Leporello catalogue' of all the sweethearts whom I didn't possess." The one who interested him the most was Lily Stumpf, whom he met in the autumn of 1899, on an evening when she played piano and he played violin. By February 1900, he wrote in his diary, "Flower of fire, at night you replace the sun for me and shine deeply into the silent human heart. . . . I want to hold your head in my hands, tightly in both hands, and never allow you to turn away from me." But Lily would not allow him to satisfy his "curiosity about the sexual mystery." To do so, he had, in his words, "begun an affair with a girl who was my social inferior."[16] Stumpf, whose father was a doctor, was, by contrast, a notch above him in the class system.

By the time he achieved his goal of losing his virginity, he was twenty years old, and a new century had begun. His own droll observer, especially about his debauchery, Klee noted in his diary, "Alcoholic excesses were an important part of the whole process. Entries made in a state of drunkenness that followed long nightly parties must be deleted here, for they invariably turned out to be completely incomprehensible." There was one "May wine orgy" after which he passed out cold. But when he was sober, he was very serious. Even though writing was "the only other thing" that "attracted" him, he was increasingly convinced that he wanted to make painting his occupation. Besides struggling to determine his professional future, he was grappling with his personal life. Klee felt guilty about Lily. Every time he had sex with his mistress, he found himself "really disgusted" that he could not combine physical pleasure with love.[17]

Klee kept one account of his drunkenness, a spectacular example of *in vino veritas:* "The only extant alcoholic entry. I know. I don't believe. I first want to see. I doubt very much. I do not envy. I do not turn back. I act. I oppose. I hate. I create in hatred. I must. While I admit. I weep. Nonetheless. I persist. I complete. I wager. Only quiet, only quiet!"[18]

THAT SPRING, there was a significant turn of events. On April 26, 1900, Klee recorded, "The most agitated days pleased me especially. I drew compositions in the morning ('Three Boys'). Then my mistress visited me and declared herself pregnant. In the afternoon I took my composition and studies to Stuck, who accepted me in the autumn class at the Academy." That evening at a concert, he met yet another young lady he liked. He slept especially "deeply and soundly that night!" Stuck was Franz von Stuck, an aca-

demic painter who taught figure drawing in his lavish villa and who, true
to late-nineteenth-century tradition, mainly painted emotionally wrought
women. At the Bauhaus, Stuck's classes would become territory that Klee,
Kandinsky, and Josef Albers had in common. Albers later recalled that
when the three discovered that each had studied with Stuck, albeit at differ-
ent times, they agreed that they had gotten no benefit from "all that draw-
ing of nude women."[19]

Klee's mistress's pregnancy had little visible effect on him. The mother of
his future baby remained unnamed in his diary. He was attracted to one
woman after another: boating on "the mirror-smooth lake" of Thun with
"Fräulein Schwiago"; obsessing over "Eveline"; meeting, on a steamer, a
"pretty damsel," named "Fräulein Helene M," who had in his childhood
been "the object of my first passion." But he was not pleased with himself.
His own harsh judge, Klee wrote: "Often I am possessed by the devil; my
bad luck in the sexual realm, so fraught with problems, did not make me
better. In Burghausen I had teased large snails in various ways. . . . Inno-
cence irritates me. The bird's song gets on my nerves, I feel like trampling
even worms."[20]

KLEE'S WRITING during this brief period of his life when he was recording ran-
dom thoughts points toward the art he would make at the Bauhaus. In
Weimar and Dessau, he would randomly mix incompatible flora and fauna
and landscape elements, jump from the serious to the larky, and juxtapose
eagerness and trepidation. His art would reveal the unexpected admixtures
of the mind.

Part of Klee's gift as an artist, which he would pass on to his students, was
his ability to achieve such freedom through painting. In 1900, he liberated
himself more with words than with a paintbrush; by the time he reached the
Bauhaus, he had become notably silent, pouring everything into his art.

Klee's diary entry one August day in 1900, when he was in the moun-
tains, in Oberhofen, could be the narrative for the watercolors he would
paint a quarter of a century later: "Nowhere I wanted to stay; of what use,
then, was a delightful landscape? The dryads' chatter bored me. The bells of
the herds up in the mountains had sounded there before. On the water the
despair of loneliness lurked around me. Unconsciousness was what I needed,
not recreation."[21]

That prizing of the unconscious, in combination with vivid imagery, was
one of Klee's great contributions to the Bauhaus. Gropius, after all, cared
mainly about functionalism and wanted to infuse design with rationalism;
the torments of his own soul were isolated from his professional life, and he
advocated that same separation in the workshops. Klee, on the other hand,
in the way he taught art, and above all in his own work, accepted, and even

embraced, desire, frustration, and doubt. He readily endorsed the expression of intense human cravings—so long as the form was correct, and the feelings, however violent, were displayed in a balanced, artistic way.

After declaring his desire for the unconscious, he wrote, "I felt drawn to the city. I shall never be capable of entering a brothel, but I know the way to reach it. I wrongly lead a vegetable life, like the blossoms of the flowers behind the iron fence in the castle of Oberhofen. I am a captive animal. . . . In a poem I sang a song to sorrow with such pathetic conviction that it personified itself in the desired woman, in whose entrance I was good to die."[22]

No one else's mind worked quite like this. Even though Klee mellowed in the two decades between writing those diary entries and accepting Gropius's invitation to Weimar, the way the Bauhaus was so hospitable to someone of such unique imagination was part of its force.

AT THE BAUHAUS, both in Weimar and in Dessau, Klee would openly discuss his conversations with snakes on his walks through the parks. It was during this earlier period in Munich that he first acknowledged his connection to a range of species in the greater cosmos:

> Worms want to console me. . . . Only the smallest creatures are still zealously active, ants, flies, and beetles.
> But me, the midday peace paralyzes. I burn on a dry bed, I am all fire on the thin carpet of thyme and brier.
> I still recall the moon's mildness. But now flies copulate on me, and I must look on it. The snow melts from the mountains, even there I shall not find coolness.[23]

If this was madness (in the course of Klee's lifetime, there would be doctors who publicly diagnosed the artist as schizophrenic), it was never treated. He channeled his disturbing visions into his art, creating rich results and giving himself relief.

Klee recognized that need early on: "When reality is no longer endurable, it seems like a dream dreamt with open eyes. . . . Religious thoughts begin to appear. The natural is the power that maintains. The individual, which destructively rises above the general, falls into sin. There exists, however, something higher yet, which stands above the positive and negative. It is the all-mighty power that contemplates and leads the struggle."[24]

That abhorrence of "the individual"—which meant a fascination with oneself and one's personal experience—would at the Bauhaus ally Klee with Gropius in the dispute with Johannes Itten, and would be something he shared with Kandinsky and the Alberses. It would also endear Klee's work

to some other modernists, like Le Corbusier, who were not directly connected with the school but who admired Bauhaus ideals — in opposition to those of their contemporaries who were deliberately and specifically self-revelatory in their work. Artists who shared Klee's fundamental beliefs, such as Mondrian, were searching for universal truths, often derived from nature and having "all-mighty power." For some, a traditional notion of God was part of this; for others, it was of no consequence. What mattered was not the precise character of the object of worship, but the shared belief in its superiority to the cult of self.

ON DECEMBER 24, 1900, before going to a Christmas tree party at Lily's parents' house, Klee stopped in at the studio of Herr Knirr — for whom he had no first name — with whom he had studied art before taking classes with Franz von Stuck. The platform on which the model normally stood was covered with wine bottles, and the model, drunk, was crawling around animatedly on her hands and knees. Then Herr Knirr disappeared and "returned triumphantly with a bucket and a few bottles of champagne. This refreshed the girls and made us slightly drunk." Klee remained with two of the girls. They were the last three people "on the field of the orgy," and, by the time they left, both women needed to lean on him. The three then repaired to Klee's rented room. "They lie down and I have the proud feeling of holding two women in my power." Following "the last moments, . . . leave must be taken, and I show up at Lily's slightly befuddled."[25]

He concludes his diary entry for that day: "Now I had achieved quite a good deal. I was a poet, I was a playboy, I was a satirist, an artist, a violinist. One thing only I was no longer: a father. My mistress's child had proved unfit for life."[26]

Klee's illegitimate son, who had been born in November, was a few weeks old when he died. We know nothing more; while he had mentioned the pregnancy and recorded the baby's death, he never referred to his birth or brief life in his diary. The infant's demise is presented without emotion. Klee was more excited describing an affair that began on December 28 with Cenzy, a sixteen-year-old model, explaining that because of their class differences he addressed her as "*du*," while she used the more respectful "*Sie*" for him. In his diaries, Klee includes the full text of a letter she wrote him after their first night together. She reported that her father greeted her with "a long sermon on morals, which I did not enjoy very much," and begged Klee "to be very discreet," especially in front of "Herr N," whose mistress of long standing she was; next she instructed Klee to "forget what took place last night," and then, contradictorily, assured him "we shall see each other again next week. I shall visit you." She signed off as "Your obedient Cenzy R."[27]

IN 1901, KLEE AND A FRIEND, the Swiss sculptor Hermann Haller, took off together for six months in Italy. By then Klee had formulated his idea of what counted: "first and foremost the art of living; then as ideals: art, poetry, and philosophy."[28] For his profession, he would be a sculptor, but if that did not enable him to earn a living, he would make extra money as an illustrator. He felt that Italy was where he could get the best education in the fields he had chosen.

Klee was more drawn to the Italian primitives than to the better-known masters of the high Renaissance. That attraction to what was pure, direct, and spontaneous was something he would have in common with many of his Bauhaus colleagues. Kandinsky loved both Russian and Bavarian folk art; Josef Albers preferred Duccio to Giotto and both of them to Botticelli; Anni Albers turned to Inca textile fragments rather than to Renaissance tapestry. They favored heightened emotional charge over formal complexity dependent on stringent guidelines.

FOLLOWING THE TRIP to Italy, Klee settled in Bern, but he continued to travel to Munich to see Lily Stumpf, and in 1902 they announced their engagement. They did not marry until 1906. It was only then that Klee moved back to Munich to join her, and his artwork hit a new stride with the change of his way of life.

Once they were husband and wife, Klee painted and made etchings, while Lily taught piano to support them. In his prints, Klee used a highly realistic style to evoke a world of grotesques. He invented comedians with oversize jaws and enormous, lethal-looking teeth, and a muscular and forbidding naked woman with gigantic limbs sprawled on a bare branch and called, ironically, *Virgin in a Tree.* He titled an image of two stooped-over, Uriah Heep–type characters (physically resembling greyhounds, they stare at each other unpleasantly with unctuous faces) *Two Men Meet, Each Believing the Other to Be of Higher Rank.* This acerbic vision of the world softened when Lily became pregnant; Klee suddenly switched to making paintings on glass that tenderly depicted maternal themes, among them charming evocations of beasts suckling their young.

On November 30, 1907, Lily gave birth to a son. Felix would remain her and Klee's only child. When he was about sixteen months old, he became so ill that his father, who was the parent at home, began to devote himself full-time to child care. At the Bauhaus, he continued to be the more involved parent, as Lily was often away, either dealing with her own failing parents or undergoing treatment for her "nervous disorders."

Nothing could keep Klee from painting, however. The making of art was such a necessity for him that he always found the means to do it. While he

was at home with the unwell Felix, he could work on only a small scale, but he further developed his highly personal style. Like child's play, the oils and watercolors were both intense and whimsical, the product of total concentration.

Klee also began to write frank and lively diaries, and, for a while, to keep a "Felix Calendar." This record of his son's life, starting in babyhood, perfectly reflected the same powers of observation that would nourish Klee's teaching at the Bauhaus as well as his painting. "Felix imitates rotating objects onomatopoetically by *woo-woo-woo;* dogs by *hoo-hoo-hoo!;* horses by *co!co!co!*—with his tongue clicked against the hood palate; ducks: *heh!heh!heh!* hoarsely in the back of his throat."[29] Klee did not think in the usual clichés of "neigh" and "bow-wow" and "quack."

4

In 1911, Klee was introduced to August Macke, another artist working in a fresh and original manner, totally removed from the dry style promulgated at the academies. That autumn, Macke brought his neighbor Wassily Kandinsky to meet Klee. Klee's first reaction to the Russian painter three years his senior, who had broken the boundaries of art by making paintings that did not refer at all to the known visual world, was that he "inspires a certain deep confidence in himself. . . . He is 'somebody,' and has an exceptionally handsome, open face."[30] They immediately understood each other and started spending time together.

Kandinsky and Klee often discussed Wilhelm Worringer's recently published *Abstraction and Empathy,* a short book that enabled them to understand why the balance and clarity that were the goals of their abstract art compensated for the lack of those same qualities in their everyday lives. Precise representation would have only echoed their emotional tumult; they were actively seeking an alternative.

With Franz Marc and Alexey Jawlensky, two other highly competent artists who painted bold forms in vibrant colors, Klee and Kandinsky created Der Blaue Reiter (The Blue Rider Group). While most people were vehemently opposed to their bold, seemingly haphazard colors and energy-laden forms, comparing them to the equally scandalous French Fauves, the Blue Rider artists encouraged and stood up for one another. When others attacked Kandinsky for the work he showed in an exhibition devoted to the Moderner Bund at the Zurich Kunsthaus, Klee wrote a review defending

the abstractions that shocked the general public. They were developing a camaraderie and a friendship that would blossom at the Bauhaus.

IN 1914, KLEE AND MACKE went to Tunisia. Their lengthy stays in Tunis, Carthage, and Hammamet opened Klee's eyes to the spectacular Mediterranean sunlight and the marvels of Moorish architecture. Minarets, cacti, tropical flowers, and blue water, all in glistening sunshine, began to appear in Klee's work. As if seen through a prism, subjects exotic and mundane were rendered in luminous pastel tones, in vibrant pictures divided geometrically like animated, irregular checkerboards.

These joys of life came to an abrupt halt, however, once Klee returned to Munich later that year. Kandinsky, as a Russian, had to leave Germany and return to his homeland. Jawlensky was also forced to leave. Worst of all, Klee's traveling companion, Auguste Macke, was killed fighting in France, at age twenty-seven.

Klee found a solution for his torment and nightmares: "In order to work my way out of my dreams, I had to learn to fly. And so I flew. Now, I dally in that shattered world only in occasional memories—the way one recollects things now and again." His only means of surviving was to escape reality. In 1915, Klee declared, "The more horrifying this world becomes (as it is these days) the more art becomes abstract; while a world at peace produces realistic art."[31]

This was the essence of Worringer's thinking. Art was a different realm, like music—not merely a retreat or a diversion, but a force powerful enough to replace an unbearable reality. What Klee was creating had the strength to compensate for the horrors of life and to provide comfort. It was a beautiful new universe that gave value to life at a moment when everything was in jeopardy.

Then Franz Marc was killed at Verdun on March 4, 1916. A week later, Klee himself, then thirty-five, was drafted into the air force. But nothing could keep him from his passions. In the military camp in Landshut, he played first violin for a performance of Haydn's *Creation*. Privately billeted, he was given the task of painting airplanes, and he managed to spend time in museums in Cologne, near his encampment, where he immersed himself in the masterpieces of Bosch and Bruegel. In the barracks, he read Chinese literature, Rousseau's *Confessions,* and Goethe's *Wilhelm Meister,* and during his leaves in Munich, he continued making art. Klee did not ignore current events; rather, he transformed them through the act of painting. He made wonderful pictures of the Zeppelin flying over the Cologne Cathedral at night.

Apart from those images of the Zeppelin, most of Klee's work depended

solely on his imagination. Some bordered on pure abstraction: geometric forms that cyclically open and fold up, simultaneously expanding and compressing. Other pieces, mostly watercolors, introduced Klee's private universe of birdlike humanoids, ships that are both child's toys and serious seagoing vessels, and cheerful monsters. The titles—*Astral Automatons, Irma Rossa, The Animal Tamer, Fatal Bassoon Solo,* and *The Eye of Eros*—evoke the unique mental realm in which the artist lived. His inner necessity to paint drove him forward in difficult circumstances, and he was further encouraged by soaring sales of his work, even during wartime.

He also began to catalogue his paintings, meticulously assigning a number to each and recording the title, measurements, and medium, a practice that he would continue forever after.

From 1916 onward, Klee was convinced that Germany would be defeated. In 1918, he asked to be demobilized and obtained his discharge. He then rented a large studio in a castle in Munich, where his wife and son joined him. His loyal dealer, Hans Goltz, also in Munich, mounted solo exhibitions of his work, but as Oskar Schlemmer, who would soon be Klee's colleague at the Bauhaus, pointed out, Klee, "the genuine artist," remained less understood by the art critics than were other famous painters.

Schlemmer adulated him; he considered Klee to be one of the best artists working at the time. "He can reveal his entire wisdom in the barest of lines. That is the way a Buddha draws." Schlemmer was overwhelmed by Klee's intensity, warmth, and, above all else, his complete originality. Klee's art exemplified for Schlemmer the realization of a broad overview executed meticulously. He believed that the mark of the greatest artistic accomplishments was that they derived from "a simple but comprehensive insight into the nature of things. To have found this means is to have found oneself, and thereby the world."[32]

Schlemmer wrote this following a furlough, when he had again donned his army uniform but could think only of the lesson provided by Klee's approach, which encouraged thinking first, then drawing. Schlemmer admired Klee's pursuit of "the One Significant Thing," however tortuous the route to get there might be. Schlemmer used the word "voluptuous" to describe the way that both he and Klee drew, in keeping with the idea that "lack of moderation leads to the palace of wisdom."[33]

IN FEBRUARY 1919, Schlemmer went to Munich to see this artist he worshipped but had never met. Encountering his hero in person, Schlemmer was disappointed. In spite of the apparent childlike quality of Klee's work, as well as its spiritual depth, he discovered that Klee was surprisingly like a tense, midlevel businessman. When they finally met, Schlemmer was astonished

at how materialistic Klee's interests were. The artist he expected to find otherworldly was, in fact, deeply worried about the cost of food and apartment rents, with an obsessiveness that "bordered on the ludicrous."[34] Nonetheless, Schlemmer, who headed the Stuttgart Academy, tried to get Klee appointed to take over the composition class being given by an older professor, Adolf Hoelzel.

Schlemmer's proposal was definitively rejected by both the academy and the Art Patrons' Guild. The official reason given was that Klee's work was too playful and did not show sufficient commitment to the issues of composition and structure that should be evinced by someone in his position. The hostility went deeper: the real reason, although not stated in public, was that Klee was "too 'dreamy' and 'feminine' an artist" and was "a Jew and a theosophist."[35] This had to do with a perception of character traits, not facts: at the same time that Klee was the choice of the students and the school director, and had a small coterie of admirers internationally, his work upset, even terrified, many viewers.

IN THE SPRING OF 1920, Goltz mounted a major Klee exhibition in Munich, which was well received, and books devoted to Klee's work began to appear. Goltz made a contract for the regular purchase of Klee's work, and a collector from Bern, Hermann Rupf, began buying a lot of work both for himself and for the great Paris-based dealer Daniel-Henry Kahnweiler. Nevertheless, Klee wrote Schlemmer that he knew he needed to take "a profitable teaching position." Having been granted his military discharge so he could teach, he declared, "My readiness to work as an art educator . . . stems mainly from altruistic motivations and a willingness to help."[36] Above all, he needed a steady wage.

Klee was also showing symptoms of emotional instability. Jankel Adler, based on what Klee himself told him, would later write about a telling moment in that time period, witnessed by the artist Alfred Kubin:

In his Munich days, at the end of summer, Klee used to sit in the late afternoon in his studio with Kubin. In the window, the sky was a soft violet. On a table near the window there was a pot with water, which Klee used for his watercolors. He watched the reflection of the sky in the pot. To do this he lay on the table, which began to shudder under his nervous weight. After a while, Kubin put his arms round Klee, who said, "I am not very comfortable—I am not like this—I have nothing to do with this." Kubin leaned over with his mouth to Klee's ear, and whispered very tenderly, "swindler." "Today I laugh about it," said Klee, "but that day I did not laugh."[37]

ON MAY 1 AND 2, 1919, when Klee was in Munich, the Bavarian government was ousted by federal troops. Artists and writers sympathetic to the old government were being tracked down and arrested. The playwright Ernst Toller went into hiding in the same building where Klee rented his studio, on the Wernechstrasse.

On June 1, police entered the building, arrested Toller, and also searched Klee's atelier. Jankel Adler recalled that "detectives knowledgeable about art immediately recognized that there was more 'behind' those pictures than met the eye." On June 11, Klee fled to Switzerland. To Lily, who had remained in Munich but was at no risk, he wrote on June 24, "It seems we have peace now, better for me."[38] This would be his attitude throughout his life—and certainly during the internecine battles of the Bauhaus.

While Klee's postcard from Switzerland was on its way to Munich, a letter from Lily was en route to him, saying that the police had returned and this time searched the entire apartment, which adjoined the studio. He wrote Lily, "House search! What do they want at my place? To view pictures which they will not find beautiful anyway?"[39]

Klee did not feel it safe to return to Munich until the end of July, nearly three weeks after Toller's trial and condemnation for high treason because of his political and antiwar writing. (Thomas Mann and Max Weber used their influence to help him escape a death sentence and receive only five years.) Following these events, Klee wrote Kubin that in spite of the searches and arrests, even if the new regime was a "communist republic" and was "unstable," it presented exciting possibilities for group living. "It wasn't altogether without positive results," he allowed to Kubin, once the short-lived government was toppled. It had made him think that "rarified individualistic art"—his own—might become more than "a capitalistic luxury" and "curiosities for rich snobs. And that part of us which is somehow striving to reach beyond the eternal values would be more likely to find encouragement in the communist community. The fertilizing effect of our example would take place on a broader basis along different channels."[40]

Even before the Bauhaus existed, Klee was envisioning "a theoretical experimental station," where "we would be able to pass on the results of our inventiveness to the people as a whole. This new art could then penetrate the handicrafts. . . . There would no longer be any academies but only art schools for craftsmen."[41]

In March 1920 the German economy was thriving. While Great Britain and the United States were having severe financial recessions, the German government's policy of monetary expansion made the art market especially strong, since buyers consider paintings a good hedge against inflation. On July 30, 1920, the Reichstag further encouraged art purchases by abolishing the 15 percent luxury tax that had been imposed on them ever since

December 24 of the previous year. Because of his contract with the dealer Goltz, Klee was "riding the crest of this boom,"[42] but he was skeptical about it, recognizing the hazards of inflation. He wanted the security of an academic position that would provide housing as well as a dependable salary, and he was hoping to find an institution that embodied his vision of an ideal community.

5

In November 1920, Klee took a holiday in the Ticino, the southernmost canton of Switzerland. He was there visiting Jawlensky and Marianne von Werefkin, two of the painters who had worked with Kandinsky and Gabriele Münter in the Bavarian Alps a dozen years earlier and who continued to paint in vibrant colors and an animated style. While he was enjoying himself in this region of steep mountains and clear lakes, he received a telegram from Walter Gropius. It was brief and to the point: "Dear Paul Klee: We are unanimous in asking you to come and join us as a painter at the Bauhaus—Gropius, Feininger, Engelmann, Marcks, Itten, Klemm."[43]

Since Itten, the dominant faculty member, was a renowned taskmaster, it was anticipated that, by contrast, students could come to Klee if they wanted more subtle guidance. Some feared that Klee would have nothing practical to contribute and was too immersed in "art for art's sake," but Klee himself had no inkling of their skepticism when, on November 25, he embarked for Weimar.

The train from Munich took him to Jena, where he arrived shortly before 4 a.m. and had to wait two and a half hours for his connection. Lingering over a cup of tea in the station, he had a wonderful sense of new worlds unfolding. The details of the timetable and the forward movement were intoxicating. Happily boarding the train that left at precisely 6:25 a.m., observing the first traces of dawn on the flat Thuringian landscape, where the sweeping fields and vineyards were punctuated by the red-tiled roofs and slender church steeples of small villages, he was in high spirits when he arrived in Weimar. On arriving at the Bauhaus, Klee was dutifully welcomed by Itten and Muche.

Informed that Gropius would not meet him until noon, Klee explored the town with its medieval walls and narrow streets. He was conscious that Goethe had laid out the English park he had strolled through that morning; "the German Athens" was even more distinguished than he had imagined. The meeting with Gropius, however, did not go as anticipated. Klee had

been drawn to Weimar by the prospect of an annual salary of 16,500 marks and a large, free studio, so when Gropius began their conversation by asking him if he would like to be the master of the bookbindery, Klee's spirits sank. He replied that, other than his love of reading, he had no reason to be involved with this particular craft. Gropius, as always, had a diplomatic sally. "Don't worry, none of our formmeisters are experts in what they do. That's what the craftsmen are there for. You would teach theory."[44]

Gropius succeeded in persuading Klee that he might apply his ideas on art to any subject being taught at the Bauhaus; it didn't take long before Klee was convinced that this was the right place for him. Together they worked out the details of Klee's teaching contract; all that remained was to have it ratified by the Thuringian government. That official accord would allow Klee to start teaching in January 1921. Initially he would spend two weeks of every month in Weimar until he found adequate housing for him and his wife and young son, as well as Fritz the cat, all of whom would remain in Munich until he had done so.

GROPIUS DID NOT WANT Klee at the Bauhaus purely for his talent. The director had calculated that Klee's presence on the faculty would help the school forge connections with the international art world. Indeed, it was an instant PR coup. The appointment increased awareness of the Bauhaus among many people who might advance the school's purposes, among them important gallery owners, museum directors, collectors, and critics. Klee's work was regularly included in shows at several museums led by visionaries who might now want to establish further connection with the Bauhaus, and the impending publication of two important books about Klee gave further luster to the school.

Klee's sister Mathilde was a major behind-the-scenes player in his decision to make the move. Mathilde assisted with the organizing and selling of his work; she accepted drawings as payment only because he insisted on it. He knew that Mathilde would need to assume even more responsibility if he left Munich for Weimar. When he let her know that he would be able to paint with renewed intensity thanks to the unprecedented financial security that would come with his Bauhaus salary, Mathilde told her brother she would gladly take on the extra burden. With her support, Klee accepted Gropius's proposal.

6

On January 10, 1921, at 7 a.m., Klee's train again pulled into Weimar. Refreshed by the overnight journey, the new arrival on the Bauhaus faculty checked his bags in the lovely nineteenth-century train station that offered such a gracious welcome to the city. He immediately took a walk in the English Garden, the large local park designed by Goethe. It was still dark out, but while Weimar could be brutally cold at that time of year, it was an unusually springlike day, and he felt as if he had arrived in a bucolic paradise.

He wandered about for a couple of hours. Then, as the day broke, he found a café that had just opened and waited there. Klee was content, anticipating that the park would put him in happy conjunction with squirrels, and, in the upcoming springtime, with many species of birds and foliage. He soon grew frustrated, however. He went to Gropius's office, but the director was nowhere to be found. Klee abhorred wasting time. He wanted to make all the arrangements for his living and working spaces so that he could resume painting right away. When Gropius finally showed up at 11 a.m., Klee resolved his practical details as quickly as possible.

Later that day, Klee wrote Lily, who was still in Munich. Rather than report on the Bauhaus, he told her about the squirrels in the parklike private gardens behind the sumptuous villas in the Golden Horn, the neighborhood where they would eventually live. That proximity to nature, and the freedom to paint, beckoned him more than his new job.

KLEE SPENT HIS FIRST NIGHT in Weimar in a pension at Am Horn 39, only a few doors from No. 53, the capacious nineteenth-century house where he and his family were to have an apartment. No. 53 was a top-heavy structure with a vast sloping roof covered in rows of scalloped shingles and punctuated by large dormers with cheerful-looking triangular pediments that looked as if they were pointing to the sky. He described it to Lily, writing ecstatically, "Let's seize the moment, and rejoice!" The neighborhood was in open countryside, on a hill overlooking the English Garden. The path to his studio in the Bauhaus building went through that lush, determinedly informal park, whose unpruned, feathery trees looked as if they had come from a painting by Gainsborough. On the morning of January 11, as Klee took for the first time that path that he knew would be part of his routine, he passed in front of what had been Goethe's private garden house. He wrote Lily

about all of this and described the beautiful market garden behind their future apartment; everything was "just simply splendid."[45]

Gropius was out of town for the day. This meant that Klee could not sort out some details that remained unresolved, but he used the time productively to set up his studio and organize his paints and other supplies. Two days later, he was painting again. He had rarely been happier than he was starting afresh in his large new workspace with its pristine white walls waiting for him to make pictures to hang on them.

Beyond the necessities for his work and minimal personal possessions, Klee had brought nothing with him. He mentally compared his new barebones existence to the way he had lived in the army. At least he had everything he needed in the way of paper, canvas, and paint, and the central heating was functioning well. His only regret was that he could not find either an easel or a drafting table anywhere in Weimar. But even without them, he could begin creating again, and to make art was to feel alive.

ON SATURDAY, JANUARY 15, Klee toured the actual Bauhaus for the first time; his studio was in a building nearby. Johannes Itten, wearing a suit whose color Klee described as "Bordeaux red," had just given a group of young men and women the task of writing on the subject of a popular song, "*Mariechen sass auf einem Stein*" (Little Mary seated on a stone). He instructed them not to begin until they had intuitively perceived the spirit of the song.

These were the advanced students, and Klee was fascinated by every detail of what they were doing and how they were learning. He wrote Lily a detailed description of the experimental assemblages made from a range of materials in the immense studio next to Itten's classroom. "They looked like the bastardized offspring of couplings between the art of savages and children's toys."[46] Klee saw almost everything both as what it was and, simultaneously, as something else.

Klee provided Lily with a vivid image of the students seated on three-legged piano stools with red wooden seats and iron legs. Each was working away at a drawing table with an enormous piece of charcoal in his or her hand. Itten, pacing back and forth in that deep red suit, looked like a clown. The ridiculous getup had voluminous, oversize trousers that he wore very high, and a tunic top that was kept closed by a belt of the same material with a large buckle at chest height. The effect of his clothing was secondary to his facial expression, which Klee depicted as a pout, but which could be misconstrued as a look of real scorn. "The head: half schoolmaster, half pastor . . . and let's not forget to mention his eyeglasses," Klee wrote Lily.[47]

For Klee, eyeglasses had great significance, as did Itten's gaze. The art of seeing dominated his conscience. He felt as if he was always being looked at, just as he was observing everything. The birds and cats, the

leafy plants and crenellated architecture, that he represented in his art, were gazing at him.

KLEE WATCHED WITH FASCINATION as Itten took a piece of charcoal, concentrated his body, and, in a sort of frenzy, drew abstract lines and elementary forms. Itten then gave the students ten minutes in which to draw a representation of a storm. Even if the master's antics and deliberate theatricality were alien to him, Klee was riveted to this new approach to artistic representation and a teaching method so opposite to the academic tradition in which he had been trained.

At 5 p.m. that same day, Itten gave another course in a large lecture hall constructed like an amphitheater, where people sat on the steps rather than on seats. This time the master projected on the wall a large image of Matisse's *La Danse* and had the students draw its essential compositional elements in the dark. Itten's wife sat at his feet, with everyone else huddled in close. The sole exception was Klee, who sat as far away as possible, at the very top of the amphitheater, in a proper chair. Looking on from this perch, he smoked his pipe.

This was how Klee would always be at the Bauhaus. At dances as at all large gatherings, he maintained his distance. Nursing his pipe in a sort of reverie, he observed and may have felt seen, but he kept to himself.

Half a century later, Ludwig Grote, who was a great friend of many Bauhauslers, told Felix Klee his firsthand impression of Paul Klee in that milieu:

> Klee seemed very well-groomed/cultivated in his habits, clothes and demeanor, just as you imagine a citizen of Bern. But you only had this impression if you didn't see his face, his eyes. One was deeply touched by the aura that emanated from him and instantly seized by the feeling of standing in front of a person who had deep insights. One could feel that he knew more than all of us and that he was very wise. I was always moved by reverence/awe when we met, I felt my own inadequacy and often didn't dare to speak—although Klee didn't emanate anything priest-like or overly self-confident.[48]

Grote also noted what he considered an Arab aspect: "The enjoyment of language, jokes and laughter were an integral part of Klee and his household. He likes participating in the Bauhaus parties. We once lent him a real Tunisian, he brought out the Mediterranean really well. Paul Klee became the ideal of a noble Arab of delicate figure."[49]

If that transcript of a conversation recorded in 1972 begs for clarification of the ideas that Klee was lent "a real Tunisian" and "brought out the

Mediterranean," the mix of vivid imagery and unknowability suits Klee well.

THE DAY FOLLOWING the visit to Itten's class was a Sunday. Klee used it to repair to his new studio to compensate "for the time lost yesterday at the Bauhaus."[50] What Gropius had offered him, and the reason he was in this new place, was, after all, the chance to paint as much as possible.

The work Klee did after arriving in Weimar at age forty-one gave no evidence of his change of location. He lived inside his own mind, or in the entire universe: what city he was in rarely had bearing. He made an idiosyncratic image, *Adam and Little Eve,* that shows Adam, his large eyes askew, his face a sort of flat mask, as a cad, and Eve as something between a little girl and a doll; he painted pears and flags and birds and goats, as well as invented landscapes and pure abstractions, that could have been created anywhere. The exception is *The Potter,* a superb watercolor of vases, the simple, bulbous shapes of the unadorned vessels being made in the Bauhaus ceramics workshop (see color plate 2). These forms, generous in scale and painted in subtly luminous colors, are abstracted almost beyond recognition; they are in many ways the product of Klee's particular imagination, but they still have their basis in what he observed firsthand in the workshop. A large head, with popping eyes and a fish-shaped mouth in which enormous teeth are bared, depicts the potter. He or she—the gender is unclear—is the quintessential Bauhausler for being absorbed so totally with the process of making those vases.

THE PENSION WHERE KLEE was staying until the family's apartment was ready in April was run by the Count and Countess Keyserlingk. Klee was delighted by these young aristocrats and their eleven-year-old son, Hugo. He admired both their refinement and the absence of stodginess, which was surprising given their backgrounds, and although the temperatures in Weimar returned to their winter frigidity after that first weekend, Klee was content with his new life. Since he would not receive his first paycheck until February, he bought nothing other than those initial art supplies, and he lived simply, but the Keyserlingks were enjoyable company, and his new situation enabled him to paint with renewed energy and concentration. Churning out watercolors and small oils without interference, he was where he wanted to be.

The high point of Klee's social life was a tasty vegetarian meal made by the sister of Georg Muche at the Ittens'. Mostly, Klee kept to himself, declining invitations even to the most tempting concerts. After what had been a slack period, this precious chance to engage in his painting free of worries afforded him a productive calm he did not want to interrupt. At the

end of his first fifteen days in Weimar, the night before his return to Munich, he wrote his parents and sister that he was extremely pleased with what he saw as the Bauhaus's gift to him. He was delighted to have finished some paintings, and he anticipated that his Weimar studio would be even better in summer.

After this first two-week stint at the Bauhaus, Klee could hardly wait to be reunited not just with his wife and teenage son, but with Fritz the cat. Knowing he would arrive at midnight the following Saturday after a ten-hour train trip, he delighted in the little details of home one savors when contemplating a return, instructing Lily not to use the inside security chain. The structure of his life was the complete opposite of Gropius's: devoid of external drama, based on orderly domestic routines and a steady marriage.

However, when he returned to the Bauhaus in the second week of February after his time in Munich, Klee was thrown off course by a series of logistical problems. The apartment for his family, which was also where he was supposed to teach, was not going to be ready as planned, so Klee would have to conduct classes in temporary headquarters in the main Bauhaus building, where he had observed Itten. He wrote Lily that if the situation was not straightened out by fall, he would have to resign from the Bauhaus.

TO COUNTERBALANCE THE CONTINUOUS FLUX of his own mind, Klee needed maximum stability around him. After telling Lily about the problems with accommodations, he restored that essential equilibrium by reporting that there was, in Weimar, an Indian "salon de thé" that had delicious cakes. Again, he reported that he had everything he needed, and that while the temperatures below freezing were hard for him, he hoped that they would not last.

Gropius now decided that until the flat and its studio were ready, Klee did not have to teach. Mathilde continued to deal with Klee's finances, even paying the bills to the gardener and the dentist, and organized the shipping of his art to exhibitions. Her assistance provided the necessary support for him to work away in Weimar—in his own words, "like a monk in his studio."[51] While the other Bauhaus faculty members partied and had lively social lives, Klee painted from 8 a.m. to noon and 2 p.m. to 9 p.m. every day.

Klee was determined to use the luxury of this new life with its guaranteed salary and free studio space to advance his work into new realms, to which he would be guided more by intuition than by preestablished goals. He considered this a period of searching—a time when he could try "to construct scrupulously the tonality" of watercolors based on only two colors,[52] and could pursue other tasks with self-imposed limitations. In this fecund period of happy experimentation, he made further advances in his

watercolor technique, presenting dreamlike scenarios in a style that appeared newly carefree and was at the same time highly adept. He was not, however, achieving the results he wanted with his oil paintings.

The combination of splendid artistry and emotional legerdemain, enhanced by Klee's unique imagination concerning both subject matter and painting methods, quickly found ardent devotees, even though Klee neither sought them out nor even seemed aware of them. While he was working away at the Weimar Bauhaus, this painter, who belonged to no movement and conformed to no style, had no idea of the ripple effect his work was having worldwide. That February, Rainer Maria Rilke, considered by many the greatest living poet in the world, wrote his mistress, the painter Baladine Klossowska, that he was sending her a new book devoted to the work of Klee. Rilke characterized Klee as a "painter-musician" who would interest not just Baladine but also her sons, Pierre and Balthazar, then ages seventeen and fourteen. Pierre Klossowski was already becoming known as a translator and writer, "Balthus" as a draftman of incredible talent—Rilke had just written the preface for a book of drawings the prodigy had made depicting the disappearance of a cat—and Rilke knew that Klee's work would astonish them.

Rilke said Klee had "an artistic experience which, by dint of being sincere, isn't afraid of the absurd; you can judge it."[53] The world of the Bauhaus enabled Klee to revel fearlessly at an apogee of freedom that was unprecedented even for him.

ON APRIL 18, KLEE bought a new easel for eighty marks and wrote Lily that now he truly had everything he needed. It was an unusually windy spring, and sometimes so bitterly cold that Klee had to wear his fur coat, but nothing detracted from his overall well-being. To fourteen-year-old Felix, he wrote that he worked all day long, and that the only time he spoke with anyone was on Thursdays, when the Masters' Council met.

This was about to change. Although the family's flat was not yet ready, Klee could no longer put off the inevitability of teaching. Thirty people had signed up for the course he was to give starting in mid-May. The number quickly grew to forty-five, at which point Klee insisted it be reduced to the original thirty. Even though he was to teach in one of the large classrooms at the Bauhaus rather than in his studio at home as originally planned, he did not want to lose a certain intimacy.

Klee gave his first lecture on the afternoon of Friday, May 13. The date that some considered a portent of bad luck pleased the man who liked to paint hooligans and demons. "Something incredible happened!" he wrote Lily. "I spoke freely with the people there for two hours."[54]

Klee was astonished that, even before the class officially began, he felt

open and relaxed with the students. In this sympathetic atmosphere that was without precedent in his life, he began by passing around ten of his recent watercolors. Just as he was discussing their formal elements in relation to their overall composition, there was a real "Friday the thirteenth" sort of event. Klee was in the middle of explaining the constituents of dark tones as opposed to light ones, and was using as a comparison baths of different temperatures, when someone knocked at the door and bounded in. It was a policeman who, in a heavy Saxon accent, proceeded to reproach a student who had not registered at city hall. Everyone in the class burst out laughing.

It was a moment Klee adored. He urged Lily to picture him in front of a herd of students too elated by his teaching even to feign respect for the angry cop. He wrote that he felt stuck between his mirth and his obligation to behave like an authority figure.

A MORE SERIOUS ISSUE, from which Klee stayed further removed than most people, was beginning to cause an emotional firestorm at the Bauhaus. Klee's apparent impartiality would be a calming force.

This was the period when Johannes Itten was polarizing the faculty and student body into two warring camps. For Klee, the issue was not, as Gropius saw it, primarily the opposition between artists focusing on their individual creation and people developing designs for industry and the public at large. Klee believed the essential problem was Itten's role as a holy figure whom many people dared approach only with a whisper. Itten had this stature above all because he was a leader of the Mazdaist sect, of which there were many members at the school.

Alma had hated the smell of garlic emitted by the Mazdaist adherents, and Gropius acknowledged the rift between believers and nonbelievers, but Klee, in his role of perpetual observer, considered the sect's divisiveness far more profound than they acknowledged.

Mazdaism deeply upset a number of people who were not its proponents. Klee not only recognized their pain, but shared it. With his strong personal spiritualism, he hated what he considered false spiritualism. He also deplored anything that distracted from the making of art and from the study of nature that he considered essential to creativity.

Rigorous ideas on nutrition, breathing, and movement dominated the everyday lives of the devotees of Zoroaster. In the spring and autumn, sect members underwent major fasts that began with the taking of a powerful laxative. They would subsequently go for as long as three weeks eating or drinking nothing whatsoever except for hot fruit juices. During the fast periods, they would repair to an orchard they owned on a hill on the outskirts of Weimar, and there they would sing piously and weed the land sur-

rounding their hundreds of raspberry bushes and fruit trees. They considered their labor a perfect analogue to what they intended to do universally, "since we were dedicated to rooting out the weeds of the whole world, the enemies of creativity."⁵⁵ Itten and his followers also took ritual baths, piping hot, in the public bathhouse of Weimar and then rubbed themselves with ashes or charcoal, purifying their skin as they had their insides.

During the fasts, the Mazdaists used a needle machine to puncture their skin before having their bodies rubbed with the same oil they had taken as a laxative. The oil was said to draw the impurities (today's "toxins") out of their blood, causing the pinpoints in the skin to scab or turn into pustules, which would be bandaged. The believers then engaged in strenuous exercise to bring on as much sweat as possible so that the ulcerations would dry and heal. That process caused them to be tormented by itching for months afterward.

Diet became the crux of a feud between Itten and Gropius so intense that everyone at the Bauhaus had to take a side. Itten managed to have the Bauhaus kitchen follow Mazdaist laws and wanted to require that his students adhere to the doctrine with complete fidelity. Gropius wanted Itten only to teach. As Oskar Schlemmer described their opposing views, Itten prized the act of contemplation as being more important than the resultant work, while Gropius believed that artists should be grounded in reality and respond to the exigencies of their craft rather than be infatuated with their own thinking. The Council of Masters was expected to respond to the split.

AT THE MEETINGS HELD to address this crucial issue, Paul Klee said the least of anyone. Marcks took Gropius's side: Muche took Itten's. Lyonel Feininger hoped that giving everyone his say would somehow lead to peace, and Lothar Schreyer attempted to persuade the different forces to reconcile. Klee, by not engaging, had more impact than any of them.

Klee's effectiveness resulted from his demonstrating that the making of art mattered more than any of the other issues. Not just with his class of thirty, but in the stained-glass workshop, where he had four students—"three girls and a boy"—he lectured on form and color and avoided other subjects. He wrote Lily that he hoped "to inject a little élan."⁵⁶ This was much needed, he told his wife, because everything at the Bauhaus was too earnest and serious. Klee felt that despite all the claims of a new spirit at the school, it was not sufficiently evident. He intended to see that spirit emerge through art.

It was thanks in part to Klee's example—through his continuous production of amazing paintings, his resistance to distraction, and the soaring beauty of his thinking and its results—that the attraction to Mazdaism and Zoroaster's rituals began, gradually, to subside.

7

In his teaching at the Bauhaus, Klee drew parallels between elemental aspects of everyday human existence and the fundamentals of artistic creation. The result was to endow both with that élan and magnificent spirit that it was his gift to perceive. He likened the development of painting technique to chemical analysis: if a commercial preparation of a given product (he did not specify the type, but was implicitly referring to substances like toothpaste or laundry detergent) sold well, he said, other manufacturers would be driven to have it analyzed so they could discover its components; the drive to master pictorial composition should inspire artists to do similar research. Here, too, he did not provide examples, but the implication was that an artist should try to understand what the underlying factors were that made Giotto's altarpieces and Cézanne's landscapes, however different on the surface, eternally beautiful.

The next comparison in this lecture on pictorial form came from the realm of food. If something eaten brought on illness, Klee pointed out, it would be necessary to discover its harmful components. The same applied to flawed pictures.

Then Klee allowed that those comparisons were only teasers. Having brought art down to earth, he elevated it. "In our kind of business our reasons or motives are naturally different. We do not analyze works of art because we want to imitate them or because we distrust them," he asserted. Rather, even if art was just another métier, it depended on creativity; artists looked at the work of other artists "so as to begin to walk ourselves."[57]

Independence and inventiveness were the goals he encouraged his students to strive toward; nonetheless, there were some vital general precepts that could be learned. Klee guided them to explore the art of others with the realization that it was not "something rigid, immutably fixed." Rather like the world itself, art had developed from complex origins. He spoke about the book of Genesis and its account of the start of earthly life, using this to define art as the result of an essential human drive. "Before the birth of form . . . before the first mark is made, there is an entire pre-history which consists not just of man's desire, his passion to express himself, . . . but also of . . . an attitude to the world. Driven by an inner necessity, this attitude demands expression in this or that direction."[58]

Art is not peripheral to life, Klee believed. Its making is instinctive, and

as grounded in irrefutable truth as is the growth of plants or animals. In turn, its creation should mimic development from a seed or an egg.

Form, Klee explained, comes after genesis. Form—meaning music or language or pictures—is essential to all expression. "The most profound feelings, the most beautiful soul, will be of no use to us if we do not have the forms at hand which correspond to them."[59]

Klee then described to his students, most of whom were in their twenties, the way a child takes a pointed pencil and puts it into motion "in whichever direction causes pleasure." Like a child psychologist discussing the beginnings of intelligence, he amplified on the pure instincts of babyhood that are subsequently tempered by the imposition of reason in toddlerhood. "The chaos of the initial game yields to the beginnings of order."[60]

As he spoke, Klee resembled both a sage and a child. The students were made privy to his unabashed enthusiasm for life's facts and possibilities, and to the intense pleasure he took in making his own work. Klee and his art exemplified his points about both the spark of creativity and the visual sophistication and technical knowledge imperative to good painting. "One remains primitive," Klee told them. "But one cannot persevere with the primitive for long. One has to discover a means of enriching the impoverished result without destroying or erasing the clarity of the simple sketch."[61] His own pictures were, the students recognized, the perfect mix of freshness and spontaneity with know-how and aesthetic judgment.

Klee emphasized to these artists and designers who were just starting out that while they needed to take care never to lose their instinctiveness, they also were responsible for organizing their vision. A line could be "a walk for its own sake. Without destination." But there were also other types of lines, more developed, designed to describe planar figures like triangles, squares, or circles, endowed with "a calming character" and "neither a beginning nor an end."[62] These concepts were, in their way, obvious, yet the students had never before heard them explained so clearly. Nor had the complementary relationship of chaos with calm previously been applied to what they could draw. Their teacher lived and breathed for artistic creation—it was his entire raison d'être, as they knew from observing how he lived—and he presented its essence just as it was his essence.

ONE STUDENT, HANS FISCHLI, described the effect of Klee's teaching:

> Klee taught us neither how to draw nor how to use colour, but what lines and points were. . . .
> There was an infinite variety of marks—lacking in character, weak or strong in character, stuck-up fellows and bluffers, lines which one would have preferred to take to hospital because one feared that their

end was imminent, and others which had had too much to eat. If a line stood up straight, then it was healthy, if it was at an angle, it was sick; if it was lying down, one thought that that was what it liked the most.[63]

The mutability of human and visual qualities was total; so was the link between the physical and the spiritual. Because he was ambidextrous, Klee used both hands to draw diagrams in chalk on the blackboard to demonstrate what he was saying; his two hands working at the same time gave the sense that the heart and the mind were functioning in tandem, that spiritual inspiration and its subsequent physical manifestation were of a piece.

KLEE HAD A BEARD in those days, and he often wore a fur cap, even on days when it wasn't cold enough for the fur coat. "With his high forehead, dark brown eyes, hair combed forward like a Roman, and skin yellowish like an Arab's, Klee made a strange impression."[64] Even people who were not aware of his mother's partially Algerian background found that there was something in his bearing and his delivery that called to mind a North African potentate.

But whether he was bearded or clean-shaven, whether his head was doubled in size by the fur cap or confined by his closely cropped hair, the first thing that struck people when encountering Klee was his eyes. When he was a teenager, he had exceptionally long and thick dark eyebrows that hovered like the valances of a theater curtain, accentuating the porcelain-like clarity of the large whites of his eyes. Even when those eyebrows calmed down following puberty, separating from each other and growing thinner, Klee's oval eyes seemed disproportionately big and clear, like those of a cat, with very dark pupils. They usually were looking upward, as if connecting with the heavenly sphere.

Everything about him was prophetlike. He walked with a slow gait and delivered pronouncements precisely and in notably economical language. "He frequently spoke a single word instead of a whole sentence, and, in true Eastern style, he might use an entire sentence as a parable."[65]

When friends visited, they would look at his latest work—he was so prolific that there were always new pieces—and he was eager to hear their responses. He was often disappointed because the commentary was insufficient. He was perpetually curious about what other people thought of his work—not just whether they liked it, but if they had concrete ideas about the subject matter and the artistry. He discussed his own paintings as if he were observing someone else's creation, and could be highly critical, encouraging whoever was with him to discover the flaws or strong points. On those occasions when he was unabashedly pleased with something he had done, he didn't seem conceited, because he was crediting a force outside himself.

The naming of his work involved those viewers. Klee would have an idea, then he would listen to the interpretations others suggested, write down what they said, and finally, using his own words, decide what he wanted his work to be titled. Thus, *Calypso's Isle* evolved into *Insula Dulcamara. Desert Father* ended up as *Penitent.* The naming, like the creating, was an evolution.

<div align="center">

8

</div>

In his dealings with the art world, as in his relationships with the other faculty members at the Bauhaus, Klee was generally disposed to like people.

That May, when the Berlin-based art dealer Alfred Flechtheim called on him, Klee put aside the many negative things he had heard and found his visitor "a purebred, and very amusing." What counted was that when he showed Flechtheim a variety of works, the dealer found them "mouthwatering."[66] For Klee, the assurance that his pictures brought pleasure to others was more important than almost anything else.

Klee depended on the calm of his home life, even if he and Lily were geographically separated. They both enjoyed keeping everything placid, although they delighted in the shenanigans of others. Klee wrote his wife that once they had both definitively left Munich, they would need someone who was still there to keep them posted on the latest scandals, but the two of them never were grist for the sort of gossip they both relished about others. Klee was so domestic that he wrote, "Laundry is the household task I haven't tried yet. If I could take it on, I'd be more universal than Goethe."[67] In the pictures, there was eccentricity and madness, as well as unabashed sexual fantasizing; in Klee's life, all was order and calm. Fritz, the cat to whom he always sent greetings in his many letters home, was the only capricious member of the family.

That even keel, the simplicity and openness, enabled Klee to pour complexity and drama into his work. Gropius, juggling three women and needing to keep secrets, made architecture that had a look of utmost frankness, coolness, and clarity; Klee, for whom the greatest drama was Felix having a cold, or the unexpectedly wintry weather that June of 1921, made art full of mystery. He could afford to celebrate irresolution.

TO KLEE, life in the park was more important than the Bauhaus. In mid-June, once winter seemed over at last, he wrote Lily: "The weather is fine. The morning scene in the valley of the Saal: a delight; the blossoming, velvet fields. There are no more flowers other than the wild roses."[68] These seasonal

transformations, the spring blossoms and the new textures that came to life as the earth warmed up, were the subject of his paintings. The tensions and joys of trees and flowers fighting their way into existence animate Klee's work of the period.

On June 21, he wrote Lily, "I'm well, which is to say that I'm working."[69] But he was getting more and more restless to have Lily and Felix and Fritz there. Klee met the seventeen-year-old Manon Gropius when she was visiting, which increased his longing to have his own child around. He felt that Mutzi physically resembled Alma more than Walter, and thought she was nice and intelligent. He empathized with this child who did not get along well with others her own age. The evening he met Mutzi, the strawberries were delicious; he wrote Lily a glowing report, penning it on such good-quality stationery that the surface and weight of the paper brought on further encomia about the pleasures of writing on such a wonderful substance. His only complaint was that she and Felix and Fritz were not there.

IN THE FALL OF 1921, Felix, who was soon to turn fifteen, became the youngest student at the Bauhaus. Itten may have seemed bizarre to Klee in his red suit, but the boy did well in Itten's class. The Bauhaus offered a freedom unimaginable in normal school settings.

Felix soon began to perform puppet shows, which were so entertaining that large audiences flocked to them. Bauhaus students and faculty delighted in these spoofs of school life, richly enhanced by the colorful costumes on the puppets Klee had made for his talented son. There were some fifty different characters in all, their faces vivid caricatures of people at the Bauhaus, most of them easily recognized.

Lily had to remain in Munich to fulfill her obligations as a piano teacher, and Klee was in charge of the new household in Weimar. At last the apartment at Am Horn 53 was ready. When father and son moved in, the furnishings were still sparse, but it had an enchanting view over the park, and once Fritz arrived and the grand piano was put in place, Klee felt it had the essential ingredients of home. He was perfectly content to attend to the various domestic details. He cooked competently, and tried to make home life agreeable for his teenage son. He ordered a living room sofa; when it arrived, he thought the upholstery was hideous, but the form amused him, so he settled for it. On November 29, he wrote Lily, "I began with the principles of perspective to end up with the sensation of equilibrium in human beings."[70] Nothing in life was static; everything went through stages — whether it was responding to a new piece of furniture, making a painting, or dealing with life in general.

Having initially gone to the Bauhaus to organize an exhibition of Klee's drawings shortly after Klee arrived in Weimar, Will Grohmann became an

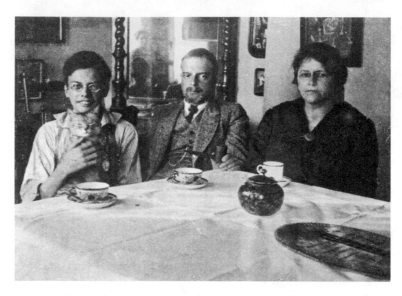

*Paul Klee with his son, Felix, cat Fritz, and sister Mathilde in Weimar
in the autumn of 1922. Klee was Felix's more involved parent;
Mathilde helped make the artist's life run smoothly.*

exceptionally astute, impartial observer of the elusive Swiss. It is from
Grohmann that we have some of the sharpest images of Klee. Every morn-
ing, as Klee walked to the Bauhaus from the large apartment he loved, he
would pass Goethe's garden house. He admired its rustic style. Visiting
Weimar today, one can still observe its rough plaster surface covered with a
lattice for climbing plants, under a steep roof of wooden shingles; this pic-
turesque dwelling must have enchanted Klee after he left his own wonderful
house, a more standard nineteenth-century residence, also still standing,
with its splendid large dormer window overlooking the park. But more
important, Grohmann observed, Klee "lingered to marvel at every bird he
saw or to ponder the parallel between the ages of man and the changes of
season. He might talk to a snake that happened to cross his path, as if it were
a human being, because after all snakes, too, form part of the cosmos."[71]
Those one-sided conversations with the snakes became part of his legacy.

Klee had a choice of dirt paths in this vast park, which for the most part
felt like pure countryside even if it sat alongside a city. Some of the possible
routes meandered through tall grass more than a meter high in spring-
time—a perfect shield for snakes. The impressive trees, many more than a
hundred years old, gave Klee a chance to observe the complex structure in
the network of roots bulging to various heights out of the earth surrounding
their massive trunks. It was not easy walking over the hilly terrain; the jour-

ney to and from the Bauhaus necessitated some fairly steep climbing and was more of an athletic feat than a promenade. But Klee delighted in listening to the chorus of birds, taking in the smells of the dense foliage, and, when he reached the river in whose clean water Goethe was known to swim, observing the strong flow over the weed beds that were visible in the shallow stretches. In the patterns of the running water, Klee gleaned a logic that he would apply to his teaching on the shared principles of natural events and the making of art.

Felix Klee would later recall:

In the fall of 1921 we moved into our new four-room apartment: Am Horn 53, second floor. At various times and in all seasons, the two of us, Klee the master and Klee the apprentice, would make our way each day through the romantic park from home to our places of work and back again. How fascinating my father made these walks with his observations about nature. The world of birds and flowers had especially bewitched him. Every day we marched along the meanderings of the gently flowing Ilm, passing by the Dessau stone and the Serpent monument or the log cabin, by Goethe's garden house and Euphrosyne's stone. After the beloved metropolis of Munich, we led an almost cloistered and rather irksome existence in the little town of Weimar; but even though we were shunned and ridiculed by the townspeople, we enjoyed a great deal of intellectual stimulation in the many castles, museums, and the national theater.[72]

If father and son did not start out together but rather walked separately, Klee would always make a mark at a precise spot in front of the bridge over the River Ilm, drawing his insignia with his cane, to let Felix know he had preceded him. Once the first snows fell, whenever there was sufficient accumulation, Klee made drawings in it for his happy son.

Felix also had vivid memories of family vacations: "From 1920 to 1922, there were also the holidays at Possenhofen by the lake of Starnberg; Klee liked fishing, and one day, as the cabin's handrail broke, he fell in the water with his line. Lily and I were at home, in the skipper's apartment, when we heard *pflotch, pflotch* in the stairway. My father was soaked. We undressed him and his clothes were hanged by the stove."[73]

IN TIME, Klee was given a larger studio on the third floor of the main Bauhaus building, behind the cabinetmaker's workshop and above the ceramics studio. Smoking a pipe while he worked, he developed numerous pictures simultaneously. Klee had a dozen easels, and each had a painting on it, in stages ranging from preliminary outlines to the verge of completion. His art

supplies were well organized, as was his collection of butterflies, sea shells, tree roots, and pressed leaves. He also had a large supply of toys he had made for Felix and now used as props in his art.

Klee worked calmly, painting on holidays, scarcely noting the day of the week, always seeming relaxed. Making art was as natural for him as breathing, and easier than speaking. But the subject matter troubled others, even if it didn't bother him. Many viewers were put off by the serpents he seemed to deify in his work. They were related to the snakes in the Goethe park, but larger. Klee readily grasped why these creatures that terrified some people had been the object of worship in ancient Egypt. They moved in such a fascinating and unusual way, and protected their mysteriousness. Like cats, his favorite of all animals, they left their human viewers with unanswered questions, evoking the ambiguity that Klee considered one of life's great thrills.

The same year that Klee married Lily, his mother had become paralyzed. Klee had often cared for her up until her death during his first year at the Bauhaus. The next evening he had a dream in which a female ghost walked through his studio. The bereaved son then began making paintings with pronounced black borders in which he depicted the afterlife or the passage into it. His *Women's Pavilion* (1921), which shows a lush forest inhabited by translucent, all-white women, should be seen as an imagined heaven. His *Dying Plants* (1922) is a morose watercolor in which the figure at the bottom appears to be a recently buried female corpse.

KLEE DOTED ON FELIX and heaped praise on the boy's work. In 1985, the seventy-seven-year-old Felix recalled, "Klee followed with attention my efforts at drawing and painting. He kept all my productions, then mounted my works with the same care he used for his, and wrote on them the titles I told him. 'The paintings of my little Felix are better than mine, too often filtered through my brain,' said Klee to Lothar Schreyer."[74]

Nonetheless, Klee cautioned his son against following in his footsteps. Felix would recall, "In 1925, when I received the title of journeyman, my father asked me: 'And now what do you want to do? You know if I can give you advice, don't become a painter, your life would be too difficult. Paint as much as you want, but don't make it your main job.'—'Then I'd like to go on the stage.' And Klee: 'Well, you will go on the stage.' "[75] Klee may never have said it, but he must have recognized that his son would always be seen as the child of a better artist. His advice was clear-headed and in everyone's best interest.

9

Occasionally, Klee dined with Oskar Schlemmer, who at the start was his only real friend among the faculty members. But mostly he spent the evenings at home with Felix. Lily was still in Munich, and he did not want his son to be alone.

Klee was an avid reader, and his passion at the beginning of his first full academic year at the Bauhaus was Voltaire, whose *Candide* he had illustrated for a publication that appeared just before he went to Weimar. In December, he read Voltaire's last book, *The Princess of Babylon.* This obscure philosophical tale published in 1768 is the story of a beautiful princess who falls in love with Amazan, a man who is both highly civilized and devoutly vegetarian. But things go wrong, and they both end up traveling all over the world trying to find each other, then fleeing from each other. Voltaire evokes the charms of Catherine the Great's Russia and Georgian England, while making Germany in the same epoch a form of inferno.

In the nineteenth century, *The Princess of Babylon* had been censored. The passages about sex, between men and other men as well as between men and women, were removed; oddly enough, so was Voltaire's invocation to the Muses. But Klee read the unexpurgated version. Afterward, he wrote Lily of Voltaire, "What a man! That art of being able to unite, in such a mysterious way, spirituality, wickedness, and profound kindness! Astonishing!"[76] What he admired in the great Enlightenment writer was his own ideal.

Klee himself had the optimism of Voltaire's Candide. Felix's success with the Bauhaus course was central to his happiness; beyond that, the cat was well, and the housekeeper was completely perfect, her most recent achievement being a mastery of potato pancakes. With Felix robust, the childhood illness a thing of the past, and the house tidy, Klee took unabashed delight in little things, like observing his son with a new watch. The teenager was fascinated by the instrument's precision; the father marveled at the mechanical elements while also relating them to the process of painting.

KLEE TITLED ONE of his 1922 lectures on pictorial form "Scenes in the Department Store." It is a dialogue between a merchant and a patron in which the merchant charges the patron a hundred marks for a bucket of one product and then two hundred marks for the same bucket full of something else. When the patron asks why the price is double, the merchant explains that it is because the second product is twice as heavy. The patron then buys a third

product, with the same weight as the second one, for which the merchant charges him four hundred marks. When the patron asks why, the merchant says, "Because this third merchandise is twice as good, more durable, much more tasty, more in demand, more beautiful."

The first encounter presents "measure . . . the realm of line . . . longer, shorter, coarser, and finer." The second depicts "weight . . . the realm of tonality . . . brighter, darker, heavier, lighter." The third is about "pure quality . . . the realm of color . . . more in demand, more beautiful, better, too saturating, cooking, too hot, ugly, too sweet, too sour, too beautiful."[77] This could be interpreted as a commentary on the nature of commodities—relevant to the Bauhaus students' task of making designs both useful and alluring—or simply as an encomium on aesthetic beauty, and on Klee's hierarchy of values in the world of the visible. It was also a perfect reflection of his own daily interchange between the practical issues of life (measurement in cooking, the cost of things) and the euphoric universe of pure color, musical sounds, and life's other inexplicable thrills.

FELIX KLEE DESCRIBES his father at work in the studio he used at home in Weimar when he didn't go to the Bauhaus: "My father had at his disposal two rooms on the second floor, where he could work undisturbed. There he tried out all sorts of surface textures for his pictures, coating cardboard and canvas with plaster and stretching gauze of newspapers over it. Over the radiators of the central heating hovered strange paper shapes, swaying in the uprush of hot air. With plaster he made sculptures and reliefs; with broken cups or mussel shells he made saucers for mixing paints."[78]

When Klee's students visited him at home, their main activity was to watch what was going on in the artist's large aquarium. Klee acquired the components of this fish tank and its underwater plant garden shortly after moving into No. 53. Once he began to stock it with tropical fish, he was so thrilled by their colors and the abstract patterns on their skin, and by the sea sponges and the dramatic forms of the plants, that he wondered only why it had not occurred to him previously to have this treasure house. When the students were present, Klee would first switch the light on and off so that everyone could observe how the fish responded. Then he would gently coax some of the colorful creatures to swim away from the aquarium walls, so that the fish that they were concealing could become more visible.

If the students hoped to see Klee's artwork as clearly, they were out of luck. There were always a lot of paintings, both in progress and completed, propped against the furniture and attached to rods suspended from the picture molding, but Klee encouraged his visitors to focus more on the fish performing their underwater dance, arrayed in brilliant colors and bold markings.

Nonetheless, the students admired Klee's collection of fine paper and his large clay pots filled with meticulously kept brushes, as well as all his thinners and lacquers and varnishes. And when they were invited to dine, they became aware that he prepared food the way he painted: spontaneously, without a cookbook, taking his inspiration from the ingredients he had on hand, using only the recipes he had developed in his own mind and altering them easily in response to the number of diners expected and the time he had to prepare a meal.

Occasionally, but never with advance warning, Klee would announce that it was a musical evening. He would then play Mozart on his violin, and if Lily was present, she would accompany him at the piano. There were at-home concerts at which Karl and Leo Grebe, from Jena, would join Paul and Lily to make up a quartet — or, with Felix, a quintet. In addition to the inevitable Mozart, they would perform Beethoven and Haydn. "Klee, who ordinarily seemed so calm and deliberate, would suddenly be blazing with a southern ardor and temperament; he played first violin with passion."[79] On other occasions, Felix would give his Punch and Judy performances, "which, irreverent but kind, gave away all the Bauhaus secrets."[80] That description was Lothar Schreyer's, who said that the more of the feuds and conflicts Felix put into the puppet shows, the more thrilled his audience was.

As an adult, Felix reminisced about those performances, and told what happened to the materials after the Bauhaus closed. The character he describes in a key role, Emilie Ester Scheyer, called Emmy by her contemporaries but always referred to as Galka historically, was a great supporter of Klee, Kandinsky, Jawlensky, and Feininger:

It was in this Weimar period too that Klee, letting his fancy run free, created most of his last puppets (1920–1925). I had rigged up a fine puppet theatre for myself and my father supplied the scenery in answer to my desires. I kept pestering him for new figures and characters, and so it was that the puppets were made.

Some hilarious performances were held at the Weimar Bauhaus, during which various confidential matters were aired in an unsparing and sarcastic way, vexing to those concerned and highly amusing to the others. Using plaster and an ox-bone, my father devised a puppet in the form of an unmistakable self-portrait, with huge painter's eyes and a fur cap. A scene played in the *kaffeetälchen* of the Bauhaus in 1922, during the solstice holiday, was a memorable success. It featured Emmy-Galka Scheyer trying to coax my father into buying a picture by Jawlensky. Klee kept saying No and remained unyielding. Finally, working herself into a passion, Galka took the picture and smashed it to pieces over Klee's head.

The making of the heads was one thing, that of the clothes another. Except for the early puppets, Klee made all the clothes himself. To my mother's annoyance, he would take strips of cloth from the drawer where she kept old clothes that needed mending, and he would sew them together on a hand-operated Singer sewing-machine. Our puppet theatre and all the scenery were left behind at Dessau in 1933. Twelve of the puppets were destroyed in a British air-raid at Würzburg in 1945. Only thirty of them survived.[81]

IN DECEMBER 1921, Klee wrote the text for a Bauhaus prospectus that addressed the rampant tensions within the school in a positive light.

It's a good thing that such diverse forces co-exist in our Bauhaus. I also approve of the fact that these forces fight against one another, if the result of the fighting is real creations.

To collide with obstacles is a sensible test for each of these forces if the obstacles remain objective and impersonal in nature.

Judgments of value always have the limitation of being subjective, and any opponent of an idea who opposes it negatively and in conflict won't be able to determine the value of the idea as a general viewpoint.

The general point of view won't be decided by notions that can be called true or false; it lives and develops through a play of forces the way that the good and the bad in the universe act in unison to end up with productive results.[82]

Klee regarded the Itten-Gropius battle and the feud between the factions supporting one or the other in this positive light, treating them as catalysts for creativity. It was the same outlook with which he managed to maintain a state of equilibrium in his own life.

Klee's impartial, temperate stance was the reason he was such a sage for his confreres. In spite of the belief of many viewers, mostly professional psychoanalysts, that Klee's art was evidence of something between extreme neurosis and complete lunacy, he helped steady those who knew him in person. In fact, deliberately outrageous characters often found him schoolmasterishly dull. The painter Balthus once described an occasion when he and Alberto Giacometti met to call on Klee, with whom they had made an appointment, only to become so enraptured talking with each other that they failed to walk the short distance to Klee's studio and simply stood him up. Neither felt guilty about the broken date because, much as they respected his work, they considered him unexciting as a conversationalist.

Klee's attitude toward Bauhaus politics was consistent with his view on the subject matter of his art. Rather than evaluate and cast judgment, he

thought, one should attempt to see everything as part of a coherent whole. The same month he wrote the prospectus, he wrote to Gropius: "I welcome the fact that forces so diversely inspired are working together at our Bauhaus. I approve of the conflict between them if the effect is evident in the final product. . . . On the whole, there is no such thing as a right or a wrong; the work lives and develops through the interplay of opposing forces, just as in nature good and bad work together productively in the long run." That determined neutrality made Klee, in Gropius's eyes, "the authority on all moral questions." The students and other teachers nicknamed him "the heavenly Father"—not because he dictated a code, but because he was above it all.[83]

This was his role when, in April 1922, a circular was sent to each member of the Masters' Council to discuss whether they should be addressed as "Professor." There was a movement to formalize the hierarchy at the Bauhaus and reinstate the tradition Gropius had renounced.

Klee and the other masters had to put their views in an allotted space on the circular. In his neat and intensely charged handwriting—with the letters close together, all slanted equally to the right, as in musical notation—he wrote, "I suffer more acutely under the half-measure of daily being addressed with a title without always being able to, nor wanting to, prevent this with explanations. I suffer more from this than I thought likely at first, and more than the formality of granting the title can seem harmful to me."[84] Four days after the circular was completed, there was a meeting of the masters at which Klee, taciturn but definite, voiced support for the use of titles, again reasoning that such usage would help to avoid confusion and disorder, more than emphasize rank, which didn't interest him.

Klee's tempered, logical approach helped cool the atmosphere. Lothar Schreyer had made it seem as if the use of "Professor" was a catastrophic return to feudalism, but Klee's less dramatic stance and quiet authority gave relief and prevailed.

THE GOAL WAS SIMPLICITY that removed distractions from work. Klee decried the long meetings of the Masters' Council as bureaucratic wastefulness that kept him from painting. After one session, he quipped that the only thing of value he had learned was that the semester would end on July 15.

But Klee was not a curmudgeon. He generally showed up at the weekly dances where the Bauhaus band performed, in one of two Weimar pubs—the Ilmschlosschen and the Goldener Schwan—and at the costume parties. He usually didn't dance, however. Rather, he puffed at his pipe and watched, sometimes grinning, sometimes looking bored, and then left early to go home to work.

Yet when he wanted to, he could be as inventive in his costumes as in his paintings. One student, Farkas Molnár, wrote about a fancy dress party in

those early years.[85] There was a snail that squirted perfume and emitted light; Kandinsky was a radio aerial; Itten was a shapeless strange monster; and Feininger went as two triangles. Gropius was Le Corbusier. But what most impressed Molnár was "Klee as the song of the blue tree." There are, alas, no details of what that looked like.

10

What today we call gender issues were not openly discussed at the Bauhaus. Active as people were, they did not talk a lot about sex.

Klee, however, addressed through his art, with spectacular ease and openness, aspects of maleness and femaleness. He did so lightly and wittily, yet he brazenly depicted sexual instincts, in all their inherent complexity, without any inhibition.

Klee's *Window Display for Lingerie* invokes, in a way both worldly and carefree, sophisticated and childlike, a plethora of issues about male and female traits within a single human being. Four large figures either melt from or emerge into a shimmering, amorphous mosaic pattern. Some smaller figures, and parts of figures cut off by the picture's right and left edges, suggest that there is a whole crowd out there of which we are seeing only part. Some of these characters sport stiletto-heeled boots and outfits that are like flared knee-length shorts or culottes; with their muscular legs and hourglass figures, they might be transvestites. They are not exactly androgynous because, rather than seeming like masculine women or feminine men, they are, alternately, very girlish or very soldierlike; instead of combining genders, they appear to flip back and forth between them. Their headgear might be helmets, large teardrops, or dunce caps. Several of the jaunty gnomelike creatures stand boldly; others look as if they are recoiling under attack.

The words Klee has painted on the picture surface add to the incomprehensibility. They look like lettering on glass with the personages being part of a shopwindow display; this reading of the scene, the most evident one, would be even more logical were it not for the abstracted mountain peak behind these creatures who resemble marionettes as much as mannequins. The lettering at the top says "Anna Wenne Special." The assumption we might make today, at a remove from the Weimar culture of the 1920s, is that Anna Wenne was either the brand name of a familiar product or a well-known actress. If so, the words "Feste Preise" (fixed prices) would perhaps

make sense underneath the word "Special," for which the crown on one of the ambiguous pieces of headgear serves as an exclamation point. And presumably the words "Eingang / Entrée" ("Entrance" in both German and, in smaller letters, French), with the accompanying arrow, would also make sense because, knowing what or who Anna Wenne was, we would know whether this indicates the entrance to a shop or to a theater.

"Anna Wenne," however, was as much an invention as everything else in the painting.

A few years ago, Marta Schneider Brody, writing in *The Psychoanalytic Review,* astutely considered the significance of the name. She points out that Klee's signature, although so small we almost cannot see it in reproductions of *Window Display for Lingerie,* is just to the right of the name Anna Wenne (not the usual place for a signature). The artist used only his last

Paul Klee, Window Display for Lingerie, *1 9 2 2.*
On close reading, this painting is full of sexual ambiguity.

name. Brody suggests he invented "Anna Wenne Klee" for a reason, a surmise corroborated by another painting, from 1923, that has the name Anna Wenne on the opposite side from the name Paul Ernst—a reversal of Ernst Paul, Klee's actual first two names—as if both of these people were the artists. "Anna Wenne," Brody writes, "may be an imperfect anagram for the German . . . *Mann Nennen Ann,* a man named Ann. The anagram is formed by transposing the letters and inverting the letter W to form the letter M."[86]

"Anna" was the name of Klee's maternal grandmother. Anna Frick was the person who had started him, at about the age of three, making art, and who had protected him as a left-hander. It was under her guidance that he developed the idea of painting and drawing being forms of play. This occurred at the same time in his early childhood when he wanted to wear "ravishing lace-trimmed panties" and "was sorry I was not a girl myself."[87]

ANNI ALBERS JOYFULLY RECALLED that every six months or so Klee would tack his most recent work to the walls of a corridor at the Weimar Bauhaus. These displays were among the greatest experiences of her life. She and other people spent hours deliriously studying the work; it's easy to see why.

To someone like Anni—sexually ambivalent, determined to shake off the traditional expectations of what women were to do with their lives—the crossing over suggested by *Window Display for Lingerie,* the fanciful rather than grave approach to the issues at hand, was liberating. So was the further doubleness of "Eingang—Entrée." The word for "entrance" is masculine in German (*der Eingang*) and feminine in French (*une entrée*). With entrance itself such a sexually suggestive idea, the use of both languages is a stroke of Klee's genius. The combining of male and female roles not only pervaded Klee's work at the Weimar Bauhaus; it was also apparent in his atypical life, where, in Lily's absence, he was Felix's main caregiver as well as the family cook.

KLEE'S ART BROUGHT the spirit of surrealism to the Bauhaus, though Klee abhorred the personal flamboyance of its well-known practitioners. His lack of "image" made the candor and psychological complexity of the work palatable to people like Gropius, Kandinsky, and the Alberses, all of whom deplored the self-conscious flaunting of personal quirks. The correctness of Klee's demeanor made it much easier for them to accept the fact that his subject matter included cross-dressing and hermaphroditism.

Klee simply accepted the human imagination. In his diaries, he wrote that in his childhood he "imagined face and genitals to be the corresponding poles of the female sex. When girls wept I thought of pudenda weeping in unison."[88] His 1923 *Lomolarm* depicts a crying man whose eyes and nose have a distinct resemblance to "pudenda weeping." He could not have been more matter-of-fact about the associative workings of his mind.

Klee did not conceal his own sexual uncertainty. In addition, there are times when hostility to women is plainly visible in his art. In his diary, he wrote, "Sexual helplessness bears monsters of perversion. Symposia of Amazons, and other horrible themes . . . Disgust: a lady, the upper part of her body lying on a table, spills a vessel filled with disgusting things."[89]

At the Bauhaus, Klee often painted dominatrixes and androgynous characters who resemble evil conquerors. He usually made women grotesque. His 1923 *Ventriloquist Caller in the Moor* depicts a creature who is about 70 percent breast. These full, sagging mammaries have a lower contour that also appears to outline buttocks; the crack between them is explicit. Inside these organs that are both breasts and buttocks are many monstrous little characters—part human, part amoeba, one a cross between a donkey and a

mermaid. The creature stands on tapered legs, and has tiny malformed arms and, on an abstracted human head, a mouth like that of a fish.

Yet the effect of the painting is by no means unpleasant. The fantastic orchestration of the background is a vibrating, irregular grid that gives the impression of exotic silk. It is a sheer marvel of watercolor painting, a super-human use of that unforgiving medium. And the creature herself, for all the ways that she is horrific, seems to be singing with joy. Balanced precariously on a sort of unmoored dock, with a mermaidlike form suspended on a thin line from her right breast/buttock, she has magical power. Even if every-thing appears about to topple, it remains upright; what should be impossi-ble is possible.

In 1956, Erwin Panofsky, the great scholar of northern Renaissance iconography, taking a rare look at modernism, wrote that Klee showed Pan-dora's box as a vase with flowers in it "but emitting evil vapors from an opening clearly suggestive of the female genitals."[90] Gropius may have founded the Bauhaus as a design school, but it became a refuge that permit-ted unprecedented freedom of artistic expression, a safe environment where people like Klee could allow themselves to present, without fear of judg-ment, their most extreme fears and fantasies.

KLEE SAW HIMSELF as simultaneously a "pedantic" father, an "indulgent uncle," an "aunt [who] babbles gossip," a "maid [who] giggles lasciviously," "a bru-tal hero," "an alcoholic bon vivant," "a learned professor," and "a lyric muse, chronically love struck."[91] His art not only allowed for this multiplicity but also celebrated it. He wrote in his diary, "So much of the divine is heaped in me that I cannot die. My head burns to the point of bursting. One of the worlds hidden in it wants to be born. But now I must suffer to bring it forth."[92] The program of the Bauhaus was to mold universal designs, but it was also a haven for people unembarrassed by their passions.

Grohmann wrote, "Klee was not incapable of loving or responding to love, but as 'nothing lasts in this world,' love to him was an ever incomplete thing, a mere part of the eternal flux of things."[93] Klee can also be seen as having loved his grandmother so intensely that her death early in his life was so painful that he had to expand his horizon beyond actual life. He did so on paper and canvas, not in his existence outside the confines of his stu-dio. He wrote, "Art plays an unknowing game with things. Just as a child at play imitates us, so we at play imitate the forces which created and are cre-ating the world." For artistic creation was as real as the making of life itself. Klee said he felt "as if I were pregnant with things needing forms, and dead sure of miscarriage."[94] Creating art was like giving birth, accompanied by the same overwhelming thrill and also the periodic bouts of fear.

When the people at the Weimar Bauhaus saw Klee's *Where the Eggs and the Good Roast Come From,* they observed a rooster as the creature laying the egg. A male animal, thus, could give birth—and could also get cooked. When, the year the Bauhaus closed, Klee made a painting of a pregnant male poet, the underlying notion was the same: to nurture art was like nurturing a new human life, and could be done by men or women. In *Adam and Little Eve,* Adam, clearly a self-portrait, wears small drop earrings, and Eve, rather than being a seductress, looks like a small girl who is being abducted. Man as woman, sexual vixen as child, innocent as demon: Klee reveled in the reversals. The Bauhaus was a place to expand his originality, unfettered and encouraged.

11

Kandinsky's arrival at the Bauhaus early in 1922 was a great event for Klee. His close friend from his prewar years in Munich had returned from Moscow only the year before; he had been absent from Klee's life for a long time. Klee was delighted with the prospect of having his intrepid spiritual kin, as obsessed with music as with painting, on the scene.

Klee believed their friendship was strong in part because it was rooted in their youth, the most creative period of life. "Everything one acquires in later life is of less importance," he would write Lily when he was preparing to leave the Bauhaus a decade later and was analyzing why he and Kandinsky would always remain close, even though they were going in different directions.

Kandinsky, thirteen years older, was emphatically Russian, intellectual, and affected by the Far East, whereas Klee was attuned more to the dictates of nature and the Arab and Islamic worlds, but from the first time they had met in Munich as young men, they had forged a lasting connection. Because of inflation, in Weimar they were in the odd position of having less money for meals than they had had in their student days, with Kandinsky even more broke than Klee, but they often got together for skimpy dinners, enjoying great camaraderie even if they never dropped the formal "Sie" when addressing each other. Kandinsky was the person who more than anyone else could get Klee to talk; Klee allowed to Lily that the Russian would ply him with questions, and he would actually answer.

When the fall semester at the Bauhaus started on October 1, 1922, Klee and Felix returned to Weimar, while Lily spent a few days visiting her

father. By then Kandinsky had settled in. Klee wrote his wife about their pleasant postsummer reunions, saying that even though he got along easily with all the other masters, however disputatious they were with one another, Kandinsky was the only one of them who was truly a confrere.

GALKA SCHEYER VISITED at that time. What interested Klee, more than anything this devoted patron might do on his behalf, was Scheyer's small son, who accompanied her. Klee told Lily he had never seen a more monstrous child. After pushing his mother until she fell down, the boy stretched out on the road, hoping to make everyone afraid that he would get run over by a car. The little horror made fun of adults and children alike, giving them all new nicknames. Naturally Felix was fascinated, but so was Klee himself. Little in his surroundings could have intrigued him more than this boy with aberrant behavior.

By contrast, Felix was his father's angel: wonderful-looking, although seen only fleetingly because he was so active. Klee took immense joy watching his teenage son flourish with the start of the term.

Klee loved all the new beginnings. His studio floor was freshly waxed. Since he was pleased enough with the paintings that he had left behind before the summer break, he was eager to resume work on them. First, though, he dealt with the new school term in his characteristically orderly way. After gradually catching up with his colleagues, one after the other, seeing a few students, unpacking his bags, and putting everything away, he got to work on his lithographs—as if warming up before starting to paint again. Within a couple of days of his return to Weimar, he also made plans to take Felix to Verdi's *Otello* on the coming Sunday. The music would be good for them, he told Lily. The one thing that made him impatient were the endless Bauhaus meetings, unnecessarily numerous and lengthy: "We assemble, we assemble, and we assemble." Naughty children, his aquarium full of fish, theater performances—the stuff of everyday life and the subject matter of his painting—were a joy; administrative issues, bureaucratic rambling, and other such human foibles he found a total waste of precious time.

NONETHELESS, HE WAS BENEFITING from the crosscurrents of influence around him. The dancing figures and marionettes that began to proliferate in his work resembled characters in the *Triadic Ballet* and theater class. His *Twittering Machine* of 1922 shows a device where you could wind a handle to make nightingales sing. This unusual music box that activates the four creatures corresponded to Kandinsky's linking of sight and sound, although the representation of birdsongs as lively shapes coming out of the birds' open beaks corresponded to Klee's own lessons on lines. The shapes suggest

Klee and Kandinsky posing as Goethe and Schiller.
Klee and Kandinsky took no little pleasure in the
great legacy of "the German Athens."

melodies ranging from joyous and celebrative to slow and somber, their dimensions going from a reedy flute to a full orchestra. His 1921 *Ceramic-Erotic-Religious* has qualities of the inventive constructions of the Bauhaus foundation course. But the work was not painted to prove a point so much as to convey delight: it shows the pleasurable course afforded by pure intuition, that human element that he also emphasized in his teaching.

IN DECEMBER 1922, Willi Rosenberg, a medical student in Jena who had been a student at the Bauhaus, handed in a thesis titled "Modern Art and Schizophrenia: Under Special Consideration of Paul Klee." Labeling Klee "a great egocentric," Rosenberg pointed out the marked contrast between Klee's lifestyle, with its apparent calm and normal domesticity, and his artwork, about which Rosenberg repeatedly used the adjective "bizarre." To the future psychiatrist, that discrepancy was the mark of "schizophrenia." Rosenberg termed Klee's recent paintings "a whole series of bizarre, fantastical works that he cannot even interpret himself." He saw Klee as struggling "to fulfill a longing" through his art, in a "fight that caused him to go crazy. Klee also found the egocentrism of the schizophrenic and his psychological alienation from the world, increased to ghastly solipsism."[95]

Rosenberg's adviser in Jena disagreed with his student's interpretations,

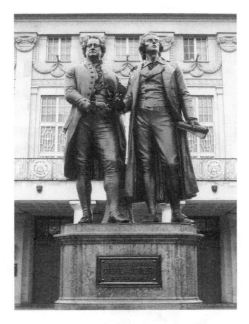

*Statue of Goethe and Schiller by Ernst Rietschel
in front of the German National Theatre in
Weimar, Germany*

asserting that the term "schizophrenic" in fact did not apply to Klee. Yet
the teacher awarded Rosenberg a doctorate, and Rosenberg's dissertation
became the talk of the Bauhaus.

Klee presumably knew about the thesis. He might not have disputed
Rosenberg's premise. Lothar Schreyer recalled Klee relishing the idea that
new "worlds have opened up which not everyone can see into, although they
too are part of nature." Klee told Schreyer that this "in-between world" was
"the realm of the unborn and the dead." Claiming that this territory was
visible only to "children, mad men and savages," Klee informed Schreyer, "I
absorb it inwardly to the extent that I can project it outwardly in symbolic
correspondences."[96]

Even if Klee thought he was privy to realms open only to the insane or to
people who were completely untutored—and said so with the knowledge
that, since he was highly cultivated and well-educated, the only category to
which he could therefore belong was that of the mentally unstable—he had
complete control of the way he related to his visions. Just as when, in early
childhood, he had imagined female genitalia resembling an udder compris-
ing four tiny penises and pictured devils peering at him, he handled his way
of seeing with self-acceptance and grace, which is what made him appear
healthy, even if slightly remote, as a human being, and saved him from the

apparent sufferings of a psychotic. His art, fueled by his sensitivity to sights that might have made other people crazy, kept him stable.

THE ART CRITIC WILHELM UHDE, who called on Klee in Weimar in 1922 and wrote about the visit shortly thereafter, provides a firsthand account of a cheerful, highly civilized man with a unique perspective on the world. The encounter was especially sweet because it followed two less successful attempts at their getting to know each other.

> My first meetings with Klee were not quite happy. He told me he had visited my apartment and carried off a very strong impression of Picasso's pictures he saw there. I have no reminiscences of this meeting because my other visitors had swamped me with questions during two hours.
>
> The second time I took initiative. I was at this time mobilized in Frankfurt, occupied to decipher a daily mail of hundreds of letters and fell ill. I asked for some days of leave but endured a row from my major for wanting to go and see these horrors of modern pictures that he called cubic sluts.
>
> Disillusioned beforehand, depressed as I was then, I couldn't remember meeting our painter.

What occurred at the Bauhaus was very different, reports Uhde:

> The third time I was his guest in his workshop in the Bauhaus building of Weimar. It was in 1922. Nonchalantly I had followed Goethe's and Jean-Paul Richter's favorite promenade that I love even more. Stimulated by the memories of this earth, I wondered if there could be a painting as German as the literature and music of Jean-Paul, Hölderlin, and Bach. Could the German painting interpret the Gothic ecstasy as had done Picasso in Latin earth? Could there be a German painting not only rendering the banal physiognomy of objects (despite the Expressionism and new objectivity), too easily served by a hazardous alliance of a pre-conceived theory, a routine eye and job? Will not there be a painting able of creating a pathetic reality, suited to the most complete men of the race?
>
> When I was at his workshop facing this discreet man, friend of the muses and music, I was at once certain to see in his eyes the love of the world that makes work. I recognized the reality of phenomenons that are not at all expressed by their faces. These present only a few hazardous and too ephemeral realizations of eternal ideas. This love of the

essential carried away the artist to the bottom of these thoughts. He organized them thanks to his intuitive and visionary strength. For the first time in a long time, I was filled up with happiness to have found in Germany such a pure demonstration of Gothic spirit.[97]

Uhde was on target with his insight that what others saw as symptoms of schizophrenia was a "love of the essential," as it could be found in the highly complex territory that most people shun.

IN MAY 1923, Klee took a walk in the forest with Felix. He wrote Lily that they could not believe their eyes because of the rich blossoming of the cherry trees. He felt that only with time had he come to discover the beauty of Weimar—in spite of his initial enthusiasm, he had given it short shrift—but now he was totally enchanted. That world outdoors was what counted most; for all the incredible leaps he was making in his art, Klee wrote his wife that, beyond his bucolic outings with Felix, nothing was new.

Even during the Bauhaus exhibition that August, when fifteen thousand people were looking at his work and he met both Paul Hindemith and Igor Stravinsky, he wrote Lily primarily about his walks in the park. What affected him more than anything else were his encounters with the plant and animal kingdom and his life at home.

When problems arose, Klee was philosophical. In December 1923, he spent his forty-fourth birthday completely alone. Lily and Felix were with Lily's father, who was on his deathbed, while Klee's obligations at the Bauhaus kept him in Weimar. Human existence seemed especially perilous, and a troubled economy with runaway inflation added to the sense of catastrophe, but Klee was matter-of-fact about it all. It might not be possible to organize Felix's Christmas as they would like, but he would do his best.

Klee and Kandinsky went to a café to have a cup of coffee and talk. When they saw the price of the coffee—they had not even considered having anything more—they counted their marks. Between them, they didn't have enough. They went straight home.

But Klee took solace in knowing that a watercolor had been sold in America for which he would receive two hundred Swiss francs on December 20. He wrote Felix that, no matter what, one could always laugh, and that "one is always in good company when one doesn't have money."[98]

When Lily's father finally died, Klee wrote his mother-in-law pointing out that her main loss was that now she wouldn't be able to keep taking care of him. He emphasized what a beautiful end of life she had given him, how essential this was. Klee allowed that his own greatest fear of age was to be alone. He had managed the solitude on his recent birthday without difficulty, but his family was still vital to his feeling in balance.

12

Being at the Bauhaus obliged Klee to formulate in words his beliefs on what an artist's priorities should be. He wrote lecture notes so that he could explain his philosophy to the students. Nature was always the starting point, and he beheld it reverently. In 1923, Klee summed up his viewpoint when he wrote:

> *The artist cannot do without his dialogue*
> *With nature,*
> *for he is a man, himself of nature,*
> *a piece of nature and within the space of*
> *nature.*[99]

In his lectures, Klee discussed the growth of plants and the structure of leaves, as well as the process of human digestion. On Monday, November 5, 1923, in a typical talk, he considered "form creation" in nature as in art. "Despite its primitive smallness, a seed is an energy center charged to the highest degree," he told the students. Klee was fascinated by seed packets. "One seed will grow into a violet, another into a sunflower—not in the least fortuitously, but by its very nature—the one always a violet, the other always a sunflower. (So reliable is this that seeds may be sorted, packed, labeled and marketed.)" This leaping from the esoteric and natural to the practical and quotidian was characteristic of Klee. So was the way he viewed science as having magical properties; laboratory research and mythological mysteries went hand in hand. "Each seed is the spin-off of a certain species and a talisman for the regeneration of that species," he explained.[100]

Even though Klee wrote and edited in advance the text he then read to his students to trace the course of the seed's emergence into a plant, his language was not easy to follow. In a characteristic paragraph, for which the original German was no easier for others to latch on to than is the translation, he declared: "A certain impetus from without, the relation to earth and atmosphere, begets the capacity to grow. The clumbering tendency towards form and articulation awakens in predetermined precision, determined with reference to the underlying idea, to the logos, or, as the translation runs: the word, which was in the beginning. The word as a premise, as the idea required for the genesis of a work. In abstract terms, what we have here is the irritated point as latent energy."[101]

Yet for all their inpenetrability and density, summary statements of this sort manage to suggest what Klee's drawings make more accessible: the thrill of growth, and the power of a kernel of energy that bursts open and from which lines begin to soar in various directions. Klee pulsed to the excitement of that process: "The seed strikes root, initially the line is directed earthwards, though not to dwell there, only to draw energy thence for reaching up into the air." From there he analyzed the development that followed the taking of nourishment from the soil, paying close attention to the possibility of a split in which, during germination, plants have more than one seed leaf. He also translated natural growth into its visual representation with the statement "The spirit of this form-creation is linear."[102] For Paul Klee, all lines embodied the idea of creation, of the emergence from near nothingness to something more substantial. Artistic creation was the representation of natural creation.

Speaking to the students, Klee then explored the progression from a sole unit of growth to multiple units—from a single line to branches, and from a stream into its divisions. Characteristically, he added the emotional element to the natural occurrence, ascribing desire to these events: "The dynamic force is space hunger—space hunger as juice hunger underneath the ground, space hunger as air and light hunger in the atmosphere."[103]

The most receptive students felt new worlds opening before their eyes. In the glass and weaving workshops, where Klee gave talks on form, recent arrivals to the Bauhaus considered how plants take water and essential nutrients from the soil and grow toward the sun, and applied those processes to their crafts. They delighted in the way Klee's teaching had the energy he prized in natural growth. The gouaches Klee tacked to the walls of the corridors they walked to get to class had the same animation. Rather than being static objects, trees emerge as creatures with needs and desires. They throw their branches outward in their joyous discovery of oxygen and space; they are proud of their strong trunks; they appear nourished by their root systems. The horizon lines of mountaintops rise and dip as if their memory of having emerged from melted glaciers is still fresh.

Klee's drawings do not look like art that is already made; rather, they appear to be in the process of formation before our eyes. One tree stands like a soldier on guard; another does a dance, pirouetting upward while also wending its way in multiple directions below the soil, like a child digging for worms.

Klee made diagrams to explain his points. He jauntily wrote the letters W, E, and L for Wasser, Erde, and Luft—Water, Earth, and Air—and drew arrows that nearly a century later seem to have just been shot from bows. He sketched a few lines to give the water a density different from the air, and even more lines to designate earth, while he also dashed in some raindrops; he

was alert to the essential elements in the same way as all so-called primitive people everywhere who depend on the right balance of sun and rain for the farming essential to their survival, and who worship deities that embody the reigning forces of nature. The continuous curve with which Klee plunged beneath the earth's horizon to indicate the wellspring of life, and then burst that horizon to suggest action on a stage, is visibly exuberant. And what it illustrates is timeless. Klee's way of dealing with death, and with the anxiety he had felt ever since viewing his grandmother's corpse when he was five years old, was to live in the before and the after as well as in the present.

Klee celebrated what Herbert Spencer called the "survival of the fittest." "Competition with other creatures, or the struggle for existence, to use a more dramatic term, provides the impulse for the enhancement of energy production."[104] He applied the same principle to the feuding factions at the Bauhaus.

But it was not the competition, the idea of winners and losers, that counted the most. "The trunk is the medium for the rising of the sap from the soil to the lofty crown."[105] That simple sentence conveys the spirit and profound appreciation that underlie Paul Klee's thinking and art. He relished the perpetual movement, and the weightlessness, inherent in natural growth. He also enjoyed the contrast of pitting dirt against a crown as if linking the fundament of life with the symbol of royalty. Klee deflated worldly pretense while extolling universal reality.

His values and his sheer enthusiasm were apparent even in the small announcement card he made for the great Bauhaus exhibition that August (see color plate 3). Of all the cards, Klee's was especially joyous and playful. A jaunty building balanced on top of a foundation of triangles and squares looks like a top hat crowning a tap dancer. Although very abstracted, at the same time it can be read as the Bauhaus itself: a place where anything is possible, and that now had the élan he told Lily he had wanted to give it.

KLEE REVERED AIR AND LIGHT. He reminded his students that leaves became "flat lobes" resembling "a lung or gills," in order to breathe in the atmosphere. That purpose, essential to the life of a tree, could be applied to all design at the Bauhaus: "Let this entire organism now become an example to us— a structure functioning from within to without or vice versa."[106] Necessity was the determinant; the liaison between form and function was vital.

On Saturday, November 10, 1923, Klee went further in pointing out how the manipulation of only a few elements can lead to complex results. He showed that by drawing, as simply as possible, a mesh of horizontal and vertical lines, one establishes a place; and by alternating lighter and darker stripes, first vertically and then horizontally, one achieves myriad tones

ranging from light to dark. He used the word "alternation" as if he were invoking a deity. In his own work, he was making mosaics that leap off the page, that have the energy and richness of the walls and paving stones at Ravenna; this vibrancy was achieved very simply by the judicious deployment of like units.

Klee went from diagramming weaving to sketching braids, pigtails, and honeycombs. He also made patterns that looked like fish scales. In his own painting, he was utilizing these formations to evoke bustling metropolises and underwater scenes—densely packed communities where the individual elements exist both on their own and as an integral part of the larger whole. He made what was ordinary extraordinary.

KLEE GAVE HIS TALKS about every two weeks. On November 27, 1923, he chided his students for their recent work on theoretical exercises to demonstrate structure. What they had done was "chillingly symmetrical ornamentation" that was unnecessarily rigid. The problem with the students' work was an absence of life: the studies were too static; they failed to convey "the act of forming" and "the process of growth."[107]

For Klee, art had to be a form of birth: not an inert conclusion. Making this point, he played with language as with line. He imbued his advice to the students with nuance, treading lightly yet with conviction. He spoke with that same combination of delicacy and assuredness that marked his painting. "I think that it is a slippery area, and for the time being, should like to discourage you from entering it."[108]

Klee amplified on "the vibratory impulse." This was, he explained, "the will or need for living action."[109] He cited as an example the imprint of the sea's movement in the sand. He encouraged the close observation of these compositions created, and shortly thereafter erased, by natural processes. Josef Albers, one of the young people most directly affected by Klee's observations, would six years later take remarkable photographs of the patterns visible as the tide begins to recede, on a summer holiday he and Klee and other Bauhaus friends took in Biarritz.

Klee had his students experiment with what occurs when one puts a fine layer of sand on a thin metal plate and then draws a violin bow along one edge to make the plate vibrate, causing the sand to arrange itself in response to that movement. He wanted them to see that the process of creation consists of an innate craving for action, followed by its "transformation into a material event" and then resulting in its "visible expression in the form of newly rearranged material."[110]

"We are the bow," he declared, describing the artistic process as an act in which matter is fertilized and becomes invested with a "life of its own."[111]

WITH HIS UNDERSTATED GUSTO, Klee returned continuously to ordinary events that escaped ordinary eyes. Standing in that classroom in Weimar, Klee never talked about the Bauhaus or modernism; rather, he conjured the universal, the behavior of oceans everywhere on the planet, phenomena both ancient and yet to come.

This man who was so famously silent outside the classroom diagrammed and talked away to make clear to his students his idea that a musical tone had the motion of a wave and that singing or the use of a string instrument "quakes or vibrates or turns on a tremolo."[112] He told them about a fascinating, and utterly original, experiment he had conducted in his garden. First, Klee planted what was nothing but a stem with two branches. Then he bent the longer of the branches and secured it to the ground. He next cut the longer branch close to its juncture with the shorter one. Now there were two plants, for the longer branch put down roots and took off of its own accord. Both grew at the same rate. Klee made sweet, childlike diagrams of plant growth, while explaining that plants adapt themselves to the need to grow in different directions and that sap flows "both up and down."[113]

In his studio, meanwhile, Klee was making drawings of beetles that look as if they bear the imprint of the little creatures' own footsteps. He painted gardens where the two-way motion of the sap animates the brushstrokes so that the images are as fresh and alive today as they were when he made them. He also made numerous images of fish and lobster traps in which the current flows in an opposite direction from the creatures swimming, a technique that creates the tension of a potential collision, and then he adds to the drama by having the fish shift directions.

Klee jumped from his discussion of plant roots and water currents to a conclusion of breathtaking simplicity and wisdom. "Creative power is ineffable. It remains ultimately mysterious. And every mystery affects us deeply. We are ourselves charged with this power, down to our subtlest parts. We may not be able to utter its essence, but we can move toward its source. . . . It is up to us to manifest this power."[114]

Encouraging his students to go into their own depths to find the force inside themselves and to make it "function in union with matter," he changed their lives.[115]

HIS LARGE EYES, which gave him the look of an amused child, and his taciturn speaking manner in no way concealed the ardor with which Klee continuously returned to the idea that art and architecture must manifest higher laws. The imperative was to create paintings or buildings that echo and encapsulate universal truths.

Klee was particularly preoccupied by the cells that constitute matter, the charged nuggets of life that are everywhere within us and our surroundings.

With his Swiss accent, his quiet, even-pitched voice, and his bemused smile, he remained soft-spoken, but was consumed by passion as he dispatched information of vital importance. "There is resonance inside the particles, immanent within them. Their oscillations range from the very simplest to the composite modes. Inexorable law must express itself throughout."[116] The making of art must have that same force, as must the resultant images.

While teaching visual art, Klee referred to the mechanics by which sound turns into music. "The bow can have no pity. Every expression of function must be cogently justified. Only then will that which is in the beginning, that which mediates and that which is at the end, belong together intimately." He preached with Calvinist conviction, fired by a belief both in the forces invisible to us and in inviolable standards of behavior. "One must get in at the ground floor," Klee continued. "That alone will avoid rigidity, and the entire growth process will then function without interruption."[117] It was a conscious mix of nuts-and-bolts information with spiritual faith—like the directions on a seed packet, invoking dirt and a shovel to give birth to life's wonders. This was what the Bauhaus was about: the magnificence of existence made manifest in the physical objects that surround us.

KLEE VOCIFEROUSLY DECRIED ANYTHING disconnected from natural growth. If artistic representation did not reflect the rooting and movement and vibration of plant development and musical creation, it lacked authenticity. "Nonsense always emerges as such, in various guises. Dead forms, creaking noise, moans, breaks, monstrosities," he said.[118]

This loathing for art that was less than reverential toward life was another point that all of the great Bauhauslers had in common. They detested artistic fraudulence as passionately as they enthused about excellence. Shams had to be pointed out; no equivocating was allowed. Klee's warning to the students was delivered with the fire and brimstone of a preacher excoriating sinners. He had no tolerance for artistic endeavors possessed of "infertility, barrenness, pseudo existence, casual false-fronts, belonging to nothing. Things without growth. Eyes without function. Unnaturalness, surpassingly fair. Aestheticism. Formalism."[119]

Klee immediately followed his list of vices with an encouraging reminder that there was an alternative: "Whatever rests on the foundations of life, on the other hand, is good, when new formation and preservation each find themselves in the other."[120]

When the students who had come to the Bauhaus looking for sources of certainty, who braved the winter cold to come hear "St. Christopher with the weight of the world on his shoulders" speak further about the essential link between the laws of nature and the creation of art, they got what they

wanted. Klee's talks provided rich answers in a time of worldwide anxiety. The students could count on their sage to be assured without being arrogant, to explain his ideas not as a self-important master but in the capacity of one who had received the truth and now considered it his obligation and joy to transmit it.

13

In 1923, seventeen-year-old Marianne Heymann arrived at the Bauhaus and attended the classes Klee gave for the weaving students. In 1957, in Haifa—where she ended up as a Jewish refugee from Nazism—she remembered those classes as having changed the course of her life.

Heymann describes the effect of Klee's teaching on her and the other young women in the textile workshop: "While his words fell haltingly, we students experienced an inner transformation." The teaching was "intimidating, intoxicating. . . . The absoluteness . . . that Klee opened our eyes to had the initial effect of overwhelming and inhibiting us. Thus, suddenly transported into a world of perception for which we were not yet mentally equipped, we naturally felt shaky, or as in a trance."[121]

In the state of being induced by Klee's teaching, the students experienced annihilation and resurrection:

> Klee could "destroy" us with a single word, i.e., make our inadequacies starkly evident. We would be "dead" for several days. Then, when he felt it was enough, he would say a few friendly magical words and we would "return to life." Klee did not look at us while he was lecturing and did not even face us. His eyes were usually fixed on his inner world. If he did look at [our efforts at textile design], it was as if he were looking through them, as though they were some inessential material, and it was necessary to discern the essence hidden by their outward appearance. . . . His external appearance has often been described. He reminded one of a Moorish wizard. Particularly his eyes, beard, and the oriental placidity of his movements. He had a pronounced Bernese accent and its slightly singsong tone would give all his utterances an amiable air. There was something almost plantlike about his poise and calmness.[122]

Heymann also vividly recalled Klee at the violin:

When he was making music, Klee's eyes shone with an extraordinary brilliance. It was as though they were illuminated from within and radiated light. He always gave off this strange luminance while and after playing or listening to music. If I met him after a performance of a Mozart opera, I had the impression that he consisted only of his eyes, which radiated the music he had just heard. This radiance affected us with such immediacy that we had the feeling that we had been standing in the dark and had suddenly been flooded with light.[123]

Heymann was among the students whom Klee invited home for impromptu meals. He was gracious and would joke with his guests, but the man who was always conjuring unexpected things in the studio and kitchen alike remained distant. "We always felt as if Klee were a wizard traveling incognito from a different world."[124]

Klee gave Heymann an etching of a donkey, which he inscribed to her. She was astonished to receive this gift from someone so phlegmatic in his comportment, but the element of surprise was essential to who he was. "We expected that any moment something extraordinary would happen, and it always did: a word or an allusion would transport us into his magical realm."[125]

ONE OF THE PLACES where unexpected things happened was in the kitchen. Klee had always been obsessed with the details of what he ate. Starting shortly after his marriage to Lily in 1906, whenever they were apart, he would write her precise descriptions of the exact type of ham someone had served at lunch; in recounting a meeting with a friend, he would delight in such specifics as really "good coffee. The skin on the milk was, thank God, so tough that it stuck to the pot. But there were also macaroons—extra for me."[126]

In one letter, he did a drawing of an extraordinary creation he called "caviar bread," explaining that it had inspired him to take a brief holiday at a village near Bern because it was served at every meal there. "Hunger and thirst are a sensation for me!" he wrote Lily in 1916 from his military encampment in Landshut, adding, "I drink a liter of beer every day without any worries."[127] When he was a teenager, he and his cranky father often got along best when they deliberately drank a lot of beer together; Klee had developed a remarkable capacity for the yeast-fermented drink. He particularly prized "wheat beer, which tastes utterly delicious, with a piece of lemon swimming in it."[128]

His taste in food was as eclectic as the subject matter of his painting, and he approached it with the same lust. During wartime, he savored "a bowl of

sauerkraut with blood sausage—the best dinner very appreciated" and "a lovely dinner consisting of tea, liverwurst, herring, chocolate, bread, apple-cake, apples, no hunger."[129] Near his air force base in Cologne, early in December 1916, he "had the good luck to find a little pub where I got veal ragout with potatoes, and bread with a thick layer of liverwurst on top. I was starving like a wolf."[130] His preferred dishes and ingredients were at times like the beasts and other images in his art: suckling pig, roast mutton, on numerous occasions a horrible-sounding "sour liver," which he describes as "very good, and useful on a winter night,"[131] as well as cabbage, beets, lots of bread, and the inevitable potatoes, in various forms.

In early 1917, Klee started putting his own creative cooking ideas into letters to Lily. He advised her on how to make what sounds like a coarse hash out of leftover roast meat and "steinpilzen" (porcini mushrooms): "Cut some fat into small pieces when raw and put them through the sausage machine. Add some onions and potatoes. Fry on low heat, and use any other leftover in the sausage maker. Put the bones into the soup."[132] As in his art, what was vital was to use everything and waste nothing, and to assemble a range of small parts into something whole.

Klee was as enchanted by cooking ingredients as he was by tubes of paint, and he sometimes invested fruits or vegetables with human feelings, just as he did lines or colors. In one letter to Lily, describing the new pota-toes and tomatoes ("all fine except one moldy one") and other vegetables he will cook with two roosters, he reports, "The cucumber was lying there hap-pily too." Often he had to make do without the desired ingredients, prepar-ing "fried potatoes (not in oil unfortunately)" or malt coffee instead of the real thing.[133] The right food could have a direct impact on what he painted after eating it. "*Ein schön gebratenes Gochelchen*" someone sent to his house "made for a nice, inspiring meal and provided me with the energy for a very colorful watercolor."[134]

ONCE KLEE ARRIVED in Weimar, the subject of what he had eaten preoccupied him all the more. He wrote Lily that his solution to living alone in that period before she and Felix moved to the Bauhaus was, every day, to make himself boiled eggs and eat them with poppy seed bread, ham, and tea, and in that period before inflation worsened to dine at a restaurant in the evening: this strategy intruded least on his painting time. Once Felix was in Weimar and they had a maid helping out, Klee delighted in the maid's potato pancakes and instructed her on how to fry chops and exactly how to use a pullet to make a soup. He sometimes invited Oskar Schlemmer for lunch, and wanted everything to be good.

Klee regularly told Lily how famished he was, and emphasized that he needed the right foods to keep his moods in balance. On one occasion when

he ate mainly wilted winter cabbage, at least there was enough leftover schnitzel so he still could paint with force. Whenever he dined on something out of the ordinary, he described it to Lily with gusto. A museum director served crab followed by what he assumed was pheasant but might have been another game bird. But the most vivid descriptions were of his own concoctions. These consisted mainly of throwing together ingredients and cooking in a completely relaxed and intuitive way. He was proud of having prepared a true "sugo"—a sauce of tomatoes and ground meat—for spaghetti, of having assembled "Hâhnchen in Topf à la caccia" with onions and apples, and of giving canned peas some extra oomph with a homemade sauce of which the main ingredients were butter and flour. The repasts were frugal; he would often eat the ingredients he used for a soup the previous day, warmed up at lunchtime and then cold at night. Soup meat and beans were staples, and if the food was humble, so much the better: "It was a meal like on laundry day, and I don't even do the laundry."[135]

As in his art, Klee was obsessed with innards. He made risotto with a steamed calf's heart—he was so happy with the cooking wine that he drank a glass as he stirred—and was pleased with tart kidneys and rice "which behaved extremely well in a piquant wine sauce." The next night, he used the leftover sauce from the kidneys to make a minestrone "mit Blumenkohlgrûnreis und Zweibely und zum Schluss Parmesan."[136] Klee delighted in reconfiguring the same ingredients, the way he did arrows and staircases and other recurring elements in his art; he put butter and cheese into or on top of almost everything, but always in different forms or proportions.

Technique interested him in the kitchen as in the studio. He was proud to concoct a chicken soup using only a leg, to mix calf's tongue with vegetables, and to make a mutton roast that he tied up with a string, advising his wife, "It isn't a lot of work once one has the hang of it."[137] Returning to a favorite ingredient, the form of which was also a leitmotif in his work, he prepared calf's heart, steamed, with vegetables. Timing was a central issue; he made a meat soup about which he instructed Lily that it was vital to add the barley only toward the end of the cooking process. He loved to experiment, and then to describe the process to his wife. On one occasion, he wrote Lily,

Yesterday I cooked and dined on a very blond but very tasty dish. I had bought sweetbreads, which at home you always eat as a lightly fried brunette dish. I remembered fairy-tale days of long ago at Marienstrasse 8 in Kirchfeld, where they looked different, and attempted a reconstruction. This was successful. I skinned them carefully and placed them in hot butter, over a low flame, and closed the lid, leaving enough time, while they steadily gave off sufficient water. Then I

added a little cold water with flour and some drops of lemon juice. During this process I set the sweetbreads aside and only returned them when the sauce, which needed constant stirring, had come to the boil. That was all. Served with flat noodles—very good and very light.[138]

There were family politics at play here. It was an insult to his wife that a preparation he remembered from his childhood was superior to her quicker method, which had heavier results. But Klee was proud of his expertise in the kitchen. On one occasion when he was a lunch guest back in Bern and he thought he was eating "asparagus with tartar sauce"—not as unlikely as it sounds, given Bernese cooking—he wanted to confirm the ingredients, but was unwilling to have anyone think he might not have recognized them accurately. "I didn't dare ask so I wouldn't diminish my reputation as a chef."[139]

THERE WAS A PERIOD during which Klee wrote his menus for lunch and dinner in his diary on a daily basis. He listed the meals in the same meticulous way that he catalogued his paintings, with every entry numbered to show the date.

Some of what he described were recipes to the extent that he followed a prescribed method, but he never measured ingredients, and instinct ruled. A typical entry was the one for "Gerstotto (risotto with barley instead of rice), cauliflower, mixed salad. Time ¾ hrs. Butter, onion, a bit of garlic, celery—steam 10 minutes. Brown the barley, boiling water, cheese at the end."[140] The essential ingredients were, time and again, every conceivable part of a calf, chicken in multiple preparations, more cauliflower than anyone else in history may have eaten, lots of spaghetti, often with sugo, and, otherwise, potatoes.

When he cooked offal, he saw it with his painter's eye. Not only did the forms of hearts, kidneys, livers, and lungs figure in his art, but the functions of these organs depended on the sorts of processes he emulated on paper and canvas. The particular language, spare and direct, in which he wrote his cooking methods was consistent with the relaxed approach, and pervading ease and enjoyment, with which he painted. On one January day, following Gerstotto, he prepared "Pork kidneys. Recipe: melt butter, add finely chopped onions and garlic, celery, beets, leeks, apple, mildly steamed with a bit of water, ca. ½ hr, at the end add finely cut kidneys, increase heat, a few minutes. 3) Salad." The combinations were his own invention. "Veal knuckles with yellow beets, celery, and leeks" called for taking out the vegetables and buttering them and then serving everything with "potatoes in their peel" and a "salad 'Sonnenwirbel.' "[141] The mix of textures in this rib-sticking comfort food also had parallels in his art.

The most remarkable of all Klee's culinary inventions was lung ragout,

which he first made for a midday meal on a winter Tuesday in January. Here he was more specific than usual about the timing, if as imprecise as always about the measurements:

> Tuesday, a) a ragout of lungs spiced with blond spices. Recipe—Start at ½ past 11—boil a little water with some salt, add the whole lungs, 12 o'clock remove the lungs and slice finely on a board, 5 past 12 return the lungs to the pot. Ingredients added immediately: a chopped onion, some garlic, a strip of lemon peel, some horseradish, two carrots, butter and pepper. Ingredients at ¼ to 1: Flour dissolved in cold water, some vinegar, a lot of chopped parsley, a little nutmeg. Serve at 1 o'clock. b) macaroni c) salad.[142]

Highly unusual, structured but playful, belonging to the obscure reaches of the cosmos, two of the essentials of his life—food and art—were of a piece.

14

The man who was so surprising in the kitchen was even more unusual in the classroom. On December 4, 1923, Klee spoke with his usual slow, singsong locutions in language that alternated between obtuse and whimsical. On that blustery winter day, the wide-eyed Swiss instructed the students, almost all of them young women who were studying weaving, that structure—"the initial organization of matter"—was an essential. These weavers already knew that warp and woof had to be interwoven and knotted if thread was to be made into material, but Klee made that inevitability of structure poetic. "Structure is not a bridge that is no longer needed, once one has gained the farther shore," he explained.[143]

Structure as Klee depicted it was not just inevitable; it was also flexible and accommodating, and, in his splendid account, beautiful in and of itself. "It is a kind of rhythm of the small parts, existing as such beside the larger articulations and adapting its character anew in the various parts, accented more or less, interrupted when the context demands it, only to be resumed once again."[144] Klee then spoke about the wonderful way that a river adjusts to the landscape through which it flows, and sketched moving water to make the point. He gave the water human qualities: it is "aggressive" when eating the riverbed, "angry" when swirling into a lather, "calm" when proceeding down a long and even stretch, and then exceptionally "mute and sweet" when settling into a lake "where it more and more evades perception."[145]

For the rest of his life, Klee would periodically depict water in his own art. The titles included *Floating, Sinking Flood, Water Route, Rushing Water,* and *Moving Rapids.* His subject appears in a variety of guises—delving deep, flowing gently, being terrifying and forbidding or sweetly mirrorlike. The qualities he emphasized to his students are realized to perfection in his own paintings, which are pure magic. Small in scale, they evoke the motion of the universe in their lively sequences of roughly parallel lines twisted and turned with apparent abandon, yet they have the underlying sense of order that governs a Mozart symphony. Their colors play against one another like the instruments of an orchestra, every juxtaposition giving the whole a burst of life; the overall impression is of a multitude of experiences occurring simultaneously.

"The parts and intermediate parts interlock mutually and with the whole," Klee told the students. No single person, no element of nature, no musical note, no form of movement (visual or audible) acted autonomously; everything was a response. Klee emphasized countermovement, comparative lightness or density, openness or closeness, "proportional action." None of this was simple, he explained; nothing was predictable or "precisely commensurable. . . . We are not face-to-face with mathematics here." Impressions mattered more than what could be measured or weighed with exactitude. "You will find, for example, that parallels are no longer parallels, when some third element intervenes and interferes (optical illusion as reality)."[146] As always, what emerged from all the logic and careful observation was abiding respect for life's mysteries and for the inexplicable.

KLEE CONTINUALLY ALTERNATED between everyday details and the greater cosmos. He made complex diagrams of zigzags, charted detailed progressions of hypotenuses, and intersected loops with ruler-straight lines. As he drew in front of the students, he noted the angles and dimensions with logarithms and complex equations and calculations, and then explained his representations with statements of Zen-like wisdom. In another of his weekly lectures, he pointed out, "In nature, after all, the water does not necessarily end in a lake. Neither in a lake nor in the sea, and the springs in the mountains too must be fed from somewhere. Our epic, in other words, has neither beginning nor end."[147] As usual, the philosophical conclusion emphasized all that cannot be known. Wisdom was the acceptance of incertitude.

When Klee spoke to his students about the human circulatory system, he elucidated the way that the myocardium functions as the central motor that dictates the flow of blood "by means of a rhythmically repeated movement of contraction and relaxation, of tension and relief."[148] He sketched the way blood is propelled through the entire human body and drew "the very finest branchings" where "movement proceeds of its own accord, as always in cap-

illary tubes."[149] He then expanded on the way that "blood deteriorates by surrendering its useful components"—again, with the word "surrendering" conferring a human attitude—before returning to the heart. He next described, and illustrated with animated chalk sketches on the blackboard, the process by which "the bad blood" travels to the lungs, "where it is purified."[150] He perpetually emphasized the circularity of everything, the miraculousness of natural processes, and the relevance of all this both to the way art is created and to the vitality essential to that art. In Klee's account, blood experienced both "exploitation" and "subjugation." He concluded, "Thus does nature act and shape, on the basis of her need of movement, both in terms of locale and content."[151] It was simple enough, as far as he was concerned. Klee was not trying to impress his students with his erudition; he was merely teaching what he had gleaned of the truth in order to help them move forward with their own work.

Once they had learned something, the students were meant to go deeper in their own explorations. "I have kept my discourse quite elementary, limiting myself to the merest hints. This afternoon, when you will be asked to represent such a circulatory system, you will have to go rather beyond the schema shown here on the blackboard."[152] He told the students to suggest the transition of blood from stage to stage both graphically and with a shift from red to blue. He further advised them that, within each color, variations in tonality and density could be used to represent weight shifts, and that a change from light to heavy or vice versa could symbolize the changes of blood traveling through veins and arteries and losing its nutrients or regaining its force.

IN SEVERAL LECTURES, Klee talked about, and illustrated, the intake and outgo of food. The year he arrived at the Bauhaus, he had sketched a "man-fish-man-eater."[153] This amazing image is evidence that, in his art as in his cooking, there was little that Klee considered off limits. But he evoked his unusual visions in such a naturally competent way that they are not terribly startling. To consider his "man-fish-man-eater" grotesque imposes a judgment on it that is alien to Klee's way of thinking. The creature's greed and barbarity are depicted so as to appear as natural as the rivers and blood flow he examined in his lectures. To Klee, the creature's actions were simply part of the cosmos.

The truncated "man-fish-man-eater" has a large boxlike head and is entirely bald. His wide open mouth is marked by upper and lower teeth that are as jagged and brutal as saw teeth; these lethal chompers anticipate by nearly two decades the brutal imagery in Picasso's *Guérnica.* He also has on top of his flat pate a form that could be read either as a large eye or as a pair of lips with a black dot at their center.

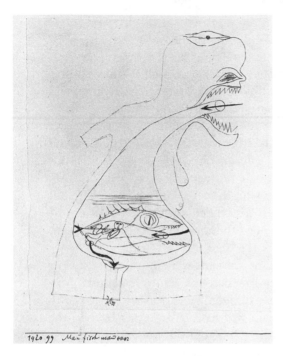

Paul Klee, Man-Fish-Man-Eater, *1920.*
Klee's vivid imagination was grounded in natural
elements, however startling the results.

A bold arrow penetrates the gulletlike opening at the top of the free-form vessel that rises through the man-fish-man-eater's throat and opens in the middle of his mouth. The route of his comestibles could not be clearer. Toward the base of that vessel, a few horizontal lines suggest water, beneath the surface of which are abstracted fish—jagged fins and all—as well as a tiny, embryonic humanoid. They are still waiting to be digested, and a second bold arrow suggests what will happen after they have been: they will be small enough to go through a little hole and then down into a discharge pipe. At the exit from that pipe is written the name "Klee."

The man-fish-man-eater has no legs, one amputated arm, and female breasts. It looks vicious, but then so do the fish it has imbibed; only the little humanoid inside its stomach has an innocence to it.

The ease with which this image has been drawn, the insouciance of the lines, and the overall impression of breeziness impart a casualness: we do not feel the call to any interpretation beyond the obvious. "We eat other creatures; we enjoy having them in our stomachs; we take the nourishment; and then we shit," it says boldly. There is, however, neither commentary nor judgment.

KLEE'S ATTITUDE IS WHAT Willi Rosenberg provided as evidence of the artist's schizophrenia, even if to most of the people at the Bauhaus it defined his genius. To render such a surreal vision with Mozartian artistry, rather than in the strident style of artists like Dalí or Max Ernst, was disconcerting to the many people who shared Rosenberg's views. They could not reconcile his light-touched, graceful, dexterous style with his imagination. They regarded Klee as neurotic because he was as restrained in his persona as he was uninhibited in his art, and more readily accepted the surrealist lifestyles of people like André Breton.

Klee's revelations were profound rather than superficial; he understood the distinction between human thought at its most expansive (not, as Rosenberg said, "bizarre," but, rather, inevitable—to anyone willing to accept the wanderings of his own mind) and forms of behavior that he, and most of his admirers, would have found unsavory. The contrast between his distant persona and his uninhibited art was part of the fundamental fascination he elicited from the Bauhaus community. As Marta Schneider Brody points out, "No matter whom he happened to be with, Klee was always reserved, not deliberately, but because he could not be otherwise. Although intensely perceptive, he seemed to live in another world. Even on the occasion of festivities arranged in his honor, Klee remained his usual self. His withdrawal was so compellingly apparent that no one dared to trespass upon his private world."[154]

Klee had adopted his persona intentionally. He admitted:

I have developed a cunning, practical strategy. . . . What is most intimate for me remains most sacredly locked up. By this, I mean not only love—for it is easy for me to talk about this—but all the exposed position around it, upon which the assaults of fate in one form or other have some prospect of success.

Whether this strategy may not lead to a certain impoverishment will appear in time. I did not choose it freely, it developed early in me.

Perhaps it is because my instincts as a creative artist are the most important.

If I had to paint a perfectly truthful self-portrait, I would show a peculiar shell. And inside—it would have to be made clear to everyone—I sit [alive] like a kernel in a nut. This work might also be named allegory of incrustation.[155]

In part he was protecting himself from the terrifying places to which his mind could lead him:

I'm quite aware that I'm entering a vast region where no proper orientation is at first possible. This terra incognita is mysterious indeed.

But the steps forward must be taken. Perhaps the hand of mother nature, now come much closer, will help me over many a rough spot. . . .

I begin logically with chaos, it is the most natural start. In so doing, I feel at rest because I may, at first, be chaos myself.[156]

He was comfortable with what others deemed his madness.

KLEE HAD ALL the more reason to develop that appearance of control because his wife was increasingly lacking in it. As a devoted father, he knew at least one parent had to seem sane. It is impossible to get a clear image of Lily, who was regarded simply as a pleasant but distant figure by the Bauhaus community, and who in the literature, including Grohmann, is depicted mainly as the source of the couple's financial stability in the early years and as Klee's musical accompanist. But while Klee was at the Weimar Bauhaus, his wife became increasingly remote. She suffered frequently from respiratory problems and angina, was extremely sensitive to hot weather, and was, at least in Felix's eyes, often very tense.

Felix Klee wrote of Lily: "My mother's nerves had probably suffered from the days when she gave all those piano lessons and felt under great stress. She had become impatient and unstable, and began spending long periods in sanatoriums, where she had time to read the paper, write letters and distance herself from her usual life."[157]

Klee's insistence on privacy was in its own way also neurotic, but his was a neurosis tightly controlled. Lothar Schreyer's recollections provide a clear image:

> Pausing in front of Paul Klee's door, I listened for a moment. Not a sound. Knocked, giving the signal we had agreed on for our visits. Paul Klee unlocked the door and let me in. He locked it again, put the key into his pocket and pushed the piece of cardboard that hung from the latch over the keyhole. He did not like to have anyone peering through the keyhole. . . . In the center of his studio three easels stood side by side, an unfinished picture on each of them.[158]

Schreyer conveyed the magic as well as the deliberate isolation of that secret universe: "And so I was back in the wizard's kitchen. Of course the whole of our Bauhaus in Weimar was a kind of laboratory. But this was the place where the real magic potions were brewed. The studio smelled strongly of a pleasant mixture of coffee, tobacco, canvas, oil paints, fine French varnishes, lacquer, alcohol and peculiar compounds."[159]

The goal of all the props was, of course, the making of art. This was part of what enabled Klee to stand on solid ground, whatever the workings of his mind were. Unlike Lily, he had found the means to use the cacophonous mix of his conscious and his unconscious thought as catalysts for spectacular creations.

15

Klee's 1923 *Group Linked by Stars,* an oil and watercolor on paper, could be seen as a portrait of his students taking in his ideas. Some of the animated sticklike figures stand on tiptoe; others are seated. Some reach upward as far as possible, while others hold their elbows crooked. Regardless, the blood is moving through their arteries and veins, and their bones and muscles are functioning in tandem—all as Klee has described.

We don't see any of this in detail, but we feel it because of the marvelous way in which Klee—for all the sophistication of this complex composition, with its musical overlays of forms and its translucent and opaque layers— has articulated his subject with childlike simplicity and corresponding childlike excitement. It is as if all the characters are connected by their exuberance. They are raising their arms to celebrate knowledge and nature, and while they stand in place on the ground, they are weightless, the way music and light are, as if the magnificence of thought and movement has caused them to levitate. Despite his concern about the cost of groceries, Klee was in another world, a cosmic universe in which music can be heard perpetually; in this depiction of the "group linked by stars," the students are in that wonderful territory with him.

The area directly above the simple flat ovals that represent the characters' heads is a symphonic burst of square and diamond and circular forms. Suggesting a Renaissance pageant, it also captures the infatuation with these basic geometric shapes that prevailed in every domain at the Bauhaus.

HALF A CENTURY AFTER STUDYING with Klee, when the precious world of the Weimar Bauhaus had long been shattered, Anni Albers claimed that she had heard him lecture on only one or two occasions. Her notebooks indicate, however, that she had in fact attended numerous talks by him. One can understand her confusion: Klee often restated the same idea, albeit always with renewed enthusiasm, as if it had just been born in him.

He repeated himself deliberately, for this was the pattern of nature. On January 9, 1924, following the Christmas holidays, Klee drew a parallel between his teaching and plant growth as he had explained it in the first class. "When we began—one must make a start somewhere, even though there is no real starting point—we proceeded from a stage that may be compared with a germinating seed." The goal all along had been, he said, "to trace the mystery of creativity, the influence of which we felt even in the

development of a line. . . . We were not bold enough to think we could actually uncover the secret mainsprings of creativity, but we did wish to get as close to them as possible."[160]

He counseled the weavers to immerse themselves in the materials at hand and the techniques for connecting them, not to focus on the larger goal. Klee excoriated the idea of artists anticipating foregone conclusions. "Form as semblance is an evil and dangerous spectre. What is good is form as movement, as action. . . . What is bad is form as immobility, as an end. . . . What is good is form-giving. What is bad is form. Form is the end, death. Form-giving is movement, action. Form-giving is life." This was the imperative of making art, and this was the urgency with which the most passionate creators at the Bauhaus viewed things. Klee continued: "These sentences constitute the gist of the elementary theory of creativity. We have got to the heart of it. Its significance is absolutely basic; and I don't think I can repeat the sentences above often enough." He was adamant, as the best of his students would be. Exult in the making! Feel growth and process! To be an artist, you must follow a similar course to the one he had charted in plants and rivers: "The approach, as the work's essential dimension, must not tire us. It must be refined, develop interesting offshoots, rise, fall, dodge, become more or less clearly marked, grow wider or narrower, easier or harder."[161]

MANY OF THE IDEAS that Klee put into his teaching were published. In 1923, he wrote *Ways of Studying Nature* and in 1924 *The Pedagogical Sketchbook.* He also codified his views on creation in a lecture he gave in Jena in 1924, declaring that

> the artist has coped with this bewildering world—reasonably well, we shall assume—in his own quiet way. He knows how to find his way in it well enough to bring some order into the stream of impressions and experiences impinging on him. This orientation among the phenomena of nature and human life . . . that's like the root part of our tree.
>
> From there the artist—who is the trunk of the tree—receives the sap that flows through him and through his eye.
>
> Under the pressure of this mighty flow, he transmits what he has seen to his work.
>
> His work, then, is like the crown of the tree, spreading in time and space for all to see.[162]

The calm assuredness with which he said this betrayed the grace with which he saw himself as transmitter and receiver. He took neither blame nor credit for what he had done, and while acknowledging that "both his competence and his sincerity" had been doubted in attacks on his lack of

verisimilitude, he easily dismissed the loud criticism of his own work. It was all okay because the artist "is neither master nor servant but only a mediator. His position, then, is a modest one indeed; and the beauty of the crown, that's not the artist himself—it has only passed through him."[163]

This was the humility with which the greatest of the Bauhauslers had embarked on their life's work. To see the Bauhaus as a design agenda in which a few gifted people tried to impose a single style on society is totally off course.

When the notes for the Jena lecture were translated by Douglas Cooper and published in English, Herbert Read, one of the greatest proponents of modern art in its early years, wrote in his introduction that Klee's notes "constitute the most profound and illuminating statement of the aesthetic basis of the modern movement in art ever made by a practicing artist."[164] Yet in that period of hostility toward the Bauhaus, Klee was one of the main butts of mockery. The painter Vilmos Huszar personally attacked Klee in the magazine *De Stijl,* writing, "Klee . . . scribbles sickly dreams."[165] This was the time when a Weimar newspaper article in 1924 described Bauhaus people rolling around naked outside, resulting in unmarried women getting pregnant. The school administration was accused of being irresponsible, not only permitting this but even encouraging it; the coup de grace was that a cradle built in the furniture workshop was carried to the flat of an unwed mother-to-be as a sort of victory celebration. Klee's art was considered further evidence of the lunacy encouraged at the school.

Gropius, according to Huszar, had made a monument in the Weimar cemetery that was "the result of a cheap literary idea. . . . In a country which is torn politically and economically, can one justify the spending of large sums of money on as institute such as the Bauhaus is today? My answer is: No—No—No!"[166]

With attacks like this becoming widespread, Klee, as unperturbed and unflappable as ever, demonstrated that art gave both meaning and stability to life. Wrestling joy and a sense of plenitude out of the morass caused by the invective and nastiness of outsiders, it was *the* answer.

16

In 1924, Galka Scheyer created the Blue Four, an organization dedicated to promoting the work of Klee and her three other chosen artists— Kandinsky, Feininger, and Jawlensky—with exhibitions and lectures in the United States. Scheyer, then thirty-five, came from a cultured Jewish

family from Braunschweig. Owners of a canning factory, Scheyer's parents were sufficiently prosperous that their only daughter had been able to study music and art and then to study English at Oxford. But while they gave her some financial support, she still needed to earn her own living, and intended to do so by selling the art of these four painters.

In October 1919, Jawlensky introduced Scheyer to Klee in Munich. Scheyer immediately developed a love for his work, and also became unusually close to the elusive Lily, whom she called Kleelilien. She first stayed with the Klees at the Weimar Bauhaus at the end of 1921, spending New Year's with them. A photograph shows Scheyer and Klee standing outside in front of bare trees in the snow. The fair-skinned Scheyer, with her strong jaw and chiseled features, smiles radiantly, her eyes sparkling. She wears a jaunty knitted cap and a fantastic cape with a wide, Pierrot-style collar, and is bravely without a scarf, her long swanlike neck exposed to the winter temperatures.

Scheyer appears consumed with happiness, standing next to Paul Klee, who, ten years her elder, resembles a little boy dressed as a grownup. This was the era when he sported a well-trimmed mustache and pointed beard, his sideburns looking as if they had been drawn with charcoal for a school play. He is wearing his Russian-style fur cap, and his officer's overcoat is buttoned to the top, the sleeves too long. In his reserved way, he appears every bit as happy as she does.[167]

Scheyer was, indeed, pleased to be there. She wrote Jawlensky that she had been immersing herself in Klee's work, starting with his childhood

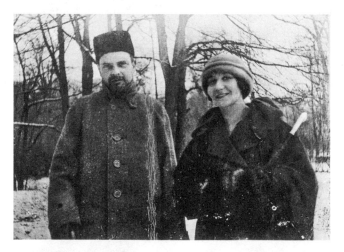

Paul Klee and Galka Scheyer in Weimar, 1922, photographed by Felix Klee. The intrepid Scheyer adored Klee's work and greatly enlarged its international audience.

drawings, and considered him "the greatest draftsman we have." For her, the art and the man had the same wonderful freshness and allure. "Klee's hand, his line, has an immense vitality and already in his very earliest drawings was free of any external influences and leads its own life. Klee is a fantastic person—good-natured, well-balanced, harmonious, and delightful to be with."[168]

When Scheyer bought a work by Klee for herself at the start of 1924— his 1912 drawing *Galloping Horse*—he wrote her a letter that was, in its tone and priorities, pure Klee: droll, quirky, serious in the guise of being flip. The salutation is "Dear Emmy Scheier! Or Emmi Scheyer!" This is followed by his opening sentence: "My wife is more in favor of canned goods"—referring to an unusual form of payment Scheyer had proposed for the drawing. From there he launches into comments about the organization that Scheyer was then in the process of forming. He is adamant about the name: "Under no circumstances should it end in -ism or -isten or -ists; it should rather . . . suggest nothing less than . . . that which is the most beautiful about it, the friendship."[169]

In March, Klee wrote a poem on the back of a Munich New Secession envelope addressed to Paul Westheim, editor of *Das Kunstblatt,* a German art magazine. The poem is called "Under the Title," which derived from the first sentence of the official announcement of the Blue Four: "Under the title 'the Blue Four,' the artists Feininger, Jawlensky, Kandinsky, and Klee have joined together in order to introduce the youth of North America to a selection of their most important works."[170] The announcement explains that the organization would get going with lectures and an exhibition organized by "Mrs. E. E. Scheyer" at Smith College in Northampton, Massachusetts. Klee's poem on the envelope declares:

> *Under the title*
> *The Blue Four have banded together*
> *for the purpose*
> *of marketing*
> *bad art*
> *in the United States*
> *of America*
> *under the direction*
> *of Madame Nursemaid*
> *Emmy Scheyer*
>
> *the following four*
> *professors blue*
> *one from the occupied*

territory of Schablensky, the other
three in the heart
of Germany called
the State Bauhaus
namely Linseed Oil
Onefinger, Prince Schlabinsky
and Lord Pauline von Grass
request Lord
Westheim
to make this known
in his Kunstblatt

The Ladder
The Easel
The Impresaria
The Expressaria
The Express-Sahra
The Four-Wheel Wagon[171]

Lord Pauline von Grass had, in the last stanza, made a list that was practically singable, in German as in English. The sequence of words—in its flow, randomness, and vital sense of unity (the four-wheel wagon is a reference to Jawlensky, Feininger, Kandinsky, and him working in tandem)—invokes Klee's own serious work of the period.

A few days after writing his poem, Klee and the other three wheels went to the official Thuringischer notary and signed a power of attorney, written in English, authorizing Scheyer to represent their "Interests, Artistic and Pecuniary, in all foreign countries, particularly the United States of America." The relationship led to exhibitions and minor sales for all of them and above all encouraged them with the knowledge that, regardless of the occasional critical diatribe directed their way, their work was now appreciated on more than one continent.

THE KLEES WERE CONTENT with the way of life Weimar eventually afforded them. After a while they were playing chamber music more regularly, generally twice a week, and there were first-rate concert performances to attend when Klee wanted a break from his routine of painting, teaching, and homemaking. He had an unusually discerning ear. On one occasion, when Lily was away and he went to an all-Mozart event, he reported to her that a violin concerto had been performed with great sensitivity, except for the kettledrum—an image that would appear in his later paintings—which remained "slightly somber and deaf." "The beautiful clarinet concerto" had

"unfortunately [been] played rather academically. And to finish, a sequence of six dances, splendidly played: among them a German dance, Canary, Organgrinder, Sleigh ride. All wonderfully pleasing compositions, you laugh and cry at the same time. The conductor is a real artist, virtuosic, subtle. Primarily intellectual. Owl-faced, still quite young. He understands the strings particularly well, the schoolmasters had to sparkle with wit, he dictated every last note. We all have our failings and one regrets that he shows no naïveté at all. His shaping of every detail sometimes borders on the excessive."[172]

Klee judged music using many of the same criteria he applied to his own paintings: the emphasis on balance, the wish for simultaneous insouciance and professionalism. If art and music were to provide grace and beauty in a turbulent world and to be the source of stability and salvation, they needed to be flawless yet fresh. For Klee, Mozartian qualities could ward off despair. Only the onset of World War II, and the recognizable approach of his own death, would reverse the salubrious effects of his work and make it more a requiem than a celebration. At the end, the kettledrum, one of Klee's chosen subjects, would be unmistakably thunderous.

AT JUST ABOUT THE SAME TIME that he attended the Mozart concert, Klee painted *Dance of the Red Skirts* (see color plate 15). Unlike the conductor of the Mozart, he managed the extraordinary feat of maintaining his naïveté. The dancing figures—at first there appear to be four of them, but then fragments of others begin to come into view—have sticklike limbs and facial features denoted only by dots and lines that could have been drawn by a child. This is not the case of a grownup trying to be cute. The drawing has the freshness of art by an eight-year-old, but its consummate technical virtuosity is undisguised.

Klee had all the skills he admired in the young orchestra conductor. For *Dance of the Red Skirts,* he sprayed many of the colors through an atomizer to achieve the harmonic blend he desired. Beyond the sprayed hues, intense dashes of vivid red bring to life some mysterious swirls of a more somber, browner red in the background of the painting. That darker red relates elegantly to the rich earthy green with which it is enmeshed. The minor and major notes have been given equal attention; in the entire mélange, every element performs impeccably.

As for being academic: no one could accuse Klee of this trait he looked down upon for its lack of imagination and its conformity to tired rules. The subject matter of *Dance of the Red Skirts* was unique. Characters float hither and yon in a universe that is simultaneously a city and a forest, and is paintbrushed vividly. Klee's invented world is as sinister as it is lighthearted, not only because of the color effects and the frightening hidden depths of space

created by the caves and black windows, but also because of the macabre looks on some of the dancers' faces, and the extreme separateness of each of them. Like Mozart in his dances, Klee invested his subject with pulse and tension; these are whirling dervishes.

His *Battle Scene from the Comic-Fantastic Opera* The Seafarer, from the previous year, is similar (see color plate 4). The orchestration is exquisite. The background moves to the left, to the right, above, and below simultaneously; a blue-white-black spectrum, created by the juxtaposition of hand-drawn squares and rectangles, vibrates and shimmers like a jewel. There is opacity, translucency, and the creation of light all at once—with the result that the painting initially fills us with joy.

Then, as one looks closely at the drama in front of this stained-glass-like background, the mood changes. Although the scenario is patterned with the delicacy of a Byzantine mosaic, and is composed as carefully as a fine miniature, it is nasty. A warrior, whose helmet gives him brutal force, is balanced on a boat he dominates; from his position of power he is spearing a fish in the mouth. But the fish is no innocent victim; the creature has jagged teeth, and is some sort of sea monster who is using his tail to try to penetrate yet another monstrous fish—unless, perhaps, this second fish is about to capture the monster that is poking it. A third sea creature, like a seal, looks more innocent, but miserable.

The placid, even-tempered man revealed great violence in his graceful art!

17

In his first years in Weimar, Klee could not afford to travel far during the holidays, but he still relished the occasional chance to get away. In 1923, he stayed on the island of Baltrum in the North Sea, and, on the way back to Weimar, visited Kurt Schwitters and El Lissitzky. Schwitters, who made wonderfully inventive collages out of detritus like discarded bus tickets and newspaper fragments, and assembled junk into sculptures, the largest of which filled an entire room, lived in Hannover. The Russian Jewish Lissitzky, who had gotten his start illustrating Yiddish children's books in order to advance Jewish culture in his homeland, and who was now an avant-garde architect, painter, photographer, and designer, recently involved with Kazimir Malevich in the development of Suprematism and working on horizontal skyscrapers intended to encircle Moscow, lived in Berlin. Klee valued the contact with these younger artists.

Klee habitually bought fourth-class train tickets, but he did not always travel in the worst car. On one occasion when he, Lily, and Felix were going to Erfurt, he had them sit in a second-class coach. He and Lily were both wearing fur coats, which did the trick; the conductor looked at the tickets, then looked at them, and said it was fine. The whole family felt triumphant. On a trip from Weimar to Munich, however, a less tolerant conductor said a ticket was required for Fritz. "Since when are there cat tickets?" asked Klee.[173] The conductor gave in.

In September 1924, thanks to sales through Goltz and Galka Scheyer, Klee's financial situation had improved enough for them to take a spectacular trip to Sicily. Lily was in good form, happy about her own experience and also about what it was for Klee. She wrote "Emmy" Scheyer about the journey, her first south of the Italian lakes. Although she was not as articulate as her husband, Lily was enthusiastic about the same things: "a tremendous artistic experience for Klee. . . . The bar cliffs, burned to a brown, rising up, steep and menacing. The sky always sunny and blue. African building techniques. Dazzlingly white. The singing of the people, African. Monstrous vegetation. Orange groves, cypress groves, lemon groves. Olives, and the cliffs covered all the way up with cacti full of thousands and thousands of figs. The sea deep blue . . ."[174] The highlights for Klee were in Taormina, the vertical village in the shadow of Mount Etna, and the Greek theater at Syracuse. In the village of Gela, he stopped his car and became reverent, knowing that Aeschylus had died there.

After Sicily, the Klees spent nine days in Rome, where Lily was enchanted by the women dressed so beautifully in black silk. She noted with delight that none had short hair—in contrast to her own, which had recently been cropped and curled, prompting her to write Scheyer, "Yielding a very round page-boy's head. Wonderfully comfortable."[175] Lily also reported on the stockings, "mostly salmon or light fleshtones," and the admirable Roman women's leather shoes. "An incomparable impression. We've decided, as soon as possible, to spend an entire winter in the South, and possibly in Southern Italy."[176]

Once back in Weimar, Klee used his memory of the trip to nourish his art, painting the enchanting landscapes and ruins of sunny Sicily. He stayed as remote as he could from the mounting hostilities that were dominating Bauhaus life: the faculty members pitted against one another, the townspeople and new government threatening the school's future, the grave financial situation—by making vibrant paintings of the place where he had been so happy.

WHILE THE WEIMAR BAUHAUS was on the brink of folding in the bitter cold November of 1924, Klee wrote Lily recollections of Taormina and Syracuse

and said that he had "the sunshine inside" him. "I am still penetrated by the warmth of the impressions of Sicily; I think only of that, am completely in the landscape, in its abstraction; there are some things which are beginning to emerge; two days ago, I started to paint again. What else is there to do?"[177]

A week later, when the future of the Bauhaus was in even greater doubt, he wrote Lily, "I am carrying inside myself the mountains and sun of Sicily. Everything else is insipid."[178]

Klee did not particularly care about the important exhibitions of his work at Kronprinzenpalais in Berlin and in New York with the Societé Anonyme, or about the way the success of these shows led to sales both to collectors and to museums. What had a greater impact was when Fritz died, leaving him "inconsolable." Yet, even after the new, conservative Thuringian government was elected in Weimar and he knew funding for the Bauhaus would dry up, he maintained his usual imperturbability in writing Lily, "I am impregnated to such a degree by my Sicilian impressions that this touches me little inside. The beauty of the park as it withers."[179]

AS THE BAUHAUS BEGAN to fall out of favor with the government, Klee's Swiss nationality was one of the reasons the school was accused of "favouring Jews and foreigners at the expense of true Germans." Powerful nationalists were vocal in charging the school with "promoting 'Spartacist-Jewish' tendencies."[180] Besides Klee, the other foreigners at the Bauhaus included Lyonel Feininger, who was American, and several Hungarians, among them Marcel Breuer.

Klee himself abhorred nationalism. In that same time period, he corrected a phrase in an essay by Oskar Schlemmer, changing it from "German art" to "art in Germany."[181] It's just the sort of detail he would have noticed, drawing a distinction between xenophobic language and the information about where art happened to be made.

Once Gropius learned that the Bauhaus masters' teaching contracts would be renewed for a maximum of six months and could be terminated at any point, and it was clear that the Bauhaus would not survive, Klee was the least vociferous of the masters, but he was also the conscience of the group. Although he would rather have avoided the politics and escaped anything that distracted him from painting, fostering the creativity of his students, and living harmoniously, Klee faced his new situation squarely. Recognizing that the consequence of the government's refusal to continue to pay faculty salaries was that the school could not go on, even though the Weimar officials were not technically shutting it down, he was one of the nine signatories to a public statement declaring that the Bauhaus would be dissolved. He and Director Gropius, together with his fellow masters Feininger,

Kandinsky, Marcks, Adolf Meyer, Moholy-Nagy, Muche, and Schlemmer, had no choice but to acknowledge that the end had come.

The Bauhaus, these signatories announced through their terse statement to the press, had been "built out of their initiative and conviction." But now the government that had formerly supported this wonderful and idealistic venture had undermined it just at the crucial moment when the state was going to be relieved of the financial burden it had borne, and when a Bauhaus Corporation, backed by private industry (120,000 marks had already been invested), was about to be established. "We deplore the fact that interference in the objective and always nonpolitical cultural work of the Bauhaus by party-political intrigues has been tolerated and supported," declared Klee and the other unhappy masters.[182]

The notion of six-month revocable contracts made the idea of the new corporation "illusory for the people responsible for it."[183] There is no knowing who worded what in the public statement, but the word "illusory" could well have been picked by Klee, who had the rare ability to ferret out and label the essential nature of human action.

18

Once everyone had accepted the idea that the Bauhaus in Weimar was no more and was preparing to leave, Klee decided to move to Frankfurt. But when representatives from the city of Dessau came to Weimar on February 12, 1925, they met with the Bauhaus faculty in Klee's studio. It was there that Kandinsky and Muche were delegated to go to Dessau a week later to look around.

Lyonel Feininger felt that Klee had contemplated moving to Frankfurt instead of staying with the school because he thought only of his own interests, not of the future of the Bauhaus. While others respected Klee's detachment, Feininger considered it unacceptable. Feininger wrote Julia that Klee was concerned "entirely" with his own "business and no one else's."[184]

Feininger's resentment grew into rage. The only Bauhaus faculty member who was jumping ship was Gerhardt Marcks, who was moving to Halle. Everyone else, except for Klee, was valiantly struggling with the decision to move to Dessau, accepting the requisite personal sacrifices and inconvenience. While all of the painters were suffering from financial problems and would have preferred to work independently had that been possible, Feininger disparaged the way Klee kept his head in the clouds and was the last to wake up to the realities the rest of the group had already acknowl-

edged. "Dear old Klee, he was quite upset yesterday, and said, 'Yes, now I am beginning to understand you!' He would have preferred to take 'a good long pause.' "[185]

That Klee only now grasped the urgency of the situation, and did so phlegmatically, was intolerable to the American. Most of the people at the Bauhaus admired that this was an intrinsic part of who Klee was, but Feininger was among the bitter few who were enraged by Klee's apparent calm.

WHEN KANDINSKY AND MUCHE and their wives reported that the masters' houses would be ready in October, their future inhabitants were ecstatic. The location where the Mulde and Elbe rivers met—at a confluence with fine prospects for fishing, sailing, and motorboating—was ideal. Yet while everyone else was enthusiastic, Klee was not. Feininger complained to Julia that Klee remained passive while still waiting to hear about his possible employment in Frankfurt. "Does nothing!" he barked.[186]

In fact, Klee was assessing the overall situation—with warranted skepticism. Gropius, having embraced the move initially, got cold feed about it in mid-March. Only a third of the necessary funding had been assured; the masters' houses were not such a certain thing after all.

Felix Klee later recalled, "Klee remained rather reserved even towards his students. At the Bauhaus, we had nicknamed him 'The Good God,' which held a hint of nastiness, and you can easily imagine that he had to show some reserve. But it was a protection rampart needed by the modest and thoughtful man he was."[187] If Feininger did not find him an enthusiastic part of the team, it's because he always needed to mull things over and contemplate the various aspects of a situation in his own way.

AS THE BAUHAUS PREPARED to leave Weimar for Dessau, there was considerable disagreement concerning the overall direction of the school. Moholy-Nagy saw the direction of art depending more and more on mechanical effects, and favored projected images, both slides and movies, over old-fashioned "static painting." It was an approach that made Klee "very uneasy." Klee's own belief that nature, and what was organic and instinctive, was vital to art, and his attachment to ancient and so-called primitive forms of expression for their direct connection to human feeling and handwork had no place in the trend championed by Moholy-Nagy. Moreover, Gropius deemed Moholy-Nagy's approach "the most important at the Bauhaus."[188] All of this added to Klee's uncertainty as to whether he should remain with the school. What was going to happen, and would he be able to continue on his own terms, once they left the city of Goethe?

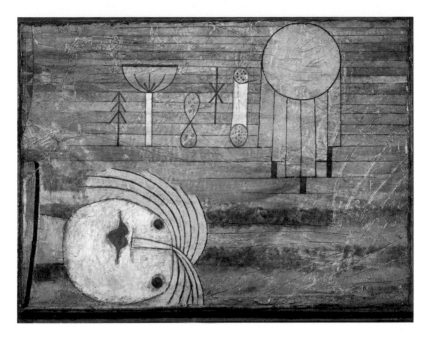

1. PAUL KLEE, *Gifts for J*, 1929. This painting commemorated the unusual arrival of Klee's gifts for his fiftieth birthday.

2. PAUL KLEE, *The Potter*, 1921. While most of Klee's subject matter had no precise location, this watercolor depicted one of the most active workshops at the Bauhaus.

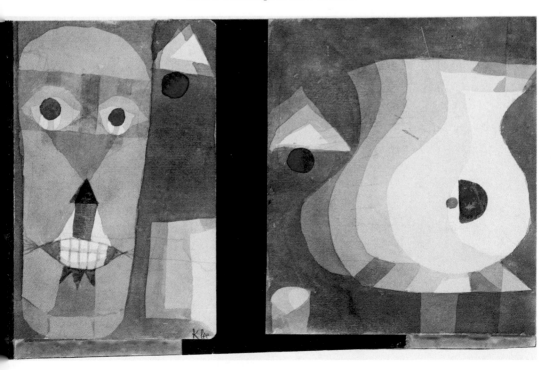

3. PAUL KLEE,
*Postcard for the
1923 Bauhaus
Exhibition.*
In this small
image, Klee
evoked the
fantastic energy
and originality
of the upcoming
presentation of
the Bauhaus's
achievement
from its first
four years.

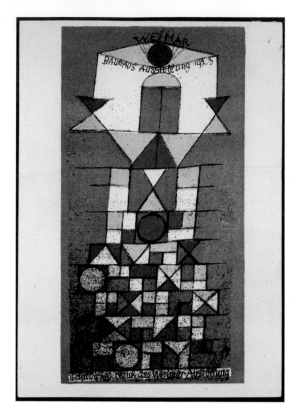

4. PAUL KLEE,
*Battle Scene from
the Comic-Fantastic
Opera* The Seafarer,
1923. In a single
painting, Klee made
violence seem comic,
and presented what
was initially charm-
ing as being fraught
with danger.

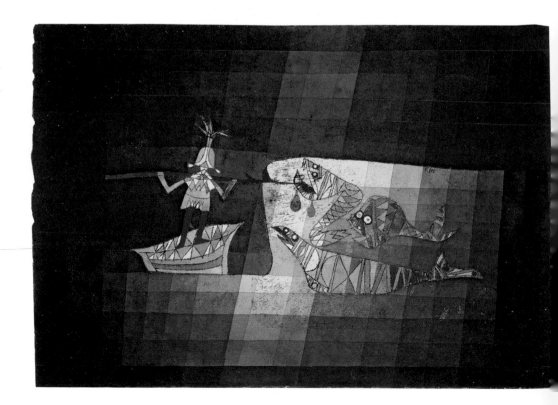

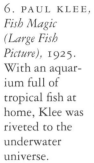

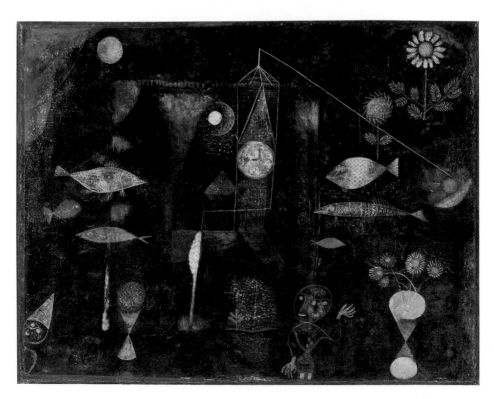

7. GABRIELE MÜNTER, *Kandinsky and Erma Bossi at the Table in Murnau*, 1912. In Münter's country house in a Bavarian mountain village, Kandinsky pushed his art into unprecedented realms of abstraction.

8. WASSILY KANDINSKY, *Theory of Three Primary Colors Applied to the Three Elementary Forms.* This image was printed in *Staatliches Weimar* in 1923.

Erläuterung: Die 3 Grundfarben gelb, rot, blau verteilt auf die zugehörigen 3 Grundformen gleichen Flächeninhaltes, Dreieck, Quadrat, Kreis.
Darunter die räumlichen Formen, Tetraeder, Kubus, Kugel.

9. WASSILY KANDINSKY, *Small Worlds IV,* 1922.
Shortly after arriving at the Weimar Bauhaus, Kandinsky
produced a series of prints in various media that remain
to this day among his best-known work.

10. WASSILY KANDINSKY, study for the mural painting
of the Juryfreie Kunstschau, 1922. During his first year at the
Bauhaus, Kandinsky designed murals that the students executed
and that realized his lively abstract compositions on a new scale.

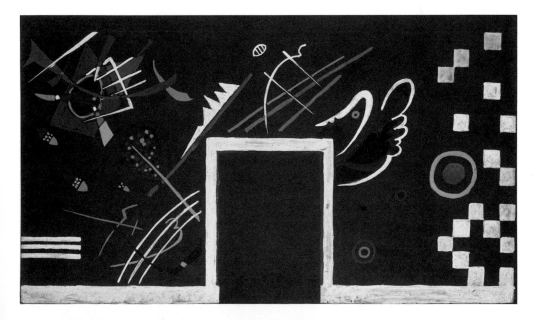

11. WASSILY KANDINSKY,
Too Green, 1928. Kandinsky
made this painting to give to
Paul Klee on Klee's fiftieth
birthday. The circle had
great spiritual significance
and suggested eternity.

12. HERBERT BAYER,
*Poster for Kandinsky's
60th Birthday Exhibition
in Dessau,* 1926. Bayer's
design announced one
of Kandinsky's most
important exhibitions
ever, a great event for
everyone at the Dessau
Bauhaus.

13. WASSILY KANDINSKY, *Postcard for the 1923 Bauhaus Exhibition.* Like Klee, Kandinsky helped promote the Bauhaus Exhibition in a way that conveyed the remarkable adventurousness of the new school.

14. WASSILY KANDINSKY, *Little Black Bars,* 1928. Kandinsky's paintings from the Dessau Bauhaus invite literal interpretations at the same time as they belong purely to the imagination.

15. PAUL KLEE, *Dance of the Red Skirts*, 1924. Having imagined demons ever since he was a small child, Klee inhabited and created a universe unlike anyone else's.

16. WASSILY KANDINSKY, *Composition VIII*, 1923. Kandinsky used vibrant colors and bold, imaginative forms to evoke sound as well as emotion.

ON MARCH 31, 1925, Paul and Lily Klee gave a farewell concert in Weimar. It was the third occasion in recent months that they had played duets in public. For this event, they performed sonatas by Bach and Mozart together and Lily played, solo, two fugues and preludes from Bach's *Well-Tempered Clavier.*

As long as they could, the Klees continued to relish the cultural pleasures of Weimar. They attended a recitation of *The Grand Inquisitor,* by Midia Pines, a well-known Dostoevsky reciter, and enjoyed two evenings of Kurt Schwitters reciting his own fairy tales. Schlemmer staged *Don Juan* and *Faust* by Grabbes, and there were concerts and theater performances. Béla Bartók performed *Bluebeard's Castle* and his ballet *The Wooden Prince.* Even as the Bauhaus was being forced out, Germany's new capital offered endless treats. Hindemith spent two hours in Klee's studio one afternoon before performing that evening.

Klee's work was given a major exhibition in Weimar that spring, as was Kandinsky's. It was hard to believe that the period of glory was coming to an end.

19

However reluctant he may have been, Klee moved to Dessau. Shortly after he got there, his *Pedagogical Sketchbook* was published as a Bauhaus book and began to find a broad audience. His international reputation was growing; his work was included in the surrealist exhibition in Paris, and he had his first solo Paris exhibition at the Galerie Vavin-Raspail.

In the midst of this complex time period—when he had success on some levels but serious financial worries and skepticism about the move—Klee painted *Fish Magic* (see color plate 6). While the turmoil surrounding him, and the stressful process of uprooting his family and moving to a new city where little about their life was certain, was not specifically referred to in Klee's art, it was indirectly reflected in this particular painting. Klee told his students, "One can, once in a while, take a picture as a dream."[189] Like all rich dreams, this one begs to be read. In what initially seems to be a vision in an aquarium or through a diver's mask, this underwater scene has, at its center, a stretched vertical canvas that fades into the horizontal canvas on which *Fish Magic* is actually painted. This device of a painting within a painting becomes a commentary on the illusion of art; the vertical canvas has the same proportions as the real one, a reminder that everything changes when you turn your painting ninety degrees, and the painting illustrated

dissolves into the actual painting in such a way that the question of what is real and what is a reproduction of reality becomes tantalizing.

In the part of *Fish Magic* that appears to be on the painted vertical canvas, a clock is suspended in a fishnet that has the form of a belfry. A moon is next to the clock. These were certainly the dominant issues of Klee's life at the time: his desire to control the passing of time so that he could, above all else, make paintings, and his wish to evoke the cosmic and eternal, as represented by the moon. Meanwhile, the fish moving this way and that, an orange one swimming eastward from behind the illusory canvas, a lavender one gliding westward in front of it, suggest transition. This was just the time that Klee, like the fish, was moving back and forth, in one direction and then another—in his case, between Weimar and Dessau. Paul had gone to Dessau, but since the only housing there was temporary, Felix and Lily had stayed behind, and he commuted. Although Klee had decided that he would be part of the new Bauhaus after all, it was as if he had put one leg into a cold ocean while keeping the other one on shore. Lily and Felix stayed in the apartment they all loved overlooking the English park in Weimar, so Klee spent a week in Dessau at the Hotel Kaiserhof, then a week back in Weimar.

What of the other elements of this pictorial enchanted land? There is a two-faced girl, one of whose mouths is like a tiny heart under a large geometric nose, with large glovelike hands that resemble sea creatures. The only other human figure is a clown, peering in from our left like an actor sticking his head out from backstage. There are large and small flowers, a pink sun, and some inexplicable objects that appear to have dropped down into the scene. And there are more fish: exotic inventions in mauve, turquoise, and red-gold, with lavish decoration and faces that give them personalities. All of this is painted with Klee's Mozartian lightness of touch, his delicacy of line and brushwork, his tissuelike filmy layers of paint, so that the end result has none of the stridency of the surrealist art to which it might otherwise be compared, but rather is deliciously insouciant. We are left with the feeling that anything can happen, and that art, like music, takes us into new and unknown territory rather than recapitulate the familiar or the literal.

Most of all, as Klee's knowing friend Will Grohmann pointed out, "Fish and flowers predominate by their very precision; the human beings are entirely schematic and play the part of visitors."[190] Such was Klee's perspective: Whatever the exigencies of the Bauhaus, whatever the issues of the day, the vast and wonderful cosmos was there before us and will be there afterward. With art, one can capture the miracles.

AT FIRST, KLEE FELT that Dessau had little to offer. It was dominated by its industrial quarter and had none of the allure of the city where Goethe had

lived. But the Bauhaus had been given temporary space and was moving forward. To cut down on travel time, Klee switched to spending two weeks in Weimar, two in Dessau, rather than moving every week. And he now moved from his hotel to a furnished room in the house where the Kandinskys were renting an apartment.

Klee taught in the provisional school building, and began to explore the city on the Elbe. By June 1925, after he had been there for a couple of months, he wrote his father and sister that the area where he and Lily and Felix would live was really very beautiful, the junction of the Mulde and Elbe rivers magnificent, and the parks enticing.

One mid-September day, Klee wrote Lily from Dessau that when he was walking to school in the morning he ran into Gropius. The Bauhaus director, Klee told his wife, was "very nice."[191] Ise Gropius, who had just returned after one of her sanatorium treatments, was less to his taste; she visited his studio with her sister, and it had not been pleasurable. But Klee was pleased because "Gropi" was going to take him the next day to a concert that would include a Hindemith violin concerto, and life at the new location held more promise than he had anticipated.

Klee was pleased that the Bauhaus theater was doing its own version of *The Enchanted Flute.* Moreover, "Gropi" had assured him that progress was being made on the new house, and that the construction site warranted a visit. Klee also told Lily that every student had shown up for his class and been very attentive, and that he had gone to a restaurant that served decent food for little money—"an unpretentious place, frequented by the good petit-bourgeois"—although the next day he would cook for himself.[192] He was seeing lots of the Kandinskys, and also enjoyed being with Franz von Hoesslin, a music conductor, and his wife, and with the Muches.

Klee, however, disliked a lot of what was "in" at the Bauhaus. On Saturday, October 24, he went to an evening of dance performed by the Bauhauslers; the next morning, he wrote Lily, "The ambiance there was vulgar and the people wild. A dreadful noise, extremely disagreeable." Nonetheless, with his usual quest for balance, he concluded, "One can say that the settling in Dessau is, little by little, taking place."[193]

THE GOAL OF THE SETTLING WAS, of course, a maximum amount of time at the easel. When the Kandinskys came in late from parties, Klee, who generally went to bed early, would hear them from his adjacent room; rather than feeling that he was missing out, since his schedule revolved entirely around his studio time, he was glad to live more calmly. If he socialized, it was likely to be at midday on weekends. He reported to Lily on a Saturday lunch with the Kandinskys—venison and noodles—and lunch at the Gropiuses the next day, although in that case the food was not good enough to mention.

On December 18, when Klee returned from a day of travel, he found on his worktable an apple, an orange, and a hand-colored lithograph, all from Kandinsky in honor of his birthday. The gesture touched him. In spite of the antipathy from the outside, as long as the heat was working and his paycheck was coming in, Klee was content. He grudgingly accepted his obligation to give lectures—while he enjoyed teaching, once he was doing it, he dreaded any incursion into his painting time—and found his fellow senior faculty members amiable. They would get together in cafés, and everyone always sent warm greetings to Lily.

Then Lily appeared in Dessau, and the two of them spent New Year's Eve with the recently wed Alberses, and the Grotes and the Muches. When others danced, Klee smoked his pipe on the sidelines—though Anni Albers, who was lame, did not dance either, it would never have occurred to her to disrupt his reverie—but, in his own way, he was part of the reborn Bauhaus.

20

At the start of 1926, Lily returned to Weimar to the apartment she preferred, but Klee was increasingly content with the new arrangements. The owner of the local movie theater would put on special films for the Bauhauslers. The Kandinskys, Muches, Moholys, and Klee went fairly often. When the theater owner showed his favorite new audience a film that took place in an artist's studio with a lusty nude model, Klee wrote Lily, "It was movvvvvving and ediffffffffying."[194]

During the days, Klee often took long walks along the Mulde. A connoisseur of weather conditions, he was delighted when the first signs of spring began to appear in late February, but he was equally content when winter reappeared in all its majesty at the start of March, providing a heavy snow that enabled him to make a superb snowman.

Klee particularly enjoyed going to the English Grounds of Wörlitz, created in the late eighteenth century on a tributary of the Elbe on the outskirts of Dessau. The philosophy of Jean-Jacques Rousseau had inspired the design of this pastoral paradise, which embodied certain Enlightenment principles that were vital to Klee. Rousseau considered botanical growth to be the model for all of life and fundamental to education, much as Klee himself did.

For Klee, this enchanting park was one of the great attractions of the Dessau Bauhaus. He regularly walked around its lake and along the canals, visited the landscaped "Rousseau Island," which was a near facsimile of the

island of Ermenonville where Rousseau was buried, and studied the neoclassical and Gothic architectural follies. Klee's usual stopping points included the Temple of Flora, an artificial version of Vesuvius, and a climbing rock. The whimsy and imagination of it all delighted him; he had no agenda on those walks, but they provided material that later showed up in his work.

Though he enjoyed his solitude, when important art gallery owners from major cities appeared to work with Kandinsky on plans for exhibitions honoring Kandinsky's sixtieth birthday in December 1926, Klee was content that they dropped in on him as well. Klee recognized that those connections with the outside world made it easier to push on with his own work, just as he now acknowledged the need to teach. On April 23, 1926, the Vorkurs was offered for the first time in Dessau, and Klee taught twenty men and one woman. Once he accepted the inevitability of losing time in the studio, he enjoyed giving the lectures, because they demanded concentration, and he felt that each time he taught, he did a better job.

In close consultation with Lily, Klee was working on making their future residence everything they wanted it to be. They would be moving to 6/7 Burgkuhnauer Allee on August 1. When he went to see how the construction was going, he was especially thrilled with the closets: one for linen, two for clothing. And his studio was the "summa." After one of those visits, he reported to Lily with childlike joy about walking with Julia Feininger along the Elbe, and buying "beautiful herrings" for dinner.

He and Lily were very precise about the colors they wanted for the interior of the house; Klee specified that more saturated paints be used for the window trim than for the walls. While Lily was still in Weimar, having decided to spend spring there, they both anticipated unprecedented comfort once their new life was in order. It was a miracle to be able to live so well when the economic situation was so terrible. Klee in this period was having large exhibitions at his usual galleries, and the reviews were excellent, but, as Lily wrote Galka Scheyer, "The financial success was almost nil. The scarcity of money in Europe is catastrophic. It affects everything and not a single person has money."[195]

"Paulie," she said, was now receiving eight hundred marks a month in salary, but it did not go as far as the two hundred fifty he had been getting before. Even with his painting sales, he could not afford the new clothing he would have liked. To have a new house being built according to their specifications was part of the Bauhaus miracle.

KLEE ATTENDED A PERFORMANCE of *Parsifal* that lasted five hours, with a fifty-minute intermission. Again, his account to Lily reads like a review by a savvy music critic. "The orchestra made a pure and harmonious sound from the first to the last note. . . . The baritone was superb from every point of

view. . . . The dramatic soprano . . . sang well but lacked personality. . . . Not the least lack of taste in the scenery."[196] He elaborated on the lighting, sets, and costumes, complaining that the only real weakness was with the voices of the men's choir.

Mainly, he focused on the household. Felix was entering the Bauhaus theater workshop, and Klee helped him get settled into it. The painting of the house was proceeding—the studio was "magnificent" and their bedroom "superb"—and he was especially happy with the armoires.[197] Life was coming into shape again.

OF THE LECTURES on form that Klee gave to the students that spring at the weaving workshop, one observer reported, "Those who were able to follow the differentiated theoretical lectures with which Paul Klee supplemented the instruction in the weaving workshop found essential enrichment in them."[198] They were, as many students noted, hard to grasp. Klee was often speaking in his own language. Another listener would recall that the talks were "like the formula of a mathematician or physicist, but, considered carefully, it was pure poetry."[199] But his method had an impact. Klee would draw on a small slate to show how to develop a form, and then would erase it to let the student proceed on his or her own rather than copy. He would, for example, focus on the cube. The students were encouraged not just to learn how to create one, but how to give it a passive or active personality so that it was not merely an inert reproduction of a form.[200]

Klee's appointment calendar reports concerts, opera performances, class days, exhibition plans, evenings at the Kandinskys', hikes, even an occasion of being naked in the garden of the mausoleum.[201] Then came the great moment in July 1926 when Paul, Lily, and Felix Klee moved into No. 7 Burgkuhnauer Allee, with only a wall separating them from the Kandinskys, who lived in the other half. On the ground floor there was, in addition to the pantry, kitchen, and maid's room, one large space that served as both the music and dining room. Above there were two bedrooms, a room just for Lily, and Klee's studio, while the top floor had Felix's workroom and a guest room. Klee's large square studio contained a black wall that made a dramatic backdrop for looking at art.

The little row of four residences—all except for Gropius's accommodated two families—was in a pine forest. In that bucolic setting, the houses were in the latest, streamlined modern style, but they imposed no orthodoxy. The Klees kept the furniture they had always had, so that even with its very modern architecture, it was home as always. Klee also had his ever-expanding collection of the sea shells and snails he brought back from travels to the Baltic and Mediterranean seas. Mollusks were an obsession: he had a second collection of photographs, X-rays, and cross-sections of them.

Paul Klee and Wassily Kandinsky at the masters' houses in Dessau.
The masters' houses had wonderful roof gardens and lawns.

In 1929, a journalist from *Das Kunstblatt* would visit the house the Klees and the Kandinskys shared. Writing about it, she never referred to the men's wives, or to Felix; it was as if the houses reflected only the "two powerful artistic personalities" of the Bauhaus masters, and nothing of their families.[202]

In Kandinsky's house, the writer noted a pale pink room with a gilded wall, followed by a pure black one "made brighter—as though by two suns—by paintings whose colors give off a powerful glow, and by a large round table shining white." Kandinsky's love for "pure cold colours" was evident everywhere.[203] But Klee's house, separated from Kandinsky's by only a thin wall, made an opposite impression. "The air which meets us already at the entrance . . . seems so different, much more intimate, closer to the earth, more humid even. So different, too—soft but impressive—is the language spoken here."[204]

For Klee, the greatest luxury of all was the location, which meant that he could enjoy long walks to the Elbe valley without having to go on city streets. He took whatever route caught his fancy, paying no attention to trespassing laws. It was as if the grounds of private castles existed only to fuel his imagination and provide material for his art.

IN LATE SUMMER OF 1926, the Klees took another trip to Italy. They started in Bern—to make the necessary banking arrangements and to change currency—and then thrilled to the many tunnels in the Alps on the train to Milan, where they changed for Genoa. Leading his wife and son on a tour of the harbor, Klee bargained toughly with the boatman. Will Grohmann, who knew his subject so well that he sounded as if he were there, observed, "Displaying a surprising amount of southern temperament . . . he seemed transformed . . . at home. The reserve he always presented to the outside world gave way to a natural openheartedness."[205]

From Genoa they took a sailboat across the bay and stayed in a *pensione* in a vast overgrown garden. Klee's quest for snakes was insatiable: they were different from those he encountered in German parks, who hid in the brush in a plant he described as spitting its seed.

Then the Klees worked their way down the Italian Riviera to Livorno, eating well at every stop. On a boat to Elba, Klee marveled at dolphins that appeared to race the ship. He ate "*spaghetti al sugo* with the captain," declaring it "Gotterasse"—food for the gods.[206]

In Pisa, he stood for hours in front of the frescos of Campo Santo, and for ten splendid days in Florence he went to the Uffizi every day. Then came three days in Ravenna, where the mosaics overwhelmed him. When he returned to Dessau to start the first full academic year there, his energy was renewed.

Once he was back at the Bauhaus, Klee's parsimoniousness and his abhorrence of politics were both tested severely. The school was off to a shaky start in its new location. Money was tight for the local government, which was the school's exclusive source of funding beyond the modest income it earned from the sale of Bauhaus products. This was when Gropius, scrimping to save money for the workshops, proposed that the masters temporarily give up 10 percent of their salary.

All except for Klee and Kandinsky accepted the inevitability of that personal sacrifice. Having stayed at the Bauhaus mainly for the financial security of teaching, and knowing that they were the most acclaimed of its artists, they would not take a mark less than what they had been promised.

Klee could not stop feeling insecure about money. When Lily had written Galka Scheyer that art sales were almost nonexistent, it was an exaggeration; times were tough, but Klee's work was now selling at decent prices in a number of places. Klee himself recognized his and Lily's inability to accept their well-being. Shortly after they had arrived in Dessau, he told Schlemmer that the next generation would do better with fame and success, that they would adjust more easily than his and Kandinsky's age group. He recognized that he and Kandinsky were both too scarred by the war and the hardships that followed to know how to enjoy their new prosperity.

Klee was in Bern on the way to Italy for his holiday when Gropius wrote him, on September 1, 1926, about the salary reduction. He immediately answered by saying, "I look gloomily ahead to further negotiations and am afraid of something that was avoided even during the worst phase at Weimar: an inner disruption. I am traveling south with the burden of such thoughts." Then, after the Bauhaus director beseeched him a second time, Klee replied to "Herr Gropius":

> The impression gained at the last meeting remains extremely disgruntling, despite the vacation spirit, sunny days, etc. It seems not to be given to us to breathe nonpolitical air, and time and again we are being forced (unfortunately) into politics. . . .
>
> The fact that the Mayor declares himself powerless in regard to the additional financing necessary for our Bauhaus, and the fact that every one of us is supposed to bleed for it, must be taken into consideration. But as far as I am concerned, I have to reject any attempt to push part of the moral responsibility for this onto me.[207]

THE BAUHAUS WAS GETTING READY for the inauguration of its new building. Klee told Lily he was keeping his distance from all the festivities; he wrote his father and sister that he was doing his best to ignore such distractions and simply to work on his art and teach his course. In addition, Klee was on his own with Felix that November, and even though his son was now eighteen, for Klee it was a priority to have the household functioning well while Felix was rehearsing opera every day. Klee often attended his son's rehearsals, frequently talking with the director, and enjoyed getting to know Felix's friends, but other Bauhaus events held little interest for him. Order at home mattered more; he was pleased with a new housekeeper who was as helpful with the meals as with keeping his evening clothes pressed. This last service was important to Klee, since formal attire was expected for concerts, where he regularly sat in the first row of the loge.

KLEE HAD BROUGHT a lot of unfinished work from Weimar and wanted to get immediately to the task of completing it. His "plan of attack," however, was taking time. He needed the right inspiration, and even fewer interruptions. And it was at precisely this moment that he was beginning to find himself in conflict with Ise Gropius concerning the concert program organized by the Friends of the Bauhaus.

Even Klee could not manage to stay completely apart from the personality conflicts that riddled the school. The concert on November 8 with Adolf Busch and Rudolf Serkin epitomized what he most valued in life. "There are always so many things to learn from Bach! These sonatas have such richness

that one is never done with them. These two men are outstanding musicians, profoundly honest." It was after the concert, when the best-known of the Bauhaus masters repaired to Gropius's house and were joined by the musicians, that the problems began. Klee had reluctantly consented to perform on November 27 at a concert for a large audience, because it was raising money for the Bauhaus canteen. At the reception after the Serkin-Busch concert, Ise was desperate to know if Lily would be there to play piano, with Mme. Schelper singing. Writing Lily about this, Klee characterized "Frau Gropius" as having "put herself in charge of trying to divert her husband as much as possible."[208] Pressured by his teaching obligations and Mrs. Gropius's badgering, Klee now felt the glorious two months in Italy, from which he had only returned on October 28, disappearing in a radiant light.

At least he loved the new classroom, which was light and spacious. And he was delighted by a cleverly designed piece of furniture there. It was a dark green board on wheels. If you turned a crank, the place for writing rolled away, leaving a new space for more drawing. Moreover, his students seemed interested in what he was saying.

On November 27, 1926, Klee, Lily, and Frau Schelper gave the all-Mozart concert that Ise Gropius had inveigled them to perform. Even if Klee would not consent to the salary reduction, he was willing to give in to pressure in other ways. After all, he had a new studio and a new place to live.

21

Once he, Lily, and Felix had moved into their new house, Klee gave his classes in the studio there. Normally there were six or seven students, although sometimes as many as ten, who one afternoon a week trooped the half mile to Burgkuhnauer Allee.

Howard Dearstyne, a young painter who had come to the Bauhaus from America, was mesmerized from the moment he walked in for the first time. "The house was very quiet," and full of "old furniture, highly polished and seemingly inherited."[209] The black wall, covered with paintings in process, was a dramatic backdrop for the semicircle of chairs where the students sat facing three easels, each of which had a painting by one of the students on it. Klee sat in a rocker between the students and the easels, facing the art so that his back was to the class. He would sway back and forth slowly, while the students, especially the three whose work was about to be critiqued, waited for him to deliberate.

For a considerable period of time, Klee would remain totally silent while

examining the paintings. When he finally spoke, he assiduously avoided either praising or criticizing the work. Rather, he offered comments on painting in general. One student, Gerhard Kadow, recalled, "Criticism of a work was latently present in these remarks but it was rarely stated, and as a result, was sensed that much more intensely."[210] Klee's discourse enabled the students to go beyond their notion of what they had intended to do in the work, but also to grasp what they had created unconsciously. They gained a perspective on their own imaginations; many of the students felt as if they were understanding their own work for the first time.

Dearstyne noted that Klee was unusual as a teacher for being "neither hated nor attacked. He lived like a strange being in the rationalistic and political world of the Haus. His withdrawal was respected. . . . His reserve and remoteness tended to accentuate the impact of his speaking."[211] His speech, Kadow noted, was distinctive: "Klee used a rather special vocabulary in expressing his thoughts, yet his sentences were organized simply and with a great deal of clarity. He never spoke a sentence for the sake of beautiful words, and he never tolerated a vague thought, though often touching on regions beyond logic."[212] Dearstyne was transfixed by the "dry and unemotional manner" of his deliberations and the sight of him drawing equally well with both hands on a blackboard in the studio.[213]

Following the analysis of student work, Klee had everyone form a circle around a large gray glazed pot for a period of general discussion. They would talk away animatedly, most of the students smoking one cigarette after another while Klee puffed away on his pipe. Klee was amazed by how much he learned from these sessions. He told Kadow that the students should not be the ones "paying tuition, but that he, the teacher, should be paying us for he felt that the stimulation he received from us was far in excess of that which he gave."[214]

Another student described Klee as being "like a magician . . . with glance, word, and gesture—utilizing all three expressive possibilities with equal intensity—he transformed, for us, the unreal into the real, the irrational into the rational."[215] The revelations tumbled, one on top of the other. The students came to see that the formation of a plane was "not a matter of the simplest deliberation but, rather, of the deepest experience." Klee simultaneously touched " 'on the nearest' and 'on the farthest,' " while also making "side springs" and taking "bypaths":

> For us, in the beginning, these seemed roundabout—in order to reveal to us most clearly the diversity of the life of forms. . . . We gradually came to realize that this person here—Klee—was talking to us about life. We were permitted, with him, to experience the development of human existence in its entire capriciousness. We raced with

him through tens of millennia. Klee made us again participants in pri-
mordial experiences. . . . There was nothing that he did not men-
tion. . . . He saw everything. And he told us everything. The question
is, did we understand everything?[216]

Even though he did not discuss the examples of his own art that were
surrounding them, Klee's private universe—populated by the man-eating
creatures, amoebic mermaids, extraterrestrial landscapes, and geometric
plants that emerged in a brightly colored world that was half familiar, half
purely abstract—added to their sense of being in new territory that con-
nected them with the remote past as well as the distant future.

As he spoke, Klee would often pause, and fall into periods of total silence.
His listeners had no idea whether these would last for one minute or five
minutes. Then he would abruptly resume talking. While full of uncer-
tainty, the journey led their consciousness to new depths.

ANOTHER DESSAU STUDENT, Hans Fischli, who eventually became an architect,
painter, and sculptor in Zurich, gave an interview sixty years after studying
with Klee. Fischli initially took the foundation course when Klee gave it in
the main Bauhaus building, and then joined the elite group who went to
Klee's studio.

Fischli recounted that Klee taught

the Vorkurs for two hours per week. He stood at the board like a
teacher; we sat at the back like students. I couldn't write down what
he said because I was listening and watching so intently. He never lec-
tured about art and music. Instead, he gave us tips, for example: "In
my opinion you have to know what you want to draw, and then you
have to be able to depict it—with only one or two lines." Then he
explained that each line is a thing in itself.

For Klee, there was no botching or smearing, not with color either.
We were supposed to respect color, hold it sacred. It was better to put
one color dot next to another instead of smearing them together.[217]

Klee also emphasized that "if you want to paint a picture, a harmonious
picture, then you must get to know the format first. You need to determine
if it is high/vertical, wide/horizontal, or square. After that, you will want to
put something onto this beautiful paper, with the knowledge that there are
different specific points on this paper. One is the middle which you deter-
mine by drawing diagonals from the corner."

Fischli recalled that Klee encouraged the students to consider themselves

personally connected with these points: "Nobody can take them from you. They're not measured points, but you've found them yourselves."

Klee looked not only at pure geometry. Said Fischli, "He also showed us how to draw a fir tree forest. It wasn't necessary, he said, to fill the whole paper with tree drawings. As a symbol for a fir tree, a simple line drawing would suffice. And a forest consisted of several such symbols—that's how easy it was. We learned to see clearly and simply, and to think while working. But we never talked about it. Either you understood him—or you didn't. He came, taught his class, and left." Unlike all the other Bauhaus masters, Klee did not give grades.

After doing the Vorkurs, Fischli decided to seek admission to

Klee's drawing class. So one day I put together a small portfolio and went to his house on the Kühnauer Strasse. Lily was also there. He looked through my portfolio, slowly, with no comment. Then he smiled very faintly—he didn't laugh—and said I should come join the group.

Each one of us would bring his or her newest work to those classes in Klee's private studio. Klee would look at the pieces one by one and then would explain what we had done. We listened with excitement. Sometimes he wouldn't say anything, he'd just leaf through the pages and nod. Sometimes he'd say things like "you watched me well." It was always very matter-of-factly, very poised. But you always felt whether he understood you or not. For example, when I showed him my *Alpaufzug* (Alp elevator/hoist)—oil on Japanese paper—he said: "Yes, the Swiss Hans Fischli is homesick, but he's done a good job of overcoming it."

Beyond the teaching, there was the fascination of seeing how Klee worked. For example, we saw how he would paint India ink into wet water colors so that the ink would permeate the color, with the tip of a paintbrush, would add blue to gray, still wet areas of ink. The color would run into it by itself, without him having to blend it in. He didn't teach us this explicitly; we had to detect that ourselves and try it on our own.

Controlled haphazardness became the essence of art. For Fischli, Klee was a distinct "type: the musician, the thinker, the dreamer. . . . In his studio his violin case was always open, the violin still had rosin dust on it, meaning he had just played on it. He was someone who created tones—on the violin and in his pictures. . . . He was a transmitter, not a school master." Fischli remarked that Klee "was a man of flesh and blood, but with an immense

charisma. Yet he was never a god or a priest for me. Rather, I always had respect for him, and esteem: for his work and for him as a person." Paul Klee disconcerted many people in the outside world, but he captivated most who were at the Bauhaus.

22

I n Weimar, the Klees had always played music after supper. In Dessau, Klee changed the routine. While he practiced violin early every morning and played in a chamber music group once a week, he gave up the evening recitals.

The ritual of Mozart, Haydn, Bach, and late Beethoven at the start of his day invigorated him. "When playing his violin, Klee surrendered himself to music. His eyes became transfixed, and he appeared to lose all awareness of his surroundings."[218] He had memorized the entire score of *Don Giovanni* and believed that his task was to play as Mozart would have played.

Klee was convinced that music was far more evolved than art. The goal of his own painting was to attain the freedom and excellence Mozart had achieved two centuries earlier. Mozart's Jupiter Symphony was in Klee's eyes "the highest attainment in art," and its fast movement "the summit of all daring. This movement is decisive for all subsequent musical history."[219]

When Klee worked, he always listened to classical music, which infused his art with its movement and sense of structure. But on the rare occasions when guests came over, he entertained them with recordings of contemporary music. He often played Stravinsky's *l'Histoire du Soldat,* a marvelously playful and upbeat piece that had had its second public performance during Bauhaus Week at Weimar in 1923. When concerts in Dessau included modern music, however, he regarded it as an intrusion. He considered Ravel coarse and Hindemith "stark" on the issue of anything spiritual.

Nonetheless, Hindemith visited his studio in May 1930, after which Klee wrote Lily saying that he admired Hindemith's vigor and splendid rhythm, as well as his economy of means and the control evident in the chamber music. But he still disliked *Cardillac,* Hindemith's first opera, proclaiming that this melodramatic fantasy had a weak text, and in its neoclassical form was full of tonal and rhythmic compromise. In music as in painting, Klee's concept of what succeeded or failed was sacrosanct.

WHEN THE KLEES MOVED to Dessau, Lily implored her husband to get a telephone. She had long wanted one, but Paul was always against the idea. "I

hour or two a day; and he reported regularly to the "brigadier of No. 6," as he called Kandinsky. Two days earlier, at dusk, he had strolled along the river, and it was magnificent. "The Sunday petits-bourgeois had already gone home. The fish were jumping out to capture mosquitoes, and some steamships were still wandering in the region."[225] He did not get home until ten o'clock, when the Kandinskys came to check up on him. Of course he was fine, he assured his wife: he ate a delicious meal that he had prepared expertly, and then put some tangos on the gramophone. The Kandinskys should stop feeling as if they had to babysit for him.

KLEE RARELY CHASTISED LILY or anyone else, but, in that same period, her insistence that he write her every other day annoyed him. "You cannot demand such regularity from me, it's not in my nature. The constraints of the Bauhaus already weigh on me sufficiently."[226] Her questions were just one more time waster that kept him from painting.

Cooking and contemplating nature, in solitude, were what recharged his batteries. Except for his long walks with Kandinsky, along the great expanses of water that he considered the best aspect of life in Dessau, he mostly needed to be alone. In the rooftop garden, he planted roses, petunias, sunflowers, geraniums, and dahlias, which he tended with care. He loved to contemplate the progress of trees: from being bare to having buds, then bursting into full leaf, and eventually assuming their splendid autumn variations before completing the cycle for winter.

Similarly, Klee was a connoisseur of the different shapes and hues of the landscapes he encountered on the holiday journeys that were his one break from daily routine. In 1927, he went to Porquerolles, an island off the southern coast of France. For Klee, that Mediterranean journey was a mission to gain knowledge and inspiration: "Once again I went in search of something to stimulate harmonies lying dormant within myself, small or big adventures in color."[227] The sequence of events that began with the initial stimulus of what he took in with his eyes continued with its processing within his brain, whereby the vision would come to activate the hands with which he made art. Whatever excited him in the sights he so eagerly surveyed would, eventually, find its way, re-formed, into the paintings that were his predominant goal.

Lily was again taking a cure when Paul and Felix made this trip to Porquerolles. Klee wrote her that the climate and the colors were so splendid that they did not mind staying in the barest of digs, with food that was just adequate at best. The petit bourgeois around him were irritating, their children badly brought up, the waiter and the maid the only desirable people, yet he was rejuvenated by the heat, and was thrilled to observe the cicadas and lizards. He and Felix hiked, swam, and picked ripe figs warmed by the

sun. Then Klee would sit on his handkerchief on a cliff top—there were many to choose from—and draw.

In his letters to Lily, Klee described the shrimp, jellyfish, sea urchins, "the ravishing snails and periwinkles, and the simply fabulous flora under the water and on its surface." He also offered trenchant commentary on human behavior: "Here, the men are polite and correct, but the women very pretentious, giving themselves stupid allures. What noble creatures Italians are by comparison! On the other hand, the men are nicer here. In France, what is dominating is chattering—in a superb language. If I could master it perfectly, I would no longer deprive myself of the pleasure of talking a lot."[228] Convinced, however, that there was no language in which mistakes were so offensive as French, he did not try.

For all of his reserve and apparent emotional distance, Klee was intensely self-aware. Underneath the taciturn façade, he knew who he was, and was more than willing to reveal himself to the person who understood. From Porquerolles, he wrote Lily:

> —I know where I'm going, but in the nature of things not where I shall be staying until I see it with my own eyes. In reality Corsica is enormous—on the map it seems small. On the map Porquerolles is almost invisible, but in reality you walk for hours and get sore feet. I think I hit the right psychological moment to leave. You get used to things and fall into a rhythm, getting up, going for a walk, lunch, a nap, painting, tea, a bath, dinner, a walk to the harbor, sitting down for a final coffee, bed. It becomes an everyday routine, and if there is an easy way to make a change one should do so. When I am on my own and perhaps more introspective, not available for others and reflect and cogitate, I always find a considerable reservoir of energy within myself and can purchase a variety of things with it. This time I am purchasing Corsica.[229]

From Corsica, he wrote his wife that "the way [Calvi] is built into the heroic landscape is so fantastic that one is confronted by a puzzle. Granite in every sense."[230] He used the word "granite" the way others might say "diamonds" or "emeralds." This was the Bauhaus mentality at its best. Education at the school emphasized the act of looking and the analysis of construction, whether natural or man-made. It was essential to see beneath the surface, beyond issues of style. Nothing was to be taken for granted. Above all, Klee's immense appreciation of life and his willingness to be enchanted were the ideal.

THE TRIP KLEE TOOK to Egypt had a great impact on what he offered at the Bauhaus afterward. The journey got off to a great start when, on Decem-

ber 19, 1928, he returned to Genoa, and ate a perfect "sugo." He was primed for pleasure; even before he arrived in Egypt, Klee revered its culture. Grohmann observed that while the artist believed that classical Greece was now "irrevocably in the past," Egypt was "more exciting, at once eternal and alive. He felt that every monument and every mound of sand proclaimed its origins, reflected the present, and foretold the end."[231] Klee's idea of the confluence of ancient time and the current era, and his belief that each grain of sand was miraculous, were both central to his teaching and painting.

In his 1925 *Bird Pep,* for example, Klee had anticipated the revelations of the Egyptian desert. In this marvelous painting, the cactus on the horizon seems to have just burst into life, as if it were born in a nanosecond. The plant is like a dancer who was not there a moment ago and now has leapt onto the stage as a mature and developed being. We feel its growth and development as if we can see its stems lengthening, its leaves gaining their span, and its red flowers assuming their color. In this as in so much of Klee's work, the history of the universe seems to have occurred simultaneously in a fraction of a minute and over countless millennia. The sun that Klee painted

Paul Klee, Bird Pep, *1925. The desert and the creatures of the cosmos thrilled Klee for their miraculous vitality and sense of eternity.*

with a core like a fertile egg yolk, and with a red aura around it, is the sun of all times. Conveying its past, present, and future, it has irrefutable power.

The bird that is the central figure of this oil and watercolor on paper has legs like those Klee drew for his students when he was depicting human development. They are signs for the limbs of a competent walker, not a realistic rendering. The bird is comic, its head and beak practically equal in size to the rest of its body. Its entire outline—of head, chest, tail, legs—is covered with fine follicles, copious and long, with many of them jutting out straight. A lot of the plants also have these follicles that look like antennae. Projecting into the atmosphere, reaching toward the future, all these little hairs evoke the miraculousness of living organisms. Three years later, Klee would be conscious that the birds he saw in Egyptian statuary were comparable: timeless and universal creatures endowed with spiritual power.

The colors of this 1925 painting are an amazing, almost lurid mix of desert rose, bilious yellow, and lime green. We are in a warm and exotic place here—certainly not Weimar or Dessau. This could be a vision of the ancient primordial past; it could be a view out the window today. Or maybe it is the future, when strange and fantastic creatures will have taken over the earth. In Egypt, he would discover its companions.

KLEE SAILED FOR ALEXANDRIA from Genoa on December 20. He wrote to Felix from the boat: "The food is extraordinarily sumptuous and perfectly prepared. In the morning you get your choice of drink and eggs or ham, as much butter, bread and jam as you like. At 10 o'clock you are offered soup and a sandwich (I dispense with this second breakfast). At 12 o'clock there is lunch, a supremely lavish midday meal. 4 o'clock is tea time and at 8 o'clock there is a gigantic dinner." To Lily, he described Naples—"from the outside, beauty in person; on the inside, character in person."[232] The boat made two stops in Sicily, in Messina and Syracuse, where Klee immensely enjoyed the return visits, however brief. The weather was cold, as well as cloudy and rainy, and Crete now had snowcapped peaks, all of which Klee adored as he anticipated the heat of Egypt.

Cruising away from Crete, he wrote Lily, "There are people from every nationality, unfortunately also Americans, the only ones lacking knowledge of how to live." Klee felt that Americans were without a belief in anything spiritual, and missed the great beauty of where they were. "What is the value of all civilization, whether good or bad, compared to this water, this sky, and this light?" he asked,[233] suggesting that such appreciation was alien for most Americans.

On the afternoon of his arrival in Egypt, he walked through the native quarter of Cairo. The following days offered one thrill after another. He studied antiquities in the museums, explored tombs and pyramids, and vis-

ited Luxor, Karnak, the Valley of the Kings, Thebes, and Elephantine Island at Aswan. It felt like a trip backward in time, as each site was more ancient than the previous one. The gardens and sunsets were even more exciting than the archaeology, the light conditions over the temples and pyramids more moving than the stones; of a storm near Crete on the way back, Klee wrote Lily a single word: "Superb!"[234]

THE TRIP LASTED LESS than two weeks, and Klee wished it had gone on longer, but its effect stayed with him. The intense Egyptian sunlight as well as the quality of simplification inherent in Egyptian art began to permeate his own work even more than it had previously. After Tunis, he had been obsessed with the moon; now it was the blistering sun. Following the trip to Egypt, Klee's work got lighter and brighter, with a noticeable change in palette.

Color, Klee told Grohmann euphorically, was "the most irrational element in painting." It wasn't only the choice of hue but the way it was applied that counted; he would use a glaze to give a color remoteness and intensify it to bring it near. Grohmann writes, "For Klee colors are actors; he is the stage director; but he does not too severely restrict the independence of his cast."[235]

Klee's work in Dessau now took off in a new direction. He began to use sequences of parallel lines, applying principles of counterpoint and the structure of a fugue to them. The lines could appear fearful, romantic, frightening, or joyous; there was never just one aspect to Klee's art, and the ups and downs of his psyche would always get in there. Forms could be deliberately still or deliberately active, and colors ranged from dark and mysterious to magisterial to flippant.

Klee's 1930 *Individualized Measurement of Strata* demonstrates with a flourish his inventive use of vibrating hues to make movement occur in parallel, nearly identical forms (see color plate 5). The painting is both the result of a series of careful decisions and a by-product of intuition. Orchestrated so that one sees the individual units as well as the totality, it has a perpetual flow, and provides a range of pleasures.

The dry and inert title *Individualized Measurement of Strata* suggests how methodical and scientific exploration can yield lively and lyrical results. The painting derives from the complex diagrams of tonal scales and the precise progressions from black to white and back again that were central to Klee's teaching. What exuberance comes from this! To the Bauhaus students, Klee constantly compared aspects of art to music, and would make visual equivalents of staccato, legato, and allegro; in this and related watercolors, he achieved those varying effects. He also demonstrated the achievement of both high-speed movement and equilibrium through visual tonality: a rare feat.

In *Individualized Measurement,* no color or form is superior or inferior to another. Klee inveighed against judgment. Fat or thin, tall or short, red or white: these distinctions did not denote better or worse. What matters, rather, is the composite, and the recognition that one set of traits never rules out another. This is why Klee preferred the word "absolute" to "abstract."

For "absolute" bestowed an intrinsic quality on every hue in the spectrum, and every shape imaginable. Grohmann often heard Klee make the distinction that "the absolute was something 'in itself,' like the absolute of a piece of music, psychical not theoretical, as he told his pupils," while the abstract ran the risk of being "unspiritual," a quality Klee deplored.[236] *Individualized Measurement* is a perfect example of the quality of the absolute as it was confirmed for Klee by the trip to Egypt.

23

In the summer of 1929, Paul and Lily Klee went to Guéthary, near Biarritz. After Josef Albers died, when I was going through the contents of a storage room that the artist himself had been the only person to enter for more than twenty years, I found photos Albers had taken on that holiday. The

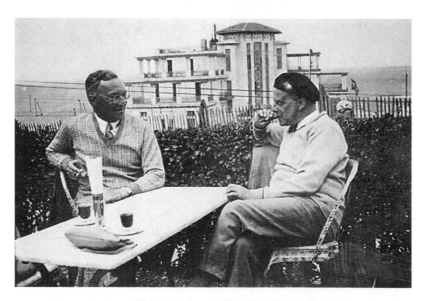

Wassily Kandinsky and Paul Klee on vacation in Guéthary, 1929. The Bauhaus artists loved to travel, especially to exotic places. This seaside resort in the Basque Country, along with various Mediterranean resorts, inspired them artistically.

Paul and Lily Klee in Guéthary, near Biarritz, 1929; photo collage by Josef Albers. For decades, no one knew about Albers's visual portrait of stylish Bauhauslers relishing the delights of charming seaside resorts during their summer holiday.

Kandinskys were also at the beautiful beach resort on the southwestern coast of France, just north of the Spanish border, and they all clearly had a blast.

Albers's photos of Klee in a white sweater with an unusual weave of cotton and linen and a contrasting V-neck collar, coupled with a beret worn at a jaunty angle, show him in a summer holiday mood. In one image Lily is also dressed in resort finery, and Klee holds a parasol. In that elegant town on the Atlantic, Klee, in the summer preceding his fiftieth birthday, has a mischievous smile that makes it easy to picture him as the playboy he had been thirty years earlier. This was not the Klee most people knew.

THAT SEPTEMBER, WASSILY KANDINSKY received a Golden State Medal in Cologne. It acknowledged the Russian's accomplishments overall. Klee was ecstatic, voicing greater excitement than was usual for him, because Nina Kandinsky, who had suffered many reversals in life and who lacked her husband's creative resources, was heartened by her husband's award. But Klee was generally troubled. On September 11, 1929, he wrote Felix, who had recently joined the Municipal Theater in Breslau, "The Bauhaus will never calm down; otherwise it wouldn't be the Bauhaus."[237] Two days later, he wrote Lily, who was in Bern, "I am now trying to paint again, but unfortunately still can't avoid

noticing a certain hastiness about it, because my time is not my own. I am not particularly irritated by the Bauhaus, but they require things of me that are only very partially fruitful. That is and remains unpleasant. It is nobody's fault except my own, as I can't find the courage to leave. Thus precious years of production are partially wasted. There is nothing more uneconomical or more stupid."[238]

Yet Klee was less involved with Bauhaus affairs than most people. On one occasion, when it was announced at a large assembly that there would be a departmental meeting on a Friday afternoon and one of Klee's students protested because Klee's painting class was scheduled at the same time, everyone else burst out laughing. Unlike the worried student, they all knew that Klee never attended such events anyway.

KLEE'S IMPENDING FIFTIETH BIRTHDAY was such a vivid reminder of the passage of time, and the progress toward the end of life, that he could not take it lightly. The only way was with an escape to the immortal realm of Mozart and Bach, so he and Lily planned a concert at home to mark the occasion.

Other people, though, could not let the milestone go without fanfare. The Flechtheim Gallery in Berlin organized a major show of Klee's work in honor of the event. Closer to home, the students and some of the other Bauhaus faculty members also decided that Klee's being half a century old warranted special attention. This inspired the event whose recounting opens this book.

The flowers and other presents that were dropped from a plane onto the Klees' roof garden were a diversion but not an unequivocal success. Klee wrote Felix that after his gifts fell from above, the flat roof collapsed and everything plummeted into his studio. "It certainly was a fine surprise." A week later, he told his son, "The fact is, I would find it hard to sum up my highly contradictory feelings about this fiftieth birthday."[239]

ON AUGUST 23, 1930, Oskar Schlemmer wrote in his diary, "Paul Klee, yesterday still a little shrimp, is today already considered an 'island.' "[240]

In spite of the international economic depression, Klee was enjoying increased critical and commercial success. Hot on the heels of the shows that had honored his fiftieth birthday, there were major museum exhibitions in Dresden, in New York at the Museum of Modern Art, and in Berlin. Another large show was planned for Düsseldorf in 1931. Museums were acquiring works, and Flechtheim got the great Paris-based art dealer Kahnweiler more involved in marketing Klee's art in Europe. The New York dealer J. B. Neumann, as well as Galka Scheyer, were buying more work for the United States. *Cahiers d'Art* devoted a special edition to Klee. However, it was not false modesty when he told Will Grohmann his reaction to this

publication: "The sight of my name in such large letters seemed quite frightening."[241]

Klee was feeling unsettled in general, especially by changes at the Bauhaus. When in April 1930 he talked with Hannes Meyer about the problems of the school, he found the director both very nice and refreshingly frank, but Klee decided the time had come to raise the issue of who his own successor would be. He knew it would not be easy to identify a candidate.

Adding to Klee's difficulties, he was suffering from migraines that he described as "hellish." These were not new to him, but they were becoming more intense and frequent. This man who was often so content with the offerings of everyday life now wrote Lily that his days were awful.

Klee complained about the German climate and the Dessau weather in particular; he was dreaming of North Africa, or Sicily. But he was so overworked from too much teaching, and, above all, from too many meetings, inevitable in spite of his concerted efforts to avoid such duties, that he had to turn down appealing invitations for travel. He could not even make it to Bern for his father's birthday or to Breslau to be with Felix. He was perpetually in the process of finishing three or more major pictures at the same time, and could not bear to be away from the studio except for essential reasons.

Nonetheless, he remained an engaged parent. He took pains to advise Felix on a range of issues now that the future theater director was on his own. Klee was obsessed with Felix's budget and allowances. When getting a new suit, Felix was to be sure that it was in an authentic English material; Klee instructed him that nothing else was of value for a man's suit.

On April 3, Klee wrote Lily a detailed analysis of a performance of the Jupiter Symphony. He was very specific about the double basses and, again, the kettledrum, concluding, "Impossible to speak about the symphony itself. It is the highest peak of art and the finale is the riskiest enterprise possible: a movement 'fatidique' for the history of music afterwards."[242]

Klee was reevaluating a lot in life. Lily was now away on health cures even more than before, and in his solitude Klee developed a new awareness of his reputation for coldness. He wrote, "People say I have no heart. Felix spent his money more quickly than he was supposed to; otherwise, our conversation on the phone was very pleasant. We imitated the cries of animals, chickens, dogs, night cats; we couldn't stop ourselves." Given his initial opposition to the telephone, the report was a concession that she had been right after all; it also was his way of showing that he was not as rigid as he often seemed. The same day, Klee wrote Felix a letter that began, "Yes, I have a heart; that's why I am writing you now . . . ," and concluded, "I didn't want you to think that I didn't have a heart; that would be untrue. I am simply possessed by demons."[243]

In the spring of 1930, Klee decided he would resign from the Bauhaus on April 1, 1931. He dreamed more and more of being somewhere else to lead the ideal life. The location should be simple and pleasant, in an optimal climate. But Italy or Crete was too much to hope for. He knew he would have to find another teaching post, to be prepared for eventualities like illness. He also was resigned to the idea that he had to teach in a place where German was the primary language.

AS KLEE PREPARED to move on from the institution of which he had been a part for more than a decade, flowers, music, and, above all, work remained the staples of his life. But at times something new excited him as well. In May 1930, he felt a new world open because of a film showing organized by Hans Richter of a movie by Viking Eggeling. The Swedish Eggeling, who was born less than a year after Klee but who had died in 1925, at age forty-five, was an experimental filmmaker who had been close to Arp and Modigliani in Paris before moving to Zurich, where Richter introduced him to Tristan Tzara. The film Klee saw was the extraordinary *Diagonal Symphony,* which Eggeling had made in the year prior to his death. In it, white-on-black abstractions, built from parallel lines, resemble Bauhaus foundation course constructions and what Klee drew on the blackboard when he taught. These shapes soar with imagination and spirit. Klee believed that if Eggeling had not died when he did, cinema would have been more of an art. He thought it still might become one, but that at the moment he was disappointed that no one gave it sufficient attention.

That same month, Klee made an exception to his usual refusal to interrupt his studio routine for nonessential reasons: he decided to go to Stuttgart for meetings in a museum. In the years since Stuttgart's Academy had turned him down, all the new Weissenhof housing structures had been built. But the inventive architecture by Le Corbusier, Mies, Gropius, and others did not interest Klee as much as the trees. Mainly chestnuts, they were, while enormous, sadly ordinary. Similarly, the vegetation in the parks was "luxuriant but cruelly lacking in soul." There was something artificial about this landscape in Klee's eyes; while everything had been cultivated to make an impression of majesty, the result "evoke[d] more of a pretentious research than a natural phenomenon."[244] Klee began to obsess over what was missing in Stuttgart's famous central park, and wrote to Lily about nothing else.

ALTHOUGH KLEE'S PAINTINGS were beginning to sell at higher prices—he received 1,150 reichsmarks for two watercolors, and 5,000 from sales in New York—his view was that he and Lily had to be careful not to get too comfortable. "It's the best way to avoid simultaneously avarice and wastefulness," he instructed his wife.[245]

He handled his business dealings thoughtfully. Typically, Klee wrote Galka Scheyer, "Between his Majesty and Your Excellence there was still an unresolved matter. His Majesty needs honor more than money (but money too)." He gave Scheyer a 25 percent reduction on his usual prices whether she kept the work for her own collection or resold it. When she asked for an even greater discount, he said that his need for income made it impossible, but that "what Your Majesty can do is offer a present."[246] Continuing with the vocabulary of royal negotiations, he called this letter a "Charter" and used it to deed her the splendid painting *Plant Seeds* as a gift of thanks for all she had done.

Some collectors were so avid for Klee's work that they sought him out. Edward M. M. Warburg, a twenty-three-year-old American heir to banking and railroad fortunes who had been one of three students to organize exhibitions of recent art in the pioneering Harvard Society for Contemporary Art and now taught modern art at Bryn Mawr College—he made an anonymous contribution to pay his own salary—secured a letter of introduction to Klee from Curt Valentin, who worked at Flechtheim's. Warburg arrived eagerly at Klee's front door on Burgkuhnauer Allee, but stopped at the sound of the artist playing Bach on the violin. The young collector sat on the doorstep and waited until the sonata was over.

Once inside, Warburg was overwhelmed. First there was the sight of the intense dark-eyed artist in the sort of white coat worn by surgeons. Although Warburg had arrived unannounced, his letter of introduction and sympathetic manner as well as his fluent German gained him a warm reception and an invitation to take a close look at all the paintings on the walls and easels. Warburg already knew the work of Calder and Miró and other modernists he had shown at Harvard, but this art was as fresh and spontaneous and free as anything he had ever seen. And the atmosphere in which it was made struck him as magical.

The recent university graduate began to go through some works on paper. When he attempted to prevent Klee's pet cat—Fritz's successor—from walking across a watercolor he was holding, the artist urged him to let the cat do as he wanted. But the watercolor was still wet. Warburg panicked, telling Klee he was terrified that the cat would leave a paw print. Klee simply laughed. He said that the paw print would later on be a great insoluble mystery. "Many years from now, one of you art connoisseurs will wonder how in the world I ever got that effect."[247]

Warburg was captivated by an oil Klee had completed the previous year. Called *Departure of the Ships,* it celebrated the ability of canvas sails to harness the flow of air in order to ferry people across the miraculous substance of water. Warburg's conception of ships had previously been linked to his father's enormous yacht and the ocean liners on which he sailed first class;

Klee's painting was a vision of all seaworthy vessels large or small, grand or functional, in the most general sense. The rich young man saw the canvas as an homage to the act of sailing, the inventiveness of the mechanisms, and the concord with natural forces, with no reference to what Warburg considered the mundanity of upper-class life. For Klee, there was no separation between the ships one might encounter on the sea and in one's dreams, just as there was little difference between the growth of trees and the making of artworks.

Klee's painting reveals motion itself. It illustrates wind. Its sails could be any type, anywhere, in the moonlight. Just as *Departure of the Ships* presents its subject as universal rather than specific, so does Klee's *Romantic Park,* an oil and watercolor that also captivated Warburg. This dreamlike compendium of jagged staircases, upside-down heads, and half-real, half-ornamental forms had also been painted the year before. In its complexity and the reading it invited, it reminded the young collector of paintings by Hieronymus Bosch. Klee's imaginative, poetic way of seeing things was irresistible. Warburg acquired the pair for about $800 each.

For a recent college graduate, it was a daring act. People in his financial position might easily buy sports cars, or even paintings by the old masters, but canvases by Paul Klee were a gamble. The artist was delighted by his young client, but when Edward Warburg brought the paintings back to New York and showed them to his parents, he was informed that the only place they belonged in their neo-Renaissance mansion on upper Fifth Avenue was on the squash court. That is precisely where he hung them, converting the plain white space into an art gallery.

24

In August 1930, Lily was at another sanatorium, this time in Sonnmatt, near Lucerne. On his own, Klee went to Viareggio, a beach resort, where he was ecstatic. When he returned to the Bauhaus in September, however, the school's problems were more troublesome than ever. Mies van der Rohe had replaced Hannes Meyer as director; Klee wondered how Mies would do, if he could avoid burning his wings in the tempestuous atmosphere of the school at a time when there were intense negotiations going on with the mayor.

With the directorship having changed hands, Klee wrote Lily that he was glad to be back at the school to give advice if Mies wanted it, even though she told him she thought he had returned for nothing. This time, rather

than bemoan his obligations, Klee told his wife he did not consider it an inconvenience to help out, and that he believed he could still find time to paint.

In that same period, Klee wrote Felix that while the Jews were becoming more worried about the rise of antisemitism, no one should come to hasty conclusions. He assured his son that there were professional politicians who had too much sense to let persecution occur, and that if anything dire happened in Germany, France and England would intervene.

But he was not always blind to injustice when he knew the victims personally. The Bauhaus had expelled a number of students that fall because Mies did not approve of their political attitudes; Klee was appalled. When these students asked to show him their work outside of the school, he said he would review it with them privately, even while he remained a Bauhaus master. However naïve Klee was in clinging to his belief that Jews were safe from persecution, when he recognized unfairness, he took action.

FOR THE SAKE of his own stability, and because he did not believe that Mies could contend with the political pressures in Dessau, Klee resigned from the Bauhaus as planned in April 1931.

By then, he had been offered a part-time professorship at the Academy of Fine Arts in Düsseldorf. The new position allowed him to teach and get paid for it, with few of the demands and pressures he felt at the Bauhaus. Now that he had a sure market for his work, he calculated that if he had more time to paint, he might no longer need a teaching salary, but he had discovered at the Bauhaus how vital it was to have an exchange of ideas with students. He wanted to maintain that connection even if he no longer needed to teach for financial reasons.

The other surprise was that, although they had not wanted to move to Dessau originally, the Klees now preferred their house there to any other possible residence. Even after the Bauhaus moved to Berlin in 1932, they stayed on at Burgkuhnauer Allee. Klee could not find as good a living situation in Düsseldorf, and was willing to take the long train trip there and back so that he and Lily could continue to make their home in the house Gropius built for them.

In 1932, Felix, still at the Breslau Municipal Theater, met the Bulgarian singer Efrossina Gréschowa—called Phroska professionally—and married her. Lily was ecstatic, and Paul very pleased. For a brief time, all was going well. Klee recommended Jean Arp to succeed him at the Bauhaus, and although nothing came of it, the idea made a lot of people happy. Wassily Kandinsky's paintings, meanwhile, began to resemble Klee's to such a degree that Schlemmer thought Klee had painted them. Whether or not Klee was aware of the extent of the imitation on the part of a senior col-

league he greatly admired, it was an indication of how much his own art was now revered.

25

In January and February 1933, Lily Klee was with Galka Scheyer in a sanatorium in the town of Braunlage, in the Harz Mountains. On March 17, shortly after she returned to Dessau, she and Klee were at home when Nazi Party storm troopers arrived. The police supervised the storm troopers as they rifled through Klee's art and papers and the family's possessions, searching everything, although what they hoped to find was unclear.

On April 1, the Klees moved to Düsseldorf. Three weeks later, Klee was suspended from the Düsseldorf Art Academy as part of a general putsch against modernism that also took the form of Gestapo investigations at the Berlin Bauhaus. The Nazis believed that most new art and architecture was counter to the interests of the German state. Klee spent two weeks packing up his studio, and the Klees moved back to Bern.

In Bern, the Klees first lived in two furnished rooms. Then, in June 1934, they found an apartment on the second floor of a three-family house in the suburbs. It was small and simple, but sufficient, with a music room, a room that could serve as a studio for Klee, a bedroom, a kitchen in an alcove—not nearly as nice as what they had had at the Bauhaus, but adequate for Klee to prepare his favorite recipes—and a bathroom. He and Lily were content that they had hot water and central heating.

This apartment had a view of the Alps. Lily Klee wrote Galka Scheyer that they were "like 2 happy children. . . . Somehow living with limitations makes one feel more fortunate."[248] However, having become a German citizen when he moved to Munich as a young man, Klee was unable to gain Swiss citizenship.

TO HIS PARENTS' DISMAY, Felix Klee remained in Germany. He and Phroska were beginning to enjoy successful careers onstage, and Felix did not want to give them up, even if in order to succeed in the German theater he had to denounce his father.

The Third Reich considered Klee's work a travesty. "The Nazis sequestered 102 Klees in German museums" in 1937, and included 17 Klees in the famous "Degenerate Art" exhibition held in Munich.[249] In the catalogue, the exhibition organizers compared Klee's paintings "to work produced by schizophrenic inpatients" and declared it to be evidence of "confusion of a

psychological instable character."[250] Felix still did not leave Germany or protest the official verdict.

IN 1934, KLEE HAD CONTRACTED MEASLES. As a result, he developed scleroderma, a disease of the mucous membrane, which slowly began to kill him. It did not, however, prevent him from producing an extraordinary body of late work, with the themes of war and death now replacing birth and the splendors of nature as the dominant subject matter.

On hearing the news that Klee had died in July 1940, less than a year after his sixtieth birthday, his old Bauhaus colleague Oskar Schlemmer wrote in his diary, "What a visual and spiritual combination he made to the world of the artist. And what wisdom!"[251] Schlemmer then pondered the question of what this would mean for the fate of abstract art in general—especially given how inhospitable much of Europe was becoming to modernism. Schlemmer wondered if, with Klee gone, the movement would have leaders and find refuge.

FOUR MONTHS AFTER KLEE'S DEATH, the American magazine *Time*, which represented mainstream thought in the United States, published an article, "Fish of the Heart," in which the artist's work was characterized as "little child-like scrawls" and "artistic babbling and cooing." The unsigned critique opined: "In this world of screwball art the most consistently screwy was Paul Klee's. An absolute individualist, whose work resembled nobody else's, Klee painted 'animals of the soul, birds of the intellect, fish of the heart, plants of the dream.' "[252]

The article informed its readers that "Walter Gropius invited Klee to teach drawing at his famous Bauhaus technical art school in Weimar." Collectors began acquiring "his infantile drawings" and "U.S. modern art connoisseurs bought his ectoplasmic scratchings at $750 a canvas."[253] This was a direct reference to the canvases Edward Warburg had bought, although it erroneously reduced their prices by $50 apiece.

The article in *Time* was in effect a report on the paintings in two shows in private New York galleries—Willard and Buchholz—that had been organized following Klee's death. The magazine described the work and its maker. "All had a look of quiet, pastel-shaded insanity. The show was posthumous: short, sharp-faced Artist Klee had died at his Swiss home four months before. It was also posthumous in another sense. To the red-cheeked, goose-stepping Nazis who after 1933 scrubbed individualism from Germany's art galleries, Paul Klee has been the most degenerate of degenerate artists. Some day history will have to decide whether Hitler was right—about Artist Klee."[254]

Wassily Kandinsky

1

Shortly after the Bauhaus moved to Dessau, Wassily Kandinsky wrote a letter to Lily Klee. This was in the period when Lily preferred to remain in the pleasant apartment in Weimar rather than move to temporary digs near the school's new location.

Lily had given Kandinsky some polenta. Addressing her with a Russianized version of her name, he wrote,

Dear Elisaveta Ludwigovna,

For years I have wanted to eat polenta—so you will easily understand what pleasure you have given me. My heartfelt thanks. For me polenta is a synaesthetic delight, for in some strange way, it stimulates three senses perfectly harmoniously: first the eye perceives that wonderful yellow, then the nose savors an aroma that definitely includes the yellow within itself, at last the palate relishes a flavor which unites the color and the aroma. Then there are further "associations"—for the fingers (mental fingers) polenta has a deep softness (there are also things which have a shallow softness!) and finally for the ear—the middle range of the flute. A gentle sound, subdued but energetic . . .

And the polenta which you served me had pink tones in its yellow color . . . definitely flute!

Kind regards to you, dear Pavel Ivanovitch, and dear Felix Pavlovitch, with best wishes for you all,

Yours,
Kandinsky[1]

Kandinsky's paintings of the period have elements of the marvelous Italian cornmeal. The word "synaesthetic" was key; the Russian invented it to describe the commingling of the various senses that was one of his artistic goals. The soft explosions of polenta cooking, the repetitive popping noise, conjured a realm that increasingly obsessed him: the sonic effects of visual experience. Beyond that, the abstract forms that appear to be in continuous motion—growing, bursting, and condensing—are like polenta when it is being cooked, with the delicate grains absorbing water and air and transmogrifying. Inevitably, too, Kandinsky's oils and watercolors have a sphere of the same vibrant yellow that the painter admired in the cornmeal, which evokes a spiritual force.

The smells and tastes of food were less directly connected to Kandinsky's art, but his alertness to their subtle unfolding in the

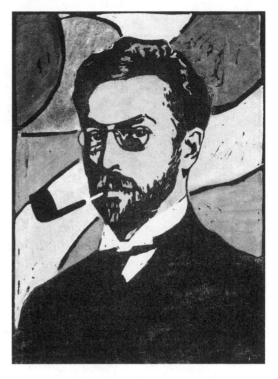

*Gabriele Münter, Wassily Kandinsky, 1906.
The year before Münter painted this, Kandinsky had
started to live with her in Munich, where he had gone
from Russia after practicing law in Moscow. He went
to Germany to devote himself to art full-time.*

polenta reflects his priorities. Sharp observation of everyday experience was fundamental. A keen appreciation for the processes perpetually occurring in the kitchen, the human body, and the wooded parks where he and Klee and Albers took their daily walks, governed his life. What was essential was to stop and look. In his pervading appreciation of existence and his overwhelming desire both to celebrate and to add to the world's store of beauty, he was possessed by a determination to make the most of every source of wonder; he would rest only in order to gain strength for action.

THOSE SAME DESIRES ruled the lives of several of his colleagues, but Kandinsky was distinguished among them in bringing to the mix "the Russian soul." He had the particular intensity that fired Pushkin and Tolstoy, that permeates the chants of the steppes and the icons of the Russian Orthodox Church, and that has characterized an entire people through all the transfor-

mations of their nation. Will Grohmann, who observed Kandinsky first-hand at the Bauhaus, writes, "His uncompromising attitude to life and art, his faith in the unconquerability of the human spirit, came with him from Russia."[2] Although Kandinsky spent most of his life in Germany and Paris, he not only retained his fervent belief in Orthodox Christianity, remained immersed in Slavic literature and music, and continued to speak his native language with his wife; he also guarded his secrets, and relished a sense of inexplicable mysteries.

Of the Russian types, he was a nobleman out of Turgenev. He looked every bit the aristocrat, and struck people "as more like a diplomat or a widely traveled scholar than as an artist."[3] While Johannes Itten wore his outlandish costumes and the Bauhaus students flaunted their bohemianism, Kandinsky dressed with meticulous elegance. This was true not just in society but also when he painted. Unleashing his furies as he brazenly applied vivid pigments to canvas, he wore, at his most casual, a bow tie and jacket. "I could paint in a dinner jacket," he once quipped.[4] But Kandinsky was marked by correctness and reserve rather than dandyism. In his appearance and demeanor, he had no wish to attract attention; he "spoke quietly and attentively, and was never wounding. He behaved impeccably even in painful situations."[5] He had genuine style; he was not a showman.

His propriety teetered at the edge of aloofness. For his students and colleagues, there was always the sense that Kandinsky, however amiable and cheerful he might appear, had some very private issues he was deliberately keeping from view. He was older than everyone else by at least a decade, but it wasn't just age that kept him apart. What was that veneer meant to guard? Grohmann thinks it was masking an overriding instability. "The more Kandinsky became aware of his psychic constitution, the more he developed a capacity to control himself . . . to save face." Kandinsky was so eager to conceal the vagaries of his mind that he preferred "chance acquaintances to half friendships."[6] The person at the Bauhaus to whom he was closest was Klee; this suited him in part because Klee, too, eschewed intimacy. It was like befriending a flock of birds or an image of St. Christopher—highly rewarding, but without threat to the privacy Kandinsky guarded so carefully.

KANDINSKY'S FACE rarely came into focus behind the cloud of smoke from the cigarettes he puffed all day long. The screening served him well. By the time he was at the Bauhaus, he had effectively excised from his story the woman who had been his truest partner, the brilliant painter Gabriele Münter; all that one could glean about Münter from the elusive Kandinsky was that, in her bitterness over his having left her and, shortly thereafter, taken up with

the young playgirl who was now his wife, she had refused to return a lot of the art he had left in her care a decade earlier.

But even if Kandinsky would not discuss the details of his past, students and teachers of every level and a range of styles admired him immensely. He was the voice of reason in Bauhaus disputes, where his ability to keep his personal reactions hidden set him apart, and he was respected for his balanced perspective on complex issues. While establishing careful perimeters around his private self, he was open to infinite approaches in most matters. Anni Albers recalled, with a broad smile, "Kandinsky often said, 'There is always an and.' " Grohmann refers to Kandinsky's wish "to express mystery in terms of mystery."[7] There were layers beyond and beneath the layers; that complexity inspired extraordinary thinking and completely original art.

2

Wassily Kandinsky was born in Moscow, on December 4, 1866—in the same decade that Tolstoy's *War and Peace* and Dostoevsky's *Crime and Punishment* were published, and Mussorgsky's *Boris Godunov* was first performed. His earliest memories consisted of shapes and colors of the sort that would eventually become the substance of his art. When he was three years old, the family's coachman would strip spirals of bark from thin branches, "cutting away both layers of bark from the first spiral, and from the second only the top layer." Little Wassily saw the forms as abstracted horses, with the outer bark a "brownish yellow . . . which I disliked, and would gladly have seen replaced," and the second layer a "juicy green . . . which I loved most particularly and which, even in a withered state, still had something magical about it." The wood of the now-naked branch was "ivory-white . . . which smelled damp, tempting one to lick it, but soon withered miserably and dried, so that my pleasure in this white was spoiled from the outset."[8] Colors would induce intense emotions in him for the rest of his life.

Bright hues made him rapturous; black induced fear. At age three, he also went to Italy with his parents and his Russian governess, and retained an impression of a frightening black carriage in which he and his mother crossed a bridge over "dirty yellow" water in Florence when he was on his way to kindergarten. Even more terrifying were "steps leading down into black water, on which floats a frightening, long, black boat with a black box in the middle. . . . I . . . bawled my head off."[9]

When Wassily was five, his family moved to Odessa, where he spent the

rest of his childhood. He had not been there long when he painted a water-color of a horse. His aunt—his mother's older sister, Elizaveta Ivanovna Tikheeva, who lived in the house and helped him with his art—had asked him to hold off doing the hooves until she was there to advise him. Initially, the boy was content to comply. Then, suddenly, he couldn't wait a moment longer.

He loaded his brush with black paint and globbed it onto the bottoms of the horse's legs. "I thought, if I make the hooves really black, they are bound to be completely true to life. I put as much black on my brush as it would hold. An instant—and I was looking at four black, disgusting, ugly spots, quite foreign to the paper, on the feet of the horse. I was in despair and felt cruelly punished." The repulsion fascinated him. "Later, the prospect of putting black on the canvas would still put the fear of God into me," he said.[10] That fear carried an excitement. In the night scenes and landscapes he would start making when he was in his twenties, and in the abstractions he crafted at the Bauhaus, he would often slather black on— perhaps deliberately to conjure what was disturbing, or else because he rel-ished a certain victory in having overcome his fear of it. In the house in Dessau where the Klees occupied the other half, he and his young Russian wife painted a wall of their dining room pure, unadulterated black.

IN A PORTRAIT PAINTED in Rome, Kandinsky's mother, Lidia Ivanovna Tikheeva, has a majestic stare. Her face is perfectly proportioned, with aquiline nose and rosebud lips framed by a complex chignon, and her gown and jewelry are splendid. "Characterized by inexhaustible energy and marked nervous-ness," Lidia was a force to reckon with.[11] Wassily, however, did not have to deal with her most of the time, because when he was a small boy she divorced his father, who was left to bring him up. In a memoir he wrote in 1913, Wassily Vasilevic Kandinsky portrays his father as "a deeply human and loving soul."[12] Wassily Silvestrovich Kandinsky, a tea merchant, fos-tered his son's interest in making art. He hired a private drawing tutor for young Wassily and let him, at age ten, choose between a school that empha-sized the humanities and one that focused on science. When Wassily picked the former, his father was delighted.

Wassily's maternal grandmother, a Balt who spoke German, and Eliza-veta Ivanovna indulged him in Lidia Ivanovna's absence. The boy had a pen-chant for a horseracing game and loved being read fairy tales—mostly in German, his first language. It was a magical childhood, except when he suf-fered from "inward trembling" and terrifying dreams. To escape, and go "beyond space and time"—his words—he latched on to drawing as the sole solution.[13] Like the young Paul Klee, he made pictures as instinctively as he breathed and ate.

At age thirteen, Wassily bought a paint box with money he had saved up from his allowance. He later described the sensation of the pigments being extruded from their tubes: "One squeeze of the fingers, and out came these strange beings . . . which one calls colors—exultant, solemn, brooding, dreamy, self-absorbed, deeply serious, with roguish exuberance, with a sigh of release, with a deep sound of mourning, with defiant power and resistance, with submissive suppleness and devotion, with obstinate self-control, with sensitive, precarious balance."[14] He "longed to be a painter" and "loved art above all else." Yet when Kandinsky left Odessa at age nineteen for the University of Moscow, he decided that "art was an unallowable extravagance for a Russian."[15] He studied economics and law, even though he painted in his free time. The "intricate, conscious, refined 'construction' " of Roman law "enchanted" him, but left him unsatisfied "as a Slav because of its far too cold, far too rational, inflexible logic."[16] He turned to the old peasant code in Russian law, which was unusual for its flexibility and the way it treated the same crimes differently according to a measurement of the good or evil at their root. This less rigid approach fascinated him, and when Kandinsky was twenty-three, it inspired him to go on a trip to Vologda, a northern province full of monasteries and medieval towns, so he could write a report on peasant laws and paganism in the Syryenian tribes.

The journey was funded by the Society for Natural Science, Ethnography, and Anthropology. Kandinsky traveled from village to village studying folk art and sketching peasant architecture and people dressed in traditional costumes. Visiting the colorfully carved houses with profusely ornamented furniture and icons, and traveling through the woods, marshes, and sandy desert, he felt as if he were "living inside of pictures."[17]

Kandinsky's report was published, and he had the rare distinction of being elected a member of the society. In 1892, now twenty-six, he passed his law exam and married a cousin, Anja Shemyakina, one of the few female students at the University of Moscow. The following year, a paper he wrote on the laws concerning workers' wages won him an appointment as instructor at the university.

What Wassily Vasilevic Kandinsky desperately desired, however, was to paint "the most beautiful hour of the Moscow day. . . . To paint this hour, I thought, must be for an artist the most impossible, the greatest joy." He was fixed on the moment when the sun is "getting low and has attained its full intensity which it has been seeking all day, for which it has striven all day." That craving to make paintings of comparable force would eventually provide the basis of his teaching at the Bauhaus. "The sunlight grows red with effort, redder and redder, cold at first, and then increasing in warmth. The sun dissolves the whole of Moscow into a single spot, which, like a wild tuba, sets all one's soul vibrating."[18]

In Kandinsky's mind, there was not just "always an and"; there was often a however.

No, this red fusion is not the most beautiful hour! It is only the final chord of the symphony, which brings every color vividly to life, which allows and forces the whole of Moscow to resound like the *fff* of a giant orchestra. Pink, lilac, yellow, white, blue, pistachio green, flame red houses, churches, each an independent song—the garish green of the grass, the deeper tremolo of the trees, the singing snow with its thousand voices, or the allegretto of the bare branches, the red, still, silent ring of the Kremlin walls, and above, towering over everything, like a shout of triumph, like a self-oblivious hallelujah, the long, white, graceful, serious line of the bell Tower of Ivan the Great.[19]

In the limited time Kandinsky could devote to painting given his obligations as a law professor, he did his best to evoke those sights. But it would be a while before Kandinsky's art could begin to live up to what he saw in his mind. "These impressions . . . were a delight that shook me to the depths of my soul, that raised me to ecstasy. And at the same time, they were a torment, since I was conscious of the weakness of art in general, and of my own abilities in particular, in the face of nature."[20] It would require him to have a totally different approach if his art was to match the forces inherent in the universe.

Two decades later, Kandinsky would develop a form of painting that completely eliminated the idea of representing known sights. Abstraction "put an end to the useless torment of the useless tasks that I then, despite their unattainability, inwardly set myself. It cancelled out this torment, and thus my joy in nature and art rose to unclouded heights. . . . To my enjoyment is added a profound sense of gratitude."[21] As the senior figure in Weimar and Dessau, he would invoke that redolent sense of gratitude and the specter of those "unclouded heights."

Such intense feelings had a hefty price. In his reminiscences about his craving to express his feelings through art, Kandinsky alludes to the inner turmoil that Will Grohmann considered the clue to his comportment at the Bauhaus. "My soul was kept in a state of constant vibration by other, purely human disturbances, to the extent that I never had an hour's peace," Kandinsky acknowledged. The slightest visual event triggered either overwhelming joy or intense anguish in him: "Everything 'dead' trembled. Everything showed me its face, its innermost being, its secret soul, inclined more often to silence than to speech—not only the stars, moon, woods, flowers of which poets sing, but even a cigar butt lying in the ashtray, a patient white trouser-button looking up at you from a puddle on the street,

a submissive piece of bark carried through the long grass in the ant's strong jaws to some uncertain and vital end, the page of a calendar, torn forcibly by one's consciously outstretched hand from the warm companionship of the block of remaining pages."[22]

IN THAT PERIOD in Moscow, even if Kandinsky did not feel entitled to devote his life to art and release that extraordinary responsiveness, to enjoy rather than repress his fiery nature, he was developing the sensibility that would determine his life's course and become the substance of his Bauhaus teaching. "Every still and every moving part (= line) became for me just as alive and revealed to me its soul. This was enough for me to 'comprehend,' with my entire being and all my sense, the possibility and existence of that art which today is called 'abstract,' as opposed to 'objective.' "[23]

In the Hermitage in St. Petersburg, the young lawyer came to believe that "the great divisions of light and dark" in Rembrandt's paintings resonated like "a mighty chord."[24] They evoked for him the trumpets in Richard Wagner's *Lohengrin,* a performance of which he attended at the Court Theatre. Listening to Wagner, Kandinsky envisioned the Moscow twilight as he wanted to paint it: "The violins, the deep tones of the basses, and especially the wind instruments . . . embodied for me all the power of that pre-nocturnal hour. I saw all my colors in my mind, they stood before my eyes. Wild, almost crazy lines were sketched in front of me."[25]

He still was not ready to let those forces determine his life's course, but he recognized that his internal storm needed an outlet. "Even as a child, I had been tortured by joyous hours of inward tension that promised embodiment. Such hours filled me with inward tremors, indistinct longings that demanded something incomprehensible of me, stifling my heart by day and filling my soil with turmoil by night."[26]

Then Kandinsky experienced a powerful moment of relief from his suffering. He was in front of a Monet in a show of French impressionist painting in Moscow. Standing close to the canvas, he could not recognize its subject as a haystack, although the catalogue listed it as such. Initially, he "found this nonrecognition painful." But then "I noticed with surprise and confusion that the picture . . . gripped me." He succumbed to "the unexpected power of the palette, previously concealed from me, which exceeded all my dreams. Painting took on a fairy-tale power and splendor."[27]

The law professor abruptly decided to start anew and to head to Munich to throw himself full-time into painting. "At the age of thirty, the thought overcame me: now or never. My gradual inner development, of which until now I had been unconscious, had progressed so far that I could sense my artistic powers with complete clarity, while inwardly I was sufficiently mature to realize with equal clarity that I had every right to be a painter."[28]

3

Anja accompanied her husband to Munich in 1896, but she disliked the artistic life. She left Kandinsky in 1903, although they did not divorce until 1911 and always remained on perfectly civil terms. Kandinsky, meanwhile, began his new life. He studied art in a traditional academy, with the same Franz von Stuck who had taught Klee and would teach Josef Albers, and about whose teaching of figure drawing the three would commiserate at the Bauhaus. Kandinsky also studied art at the Munich Academy, but often cut class and worked at home or outdoors, painting with such intense colors that, over a quarter of a century later, when the Bauhaus moved to Dessau and he needed to describe his credentials to the Municipal Council, he told the officials that he had been in deep trouble at the Munich Academy for being so "intoxicated by nature" that he tried to express "everything through color," and that he failed a drawing test there.[29] He believed that this conflict with the establishment in Munich a quarter century earlier was one of his main qualifications for teaching at the Bauhaus.

Between those confrontations with the hidebound art establishment and his joining the Weimar Bauhaus in 1922, Kandinsky altered the course of world art. In 1901, he founded "the Phalanx," an organization to advance new artistic methods that was named after a word invented by Homer for the battle line in ancient Greece, where heavily armed soldiers, working in unison, vanquish their enemy with heavy swords and twelve-foot-long pikes. The Phalanx showed work by Monet as well as other impressionists, while Kandinsky pushed his own work into a new realm by using tempera to create vibrant colors.

Teaching a breakthrough approach to painting and drawing, the Russian led his students to Bavaria by bicycle and summoned them for critiques with a police whistle. In 1902, one of the students who cycled in agreeably when the whistle was blown was Gabriele Münter, a quiet and thoughtful twenty-five-year-old woman, of slight build and almost Japanese looks with her smooth dark hair and porcelain skin. The mutual attraction was immediate, and once Anja moved out, Kandinsky and Münter began to live together; they traveled to Venice in 1903, and, in the winter of 1904–5, to Tunis. Kandinsky returned to Odessa and Moscow on his own, but afterward he and Münter moved to Sèvres, near Paris, for a year, then for nearly another year to Berlin, before returning to Munich.

In this period, during which Kandinsky became one of the principal

painters in the the Blue Rider movement, his work went from animated woodcuts based on Russian folk art and fairy tales to landscape paintings in unprecedented combinations of saturated colors. Münter worked similarly: there are paintings from 1908 and 1909 where it is difficult to tell who painted which one. She had extraordinary natural gifts, and was one of those rare people who could spontaneously make dazzling art, almost primitive in its untutored freshness yet revealing complete competence, that evoked natural sights with unequivocal joy. Kandinsky learned an immense amount from her approach — more than he would ever acknowledge. At the Bauhaus, he would be with a woman who had no such artistic skill, who worshipped him giddily; it would be as if there was something intolerably threatening about having once been with a fellow artist who had direct access to her own brilliant instincts.

MÜNTER AND KANDINSKY'S APARTMENT on Munich's Ainmillerstrasse was two houses away from where the recently married Paul and Lily Klee were living. The moment that Klee and Kandinsky met, they enjoyed a remarkable rapport. Each was delighted to meet another person who cared so deeply about making art, and who was so bent on exploring new means to imbue that art with vitality. The rare sense of comfort and pleasure Kandinsky experienced with Klee, in spite of Klee's apparent remoteness, would over a decade later be a lure to the Bauhaus.

There were halcyon evenings when Kandinsky and Münter would go over to the Klees' to hear Paul and Lily perform violin and piano duets. Kandinsky adored little Felix, who, starting at the age of two, in 1909, would spend time in the Russian's studio when his parents were busy. Felix Klee would never forget Kandinsky's and Münter's apartment, which was larger and more elegant than his parents' and distinguished by its white doors.

Once they were based in Munich, Kandinsky and Münter spent their summers in the Bavarian Alps, in the picturesque country town of Murnau, where Münter bought a house in 1909 (see color plate 7). There, Münter's natural skill as a painter became all the more evident. Her exuberant renditions of idyllic life in the countryside seemed effortless, spontaneously evoking the sweet local church, apple trees bursting with fruit, and farmhouses bathed in summer sunlight. Kandinsky was more of a struggler, perpetually intellectualizing and pushing himself to the next step, although he benefited immensely from his exposure to Münter's forthright style. Kandinsky and Münter were both affected by the *hinterglasmalerei*—small folk art pictures with the images painted on the reverse side of glass — that they collected together. With their simplified forms and vibrant colors, these anonymous works had a charm and an immediacy that both painters sought to retain in their more sophisticated work.

But the Russian could not stop his inner wheels from turning. By 1910, he was determined to explode the boundaries of painting. He started to improvise compositions that convey sheer energy. Their charged, dark lines of scant representational value, and their sequences of fantastic yellow, red, indigo, and mauve biomorphic forms, pulse in deliberate dissonance. With these paintings simply named *Composition* or *Improvisation,* Kandinsky unleashed a way of painting that was unlike anything that anyone else had ever done or even considered.

While Kandinsky's fellow Blue Rider artists—Auguste Macke, Franz Marc, and Klee—adhered to figurativism, they admired his independence as well as the consuming zeal with which he approached the task of painting. As Grohmann observed, "Kandinsky himself was a very unusual, original type, uncommonly stimulating to every artist who came in contact with him. There was something uniquely mystical, highly imaginative about him, linked with rare pathos and dogmatism."[30] It was impossible not to respond to him and his work.

4

In 1910, Kandinsky painted a watercolor that went one step further than his previous work by eliminating any reference whatsoever to known subject matter. This is possibly the first entirely abstract painting—as opposed to objects with abstract decoration—by anyone, ever. That same year, he wrote *On the Spiritual in Art.* This book, which declared painting "a spiritual act," embraced the supernatural and irrational as valid components of art.[31] In advocating what was sensory and intuitive and opposing materialism, *On the Spiritual in Art* liberated many readers; following its initial publication at Christmastime of 1911, it went through two more printings within a year.

Observing Kandinsky firsthand, Grohmann had the opinion that the artist's beliefs derived directly from his own mental state.

> According to all who knew him, his was a complex mind, given to violent contrasts, and his deep-rooted mistrust of rationalism drove him in the direction of the irrational, that which is not logically graspable. We know that he suffered from periodic states of depression, imagining that he was a victim of persecution, and that he had to run away. He felt that part of his being was closely tied to the invisible; life here and now and in the hereafter, the outer world and the inner soul, did not seem to him opposed.[32]

Although the stated goals of the Bauhaus stressed the practicality of objects and the utilization of modern technology for aesthetically worthy results, Kandinsky's presence there would cause many people to explore mystical realms and to accept the inevitability of neuroses as an aspect of creativity. Kandinsky declared his purpose to be the creation of "purely pictorial beings" with their own souls and religious spirit. He believed that such art would have major ramifications. At the same time that he bravely accepted the reality of the mind's tortures, Kandinsky had "an absolute faith in the onset of a new era, in which the spirit will move mountains" and in which painting would defeat materialism "by asserting the primacy of inner values, and by directly appealing to what is good in man."[33]

In *On the Spiritual in Art,* Kandinsky conceives of a "spiritual triangle" divided into three tiers, with atheists in the lower segment, and, in the layers above, "positivists, naturalists, men of science, and art students." This middle category does not have an easy time; "they are dominated by fear," for they grapple with "the inexplicable" while remaining unable to accept it, and thus suffer great "confusion." He writes of the plight of these people as if he were narrating the plight of the damned at the Last Judgment: "The abandoned churchyard quakes, the forgotten grave yawns open. . . . All the artificially contrived suns have exploded into so many specks of dust."[34]

Denizens of this middle tier suffer from their illusion that it is possible to create or live in an "impregnable fortress." The occupants of the highest realms of Kandinsky's triangle recognize the fallacy of that assumption. Among this select group of "seers" and "prophets," creative geniuses who have entered the realm of "light" and "the spiritual," Kandinsky names Robert Schumann, Richard Wagner, Claude Debussy, Arnold Schoenberg, Paul Cézanne, Henri Matisse, and Pablo Picasso, explaining how each eschewed superficial beauty in preference for a true representation of "inner life" as well as "the divine."[35]

Kandinsky considered music the ultimate art form, which is why he included more composers than painters in his pantheon. But he attributes to color some of the same transformative effects he cherishes in music. To chart the process of the impact of color on the viewer, he draws an analogy to the workings of a piano: "Color is the keyboard. The eye is the hammer, while the soul is a piano of many strings."[36]

THESE IDEAS that Kandinsky developed in a phenomenal burst of energy in 1910–11 would underlie his teaching and his comportment more than a decade later in Weimar and Dessau. "My personal qualities consist in the ability to make the inner element sound forth more strongly by limiting the external. Conciseness is my favorite device. . . . Conciseness demands the imprecise." For Klee and Gropius, but also for the Bauhaus population

at large, he was an exemplar of the idea that the most mysterious people are often the most restrained in demeanor; in his case, the veneer and carefully controlled behavior were deliberate. "I have an explicit dislike for 'shoving things under people's noses,' " he wrote. Kandinsky abhorred those people who, "like street vendors, proclaim their excellence in loud tones to the entire marketplace."[37]

In his art, though, he had no inhibitions. There was nothing boastful or immodest about his work; it openly soared with a feeling of liberation. Between 1911 and 1914, Kandinsky made paintings of stupendous physical and emotional charge. These extraordinary artworks are paeans to energy, to the power of line and color to evoke spiritual and physical force.

EVERYTHING CHANGED with the onset of world war. It wasn't until Kandinsky went to the Bauhaus eight years later that he regained the strength of his fertile prewar period.

On August 3, 1914, Kandinsky, who as a Russian could not remain in Germany, went to Switzerland. He felt no need to go as far as Russia, because he thought the war would not last. Münter had stayed behind; on his own, he went from one friend's house to another, waiting out the situation. In September he was in the village of Goldach, on the Bodensee.

In that tense time period, the Klees came to visit, both to offer Kandinsky some companionship in his solitude and to enjoy the beautiful mountain lake themselves. The friend's villa where they all were staying was in a small park, where Felix, now seven years old, liked to play.

After the Klee family had been there for a couple of days, Felix was running around in the park when he came upon a toolshed he had not seen before. He could hardly wait to explore it, and was about to open the door when he heard unexpected sounds coming from inside. Felix, whose imagination was not unlike his father's, pictured ghosts. He quickly bolted the door to keep them from escaping the shed and attacking him. Then he ran off in terror. But he did not tell anyone about his moment outside what he considered a haunted house.

Felix had his dinner earlier than the adults, then went to bed. Later in the evening, when everyone else was summoned to the dining room, Kandinsky failed to appear. The host and Paul and Lily Klee went to search for him, assuming he was outside painting or enjoying the evening air and was out of earshot. He was nowhere to be found.

Just as darkness was setting in, the search party spotted a white tissue waving from an upper window of the toolshed. Felix had locked Kandinsky into his improvised studio.

Years later, at the Bauhaus, the Klees and Kandinsky would roar with laughter at the memory of that event. Given all that had happened since, it

was nice to have such an lighthearted problem to think back on. It wasn't long after that summer in Switzerland that Kandinsky realized that the conflict sweeping through Europe wasn't going to end quickly, and that, as a Russian, not only was he unable to return to Germany, but he could not even remain in neutral Switzerland. In mid-November, he left Zurich to go via the Balkans to Odessa, where he arrived on December 12. He then traveled on to Moscow, arriving there on December 22.

Münter continued to stay in Munich. They got together in Stockholm, where they both had exhibitions at the start of 1916, but shortly after the opening of Münter's show there, Kandinsky returned to Moscow. They never saw each other again.

Gabriele Münter, who lived to be eighty-five, would, for the rest of her life, lament that they were no longer together. For her, it had been both a great love affair and an extraordinary period of artistic cross-pollination. They were co-workers as well as lovers, and if, to the people he knew at the Bauhaus, Kandinsky was always like a Russian general with a slight air of superiority, and an intellectual painter preoccupied by theory, to the fetching Asian-looking young woman who had bicycled to his class in Munich, he was a warm companion in their mutual effort to use animated forms and vigorous color to convey the magnificence of the act of seeing in art that was a celebration of love and sunlight and rural living.

5

Unlike Münter, Kandinsky quickly got over their split-up. Toward the end of 1916, he met Nina de Andreesky and hired her as his maid. Though now reduced to domestic service, she was the daughter of a Russian general—or so she told people. She was nineteen when she met Kandinsky, who was then forty-six. But she never let anyone know her exact age, and at the Bauhaus she wanted to be thought even younger. Anni Albers never got over Nina's refusal to give the information to a policeman who requested it after stopping her for riding a bicycle on the sidewalk in Dessau; facing the cop, Nina simply batted her long eyelashes and told him she was younger than he was.

Shortly before she met Kandinsky, a fortune-teller who was subsequently thrown out of Moscow because of the scary accuracy of her predictions had told Nina "that she would marry a famous man."[38] On February 11, 1917, she proved the seer right by wedding Kandinsky, at whose side she would remain for the rest of his life. Beautiful, coy, and frivolous, Nina would be

Photograph of Wassily Kandinsky with his son, Vsevolod, 1918. No one at the Bauhaus knew about the little boy who died of malnutrition before his third birthday.

an amusing but peripheral presence at the Bauhaus. It's hard to imagine what things would have been like if Gabriele Münter had been there in her stead.

IN SEPTEMBER 1917, Nina, who was two months pregnant on her wedding day, gave birth to a son, Vsevolod. A 1918 photograph shows the toddler seated in his father's lap. Kandinsky and his adorable son both appear uncomfortable; they are pasty-faced and languid. Wartime rations were scarce in Moscow, and no one had enough to eat.

Nina struggled to scrounge additional food for Vsevolod as he started to grow. The responsibility for the toddler's nourishment was primarily hers. In addition to now being Kandinsky's secretary, bookkeeper, and general assistant, she took charge of the household tasks and child care. She did her best to feed her son, but it was impossible to find adequate sustenance. Before his third birthday, Vsevolod was dead from gastroenteritis attributed to malnutrition.

The Kandinskys never referred to their tragic loss at the Bauhaus. They would periodically leave Weimar, and later Dessau, to go to Moscow, but they carefully guarded the secret that the main reason they made the trip was to visit their son's grave. Anni Albers said that in spite of the intimacy between Kandinsky and Josef, she only heard about Vsevolod years after the Bauhaus had closed. Even then, she was under the misconception that it had been a baby of six months who died.

The unknown fact would have shed some light on a great puzzle. Nearly everyone at the Bauhaus was struck by what an unlikely pair Kandinsky and Nina were. What the observers did not realize was that the couple's shared loss, kept between them, was a linchpin of their marriage.

THE PERIOD in Moscow was a low point in Kandinsky's artistic production. In 1915, he was so depressed about the war, as well as about his change of personal circumstances, that he made little art for almost a full year. Between 1916 and 1921, he gradually picked up speed, producing six to ten major paintings annually, but the time comprised of Vsevolod's short life and its aftermath was mostly a creative lull. Following the Russian Revolution, Kandinsky was appointed professor at the University of Moscow, and he founded the Institute for Art Culture, yet he still longed for a change that might re-energize him.

In 1921, shortly before New Year's, Wassily and Nina Kandinsky, determined to leave their tragedy behind, moved to Berlin. One reason was that the painter had, in 1914, stored approximately 150 paintings at the Sturm Gallery and now hoped to reclaim them. His dream of financial security was shattered when he discovered that the gallery owner had sold most of the work. Even if Kandinsky had managed to secure payment, the marks for which the paintings had been sold before the war now had practically no value. He was able to recover two unsold paintings, but nothing more.

Worse still, Gabriele Münter, who had been storing hundreds of Kandinsky's paintings as well as most of his personal effects in Munich and Murnau, refused to release them. His struggles to get his things back obsessed him and were a constant thorn in his side throughout his first years at the Bauhaus—although few people knew about it, any more than they knew about the dead child.

6

On December 27, 1921, Kandinsky, still in Berlin, wrote to Klee, who had by then been teaching at the Bauhaus for a full year and was happily ensconced in his house on Am Horn in Weimar. Kandinsky made roses a metaphor for his situation and his hopes. He was delighted to have a bunch of the flowers in his rented flat in Berlin—they made him more content than he would have been otherwise—but he imagined that the same flowers would be cheaper in Weimar. Kandinsky told Klee that he was astonished by the rise in the price of roses since he had last bought them in Germany—in 1914.

This was Kandinsky's way of asking Klee not just if life in Weimar would be more economical, but also if Weimar would be a good place to contemplate and explore the forms of beauty that were dear to him. Kandinsky

then became more direct. He allowed to Klee that he had no idea how long he would stay in Berlin—and that he wanted to get to know the Bauhaus. Above all, it would be wonderful to see the Klees again after the seven-year hiatus.

Kandinsky wondered if the apartment situation in Weimar was as bad as that in Berlin, and whether it would be difficult to find a room for him and Nina. He would willingly put up with a makeshift solution; he told Klee how happy he was that he at last had enough money to buy new shoes, but even that acquisition was a reach with money so tight and the cost of living so high. As long as he and Nina could live somewhere that had minimal comforts, the emotional relief would more than compensate for other hardships.

It all went far better than he anticipated. The first time that Wassily and Nina Kandinsky traveled from Berlin to Weimar to case out the Bauhaus, Gropius hosted a dinner in their honor. Kandinsky may have had no money, but the esteem for him in avant-garde galleries and museums had the potential to forge links Gropius greatly desired for the Bauhaus.

The welcome dinner was one of the rare occasions when Alma Gropius was at her husband's side. The coquettish Nina, attempting to be friendly to the formidable Alma, who she knew lived in Vienna, asked her when she would be back in Weimar. Alma's reply was a loaded "That depends on you"—after which she proposed that the Kandinskys visit her in Vienna.[39] Nina thought Alma was openly pursuing her husband. But Nina was also convinced that Wassily was blatantly rejecting the renowned seductress. Starting that evening, Nina developed a theory that Alma deliberately made Kandinsky's life difficult whenever she could—to punish him for his resistance.

SAVVY OBSERVERS believed that Gropius wanted Kandinsky on the Bauhaus faculty mainly to help him with the power struggle with Johannes Itten. The pithy Oskar Schlemmer felt that the Russian was appointed to teach so he could serve as Gropius's "chancellor"—a term Schlemmer used in private only.[40] It wasn't just the man Gropius wanted. He was also eager to establish connections with the prominent galleries in Berlin and Munich where Kandinsky was exhibiting, and with the organizers of the upcoming first International Exhibition in Düsseldorf, who had invited Kandinsky to have his work included.

It was, however, Paul Klee who—more than anyone else—paved the way for Kandinsky to come to the Bauhaus. The central issue was housing. The Kandinskys gave notice on their Berlin apartment that May, and needed Klee to help them find a place to live. They had raised their standards, and were hoping, ideally, to have two rooms in addition to a kitchen and bathroom, and to be near the park and the Bauhaus. When they moved

to Weimar in June, Wassily and Nina Kandinsky had to make do at first with a single furnished room at 7 Cranachstrasse, but in July they moved to a more spacious apartment at 3 Sudstrasse, and were able to begin living again with some of their beloved Russian furniture. Klee helped them find both these places.

Not only had Klee rescued a friend and a painter he admired, but he had brought another reasonable voice into the circle. With the constant disputes at the Bauhaus, he was delighted to have a colleague who maintained the long view—and who cared so passionately about the priority of making art.

UNLIKE KLEE, Kandinsky did not find it easy to settle into the task of painting so long as other matters distracted him. He completed only five oils during the year of his relocation. He did, however, paint a number of watercolors, and the body of work, though small, shows the painter revitalized. These intensely animated, exuberant compositions reveal nothing of the harsh realities of his recent life. The individual elements look scattershot and as random as particles in a kaleidoscope, yet, while at first they resemble nothing precise, the flurry of shapes is organized so that they also form clouds, eyes, insects, stars, and seawater—and convey the glorious force of those natural phenomena.

Kandinsky had not yet arrived at the Bauhaus when the first round of debates on the "professor" or "master" question occurred, but the controversy was still alive, and it was no small matter, especially given the obsession with titles at every level of German society. The issue was among the many concerns that prevented him from painting more. One of the first things the Russian did after moving to Weimar was to hand in a statement on the subject. What was a burning topic for others was for him primarily an example of misguided priorities. His approach was as refreshingly free of cant or hidebound tradition as the way he painted. "As far as I am concerned, I would like to see every chance used to demonstrate that the title problem is a completely useless problem. . . . That which is important is the inner characteristic of the nut, not the naming of the shell."[41] If "professor" was now reinstated, at the insistence of those who wanted to be addressed as such, the students would be focused on extraneous meaning in a way Kandinsky considered detrimental. He proposed that the government let people know that "master" was the equivalent of "professor."

THE SAME FRESHNESS AND SPARK—and irreverence—marked Kandinsky's teaching. Once he and Nina settled in, he gave the basic Theory of Form course and served as master to the wall-painting workshop, quickly breaking new ground by getting students to experiment so that known forms took on unprecedented meanings. Rather than instruct, he encouraged stu-

dents to try the unknown and to ask questions. Teaching was an interaction; according to Grohmann, "Kandinsky felt as Klee did when he said that he actually should be paying tuition to his pupils."[42] Nonetheless, he would not have been in a financial position to do so, because when he received his first paycheck, he used most of it to buy Nina a striking pair of earrings that juxtaposed black and white pearls.

One of his students in the form course that first year in Weimar, twenty-year-old Vincent Weber, said that Kandinsky was like "a drawn pantomime. . . . His expression was curious; sometimes comic, sometimes innocent, or also enigmatic, or cheery, or even gruesome. . . . He encouraged fantasy." The first thing the quixotic teacher with his heavy Russian accent had the students do was to draw a pitcher and mug, "but it wasn't long before the Master began to speak about . . . the expressive possibilities of line as active or passive element."[43]

The students first arranged the elements of their still lifes with an eye to traditional representation. Their initial goal was to use lines to indicate the boundaries of forms. But Kandinsky quickly guided them into unexpected territory. They were encouraged to explore how each dash or curve could be used to build rhythm. They created linear rhythm on the picture plane, and an even more dynamic three-dimensional rhythm once they added the element of spatial depth. Kandinsky also encouraged his students to create imaginary relationships: connections between knowable images or abstract forms that had no logic or purpose.

He talked, too, about "the mystique of numbers . . . three as the divine number, four as a human number, and seven as a lucky number. From number mysticism he then moved to the symbolism of forms. . . . He pursued everything to the hundredth degree."[44] Familiar digits, everyday objects, and ordinary sights all became magical.

Coaxed by Kandinsky to animate his own drawings so that forms appear to devour or laugh at each other, Vincent Weber felt an unprecedented excitement about the possibilities of making art. He drew lines so that they skipped and danced all over the page. Weber was delighted to be using his pencils and brushes to create surfaces he had never before imagined, and that would not have been encouraged, or even permitted, anywhere else in the world.

The students who could not loosen up, however, encountered Kandinsky's scurrilous side. One who diligently made an imitation of a Japanese screen was met with a scathing "Are you a Japanese, then?"[45] Kandinsky looked at another student's arrangement of a coffeepot, milk jug, and sugar bowl and started to laugh, pointing out that these objects standing in a row were not exciting. Then he spoke about the "special tensions, lyric or dramatic" that might exist among these objects.[46]

Look at the coffee pot: fat, stupid, and haughty. She has a very arrogant air when we turn her a little sideways and draw her spout still higher. Now the little milk jug: small, modest. It looks humble if we turn it down thus at an angle. An obeisance before the powerful coffee pot! And now the sugar bowl: satisfied, fat, well-to-do, content, because she is full of sugar. She laughs when we put her lid on at an angle.[47]

Once he had finished explaining this, his own laughter, which had initially seemed derisive, became an indication only of Kandinsky's own excitement over these possibilities. He was giddy about the objects' personalities.

Kandinsky, like Klee, wrote detailed notes before his classes. There was no existing textbook he could use for a course he was inventing, and he needed his own guide so as best "to train the artist in such a way that he will be able to realize his 'dream' with the highest degree of precision."[48] He had no doubt that painting, the highest of the arts, and abstract art in particular, was the means that would allow the dream to be realized and the spirit to emerge.

Also like Klee, he allowed his own work to demonstrate that principle. Color and forms, liberated from their former obligation to reproduce known subject matter, should flourish, he believed, in all the Bauhaus workshops. Every metal, wood, ceramics, or glass offered the chance to evoke wonder.

THAT FIRST FALL in Weimar, even if Kandinsky produced fewer large paintings than usual, he made new strides in printmaking in the Bauhaus graphic workshop. Depending as well on the capabilities of a local printing company, he created *Small Worlds,* a remarkable portfolio of twelve prints (see color plate 9). While each measured 14½ by 11 inches, they were in a range of media, and Kandinsky used the various technologies to achieve results that have the energy of machinery.

Kandinsky believed the prints could be heard. He also was convinced that they had their own emotions. Describing them according to a numeric system, which in his eyes had a mystical significance, he wrote:

The "Small Worlds" sound forth from 12 pages
4 of these pages were created with the aid of stone,
4—with that of wood
4—with that of copper
$$4 \times 3 = 12$$
Three groups, three techniques . . .
In 6 cases, the "Small Worlds" contented themselves
with black
lines or black patches.

The remaining 6 needed the sound of other
colors as well.
$$6 + 6 = 12$$
In all 12 cases, each of the "Small Worlds" adopted,
in line or
patch, its own necessary language.
$$12^{49}$$

These exuberant gems, in spite of their varied techniques and differences of visual vocabulary, have in common their high charge of energy. Their animated, brightly colored shapes seem palpably alive. It isn't that they convey specific emotions, any more than musical phrases do, but they are filled with intense feeling, a sense of experience taken to the extreme. They leave the responsive viewer invigorated.

NOT ONLY DID THE BAUHAUS provide Kandinsky with a chance to explore printmaking in a new way, but it gave him an unprecedented opportunity to collaborate with his students in the wall-painting workshop. He painted extraordinary maquettes, which his students then executed as vast murals. The finished works were to go into the octagonal entrance room of a museum in Berlin.

Wassily Kandinsky, Small Worlds VII, *1922.*
The print series Kandinsky created during his first year at the Bauhaus in Weimar made his revolutionary art available to a larger number of people.

While *Small Worlds* put Kandinsky's ideas before a larger audience by realizing them in multiple forms, the murals were to reach an even greater number of viewers. Now his emotive abstractions were intended to exist on a monumental scale in a public space.

In Kandinsky's vibrant maquettes for the murals, brilliant stripes, circles, and planar forms sing against a dark background (see color plate 10). As if they are mod-

ernized versions of the Tiepolo frescoes that grace the ceilings of Venetian palaces, their cacophony of starbursts and floating forms invokes a celebrative rococo spirit. With those maquettes in front of them, the workshop students, mostly young women, sat with their long skirts spread beneath their knees on the floor of the Bauhaus auditorium and executed Kandinsky's images full scale in casein on canvas.

The murals were never installed in Berlin. If they had been, painting would have served architecture as Gropius had intended, consistent with the Bauhaus's mission of providing the broader public with a new way of seeing.

7

Wassily Kandinsky's revolutionary abstractions were not to everybody's taste. What was supported at the Bauhaus and admired by most of the students and his fellow faculty members was, predictably, disliked by the majority of unsophisticated viewers; beyond that, it attracted the ire of many of the so-called cognoscenti. Kandinsky was criticized vociferously in the art press. Many people did not even try to understand his work; others felt that they knew exactly what the artist was up to, and that he was coldly didactic. The critic Paul Westheim accused Kandinsky's geometric work of "fossilization and intellectual frigidity." The artist's rebuttal was as close to self-revelation as he got: "Sometimes there is boiling water flowing beneath the ice."[50]

This attack spurred him to forge ahead in his campaign to prove that what seems rigid can pulse with life. Kandinsky devised a questionnaire, which the wall-painting workshop distributed to everyone at the Bauhaus. It had straightforward line drawings of a circle, a triangle, and a square. The instructions were for each participant to indicate his or her profession, sex, and nationality, but not name, and then to assign a color—red, yellow, or blue—to each shape, filling it accordingly and, "if possible," writing an explanation for the choice.

Most people, by a considerable margin, came up with the same response. The circle was blue, the triangle yellow, and the square red (see color plate 8). Those results satisfied Kandinsky immensely, for they concurred with his premise that "the circle is cosmic, absorbent, feminine, soft; the square is active, masculine"—and the triangle, with its acute angles, intrinsically yellow.[51]

Oskar Schlemmer was among the opinionated minority that disagreed.

Wassily Kandinsky, questionnaire from the wall-painting workshop, filled out by Alfred Arndt, 1923. Kandinsky wrote a questionnaire asking everyone at the Bauhaus to assign colors to shapes.

For him, the circle was red: the red of a setting sun, an apple, or the surface of red wine contained in a glass or bottle. The square, being a man-made concept not found in nature, was blue, which for Schlemmer was the metaphysical color. The yellow-ness of the triangle, however, was beyond dispute.

Schlemmer's views, however, had no impact on Kandinsky; nor did any other opinion that contradicted his precept. Kandinsky was com-pletely dogmatic about the issue. He insisted that all curved lines, as parts of circles, should be made blue, all straight lines red, and all points yellow.

People reacted differently to the absoluteness of his stance. Most of the students accepted Kandinsky's system as gospel; they seemed un-able to question the merits of a viewpoint he extolled so emphati-cally. Schlemmer, who was per-turbed by the intractability with which Kandinsky insisted on con-clusions of dubious value, was even more upset by the students' submissiveness than he was by his colleague's rigidity.

While Kandinsky could be as haughty as a tsarist nobleman command-ing his troika, his arrogance was subtle, which is one of the reasons the stu-dents readily submitted to his views. He simply believed without question in his own rightness. He was all the more effective, because, as bold and exuberant as his art was, when he spoke as well as when he wrote, he demonstrated utmost reserve. He was too certain of his "truths" to have to shout.

Kandinsky was responding to sensations that he felt came to him directly from realms far beyond the sphere of what is explicable; he succumbed to the dictates of his own soul and of color and music, all intertwined. The resultant confidence and lack of doubt convinced many people, even as it distressed Schlemmer.

KANDINSKY'S SELF-ASSUREDNESS could reach a disastrous level. This was the case in his relationship with Arnold Schoenberg.

Two months after he arrived at the Bauhaus, Kandinsky wrote Schoenberg that he felt as if he had "experienced centuries" since seeing the Viennese composer and his family in Bavaria in the summer of 1914. He explained that for his seven years in Russia he had been "completely cut off from the whole world" with "no idea of what was taking place here in the West," and that in Berlin he had initially been too overwhelmed to look up old acquaintances: "I came with mouth wide open and gulped and gulped."[52] But now that he was at the Bauhaus, he was eager to renew their connection.

To the extent that friendship was possible for someone as reserved as Kandinsky, he and Schoenberg were friends, as well as mutual admirers with many interests in common. Kandinsky had been the one to initiate the relationship when, in 1911, having attended a Schoenberg concert, he wrote the composer to say that Schoenberg's work "realized" what he had "so greatly longed for. . . . The independent progress through their own destinies, the independent life of the individual voices in your compositions, is exactly what I try to find in my paintings."[53] Kandinsky accompanied the letter with a portfolio of woodcuts as well as photographs of his recent work.

Even before they met, Kandinsky assured Schoenberg that "today's dissonance in painting and music is merely the consonance of tomorrow."[54] But he also let the composer know that he could not understand the last two sentences of the concert program—even after reading them repeatedly.

Schoenberg, eight years Kandinsky's junior, replied warmly. He knew that there was "no question of my work winning over the masses"; therefore he was especially pleased to have moved "those really worthwhile individuals who alone matter to me." He thanked Kandinsky profusely for the woodcuts, writing:

> I like the portfolio very much indeed. I understand it completely, and I am sure that our work has much in common—in what you call the "unlogical" and I call the "elimination of the conscious will in art" . . . One must express *oneself*! Express oneself *directly*! Not one's taste, or one's upbringing, or one's intelligence, knowledge or skill. Not all of these *acquired* characteristics, but that which is *inborn, instinctive.*

As for the sentences Kandinsky had not understood, Schoenberg explained that they had been added by the concert agency without his knowledge, and thus fell into the category of "unwanted and distasteful" advertising.[55]

What had been a conversational risk on Kandinsky's part therefore strengthened their rapport.

An intense correspondence ensued, each man extolling the merits of the other's work; that April, Kandinsky sent Schoenberg a photo of himself, requesting one of the composer in return. In late summer of 1911, they finally met, on a lake steamer, near Murnau, Kandinsky in short lederhosen, Schoenberg all in white. That same year, Schoenberg published his groundbreaking *Theory of Harmony* and Kandinsky published *On the Spiritual in Art.*

Now, more than a decade later, when Kandinsky was in touch from Weimar, Schoenberg responded first by reiterating to Kandinsky why he considered *On the Spiritual in Art* such a seminal work. The composer also wrote a lot about his son, Georg. Georg was showing great prowess at football, and Schoenberg felt close enough to Kandinsky to want the painter to know how proud that made him.

In the letters that Kandinsky and Schoenberg continued to exchange throughout the painter's first year in Weimar, Kandinsky allowed that his administrative tasks made it hard to concentrate on his work. "I can never accomplish half of what I would like to," he complained to his old friend.[56]

IN THE SPRING OF 1923, Kandinsky had the idea that Schoenberg should become the director of the Weimar Musikhochschule. On April 15, he wrote that if Schoenberg had an interest in the post, he would "set to work with a will." Schoenberg responded by return mail. A year before, he would "have plunged headlong into the adventure" and would have given up the idea of being able to compose and do nothing else. The idea of the teaching post was a great temptation, "so great is my taste for teaching, so easily is my enthusiasm still inflamed. But it cannot be."[57]

The reason Schoenberg could no longer entertain the idea was that in the past year he had learned a lesson he would never forget. "It is that I am not a German, not a European, indeed perhaps scarcely a human being (at least, the Europeans prefer the worst of their race to me), but I am a Jew."[58] He blamed Kandinsky for this brutal new awareness of antisemitism.

On the issue of being Jewish, Schoenberg continued: "I am content that it should be so!" He did not mind being "lumped together with all the rest," even though, he let Kandinsky know, "I have heard that even a Kandinsky sees only evil in the action of Jews and in their evil actions only the Jewishness." Schoenberg informed Kandinsky he had given up hoping to achieve "any understanding. It was a dream. We are two kinds of people. Definitively!"[59]

The person who had apprised Schoenberg that Kandinsky had made antisemitic remarks was probably Alma Gropius. She was especially alert to the issue since Franz Werfel and Gustav Mahler were Jewish, although the lat-

ter had converted to Christianity. Schoenberg had also converted, two years prior to this exchange of letters, but recognized that his religious choice made no difference whatsoever in the face of the prejudice that was mounting all around him.

A citizens' committee had recently faulted the Bauhaus for "harboring 'elements of alien lineage.' "[60] To determine whether or not this was so, an official state inquiry had calculated the percentage of Jews at the school. The census revealed that of the two hundred students, there were only seventeen Jews. Most people were simply relieved, but Schoenberg was appalled that anyone had either wanted or conducted this research. He believed Kandinsky was among those who had supported this distinction between Jews and non-Jews.

KANDINSKY QUICKLY ANSWERED Schoenberg's letter. His first reaction was irritation at the unnamed person who had poisoned their relationship. The next was a classic "Some of my best friends are Jews" remark. He assured Schoenberg that he had had a Jewish friend for forty years, ever since grammar school, and they would be friends to death; in fact he had as true friends "more Jews than Russians or Germans."[61]

Kandinsky went on to discuss what he termed "the 'Jewish problem.' Since every nation has particular characteristics which can move in a particular orbit, there are sometimes, in addition to 'possessed' human beings, 'possessed' nations. . . . Surely you understand me?" However, Kandinsky pointed out, neither he nor Schoenberg conformed to the stereotypes. Yet while each of them was proof that the generalizations were not always valid, he advised Schoenberg that "one can at least reflect on one's nation coldbloodedly, or with pain, but always objectively, and examine its innate qualities."[62]

Kandinsky also emphasized to Schoenberg how annoyed he was that the composer had not written him "at once" upon hearing the remarks Kandinsky had made; he should have voiced his objections right away. But Kandinsky did not deny, or apologize for, what he had purportedly said. Digging himself in deeper, Kandinsky wrote, "I reject you as a Jew, but nevertheless I write you a good letter and assure you that I would be so glad to have *you* here in order to work *together*!"[63]

THIS TIME, Schoenberg did not answer by return mail. After a week had passed, he wrote Kandinsky a response of many pages. It begins, "When I walk along the street and each person looks at me to see whether I'm a Jew or a Christian, I can't very well tell each of them that I'm the one that Kandinsky and some others make an exception of, although of course that man Hitler is not of their opinion." He goes on to point out that even if he

wrote that information on a piece of cardboard and hung it around his neck, it would do him no good. The previous summer, Schoenberg had been working in Mattsee, a resort near Salzburg, and had to leave after learning that Jews were unwelcome. He quipped to his old friend, "Must not a Kandinsky have an inkling of what really happened when I had to break off my first working summer for 5 years, leave the place I had sought out for peace to work in, and afterwards couldn't regain the peace of mind to work at all."[64]

Schoenberg couldn't believe that Kandinsky had so much in common with the people who railroaded him out of Mattsee. He responded to Kandinsky's "one's nation" commentary by asking why, when Jews are compared to "black-marketers," Aryans are not similarly equated with "their worst elements"—and are, instead, put in the category of Goethe and Schopenhauer.

> What every Jew reveals by his hooked nose is not only his own guilt but also that of all those with hooked noses who don't happen to be there too. But if a hundred Aryan criminals are all together, all that anyone will be able to read from their noses is their taste for alcohol, while for the rest they will be considered respectable people.
>
> And you join in that sort of thing and "reject me as a Jew." . . . Do you think that a man who knows his own value grants anyone the right to criticize even his most trivial qualities? . . . How can a Kandinsky approve of my being insulted; how can he associate himself with politics that aim at bringing about the possibility of excluding me from my natural sphere of action; how can he refrain from combating a view of the world whose aim is St. Bartholomew's nights in the darkness of which no one will be able to read the little placard saying that I'm exempt![65]

Schoenberg proposes that a bad Jew should be seen as the exception, not the norm. After all, among his pupils, the Aryans had had cushy jobs during the recent war while most of the Jews had done active duty and been wounded. Schoenberg asks Kandinsky, "Are all Jews communists?" and then reminds the painter that of course this is not the case. Schoenberg himself loathed Trotsky and Lenin—and separated himself from the Communists as from the Elders of Zion.

The point was essential because he believed, to his horror, that because he had been born Jewish, Kandinsky instantly associated him with both groups. "You are perhaps satisfied with depriving Jews of their civil rights. Then certainly Einstein, Mahler, I and many others, will have been got rid

of. But one thing is certain: they will not be able to exterminate those much tougher elements thanks to whose endurance Jewry has maintained itself unaided against the whole of mankind for 20 centuries." Horribly prophetic in his use of the word "exterminate"—this was only 1923—Schoenberg's only error was in underestimating the future slaughter. For he believed that the Jewish people were "so constituted that they can accomplish the task their God has imposed on them: To survive in exile, uncorrupted and unbroken, until the hour of salvation comes!"[66]

In spite of his rage, Schoenberg believed that there was an old, better Kandinsky. The person he had in mind was different from the one in his "new guise. Kandinsky is still there . . . I have not lost the respect for him I once had. . . . If you would take it on yourself to convey greetings from me to my former friend Kandinsky, I should very much wish to charge you with some of my very warmest."[67] But now that Kandinsky had disparaged Jews, he seriously doubted that they would ever see each other again.

KANDINSKY WAS SO UPSET about Schoenberg's letter that he showed it to Walter Gropius. Nina Kandinsky would later recall, "Gropius turned pale and said spontaneously: 'That is Alma's doing.' "[68] But Nina's accounts of history often served her own purposes, with little regard for accuracy, and even if it had been Alma who initially told Schoenberg that Kandinsky had made antisemitic remarks, and possibly had invented or exaggerated them, Alma had not written Schoenberg the letter that gives stronger evidence of Kandinsky's attitudes than anything Alma could have transmitted. In what he wrote the Jewish composer, Kandinsky revealed not just what he felt, but also the coldness and insensitivity with which he said it.

Alma continued to characterize Kandinsky as an antisemite, but what is unclear is whether this was a case of her falsely maligning him or was something more valid. In 1924, the year after the rupture with Schoenberg, Kandinsky gave a lecture in Vienna, where he and Nina had been invited "to stay with a bank director."[69] Nina, writing in her autobiography about what happened subsequently, does not identify the man as Jewish—presumably because she assumed that his being "a bank director" indicated as much—but goes on to report that a friend, Fannina Halle, met them at the train station and said that they were staying with her instead. Halle explained that Alma Mahler had told everyone that Kandinsky was antisemitic and therefore could not stay with his original host.

Nina's story, however, is full of holes. Fannina Halle was also Jewish, and the bank director's wife still hosted a dinner for them. All of this was according to Nina herself. She gloats in adding that Alma and Franz Werfel were at that dinner and that, while Alma wanted to sit next to Kandinsky,

Wassily and Nina Kandinsky with Arnold Schoenberg and his wife. Nina Kandinsky dated this photo 1927. If this date is accurate, the Schoenbergs only joined the Kandinskys on the grass very briefly; even so, they look unhappy to be there.

he refused, accusing her of doing him harm, and so he ended up between Fannina Halle and the director's wife, with Werfel in the place next to Alma where she wanted Kandinsky. Promoting the notion that Alma was the culprit, and Kandinsky himself not really antisemitic, Nina Kandinsky seems bent above all on making herself victorious over a rival for her husband's attentions.

NINA ALSO WRITES that in 1927 she and Kandinsky were on holiday in Portschach, a village on the Worthersee, and were taking a walk along the lake when Schoenberg, also with his wife, warmly called out to the painter. The two couples then had a brief conversation. Nina Kandinsky uses that reunion as evidence that all was forgiven, and that the only issue had been Alma's rumormongering. In fact, Schoenberg and Kandinsky never really got together again. In 1928, when the Kandinskys were in Juan-les-Pins, they invited the Schoenbergs, who were nearby in Roquebrune-Cap-Martin, to visit them, but there is no sign that the composer and his wife accepted. And while Kandinsky would write Schoenberg a long and warm letter in 1936, no evidence remains of a response. When Schoenberg informed Kandinsky in 1923 that he could not go to Weimar and intended never to see Kandinsky again, he meant it.

8

In 1923, during his first full year at the Bauhaus, Kandinsky painted *Composition VIII* (see color plate 16). His new life in Weimar was having splendid results; he considered this large canvas the pinnacle of his own work after World War I.

Grohmann perceived *Composition VIII* as the exemplar of the "creative freedom" Thomas Mann identifies in *Doctor Faustus.* "Every note, without exception, has significance and function," Grohmann points out, while there is, at the same time, a welcome and radical "indifference to harmony and melody."[70] In this painting, which is nearly six feet high, each of the many individual elements radiates power. Every circle, dot, squiggle, triangle, checkerboard, and dash functions inde-pendently and has inner strength. The spare, vibrant colors add to the punch. And while each form exerts its own force, the elements also work in an energetic, de-liberately cacophonous relationship to one another; this, Grohmann asserts, "results in cosmic order, law, and aesthetic grati-fication." He goes on to quote Mann's Leverkuhn, declaring, "Reason and magic may meet and become one."[71]

In his friend Grohmann Kandinsky had found the perfect apostle. Kandinsky's own published writing about his *Compositions* lacks Grohmann's gaiety. In *On the Spiritual in Art,* the painter calls his *Compositions* "the expressions of feelings that have been form-ing within me . . . (over a very long period of time), which, after the first preliminary sketches, I have slowly and almost pedanti-cally examined and worked out."[72] Groh-mann managed to elicit livelier language from Kandinsky in a personal letter. In this document, which Grohmann cites, the painter lets his guard down and allows a

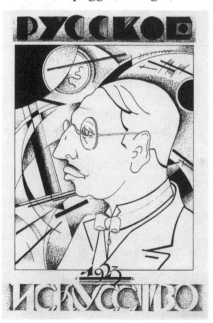

Serge Chekhonine, sketch for a magazine cover with a portrait of Igor Stravinsky, 1923. This image shows Stravinsky in the same year that he visited the Weimar Bauhaus for a performance of L'Histoire du Soldat. *The artist clearly saw the impact Kandinsky's art had made on the composer.*

warmth and fire to come through. In the book he wrote about the painter, which remains the best firsthand account of Kandinsky and his work, Grohmann brings us closer to Kandinsky's mystical engagement than did Kandinsky in his self-presentation. Elucidating the breakthrough achieved by *Composition VIII,* Kandinsky wrote Grohmann that the circle

> is a link with the cosmic. . . . Why does the circle fascinate me? It is
> (1) the most modest form, but asserts itself unconditionally,
> (2) a precise but inexhaustible variable,
> (3) simultaneously stable and unstable,
> (4) simultaneously loud and soft,
> (5) a single tension that carries countless tensions within it.[73]

Grohmann also quotes the responses Kandinsky gave to the psychologist P. Plaut, who sent out a questionnaire polling artists on some of their practices. Kandinsky informed Plaut, "I love the circle today as I formerly loved the horse, for instance—perhaps even more, since I find more inner potentialities in the circle, which is why it has taken the horse's place. . . . In my pictures, I have said a great many 'new' things about the circle, but theoretically, although I have often tried, I cannot say very much."[74]

The mix of hesitancy with passionate conviction, that abiding faith in himself paired with self-doubt, defined Kandinsky. So did his ability to feel greater animation and life in an abstract form than in his favorite animal. Color and shape were more real to him than living beings.

THE ELUSIVE RUSSIAN ARTIST maintained a persona of imperial detachment, but in his controlled, abstract art he used distilled forms to reveal his inner furies. He urged the Bauhaus students to take his same approach. In Kandinsky's classes, the younger artists did exercises to express aggression with triangles and to suggest calm with squares. They employed the circle, the form that led to the fourth dimension, to invoke the cosmic.

That realm of the circle, the shape he made blue, was the one in which Kandinsky lived mentally. Married to a mundane woman who perpetually fretted about everyday occurrences, he escaped into his own mental territory. Nina suffered, for example, from a severe fear of fireflies; she was convinced they would burn her on contact. Kandinsky tried, unsuccessfully, to reassure her; where he found nature magical, she became terrified. His way of coping was by mentally inhabiting the world he evoked in his paintings.

When Kandinsky tried to capture this imagined territory verbally, as he did ad nauseam, in endless written treatises on his approach to color and form and on his theories about art as a form of investigation, the results don't have the impact of his paintings. But the *Compositions* themselves pre-

sent his invented universe in such a way that it is as welcoming as it is unknowable. And they soar with vigor and energy.

IT WAS DURING this period of his life at the Bauhaus, when Kandinsky was making *Composition VIII* and similarly euphoric works while existing completely outside the earthly sphere, that he had the meeting with Klee, already described, in which they went to a café and, after counting their marks, had to return home without coffee. Because they had completely lost whatever wealth they had in Russia, the Kandinskys were in even worse straits than the Klees, while they were used to a higher standard of living—or at least longed for one. The artist could scarcely afford crates to ship paintings to exhibitions, while his wife craved new dresses and hats.

In spite of a pressing need for cash, Kandinsky, like Klee, was content to be paid in canned food for the artworks sold by Galka Scheyer. On January 17, 1924, he wrote Scheyer from Weimar with his specifics: "Fruit in the larger cans because there probably aren't any smaller—otherwise 1 lb. or 1/2 lb. would be much better. Vegetables we eat mainly as a side dish along with potatoes, so we can use smaller cans, but now and then larger ones would also do."[75] When he wanted to be diplomatic and agreeable, he evinced charm and generosity. Kandinsky tried to persuade Scheyer to take a larger commission; if, however, she insisted on forgoing it, she could just increase the amount of tinned food. He was determined that she not deplete her precious supply of cash at the moment when she was just starting his enterprise.

His own financial situation would improve in 1925 when the Kandinsky Society was formed. That organization consisted of a group of subscribers who gave money, with each receiving a watercolor at the end of the year. Once the society was active, their support provided the painter with a dependable few thousand marks annually.

Kandinsky's arrangement at the Weimar Bauhaus was not unlike Klee's. It enabled him to devote a considerable amount of time to his own painting, in exchange for which he did a limited amount of teaching and undertook some administrative duties. But for him the effort to combine writing, teaching, painting, and helping Gropius with administrative and diplomatic matters was often immensely frustrating. Kandinsky generally felt that he should be doing something other than the task at which he was currently working. Although Grohmann observed that "from the outset Kandinsky felt at ease in Weimar, for he was surrounded by men who understood him,"[76] he suffered, at the Bauhaus as everywhere else, from being one of those people who rarely believes he is achieving his objectives. Kandinsky always lamented what he was *not* doing, and was dissatisfied with what he *was* doing.

He tended to analyze his own analysis. The Russian had none of the devil-may-care decisiveness of Gropius or the sheer delight in nature and all forms of creativity enjoyed by Klee; rather, he was mostly dissatisfied. There was, indeed, always an "and," but, as in his love life, there was never a perfect moment of unequivocal joy—except at the moment of making art.

In 1924, the *Braunschweigische Landeszeitung* published an article calling Nina and Wassily "Communists and dangerous agitators." In response, on September 1, Kandinsky wrote to Will Grohmann from a holiday in Wennigstedt, a resort on the North Sea, "I have never been active in politics. I never read newspapers. . . . It's all lies. . . . Even in artistic politics I have never been partisan . . . this aspect of me should really be known."[77] He was so disgusted by the accusations linking him with the political party now ruling Russia and with forces that might undermine the stability of the world he was now enjoying that he considered leaving Weimar to become a less public figure. But, as he wrote Grohmann a month later, he really believed in the purposes of the Bauhaus.

Beyond that, in spite of his perpetual personal woes, he had a goal that was entirely his own, far loftier than Gropius's aims of good design for industrial mass production and the joining of the various arts. "In addition to synthetic collaboration, I expect from each art a further powerful, entirely new inner development, a deep penetration, liberated from all external purposes, into the human spirit, which only begins to touch the world spirit."[78] Kandinsky always pushed everything to its extreme—into that disembodied realm where he might find a well-being absent in his everyday life.

IN LATE 1925, Oskar Schlemmer heard Wassily Kandinsky give a Bauhaus Lecture—a special event whose audience consisted of many of the school's leading figures as well as important outsiders. Schlemmer disliked most of what he heard. Kandinsky seemed to denigrate everything except for nonobjective painting, and Schlemmer was offended not just by what he said but by the stridency with which he said it. Yet the speaker was fluent and intelligent: "He also spoke with resignation of his own isolation, of the fate of the modern artist."[79]

For long periods, Kandinsky had tried to verbalize his ideas in a room he had in Weimar exclusively for writing. "The combination of theoretical speculation and practical work is often a necessity for me," he wrote Grohmann. Yet as he approached the age of sixty, with his usual feeling that he was doing one thing while he should be doing another, he was impatient with the amount of time he had spent formulating and verbalizing his ideas on paper rather than engaging in painting. In the fall of 1925, he informed Grohmann, "For three months now I haven't painted as I should, and all sorts of ideas are begging to be expressed—if I may say so, I suffer from a

kind of constipation, a spiritual kind."[80] The man who could describe himself as pedantic and spiritually constipated was, however ferocious the diatribes against him from others, his own worst critic.

9

In that room in Weimar where he enjoyed an author's idyllic circumstances—quiet, solitude, minimal financial and time pressure, even if he wished he were painting instead—Kandinsky wrote *Point and Line to Plane.* He was glad when it finally went to press, because he kept revising until the last possible minute. But for all the discontent that privately surrounded its creation, *Point and Line to Plane* is an upbeat, enthusiastic treatise. The book puts forward the case that "form is only a means to an end" and amplified Kandinsky's own goal "to capture the inner secrets of form."[81]

In relation to the goals of *Point and Line to Plane,* Kandinsky wrote Grohmann, "Once you referred to 'Romanticism,' and I am glad you did. It is no part of my program to paint with tears and to make people cry, and I really don't care for sweets, but Romanticism goes far, far, very far beyond tears." Talking about his art in its ideal form, the Russian made the exact comparison he made when talking about himself:

> The circle which I have been using of late is nothing if not Romantic. Actually, the coming Romanticism is profound, beautiful (the obsolete term "beautiful" should be restored to usage), meaningful, joygiving—it is a block of ice with a burning flame inside. If people perceive only the ice and not the flame, that is just too bad.[82]

This wonderful life force pervades *Point and Line to Plane.* In his text, Kandinsky starts with the simple point. He then describes the life that grows from it, the chords that develop. He also analyzes the straight line, outlining the personality shifts that occur according to its position: "As a horizontal it is cold and flat; as vertical it is warm; as diagonal it is lukewarm." He also discusses the drama that occurs when lines meet at angles or are curved. "Straight, zigzag, and curved lines are to each other as birth, youth, and maturity."[83]

That multifacetedness of the purely visual applied to life itself. Kandinsky accepted the apparent contradictions of his own personality, and he celebrated the immense diversity of human experience. Following a summer holiday with Nina at Binz-on-Rugen, the normally hardworking, self-

punishing painter wrote Galka Scheyer, "Our laziness had no limit."[84] He delighted in creating a picture of his wife and himself on vacation, comparing their existence to a zigzag line curving in a carefree way to a relative halt. He was pleased to have a side that was the opposite of being pedantic or spiritually constipated; there was, indeed, always an and.

When Kandinsky wrote that letter, Scheyer was in Honolulu, which, Kandinsky wrote her, "for me might as well be Mars or Jupiter."[85] That idea of the unknown, the notion of living on another planet, was in keeping with what Kandinsky had discovered visually. The quip had the larkiness and escapism he considered essential to human existence if one were to have a chance of prevailing over life's harshness—just as verticality is vital to the life of a line that is otherwise horizontal.

SCHEYER, WHO WORKED WITH KANDINSKY much as she did with Klee, had in 1925, in her effort to find an audience for modernism, moved from the East Coast of the United States to Sacramento, California. Kandinsky wrote her:

> Let's hope that the people in California have a better sense and can see the difference between art and currency. The so-called mentality of New Yorkers is something so deadly and repulsive that it gives one goose bumps. But this is inevitably the last stop for the purely materialistic mindset. The Germans and, as far as I know, the Russians have already begun to suffocate in this atmosphere.[86]

Revealing his usual blend of enthusiasm and skepticism, hope and doubt, he continued:

> The youth are still ashamed (at least in Germany) to admit their—in part unconscious—hunger for a different purpose in life. They generally want to appear very serious, logical and matter-of-fact. They also demonstrate courage, but a false courage; since it only serves to conceal the inner division, it is easily seen through. It appears to me nonetheless that for many the burden of this little coat appears to be too much of a bother, and I see here and there a gradual inner transformation. In such cases Germans are too cautious, and even the young person has an exaggerated fear of looking foolish.[87]

Kandinsky craved the spiritual aspect of life, in a territory devoid of materialism.

Yet, with a perpetually needy wife and desiring certain luxuries himself, he was not without some of the same conflicts he observed in others. His thinking was like his painting: tortured and then celebratory, lighthearted

and then overwrought. His keen alertness to appearances, the human veneer, combined with his craving for the soul and the revelation of the inner self, gave the man the spotty energy of his canvases.

At times, however, he could not contend with the complexity of his own observations and feelings, the pull in contradictory directions. He told Scheyer, "Sometimes it drives one to despair and one wants to see nothing other than one's studio. It's no less despairing sometimes, when one thinks about for whom one is really working, for whom and what purpose! But luckily, the artist can no more shake off his work than the drinker his schnapps. So, pour me 'nother one!"[88]

This was classical Kandinsky: to move, in one brief but sweeping monologue, from anguish to a solution, then return to anguish, and, finally, achieve a joyful acceptance of the addiction to art.

10

While Wassily was trying to paint and to conquer life's imponderables, Nina in 1925 was miserable at the prospect of giving up the charms of living in Weimar and moving to industrial, unglamorous Dessau.

She had been among the original reconnaissance group to check out the Bauhaus's future home and had acknowledged its potential, but for someone who loved the cosmopolitan offerings of Moscow and Berlin, and the charms of Weimar, it felt like repairing to the wilderness. For Kandinsky, however, the new location offered great opportunities. Mayor Fritz Hesse's enthusiasm for the Bauhaus, and his determination to have the local government provide generous funding for new buildings, was a boon. Although much of the city consisted of manufacturing plants and bleak neighborhoods filled with workers' houses, there was a Gothic church and the state theater; the Junkers aircraft factory added a dash of the modern era.

Kandinsky was among the few people who recognized that while Gropius was still the director of the Bauhaus, his interest in the administrative hassles was flagging even as he delighted in designing its new campus. As a distinguished figure with diplomatic capability, Kandinsky now assumed a major role in assuring the success of the school in its new home.

The first issue to resolve was the resistance of the local population in Dessau. Kandinsky organized a meeting of the most important Bauhauslers in the house where he and Nina were living temporarily. Kandinsky informed his colleagues that he had had a local government minister come for tea, and that the minister had proposed that the Bauhaus organize lec-

tures and exhibitions to make the goals of the school clearer to an unsympathetic community. The minister told Kandinsky that many people were so enraged that luxurious houses were being built for Bauhaus faculty, at a time when some Dessau residents whose families had been there for generations could hardly afford roofs over their heads, that there was an outcry for Mayor Hesse's impeachment.

Kandinsky's centrist position within the school itself, and his wife's capacity for socializing, enabled him to get along with almost everyone, even if he remained aloof. He and Nina often had people to their home for dinner, and even more often went out. He spearheaded a program that tried to help the citizens of Dessau understand the Bauhaus mission.

Klee—who was living with the Kandinskys and was, for the time being, without either Felix or Lily—often waited up at night for the Kandinskys to come home. Klee was happy to avoid the social life in which they constantly participated, but he liked to chat and hear the latest gossip. When Klee went out with the Kandinskys, it was more likely to go to the movies than to be with other people—there was an excellent cinema in Dessau, which showed the latest films—but he enjoyed the Kandinskys' reports of the relatively convivial atmosphere at the Bauhaus's new location. In his letters to Lily, Klee made clear how impressed he was with the way his great friend got on with Dessau's upper echelons as well as with the various factions at the school, and the role he played in bridging the two communities.

Kandinsky was living with the appearance of more ease than he was actually feeling, however. From his and Nina's temporary digs at Moltkestrasse, he wrote Galka Scheyer a telling letter in October 1925. Congratulating Scheyer on the enthusiasm she had found for the Blue Four in the United States, even if she had not yet made sales, Kandinsky compared it to his own reception in Europe. "I've been working for decades, for example, and have been treated like a dumb kid on numerous occasions by 'the public opinion.' You can hardly imagine what orgies the current 'art critics' in Germany are currently celebrating more and more often." In his withering way, he pointed out that they were declaring expressionism dead—while misusing the term to denote his form of abstraction. Miserable about the triumph of the highly realistic painters then in vogue, Kandinsky called the "national thought . . . a superficialization." He lamented to Scheyer that his sort of work was deemed "an aberration" or "an intentional lie"; in spite of his previous remarks, he now suggested that maybe Americans will end up being "the smarter ones after all."[89]

ALMOST AS SOON as they got to Dessau, Kandinsky and Klee began their ritual of taking walks together in the valley of the Elbe River, which was often shrouded in a soft mist. After one such walk, in late November 1925,

Kandinsky wrote Grohmann about that landscape in the fog: "Whistler could not paint this, nor could Monet."[90] In spite of threatened salary cuts and the awkwardness of living and working in temporary quarters, he did not lose his eye for magnificence.

And then life improved as the Kandinskys watched construction begin on the two-family master's house they would share with the Klees. They saw the well-lit studios and marvelous living spaces begin to take form. In addition, improved financing—thanks largely to Fritz Hesse—meant increased support for a flurry of work at the Bauhaus. The furniture, metalwork, and printing workshops began producing designs that were quickly taken up by industry. Marcel Breuer was making splendid chairs and tables, Marianne Brandt streamlined lighting fixtures and teapots, and Herbert Bayer stunning graphic designs. Kandinsky enjoyed this sense of progress all around him and the buoyant mood that went with it. And even if he had to give up far more time than he would have liked for his administrative and teaching responsibilities—he had only three days a week for his own work—he was painting prodigiously. Anticipating his sixtieth birthday, he wrote Grohmann:

> In a Russian novel there is this sentence: "The hair is dumb: ignorant of the youth of the heart, it turns white." So far as I am concerned I neither respect nor fear white hair. . . . I'd like to live, say, another fifty years to be able to penetrate art ever more deeply. We are really forced to stop much, much too early, at the very moment when we have begun to understand something. But perhaps we can continue in the other world.[91]

The completion of the new house furthered his feeling of regeneration. After the Kandinskys had moved in, during the summer of 1926, Wassily wrote Galka Scheyer, "Where we are living is wonderful, . . . right in the woods. We are happy to be rid of the nasty Dessau smells (sugar refinery, gas works, etc., etc.) and are enjoying the real country air." He was contending with disorder in the house, and had to unpack the boxes in which his and Nina's possessions had been stored since they left Weimar, so he could not properly benefit from "the most beautiful sunshine,"[92] but he still had a new sense of well-being. When the Klees moved in next door, he was even happier.

Yet, as always with Kandinsky, things were never 100 percent. "I'm beginning only very slowly to work, although the burning desire has been torturing me for a long time already. The studio is very, very nice and hopefully the work that will be done there will also be respectable."[93]

The Kandinskys decorated the house very much according to their own

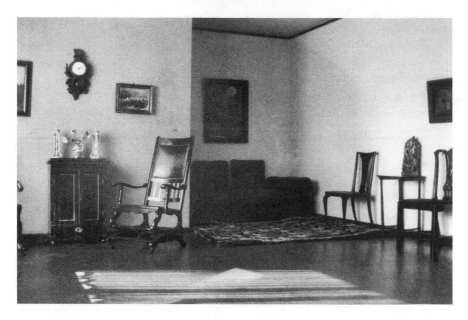

The Kandinskys' living room in Dessau. In most of this house, the Kandinskys
had traditional Russian furniture that recalled their childhood homes.

taste. They had antiques and traditional Russian furniture in almost every
room. It was an unusual combination: tables and storage chests that looked
as if they came from a dacha, with armchairs and commodes that belonged
in an elegant St. Petersburg apartment, thrown together in Gropius's mod-
ern functionalist shell. Furniture that called for rough wooden planks or
ornate paneling now sat in front of flat white plaster walls.

The dining room, however, was stridently modern—with a new table
and chairs that Marcel Breuer had designed especially for the Kandinskys.
There was a china cabinet with a rigidly geometric design of black and
white panels, and one of the walls was painted solid black. Kandinsky
delighted in hanging his brightly colored paintings on this particular wall.
If black had induced anguish in his childhood, it now had bravado.

The Kandinskys' living room walls were a soft pink, except for the one
behind the sofa, which was a creamy off-white. The ceiling was a cool neu-
tral gray. The doors were in the same black as the dining room wall. There
was also a niche in which the walls and ceiling were covered in shimmering
gold leaf. Kandinsky as a person concealed the drama of his own feelings,
his changing moods, in which darkness and high spirits both had their
roles, but in the surfaces of his surroundings he was happy to have colors
express the alternating humors of his soul.

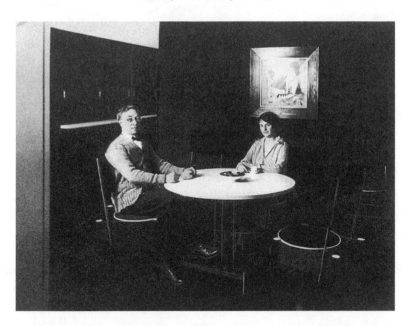

Wassily and Nina Kandinsky in the dining room of their masters' house at the Dessau Bauhaus, 1927. Marcel Breuer designed the furniture especially for this space, where one wall was painted black and the ceiling gold.

IN DESSAU, the Bauhaus started to publish a new periodical to report on all that was being done at the school. Its first issue, which coincided with the inauguration in December 1926, was dedicated to Kandinsky on the occasion of his sixtieth birthday. His birthday was also the occasion of a large show that received considerable attention in the press (see color plate 12).

Most of the articles were favorable, but there was a stinging attack by an important critic, Carl Einstein, in a book on recent art. Einstein called Kandinsky "an artist who created things solely from within himself and was incapable of communication." Kandinsky defended himself by responding that the attacks testified to "the inner strength of this art, its inner tension and the implications bound up with it in particular as concerns 'life.' "[94] This was, once again, the blood boiling beneath the ice: his analogy to his own being.

Although Gabriele Münter would not permit him to communicate directly with her, "after long negotiations through intermediaries," that same year she finally returned twenty-six crates of paintings Kandinsky had made before the war.[95] She held on to many significant pictures—as well as to countless watercolors, drawings, sketchbooks, and personal papers, among them an important lecture manuscript—but the work she gave him back

from storage provided the backbone of his exhibition. Münter also returned his beloved racing bicycle. With the show, the Bauhaus publication in his honor, the return of his early work, and the object that enabled him to pedal off to Wörlitz and other local pleasures, Kandinsky's new life truly began in Dessau.

KANDINSKY'S 1926 PAINTINGS of circles are rich and imaginative. These spectral visions are rewarding to look at simply for the jolt of energy they give; they also present the basis of the artist's latest theorizing, and therefore of his teaching following the Bauhaus's move. Kandinsky was thriving, and it showed. He was reveling in the access to nature offered by his new house; he had written Grohmann following the move there, "We live as if we were in the country, not in the city: we can hear chickens, birds, dogs; we smell hay, linen blossoms, the woods. In a few short days we have become different people. Even the movies don't attract us, that is saying a great deal."[96] Given his passion for Buster Keaton, to be able to forgo films was a mark of his contentment on Burgkuhnauer Allee. But there was no greater evidence of his high spirits than the work he did that summer and fall and put on view in his birthday exhibition at the end of the year.

Klee wrote the preface for the exhibition catalogue. Admiration shines in his text: "He developed in advance of me. I could have been his pupil and was, in a sense, because more than one of his remarks managed to illuminate my quest beneficently and confirmingly." Klee wasn't commenting so much on their age difference (he was only twelve years younger than Kandinsky) as on the courage of his Russian colleague's early strides into pure form and vibrant color. Klee had witnessed this astonishing development firsthand in Munich before World War I. His preface is awkwardly written—"Emotional connections remained, it is true, uninterrupted, but also unverifiable, until Weimar realized my hope for a fresh encounter"—but testifies nonetheless to the splendid link between the two men who now shared a house in Dessau. He also extols Kandinsky's youthful energy, declaring of the work the artist had completed while approaching his sixtieth birthday, "This is not sunset, it is simply action . . . which by the richness of its achievement transcends not only the life span of artistic experience but also the epoch." This, Klee says, will surely continue after sixty. In summation, he encapsulates, in marvelously few words, what it is that made Kandinsky great: "the achievement of a work that concentrates all tensions within it."[97]

11

In addition to the show in Dessau, Kandinsky had exhibitions that year in Dresden and Berlin. He also had visits from the conductor Leopold Stokowski and the copper magnate Solomon Guggenheim, both of whom bought paintings. Major museums in Dresden, Berlin, and Hamburg were collecting his art as well.

Yet his life was never simple. Oskar Schlemmer, who was designing costumes in 1926 for "The White Festival"—they were four-fifths white, one-fifth color—wrote his wife, Tut: "Quite a rivalry has sprung up among the women: I was designing the Kandinska's costume (in the form of a little Kandinsky); the Gropia floated off with the sketches and was no more to be seen. I am curious."[98] Nina was both prettier and less intelligent than almost all of other women at the school, and the atmosphere at the Bauhaus could be as competitive and petty as in any other small town.

Schlemmer also reported on Kandinsky's relationship to his students, as opposed to his connection with local officialdom. Kandinsky's teaching aroused dissent in the Bauhaus community because of its stridency and dogmatism. On the other hand, Schlemmer admired Kandinsky's diplomatic skills and rare ability to get along with some of the most prominent people in Dessau, whom most other Bauhauslers found unapproachable. Even if some of the students recoiled at his arrogance, and even though he would have preferred to devote more of his time and energy to his own work, Kandinsky had become the backbone of the Bauhaus at one of its shakiest moments.

AT THE END OF 1927, Kandinsky sent Galka Scheyer a miniature painting as a Christmas present. It was to be worn as a pendant. She wrote him that it was "a symbol of incomprehensible realities that is concentrated in this small surface but also streams endlessly forth, like the secret law of the forces of life in movement."[99] She wore the magical talisman often. To the few people who understood the fantastic realm of his art, the factors that were both patently visible and deliberately invisible, he was thrilled to give presents.

In 1928, Kandinsky painted *Too Green,* which he would give to Paul Klee the following year for his fiftieth birthday (see color plate 11). The watercolor, created by using a spray gun, is an irregular sequence of gyrating circles. At the same time that they are purely abstract, representing nothing other than themselves, the disks, which appear to rotate and to be millions

of miles away—the spray painting makes their surfaces appear to be in an atmospheric fog—resemble spectral bodies in orbit.

It was the perfect way for one friend to communicate to the other in the language they knew best. In visual rather than verbal language, Kandinsky was celebrating what he and Klee cherished: eternal beauties, the power of abstract form, and access to the larger cosmos. In addition, these intensely serious men were devoted to fun, and *Too Green* is as playful as it is accomplished.

THAT SAME YEAR, Kandinsky designed costumes and sets for a performance of Mussorgsky's *Pictures at an Exhibition,* for which Felix Klee was production assistant. His engagement with the boy whom he had taken care of in Munich at age two, and who had inadvertently locked him in his temporary studio a few years later, was of great meaning to both of them.

Kandinsky used lighting for the ballet in such a way that he realized his own goal of synthesizing science and technology and art. He wrote a description:

> At the first *expressivo* only three long vertical strips appear in the background. They vanish. At the next *expressivo* the great red perspective is introduced from the right (double color). Then, from the left, the green perspective. The middle figure emerges from the trap door. It is illuminated with intense colored light.[100]

It was Felix who made this fantastic scenario occur in sequence with Mussorgsky's music as it went from dramatic to playful to lyrical to stormy. Felix managed the lighting changes and complex switches of backdrops and props through sixteen scenes.

Kandinsky made the backdrops and costumes, as well as props that moved around or hung from above. Rather than create the specific pictures Mussorgsky had in mind, they formed a sequence of abstractions that coincided with the changes in the music. Felix, whose puppet theater had trained him in rapid movements, controlled the action with dexterity.

The scene called "Samuel Goldenberg and Schmuyle"—meant to represent two Polish Jews, one rich, the other poor—featured two figures standing behind tall and thin transparent rectangles, backlit so that their silhouettes were visible. "Promenade" and "Ballet of Unhatched Chickens" were both animated by flashlights moving along wavy lines. Grohmann vividly describes the penultimate scene, "The Hut of Baba Yaga":

> The central portion of the set was first concealed by a black cover, while hand-held spotlights positioned behind the scenery illuminated

Wassily Kandinsky, Study for Pictures at an Exhibition: Gnomes, *1928. Kandinsky made numerous sets for the production, of which Felix Klee was stage manager. Lighting, music, and scenery all worked together in happy collaboration.*

the various patterns of dots and lines cut into its left and right sides. When the central image, the hut of the witch of Russian folklore, was revealed, the clockface glowed with a yellow backlight while the single hand rotated. . . . The Great Gate of Kiev, the final scene . . . began with the side elements and twelve props representing abstract figures, to which were added successively the arch, the towered Russian city and the backdrop, each lowered slowly from above. At the end these were raised, the lighting became a strong red and then was completely extinguished and the transparent disk used at the beginning of the performance was lowered. Quickly this was illuminated at full strength from behind and the lights finally were extinguished once more.[101]

Music, mechanics, and artistic invention were thus combined to achieve an art form that was energetic, diverting, and unprecedented. At the same time, the collaboration of a sixty-year-old artist and his best friend's teenage son showed what a community the Bauhaus could be.

Celebration at the house of Nina and Wassily Kandinsky, 1928.
When the Kandinskys received their German citizenship,
their friends organized a lavish costume party.

ON MARCH 13, 1928, Wassily and Nina Kandinsky both became German citizens. The country from which Kandinsky had been forced into exile fourteen years earlier was now his official homeland. He and Nina were overjoyed.

The Kandinskys' friends quickly organized a costume party to celebrate. Marcel Breuer and some of the other faculty members became "Schillian officers" at the festive evening. That chosen role encouraged great feats of imagination: Ferdinand von Schill had been a Prussian patriot who commanded a regiment of hussars and who, in 1809, unsuccessfully led an uprising against the French during the Napoleonic Wars. He did so independently and without government approval. He died in street fighting; his officers were court-martialed, after which most were shot or imprisoned. László Moholy-Nagy decided to be an old person from Dessau. Herbert Bayer, always as swashbuckling as possible, was an Austrian officer. Ludwig Grote and Hannes Meyer were officials—giving the evening an air of legitimacy—while Klee was a Turk. Kandinsky himself was "a half-breed, comical." He was overcome with joy at the many times people raised their glasses to toast him and Nina as "real Anhalt natives,"[102] and seemed to have no premonition that they would yet again be forced out of their chosen country.

In a letter Paul Klee wrote Lily in September 1928, he provided a splendid rendition of Nina's conversational gambits. Lily was still in Bern. The

Kandinskys had gotten back to their half of the house a couple of days earlier. Once they knew Klee had reinstalled himself, they started to knock on his door repeatedly, but he was invariably out on his long walks into the countryside whenever they called, and so they had no response. Finally the Kandinskys had left their visiting card, folded at the corner, in his mailbox.

Late one evening, the Kandinskys and Klee were at last reunited. Klee and Kandinsky were eager to talk about what had happened with their painting during the summer. Nina, however, completely dominated the conversation, making it impossible for the two men to discuss what most mattered to them. There was no stopping her monologue about her and Wassily's recent holiday. Klee quoted Nina's comments: "In France I'm proud to be a woman, because everyone is so polite—and—and—and above all Paris, but black suitcases get terribly beaten up; that comes from the automobile, when they're put underneath them."[103]

A connoisseur of Nina's silliness, Klee willingly subjected himself to her babbling. Nina was good-natured and devoted to her older husband, which counted for a lot. She was, at the same time, completely ditsy. In October 1929, Kandinsky was bedridden with a kidney infection. He was getting better, but there were high and low points, and while Klee knew it was not too serious, Nina, predictably, was alarmed. Klee mocked the way the nervous young wife went into action. Nina came to him for instructions on

Wassily and Nina Kandinsky in Dessau, 1929. This is a rare photograph
by Paul Klee. Klee saw the Kandinskys, who lived in the other half
of the same house, on a daily basis. While Wassily was a close friend,
Nina was mainly an object of amusement.

how to make hot compresses. Klee thought there was something quite fantastic about the idea that she could not figure out how to soak a washcloth in warm water.

THE KANDINSKYS' GERMAN CITIZENSHIP enabled them to get new passports, which made it easier to travel. Naturally, Nina's first choice was the French Riviera.

In 1930, when she and Kandinsky returned to Paris, she was thrilled by the latest fashions, but he was eager to get to Italy for the art. She complied, but not because she shared the interest. Kandinsky wrote Grohmann from Ravenna: "What I saw was beyond all my expectations. They are the best, the most powerful mosaics I have ever seen—not only as mosaics but as works of art."[104] As the pioneering abstractionist stood with his pretty young wife in front of those extraordinary fifth-century masterpieces, and marveled at the tiny squares of color forming graphically vivid images of biblical scenes, he was aware that his companion was happy because he was happy, yet did not truly understand. Nina adored him, perhaps in ways Gabriele Münter had not, yet she was alien to his capacity to be thrilled by ancient religious art just as she did not even try to understand his tireless experimentation.

12

In the late 1920s, a small group of young Americans with an eye for modern art became aware of the Bauhaus as a hotbed of new and exciting ideas. Kandinsky, along with Klee, loomed as an inventive genius whose presence at the school's revolutionary headquarters in Dessau made it a center of pioneering ideas and artistic creativity.

In 1926, Alfred H. Barr, Jr., who was teaching a course in modern art at Wellesley College near Boston, gave his students a quiz to evaluate their knowledge of modernism. The quiz subsequently appeared in the August 1927 issue of *Vanity Fair,* the fashionable monthly magazine whose editor, Frank Crowninshield, would two years later be one of the seven members of the founding committee of the Museum of Modern Art in New York—where Barr would be the first director.

Those who took the quiz had to answer the question "What is the significance of each of the following in relation to modern artistic expression?" Fifty names followed, among them George Gershwin, James Joyce, *The Cabinet of Dr. Caligari,* Saks Fifth Avenue, Franz Werfel, the Sitwells, Arnold Schoenberg, and *Das Bauhaus,* which was number 48. The answers

followed so that the quiz takers could see how well they had done. The answer for 48 was "*Das Bauhaus:* At Dessau, formerly at Weimar, Germany. A publicly supported institution for the study and creation of modern architecture, painting, ballet, cinema, decorative and industrial arts. Among the professors are Kandinsky, the Expressionist, Paul Klee claimed by the super-realists, and Moholy-Nagy, the Constructivist."[105] The labels for Kandinsky and Klee were inaccurate, but at least there was an awareness that something major was going on at this unique institution.

Barr had distinct impressions of the Bauhaus as a place with an overarching agenda. In 1928, on a trip to the Soviet Union with the Mexican painter Diego Rivera, he visited the School for Art-Culture in Moscow, where he engaged in a conversation with its director, Professor David Sterenberg, about what was happening in Dessau. Barr wrote in his diary, "They were very much interested in the Bauhaus and have evidently learned much from it. I asked Sterenberg what were the chief differences between the two. He replied that the Bauhaus aimed to develop the individual whereas the Moscow workshops worked for the development of the masses. This seemed superficial and doctrinaire since the real work at the Bauhaus seems as social, the spirit as communistic, as in the Moscow school. Kandinsky, Feininger, and Klee have actually very little influence among the Bauhaus students."[106]

Barr had spent four days at the school on his way to Moscow. His quick impressions would do the Bauhaus considerable harm, because as the most influential person in America in cultivating attitudes toward the modern art movements of the era, he would convey the impression that the goals of the Bauhaus were primarily political in nature, having more to do with collaborative work and the spreading of design standards throughout society at large than with the making of great art. All the firsthand accounts from Bauhaus insiders make clear that Sterenberg was more accurate than Barr. By identifying the central issue as "the development of the individual," the Russian pinpointed the goals of Kandinsky and Klee and Josef Albers as artists and teachers. None of these three was interested in a political agenda, even if Hannes Meyer was, and even if Gropius's ultimate goal was societal transformation.

Another young American, the designer and future architect Philip Johnson, wrote Barr a letter about a year later in which he discussed Kandinsky specifically. He deemed the Russian "a little fool who is completely dominated by his swell Russian Grande Dame of a wife. He had millions of his sometimes painful abstractions sitting around the house and thinks he is still the leader of a new movement."[107] One man's "little fool" was another's tall gentleman. In his unpublished diary, the art dealer Hugo Perls describes Kandinsky, even at a slightly later point in his life, as "straight, tall, healthy,

and jovial like a major or a professor!" Perls was greatly impressed, as well, by Kandinsky's meticulous sense of order. "Once when we spoke about a certain painting of his, he fetched a diary with an exact inventory of his work. Vertical lines divided every page into 3 columns: in the first a pen-and-ink sketch of the painting, in the second a description of subject and colors, and in the third the date when it was finished and the time he had worked on it."[108]

PHILIP JOHNSON WAS NOT the only person to make, from afar, a withering assessment of Kandinsky, even if most of the attacks focused on the art rather than the man and his wife. In April 1929, Ray Boynton, a highly respected American professor who taught at the University of California in Berkeley, wrote a broadside on the Blue Four that singled out Kandinsky as the worst culprit. Kandinsky's response was more excitement than displeasure. He wrote Galka Scheyer, "So, there was a fight after all!" and asked her to send all the articles and tell him whatever she heard. He told her, "It's very nice of you to defend me so energetically, . . . and to train the people to look through or behind the surface of my painting—woe to those who remain on the surface! Woe therefore to almost everyone!"[109]

Not only was he feeling that "almost everyone" from the outside was not getting beyond the surface, and was therefore seeing only his cold veneer without his inner fire, but the Bauhaus itself was becoming an increasingly unsympathetic environment for him. One problem was that Hannes Meyer, who had replaced Gropius as director, rejected the idea of Bauhaus theater productions. This forced Oskar Schlemmer to give up what had been his passion, and to leave the school. Kandinsky had been one of Schlemmer's most vocal supporters: Schlemmer wrote his colleague Otto Mayer, "Kandinsky openly shows his sorrow at the end of the Theater in its present form."[110] Schlemmer asked Kandinsky if he wanted to take over the theater workshop, but the Russian declined, saying the whole notion of theater at the Bauhaus had become too controversial. But Kandinsky felt such affinity for Schlemmer's ideas, in particular the way he used solid colors in the *Triadic Ballet*, that Schlemmer's exile stung.

Kandinsky was increasingly pessimistic about the ability of people, anywhere and under any circumstances, to grasp truly new approaches. Shortly after moving to Dessau, he had written "And, Some Remarks on Synthetic Art." It acknowledged his "despair at the slowness of the human spirit." Kandinsky was impatient with the continued application of nineteenth-century values. He felt that painting itself had made progress—"with the principle of inner necessity, with the recognition that form is a bridge to inwardness"—but that even if he and other artists were finding the means

to express the soul visually, and to illustrate the force of human feeling through color and line, the general population was lagging in its ability to understand. Another of his goals, the universal recognition "that science and technology both can co-operate with art," was at least accorded proper respect at the Bauhaus.[111]

Kandinsky was criticized not just for painting work that people could not grasp, but for giving it names that didn't provide the hints and instructions for which they were looking. Titles like *Composition VIII* were an affront to people who wanted something more lyrical and informative. In 1928, he wrote Grohmann, "My titles are supposed to make my paintings uninteresting, boring. But I have an aversion for pompous titles. No title is anything but an unavoidable evil, for it always has a limiting rather than a broadening effect—just like 'the object.' "[112]

Because "almost everyone" failed to understand his work, Kandinsky was, in spite of his guaranteed annual income from the syndicate of supporters who had formed the Kandinsky Society, short of money. Unlike Klee, he suffered from a lack of collectors. When his work did sell, the prices, in 1929, were three thousand reichmarks for a small painting, and up to ten thousand for the large ones. When Galka Scheyer arranged for the film director Josef von Sternberg to visit the Bauhaus to buy some of his work, Kandinsky cautioned her that von Sternberg must be told he would not lower those prices. He only made "exceptions for people who would like to buy out of pure interest but have no money";[113] but he never gave deals to the rich. Still, he hoped von Sternberg would pay the asking price, since Nina always needed more money.

13

Nothing was ever 100 percent right. In 1929, Kandinsky had a major exhibition in Cologne, where he was pleased to receive the Golden State Medal. But the success he was enjoying on many levels brought its own problems. Just being Kandinsky was becoming a profession in itself. Managing his exhibitions and sales exhausted him. Klee had his loyal sister to perform those functions; Kandinsky had to do it all on his own. He was desperate to get back to painting, but he had too much administrative work, too many letters to answer. It was a struggle to organize his days.

He chose to keep a meticulous catalogue of his work, going to great effort to track everything that was sold, applying numbers to each piece whether

or not it was still in his hands. But that craving for order deprived him of many hours that might otherwise have been spent with a brush in hand.

Anguish, nevertheless, served as a catalyst. Kandinsky believed that an "antecedent psychic state" was essential for a work of art to "come into being."[114] His mental darkness affected his creative process and led to his exuberant art.

Despite all the pressures on him, Kandinsky's paintings from the Dessau years appear to smile at us. Noticeably warmer than his work in Weimar, they are paeans to motion and a height of energy. His 1928 *Little Black Bars* infuses the viewer like a shot of adrenaline (see color plate 14).[115] An ovoid—for some of us it is hard to resist reading it as a hurled football or rugby ball—descends from the heavens. A small glowing moon (or possibly sun) appears above the ovoid. It suggests the distant realm from which the fast-moving form originates—and which it is clearly descending from rather than rising toward, thanks to the way Kandinsky has weighted its downward point with heavier colors.

Then, just as we start to read things literally, we realize we cannot. What was the moon or possibly the sun is just a yellow sphere. What might be the sails of a junk are just billowing shapes. Lines that are remarkably spermatozoid are possibly only eager squiggles. Yes, these are sights we know— a world of forms, of objects that move through air or float on water—but they also belong to a universe that did not exist until Kandinsky invented and painted it. The richly mottled textures, the deliciously rich brick red and warm black and satisfyingly sturdy yellow are all pleasures in themselves, not suggestions of some other reality. A bold diagonal line is just that; it has no representational purpose, any more than the sound of a violin does. And the more we look, the more we feel the sheer life of the painting.

The artist's mind was endlessly fertile. *Attraversando,* of the same year, has a background that resembles crossing rays of light. It seems that Kandinsky may have gone into the glass workshop, run by his friend Albers, and used the handheld gun essential to sandblasting; clearly Kandinsky sprayed the surface with a fine coat of granular paint, and applied tape to the canvas and then lifted it to create unfolding linear bands that are like the planes of a pleated fan. On top of this background, which has some of the same feeling as the sweep of spotlights at the start of an old-fashioned Hollywood film, there is a sequence of black verticals that would if they could extend above the top of the canvas and below the bottom. Are these tree trunks in a forest? Strips of material in front of a stage? Of course they are nothing literal, but they evoke memories and associations at the same time that they exist as something entirely without precedent. Above all, the animated and vibrantly colored shapes are a means to fill the viewer with a suffusion of sheer energy and joy.

AT THE END OF 1928, Kandinsky himself described his work to Grohmann as being marked by "great calm and strong inner tension."[116] He did not see those forces as incompatible. His only way toward serenity was to live in the extreme. When he and Nina hosted a New Year's Eve party to welcome 1929, people danced until three in the morning; nothing was done by half measures.

His life had grown easier. Schlemmer now observed, "Kandinsky, once one of the wildest, impossible to classify, has entered the ranks of the classics, clear and unruffled as a mirror."[117] The remark was deprecating in its way, a reference to the assuredness Schlemmer found unnerving, but it zeroes in on the new level of recognition Kandinsky was enjoying.

That success allowed a degree of luxury. For Christmas 1930, Kandinsky and Nina gave themselves a new radio as a present. Nina, Kandinsky wrote Scheyer, was "always enthusiastically turning the knobs. This way we are exploring all of Europe. Unfortunately one needs a special receiver for America, otherwise we might be able to hear your lectures! That would be nice! Perhaps a hole will soon be bored through the earth and then through the hole we can say hello. Radio is such a wonder that nowadays nothing astounds us anymore."[118] That imagined hole through the earth was like the shapes in his paintings of the time, evoking the feeling that anything is possible.

In that same period of relative well-being, however, he had become deeply concerned about his old friend Jawlensky, who was ill with severe rheumatism. In order to improve the patient's morale, Kandinsky had managed to get Galka Scheyer to sell Jawlensky's work. Kandinsky's brief respite from problems and immersion in his private mental universe did not make him blind to other people's needs or keep him from acting effectively on their behalf.

IN 1931, A SOPHISTICATED YOUNG WOMAN, Ursula Diederich, went to the Bauhaus specifically to study with Kandinsky. She had been educated in her native Hamburg and then in Berlin and Heidelberg before going to Paris to study art. In France, she saw Kandinsky's work for the first time. In addition to the paintings she found in commercial galleries, there were reproductions in magazines and exhibition catalogues. Diederich was so moved by the energy and originality of the art that she became determined to work with the artist himself.

The adventurous Diederich, who would eventually marry the producer Oskar Fritz Schuh, was by her own account totally nervous and intimidated at her first class with the man she imagined would transform her entire existence. As she walked up the two seemingly vast flights of stairs of Gropius's building, passing students who were more animated and dressed less tradi-

tionally than most of the people she knew, she could not quite envision what lay ahead. She continued down the long corridors to get to the classroom. After the noise and liveliness of the stairs, the hallways seemed quiet and empty. Once she arrived at the classroom, she was glad to be seated before Kandinsky himself arrived. The benches and tables were the same as in other painting classes she had attended, although the polished linoleum floor was an advance over the usual paint-splattered wood. But Diederich knew that, even if the space had familiar elements, the master would be very different from her previous instructors, who had tried to teach her old-fashioned methods of painting in order to render the subject matter in a given style. She was waiting to replace those methods with a new approach that would give her life meaning.

As soon as Kandinsky strode in, the first thing Diederich noted was his "lively, fast-moving, pale blue eyes looking through sharp glasses. A glance interested in everything, which continuously seems to discover new secrets in the world around us." The man whose vibrant compositions had so excited her quickly held up transparent tinted rectangles, squares, disks, and triangles. Superimposing one on top of the other in various arrangements, he created juxtapositions like those she had seen in his paintings. "Only later did I notice Kandinsky's almost feminine, sensitive, but very controlled mouth, the graying hair, his dignified, rather perceptive appearance, the correctness of his dark suit, the snow-white shirt, the bow tie . . . brown shoes—the well-groomed elegance of a scientist in 1931."[119]

Diederich found Kandinsky "altogether very attractive." There was something "impersonal" about him, but this added to his aura. He certainly did not flirt with the female students, or engage with them directly, which made him and his task seem more noble to her. Kandinsky was in his own world, intensely dedicated to the act of painting with what Diederich termed "his relentlessness, his consistency, his love of truth in art." Above all, Kandinsky was "drunk with the pleasure of exploring free use of color and form."[120]

HE WAS ALSO extremely courtly, playfully so, when he chose to be. In June 1932, Kandinsky wrote Galka Scheyer a letter in which he addressed her as "Dearest Excellence, Minister President and Authorized Ambassador." He continued, "In light of your deeds, efforts, and especially your successes, these titles are far from sufficient!"[121] For Scheyer was now so successful with the exhibitions she organized of his, Klee's, and their colleagues' work that she was having to fend off requests from museums. Only a few years earlier she had been desperately seeking venues; now she did not have enough work with which to supply them.

Kandinsky wrote her, "I want to wish you the most lovely transformation from flea to human being." This Kalkaesque image was typical of the

quirky twist of his imagination, a way of thinking and speaking that was his alone. Scheyer had sent him a photo with one of his paintings in the background; he wrote, "I have the impression that you are just waking up and we could have a nice chat. It's amazing how powerfully such a small picture with an impression of a head can transplant one across the ocean into an unknown land."[122] Again his words have the sense of otherworldly happenings, of the shifts between the consciousness of the waking state and the fascinating unconsciousness of sleep. In his mind as in his art, Kandinsky perpetually inhabited foreign and unvisited territories.

Yet the horrendous realities of the time penetrated the bubble provided by his imagination. Kandinsky wrote Scheyer that sales of art had almost come to a halt in Europe, "and things are getting steadily worse."[123] At least Ida Bienert, a collector in Dresden—whom Anni Albers described as one of the unsung heroes of the Bauhaus—had bought two paintings, for which she was paying in installments, but the National Socialists were now in the majority in the Dessau government, and he knew that the Bauhaus might possibly be forced to close.

That year, in September, once the Nazis had gained a majority in the Anhalt government, the Dessau Bauhaus did close. Once the school moved, under Mies van der Rohe's directorship, to the derelict telephone factory in Berlin that would be its last home, the Kandinskys decided to move with it. Even as the Klees stayed behind in the house the two families shared, on December 10, 1932, Wassily and Nina left their paradise with its black wall and gold-leaf ceiling and again took modest digs in Berlin.

In April 1933, Wassily Kandinsky was among the seven remaining faculty members who voted to close the Bauhaus forever. Three months later, he wrote Galka Scheyer that his Dessau salary, which should have continued for another two years, "seems to have been permanently stopped, because . . . the BH functions as 'a culturally destructive communist cell.' Wonderful—isn't it?" Even though he thought the closure of the school might be only temporary, Kandinsky complained that there were no exhibitions, and that any further sales were unlikely. He was considering going to America: "You know that this is an old dream of mine, to visit the 'new land' once." He recognized that even if the Bauhaus were allowed to reopen, he would not be likely to remain on the faculty, for the new government, which held the view that " 'abstract art = subversive art,' " would not want him teaching.[124] But he doubted that he could afford the steamship fare of nearly 1,500 marks ($360) for two people to cross the Atlantic.

Kandinsky begged Scheyer to let him know if she had any ideas about how he and Nina might make the trip to the United States. In August, she wrote him from Hollywood that they should be patient and hold on until she had sold enough of his work so that funds would await him and he

would not have to deplete his savings in Europe. But at the moment, while there were some pending sales, nothing was certain, as hard as she was trying, and hopeful as she remained of some unexpected development, she could make him no promises.

Scheyer had hoped to get Solomon Guggenheim and his art adviser, the Baroness Hilla Rebay von Ehrenwiesen—whom Scheyer repeatedly referred to as "Rabbi"—to buy Kandinsky's work, but she complained that they were devoted exclusively to the work of Rudolph Bauer, an inferior abstract artist whose style seemed a thin imitation of Kandinsky's. "Bauer is God and you are only a painter," Scheyer wrote, dismayed.[125]

America would not be the answer. On June 16, following the closing of the Bauhaus, Oskar Schlemmer wrote the weaver Gunta Stölzl that Kandinsky "still cannot believe it has happened."[126] He and Nina soon had no choice but to recognize that reality, however. For Christmas of 1933 they went to Paris to decide whether to move there. The French capital was where the artist lived until his death in 1944. Eventually he attained some of the creature comforts that Nina craved. But he never again painted with the force and bravura, the profound texture, that made his art at the Bauhaus such a vibrant and rare universe.

Josef Albers

1

A young female student at the Dessau Bauhaus claimed to be pregnant with Josef Albers's baby without having had sex with him.

For his entire life, there were people who thought Albers was invested with godlike power. Students worshipped him, even as they feared him. His partisans revered him as a seer; his detractors recoiled at his absolute faith in his own convictions and deemed him a tyrant.

Compared to his colleagues, Albers came from nowhere and invented himself. Kandinsky, Klee, and Gropius were raised in intensely cultured families, educated in a way that made their subsequent development natural and of a piece with their earlier lives. They were brought up in milieus where it was not a radical step to devote one's life to art or architecture and be part of the world that would support such a profession. Albers's wife, Anni, had a childhood where opera performances and museum visits were intrinsic to life, so an interest in art did not come as a shock to her family even if its choice as a profession did. Josef Albers, unlike most of the people around him, leapt from one world to another. And the daring and decisiveness that marked his personal actions shone in his work and teaching.

Josef Albers, Perdekamp, *1917–18. In drawing the profile of his soulmate of his early years, Albers used a single decisive line to encapsulate a face he loved and to make the flat paper seem round.*

ALBERS WAS BORN on March 19, 1888, in Bottrop, a small industrial and mining city in the

Ruhr region of Westphalia, its air so clogged with coal smoke that he used to say, "Even my spit was black." His family was working class; no one had advanced education. Of the other major figures at the Bauhaus, only Mies van der Rohe came from a similar background, but Mies's way of dealing with it was to mask his humble beginnings and embrace an aristocratic style as if it were his birthright. Albers claimed his humble origins as the key to his talents. He considered the menial skills he had been taught growing up vital to what he subsequently became, and he wore his heritage as a badge of pride.

"I came from my father, very much, and from Adam, that's all," Albers routinely responded when questioned about who had influenced his art. His grandfather, Lorenz Albers, was a carpenter; his father, also named Lorenz (without a "Junior"), was a housepainter whose skills went in many directions.

> I came from a handicraft background, and I know lots of handicraft. . . . I watched as a boy how shoes were made, and how black-smiths worked, and how a painter like my father did everything. . . . I worked in his workshop. . . . He knew the rules, the recipes, and he taught them to me too. And he was what I think you call a tinkerer. He put all the electricity into our house. He, himself. Could do the plumbing. He could do glass etching, glass painting, he did everything . . . he was a very practical man. He was an artisan. He could solder. He made soap during the war from wax which he used otherwise to etch with. He could sandblast. He had a very practical mind. I was exposed to many handlings which I learned to steal with my eyes.[1]

Josef Albers, Self-Portrait III, *ca. 1917. After studying Cézanne's work, Albers skillfully used small planes to create a bold yet reserved image of himself.*

That notion of looking and visualizing as thievery was central to Albers's way of seeing things. The inexplicable processes that occur via the eyes and their messages to the brain captivated him. He emphasized the practical, but exulted in the mysterious.

Albers contradicted himself in

many directions, although he always resolutely maintained that the last thing he said was the unequivocal truth; if you argued with him, you would get nowhere. Having just insisted that he came only from his father, he would then speak fondly of the impact made on him by the blacksmiths on his mother's side of the family: "To make a good nail for a horseshoe, it was necessary to have skill of hand."[2] He was also pleased that his mother, Magdalena Schumacher, had a name that indicated a worthy profession.

"When I think that I might have been born into a family of intellectuals! It would have taken me years to get rid of all their ideas and see things as they are. And I might have been awkward with my hands," Albers announced. Manual dexterity and the understanding of tools would be fundamental to his teaching at the Bauhaus and afterward. His attitudes echo those the film director Jean Renoir described in his painter father, whose know-how Albers greatly respected: "What is to be done about these literary people, who will never understand that painting is a craft and that the material side of it comes first? The idea comes afterwards, when the picture is finished."[3]

AMONG THE SKILLS Albers learned from his father was how to use a comb and a sponge to make imitation wood grains and marbleized surfaces. Lorenz Albers occasionally designed theater sets using those techniques. Josef would pound his fist when any art historian was ignorant enough to link him to the German expressionism that dominated the schools he attended in Berlin and Munich, but he was proud of the concern with practical effectiveness that had been passed on to him. When he arrived at the Bauhaus, he was a stranger to the urbanity and patina of sophistication that came with most of his colleagues' privileged upbringings, but even if he was from a provincial backwater, he had in common with them a disdain for ineptitude and a belief that discipline and technical skill were absolutely essential for any artistic pursuit.

Like Klee and Kandinsky, Albers was one of those rare people for whom the visual world was laden with power. Color and line had an immense impact on him, even when he was a child. In the 1940s, Albers would tell his students at Black Mountain College—the renowned experimental school in North Carolina where Robert Rauschenberg, among others, studied with him, and Merce Cunningham and John Cage, as visitors, delighted in the magic of his words—about one of the strongest memories of his childhood. As a young boy, he had gone with his mother into a bank in Bottrop. The floor was made of black and white marble tiles in a checkerboard pattern. While his mother did her banking, the pale, blond youth contemplated the floor pattern. He felt he might sink into the black squares, as if into quicksand. He would have to climb out to be elevated on the cloudlike

whites. Cigarette in hand, Albers now demonstrated the process to his students by lumbering in an exaggerated manner around the front of the classroom. His performance demonstrating the power of black and white was testimony to forces that moved Albers in the way that the veining of the marble tabletops affected the five-year-old Klee and the black of the horses' hooves terrified kindergarten-age Kandinsky. The visual world was potent. Their responsiveness to what they saw set these individuals apart from almost everyone else they knew.

2

While it lacked the cultural richness, particularly the immersion in music, of the environments in which the others were nurtured, the household in which Josef Albers grew up was a bit like a medieval guild—a preparation for the communal living at the Bauhaus if not for its intellectual expansiveness. The apprentices of "Lorenz Albers Meistermaler" lived with the family. So it was not only from his father but from the trainees a decade or so older than he that young Josef learned the skills of carpentry, stonecutting, and housepainting. Before he thought about art, he knew the way to paint a door: "from the inside out, so that you catch the drips and don't get your cuffs dirty," how to control his brush for window trim, and the methods for making the large flat expanses flawless. He told me this when he was in his eighties and explaining why he always started his *Homages to the Square* at the center and then worked his way to the edges, never superimposing colors, deliberately avoiding the appearance of his own hand and managing to have the edges of the flat colors abut each other with perfect registration.

Within a decade of his birth, Josef's parents had a second son and two daughters. But then the relative equilibrium enjoyed by the family on Bottrop's Horsterstrasse took an abrupt turn. When Josef was eleven, Magdalena died. Her youngest child was only two years old.

His father remarried the following year; then, at the age of fourteen, Josef went away to school in Langenhorst. While he was there, his father and stepmother had a son who lived for only nine months; a second son would not survive a full day. After those two tragedies, the couple stopped trying. Life's vagaries and hardships made Josef long for balm, and during his three years in Langenhorst, he developed the idea that he would become an artist. The prospect turned his melancholy into optimism about life's richness.

Lorenz Albers opposed the idea. In his view, the very thought of a life cen-

tered on art was a dangerous fantasy, and he was determined that his children have solid professions. Compliantly, Josef went to the Royal Catholic Seminary in Buren to train to be a schoolteacher. He was an unexceptional student. When he earned his diploma in 1908 his grades were a "sufficient" in musical harmony and gymnastics and a "good" in agricultural instruction and nature studies, although he achieved a "very good" in conduct, diligence, and drawing. His self-confidence had to come from within. But at least he passed his teacher's exam, took the official oath, and was allowed to teach the full range of subjects in elementary school back in Bottrop.

Albers was, however, still magnetically drawn to visual art. As soon as he had sufficient funds and a day with no teaching obligations, he made the two-hour train journey to the city of Hagen. Having learned that there was a remarkable art collection there, he was eager to see original paintings by some of the most innovative artists of the era.

In 1902, the twenty-year-old Karl Ernst Osthaus, one of those exceptional artistic patrons who had the foresight and courage to go beyond the givens of his day and to embrace what others had not yet approved, had founded the Folkwang Museum. Osthaus was guided in part by Henry van de Velde, the architect who, more than a decade later, would beckon Gropius to Weimar. He collected work by the German expressionists—Ernst Ludwig Kirchner and Emil Nolde among them—and also had late-nineteenth-century French paintings by the revolutionary artists who had transformed painting more subtly. Osthaus had startling canvases by Paul Cézanne and recent work by Henri Matisse.

What Albers later recalled as a simple fact—that he had taken himself to Hagen at age twenty to meet Osthaus and see the Folkwang—was exceptional. Like his brother and sisters, he had been brought up with the expectation that he would live pretty much as their parents had. But Josef responded to everything more intensely than his siblings did, and had more romantic aspirations. Hagen was at the edge of the Sauerland, a bucolic region where he managed to go, on a shoestring budget, for vacations. He adored the deep shade of its pine forest, of which he made evocative drawings, just as he succumbed, by an inexplicable instinct, to the works by Cézanne and Matisse that were total anathema to most viewers. In his receptivity to new visions of beauty, he was different from the rest of his family and most of the people he knew. He also craved universal truths, and imagined they would be disclosed through the eyes.

The revelations afforded by Osthaus's pictures were startling. For the rest of his life, Albers would consider that first visit to be a pivotal event. "I had my first meaningful contact with modern art in Hagen, where I spent my time as often as I could, and where I knew and admired Osthaus and experienced Cézanne, Gauguin, Van Gogh, Matisse, and Denis for the first time."[4]

He was dazzled by the directness of these works, by the boldness and courage with which their makers animated nature and evoked the power of painting. The sight of these modern French canvases changed Albers's life forever.

FROM NOVEMBER 1, 1909, through September 30, 1910, Albers taught in Weddern at a Bauernschaftsschule. This is an old German term, no longer in use, and is translated as either "school for farm children" or "peasant school." The experience helped define Josef Albers as an educator. In Bottrop, he had taught a single age group in a traditional way; now he was faced with a one-room schoolhouse. "I had all age-groups ranging from 6 to 14 years, boys and girls, together in one schoolroom. To do oral and written work in all elementary subjects—from religion to gymnastics—with these different age-classes in groups of changing combination, called for more than a carefully organized plan of study and curriculum." As a result, Albers acquired (again the words are his)

> a new understanding: That learning by experience cannot be lost and therefore outlasts book knowledge. That the experience of inner growth is the mainspring of all human development, just as the example of the teacher is the most effective educational means. That education by the school must lead to self-education . . . Education is not only an accumulation of so-called knowledge, but first and last seeks to develop willpower. For this is what education was originally invented for and why it was recognized time after time through the centuries: The integration of the individual into the community and society—that is, beyond economic aims for moral aims.[5]

As the Bauhaus professor who gave the introductory foundation course to more students than did anyone else—and later at Black Mountain, Yale, and the many other institutions where he lectured—he would emphasize experience over the accumulation of facts. He would also make himself the example of someone who learned by reacting and experimenting, not by amassing information. For Josef Albers, art was the encapsulation of morality—or of its lack. How one paints, designs, or builds testifies either to clarity and humanity or to selfishness and self-importance; art manifests generosity and intelligence or egocentrism and ignorance.

IN THE SUMMER OF 1910, Albers served briefly in the military reserves. That fall, his occupation as a teacher gave him a deferment, and he took another one-year assignment in an elementary school, this time in the town of Stadtlohn. Stadtlohn is in the Münsterland, a pleasant region of farming country and

handsome villages whose center is the city of Münster, with its fine Gothic cathedral and narrow streets of half-timbered houses. Albers was delighted to be in this lovely part of the country, away from the bleak, industrial region where he had lived. His earliest extant drawing, *Stadtlohn,* dated 1911, depicts the view out the window of his rented room; by instinct, he enlivened an ordinary sight. This rendition of an unspectacular church pulsates with the artist's visceral reaction to the force of right angles and architectural massing. He simultaneously animated two-dimensional and three-dimensional space, so that the viewer is moved sideways and up and down as well as into and out of the background. Albers could not possibly have anticipated his future — the Bauhaus did not yet exist even as an idea — but within a decade he would be manipulating glass and wood to similar effect in Weimar, and developing, with abstract shapes and folded paper, the approach to form that would take Bauhaus students into uncharted realms.

The young teacher was as enchanted by the possibilities of black and white as a musician is by changes in rhythm and tone. In *Stadtlohn,* Albers used unmodulated black lines and white paper to create a range of grays, demonstrating a point he would reiterate later in life: that in art one plus one can equal more than two. Most of the church windows have black panes and white mullions, but one is equally convincing with white panes and black mullions. The tower is white with black detail; the wall of the house in front is black with white detail. There were no factual reasons for these reversals. They reflect, rather, the spontaneous joy Albers took in transforming what was before his eyes. At the Bauhaus, he would pair photographs and sandblast refined geometric forms with a similar playfulness, exploring the unique territory opened up when one re-creates rather than reproduces.

Technique in hand, the artist was free, Albers demonstrated, to inject the visual with the quality of music. Beginning with his first drawing, he luxuriated in the opportunity that making art provided to enter the realm of imagination.

IN 1911, ALBERS RETURNED to Bottrop, where he continued to teach grade school. He was fascinated by teaching and learning in general, but became convinced that visual art was the most interesting realm. Now twenty-five, he felt that he had honored his promise to his father and earned the right to venture further. In 1913, he took a step no one in his family had ever taken before: he moved to Berlin.

In the sophisticated capital city of Germany, the housepainter's son from an industrial backwater attended the Royal Art School in order to obtain a diploma that would enable him to teach art at the high school level. His professor, Philipp Franck, was a painter of mild-mannered impressionist-style scenes. Franck was a competent but unexciting artist; he had, however,

developed a revolutionary approach to teach young people how to draw and paint. Franck had pioneered an educational method that required his pupils to be student teachers in the tough working-class neighborhood where the Royal Art School was located. In his book *The Creative Child,* he explained, "To be an art teacher requires a different disposition than being an artist. . . . Just as the artist can and must be as egocentric as possible . . . the art teacher must, with understanding and love, put himself in the place of his pupils whose natures are often quite different than his own."[6] Franck emphasized the need to draw from nature without attempting exact replication. The students' task was to incorporate natural structure and growth in their work—very much the same principle Paul Klee would inculcate in his Bauhaus students a decade later.

Franck stressed that whatever the level of the student, seeing and observing were the essential prerequisites to attempting to record what one saw on paper. It was a simple enough idea, but given the way most people hurry without reflection, the idea of this Zen-like approach to contemplation was as radical as the interest in working with the poor. Albers was deeply impressed.

IN FEBRUARY 1930, when Albers was an established professor at the Bauhaus, he had a significant encounter with Philipp Franck. The occasion was Albers's first public lecture outside of the Bauhaus, in Berlin in a large lecture hall at a library that specialized in the applied arts. Albers's subject was "creative formation." He had anticipated a small turnout and was pleased to find the hall nearly packed. The audience surprised him with their enthusiasm. He was particularly happy when his former professor was among those to come up to him afterward. Franck told Albers something he had never known: that Max Lieberman, probably the best-known contemporary painter in Berlin at the time, had chosen a colored paper "Montage und [sic] has today the much weaker name Collage" made by Albers[7]—the subject was a bottle of Benedictine—as the best in the class. Fifteen years later, he was delighted not only by Lieberman's approval, but by the generosity of his own admired teacher in telling him this story.

Most of the paintings Albers did in Berlin, however, were, while spirited, rather coarse. Deny as he might the influence of other artists, the evidence makes clear the profound impact on him of Van Gogh's work. Albers admitted to having a passion for Van Gogh, and at the early stage of his own painting, he could not help but imitate what he admired. Yet while his Berlin oils and watercolors have Van Gogh's boldness in their charged brushstrokes and vibrant colors, they lacked the Dutchman's refinement. Albers was still grappling with new styles in a new world, and had not yet developed a fine touch; it's as if he was so excited by the possibilities of raw paint, applied

directly from the tube, that he could not control his exuberance. The results are energetic, but short on subtlety.

His drawings of the period are far better. Here it became clear that Albers had an extraordinary gift, as well as the intelligence to take advantage of the chance to see, firsthand, work by Albrecht Dürer, Hans Holbein, and Lucas Cranach the Elder. He used his study of those northern masters to make real people emerge from his own subtle renderings in pencil.

Albers could turn a head, pull back hair, define a profile, and bring out a cheekbone. He knew how to use every line and angle to create weight or lightness. This was in part because he followed Franck's advice of lengthy contemplation, and also because he studied the technique of some of the greatest artists of the sixteenth century. Beyond that, Albers modulated his pencil strokes to differentiate between quiet contemplation and feverish intensity. He could, when he chose to, draw in a competent, traditional style that was forthright and tender—rendering an old lady's profile with authority and handling the graceful mass of her bun and the knotting of her scarf with skill and freedom, establishing the volume of a head as a complex sequence of curves. On these occasions, he adhered to many of the techniques of the masters. He was equally capable of sketching with lighter, faster strokes, charging his images with tense energy. At those moments, he was a mix of warrior and modernist: a product of his own invention.

But it was the Bauhaus that unleashed Albers as an artist of true originality and panache. There, the skill and knowing eye he had had from his start would be liberated; he would escape the last remaining bonds of tradition and make art that was more original and vigorous than any he had made before. Secure in a world where other open-minded individuals would marvel, rather than scoff, at art made from unexpected materials, and where rhythmic lines and vibrant colors were allowed to be the raison d'être rather than devices in the service of representation, he would leap into an entirely new realm.

ALBERS RECEIVED his diploma from the Royal Art School on June 30, 1915. No one encouraged him to take the unusual course of becoming an artist rather than working in a trade like everyone else in his family. His grades on graduation were unspectacular: "adequate" in drawing from the live model and painting; "good" in drawing after natural form, drawing of objects, and drawing on the blackboard, with his only "very good" grades in line drawing, method, and art history.

That same year, Josef's only brother, Anton Paul, was killed, at age twenty-five, fighting in the German army in Russia. With his own deferment from the military, Josef remained in Berlin, where he taught drawing at a high school level. But in November, when his leave from the regional

teaching system in Bottrop was coming to an end and he sought to renew the permission to remain in Berlin, the authorities turned him down, although his sister Magdalena had replaced him at his teaching post, in effect fulfilling his obligation. After two years in an international metropolis, with great art and lively friends, he hated the prospect of returning to the small-town atmosphere and visual heaviness of smoggy Bottrop. It was equally disconcerting to him to be back under the watchful eyes of his family. But he had no choice. The Bauhaus did not yet exist.

3

In Berlin, the lean and rakish Albers had encountered beguiling women very different from the girls back in Bottrop and developed a circle of male colleagues who shared his interest in art, as well as in fine clothing and in worldly living. It was a setback to have to resume teaching at the Volkschule, and move back in with his family.

Albers's solution was to make art as never before. He compensated for his isolation from urban pleasures by beginning to draw more, and in a freer style, than he had in Berlin. He returned to the Münsterland and sketched its picturesque life—the horse-drawn carts and barnyards full of chickens. He made vigorous drawings of the grandest houses in the towns—they suggested affluent living, and he was enchanted—and of the Münster Cathedral with its richly variegated surface. He also made multiple images of the dramatic interior spaces of the naves and side aisles, and of the towers reaching heavenward.

He became fascinated with rabbits and made vivid sketches of them. But he did not turn only to subject matter that was intrinsically charming. Albers also did many drawings of the sand mines and workers' houses in Bottrop. There seemed to be no sight that did not fascinate him: schoolgirls with their feet slipping out of their wooden shoes underneath their desks, workers climbing electrical poles to repair power lines, the myriad aspects of ordinary everyday life—he captured them with a style less inhibited than in his earlier work.

That range of subject matter is emblematic of Josef Albers's approach. When he began to work with color at the Bauhaus, and then when he taught and wrote about color for the rest of his life—treating it as something that should be seen on its own, independent of associations with known subjects—he stressed the need to abandon judgments that elevated one hue over another. In his eyes, every shade of the spectrum was valuable.

If it could be seen, it was interesting: this is the approach that emanates from his drawings of bleak streets of humdrum architecture in Bottrop, as it would in his teaching at the Bauhaus.

In Albers's drawings from 1915 to 1919, every stroke is loaded with significance and intensity, and with an ease that was previously missing in his work. Albers had developed a rapid shorthand that enabled him to sum up sights without a gratuitous dot. He revealed his subjects as they were, encapsulating the unique shape as well as the timidity of those rabbits, and the haughtiness of owls. He endowed dancers with suitable grace and made children sweetly awkward, all the while strictly eschewing any hint of personal commentary or evaluation. The idea was to observe and then to present.

Beyond teaching at the Volkschule, he gave courses at the high school level, studied at the School for Applied Arts in nearby Essen, began to work in stained glass—designing and executing a rose window for the local Catholic church—and made a number of woodcuts and lithographs. In the prints of the grim neighborhoods where the local miners lived, Albers managed with just a few short, rapid strokes to put the streets and buildings solidly within our grasp. He may have labored, but the labor does not show. Every spontaneous yet controlled movement of the crayon serves a purpose and reveals a trained hand.

The making and teaching of art completely absorbed him. The exigencies of wartime didn't allow for travel or many escapes from his father's household, and whatever extra money he had went for art supplies and to cover his printmaking expenses, but he was doing what he wanted. Fortunately, he had a soul mate who understood his priorities. Franz Perdekamp, a poet and writer, the youngest of his father's nineteen children (by two different wives), was both a good drinking companion and someone to whom Albers could elaborate about his artistic obsession, which no one else he knew understood. They caroused happily when they weren't working, and emboldened each other to believe that it was possible to follow one's passion in life.

ALBERS WAS YET another future Bauhausler whose life changed in a sanatorium. At the start of 1916, a bout of what was probably pneumonia required him to go for a cure in the mountains south of Bonn. But while the sanatorium in which Alma Mahler and Walter Gropius met was an elegant hostelry that might have appeared in a Thomas Mann novel, the one where Albers received his treatment, Hohenhonnef, was for civil servants and soldiers recovering from disabilities caused by the war. He was there for nearly six months.

Albers's deliberate lack of interest in health problems, and his denial of anything that got in the way of making and teaching art, caused him to

eliminate those six months from the meticulous chronologies he made of his life. When I met him, he was in his eighties; he told me he had never been in a hospital or suffered a health problem beyond a cold. It seems that Anni Albers, although she was married to Josef for fifty years, never knew about the sanatorium stay either, since she often said that Josef had "never once been ill, except for colds and sometimes a hangover"; when she took him to the hospital on his eighty-eighth birthday, she told the doctors he had never been hospitalized before. All of the existing literature places Albers at work at Bottrop during the time period, as does the information Albers carefully disseminated during his lifetime.

If not for the letters Albers wrote to Franz Perdekamp—which became known only in 2003, when Perdekamp's grandchildren revealed their existence—that half-year medical leave would still be unknown. And vital insight into the artist's nature would be lost. The correspondence is remarkable, for it unveils the real Josef Albers, the very opposite of the Josef Albers most people saw. The world encountered an Albers who was entirely resolute, didactic, and lacking in playfulness. That misconception was largely perpetuated by the artist himself. Albers concealed his lack of certainty as well as his sense of mischief. The assumption that he lacked normal foibles is equally the result of a misperception of his best-known artwork, which at first glance looks austere. Most viewers don't initially see its humor or poetry, or recognize the romanticism behind its creation. The letters to Perdekamp, which began when Albers was taking his cure in the mountains, show someone who was emotional in the extreme, who struggled hard against his demons, and who relished forms of beauty that bowled him over: this, in fact, is entirely consistent with the character of his art, even if the burning passion is initially recognizable only to people of unusual perceptiveness.

At Hohenhonnef, Albers—whom Perdekamp addressed as "Jupp"—was feeling, even more than before, how different he was from the people around him. Jupp wrote his friend:

> My neighbor here in the hall has just returned from [a visit to] his wife and child and tells me of the treasure of having one's own hearth while upstairs I am trying to write and abuse my homeland. I feel both love and and hate inside myself. The faithful tales next door go on. The attic in my head is in a terrible jumble.[8]

Alcohol brought him some relief. Part of the prescribed cure consisted of taking long walks, and Albers would head off to a small town on the banks of the Rhine, where he snuck the occasional schnapps. To describe this to Perdekamp, he invented a verb derived from the name of the strong wheat-based liquor indigenous to the region: "I doppelkorned too much," he

wrote.[9] Pleased to have gained a needed six pounds, he considered the drinking that the sanatorium authorities forbade part of his private cure.

IN THOSE SIX MONTHS, Albers had more time to reflect than he had ever had before. He further crystallized his belief that artistic and human values are the same. He considered painting and poetry, the forms of expression most on his mind, as exemplars either of humility and compassion or of pretentiousness and mendacity. He became insistent that tenderness was one of the most essential elements of painting and poetry—as it was of a person's soul.

Albers also prized and exemplified forthrightness. A person must never dissemble about what needs to be said and is true, even if its effect is painful. When he wrote Perdekamp a frank evaluation of a recent poem, he did not hesitate to risk hurting his friend's feelings; the need to perfect one's art mattered far more than the possible pain of a critical word. That belief would underlie all of his teaching at the Bauhaus and afterward. The opinions Albers voiced kindly but candidly to his closest friend were the essence of the standard he would bring to the Bauhaus and try to imbue in his students: "You want it that way, namely firm and wild. And yet you have, I think, so much warmth and softness in you. Why don't you yield to that a little more. Perhaps it speaks in other poems, particularly as the ones you sent cover only a short time span. You know I like spikiness and hardness, but it has to be organic."[10] Albers believed that artwork, while it should be done well and done carefully, failed if it was too emotionally restrained.

Albers had not yet formulated the credo he would promulgate for the rest of his life—"minimal means for maximum effect"—but his subsequent reflections on Perdekamp's poetry led him directly to that idea. Modernism was not, nor would it ever be, the issue; what counted for him were qualities that were universal and timeless, and could be found in various civilizations throughout history. This was the consciousness he would urge on others in Weimar and Dessau, and then when he carried the gospel of the Bauhaus to the New World:

> On reading your poems I have often thought about my old theme: equilibrium in works of painting.
> And I always came back to the old (or better early) Italians. The ones you can still call primitive: the group around Giotto and the Siennese. Why do they give such an immediate impression of greatness? Because their techniques were so simple. They only had tempera and fresco and a few pigments. The master had to make his own tools and so there were not many. Look at a modern catalogue of artists' materials and ask yourself what percentage of this was available to the great old masters. They had great souls, but the limitations of

their means certainly helped to prevent them dissipating themselves. With modern sophisticated materials all you ultimately need is a certain cleverness. But that needs to be searched out, and the overall result is not so outstanding. Juggling about with particularly attractive details destroys the balance. That is what the old masters had. You find the same brushstroke in the corner as on the face of the principal figure. They don't tie themselves in knots, and although they had no theory of composition they instinctively made their works harmonious. And they did not hold back their emotions. This is what I would like modern art to value: spatial distribution. It is so much better than composition and comes much closer to the ideals of the old masters, and for me it feels much less artificial (think of the idea of composing by the golden section), much more artistic, and much freer.[11]

The work by Giotto that Albers knew firsthand was a single magnificent panel in Berlin: the large *Death of the Virgin,* a tempera from circa 1310. This tympanum in what was then the Kaiser Friedrich Museum is a complex and delicately balanced arrangement of a crowd of characters. What Albers calls the "spatial distribution" has been achieved with such eloquence that the scene perfectly accommodates the broad triangular form for which it was made. The subtle colors, and the precision and flair with which the facial expressions and postures have been rendered, give great poignancy to the scene. The end of the life of the Holy Mother is both suitably sad and exquisite.

The overlapping in a graceful sequence of golden halos testifies to the supreme artistry of the early Italian master who, by the standards of the early twentieth century, was still considered a "primitive" rather than an artist of the Renaissance. Albers had studied Giotto's work through black-and-white reproductions, which is all that were then available, but the Berlin tympanum had been his only chance to observe the color orchestration the Italian had managed with his restricted palette. The young artist from Bottrop marveled at the way that Giotto's adjustment to certain limitations—the obtuse angle of the top of the panel, the dictates of his medium—enhance rather than diminish the result.

That take on Giotto's work was unusual. What Albers admired—the small number of hues, and Giotto's great reach in spite of shortcomings inherent in tempera and fresco, the only media available to him—were not the qualities most people first discerned in the Italian. The direct connection between the impact of the artwork and the realities of the technical means was vital. Without knowing it, at the very moment when Gropius

was formulating his ideas in a military tent, Albers was embracing what would be one of the fundamental principles of the Bauhaus.

4

For Albers, the calmness and grace of Giotto's work, achieved as much through the consistency of the brushstrokes as by the composition, exemplified the overriding control fundamental to good art. Equanimity through visual means would be a lifelong search for him and his future wife. He had no wish to imitate the appearance of Giotto's work, only to try to achieve its eloquent clarity in the language of the twentieth century.

Albers was, in the most traditional sense, a picture maker. His priority was always the creation of wonderful artworks. Like Gropius, he was a connoisseur of beauty, but for him it required a spiritual element. Much of what topped Albers's list of humankind's greatest creations had a deeply religious aspect. The deities varied—the Parthenon, Piero della Francesca's frescoes, and Machu Picchu were among his chosen masterpieces—but the attitude of worship was consistently vital.

As Albers formed his taste, Cézanne increasingly became the recent artist who mattered most to him. Once he received his certificate of good health, which allowed him to leave the sanatorium and resume teaching in the second half of 1916, he looked at Cézanne's work wherever he could. He zealously applied his discoveries to his own drawing and printmaking. There were good paintings by the Frenchman in the museum in Essen, and Albers also made return visits to Osthaus's collection in Hagen. He later said that this was the time when "Cézanne got into my bones."[12]

What he learned from Cézanne became the artistic priorities Albers would take to the Bauhaus. With his blocky forms and undisguised brushstrokes, Cézanne made human presences and physical matter more impressive and real than did the nineteenth-century academics who attempted a flawless verisimilitude of surfaces. Where the traditionalists were fussy, Cézanne was earthy. He disregarded everyone else's dictates, painted from the heart, and carved out flatness and three-dimensionality at the same time. He also presented colors boldly. Albers spoke of Cézanne's "unique and new articulation in painting. He was the first to develop color areas which produce both distinct and indistinct endings—areas connected and unconnected—areas with and without boundaries—as means of plastic organization. And, in order to prevent evenly painted areas from looking

flat and frontal, he used emphasized borders sparingly, mainly when he needed a spatial separation from adjacent color areas."[13] The acquisition of technical knowledge, the development of one's eye, the will to push one's art to an extreme and to brave the unprecedented: these were the main issues.

The notion of what was German, or in vogue, was irrelevant. Albers's priority was visual art of universal appeal and staying power. The German expressionist Max Beckmann, his countryman and contemporary, was his artistic nemesis; Albers had a physical loathing for the thick lines Beckmann used to divide colors, and considered them a trademark of incompetence and crudeness. Such lines stopped the special flow and prevented color from creating movement as it did in Cézanne's work; it also denied each hue the magical power to affect the tones to which it was adjacent. (Several years after Albers's death, when I was looking up a word in the dictionary he used, a handwritten note fell out from a page in the *s*'s; on it he had written " 'swindle' like Max Beckmann, who didn't know his colors.") In art as in his life, the housepainter's son was in search of harmony and subtlety. Precision, clearheadedness, and the discipline required for magic were his goals.

THEN ALBERS WITNESSED an extraordinary dance performance. *The Green Flute* was a three-act ballet with a libretto by Hugo von Hofmannsthal set to the music of Mozart. Max Reinhardt directed it as a sort of musical pantomime; the performers included Ernst Lubitsch as well as Isabella and Ruth Schwarzkopf.

From Bottrop, on November 19, 1916, Albers wrote Perdekamp:

Dear Franz! if you want to see something insanely crazy (in a good sense), enjoy good expressionist stage art, then you must be at the Düsseldorf City Theater tomorrow (Monday) evening at half past seven. They're presenting *The Green Flute* (by the Deutsches Theater, Berlin), a complete ballet with narration. I saw it on Friday in Duisburg. The greatest thing I have ever seen, the little old fairy tale is absorbed into something hugely dramatic and deeply *fantastic.* I could have screamed. In short: you have to see it! But the seats are very expensive. Try to be at the box office early. First try to get something in the stalls, seated or standing. Not the balcony! Rather standing in the stalls (that is already 5 marks!). I shall certainly be there—cost it what it may. In frenzied anticipation, best wishes

Yours, Jupp[14]

His enthusiasm inspired a series of drawings and lithographs based on the performance. They have a finesse and articulateness, as well as a Mozartian animation, that make them Albers's finest work up to that time. These

artistically restrained yet emotionally exuberant graphic images utilize lean, economical form to provide a succinct picture and create a powerful mood. With only the most essential lines and dashes, the *Green Flute* drawings and prints flow with a rapturous, graceful movement.

Celebration emerges from this work. Their mood is completely counter to the prevailing spirit of a grim mining town not far from the action of one of the worst wars the world had ever known. All of this would be essential to Albers's teaching at the Bauhaus and afterward: the ability of art to provide energy and joy as an antidote to a less felicitous reality, and the use of a bare minimum of elements to impart volumes of information.

LITERATURE BECAME another route to transport in this period when Albers was enjoying renewed physical health. On April 14, 1917, referring to a play by Reinhard Johannes Sorge, who had died the previous year at age twenty-four, he wrote Perdekamp:

> Sorge's *King David* has set me all aflame.
> I have never cheered so continuously while reading anything. He has *it:* a glowing temperament and iron discipline. Oh, the glorious sun in the first act. I was so absorbed that I thought I could play the young David myself, I had to act him (in mime).[15]

Albers was at the same time making self-portraits in which he depicted himself as a hollow-cheeked, psychologically haunted young man. In 1916, shortly after he left the sanatorium, he vigorously gouged linoleum to make his own profile ferocious. The piercing strokes and the harsh juxtaposition of concentrated, pitch-black ink and the white of the paper in the resultant print—evoke raw emotional force. Having mastered, as if by instinct, the ability to reconstruct and evoke his own appearance, transforming the flat sheet of paper so that the void appears contoured and rounded, authentically representing the bulges and indentations of a lean human head, while simultaneously using line and shape to create a violent energy, he invests himself with all the force of Sorge's David. Albers would shed this persona at the Bauhaus, where he structured and polished his art and became an elegant young man in spats, but he would not subdue the vehemence.

Albers continued, in his account to Perdekamp: "I was so absorbed that I forgot my *Mephisto.* And that means a lot to me: as I find it so difficult to get out of myself (and for that reason) so difficult to empathize with others: here I read with more assurance and confidence than ever before."[16]

"My *Mephisto*" was a reference to a small oil self-portrait in which he presents himself looking so grim and demonic that, when she saw the work

sixty-five years later, the elderly Anni Albers refused to authenticate it (see color plate 18). Although she finally acknowledged that she suspected the painting really was by and of Josef, who had died a few years before the canvas reemerged from the collection of one of his sister's heirs, Anni would not include it in the catalogue of his work because he looked "so unbearably tortured."

Why Mephisto? In the German literary tradition—Albers probably knew the character through Goethe rather than Christopher Marlowe—Mephistopheles (also known as Mephisto) is the devil summoned by Faustus in the presence of Lucifer. Mephisto is so hideous that Faustus orders him to assume the appearance of a Franciscan friar. Faustus then becomes immensely proud for having gotten the devil to succumb to his will; he fails to realize that Mephisto serves only Lucifer, the prince of devils. Faustus ultimately learns from Mephisto that hell is a state of mind, not a place.

There was nothing extraordinary about a gallivanting young man playing with the idea of himself as a diabolical creature dressed as a friar. Albers was determined to break away from the moral and artistic confines of his upbringing. He wanted to eradicate the past and live differently in every way. But the direction of his rebellion was uncertain. It would take the Bauhaus to give that rebellion a purpose.

WHAT GROPIUS ESTABLISHED in Weimar would be the catalyst for Albers's maturing. It was there that he would learn to combine his wish for self-control with his emotionalism—in his persona as in his art. New technologies and abstract form would be his means to let exuberance, somberness, tranquillity, euphoria, and other states of mind exist in single objects, fastidiously made. The psychological element, while as strong as in the letters to Perdekamp and the *Mephisto* self-portrait, would now be presented with balance and distance. And he would be given a new way to embrace the skills that were, in his eyes, the high point of his upbringing.

In the period before the Bauhaus opened its doors to him, however, Albers had two different, compartmentalized sides. At the same time as he was creating the harsh linoleum cuts, he was blatantly emulating Cézanne. Here he used the side of a lithographic crayon to construct a series of small adjacent planes that move us through the composition. Dexterously employing the ridges of the laid paper to enrich the gray tones, he leaves blank spaces to help build up the mass. The control and restraint are impressive. Every area reads clearly, and the picture surface and three-dimensional space interact dynamically.

The economy, and the play between flatness and depth, are of a piece with

the Mephistophelian work, however different the spirit. What would make Josef Albers the first student at the Bauhaus to become a teacher there was his consistent sureness and know-how even as he presented different emotional climates. All the work looks fresh and spontaneous, yet it has the presence of a building for which there have been a hundred blueprints.

In a large self-portrait lithograph that echoes Cézanne's work, there is a consistent rhythm, and every area has significance. Each stroke contributes to the physical solidity and the organic coherence. The mass of shoulder and chin and skull is clear and distinct. A solidity of character emerges as well. We see a believer in principles, newly capable and convinced of his own rightness. The self-doubts Albers revealed to Perdekamp and the anguish of his other images of himself are here under wraps. If this is Mephistopheles disguised as a friar, he wears his persona convincingly.

5

Like his future confreres at the Bauhaus, Josef Albers was painfully alert to his own feelings. Everything was extreme: his consciousness of himself, his awareness of the world around him, his faith that art was salvation.

Albers wrote Franz Perdekamp, "Elsewhere I know no pure or complete attention to anything but myself." He had been inspired by *The Green Flute* to think of Perdekamp's life and work. "I think that this is because of the clarity of this glorious dance. And the shining drunkenness of the dancer (R.J.S.) that gilds even the slightest Spanish footnotes."[17] R.J.S. was Ruth Schwartzkopf, who danced the part of the one of the princesses; "Spanish footnotes" was code for sensuality and exoticness. Perdekamp was the rare soul who lived in that same world of unabashed passion.

The young teacher from Bottrop felt beckoned from the emotional deadness of the milieu in which he had been raised. He described to his poet friend his awakening, albeit obliquely:

Now I sense how you must have felt about it. About him, who delivers so much of what I have wished for so long, and what (it seems to me) you also wish for.

Man, you have put the right thing in my hands, where everything feels so unreal to me. Where just before the Golem seemed to speak from my soul: "Night is there to be destroyed by our thoughts, only *then* does life begin." Before, I could not so easily rid myself of this

(and I don't want to); however, crystalline clarity does do one good. With grateful best wishes, from your Jupp[18]

What Perdekamp had in common with the unidentified "him" and what Albers joined him in desiring is unknown; what is certain, though, is that it involved unbridled feeling.

AS LONG AS GERMANY was still fighting, Albers had little chance to spread his wings to the extent he desired. He might scrounge the money for a ballet ticket, and at least he had the possibility of making art on paper, but he still craved greater change. On April 25, 1917, he wrote Perdekamp from Bottrop: "Voracious longing in me, haste right through me, stifling dark heaviness around me (screaming for a form!): it sears and shatters me with prickling unrest."[19]

The way out of that restlessness and beyond "the hell of my home" continued to be literature.[20] Albers was discovering the world he would soon enough be joining. He was captivated above all by two contemporary writers: Franz Werfel and Oskar Kokoschka, who was a playwright as well as a painter. Albers could not have anticipated that both of these men would be lovers of the wife of the founder of the institution he was soon to join, but he clearly felt the magnetic pull of the sophisticated, daring world they inhabited. On June 20, 1917, he wrote Perdekamp that he had read Werfel's *Wir sind* [We are]—it was "magnificent" and Euripedes' *Trojan Women* translation, which was to be presented in Düsseldorf. In Dresden they performed Kokoschka (directed by him). They say it had very good reviews. Man. A new age is dawning."[21]

Albers, though, was still in his "dark heaviness" of depression. On the back of the postcard where he reported these performances, he added, "I'm no use any more. I don't even enjoy a smoke. Can't really enjoy myself or let myself go. Maybe it's for the best."[22] Albers's vulnerability, which he carefully concealed in public, was a driving force behind his clean and logical designs. He longed to corral his wayward emotions. His approach to teaching, and his imposition of geometric order on the inherent disorder of the human mind, would enable him to achieve his goal. But, like Kandinsky, whatever the façade, he had the fire within.

TWO DAYS AFTER mailing the card that pitted manic joy against deep despair, Albers sent Perdekamp a poem, "The Mosquito Swarm." For the rest of his life, he would periodically write poetry, but he would never recapture the candor of this first known effort, with its leitmotif of independence and leadership, and, at its conclusion, the writer's powerful swipe at placing

value on the latest fashion and his defense of the notion of real rather than superficial progress:

All afloat (The Mosquito Swarm)

I see many men — many paths
Everywhere a restless to and fro
Or up and down
Without moving from the spot.
Each feels his place by sensing his neighbor
But if one wants to advance he cannot
attend to others,
must go differently from them — straight ahead
Likely he will be alone
But outside — though it be the death of him: —
he will feel the infinity of the universe —

Will the others ever follow?
(That need not trouble him)
Perhaps a later swarm will
(unconciously, not on his account,
maybe blown there by the wind)
reach his solitary place or follow his path
and perhaps then sense a new air

I see a second one,
who wants to tear the mass away from the spot
he must not fly straight ahead.
He would glide past the others and they would not notice him.
Only by perpetual slow tugging forward, moving up and down or right and left
Could he tow the others along his path
(But the many knocks in his neighbors' ribs and the leader's bruises
bring him down before his time.)

And yet there was a gothic time,
when the whole swarm moved forward
Maybe that was the result of a conjunction
Of many strong congenial leaders.
Later, though we still had very strong men
They were singular and unrelated
And did not give their time a great purpose.

Of the third kind who aim to achieve it smoothly,
My brief opinion is: cunning is not leadership
And a fashionable hairdo will not breathe new life
into an outmoded movement

And if we sense today
 a great common urge
And divine and hope for
 a new gothic age
(I just give the name Expressionism)
 That only gives us the
 involuntary unity
 *of many eyes "focused on infinity"*²³

These would be the values Albers would promulgate to hundreds of students every year at the Bauhaus: the need to set one's own course, the silliness and futility of trends, the dangers of "Expressionism."

Eyes needed to focus not "on infinity," but on what was near, finite, and comprehensible. Inner passions might burn, but emotionalism worn on one's sleeve was an unpardonable indulgence, a diversion from the search for clarity. Albers craved precise articulation. He believed that the overarching goal of communication must be the recipient's comprehension—even if what was being communicated was the inherent imprecision and mysteriousness of life. These standards would dominate Albers's thinking as a painter and a teacher for the rest of his life, especially when he and Anni became the first émigré Bauhauslers and Josef was, through his teaching, the primary transmitter of Bauhaus ideology to the New World.

ALBERS WAS DRINKING a lot in those days. On March 26, 1918, he wrote Perdekamp:

It was too delightful to sense health in Lersch and to see Winkler getting steadily grayer with the "Equals" and "Knockheads" (till I lightly stroked his little beard). How I got to bed I do not know. In the morning Mostert informed me that he had taken me to room 12 (afterward I remembered a green chaise longue) but that I had got into another room and crawled into Winkler's bed there. At 9 a.m. Lersch then recited Franz Werfel to me in his boat. All vague. Except this one thing: that Brinkman (who met me for the first time and who valued me for my ingratitude) threatened to smash my windows if I would not accept him.²⁴

What this was really all about—the sharing beds with other men—remains a mystery. Anni Albers was fascinated by homosexuality, male and female; Josef seemed completely uninterested.

When I knew him, Josef Albers was a very sensuous octogenarian, and by current standards out of control. After my first visit to the Alberses' house, Ruth Agoos, the beautiful woman who had taken me there, described a moment that afternoon when Anni and I were upstairs looking at Anni's prints and Albers invited her to see his latest *Homages to the Square.* They had no sooner stepped into his basement studio than Josef, gazing into Ruth's face, cupped both of his hands around her ample breasts, massaged them for a few seconds, and then just exclaimed, "Ach! Ja!"

When he had to go to New York for the initial meetings about his retrospective exhibition at the Metropolitan Museum of Art—the first ever given to a living American—Albers had a young driver who would take him to bars in Yorktown so that he could drink a schnapps and savor the sight of the young German waitresses. That was the extent of things, but when Josef was middle-aged, he had a series of love affairs, of which Anni was well aware. She was so insecure about herself as a woman that after Josef died she told me that one of her proudest moments in their fifty-year marriage was when Josef came to her saying he required her help to end a relationship with a mistress. Unable to shake off the woman with whom he had been involved, he needed his wife to step in; she willingly set up the necessary meeting and did so.

Albers associated homosexuality with weak art. His student Robert Rauschenberg (the Albers-Rauschenberg relationship merits a book in itself) was, he thought, a messy, out-of-control artist whose work garnered disproportionate attention; part of the problem was that the stars in the Rauschenberg–John Cage–Merce Cunningham galaxy struck him as something less than real men. (When asked by an interviewer how he felt about Rauschenberg's work, Albers replied, "I've had so many students, you can't expect me to remember all their names.")

He also made withering remarks to gay men. One day, a well-known textile designer and businessman who dressed and comported himself like a stand-up comic's version of a gay interior decorator came to pay a call on Anni. In the eyes of people who really knew the field, he was above all a clever fellow who had taken Anni's approach and made a fortune with it by creating commercially viable draperies and upholstery fabrics, then marketing them worldwide; with none of Anni's genius or originality, he had taken her ideas and made millions of dollars with them, while she probably never garnered as much as $100,000 in royalties in her entire life. None of this

bothered Anni, even as she acknowledged it, for she was beholden to the man for having enabled her to receive some major awards and for praising her at every opportunity. But the fellow was of no interest to Josef. He dressed too flamboyantly, and even if he was a cult figure to certain elements of the New York design world, to Josef he was neither an authentic human being—the man was too enchanted with gossip and big names—nor someone with creative genius. And, although Josef would not admit it, the man's lack of masculinity was unbearable to him. When the designer walked into the house, Josef waved hello to him from the kitchen but did not offer a real greeting. He had the air of a schoolmaster looking at a student he did not take very seriously. When he noticed that the man was wearing large, pink-tinted sunglasses beneath his wide-brimmed hat, he exclaimed, after addressing the man by his last name, "You look like a rabbit!" Josef then bustled by to go to his studio, making it clear that he had important work to do.

Once, during lunch at the Metropolitan Museum of Art, the openly homosexual curator Henry Geldzahler, whose father had been in the jewelry business, was wearing several rings, including a gold band with diamonds. Josef suddenly looked across the table at the moment when the diamonds caught the light and said, "Hen-ah-rheigh, zat ring is for a voman!" To this, Geldzahler grinned and calmly replied, "That's right, Josef." Both men were pleased to have made their points.

As for his drinking: he was one of those people who could go for long stretches without alcohol, then imbibe to excess. When Josef was in his eighties, the collector Joseph Hirshhorn knew that if he arrived at the Alberses' house with a bottle of Johnnie Walker Black Label scotch, he could leave at the end of the visit with a group of artworks at a significantly discounted price. Anni described an occasion at Black Mountain when Josef passed out on the front porch of the small wooden house they were living in. She decided to put him into his pajamas and drag him to bed. Again, where many women would have been furious, Anni delighted in being helpful. The great manipulator of textiles removed what her husband was wearing and eased him into his pajamas. When she was done, she stood and admired him on the wooden floor, thinking he looked "beautiful and innocent, calm like a mummy." She then realized the reason he resembled a mummy was that she had put both his legs into one pajama leg.

What exactly happened back in 1918 with Lersch and Winkler and Brinkmann is unclear. But there is no doubt that Albers was inebriated—and that, as was always the case throughout his life, whatever occurred, he appeared completely comfortable with himself. Although she had a sense of assurance when she wove or made prints, Anni Albers never enjoyed a feeling of self-confidence in her social interactions. Josef never lacked it.

IN THAT PERIOD just after World War I, Albers developed his draftsmanship further. He fine-tuned his ability to angle his lines and mete out their proportions so as to establish the volume of a head or the spatial configuration with nothing but a dash here and a stroke there. In his figure studies, he trained himself to present as few facts as possible—one line of one shoulder, the outline of its opposite hand—so that the viewer knows the entire pose and feels what he does not see.

A drawing of Perdekamp on plain brown paper brings his great friend to life simply and effectively. Albers had whittled his art down to basics: volume and plastic reality. He said a lot simply, as he would in the glass constructions he made in Dessau and, much later in life, in his series of nearly three thousand paintings, each composed of only three or four squares in identical relationship but offering an infinite range of visual experiences. The steady pencil profile line of Perdekamp's profile is masterful, and the hair and spectacles exemplify Albers's steely articulation. His ability to make flat paper a gently rounded head is nothing short of alchemy. The effectiveness of that visual conciseness was echoed by the inscription on this drawing—"Mein freund Perdekamp!"—with its out-of-character exclamation point, and the rare, euphorically scribed signature "a." Having achieved his objectives, Albers savored the victory.

TOWARD THE END OF 1919, Josef Albers managed at last to escape, for a second time, the hometown that oppressed him. With the war over, he was desperate to taste the wider world again as he had in Berlin. In October, having saved up sufficient funds, he went to Munich to study at the Royal Bavarian State School of Art.

He was following the footsteps of Klee and Kandinsky, although he did not yet know it. His painting professor at the Academy was Franz von Stuck, with whom Kandinsky and Klee had studied a decade earlier. At the Bauhaus, the three of them would agree that von Stuck's practice of having them draw from the nude had no value. Albers would further belittle von Stuck's method later in his life: "They teach them in front of naked girls to draw. When they called me to teach at Yale, I saved them 7,000 a year for models."[25] That absolute stance was part of how he presented himself to others, but it was as much a construction as were the geometric drawings he called "structural constellations," for to create his identity as an abstractionist, Albers hid his own past as a figurative artist. What he had drawn "in front of naked girls" had been central to his own formation just before he went to the Bauhaus.

Two months after Josef died, while I was helping Anni Albers organize the artwork he had left behind, I drove Anni to New Haven, Connecticut, about fifteen minutes from where she lived. She asked me to park in front of

a building that had previously been the headquarters of the Yale University Press, the publisher of Josef's great portfolio, *Interaction of Color*. Anni handed me a large bunch of keys and said that she thought Josef had a storage room in the basement, down a steep flight of stairs that she could not possibly manage. She asked me to go down there and see if there were any locked doors, and, if so, to determine if one of those keys could open it. She said the cellar would be so deserted that no on would even ask what I was doing. She was correct.

Twenty minutes later, when I returned to the car, I told Anni that she was completely right, and that I had just found a treasure trove that set my knees wobbling. On walking in, I had spotted, on top of a pile of magazines, a drawing by Paul Klee that was the first page of a folded letter Klee had written Josef. I then realized there was a sizable number of Josef's glass assemblages stored on racks, and I had happened onto a stack of photo collages; this was when I had my first glimpses of the Bauhauslers' summertime idyll near Biarritz. I had also found some file folders labeled "my early drawings"—and realized that Josef had been drawing nudes and landscape scenes right up until he went to the Bauhaus. Like someone concealing a crime he had committed long ago, he had saved them as carefully as he had kept his students and the rest of the public from knowing of their existence.

OVER THE NEXT FEW MONTHS, I returned regularly to that basement. Because Albers had dated a handful of the several hundred figurative drawings he had kept, it was possible to group them according to style and establish an approximate chronology for the work. It became clear that once he got to Munich, Albers drew more fluidly than ever before.

Von Stuck might be considered Munich's Bouguereau: a highly sentimental painter, stylized and embodying the latest short-lived chic. It is difficult to imagine what he could have taught Albers, who already knew basic technique, any more than one can see an impact of von Stuck on Klee or Kandinsky. But Albers mastered a fine calligraphic style in the course of that year, applying ink with a brush in a way that echoes Chinese drawing at its most refined. He had a new assuredness, and utilized a principle he had gleaned from Van Gogh's work: "The strokes of van Gogh, particularly in his portraits, always go with the form, the lines go down the nose, the lines follow the form. . . . I tried, indirectly, to do something similar. I was not copying Van Gogh; but afterwards I realized I was doing what he had done."[26]

In Munich, Albers developed the practice of tackling an identical subject in different media and of presenting a single subject from various vantage points. He drew a nude with a thick brush and ink, and then did the same pose, with the same black ink, but applying it with a fine-pointed pen. The

first drawing has a deep, basso voice; the second is a light soprano. While having his model remain absolutely still, Albers also shifted his position from her right for a first drawing, to her left for a second one, and then presented her squarely from behind in a third. The first image emphasizes the interior musculature of her back and torso, the next reveals more of her breasts, and the last of the three, in its descent farther down her bare buttocks, is, more than the other two, undeniably sensuous. Albers was realizing to what extent the issues of art were a matter of choice—not merely of the subject, but of the way we perceive it and the means with which we present it. The subject is incidental to the selection of medium and vantage point, and to the nuances of the artist's own attitude.

AMONG THOSE DRAWINGS that Josef Albers had concealed for more than fifty years were two that show a pair of nude figures. In one, the two naked people are dancing in an orgiastic frenzy; in the other, they embrace with their bodies pressed together. It's unfortunate that these drawings and photos were not known by the larger public during the artist's lifetime, because that knowledge would have prevented the clichéd thinking that has led viewers to miss the sensuality and fire that underlie all of Albers's work.

Albers certainly did not see either pose in von Stuck's class. The naked man in the dancing couple is a self-portrait; even though this may not seem obvious since he is seen from behind, he has Albers's identical head shape and haircut, the same thick neck, the same stocky build. Albers, who liked to dance, renders himself as perfectly in control. His posture and pose are confident and graceful. Doing what appears to be a tango, he is sturdy and dominating while at the same time calm and patient: an unbrutal master. He has his massive arms precisely where he wants them, and his bulging muscles function well. His feet are perfectly placed. This impressive specimen is a good dancer under whose steady guidance the woman is gyrating with pleasure. In the other drawing, a naked woman is being embraced by a second naked person we see from the rear and whose gender is indeterminate, although the hips and build suggest that it is a second female—an impression furthered by the hair, although not decisively. The two press their bodies against each other with tremendous physical and emotional force.

Loathing artists like Klimt and Schiele for their unconcealed eroticism, and even more for the excesses of their visual style, Albers was not going to risk the comparison, as he would have if he let the world see these images (and, we might imagine, many similar ones that have not survived). But, subject matter aside, they are, at heart, consistent with everything he would do once he arrived at the Bauhaus. They reveal a high level of concentration and a sure hand. They make clear how much Albers liked to tease and

manipulate, to force our imagination. We picture the passionate looks on the dancers' faces all the more forcefully because we cannot see them. Albers has us keyed up and stimulated rather than satiated. These deliberately enigmatic drawings anticipated the taste for unresolved mysteries that would underlie his teaching and his abstract work in Weimar and Dessau.

We cannot fathom everything at once; we feel the moment fleeting. The mood is one of expectancy and tension; the figures that join only at their hands are like the colors that touch only along shared boundaries in Albers's later art, yet are palpably connected beyond their physical contact because of the way they interpenetrate and create mysterious shadows and illusory afterimages. Albers would deny the value of drawing nudes, yet in his own figurative work, the very stuff he would conceal forever after, he was acquiring the force and integrity that would define him at the Bauhaus.

THE WOMAN DANCING with Albers was most likely Frieda Karsch, whom he called Friedel. Two years younger than Albers, she was from a rich family; her father was a prominent architect. Born in Münster, she had been sent to Ireland as a young girl as part of her parents' efforts to have her learn manners and become a society lady, but she returned wanting to take up a profession. Her parents would have nothing to do with the idea, so she ran away.

In Munich, Karsch sold her jewelry to have some money to live on. She arrived on the scene not long after Albers; in his first letter to Perdekamp, written a month after he arrived, he refers to a wonderful outing to the countryside with her. Karsch's presence, however, did not mitigate his despair over his new life. It cost a lot more to live in Munich than it had at home, and the money he had to pay for his classroom replacement while he was on leave added a sting. Worse still, he was experiencing a form of painter's block. From his cold rented room on Tuerkenstrasse, Albers wrote Perdekamp:

> I must write to you of my complaints to Elenah. I would have preferred to write earlier and differently, but I cannot get free of myself, and the outside world is wearing me down. I see myself as a last [violin] string stretched to breaking point. And cannot release itself. No one can get it to sound. Nor to break. Not until the peg screeches back and it hangs loosely in space. Beside the instrument. Then an invisible spiteful finger comes and tensions it to the utmost. And so on. Changing quickly or slowly. Unpredictably.
>
> Instead of doing something, I run around wildly. Do errands for others who put them to good use. Give the best advice, that brings rich profits. And steal myself from myself, so that I am left without time, money, or leisure.
>
> Oh damnation, to be able to tear my bound hands painfully free,

and the consciousness of having tied the bonds myself. So many obligations and considerations on all sides and such weakness.

I need to earn some money since I am so high and dry: the school office is demanding 1600 marks for a replacement for 4 months. According to that calculation I am left with 61 M[arks] for a whole year after 11 years' service with corresponding seniority and cost-of-living increases. And I could earn good money. But I dissipate time and energy. Annoyed by silly insufficiencies I fill my palette but just sit there with my head in my hands. Paint one stroke and lie down. Work out the finest financial plans but am the most unbusinesslike person where my own interests are concerned. And am always aware that the roll of money would crumble away before the bare necessities had been purchased. So much has already gone and I hardly know where except for a glass of good wine.

While the ugly words stuff, leather, food buzz around in my head, because they have to be materialized. I am not where my efforts would pay off, carry sacks of potatoes for other people. Don't send Merkauf the ordered pages, don't paint the promised portrait that would bring in something, because I let myself in for silly distractions, because other people want to have company.

All the best, your ill Juppi[27]

The Josef Albers whom the public—and even his closest acquaintances—later came to know would have none of that vulnerability or stymied capability. If he had any sense of inadequacy, he would keep it under wraps. But for now he was contending with a self who suffered extreme low points and skepticism, and who felt as fragile as the taut violin string he depicts in his overblown analogy.

It wasn't long, however, before life was looking up. Albers turned ebullient over the next couple of weeks, for reasons he explained to "Franz, Franz!":

And don't know whether I should rather be pleased or regret my last letter. For I am doing very well, since I already knew how many people were sympathetic to me. And it was nice to be able to be such a help to poor Friedel who coming from such a wealthy background now lives and eats so meagerly and has for so long been without not only ration cards but also coal and so freezes into the bargain. But doesn't want to return home, where they want her back and always send her money so late. And she can't come up to my room, so I carry bread and butter and baked apples out to her on the street and can only warm her with my hands. I may only carry a sack of coal just to her door. And play the

flute beneath her window in the evenings. Sunday mornings we go for a walk, out to Schömenmacher. Me and my little child. And then Christmas. That will be beautiful. Bright and warm and beautiful.

Your Jupp[28]

ALBERS WAS DEVELOPING a specialty in wealthy young women intrepid enough to break away from their families. He was also awakening to an idea alien to his upbringing: sybaritic pleasure.

The idea that art and creativity might be one's primary focus was revolutionary. In Bottrop, men got jobs, supported their families, and went to church; any enjoyment came mainly with schnapps. Albers was primed for something totally different. What the Bauhaus would be for him, as it was for Klee and Kandinsky, was not so much a place that pushed a particular philosophy and advocated modernism as a sanctuary in which to lead the good life and devote one's self full-time to the unusual priority of making and thinking about and teaching art without feeling that this was an inappropriate distraction from some other, more "real" work.

At that moment in Munich, Albers did not yet know what Gropius had just started in Weimar, but he was ready to make a radical shift in his life. His plan at first was to join a trip to America organized by Backhaus, the man about whom he had written Perdekamp. Then he intended to head east and go to India, and was trying to work out the details. It was time for a life-altering change:

Easter Sunday, 1920
Franz!
We have been in the mountains for the last three days, where it is quite glorious. Although Friedel's shoes have no heels anymore. But yesterday she wept for joy. . . .
Only one word comes to mind, "glorious." One really is lost for words in the presence of such overwhelming timelessness.—
Now something else: travel. . . . Do you know anybody who could make a donation of part of the money, that he will anyway soon have to pay as a unification tax, for a scientific expedition or artistic experiments. Or perhaps a loan.[29]

If no one would back his going to America or India, or to Constantinople and Alexandria—which he was also considering—he was open to any adventure where the bills could be paid.

IN THAT TIME PERIOD, however, the farthest Albers went was to the Bavarian Alps—with Friedel Karsch. Now he began, with a loaded brush, to draw

mountain peaks and chalets. These pictures of Alpine scenery soar with vitality. Art was a vessel for confidence. On July 5, he wrote Perdekamp a quick postcard:

> From a cool bower surrounded by mountains of gooseberries and cur-
> rants, birds chirping, cows mooing, dogs barking and distant boom-
> boom of the soldiers' homecoming dance, best wishes from your
> block-nosed and smoke-tongued,
>
> Jupp[30]

In his euphoria over nature's bounty and the sense of life opening up in new ways, Albers stumbled upon the four-page leaflet with Feininger's woodcut of a cathedral and Gropius's few paragraphs describing the Bauhaus. In a society where documents about the most minor matters could run on for pages, this concise brochure, with its single illustration and one page of text, offered everything the restless Bottrop schoolteacher was looking for: a fresh approach to existence, freedom from the shackles of tradition, a place to pursue art, the chance of financial security, and the unknown.

6

By that fall, a year after the Bauhaus had opened, Albers was there. He later wrote, "I was thirty-two, . . . threw all my old things out the window, started once more from the bottom. That was the best step I made in my life."[31] Gropius's workshops in Weimar were a chance to put Bottrop, figurative art, and—he initially thought—the need to teach behind him. He replaced a life of isolation and borderline poverty with sympathetic companionship and, at least, rudimentary room and board.

He took the foundation course required of all students. But he was older than most of the others, and already had his own ideas. In little time, Albers had invented a new art form. Unable to afford paints or canvas, he searched for free materials with which to make art. The Weimar city dump was not far from the Bauhaus; pickax in hand and rucksack on his back, he began to hack up discarded bottles and other bits of broken glass, and filled his pack with the fragments that interested him the most.

Back at the Bauhaus, he used lead and wire to assemble the shards into vibrant compositions. Albers extracted a radical and startling beauty from the detritus. The art he made was organized yet playful. With his unerring eye and instinct for visual rhythm, he constructed assemblages that were

harmonious and at the same time possessed of the unguarded exuberance of his happiest frolicking.

In that period of financial hardship and abrupt social change, many German artists were focusing on society's woes, making human suffering their primary subject matter. Albers organized the resurrected junkyard pickings into windows that sang. He mounted three of them on light boxes and hung others so they would be penetrated by daylight; the light pouring through them intensified that spirit of sheer pleasure.

Albers's initial exploration at the Bauhaus also included a print portfolio cover composed of oscillating horizontal rectangles, and some imaginative efforts to create wooden furniture. In the next thirteen years—he stayed at the school longer than anyone else—he would design and make tables and chairs, formulate new alphabets, plan buildings, use a camera in unprecedented ways, and progress from assembling broken bits of glass to stenciling and sandblasting flat panes of the material in compositions of mathematical rigor and great artistic power. Without the originality of Klee or the intellectual reach of Kandinsky, he would be the school's greatest polymath, proving his versatility in many domains. He would also become a gifted writer and public speaker who helped articulate for the larger public much that was vital to the Bauhaus approach, and the teacher whom Gropius credited above all others for furthering the school's educational mission.

WHEN EIGHTEEN-YEAR-OLD Marcel Breuer arrived at the Bauhaus in 1920, the first person he asked for was Johannes Itten. "I had to wait for a while and then he came out in the corridor. And I didn't tell him anything, it was obvious what I wanted."[32] Breuer, as Itten knew, had come as a new student and was trying to figure out what his first moves should be, given that the Bauhaus did not yet have much structure. Breuer presented the teacher of the foundation course with a small book of drawings he had made.

> He went through them this way: "Hmmm, hmmm . . . hmmm."
> He was a very arrogant man, you know, in the first moment I had an antipathy toward him. You know, it's a kind of importance tactic. . . . He believed in himself . . . very much . . . Mrs. Mahler, who was Gropius's wife at that time, she knew Itten and she thought this is an interesting man and he made an impression of an interesting man. And the shaved head . . . He was originally Swiss, Itten, and had been a painter, and had in Vienna a private art school, and then Gropius invited him to come with him to the Bauhaus.

Describing his very first day in Weimar forty years after the fact, Breuer recalled how, feeling like an outsider as a Hungarian Jew, his loneliness and

uncertainty were exacerbated by Itten's treatment of him. But Breuer did not lose hope. He decided to go into the glass workshop. There he encountered a tall man in a military cape and pointed black hat who picked up a large brush and splattered paint all over a piece of metal. This was Papp, another Hungarian.

Breuer saw a piece of paper on the door. His was one of the three names written on it. But because he knew little German, he did not understand why.

> So I asked the guy who was next to me, what does that mean? I somehow stuttered it out. He understood what I meant. He said something like . . . "You are the man who on that week has to keep order in the classroom."
>
> I said, "I don't understand." And he had seen that I didn't understand much, so he said, "Take a brush and a broom and sweep the floor." "What is a broom?"

The stranger reached for a broom and handed it to Breuer. It was Albers, who had arrived at the school only shortly before Breuer. Simply by dint of being approachable and down-to-earth, the carpenter's son from Bottrop had already assumed a unique position at the Bauhaus.

IN JANUARY 1921, Albers wrote Franz Perdekamp from Weimar, "So often or so many times I have wanted to write to you about so many things, but the way things go here, either all the liveliness here stops me writing about our young people or an upset stomach about over-rich Christmas parcels. Or cold compresses about grotesque love affairs. In short there is too little boredom, so that I had to work out that my first new year's resolution would have to be to give up letter writing. The following idea also popped into my head: ban all women." He told Perdekamp that he was in an "expensive but great apartment" but needed money. He had been forced to borrow money from friends "because the canteen cash in my purse had dwindled so much. So: things go wildly up and down. So much so that I need to apply the brakes. . . . About my old surroundings, the new people and the Bauhaus. Probably a lot needs to be broken. And possibly it will be worse because it should have been broken long ago."[33]

The detritus he was hacking up in the Weimar dump could be seen as a metaphor for the preconceptions—his own and his father's—that he was shattering. The octogenarian Josef Albers I knew disapproved vehemently of the notion of art as autobiography; nonetheless, his work often reflected his own needs and his psychological state. The glass assemblages were analogous to what the Bauhaus facilitated: destruction and resurrection. Coaxing beauty from what to others was nothing but refuse, he demonstrated the

possibility of transformation that was one of the Bauhaus's greatest offerings. (See color plate 19.)

ALBERS'S TEACHER for the Bauhaus preliminary course was Gertrud Grunow, a musician who taught under Itten's supervision. Albers wrote Perdekamp about the liberating effect of her educational method: "You cannot give it a name. It is about loosening up of people. . . . You have to walk in tones or experience them while standing, move in colors and light and form."[34] A single course sufficed, however. It was not in Albers's nature to study under someone else. On February 7, 1921, he was one of three students who applied to be exempted from the preliminary drawing course. He was granted his wish on the basis of his work with Grunow, which was considered exceptional.

Eager as he now was to enter a workshop, Albers was not sure he could afford to remain in Weimar. He was still a student, even if he didn't act like one, and had no money coming in beyond his regular stipend from the regional teaching system back in Bottrop, which was diminished by what he had to pay them back for his absence.

He wrote the officials in Westphalia asking for more support for his training at the Bauhaus. He claimed it would make him a better instructor when he returned to teaching in Bottrop—although he had no intention of honoring his agreement to go back. The Bauhaus masters, meanwhile, told the habitué of the junkyard that his glasswork was not an acceptable artistic medium and that he had to study wall painting. He refused, jeopardizing his future even more.

At the end of the second semester, Gropius "reminded me several times, as was his duty, that I could not stay at the Bauhaus if I persisted in ignoring the advice of my teachers to engage first of all in the wall-painting class."[35] Treating the director's threat as just another challenge, Albers continued to work only with bottle shards on flattened tin cans and wire screens. Then, at the end of his second semester, he was required to exhibit his work to date.

"I felt that the show would be my swan song at the Bauhaus," he later recalled. In fact, it was the reverse. Following the presentation of his assemblages of painted bottle bottoms and other glass fragments he had hacked up, he received a letter from the Masters' Council not only informing him that he could continue his studies but asking him to set up a larger facility for working in glass at the school. "Thus suddenly I got my own glass workshop and it was not long before I got orders for glass windows."[36]

BETWEEN 1922 AND 1924, Albers made a window for the reception room of the director's office at the Weimar Bauhaus (see color plate 21). A mosaic of syn-

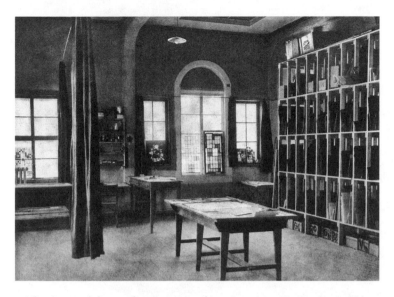

*The glass workshop at the Weimar Bauhaus, ca. 1923. Having been told by
the Bauhaus Masters' Council that if he worked only in glass he would not be
allowed to remain at the school, Albers showed such originality and mastery
of the medium that they ended up asking him to run the glass workshop
and to be one of the first students to serve as a master.*

copating rectangles, it glowed a vibrant red, with other colors quickening
the pulse. To everyone who entered that room, the mélange of forms
instantly conveyed the energy and optimism of the new institution. This
was not the only Albers work that greeted visitors waiting to see Gropius.
He also made a large table and a shelf for magazines and catalogues, both
composed of lively arrangements of contrasting light and dark woods. There
was a complex storage unit, constructed from white milk glass and stainless
steel, that turned a corner. Albers's unusual glass lighting fixture depended
on a recently developed clear bulb, while his row of folding seats looked like
something out of an ancient monastery. All of these objects used right
angles and bold planes to create a lively rhythm. At the same time they sub-
tly provided a sense of orderliness, for their measurements were all based on
the use of a single underlying unit. In the corner cabinet, the shelves were
precisely two centimeters thick; the recesses in the glass doors were two cen-
timeters wide; and every other dimension was a multiple or precise fraction
of two centimeters. The result is a soothing feeling of stable underpinnings:
an important message to impart, given the crosscurrents of difficulty at the
Bauhaus.

These pieces were in the vernacular of the other Bauhaus craftsmen, but
Albers brought to his designs his own eye for simplicity, purpose, and scale.

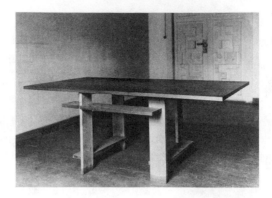

*Lucia Moholy-Nagy, photograph showing a table
designed by Josef Albers for the reception room to
Walter Gropius's office, ca. 1923. Albers's furniture
depended upon minimal elements that were measured
as precisely as the notes of a work of classical music.*

His furniture was not startlingly original, but it was refined in a particular way. And in adding the dash of art to these functional objects, Albers had made a major leap forward.

Albers's designs are distinctive in both their relative airiness and their sureness of form. The voids have a sculptural richness. Planes interlock in crisp rhythm. The way in which elemental shapes embrace and respond to one another clearly betrays the painter's eye. The corner cupboard was wonderfully inventive in details like its concealed liquor storage, but its juxtapositions of forms and materials were equally surprising. What Albers made was practical, but it also betrayed a rare inventiveness and artistic eye, and a courageous yet seemingly effortless originality, that were among the most vital goals of the Bauhaus.

IN *GRID MOUNTED,* a glasswork of that period, Albers applied a principle he had discerned in Giotto's work. He built the whole out of minimal vocabulary of form, confining himself to a single unit of construction. What necessity imposed on the Italian, Albers imposed on himself. It was the same principle by which Klee limited himself to only a few colors, or to variations of a single form. In *Grid Mounted,* Albers deliberately used, as his sole means, glassmakers' samples that he filed down to small, uniform squares. He then organized these like components in a checkerboard pattern and bound them together with fine copper wire within a heavy iron grille.

Itten had used the checkerboard pattern as a teaching tool in his preliminary course, but Albers applied his own alchemy to the motif. Candid as it is in material and technique, the underlying units a tradesman's means of

showing types of glass for sale, in a range of hues and textures, *Grid Mounted* has a celestial radiance. The color juxtapositions create vigorous movement, and the lively interplay has a spiritual force, a sense of something miraculous occurring, as in Giotto's *Annunciation* scenes. Having thrown himself into the making of this work with the enthusiasm of one who has found his way, Albers breathed life into the grid.

This was Josef Albers's particular contribution to the Bauhaus: manifest in his glasswork, his functional objects, and his teaching. He deliberately built an orderly, well-regulated universe in which one both subscribed to rules and exercised one's imagination. The tied-down squares of color in *Grid Mounted* are full of surprises, free-spirited within their very rigid boundaries. Again, an abstract artwork was uncannily like its maker. It appears grounded in the practical—the craftsman's manipulation of color and texture—but it is jubilant. On the surface, Albers adhered to accepted standards of comportment—he had nothing to do with the Mazdaist eccentricities of the Ittenites—but in his work he dared the outrageous. *Grid Mounted* is euphoria within the confines of structure.

LIKE KANDINSKY THAT SAME YEAR, Albers was hoping he would have the funds for a new pair of shoes. On March 22, he wrote Perdekamp:

> Dear Franz! I have not thought about the shoe purchase for a long time. I expected to get money from home, but nothing doing. And so I do not have the ready money. And then it seems to me they would be more like mountain boots. But I want to be able to wear them as "good shoes." So I can't make up my mind.[37]

He was also uncertain about what his position at the Bauhaus would be, and whether he would find his niche there. He had made strides in his own work, but it wasn't clear which workshop he should be in, and what he should be doing. At Itten's beckoning, he was teaching the Bauhaus foundation course, but he considered his role as an educator only a temporary gig; he preferred making things, even if he lacked the support to do so exclusively.

During that period of unanswered questions, Albers encountered the intensely determined, strong-willed Annelise Fleischmann. The twenty-two-year-old daughter of a prosperous Berlin furniture manufacturer and of a woman whose family owned the largest publishing company in the world, Fleischmann had opted to leave behind her parents' luxurious way of life, and their notion that she should settle down to a life of domestic ease like her mother's. When she and Josef first met, she had not yet been accepted at the Bauhaus.

Josef was blond and outgoing; Annelise was dark-haired and brooding. She was smarting because Oskar Kokoschka had turned her down when she went to Dresden, her portfolio under her arm, to study art with him. "Why don't you go home and become a housewife?" Alma Mahler Gropius's lover had asked. Determined nonetheless to devote her life to art, she then enrolled in the School for Applied Arts in Hamburg, but left after deciding it was nothing more than "needlepoint for ladies."[38] Having persuaded her parents to let her go to the Bauhaus, she was turned down in her first attempt for admission. By then, she and Josef had met, and she was in no hurry to return to Berlin.

Josef offered to guide Annelise with some of the basic exercises in folding paper so that she might have a better chance on her second go-around. This time she was admitted. The heiress still was not certain, however, of where she stood with the man whom she described as "a lean, half-starved Westphalian with irresistible blond bangs."[39]

There was a Bauhaus Christmas party at the end of 1922. Annelise attended dutifully, sat in the back of the room, and girded herself to get through an event where no one would notice her presence. Not only was she a newcomer; she was, in her own view, a perpetual outsider. She was certain that Father Christmas—Walter Gropius dressed as Santa Claus—would have nothing for her as he called out the names on the cards attached to his pile of gifts. Annelise was so surprised to hear her own name that she thought it was a mistake. But people were staring in her direction, waiting for her to get up, and she realized she should step forward to receive her gift. It was a print, rolled up, with a gold ribbon around it, of Giotto's *Flight into Egypt*. Attached to that image from Giotto's fresco cycle in Padua was a card with Josef Albers's name on it.

The scene of the Virgin Mary on a donkey, the infant Jesus in her arms, with the triangulated mountain behind them perfectly echoing the form of the figures on the animal, embodied the harmony and beauty for which Annelise was longing. Josef knew the effect his gift would have. Besides, Friedel Karsch had, in August 1922, married Franz Perdekamp—to whom Albers had introduced her in Munich.

Josef had no shortage of women in his life—the ones who periodically made him swear off other members of the opposite sex—but Annelise Fleischmann was different. She had his consuming dedication to art, and a rare strength and intelligence. She had striking looks; while she wasn't pretty, she had an utterly fascinating face. She was pensive and observant; little escaped her. She also offered access to another stratum of German society, although her background made her intensely uncomfortable. Josef's attraction to a Jewish woman who wanted to devote her life to art and was

eager to abandon the expected female role further distinguished him from almost everybody with whom he had grown up. Yet again he was making an extraordinary choice.

WHEN JOHANNES ITTEN LEFT the Bauhaus at the start of 1923, Albers was relieved. He thought that the teaching he had been doing at Itten's request would come to an end, enabling him to concentrate his energies on his own work. But after Itten's departure, Gropius came into the glass workshop at a moment when it was full of students and, in front of all of them, said to Albers, " 'You are going to teach the basic course.' " Albers later recalled the dialogue precisely: "I said, 'What? I'm glad to have teaching behind me; I don't want to do it any more.' . . . He put me in his arms and said, 'Do me the favor, you are the man to do it.' He persuaded me. He wanted me to teach handicraft, because coming from a handicraft background on my mother's side and also on my father's side, I was always very interested in producing practical things. Gropius said 'You take the newcomers and introduce them to handicraft.' "[40]

He felt he had no choice.

Albers had found Itten's preliminary course "at first quite stimulating," but he came to dislike the teacher's "emphasis on personality." It bothered Albers that Itten's presence was "terribly dominant."[41] Albers abhorred anything he considered disorderly or self-indulgent. He felt that character quirks should be concealed; a clear sense of purpose, and the appearance of harmony and balance, were essential in personal comportment and in art. He could hardly be expected to like the blatant eccentric who taught in a burgundy red clown's costume and practiced Mazdaist rites.

Itten's worst flaw in Albers's eyes was that he was a bad painter. His work had a relentlessly deliberate spirituality, but to look at it was not a spiritual experience. The opportunity to make up for Itten's weaknesses was irresistible. The mission Gropius gave Albers was "to counter the remnants of slack student attendance and mystical preoccupations in the wake of Itten's departure" and to overcome "the reigning desultory attitudes."[42] In the fall of 1923, Albers began teaching eighteen hours a week—more than anyone else at the Bauhaus, even if he had to be off campus—mostly in the mornings. To his surprise, what he undertook reluctantly quickly became a consuming passion.

When toward the end of his first term he changed the course name from "Principles of Craft" to "Principles of Design," it was because he was teaching a general approach to form that utterly captivated him. Emphasizing the need for visual clarity while simultaneously exalting the possibilities for visual trickery, Albers had found himself.

OFFICIALLY, HOWEVER, he was in limbo. Following Itten's departure, László Moholy-Nagy had been appointed head of the preliminary course. For Albers to assume a position on the faculty, a second vacancy was required, but no one else was leaving. He was relegated to give his workshop in the Reithaus, a fifteen-minute walk from the main Bauhaus buildings.

The Reithaus, on the banks of the tree-lined River Ilm, had been built by the Grand Duke of Weimar. A former riding academy, it was not where students expected to go to learn about art. But if Albers felt like a second-class citizen for having been put there, at least his classroom had large windows that let in ample daylight. The windows also served to let in the students; the low-level bureaucrats who worked in the government offices above complained about the way the young people in Albers's class would noisily climb in and out.

It irritated Albers that Moholy-Nagy, who arrived at the Bauhaus after him, had been made head of the course because of his seniority and past experience. Half a century later, Moholy's name always elicited scorn and prompted Albers to remind people that the Bauhaus should not be glorified. The conflicts, power struggles, and hurt feelings there were the same as at any other institution, Josef and Anni both insisted; no place or organization, including the Bauhaus or Black Mountain College, where they were for sixteen years after the Bauhaus closed, was as interesting as art itself.

7

I was taken to meet the Alberses for the first time on a fall day in 1970. In my mind's eye, the last surviving Bauhaus masters would live in a sleek, flat-roofed house, glistening white, with a band of industrial windows. I imagined them appearing on a balcony railed in stovepipe—just like the ones I had seen in photos of the Dessau headquarters of the revolutionary art school. They would eat lean, geometrically organized food—possibly in keeping with the Mazdaist rules of vegetarianism—and drink tea poured from one of Marianne Brandt's streamlined metal teapots.

This was one of the many ways I had pictured a very different encounter from the one I had. I certainly had not anticipated that within a couple of hours I would watch Anni Albers put Kentucky Fried Chicken out on a three-tier hospital-style rolling cart, explaining, with her soft voice and German-accented English, that it was always essential to specify "extra-kahrispy"—in order to have chicken like the classic Viennese version. Nor had I imagined that the former Annelise Fleischmann would arrange that take-out chicken

on her perfectly plain white Rosenthal porcelain plates in a way that created a lunch with an aesthetic harmony I had never before witnessed.

Nor had it occurred to me that in extolling the merits of Heinz ketchup and observing the charming emphasis on "fifty-seven" as the fixed number of the company's "varieties," making me consider the excellence of a glass bottle properly shaped to fit into the palm of one's hand, Josef Albers would lead me to an understanding of the goals of the Bauhaus. This was my way in to an appreciation for the Bauhaus's fundamental values: knowledge of materials, the need for an object to be designed according to its purpose and executed with a respect for human scale, the willingness of businesspeople as well as artists to devote themselves to bettering the experience of others, and the real emotional benefits of such intelligent, moral, generous thinking.

All that I knew was that the Alberses had been associated with a lot that was pioneering in twentieth-century art. Josef's *Homages to the Square* had made such an impact on modern painting that he was soon to be the first living artist to be given a solo retrospective at the Metropolitan Museum of Art in New York. Shortly after the end of World War II, Anni had been the first weaver to have a one-person show at the Museum of Modern Art, and had subsequently become an innovative printmaker. I looked forward to encountering living history, but I did not yet grasp what the lives of serious artists were like.

As I went off on that autumn day nearly forty years ago to meet the only remaining gods of the Bauhaus, I looked forward to the encounter with combined thrill and anxiety. But I did not imagine that my eyes would be opened to an entirely new way of seeing. Nor did I realize that with Anni and Josef, and the link they gave me to Klee and Kandinsky and the architects who led the Bauhaus, I would glimpse the humor and pain and the everyday realities as well as the consuming goals of the great Bauhauslers. More important still, I would discover that dedication to one's passion, and the celebration and attenuation of what is wonderful in life, could become the fulcrum of earthly existence. The immersion in the visual world, not as something peripheral but as the central issue of one's being, was strong enough to assure not merely one's survival but an abiding sense of joy.

TURNING THE CORNER from a divided state road onto the Alberses' winding residential street in the suburban Connecticut town of Orange, fifteen minutes from New Haven, I could have been anywhere in America, but I still expected to end up at a streamlined modernist villa with the style and perfection of a movie set. Instead, we turned into the driveway of an awkward, raised-ranch house, its wooden shingles stained the flat beige of Band-Aids, its slanted roof covered with the same asphalt as every other house on the block (see color plate 23). I was astonished by its ordinariness.

But the exterior of the Alberses' house did have some startling elements. The graceless pair of standard rolling garage doors, the first thing that faced us when we stopped the car, had their windows painted out, as if to conceal something important. (I would later discover that there was a treasure trove of paintings behind them.) And the concrete foundation around the perimeter of the house was bare. Whereas most people shielded such foundations behind shrubbery, the Alberses had elected to leave exposed a rough, off-white expanse that conjured images of diggers and cement mixers and boldly acknowledged the demands of building in a climate with frost.

Perceptive visitors noticed. Joseph Hirshhorn, the collector and museum founder, went to the homes of many artists, as well as to those of his rich friends. He told me later that he could not get over the impact of that absence of foundation planting.

The barebones American idiom that suggested L.L. Bean ruggedness more than the international style of Gropius and Mies was deceptive. For, as I would come to learn through the Alberses, this unusual place was more emblematic of Bauhaus values than I initially realized. Its true simplicity and the use of standardized components made this shingle-covered raised ranch the perfect extension of the values of the art school that was one of the glories of Weimar Germany. The way that house facilitated the work and creativity of its residents, and made possible a pleasant standard of everyday living, achieved a Bauhaus ideal.

The essence of the Bauhaus workshops in glass and metalwork and furniture, all of which Josef was in, and of textiles, where Anni ended up, and glass and ceramics, had nothing to do with a set style. The importance of Bauhaus ideology was in the way it addressed the connection between our surroundings and our feelings. Morality, emotion, religion, humor: all could be echoed and nourished by what we look at and touch.

The Alberses exemplified this spirit in ways that were, like this house in Connecticut, surprisingly usual and completely unusual at the same time. Josef and Anni were direct and unaffected in their manners; they bought their groceries at the large local supermarket as well as at the more upscale family-owned market nearer by; they went to nearby discount stores and knew the ins and outs of the nearest strip mall. It's just that as they did these ordinary things they brought magic to the experience, through their astuteness and powers of observation. Moreover, when they returned to their studios from their errands in Middle America, they made art that was poetic, original, and inestimably rich.

RUTH AGOOS, the friend who had brought me to Bauhaus North, was a collector of the Alberses' work whom I had first met because her daughter and I taught tennis together in New Hampshire during the summers when I was

at Columbia College. Now studying art history at Yale Graduate School, I was intimidated by the prospect of meeting these gods of modernism who were two generations older than me. Wanting to get everything right, I had tried to dress neatly for the introduction to these artists whose work was so impeccable, but my car had failed to start, and while hammering the fuel pump with a rock, I had gotten grease all over my one respectable pair of corduroys. My nerves were jangled as we walked in.

Knowing that the Alberses did not negotiate steps easily, Ruth had rung the bell and then opened the door on her own so that they did not have to come down the half flight of stairs between the main floor of the house and the entrance. As we stood in the entranceway and looked up over the scuffed white risers and worn wooden treads, Josef materialized first, from a corridor, with Anni following him. As soon as they were standing side by side, it was apparent that the immaculately dressed pair were almost the same height, about five-foot-seven. They could have been brother and sister — or a priest and a nun at a church parish house.

Josef greeted Ruth warmly. Not only did she collect his work and have the impressive cleavage that he found irresistible, but she was exotic in a Gauguin-like way, and he lit up at the sight of her. Resembling Spencer Tracy with his shock of straight white hair, he then took a moment to study me. He was polite, his speaking manner carefully modulated, but there was something slightly Teutonic in the way he immediately asked, "What do you do, boy?"

"I'm studying art history at Yale, sir."

"Do you like it, boy?"

What should I do with this question? Albers had asked it with an edge to his voice, as if he were trying to penetrate to the truth.

I had just started my second year of graduate school, benefiting from a full fellowship that I would have hated to lose in an era when everything seemed up for grabs because of the Vietnam War. Albers had been chairman of the Department of Design at Yale through most of the 1950s. I feared that, with someone so high up in the university power structure (or so I falsely assumed, having no idea that Albers considered himself a renegade who had been victimized by power-hungry inferior faculty members and their hidebound backers in the upper ranks of precisely the sort of institution he had spent his whole life challenging), I risked losing my foothold. But my interlocutor's direct manner invited an equally candid response.

"No, sir, I really don't."

"Why not, boy?" I explained that I was being forced to research the minutiae of iconography, that for a course on Seurat I was consigned to a library basement to learn about gas lighting fixtures in nineteenth-century France, and that when I asked my professor about the color relationships in

A Sunday on La Grande Jatte, or about how Seurat applied his pencil to the textured paper on which he often drew, I had been reprimanded for the irrelevance of those questions to the subject matter of the course, which was exclusively socioeconomic. I told Albers I was afraid that my passion for art was being eroded. The effect of this sort of education was that when I now went into museums, rather than having the direct visual responses that had until now made me want to devote my life to art, I was tending merely to process information.

"This I like, boy. Which of those bastards in art history don't you like?" We discussed a couple of well-known names in the department at Yale, and then Albers asked me the key question: "What does your father do?"

I wanted to tell him what my mother did. My mother was a painter— I had grown up with a studio in the house, redolent with the smell of oil paint—which I thought would be of greater relevance than Dad's profession. But I sensed that my questioner cared far more about my male lineage.

"My father's a printer, sir."

"Good, boy, then you know something about something. You're not just an art historian." I suddenly had the feeling that the grease stains on my corduroys, making me resemble a car mechanic more than a graduate student, had not done me any harm in Albers's eyes.

I WAS SO TRANSFIXED that I cannot remember at which moment in the conversation we had walked up the stairs to where Josef was standing, the statuesque Anni silent but beaming at his side. I had never before encountered someone so visibly possessed by his beliefs, and who gave of himself so totally. Both he and Anni—she was commanding and radiant even while saying little—appeared to be partaking of the richness of life to an extent I had not previously witnessed.

I felt that if I remained receptive, I might be taken into their world. Josef clearly had absolute opinions, but what was equally apparent was that, while issues like the craft of printing and the irrelevance of much art history obsessed him, and he knew he was set apart from most people, he was open and receptive, and eager for connection. He engaged with the totality of someone who was interested in *giving.* He thought of himself as a vessel of ideas, not an eminence; being privy to the miracle of art and of visual experience, he was determined that others have similar pleasures. He and Anni were the real thing.

THE MAN I ENCOUNTERED that day in 1970 was in many respects unchanged from the person who had started giving the Bauhaus foundation course in 1923. Albers followed a teaching method and approach he had developed even before Moholy-Nagy joined the staff, and which he considered superior

to Moholy's ideas. He deemed Moholy's teaching, like the man himself, confused and unpleasant. His own teaching was, in contrast, an extension of the training he had received from his father, and therefore eminently sensible. He determined that the physical properties of the components of one's work should be the starting point. While he believed that Itten went no further than texture—Albers often compared himself favorably to his contemporaries, stressing not just that they were second-rate, but also that they were morally corrupt—he was determined to investigate the *real* properties of materials. He would recall telling his students, "Let's try what we can do new with wire. Give it a new shape, what can we do with matches, what can we do with matchboxes in a project. And then later I introduced the study of paper, what [*sic*] was at that time considered a wrapping material." He exposed the students, he explained, to "the most important craft materials, such as wood, metal, glass, stone, textiles, and paint, and to an understanding of their relationships as well as the difference between them. In this way we tried . . . to develop an understanding of the fundamental properties of materials and of the principles of construction."[43]

Albers had the students work with their hands with materials ranging from paper to steel, with rock that was resistant to cutting and rock that quickly crumbled, and with a diversity of artistic media. He also arranged for them to observe professionals using various techniques. "We visited the workshops of box, chair, and basket makers, of carpenters and cabinetmakers, of coopers and cartwrights, in order to learn the different possibilities of using, treating, and joining wood."[44] The students were then assigned to make objects, among them storage containers and toys and toy furniture, first from a single material and then from various materials combined. Once they had achieved the necessary mastery, he encouraged inventiveness, but the know-how came first.

IN THE EARLY 1970S, half a century after he taught this use of materials in Weimar, Josef Albers had a favorite restaurant on the Boston Post Road, in the strip mall nearest his home. It was called the Plank House; even the name appealed to him, with its straightforward reference to solid materials.

The Plank House—which Albers pronounced "zee puh-lehnckhaus"—was part of a chain, a forerunner of the restaurants that have proliferated since, with a menu that consisted mainly of broiled steaks and a copious salad bar. It also featured an offering of fish sturdy enough to stand up to firing on a sizzling grill, which fascinated Albers because it showed an understanding of the chemical components and structures of the fish in relation to the way its flesh responded to heat, and also because he liked swordfish. What has since become a restaurant cliché seemed, at the time, excitingly inventive, and it was to the Plank House that Anni and Josef would take Henri Cartier-

Bresson, Lord Snowden, Henry Geldzahler, Maximilian Schell, and the other interesting visitors who came to see the master in his modest studio. The regular lunch crowd of bank tellers and car salesmen seemed impervious to the colorful art world figures who arrived with the elderly German couple in their dark green Mercedes 240 SL, while the Alberses marveled at every detail of this ordinary slice of American life.

On one of these state occasions when I was lucky enough to be invited along, the first thing Josef pointed out was the laminated tables. Their heavy wood veneer tops were coated in a thick layer of shiny polyurethane. Josef liked to rub his hand across the surface, saying it was a perfect use of technology, because it was comfortable to eat on, satisfying to look at with the wood grain shining through, and, most important of all, easy to clean. With one wipe of a damp sponge after every use, it always looked brand-new, he explained with unabashed joy—the same delight with which Anni, discussing new materials, would say, "I *love* 'drip-dry.' "

Josef also admired the salad bar. For this, there were many reasons. The clear plastic domed shield that served the purposes of hygiene while one looked at the produce was, again, a perfect match of a modern material with multiple goals. The array of salads and condiments thrilled him—especially the pickled beets and the various seeds, which reminded him of some of the tastes and textures of his youth. But what was best of all was the way that the serving bowls and the plates were all kept chilled. He noted particularly how the metal containers retained their coldness even longer than other vessels.

He didn't just make casual comments about these details; he marveled at them. They reflected an intelligence, a knowledge, and a clarity of thought that had, he told me, been the very essence of what he had tried to impart at the Bauhaus.

8

In January 1924, Albers was obliged to return to teach a semester in Bottrop, in order to retain essential funding from the regional school system there. When he came back to Weimar, he devoted himself with renewed purpose to the foundation courses he gave. He was disgruntled, however, by the amount of time his students had to spend on their homework for their other courses, mostly in technical drawing. He protested in writing to Gropius, who forwarded his complaint to Klee, Kandinsky, Moholy-Nagy, and Schreyer, urging them to lighten the load so that the students could do

justice to their work with Albers. Everyone agreed, and Albers's course became central to Bauhaus education.

Albers described himself in Weimar as uninterested in decrees "from some higher direction . . . independent . . . alone." He went his own way, educating by encouraging experimentation, and by personally exemplifying traditional skills combined with independent thinking. Albers admired that same level of artistic passion and free thinking in three of his colleagues. Years later, in a 1968 radio interview with the BBC, he explained:

> Klee, Kandinsky and Schlemmer . . . were masters in this sense, that they didn't give a damn for their old masters. They did not look backward or read books before they went to class. They had developed themselves and therefore they were able to develop others. . . . I have never taught art, I think. What I have taught is philosophy. I have never taught painting. Instead I have taught seeing.[45]

Not that Albers was in the same echelon as Klee, Kandinsky, or Schlemmer at the Weimar Bauhaus. They were older than he was and had already proven themselves as artists; he had not. But he was on a steep learning curve. Of all the Bauhaus students, Albers had a fire and conviction—and an originality—that put him closer to being in the same league as his heroes.

Klee's poetry and sense of the cosmic were unique, and Kandinsky's spirituality and ability to pair abstraction with sound made him unlike anyone else. Gropius was apart in his multidimensionality, his extreme diplomatic grace and prodigious energy combined with a sense of conviction. Schlemmer was talented not only as a painter but as a choreographer, besides being a pithy observer of the cast of characters at the Bauhaus. Josef Albers, though less formed than they were, was distinguished by his rare combination of rigor and adventurousness, and by a ceaseless energy that enabled him to achieve a lot and enjoy himself fully while never appearing to have made enormous effort.

By 1924, Albers's accomplishments in glasswork and his furniture designs had made him one of the star students at the school. But above all it was the impact of his teaching, which caused him to be, even while he was not officially on the faculty, one of the most influential people at the Bauhaus. His ideas were not as original as Klee's or Kandinsky's, but the way in which he delivered them made him uniquely effective as a teacher. He used language succinctly, and students felt the tremendous joy that could result from the skillful manipulation of materials and the creation of artistic form. Albers had fire in his eyes. With the force of a great preacher, he made complex ideas simple, so that his intoxication with seeing became

contagious. As the situation of the Bauhaus in Weimar became immensely precarious, more and more people turned to him for guidance.

At that time, however, Albers was not even sure if he wanted to stay on. That October, he wrote the Perdekamps:

> Dear Franz, dear Friedel,
>
> There's a great rumpus here. Pro and contra louder and louder. Whether we shall pull through or not is unclear or perhaps clear. We are getting an enormous number of expressions of strong support from all over the place.
>
> I think that if we are allowed to stay we need to find a better atmosphere. I want us to succeed again so that we can take off for some other place so much the more splendidly. I am thinking of the West. A move will cost us a year, but that may help overcome internal defects. Of which there are not a few. Perhaps only the spirit should survive. So many people are thinking of their own legs in the spring. You have probably already heard that all masters have been given notice.[46]

What was telling was that, even as he considered going his own way, he had become enough a part of the Bauhaus community to say "we." And he was unusually sanguine through the ups and downs of the institution. Albers dealt with life's events the way he adjusted to the requirements and realities of the wood he was joining into intricate shelf units, or the glass he was cutting and mounting for windows. The goal was to do one's best with whatever the reality was, without losing sight of one's artistic goal.

He believed that the dismissal of the masters was just temporary, and that the negotiations to keep the Bauhaus in Weimar had a fair chance of success. Nonetheless, he favored pursuing the idea of the school moving to Cologne, as Konrad Adenauer had suggested. The priority, whatever was happening, was to maintain one's perspective and keep making art. While he was not yet officially on the faculty, in spite of his doing more active teaching than anyone else, Albers was already proving himself to be one of the most stable personalities at the Bauhaus. He was completely alert to the conflicts within the school as well as the challenges from the outside to Gropius, yet he soldiered on cheerfully, assuring the Perdekamps, "We have a lot of work ahead of us and feel secure."

For a special Bauhaus issue of the magazine *Young People,* published that November, Albers became a spokesman for the school. There was, as he described it to the Perdekamps, "a revolutionary essay written by me: 'Historical or Present,' in which school and youth movement and Bauhaus are projected in one line." In that essay, he further articulated his credo of respectful independence. "If we adopt the corrective action of freeing our-

selves from history, to be able to walk on our own two feet, and to speak with our own mouths, we need not fear disrupting organized development." He advocated "freeing ourselves from the conceit of individuality and from received knowledge." Albers believed that such an approach would lead to "becoming united."[47]

Similarities of human dwellings, clothing, and household objects produced by machines would, Albers wrote, lead to a better way of life. That was one of the objectives of the Bauhaus; the growth of each human being was another: "Schools should allow much learning to occur, i.e., teach little. May each individual be given the widest latitude to explore his options, so that he finds the place that suits him best in working life. The Bauhaus is pursuing a path toward this goal."[48]

In this early essay, Albers expressed his desire for everything to lead toward "construction as synthesis. . . . Our desire for the simplest, clearest form will make people more united, life more real, and therefore more essential."[49] Albers's embrace of rational thought and the belief in the removal of excess were always in service of those higher purposes. He sought to use arts education as the means to achieve greater harmony among individuals and a deeper understanding of the inherent wonder of life. He had the charisma to convince others that this was possible. The schoolteacher from Bottrop became the Bauhaus's first homegrown deity.

MOST OF THE MAJOR BAUHAUSLERS had their angels in the outside world. For Kandinsky, it was Galka Scheyer; for Klee it was, above all, his dealer Goltz, in combination with his devoted sister Mathilde. Albers's ambassador and source of financial support, Franz Perdekamp, had far less importance in the art world, but he still provided the emotional and practical sustenance that enabled Albers to go on. In that period of the early 1920s when inflation was most dire, Perdekamp sent him small amounts of money. Like Kandinsky with Scheyer, Albers wanted to make sure it represented an exchange and was not just a gift. He wrote his friend, saying he hoped Perdekamp had "subtracted the necessary bottles for the art dealers. This is most important to me. If you did not, please catch up on this." ("Bottles" was Albers's way of discussing commission money, which could be used to buy *doppelkörn,* or other libations.) At the same time, he was eager not just to sell his own work, but to help the Bauhaus in general: "If you know somebody who wants to build a house, please get him interested in us. We will organize everything."

In Hamburg, Albers had met a Mrs. Monkeborg, who lectured at Hamburg University and who "reinforced my belief that young Catholics are the best basis for our new efforts. I would like to meet with them in the West. Who is the director of the 'Weißer Reiter'? Are there any other major

groups and any individual big guns?"[50] The Weißer Reiter—White Rider—was an organization in Bavaria that focused on Jesus as the prophet. Albers believed that this religious group might support Bauhaus modernism, and he also shared their faith.

Neither Albers's family nor the regional teaching system in Westphalia approved of his self-imposed exile, but he was increasingly sure it was the right decision.

> At home they seem to be very disappointed that I am not coming back. I am only sorry that I may have to disappoint them further. Life is after all terribly hard and yet wonderful. Recently I have been a little down. But otherwise I feel very confident. And I am enjoying the mutual education in my preparatory course enormously. Write soon and tell me all about you and Friedel and the children. Long live life.
>
> Your Jupp [51]

BY DECEMBER, life at the Weimar Bauhaus no longer seemed tenable. Josef and Anni and Marcel Breuer were considering starting off on their own.

He wrote the Perdekamps:

> My dear chums,
>
> It is really nice of you to send me something again. I feel myself strongly in your debt and I know that you do not have all that much yourselves. It has become terribly difficult to stay here. My relations with Gropius and the Bauhaus ideal have shifted so far that I shall have to roll out the heavy artillery. It emerged in a meeting today that I am financially the worst off of all and that there seems to be no possibility of an improvement. For me it is now critical to think of leaving and finding something better elsewhere. Anke [Anni], Lajko [Breuer], and I are thinking of trying to set up on our own in Berlin or somewhere else. . . .
>
> I don't think anyone believed in the Bauhaus ideal as much as I did. But I see the inifinite possibilities that are available here draining away because nobody believes in a financial change for the better. I can't give you all the details. Perhaps the start of the letter does not indicate clearly enough [that] it is not just one thing that is causing me to leave. For a long time all efforts here have been expended on wasting all our resources polishing the façade and it is impossible to combat the internal tuberculosis.
>
> As I said, it cannot go on like this. What would be needed is a thorough reform, starting in particular with improving personal relations. But nobody sees this as a possibility.

Perhaps it may be possible to get more people together somewhere else, and find better ways of cooperating without harmful centralization, based on individual independence.[52]

Albers's next communication to his friends was from the small island of Sylt, in the North Sea off the coast of Schleswig-Holstein. He was in high spirits, had gained weight, and now knew that the Bauhaus would relocate to Dessau, where he would have a real teaching position and a large workshop in which to make glassworks. Yet again the Bauhaus was a source of hope.

9

On May 12, 1925, Albers sent the Perdekamps a postcard that showed the lobby of the luxurious Hotel Bellevue in Dresden. He wrote, "My dear friends, now I have entered it, namely the haven of marital bliss. And on the reverse side our 'Lucky Ship.' Wedding on Saturday we have to be back in Dessau today—Tuesday—because the term starts tomorrow. Best Jupp."[53] Underneath the signature was written "the wife."

When the Bauhaus moved to Dessau, Albers had been officially appointed to the Bauhaus faculty. The guarantee of a respectable position and a regular salary enabled him to ask Anni's father for her hand in marriage. His life and his work were soaring.

In the provisional headquarters in the Bauhaus's new location, and then in the spectacular new building, Albers would teach basic design. Gropius would later recall his impact as an educator:

In Dessau, Albers had the very rare quality of a teacher who treated every student in a different way. When the student was unsure of himself and he couldn't swim yet so to speak, he pushed him into the water and when he started drowning, then he rescued him and he was open to give advice. . . . He was the very best teacher I could imagine as he brought the student to himself. Imitation was taboo and he brought him down to earth and developed him out of his own qualities. We recognized at the Bauhaus that every human being is completely different from the other, so the aim of the whole system which he used was to provide an education which is individualistic as possible: Getting everything out of that single individual which is given him by nature.

We developed really quite an understanding with anything we do—whether it's a painting, a building, or a chair or anything we have to study the human being using that. That is the starting point. Not this or that aesthetic idea. This is the true functionalism.[54]

For Gropius, it was Albers who most successfully convinced the students that this was so.

FOR HIS OWN ART, Albers now invented a technique in which layers of opaque glass were fused or flashed together and an abstract geometric design was then sandblasted out of the top layer. The actual fabrication was done by professional artisans, but under his direction. Albers started by coating a sheet of pure white milk glass with a hair-thin layer of glass in a second color: red, yellow, black, blue, or gray. The front color was melted on by blowing the glass a second time. On top of it, the artist placed a stencil cut from paper. He did the sandblasting with a compressed air blower that resembled a water pistol; it released, at high force, a spray of many fine particles of sand. That treatment removed all those areas of the surface that the stencil left exposed. Then Albers took off the stencil and added another color with paint (often a glass painter's black iron oxide). Finally, he baked the entire piece in a kiln to make the paint permanent. He varied the method, sometimes blasting a shiny black front to achieve a dull dark gray rather than allowing it to go all the way through to the white. This was no easy feat; it required going far enough but not too far, and maintaining uniformity. (See color plate 20.)

The technique warranted the time and patience involved because it enabled Albers to achieve his desired results. Sandblasting through a stencil created sharp contours. Those perfectly straight lines gave crispness to Albers's lively abstract compositions, in which right angles and parallel stripes were arranged to create nonstop rhythm. The method also facilitated a subtle textural play: some surfaces could be matte and grainy, others smooth and glistening, with both types perfectly uniform within themselves.

The lessons Albers had gleaned from Giotto could be seen in his work. Thriving on limitations—as he would, later in his life, with the *Homages to the Square*—he achieved the rich reduction to essentials about which he had written in his essay. Of his new method, he declared: "The color and form possibilities are very limited. But the unusual color intensity, the purest white and deepest black and the necessary preciseness as well as the flatness of the design elements offer an unusual and particular material and form effect."[55]

Applying himself with the rigor befitting a member of a medieval guild, Albers began a sort of serial work that would in time influence the next gen-

eration of artists. He made closely related constructions, sometimes with only a single element varying between them, so that the sole difference between two pieces might be that one had a short line the other lacked. He also made works that were identical in form, with only their colors being different. Producing two glass constructions that were completely the same except that what was blue in one was red in another, he demonstrated that the variation in color, and in nothing else, causes surprising differences in the viewer's perception of the works. The pieces have totally different rhythms when they are seen side by side. The identical square appears larger when it is red than when it is blue. What appears in front and what appears behind it is totally contrary in the two works; so is the pace of movement.

What a luxury it was to indulge himself with the subtleties of fine art and refine his vision. The pursuit of these nuances, profound in their effect, became his obsession.

THE MATERIAL OF GLASS and the method of sandblasting enabled Albers to achieve the detachment and control he considered requisite for the optimal functioning of color and form. Hue and line had their own independent voices; Albers's own hand was not evident. Even if a few brush marks showed in the parts he painted in black and baked, those strokes were no more revealing than housepaint, and the mechanical method removed "personal handwriting"—as Albers called the undesirable imposition of the individual self. This deliberate avoidance of certain truths of human existence permitted visual performance not unlike the perfect playing of a Mozart symphony, with the orchestra working in tandem, the instruments perfectly tuned, the conductor's baton unifying the whole.

Albers's right angles and carefully measured rectangles are triumphant. He explained, "Abiding equilibrium is achieved through opposition and is expressed by the straight line (limit of the plastic means) in its principal opposition, i.e., the right angle."[56] The encapsulation of this premeditated man-made harmony uplifts the viewer.

Sometimes Albers did not even execute the pieces himself. Rather, he designed them in his studio and had them made in a commercial workshop in Leipzig. The resultant works are like cut jewels: simultaneously pristine and radiant. With their intense sheen, they do not belong to the realm of everyday textures and substances.

The most traditionally religious of the Bauhaus masters, still a practicing Catholic, Albers had used the medium of church windows in an unprecedented way. He applied a relatively modern technique (sandblasting had been around for a while but had not been put to this exact use) and the completely new visual vocabulary of geometric abstraction to a material traditionally representative of miracles. The passage of light through glass and

the consequent creation of glowing color is analogous to the immaculate conception. This was the metaphoric role of glass as made clear by a medieval hymn:

> *As the sunbeam, through the glass*
> *Passeth but not breaketh*
> *So the Virgin, as she was,*
> *Virgin still remaineth.*[57]

Glass evoked the light and brightness born of Christianity; more specifically, it symbolized the birth of Christ. Albers was attuned to that sacredness: his sense of the cosmic was vital to him. Light and color, their radiance, and the magic of their effects were intensely spiritual.

Having made a window for Saint Michael's church in Bottrop shortly after he got out of the sanatorium in 1916, Albers had long been aware of the medium. With his radical use of multilayered glass, he fixed abstraction into confident materiality, and gave interlocking lines and solids a holy force. The abstract, the spiritual, and the physical were all aligned, rather than seen in their usual opposition.

More than Klee or Kandinsky, Albers believed in careful meditation and exacting execution as elements of art. But he was on the same quest. By using such a radiant substance, he created the pulse as well as the mystery that was essential to these revelers in human experience.

10

To be concerned exclusively with relations, while creating them and seeking their equilibrium in art and in life, that is the good work of today, and that is to prepare the future," Albers wrote.[58] He had no doubt that to approach art with integrity went hand in hand with how one addressed everything else in life. Balance and temperance were vital; so was enthusiasm. If in his personal relationships, other than with Perdekamp and Anni, Albers was a shade remote, he made a conscious effort to get along not only with everyone at the Bauhaus, but even with the family members back in Bottrop with whom he shared so few interests. His goal in his human connections was consistent with that of his art and design work: to guide others to the visual pleasures to which he was privy.

Among his Bauhaus colleagues, Albers spent a lot of time with Kandinsky, a friendship they maintained with an intense exchange of letters after

the closing of the school. They did not, however, reveal personal intimacies to each other. What Albers wanted, more than the storminess inevitable in truly close human relationships, was a quality of equilibrium, a mutual support—which suited the very private Kandinsky.

With his desire to avoid disturbances in life, Albers remained deliberately distant from politics. He avoided anything associated with Communism during Hannes Meyer's reign in Dessau. In America, in the 1960s, he declined to join an exhibition of work by artists opposed to the Vietnam War, saying he felt a debt to the policies of the government that had offered him and Anni a safe harbor when they fled Germany. (In that instance, what he considered "respectful" antagonized many in the art world, affecting the market for his work and his overall artistic reputation in a liberal milieu that not only endorsed such protest but expected it.) Rather than argue with people, Albers would express anger and then walk away. What for him was the satisfactory resolution of a problem was a source of hurt feelings for others.

Albers ultimately had rifts with almost all of his former colleagues. In the case of Marcel Breuer, he would come to feel wronged, and while he stayed in touch with Bayer and Feininger, he never went out of his way to see them, although they maintained their connections at a distance. Albers seemed to require detachment in order to focus all his energy on his work, and he often assumed a superior position, cloaked in modesty that made his reserve come easily. He did not feud with Mies van der Rohe—they were never close enough for there to be a reason—but he claimed that, when Mies was in Chicago, his collection of Klee paintings faded because of all the cigar smoke and gin fumes in the apartment. Unlike Anni, Josef wasn't bothered by any of the schisms, even by a dreadful feud with his last printmakers, Sewell Sillman and Norman Ives, whom he initially intended to manage his legacy. Ives had a terrible automobile accident after their split. When eighty-six-year-old Josef and seventy-five-year-old Anni learned of it, they drove to the local hospital and delivered a card to the nursing station but did not visit the patient, who was just down the hall. This was Josef's idea of equilibrium.

Albers's retreat to essential solitude and his well-tempered but relatively cool connections with family were, like his eschewal of his own hand in his work, a means of staying pure by avoiding anything disruptive. His art did, indeed, represent his ideal for how the individual should integrate with society—by maintaining the same independence and the well-regulated interdependence he gave to colors and forms. Mondrian wrote that "equilibrium, through a contrasting and neutralizing opposition, annihilates individuals as particular personalities."[59] That balancing act, in painting as in human interaction, was Albers's objective.

FORTUNATELY, when he was at the Bauhaus, Albers confided more deeply in the Perdekamps than he did in most of his friends later on, so we have a record of his inner life. The recently discovered letters let us see the fire and vulnerability and humor he was intent on concealing. On New Year's Day 1928, from the Hotel Zum Löwen, in Oberstdorf (Allgäu), a resort in the Bavarian mountains, Albers wrote to those exceptional friends who were allowed behind the façade, and who evoked the warmth he generally kept in reserve:

Dear Franz
Dear Friedel
We are so far apart that we have rarely been able to hear each other. So today I must shout more loudly. First of all our best wishes for the 28th. That you may be happy. Your children well. Your house in order. Your work satisfying.

I have the feeling that we have told each other very little since the summer holidays. There was a lot to tell. Anni had a kidney problem, which troubled her for a long time and has still not quite gone away. At the Bauhaus there have been internal and external frictions. The internal ones due to the obligatory autumn student revolt. External ones with the press. City elections in which we were the point of contention. Slurs as usual but on the other hand unexpected interest. Over 12,000 visitors in the last year. From all over the place. But the financial situation is very difficult. Everywhere lack of money, space, time. Everyone had to do their bit. For me it is relatively easier than for the other Junior Masters because I have no workshop, but if I could not frequently get to Berlin I would probably already be more rigid.

This year I shall be 40. So I must make my mark soon. I have two aims for the coming year. A pedagogical text about my teaching method, just aims and results, and an exhibition of my new glass pictures. That will be a lot of work. I must not let this book evaporate like my planned one on "Functional Formulas," for which I still have a lot of material.

In my classes I have developed a new method of teaching design, which is generating a lot of interest and attention here. I am after all supposed to be a pedagogue.[60]

Albers had, he told his friend, as many as seventy students per term. He was also creating what he called "wall pictures in glass," for which he invented a form that his friend Ludwig Grote, director of the Dessau Museum, termed the "thermometer" style—an expression the nonchalance of which Albers liked and used forever after. He had a commission for large

windows at the Grassi Museum in Leipzig, and had been asked to make proposals for windows in the lecture halls of the new Folkwang Museum in Essen as well as for a modern church in Berlin, all in keeping with Gropius's wish for Bauhaus work to be broadly disseminated. Albers continued his letter:

> So I have boasted enough, because business is not what I really want. I would much rather sit quietly to one side and occupy myself with my experiments and investigations into form. Not too long, and then back to business, preferably in Berlin, which is getting a fabulously modern look. We are always dreaming of erecting a shanty hut there.
>
> As yet we are a long way from there.
>
> For the moment we need to air ourselves here, especially Anni, who is still not fully recovered.
>
> Every morning we go skiing, although the snow here sometimes fails us. We have to trek ½ an hour and only find crusted snow, falling on which (and that is what we are best at so far) can be quite painful, but afterward one is out of breath, tired and hungry so that it is wonderful to lie down again.
>
> How are your children? How many will there shortly be? I have heard nothing from Andres. Give him my regards if you see him and also the Hunkemöllers. I have indirectly heard that Alois Bürger had blood poisoning and lost a finger. Natz Becker has died.
>
> My sister Lisbeth has got married. I not only hear very little about how things end up, but almost nothing from the West. But I have made a note to send you some photos soon, so that you can see that it only seems that way.
>
> So have a happy 28th and all our best wishes from your Alberses[61]

This was the dash with which Albers was proceeding in life. As was true for Klee, his marriage provided a stable base that enabled him to put the greater part of his prodigious energy into making art, designing, and teaching.

Albers's wish to transform the world visually, to modernize it intelligently, consumed him. In February, he sent Perdekamp a postcard:

> Dear Franz. There are certainly reservations about flat roofs. Namely for the reason that our builders do not want to do a high-quality job. There are different methods of constructing a flat roof. But the most important thing is that it is done conscientiously and thoroughly. Here in our area it works well if it has been properly constructed. The cleverest method seems to me to be the one Le Corbusier used in

Stuttgart. He says that too much movement of the reinforced concrete due to heat and cold can cause cracks, he covers the waterproof membrane with a rain-dampened layer of sand which he covers with concrete slabs. Grass grows in the gaps (c. 5 cm). He has flower beds with direct connection to the layer of sand. So it always has the same humidity. The contractors: Durumfix-Roofing Ed Klar and Co Ltd, Stuttgart, Ulmer Str 147.[62]

Albers continued on the back of the card:

A steel house built according to your own plans would probably come much more expensive. Or you would have to adopt ready made plans, and they are unlikely to have several stories. Exterior *and* interior plastering? That doesn't seem right to me. It must be the most significant thing about steel houses, that plastering is not necessary: dry assembly.

"Experiments" are really thankless unless the contractors are trained and interested. So I advise you not to try things with the walls that are not well-known in the area. The flat roof will also cost more, but it adds space. With a house the interior is the most important thing. Use plain *standardized* doors without panels. Plain fittings and handles. The Planning Department in Frankfurt has good used ones. Plain walls, sharp corners, no molding on the ceilings. A large surface is the most beautiful thing about a room, as the ancients knew from the Egyptians to Pompeii and up till Schinkel, then it went wrong.

Simple, simple, simple. Empty space is the most beautiful thing !!!!!!!!!!! Best wishes, the children must soon be well, Jupp[63]

Albers was as adamant about these points half a century later as when he wrote Perdekamp. He was outraged by the flat roofs his old colleague Breuer had put on houses in Connecticut, because they were not engineered to withstand the snow and ice of New England winters. The emphasis on "design" rather than effectiveness was, Albers remarked, "the problem with architects," which was why he "preferred engineers." And the need for standardization was essential. Breuer had designed a school with seventeen different sizes of windowpane, many of which had to be custom-cut. Albers was appalled. Especially at a school, where "children playing ball can be expected to break windows," it was imperative, he felt, to have only one or two sizes of windowpane, even if they were multiplied in different configurations, "so the janitor can keep them in stock and easily replace them."[64]

It wasn't just that he had opinions; he was passionate about these issues of

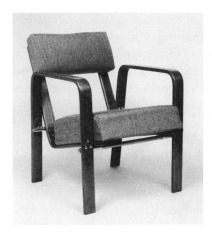

A chair that Albers designed in 1929, which could be broken down for easy shipping, was featured in an exhibition of the latest Bauhaus products.

right and wrong. Albers, who often described himself as "a frustrated architect," felt that illogical design choices that made people's lives unnecessarily difficult were immoral. He found the falseness of postmodernist façades, just coming into vogue at the end of his lifetime, an inexcusable lie.

Albers himself never lied. He just became silent if Anni asked him a question he didn't want to answer.

ALBERS'S CHAIR OF 1929 exemplified his beliefs. It was made of units that could readily be assembled and disassembled and could fit into a tidy flat box for shipping. These pieces of bent laminated wood—veneers molded around matrixes and glued—were as thick as they were wide. This was not an original idea—knockdown chairs had been made and sold through catalogues since the nineteenth century, and other designers had worked in bent laminates—but what distinguished Albers's work was the subtlety of its proportions and the perpetual flow of its gracefully modulated right angles. That aesthetic grace combined with functionalism was rare. Albers brought the painter's eye to the crafts. He made objects that had the meticulousness, and the splendid sense of measure, of his glass constructions. Thus fulfilling his concept of moral form, he gave harmony to the everyday act of sitting.

A person sitting in this chair acquires something of Albers's own attitude toward life. Held upright, ready to read attentively or to talk alertly, the user is impressed by a quality of decisiveness. The chair is not tough or hostile—the seat is cushioned, the wood smooth—but it encourages alertness; one does not slump.

While the supporting elements provide essential structure, a cantilever causes a slight oscillation. The result is that the chair is steady yet vibrant, grounded yet floating, so the experience of being in it is at once earthly and fanciful. And whether one simply feels that life is in order or allows one's mind to wander, the correctness of the proportions and the logic of the material impart a sense of rightness and, therefore, well-being.

Albers's design was in deliberate contrast to the furniture of Mies van der Rohe, which Albers knew well. Mies's seating and tables are emphatically elegant. His Barcelona chair of 1929 was a modern version of a throne; for all of its purported simplicity, it connotes grandeur. The materials of Mies's tables are fine and expensive, the chrome polished and shiny, the marble the richest travertine. Albers used stovepipe and structural steel brackets. Rather than employ saddlemaker's leather, he chose a modest, easily cleanable textile. Artistic flair was evident not in the lavish choice of expensive materials, but in the proportions, which cost nothing. That approach realized Gropius's original ideal: design that would work for the masses.

He honored the dictates of the wood and steel and glass he used for everyday objects, but he also manipulated them. For a fruit bowl, Albers measured and fit contrasting materials to render them ethereal. Wooden bearing balls, a sphere of glass, and a chrome frame—impeccably machined parts put to rare domestic use—create a container with a spirit and visual harmony that made the mechanical lovely.

Albers also designed a hotel room and two kiosks for the Ullstein Publishing Company, which was owned by Anni's family. The kiosks were never built, but the hotel room was assembled on the second floor of a house Mies van der Rohe built for an exhibition in Berlin. Anni Albers's brother recalled that on the wall there was a map of the city of Berlin, so visitors could find their way. This bit of logic, which garnered his young brother-in-law's admiration, was a perfect Albers touch.

ONE AFTERNOON when I arrived at the Alberses' house, Josef had me join him in his studio right away. He had just solved a major problem and was eager to tell me about it.

At the Bauhaus, he explained, he had designed an alphabet in which every letter was constructed from small squares and circles or fractions thereof. These were the only components allowed.

Having drawn the letters, he also made them out of white milk glass, cutting the geometric components out of a sheet about a centimeter thick. This was so they could be used in relief. The arrangement was such that if these letters were applied to outdoor surfaces, neither falling snow nor dead leaves would get stuck on them. Rather, they would fall through the letters, which had vertical slits and concave, never convex, shapes at their tops.

Besides having in common with Klee's work the artist's self-imposed restriction to a bare minimum of underlying units, the "Kombinations-schrift" adhered to these inviolable rules. Thus Albers outsmarted nature.

At the Bauhaus, however, Josef had never been able to resolve the letter Z. He had tried reversing the S, but deemed the mirror image of the S's right-angled triangles and semicircles not quite fluid. Now, after all these years, he had figured it out, and designed a Z that satisfied him. He had drawn it in pencil on top of a photograph of the original glass alphabet he cut at the Bauhaus. Looking triumphant, he showed me the new Z, and then handed me the photograph. "Here, Nick. You are the keeper of the Z."

I tried not to overread the moment, but I took the responsibility seriously.

IN ALBERS'S TEA GLASSES, two ebony handles, each half of a flat disk, one verti-cal and one horizontal, are attached to a curved stainless steel band that holds the glass cup under its slightly flared lip. Here Albers was accommo-dating the way in which human beings instinctively pass or receive small objects. He explained to me, with considerable satisfaction, that for the per-son handing over the tea glass, it made sense to hold the horizontal handle, while the recipient did better with the vertical one. To deduce this, he had studied the way people cocked their wrists and used their fingers. That attentiveness to everyday experience, with its implicit reverence for human capability, was fundamental to Bauhaus thought. This was Josef Albers's vital message: "Observe! Celebrate! Apply your intelligence to every act! Make the most of things. Relish the moment."

YEARS AFTER GOING to America, Albers wrote, in English, about a conversation he had with Kandinsky in the time period when he was making these objects and advancing his work in glass:

> *Kandinsky*
> *in one of our talks*
> *we had on our way home*
> *from the classes at the Bauhaus*
> *to the Meisterhäuser on the Stresemann-Allee —*
> *he told me about his belief about great art.*
> *That he believed that no real work of art*
> *had been lost.*
>> *Because: First they are done so well that they will last*
>> *Second, they have been appreciated to such an*
>> *extent that every care was taken to*
>> *preserve them.*

This truly is the philosophy of a
true artist.
It throws shadows on those who declare:
I don't care whether my work lasts or not!
It answers also the question
who is a sincere artist.

In this connection
I remember also
that he always painted in full suit
without smock or apron
and I believe that he never
spoiled a canvas.[65]

By the time Albers wrote this, he had fled Germany; he had also had the devastating experience of finding that a number of his own glass constructions had been broken by U.S. Customs authorities, resulting from sloppiness in removing them from their meticulous packing, when these fragile objects arrived in America a few months after he and Anni did. But he still kept and repaired them, and believed he could order his life no matter what. Doing things well, staying neat and orderly, and maintaining optimism were essential.

11

On April 22, 1928, from the Dessau Bauhaus, Albers gave the Perdekamps an insider's view of the uncertainties there:

Dear Franz. Dear Friedel

Today I want to write from under a blue sky. Because we got into the rain while cycling today and had to sit outside a long time.

The holidays are over and the return here from Berlin was not easy for me. Dessau is too small.

You have probably heard that all sorts of changes have been made here. Gropius left, because he wants some peace after all the quarrels and perhaps also because he sees more opportunities in Berlin. For now he is on an exchange visit to America. His successor is Hannes Meyer, who has already been here a year. He is an architect and will deal with the administration. The whole trend is such that there is not much

scope for reform. Breuer, Bayer and Moholy have also left. I am stay-
ing. Though I hesitated for a long time. According to plan I will get a
house in the masters' settlement, when Moholy has moved to his new
flat. We are looking forward to that.[66]

With Breuer leaving, Albers was to manage the furniture workshop. He
was also exhibiting his glasswork and preparing an exhibition for the interna-
tional art teaching congress in Prague, which would be held with the support
of the Czech president, Tomás Masaryk, a great proponent of the Bauhaus.

Having just turned forty, he was dealing with age: "I am turning a bit
gray and wear glasses when I read." That emphasis on the ordinary and
everyday comes through in his photography. When I went through the stor-
age room for which Anni had given me the key after Josef's death, I found
piles of photographs and photo collages, as well as contact sheets and tins of
film. As with the early drawings, Albers had essentially concealed this early
figurative art—as if his obsession with the representation of the human
body and various landscapes and buildings would later detract from the
emphasis on pure line and undiluted color. While a handful of Albers's pho-
tographs were known during his lifetime, the size and richness of the collec-
tion that he had squirreled away in a basement was extraordinary.

In addition to their exploration of the chromatic possibilities of black,
white, and gray, the photographs further reveal Albers's preoccupation with
taking different approaches to the same theme. In the collages he carefully

Umbo, Josef Albers 28, *1928. Albers took these two portraits by
the photographer Umbo and pasted them side by side, making clear the
possibilities of the different approaches one could take to a single subject.*

Josef Albers, Oskar Schlemmer IV, '29; im Meisterrat '28; [Hans] Wittner, [Ernst] Kallai, Marianne Brandt, Vorkursausstellung '27/'28; Oskar & Tut Sommer '28, 1927–29. *Albers made this collage of his photos of Oskar Schlemmer and other Bauhauslers, taken over a two-year period. It captures the animation and style with which these inventive geniuses lived.*

Josef Albers's collage of photos of Gropius with Shifra Carnesi, taken in Ascona, 1930. Even in troubled times, life for the Bauhauslers contained more pleasure than most people realized.

Josef Albers, Herbert Bayer, Porto Ronco VIII, *1930. Bayer*
was an inventive graphic designer and a man who proved irresistible
to many women at the Bauhaus, among them Ise Gropius.

positioned, and pasted on cardboard, large prints alongside dozens of
postage-stamp-size contact prints, so that the work vividly presents multi-
ple responses to a single subject, and invites consideration of quality judg-
ment, selection, and scale. He made these collages of his close-up photo
portraits of the pensive Paul Klee, with Klee's astonishing eyes, one pair
after another, looking off into space as if to connect the artist directly with
distant planets. He also made a collage from multiple images of Gropius
frolicking on the beach at Ascona in 1930 with a woman named Shifra Car-
nesi. In each image, the former Bauhaus director—bare chested as if just in
from a swim, except that his hair is perfectly parted and combed—has a
different way of embracing Shifra, who looks as if she is desperate to get into
bed with him as quickly as possible. There is a sensuous collage of Anni
relaxing in one of Josef's jackets. Another, of her handsome brother Hans, is
composed of large and small snapshots that present him as a rakish playboy
with the world at his beck and call—as it was for this carefree young man
in Berlin until the Nazis brought his life of sailing and opera-going and
cavorting to an end he could not have imagined when these photos were
taken. A decade after these images were shot of the dapper Hans leading the
high life, he would leave Germany as a refugee, grateful to be saved by his
rebellious sister and the brother-in-law he had admired from the start, how-
ever difficult his new circumstances were.

Much of Albers's photographic work concentrated on ordinary sights.
Exalting the rhythm of parallel lines, he put close-up images of railroad
tracks side by side. With his characteristic visual gamesmanship, he juxta-
posed a photo of the view from the window of his new house, the bare trees

black against the whiteness of the snow covering the ground, with one in which trees coated in fresh damp snow are white against the darkness of the earth on which the snow has melted.

His excitement as a child when he saw the black tiles as one world and the white squares as another never failed him. In these paired photos, the whites are a source of space and lightness and energy. These airy voids provide the oxygen essential for us to see all the depth within the blacks. These photo compositions all have the energy the little boy felt. At the same time, they are sophisticated, rational artworks in which the artist used juxtapositions of tone, line, and scale to create unexpected relationships.

As a photographer, Albers took the same approach evident in his early drawings, glass constructions, and furniture. His goal was to have the artist function only as a presenter of phenomena and server of possibilities he deemed far greater than himself. In his camera work, the subject emerges in fullest force. The marvelous construction of the Eiffel Tower, Kandinsky's intelligent face made mysterious by clouds of cigarette smoke, the funny imperiousness and mystery of mannequins in a shop window: each is its essential self. With mechanical means, Albers animated these images that celebrate both what exists in reality and what exists only in the imagination.

12

One could not be too attentive to detail in the Alberses' world. Their house in Dessau was organized meticulously. Josef's sandblasted glass constructions—all pure abstractions, some of them lean and minimal exercises in black and white, others jazzy syncopations of vibrant color—were lined up in a row on the living room wall. Wassily chairs—designed by Breuer and named for Kandinsky—were positioned against a wall in a pose more sculptural than friendly, so that their users looked at space rather than at one another. The arrangement was strident, a brave declaration of work and serious purpose, with a deliberate eschewal of prettiness.

Details of appearance mattered both for their visual impact and their narrative significance. The alteration of the cuff on a jacket sleeve by half an inch is the difference between having the right amount of shirt material extending beyond it—adding an essential visual element, an accent of welcome lightness—or depriving others of that optical relief; it is also a mark of class. If a jacket looks like a hand-me-down from a larger person, never altered, or like something one has outgrown, it is essentially displeasing and

also tells a very different story than if it has been correctly tailored. Anni Albers considered oversize sweaters on men the mark of American, as opposed to European, aristocracy, while tight sweaters not only designated a lower class but were unappealing to look at. Josef put a tint into wall paint that no one could possibly discern but that to him made all the difference, both optically and for the mood it transmitted.

He also regulated the lighting under which he painted his *Homages to the Square.* The fluorescent bulbs over one worktable were arranged warm, cold, warm, cold, and over another, warm, cold, cold, warm; he examined every painting under both types of illumination. What others might consider the subtle nuances of visual experience were to him the essentials. Seeing was too sacred an act to be compromised.

A letter Albers wrote the Perdekamps in December 1928 on Bauhaus Dessau stationery shows that same concern for every aspect of household design that I encountered with the Alberses. When I came to know them in the 1970s, Anni spoke of their battle for simplicity. Since no such thing existed as a perfectly plain, unadorned light fixture, and she and Josef were insistent on having a pure glass cylinder over their entrance hall, she had solved the problem by buying a lantern meant to be mounted on a post out-doors, then removing the garland of metal flowers that was its main appeal to most people, leaving only the functional glass substructure that sur-rounded the bulb. What the lantern's designer had deliberately concealed was precisely what she and Josef wanted to look at all the time.

Josef wrote:

Dear friends,

Attached you will find our lamp designs. They are very simple and not expensive. If I knew your rooms I could give specific advice.

I recommend Me W 94/a for the living room. The sphere has clear glass above and white glass below. That gives semi-indirect lighting. If your ceilings are low we can shorten the tube, but the light should come down to 2.40 [m]. So let us know your ceiling height. For smaller spaces, alcoves or work spaces Me 107 l, not so bright because the upper glass is not clear. The spheres are hung on chains inside the mounting and are thus easy to open and close.

Over my worktable I have a small reflector 14 [cm] diameter, 17 [cm] height, hanging at eye level, does not dazzle because it has an aluminium shade. It gives very good light, precisely calculated. The thing looks very good to me. . . . Our lamps are very sober. If you want to avoid using metal altogether, on the stairs, in the lavatory, next to the bathroom mirror, in the hall, use the china lamps by Palzer, Frank-

furt am Main, Weserstr. 47. Perhaps a local decorator can get you a
catalogue.

Take the simplest shade for pearl bulbs. I use them a lot in my
place. Over the dining table I have a PH lamp, a Danish invention,
but expensive.

[There is a drawing of the lamp alongside the text.]

I have the red painted one. I can get 15% or 20% discount on this
for you, but then the order has to come from me. Anyway, I hope that
you will finish your place more quickly than I have finished mine.
Since the end of the holdays we have been living in a masters' house,
much too big and too expensive, in particular because of the insane
heating. Only borrowed tables. Too few chairs. But empty rooms are
the most beautiful. Keep your rooms as light as possible, put as little
into them as you can, that gives freedom. . . .[67]

Possessions were not meant to oppress the individual but to facilitate
freedom. For that essential liberty, it was vital to live economically, and to
be able to leave home behind on occasion.

The prices of the Bauhaus lamps are those for members of the
Bauhaus. If necessary order them through me. Outside they are more
expensive. I have to get to the mountains and snow for Christmas, oth-
erwise I shall become bad-tempered. We have 3 weeks holidays—
thank goodness.

Good-bye for now, make your house smart, light, empty. Most old
things are unnecessary and they make you heavy.

With best wishes from our house to yours,

Juppi and Anni[68]

The attention to the details of his friends' house, besides being emblem-
atic of the precision and carefulness fundamental to Albers's teaching, was a
mark of how much he valued their relationship. And light was a subject
whose importance to him could not be overstated. A component of color, a
transmitter of mood, an essential in every task, it required utmost attention.
In January 1929, Albers wrote Perdekamp:

I ordered your lamps yesterday. I ordered a cheaper china shade for the
WC instead of Me 93b you chose. I am sure you will prefer it. I would
switch the lights for the bay and the study, so that you have better
light where you work.

I have written to the Berlin distributor about the PH lamp and
asked them to suggest something for you. I'm afraid I no longer have

my receipt to give the correct order number. I will ask them to give you the same architect's discount as they give me.[69]

Money, too, was an undeniable reality.

IN SPITE OF MARRIAGE and his elevated position at the Bauhaus, Albers had an abiding wish for simplicity in his home. At the end of his life, this desire became even more extreme, and he lived like a monk. His bedroom had nothing whatsoever on its white walls. There were two cheap 1950s side chairs that were intended for a kitchen table. The bed was a single mattress on a box spring, supported by short, screw-on legs. Only the desk, the top of which Albers had crafted out of a plane of cherry wood at Black Mountain, had style. The top rests on one-by-fours, narrow side up, spaced at intervals and sitting on a bottom plank supported by tapered rectangular legs. The two expanses of wood are positioned like the pieces of toast in a sandwich with a void in between. That inner space, divided by the one-by-fours that run from front to back, serves perfectly for storing paper and stationery supplies. The hard and firm work surface, which has a beautiful grain and rich auburn color, is excellent for writing, while it is irregular enough, and sufficiently treelike, to suggest the power of nature. The place for work, as opposed to relaxation, was the sole beautiful object in the room.

His taste was much as it had been at the time he wrote Perdekamp:

My rooms are still very empty. I would really prefer to leave them that way, but you have to be a bachelor to do that. I am feeling wistful about my old studio flat. No washing tub or stairs. No cupboards and no worries about windows, stairs or WC. You get older and there's no changing that. So I try to stay happy in spite of too many obligations. Otherwise you become grumpy in the bargain. And once you are 40 you should not encourage that. Particularly if as a workshop director you have to act like a businessman. Sometimes the Bauhaus gets to be too much for me and then my old longing for Berlin returns. That has now become more American than America, but you see fresh faces. And the speed is exhilarating. . . . How is your literary work going? Art is in a bad way. All that's left is photography.[70]

That Albers was discouraged by so many issues was known by few people. But he was contending with brutal circumstances. In February 1930, a newspaper in Essen, the city adjacent to Bottrop, characterized him as a Bolshevik.[71] In June, he informed Perdekamp, "Here there's trouble in the air. The Haus has become politicized. It can't go on that way much longer. We live in lovely surroundings but our work is poisoned."[72]

By the spring of 1932, things had only gotten worse:

The Bauhaus devours men. Demands and workloads rise while re-
sources are steadily cut. It would still be glorious if politics did not
destroy our young people. Away from my duties, I have lots of meet-
ings, I am on the Council of Masters and on various commissions and
also vice principal, I withdraw into privacy. I don't like company, would
prefer lots of nature. I enjoy the nighttime walks with Mies. And with
the director of our Gallery and County Art Director Grote. Otherwise I
am painting pictures again and considering a new exhibition.

Anni has done some weaving and now has her own enterprise. She
had a very handsome stand at the Leipzig Fair and had a lot of praise.
Unfortunately an expansion of the business is out of the question.[73]

IN HIS SANDBLASTED GLASS from this period in the late 1920s and early 1930s,
when so much in his life was uncertain, Albers revealed a particular fascina-
tion with impossibility. He developed forms with multiple, contradictory
readings. Two-dimensional imagery offered possibilities unknown in three-
dimensional reality.

He titled a pair of ambiguous cylinders, which we seem to see from the
outside and the inside at the same time, *Rolled Wrongly. Steps,* of 1931, has a
large flight of steps that clearly moves upward and to the right; alongside it,
smaller steps appear to recede upward to the left, or, contradictorily, upward
to the right. These smaller steps then flip-flop back and forth between
the two readings. When we continue to gaze at them, they seem to go up
halfway in one direction only to reverse on the middle riser; this impossible
shift occurs in both directions. Multiple readings of a single form fascinated
Albers, just as in his later *Homages to the Square* he could present the identi-
cal color in two different situations so that it appears one way in the first and
another in the second.

Again, his art was a reflection of his life. The first glass assemblages
Albers had ever made at the Bauhaus soared with faith and optimism. These
later pieces suggest, above all, how much in life is unexpected and surpris-
ing. The only reality was art itself, and that art testified to the uncertainty
of everything.

13

In 1932, after the city legislature of Dessau voted to dissolve the Bauhaus and the school moved to Berlin, the city of Dessau was still obliged to pay faculty salaries—once the courts had determined that the contract with the masters had been terminated prematurely. So, for a while, Albers and Kandinsky and the others were able to manage, even if the school was now located in a derelict telephone factory rather than in the splendid headquarters Gropius had built for it only six years earlier.

Albers fared better than the others, since Anni's family got them a nice apartment in the Charlottenburg section of Berlin. Besides paying the rent, the Fleischmanns covered the cost of refurbishing. While the few of his colleagues who had remained were living in reduced circumstances compared to what they had had in Dessau, because he had married a rich woman, Josef was helping her select new flooring (white linoleum, a revolutionary choice in 1932) and other details of their appealing, if smaller, nest.

They spent about a year there. On June 15, 1933, the Oberstadtinspektor of the Dessau City Council wrote Josef Albers a letter:

> Since you were a teacher at the Bauhaus in Dessau, you have to be regarded as an outspoken exponent of the Bauhaus approach. Your espousing of the causes and your active support of the Bauhaus, which was a germ-cell of bolshevism, has been defined as "political activity" according to part 4 of the law concerning the reorganization of the civil service of April 7, 1933, even though you were not involved in partisan political activity. Cultural disintegration is the particular political objective of bolshevism and is its most dangerous task. Consequently, as a former teacher of the Bauhaus you did not and do not offer any guarantees that you will at all times and without reserve stand up for the National States.[74]

A similar document was sent to the other masters.

Not only would there be no pay in the future, but there was now a hitch concerning the overdue salary to which Albers was entitled. The nasty missive went on to explain, in a series of circumlocutions that even a person used to German bureaucratic gibberish would find difficult to understand, that what he had received for remuneration through the second week of

April—his most recent salary payment—would be his last. This was justifiable, according to Oberstadtinspektor Irmscher Sander, "especially since recoverable salary payments with consideration of the fact that the private contract of employment was concluded according to #1, chapter 1, section 4 of the economy regulations of Anhalt of September 24, 1931 (statute book of Anhalt p. 63, of September 30, 1932) had been dissolved and that after the dissolution obligation for further payment of salaries no longer existed."[75]

FRANZ PERDEKAMP, who had read Hitler's *Mein Kampf* that spring, advised Albers to leave Germany if he possibly could. On June 10, 1933, on a letterhead that read "Professor Josef Albers, Berlin.-Chbg. 9 Sensburger Allee 28" (with no mention of the Bauhaus), Albers wrote Perdekamp:

> Dear Franz,
> This is how it stands with us: shortly before Easter the B.H. was surrounded by police, the building and people were searched, many taken away and released after producing their papers. The house was closed, according to the press: because much incriminating evidence and illegal pamplets had been found. . . .
> Three weeks ago, after much effort in many places, it was accepted that there was no incriminating evidence. They promised to remove the police seals, but did not do so. In mid-May we should have got our May compensation payments from Dessau. After a complaint at the end of May we received a notice: stopped by reason of the Law for the Renewal of the Civil Service. A few days ago the return of furnishings lent by Dessau to the Bauhaus and its workshops was required by 1st July. So the BH. is closed, no money and no furnishings. The staff has been cut. One had to show a family tree, one was politically suspect, one stays in Dessau—he had been part-time, now he is in full employment there.
> So we are correspondingly happy.
> Additionally the internal atmosphere—among colleagues—is no longer all right. Waiting for the end. What we worked for was in vain, now no money. No prospects. We make little plans.
> During these weeks off I have retired to my little room and "ora et labora" alone.
> As never before. And as making glass pictures has become too expensive since the summer, I have been making woodcuts, which I think are very good, one or two really clever. The other blocks are waiting. But a few days ago I found someone who will print them for me for nothing. I still have to get hold of paper and have some debts. I

can't pay the rent. But we still have some food from my parents-in-law, who are also not very well off.

My exhibition has been canceled.

I am prepared for anything.

Spiritual development continues in spite of everything, each individual has to decide how to hold out.

Art has always been a special occupation with special values.

"Art from the people" or "for the people," as it is now said, are misconstructions.

Bach will never be played on the streets. It will always be "Baby, you are the star of my eyes" or something similar. Even if they dictated Wagner every day.

But thank goodness there's still Whitsun and that will stay. But then the masses go on outings.

We send our best wishes from our work and beautiful nature.

Your Jupp[76]

In November 1933, Josef and Anni Albers left Germany forever.

ON MARCH 19, 1976, Josef's eighty-eighth birthday, Anni had just finished making whipped cream to put onto a store-bought cake for a modest celebration with the actor Maximilian Schell and Schell's tall and glamorous girlfriend, Dagmar Hirtz, when Josef complained of chest pains. Anni phoned the doctor, who advised her to drive him to Yale–New Haven Hospital.

Once he was in the hospital, however, Josef felt quite well. Schell had recently become a collector of paintings from the *Homage to the Square* series and had proposed enlarging two black and gray ones as a stage set for a performance of *Hamlet,* which he intended to direct and star in. When he and Hirtz visited the patient, they found him robust and cheerful. But the doctors advised that Josef remain in the cardiology unit under observation. The story put forward that day, which Anni had no reason to question, was that this was the first time he had ever been hospitalized.

On March 25, just as Anni was about to leave the house to pick up Josef and bring him home, she received a phone call: he had suddenly died—as cleanly and rapidly as he would have liked, with no pain or dread.

Within a couple of hours, once her brother was on his way to help with the practicalities, Anni telephoned me at my father's company, where I was then working. "Anni Albers," she announced, as she always did at the start of every phone call, in her soft but strong voice. Then came two more words: "Josef died."

I commiserated, and she went on to ask me to go to Tyler Graphics, about an hour from where she and Josef lived, with a proof that Josef had approved

Anni and Josef Albers in the garden of their home at 8 North Forest Circle, New Haven, Connecticut, ca. 1967. The Alberses were like a two-person religious sect. They considered visual experience an unequaled source of stability and joy.

in the hospital and would have wanted them to have so that his latest print series could still go into production. We made the necessary plans. When I hung up the phone, I realized, as I never had before, that everyone dies. Josef, by being as physically robust as a boy until the end (he still took brisk daily walks, rain or shine, at age eighty-seven), by creating art that belonged to all times, and by never showing any sign of waning energies, had enabled me to hold on to the hope that, even if ordinary people had to die, immortality might be possible. Now I knew that this could never be the case.

Only nine of us were present for the funeral rites, held three days after Josef's death. In addition to Anni and me, they were her sister and brother and sister-in-law, the architect King-lui Wu and his wife, Vivian, Josef's lawyer Lee Eastman, and Lee's wife, Monique. While the other eight stood at the graveside for the Catholic service, conducted by the priest from the Holy Infant Church, I ceded to Anni's request that I guard the house, since she had read about burglaries committed during funerals. This was the first time I played a watchman role, which would eventually assume many forms.

At lunch after the service, Lee Eastman asked if I would help Anni with everything that had to be done concerning Josef's estate. We were in the Alberses' living room, eating Josef's favorite foods, including Westphalian ham and black bread, and vinegary as opposed to mayonnaisy potato salad—Anni had specified this—all of which I had picked up at the family-owned German store where I had often gone during the previous couple of years to satisfy Josef's culinary nostalgia. He was sentimental about little else, but words like *rheinische appfelkraut* (a sweet apple butter) and certain "wursts" made him light up with pleasure.

17. ANNELISE
ALBERS,
design for
Smyrna rug,
ca. 1925.
As her work
developed, the
artist broke
away from
symmetry to
create exception-
ally dynamic
compositions.

18. JOSEF
ALBERS, *Mephisto
Self-Portrait,* 1918.
Josef enjoyed com-
paring himself to
Mephistopheles,
but Anni was so
bothered by this
image that she
denied he could
have painted it.

19. JOSEF ALBERS, *Untitled,* 1921. When he could not afford traditional art supplies, Albers went to the town dump in Weimar and hacked up bottle bottoms and other glass fragments, which he then assembled into luminous and vibrant windows.

20. JOSEF ALBERS, *Bundled,* 1925. Once Albers began to use sandblasting, he made glass compositions that took geometric abstraction into completely new territory.

21. JOSEF ALBERS, *Red and White Window,* ca. 1923. Albers's window for Gropius's reception room at the Weimar Bauhaus gave visitors a sense of the warm optimism that pervaded the school at its best.

22. ANNI ALBERS, design for a rug for a child's room, 1928. Albers designed a rug that gave children spaces for their toy soldiers or dolls or checker pieces. The concept of play was vital to her.

gouache, 1928

23. The Alberses' house at 808 Birch wood Drive, Orang Connecticut. The house where Anni and Josef ended up at the conclusion of their lives was startling in its starkness and ordinariness, yet it served their need perfectly and honored their values.

24. ANNELISE FLEISCHMANN, wall hanging, ca. 1923. Fleischmann's first wall hanging was an astonishingly bold and simple abstract composition.

25. ANNELISE ALBERS, wall hanging, 1926. Albers avoided repetition in her compositions, yet maintained a clear number system and limited her elements and colors. Considering this her finest work to date, she gave it to her parents. They put it on the grand piano, where it was damaged by a damp vase of flowers that left a permanent circular stain halfway down on the right-hand side.

26. ANNI ALBERS, Bauhaus diploma fabric, 1929. At the request
of the director of the Bauhaus, architect Hannes Meyer, Albers devel-
oped a wall covering for an auditorium that absorbed sound, because
of qualities on the back, and reflected light on its visible side. Its
shimmering materials and careful composition, candidly revealed,
lend visual beauty at the same time as they perform their functions.
Albers was awarded her Bauhaus diploma on the basis of this piece.

27. ANNI ALBERS, *Fox II,* 1972. This image came out of the process
of printmaking and was the accidental result of the way a photographic
negative fell on top of a Velox. Albers relished the idea that she could
never have anticipated or made studies for these rich results.

28. ANNI ALBERS, *Fox I,* 1972. Fascinated by the technology of photo-offset, which she had never before tried, Albers enjoyed reversing an image and reproducing her hand-drawn pencil strokes in juxtaposition with the opaque red ink.

29. ANNI ALBERS, *Six Prayers,* 1966–67. Albers's memorial to the six million Jews killed in the Holocaust is among her most moving works, evocative of intimate human lives, full of palpable connections, and seemingly audible.

THE NEXT WEEK, at Anni's suggestion, I began to use the desk Josef had in the basement of their house, in a little office off his studio. The design of the desk was the same as that of the cherry version upstairs, but the materials could not have cost more than fifty dollars. The eight-foot-long top was constructed from the same Masonite Josef used for his *Homage to the Square* paintings—while he painted on the rough side, here he had the smooth side faceup—with the bottom a second piece of Masonite, on stovepipe legs. Josef had shoved everything from writing paper to train schedules into the four-inch-high space between the top and bottom. For many years, I continued that practice.

In about 1985, I was looking for a list I had made long before of some of Josef's paintings. I ended up emptying out the space that held a mélange of his and my paperwork. Way in the back, I found a carbon copy of a typed letter composed in German on a manual typewriter. The paper was a fragile onionskin, but it had survived.

It read:

Minutes of the conference of July 20, 1933.

Present: Albers, Hilberseimer, Kandinsky, Mies van der Rohe, Peterhans, Reich, and Walther.

Mies van der Rohe reports on the last visit with the county board of teachers and on the accounts which the investigating committee gave in Dessau newspapers. In addition, Herr Mies van der Rohe informed the meeting that it was possible to terminate the lease effective July 1, 1933, but that despite this the economic situation of the Institute, because it had to be shut down, was in such poor condition that it was impossible to think of rebuilding the Bauhaus.

For this reason, Mies van der Rohe moved to dissolve the Bauhaus. This motion was carried by a unanimous vote.

Following the review of the financial situation, Mies van der Rohe announced the agreement which had to be made on April 27, 1933, with the firm of Rasch Brothers. Herr Mies van der Rohe intends, however, to negotiate further with Mr. Rasch, in order to see if he can get another payment to help settle the debts.

If at a later date the financial situation should improve because of the royalties from the curtain materials, for example, Mies van der Rohe will try to pay the members of the faculty their salaries for the month of April, May, and June 1933.

(signed) Mies van der Rohe [77]

14

During the period I knew Josef Albers, by which time he was an octoge-narian, he was focusing on two bodies of work: a series of geometric drawings he called the *Structural Constellations* and his *Homage to the Square* paintings. Although he would rarely allow conversations, with me or any-one else, to stray to the subject of the Bauhaus or of his youth, it was clear that his early religious faith and the territory he explored in the Bauhaus glass workshop were still essential to him.

For the *Structural Constellations,* he made countless sketches on scraps of lined notebook paper, or even paper napkins. These led to hundreds of large, polished ink drawings, related engravings, embossings, and lithographs; machine engravings on vinylite; and several vast architectural commissions. The *Constellations* were the optimum vehicle by which to communicate the special ambiguity and geometric mysteries that, along with color, had fasci-nated him even before he began teaching in Weimar. The name "constella-tions" is apt: Albers drew them by connecting dots with straight lines. The points of intersection appear to fluctuate in space, like stars that seem to move because of their brightness and gaseousness. Stellar constellations are an attempt of man to organize the infinite, to pin down the eternal by creat-ing imaginary representational forms; Albers, contrarily, wanted to evoke vast, timeless phenomena, to use his tidy images to create infinite variability.

In these images, the outlines are the result of constant refining, and their subtle interior variations—the addition or deletion or widening of lines—are the product of further deliberation and perseverance. The result is that shapes that are open and inviting become impenetrable. Illusory paper-thin surfaces show both of their sides at once. Flat planes bend. Straight lines curve. Parallel lines appear to be at oblique angles. Parallelograms flip-flop and twist as we look at them. This action diverts us and takes us out of our-selves. We feel secure, on a course that has been precisely premeditated, and at the same time adventurous, as we perceive impossibilities. We learn to maintain our faith in the face of ever-changing situations.

These graphic images depend on selectivity and economy of activity. They result from carefully calculated decisions, with anything extraneous cleared away. They reflect Albers's belief that, while we are constantly con-fronted with an infinity of impressions and possibilities, we must choose a direction and adhere to it to survive. We must trust in what we are doing. The basis of the *Structural Constellations,* this confidence and forging ahead,

methodically but with an openness to mystery, was Albers's view on how to live.

Compared to Albers's *Constellations,* much geometric art is oddly muted and "laid back"; its elegance seems blasé, worldly, the least bit languid. Here is Albers the mad magician, telling us to go for broke. We run through city streets, in and out of neighborhoods; we move into unknown territories. The man who taught students the value of "repeating and reversing," and of varying the spaces between parallel lines to create three-dimensional activity, used his elements, his parallels and right angles, to give us all he could, something that never existed before. The results are like marching bands with everyone playing at once. Our eyes move here and there at the same time; sounds go off in all directions simultaneously. We take many paths in a single moment.

Albers wrote:

Looking at my *"Structural Constellations"* demands from us repeated changing of the direction of our vision and of our reading.

Thus we follow the lines, and so look down and upward, in and outward, from the left to the right. We read along the extension of planes and volumes, but also penetrate them forward and backward.

Changing our viewpoint changes besides our standpoint also the position of the construction. It seems to tilt, to turn, to recede, to advance as a whole or in parts.

With this the 2-dimentional arrangement of lines appears as a 3-dimentional body, and also as opaque and transparent. It presents simultaneously front and back, face and profile.

And all this is to demonstrate that true mobility is not achieved by making an object move but making an object that makes us move— besides moving us.[78]

ALBERS'S OBJECTIVE, impersonal absorption in visual phenomena—the approach that we allow and in fact demand of doctors and scientists—is hard to accept in an artist. But this rigor and austerity led him to fertile ground. The work he produced so methodically is vibrant and mysterious; its calm is not shallow or stagnant. The late drawings impart movement that, without imitating or replacing natural phenomena, has natural complexity. Albers simplified but never put a brake on motion; the work evokes temporal progress, and has a rich structure that saves it from the emptiness that often

occurs in refined, geometric art. The result of years of development and planning, the *Structural Constellations* are built on a solid base and describe activity and flow, not a void.

Albers's geometric drawings parallel nature in some ways and outperform it in others. They allow north light and south light to shine simultaneously, just as certain *Homages* permit the darkness of midnight to coexist with the brightness of noon. They move us in opposite directions at once. Spare as they are, they are not "minimal" art. Even as they are reductions, they are all the richer for the ingredients distilled in them and the complexity of their development. Their combination of industrial meticulousness and spiritual mystery was the essence of the Bauhaus belief system.

The weightless figures of the *Structural Constellations* came from Albers's mind and spirit. They have no physical mass. Albers did not like heaviness; he used thin white porcelain teacups and functional light steel furniture that was easy to move. He preferred airy, uncluttered spaces. And the spaces he invented and cultivated are not contained, like spaces in the real world, but are more mercurial and vaporous. Their forms move dramatically; their combination of black and white pulsates rhythmically. Their activity is as unflagging as the energies of the universe and as Albers's own energy in seeking every possible variation on his chosen themes. Thus, they resurrected Klee's and Kandinsky's ideals after those artists' deaths, and kept the Bauhaus spirit alive after World War II.

Albers wrote:

An element plus an element must yield at least one interesting relationship over and above the sum of these elements. The more different relationships are formed, and the more connected they are, the more the elements intensify each other and the more valuable is the result and the more rewarding is the work. This leads to a major factor in the instruction: economy, economy in the sense of being sparing of expenditure in material and labor and optical utilization for the effect aimed at.[79]

In the *Structural Constellations* there is not one line too many. Form is streamlined in them, just as color is intensified through the absence of medium in the *Homages*. Albers's reductionism left punch and quality and dispelled anything peripheral.

The values were the same as the fundamental precepts of Albers's Bauhaus teaching. He told his students:

Through works of art we are permanently reminded to be balanced within ourselves and with others; to have respect for proportions; that

is, to keep relationships. It teaches us to be disciplined, and selective between quantity and quality. Art teaches the educational world that it is too little to collect only knowledge; furthermore, that economy is not a matter of statistics, but of a sufficient proportion between effort and effect.

Art problems are problems of human relationship. Note that balance, proportion, harmony, [and] coordination are tasks of our daily life, as are also activity, intensity, economy, and unity. And learn that behavior results in form—and, reciprocally, form influences behavior.[80]

The *Homages to the Square* share traits with the geometric drawings. There is a similar spatial play: simultaneously inward and outward, forward and backward, horizontal and vertical. We are near and far at the same time. Forms are at once together and apart. The mood is calm and controlled, the quiet activity constant. The means are always mechanical. The purpose resonates. These works are clearly the result of relentless, uncompromising pursuit, yet the effort is concealed, making them objects for serene contemplation.

In line as in color, proportions and relations are the key. To add or remove or thicken or lighten a single line would totally change the nature and rhythm and motion of a geometric form; similarly, to lighten or vary a single color would change the physical action and spiritual presence of any *Homage.*

Albers would often talk of nothing but these visual nuances and discrepancies. They were his lifeblood. He would take visitors to his studio to see his latest work—an *Homage,* or a drawing for a stainless steel *Structural Constellation* relief sculpture to go in a new skyscraper or on a city square—and would marvel yet again at the shifting movement and appearance and disappearance of form. He liked to explain the visual activity; his friends were those people who listened attentively and made the right remarks. He did not act as if he had created the miraculous phenomena, only as if he had brought them down to earth and made them accessible to us. In his late work, this devout apostle of optical mystery was as close to its wonders, and as able to make them occur, as he could be.

ALBERS STARTED OUT earthbound and then moved heavenward. This is especially true of the *Homages to the Square.* Having first given us implicitly weighty three-dimensional bodies, he makes them float. The transformation through which their mass is rendered weightless was his form of alchemy. In the sandblasted glassworks he had countered the heavy mass of the materials with the effect of light. In the *Homages* he began by methodically applying paint grounded to the panel, but he subsequently made the forms

buoyant and the color ethereal. This achievement of poetry through the application of overtly scientific means was a Bauhaus goal.

The *Homages* have their feet on the earth and their heads in the cosmos. The central, or first, square is like a seed: the heart of the matter, the core from which everything emanates. The intervals underneath that first square, created by either two or three larger outlying squares, are doubled to the left and right of it and tripled above it. In the four-square format, for example, which is ten units wide and high, the middle square is four units wide, each of the outer squares is half a unit wide underneath the middle square, one unit wide at left and right, and one and a half units high above. In *The Power of the Center,* Rudolf Arnheim explores the ways this 1:2:3 ratio shifts the normal balance of earthly (horizontal) and heavenly (vertical) elements of a single square in favor of the heavenly. "This asymmetry produces the dynamics of the theme, a squeezing below, an expansion above. It promotes a depth effect, which should be counteracted if all the squares were grouped symmetrically around the same center."[81] The asymmetry is subtle—the squares are *almost* centered—so the upward thrust is gradual rather than pronounced. Thus the spiritual element is achieved with a soft voice rather than a loud shout. Albers's spirituality transmitted in poignant, muted tones rather than with evangelical ardor.

In analyzing the ascendant quality of the *Homages,* Arnheim points out that if we follow the four diagonals created by the corners of the squares within squares, they converge on a point precisely one quarter of the way up the painting. The diagonals created by drawing lines through only the two bottom sets of corners and carrying those lines all the way across the panel make an X that demarcates the rectangle that is the lower half of the composition. "A solid base is thereby provided on which the sequence of squares can rise with confidence from step to step—not so different from the coffin in Piero's *Resurrection,* from which the movement toward heaven takes off."[82]

Like the image of a cathedral on the original Bauhaus brochure, Albers's *Homages to the Square* have massive, sanctuary-like bodies and, simultaneously, the attributes of steeples. In buildings and paintings alike, there is a mix of solid craft with philosophical concerns. That blend of fact and spirit parallels the issues of mortality and immortality that loomed large for Albers in his later years. Determinedly antibohemian, in persona he was the honest craftsman, clean-shaven and well scrubbed, dressed in neat, almost uniform-like clothing (mostly permanent-press beige). In 1950, when he and Anni moved to New Haven so that he could take his teaching position at Yale, they chose a small Cape Cod–style house that looked like everyone else's: a no-nonsense place good for living and working. Twenty years later, when they were more affluent and able to enjoy the rewards of the art boom

of the 1960s, they moved to the slightly larger raised ranch where I met them. On a quiet suburban street a few miles from their former house, it was convenient to a cemetery plot they had selected so that after the first one died, the other could drive by on the way to the post office.

But as matter-of-fact as he tried to seem, Albers enjoyed the feeling that his achievement might have the immortality he knew his body lacked. Having reduced the trappings of his everyday existence, he thought often of the afterlife. The words of George Eliot describe his state of mind: "It is strange how deeply colours seem to penetrate one, like scent. . . . They look like fragments of heaven."[83]

THE WORLD BEYOND our individual earthly existence was in Albers's thoughts when he made a blue and green twenty-four-inch *Homage* in January 1976, some two months before his death. By the time he created this *Homage,* he was working on very few paintings—his hand was too unsteady, so he focused more on printmaking—but he did this panel as a study for an Aubusson tapestry that had been commissioned for a bank in Sydney, Australia.

I discussed the painting with Albers on several occasions. He told me that he had one problem with it. He had found a combination of his chosen colors that interacted perfectly in an *Homage* format when the central square was four units wide, but that did not work as well in the format with a larger (six units) central square. (All of the paintings were ten units by ten units, whatever their size.) Showing me studies of halves of these paintings (he often worked in half *Homages,* especially when designing prints or tapestries), he explained that in the version with the larger middle square, "downstairs" was fine, but "upstairs" was "hell." He wanted both a spatial flow and a color "intersection."

Albers describes this intersection in his book *Interaction of Color.* It is the process by which a correctly selected color lying between two other colors takes on the appearance of both. When colors properly intersect in a three-square *Homage,* the color of the innermost square will appear toward the outer boundary of the next square out. The color of the outermost square will also appear within the second square, toward its inner boundary. "The middle color plays the role of both mixture parents, presenting them in reversed placement."[84] This is illusory. The second square is not in fact a mixture, but is paint straight from the tube, applied flatly. But at a distance our perception tells us that it is modulated, and that some of the first and third colors are visible within it.

Albers then pointed to the version with the small central square. Here the intersection occurred, but he was not satisfied. Moving his hand over the

sky blue center, and then over the more terrestrial forest green and the sealike aqua surrounding it, he explained that these colors were the earth and the cosmos, the cosmos being in the center. In the version with the smaller middle, the cosmos was too distant.

While the earlier *Homages* generally depend on sharp light-dark contrasts, the later ones are more subtle, with closely related hues. Here Albers's development parallels that of Cézanne and Monet, who in their late work also moved toward hazy, atmospheric effects. In the version of this last blue-green painting with the larger middle, Albers wanted all boundaries and edges virtually to disappear. Additionally, there should be no sharp corners on the inner square. (He said that Cartier-Bresson once told him that he made "circular squares," which delighted him.) To achieve these effects he needed to find colors with the identical light intensity. The cosmos should have neither sharp boundaries nor corners.

He said that even the supreme colorist J. M. W. Turner had never been able to match light intensities exactly. Yet by making studies with painted blotting paper, Albers found precisely the paint he needed for the middle square. With Winsor & Newton Cobalt Green, batch number 192, he could obtain both his desired intersection and the match of light intensities. At that moment, however, the only Winsor & Newton Cobalt Green available was from a newer batch, number 205. He admired the paint company for changing the code number to indicate a revision of the pigment, but he was frustrated at not being able to duplicate a paint that had been discontinued several years earlier.

I telephoned the American corporate headquarters of Winsor & Newton, an English company, in New Jersey. I managed to get the director on the phone and explained that I was trying desperately to locate some old tubes of Cobalt Green 192. He assured me that there was no perceptible difference between 192 and 205.

I then said that I was calling on behalf of Josef Albers. "Josef Albers!" the paint specialist exclaimed. Within a couple of days, a shallow box containing five tubes of Cobalt Green 192, packed tightly side by side like sardines in a tin, arrived. Josef went back to work.

The correct paint enabled him to make the painting exactly as he wanted. The Bauhaus-style insistence on the most apt material and the will to achieve his goals were crucial. The intersection he achieved is like magic. Looking at that *Homage* with me, Albers demonstrated the color penetration by interlocking all his fingers, and praised the ability of the outer and inner squares to span the middle color. He again spoke of the need of "the universe" (rather than "the cosmos") to be immaterial and without boundaries. "And for me the cosmos is getting nearer, which is why I had to paint it larger," he added. This was his last painting.

Anni Albers

1

It has the makings of a scene in an old-fashioned Hollywood movie. The rich girl from Berlin, having insisted on going to a new and experimental art school in spite of her parents' protests that she should simply marry and run a household even if she painted on the side, brings home her impoverished artist boyfriend. He comes from a city no one had ever heard of or would want to go to, and he is significantly older than she is. She presents him to her mother and father and younger siblings in their elegant flat in the finest quarter of the cosmopolitan metropolis. In the film version, the mother and father, even the sister and brother, would be disapproving at best. His family would be delighted at their son's ascent into money and the higher ranks of German society; hers would fight the match tooth and nail.

With Anni and Josef, that was the scenario, but Hollywood didn't write the script. One day I was sitting at their kitchen table with the two of them when Anni recalled, "You know, when I brought Josef home for the first time, the parents liked him so much, right from the start, that they said to him, 'Our Anke is so difficult: if you can't deal with her, you can always come home to us.'" Annelise's teenage brother, twenty-one years younger than Josef, instantly had a new hero; her sister approved equally of the young man she thought looked like "a beautiful Memling."

By then Josef had been offered a teaching position, and Annelise had made great strides in the Bauhaus weaving workshop, constructing innovative wall hangings and subtle upholstery materials that established her as one of the leading textile artists at the school, where weaving was one of the

341

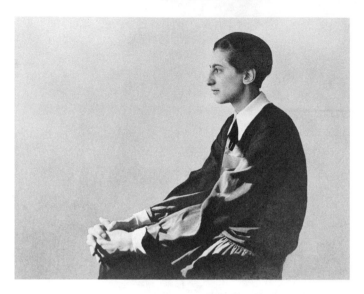

Annelise Fleischmann, ca. 1923. Photo by Lucia Moholy-Nagy. Taken shortly after the future Anni Albers arrived at the Bauhaus, this photo shows her dressed in the white collar and cuffs she favored at the time. When she saw this image later in life, however, she compared it to Whistler's Mother *and, saying she hated her haircut in it, wanted it banished.*

most important activities. Her parents were, astonishingly, very content with the progress of the family rebel.

THE ALBERSES OFTEN REFERRED to the warmth between Anni's family and Josef, but never alluded to Josef's family's take on the match. It was only when the correspondence with Perdekamp emerged that I learned about their reaction. Anni's family was Jewish, although both sides had converted to Protestantism a generation back. As Catholics, the Albers family thought the conversion only made matters worse.

In 1925, on a summer holiday in Val Gardena, which had been in an Austrian province until 1919 but was now in Italy, Josef wrote Franz Perdekamp:

It is wonderful here.

I knew nothing. Anni made all the plans, packed everything, got the visas and the tickets and I was just taken along. And will continue to be taken along. We have been here nearly 14 days and will stay a few days more. Then its off further south, maybe a long way. I am already much restored. What with the high-altitude air and the wine

and the sun and the tanned skin. Selva is 1,600 m [4,800 ft.] high and once we climbed very high all on our own to the great Schierspitze— 2,600 m [7,800 ft.] but we had to turn back 20 m [60 ft.] below the peak, I could not drag her any further. The paths are glorious here and one can quickly get into the high country. —In Dessau all is well up to the point that Anni thinks the town is ugly. It is frequently very dusty and the many factories often spoil the air. But we hope we will succeed there, though even there our opponents are already very active.

Nevertheless, the new buildings have been unanimously approved for 1¼ million [marks] and building work has already started, though unfortunately interrupted by strikes.

I shall not come to the West in the near future. Our interracial marriage is still too fresh for me to show my face.

It is quite all right to let people know about my marriage, I have written about it to acquaintances myself. At that time I did want to keep my marriage plans quiet. It seems that at home they do not like to talk about my bad match. And my sister Lore is angry because I didn't tell her beforehand. Well let her be, I am well and I didn't want to hurt other people. In spite of everything, I am not angry with anyone and wish them all well. That I may not now have as many opportunities to express this wish changes nothing.

In winter I shall set up a new glass workshop in the new building. I am looking forward to the new enterprise very much. I am confident about the future and hope it is the same for you. Give my love to Friedel and the children.

And though Anni is still asleep I send her love too.

Your Jupp[1]

While the Alberses never mentioned to me that Josef kept their relationship and then their marriage secret from his family until well after the fact, Anni did tell me that she met Josef's father and stepmother only once. The occasion was an awkward visit to Bottrop, during which Josef's father drank a lot. And although they remained on polite terms with his two sisters lifelong, Anni suspected one of them of being a Nazi. That it was a "Mischehe" (the word Josef used for an "interracial" or mixed marriage), and therefore took him even further from them than had his move to the Bauhaus, was his family's point of view to the end.

Josef's way of handling their feelings about the match—without disputation, keeping his distance—was in character for him, given his goals of balance and temperance, studiously achieved, in human relationships as in art. Anni, however, wore her passions on her sleeve. She was totally, consum-

ingly in love with Josef, not only with the man, but with his reverence for visual art and his priorities concerning all that he did; at the same time, she disdained his family and the world he came from, which had none of his style and placed no value on what were, for her and Josef, top priorities. She was also alternately condescending and indifferent to the world *she* came from. She disliked her family's aesthetic taste—an apartment with raised paneling, ornate cornices, and Biedermeyer furniture—and, although she enjoyed her father's companionship, she resented, right up until the end of her life, her mother. This was, and remains, strange to me, for Anni by then had achieved so much that made her unlike her mother that she could have afforded to recognize Mrs. Fleischmann's charms at no expense to her own self-definition. Anni's younger sister and brother found their mother amusing and warm. In addition, Toni Ullstein Fleischmann kept a personal journal describing the family's escape from Nazism and flight to America, which shows great intelligence and depth of feeling, as well as rare humor under dire circumstances, yet all Anni ever said about her mother was that she was "not interesting with her bourgeois values" and was "fat."

The connection with Anni's parents, in spite of all of her mixed feelings about them, remained important to both Josef and Anni. For one thing, there was the simple fact of money. Without her family, in this period of tremendous inflation, when Josef was on a meager salary, there would have been no holiday in Val Gardena. That Anni had taken full responsibility for organizing it and was so good-spirited about a mountain trip was remarkable; the reason Josef had to pull her along the trail was that she had a genetic illness that affected her leg muscles and the formation of her feet. But she was one of those people determined to live to the fullest, to ignore her physical disability as best she could.

Siegfried and Toni Fleischmann were, in 1925, delighted to give the young couple a wedding at a Catholic church near their flat, with an elaborate lunch afterward at Berlin's finest hotel, the Adlon. They saw Josef as a stabilizing force for the daughter whose passions they could hardly fathom. Their son-in-law was rare in matching her devotion to artistic modernism while, at the same time, being down-to-earth, good-humored, highly intelligent, and presentable. That he was from another stratum of German society mattered far less.

While Anni was uncomfortable about the milieu in which she had been raised, Josef was enthralled by it. The world of the Ullsteins, even more than that of Anni's father's family, was as new to him as the Bauhaus was. He once told me, as if he were pronouncing a miracle, that during World War I, when most people in Germany did not have milk, Anni's maternal uncles "had crème fraiche." Anni was palpably annoyed at his delight in her family's extravagance, but to the poor child of Bottrop it was immensely

significant, and he was unembarrassed by his fascination with Anni's family's wealth and prominence.

No one went to the Bauhaus to get rich, but—as was equally evident with Gropius, Klee, and Kandinsky—in the volatile financial situation of Germany in the 1920s, money was an issue to be confronted on a daily basis. Josef had greatly improved his lot. And Annelise, by marrying someone who was both indigent and strong-willed, had satisfied her desire for something different from the wastefulness and fluff of her upbringing.

Annelise Else Frieda Fleischmann now became Anni Albers, replacing what was baroque and flowery with a trim reduction. On all fronts, she preferred concision and opted for the streamlined over the frilly. It was one of her ways of becoming modern, similar to what another young Berlin woman—almost her exact contemporary, although in most ways her polar opposite—did by shortening the Helene Amalie Bertha that preceded Riefenstahl to the crisply effective Leni. Both of these women now sported short bobs rather than long tresses, and favored tailored jackets over lavish dresses; clean lines and compactness were the order of the day. There was no better exemplar of the lean and trim, of concentrated thinking and a diamond-hard strength, than the man Anni had chosen to marry.

2

Anni Albers had two great love affairs in her life. The first was with Josef, and it lasted for fifty-four years, from the time they met in 1922 until he died in 1976. But not long after his death something switched inside her. She began to remember, above all, the fights, the times he was annoyed with her prolonged coughing spasms, his failure to praise her work. At times she looked at some of his artwork worshipfully, or grew sentimental and said how much she wished she could still buy him socks, but the woman whose art was uniformly serene (so that even *Six Prayers,* her memorial to the six million Jews killed by the Nazis, has an overriding beauty and grace in spite of its tragic theme) was haunted by a mix of classic grief—she desperately missed the only really close companion of her lifetime—and some form of fury.

It was not long after Josef died that Anni became obsessed with the powerfully handsome Maximilian Schell, the friend who had been there when Josef was hospitalized on his eighty-eighth birthday. The Austrian actor-director was extraordinarily seductive toward her.

In that relationship, too, she could not bear the idea that her money and

power were part of her attraction. By then, she had lost almost every penny of Ullstein and Fleischmann wealth—both families had had all of their property taken by the Nazis—but had, late in her life, become newly affluent once Josef's paintings began to sell in the art boom of the 1960s. After Josef's death, she inherited a collection of his artwork that was worth many millions of dollars, and some of the most important art dealers in the world were eager to represent it, just as museums wanted gifts; Anni lived modestly, and seemed loath to acknowledge her fortune and consequent position, but they were no secret.

For many years, Schell would phone or visit her periodically, and invite her to come see him play Jedermann in the summers at the Salzburg Festival, a trip she loved to make, and which would be followed by time with him on his farm in the Austrian Alps. The most that he received in return, materially, was, every year or so, an important painting by Josef, at the time worth as much as two hundred thousand dollars. Anni would labor over the selection, giving him a spectacular *Homage to the Square* for his fiftieth birthday, picking out just the right oil on paper for his stepson, but she always ended up feeling that he was slightly disappointed. He, meanwhile, often complained to her about his need for "pennies," saying that in spite of an Academy Award (in 1962 for *Judgment at Nuremberg*) and the success of his films, he never had enough money, especially because he liked to produce and direct his own work, which was far less commercial than the blockbusters in which he took roles.

On one of his visits, Anni presented Maximilian with an exquisite painting from Josef's *Variant* series—a rectangular arrangement in which five solid colors, in a geometric layout that resembled the façades of adobe architecture in the American Southwest, interacted so as to create an endless pulsating movement. Maximilian, with his usual long black cashmere scarf draped around his neck, his shock of thick graying black hair swept off his dramatically furrowed brow, looked at the painting as if he were seeing things no one else in the world saw, and Anni looked at him as if she were seeing a beauty she had never seen before either. Then Maximilian studied the back of the painting and saw its title: *Light in the Dark.* Josef's name for his work succinctly summed up the effect of glowing orange and dawnlike pink surrounded by much deeper tones, a burnt umber and a brown that appear almost the same.

"How perfect this is," Maximilian said in his "I am about to utter something amazingly profound" voice. Then he turned to Anni and said, as if it were as original as a dictum of Kant's, "Because always in my darkness is there a little bit of light."

Anni—who, because she was such an outsider to the things people say all the time, was surprisingly unaware of clichés—looked at him as if she

were about to implode in ecstasy. "Ach, Maximilian, du bist der light in my darkness!" she exclaimed.

But even then, as soon as he left that day, Anni worried that her light in the darkness was not as happy and bright as she wanted him to be. The next day, when he phoned from his usual suite at the Essex House in New York and said he had an idea that would bring him great joy, she was relieved that she might be given the chance to make him as happy as he deserved to be—while at the same

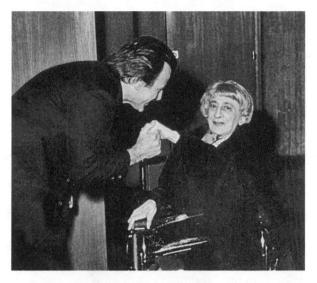

Maximilian Schell and Anni Albers at the Yale University Art Gallery in New Haven, Connecticut, 1978

time helping Josef. Maximilian proposed that, in his large and relatively empty house in Munich, he could have an Albers museum. That way, the public could really see Josef's work, while he, Maximilian, would be able to explain the art to visitors. If Anni just gave him fifty or so paintings, this beautiful idea could become a reality.

While she entertained the prospect, I phoned the Alberses' lawyer, Lee Eastman. I explained that I thought I could get Anni to face reality and not go along with the idea, but that I was worried that she would be devastated if she realized that the man she adored was interested in her in part because she owned a gold mine of art. I well remember Lee's voice on the phone saying, "The fox has stepped out of the den, Nicholas Fox Weber."

It took some gentle cajoling from me, and a phone call from Lee, for Anni to consider that transferring a multimillion-dollar collection of Josef's work to Maximilian was not so wise after all. I suggested to her that she simply tell him she would discuss it with Lee, whom he knew. She did so, and Maximilian dropped the idea.

THAT ANNI'S POSITION in the world, and her money, mattered to both Josef and Maximilian was something she knew and also denied. Artistic passion was the consuming issue for her, as was charisma, and she liked to feel that spiritual and personal issues were the sources of the attraction that underlay the two relationships that preoccupied her day and night. But Anni often said to me, "Don't trust anyone who says money isn't important." On some level

she recognized that both her lost fortune, the one from her family, and the one she came into unexpectedly late in her life, from Josef's success, were pivotal elements in her existence.

Yet in this period when a movie star became her obsession, when although she continued to forge ahead with her printmaking, she lived mostly for Maximilian's phone calls and potential visits (often planned and cancelled) or her possible trips to see him, the one thing she could not bear was the idea that he was primarily interested in Josef's art. Not only did any consideration of that possibility raise the issue of money, but it put her, and her own work, in second place. Contradictorily, Anni knew that Maximilian's fondness for Josef's work went deep—he had bought a number of works at the Sidney Janis Gallery during Josef's lifetime—and was a point in common between them, and she continued to give him a valuable work almost every time he came to visit, as it represented their spiritual connection, even if on some level she knew, and resented, that this was what got him up to Connecticut.

At one point Maximilian began to discuss her will with her. She very much liked a painting he owned by Jean Dubuffet, *The Geologist.* During one of her visits to him in Munich, where she had seen the Dubuffet for a second time and expressed surprise at how engrossing she found this complex canvas by someone so far outside the Bauhaus canon, Maximilian told her he would leave it to her in his will. He then explained to her that this was a wonderful thing to do: to leave art to the people you knew who loved that art, and that a will was a good way to do this. He suggested, as an example, that just as he was leaving her the Dubuffet, she might leave him some of Josef's paintings: what could be better, in Josef's memory, and for everybody's happiness?

When Anni returned to Connecticut, she told me about this: Wasn't it touching that Maximilian was leaving her the Dubuffet? Shouldn't she do something along the same lines? He had told her that the Dubuffet might be worth half a million dollars; she should be just as generous in her own will.

Then I pointed out to Anni that, much as I hated to say it, she was ninety-one years old to his sixty-one. I explained the concept of the actuarial table, new to her, and suggested that in all likelihood she would die before he did; I hoped she would forgive my indelicacy in saying so.

An hour later, Anni told me how brilliant I had been to call this to her attention, that it had not occurred to her. She was smiling; she liked catching someone being naughty, even if the someone was Maximilian. She relished the feeling of coming to her senses and having the upper hand. It was the same sense of triumph she had when she left behind the milieu of her parents and went to the Bauhaus. But then she looked at me with a very

serious expression on her face and, again alluding to Maximilian, said, "You know, I need the obsession to live."

THE WAY THAT OBSESSION sustained Anni was evidence that, much as she would make the case for art as a constant in her life and would claim textiles as her source of fulfillment and meaning, the love of another person, and the strength of a connection with a man who was independent and powerful, was essential. Indeed, it had been so ever since she met Josef.

In 1980, I took Anni to the blockbuster Picasso exhibition that filled almost the entire Museum of Modern Art in New York. I wasn't sure whether she would like it or not, but I felt that she had to see it. Anni was by then totally dependent on a wheelchair. As I wheeled her through the show, she was totally riveted. She connected viscerally to the early work from Barcelona, the Blue and Rose Period figure paintings, the cubist portraits. When we reached the monumental, neoclassical figures Picasso painted in the early 1920s, she turned to me and said, "You know, we were wrong at the Bauhaus. He was *the* genius. Finally, nothing is more important, or exciting, than man."

3

That Anni had been uniquely attuned to the visual had been clear from the start. Born on June 12, 1899, her earliest childhood memory was of waking up on her third birthday to a garland of flowers strung around the bedposts; she never forgot the joy of the brightly colored assortment of shapes suspended above her. She would remember for the rest of her life how as a child, whenever she went to the family box at the Berlin opera, she and her younger sister wore black velvet dresses with white Irish lace collars and cuffs made by the dressmaker who came to the house. That crisp counterpoint of black and white and the play of textures retained their charm for her forever.

What Anni considered most telling in her recall of those opera performances was that her favorite moment had always been when the orchestra was tuning up. Later in life she recognized this as a sign of her fascination with process, with how components join to achieve the end results, even more than with the finished product. Anni would become as intrigued by thread and its interlacing, and by the processes of printmaking, as she had been by the sound of the violinists tightening their strings and testing the results with their bows.

Transformation and the working of components were Anni's nectar. When her parents gave costume parties in their Berlin apartment, she was riveted to the sight of the usual furniture being taken away and the painted scenery brought in, just as she was fascinated by the return to the norm after the party. For the family's formal flat to become the Grunewald, the vast area of parks on the outskirts of Berlin, large canvases of landscapes were installed. The idea was to make the cushy interior a relaxed setting for a picnic. Guests entering the verdant paradise were met by a simulated boat, constructed on a bed frame on wheels, which ferried them a few feet through the entryway, as if they were crossing one of the lakes of the Grunewald. For another party, with a railroad station motif, Anni's parents installed murals of sausage stands, ticket booths, and information desks. Young Anni was mesmerized by the possibilities of the imagination and the way these fantasies heightened human spirits. She also had a feeling for the bizarre, such as her mother's behavior at the make-believe train station; Mrs. Fleischmann arrived at her own party screaming because she had lost her child, and then ran out the door pretending to be a child looking desperately for her mother.

When Anni told me this, I had the impression that she had never discussed these memories with another soul—except possibly Josef, who would not have shared her amusement. She did not consider her personal history noteworthy. On some level, she must have recognized that the events of her childhood and the nature of her memories were of a piece with her extraordinary life as an artist, that there was a consistency to her passion for imagination and her fondness for metamorphosis and change, in whatever guise, but until we met, she had not encountered anyone who was quite so fascinated with her or her life story—or who loved her the particular way I did. At last she felt secure—with good reason.

ANNI WAS COMPLETELY unusual as a child in bourgeois, early-twentieth-century Berlin. She disliked the paintings her parents had at home, almost as much as she disapproved of the Biedermeyer furniture. She scowled when she told me this. It was not simply that her parents' style was counter to her taste; in her eyes it represented wastefulness.

Josef, who was present at the time, explained to me what Biedermeyer was, since I clearly had no idea. He, unlike Anni, had a certain fond nostalgia for the heavy and ornate nineteenth-century style, because at least the construction of the pieces had required considerable skill. But Anni would have nothing of his enthusiasm. While he described Biedermeyer, she grimaced, not even waiting for him to finish his brief summary before she said, "No, no, you're wrong, Juppi."

She did, however, like what she saw when her father took her to the Secession shows. This was not, she realized later in life, because the art had great merit; rather, it was because she was the only child at the exhibition, and her instinctive reaction to the shocked crowds turning their heads disapprovingly was to think, "Why not?" Remembering this at age seventy-five, she said that for the rest of her life she generally considered herself the youngest person in the room. It was only when my children became teenagers and had their friends around that I understood what she meant; she was correct that she was more open-minded, and adventurous, even than most adolescents, and she was more receptive to visual beauty, and to the quirks of human behavior. This openness and longing for the extremes of existence is why she had gone to the Bauhaus and embraced its opportunities, and half a century later embodied its legacy.

Until Anni was thirteen, she and a few other children were educated together by tutors. Her first art teacher was a Miss Violet; Anni adored the name. Her watercolors of delicate autumn leaves were well received, and when Anni went on to the lyceum, her parents saw to it that she had a private art teacher, Toni Mayer. For Anni, the only problem was that Mayer had the same first name as her mother, and therefore in her mind seemed overweight and intrusive. Anni was delighted that when she added a Russian flourish to "Toni," it took on a completely different character. Moreover, "Tonuschka" brought a nude model into the house for the fourteen-year-old girl to draw. This made her feel very professional, even if she, like Josef, later claimed that such training was pointless.

ANNI WAS BOTH star pupil and bête noir in her art studies. She attended a lyceum, where there was a competition for posters to give to children orphaned by the world war that had broken out the previous year. Fifteen-year-old Anni made as her entry a picture of short-haired little girls sitting behind each other in a row. The girls were all shown knitting, and each wore a skirt with a hem slightly above her knees. Her teacher declared the work immodest. A poster of a more acceptable subject, which Anni considered artistically inferior, received first prize. Although hers garnered an honorable mention in spite of its scandalous imagery, a sort of fury began to burn.

The Anni I knew saw her life as a series of hard challenges in which she was perpetually butting her head against disapproval. By the time she was in her seventies, she had had considerable success—major exhibitions, glowing press, attention from devoted collectors—but her memory generally dwelled on the swipes against her.

Even though she described the Bauhaus as "*the* place" and a form of paradise, her specific recollections of the school ranged from feeling that no one

knew who she was to the pain she felt when Mies van der Rohe deprecated "rich Jewish girls" in her presence. When I asked her about the retrospective of her textile work held at the Museum of Modern Art in 1949, the first thing she told me was that her younger brother had asked her why it had not received more attention in the media. The reason, she explained, was that there had been a newspaper strike; the strike itself, which worked against the show, and her brother's quips were what she recalled—not having the first solo exhibition ever given a textile artist at the Modern, or the dramatic and effective installation by Philip Johnson.

That sense of hardship inflicted on Anni was part of her self-definition. The energy required by battle fueled her, almost as much as her love for beautiful art and determination to work as she wanted. When she recalled her childhood, she showed no gratitude that her parents had been so forward-thinking compared to most of the people in their milieu that they hired tutors and art instructors for her and supported her unusual desires. Her inability to credit her mother for encouraging her interests was almost pathological.

Anni went from the lyceum to study art full-time with the post-impressionist Martin Brandenburg, who had a studio on the floor above Lovis Corinth's. This, too, was with her parents' support. She liked Brandenburg, and felt that she benefited from the strict discipline he imposed by having his students work on precise figure drawings, about half life-size. Especially with her father away in the war, she regarded Brandenburg "as a strong manly figure. His word had weight." Brandenburg once told her mother that Anni had worked so hard that she should be taken as a treat to a winter resort, and Mrs. Fleischmann happily complied—although Anni remembered the trip only for the burden of being with the overweight mother whose company she did not enjoy.

What animated Anni far more than her teacher's admiration were her conflicts with Brandenburg as an authority figure. When Anni, having seen a beautiful Lucas Cranach *Eve* painted against a black background, started to use black in her painting, he told her its use was forbidden. She broke down in tears, and when he said that if she continued to use black she could not return to his classes, she left.

Her mother engineered a reconciliation between her willful daughter and the tradition-bound instructor. Anni promised never again to use black, and resumed her studies. When she told me the story, she blamed herself for not having expected this reaction from a teacher of classic impressionism. This mix of self-criticism and annoyance with the forces arrayed against her was her norm.

But she had found a solution to her angst. She reported this dispute about black with the satisfaction of someone who, following that encounter,

had managed continuously to make black—in bold, solid units—one of the major elements of her textile and graphic art.

BRANDENBURG DIED IN 1918, which was when Anni decided she would try to work with Kokoschka. She had recently bought as her first art acquisition a Kokoschka lithograph of a woman's head—this was in the period when he was preparing images for his Alma Mahler doll—and her mother went with her to Dresden to seek him out. Again, she gave no credit to her intrepid parent, although Mrs. Fleischmann did considerable detective work to find the painter, who was deliberately elusive. Kokoschka regularly changed hotels, and Mrs. Fleischmann had done a lot of tracking down leads by the time she and her daughter finally knocked on the door—all for an encounter that lasted five minutes at most. Kokoschka glanced at the portfolio that included an oil portrait of Anni's mother, but then, as Anni would tell Josef a few years hence, sent her on her way.

Anni went to the School for Applied Arts in Hamburg, but a two-month stint was all she could bear. In a class on wallpaper design, her drawing of a man was considered "unacceptable because it had too much expression." Anni decided to stop wasting her time.

ANNELISE FLEISCHMANN had few personal friends, but one of the rare ones was Olga Redslob, the sister of Dr. Edwin Redslob, the liberal-minded arts commissioner of Germany who was a vital supporter of the Bauhaus. Edwin Redslob recommended to her that, given her disappointment with the teaching methods in Hamburg, she should consider the pioneering educational experiment started in Weimar three years earlier. One look at Feininger's abstracted Gothic cathedral and a quick reading of Gropius's manifesto, and she was determined to be on her way.

Her father was against the idea. "What are you talking about—a new style?" Siegfried Fleischmann asked after she described the Bauhaus to him. As a furniture manufacturer, he felt he knew what all the possibilities were. "There has been the Renaissance, there has been the Baroque—it has all been done already." At least this was how she often cited his response, which was the canned recollection of her pre-Bauhaus life that she gave, always with a laugh, in interviews. Siegfried Fleischmann was probably too enlightened and sophisticated to have made the remark, unless he did so as a joking quip. But to Anni, later in life, it served a purpose by portraying both her own temerity and the mentality she was bucking with her exceptional willpower.

SINCE THE BAUHAUS provided no housing for its students, Anni rented a room in Weimar. For Josef, the move there had meant swapping hardship for rel-

ative comfort; for her, it was the reverse. Instead of the luxurious surround-ings of her parents' Berlin flat, she had willingly opted for a place where, when she wished to bathe, she had to go to the downtown bathhouse, where the hot water was so limited that she needed to make an appointment in advance. She was, however, gleeful to relinquish bourgeois norms; Anni rel-ished the pride and superiority that came with voluntarily submitting her-self to arduous conditions. With me, she was deliberately matter-of-fact about it: "Since there was no way of comparing it to any other situation, this was the way it was."

Anni attended sessions of the Vorkurs under Itten before seeking full admission to the school with her entrance project. "Alone and shy and somewhat unsure"—for all her willingness to seek a new life—she felt her-self to be very much of an outsider, full of doubts about her own worth. A sympathetic fellow student, somewhat older, Ise Bienert, whose back-ground was similar to her own, reassured her that the new venture was worthwhile and that she was not completely alone. Ise's mother, Ida Bienert, was a major art collector who lived in Dresden and was sufficiently avant-garde to buy work by Klee and Kandinsky. It was Ise, whose family gave her rare access to the more established Bauhauslers, who introduced Anni to Josef Albers. The "thin and ascetic-looking"—how Anni relished saying those words decades later as she remembered the first sight of him—hero of the glass workshop instantly exerted a strong magnetic force on her.

Besides being one of the oldest students, Josef was already greatly admired at the school, both by the faculty and by the other pupils, not just for his glass assemblages, but also for his success in a range of other disci-plines. When Anni was among the eleven of sixteen newcomers to Weimar to be rejected for the upcoming Bauhaus semester, she was disappointed mainly because she "had had a second look at Josef Albers and was inter-ested in possibly seeing a little more of him." Anni's understatement in telling me this, as she did while Josef was still alive, was deliberate, and she made this remark about the love of her life in a carefully modulated, soft voice, but she had a mischievous smile and a spark in her eyes when she said it.

Anni registered for a further six months of preparatory courses, with Josef now proffering advice on her entrance project. This project, which was constructed from interiors of thermos bottles, broken bits of glass, and metal, had a clear allegiance to his notion of utilizing detritus. Anni also made a highly naturalistic drawing of a piece of wood, and a color scale that went from black to white with a progression of grays in between. The three projects secured her acceptance at the Bauhaus on her second attempt.

In 1947, twenty-five years later, Anni Albers wrote—in the English she

had begun to develop under the guidance of an Irish governess in her child-hood and in which she had since become so eloquent at Black Mountain College, where she and Josef had by then been living for fourteen years:

> I came to the Bauhaus at "its period of the saints." Many around me, a lost and bewildered newcomer, were, oddly enough, in white—not a professional white or the white of summer—here it was the vestal white. But far from being awesome, the baggy white dresses and saggy white suits had rather a familiar homemade touch. Clearly this was a place of groping and fumbling, of experimenting and taking chances.
>
> Outside was the world I came from, a tangle of hopelessness, of undirected energies, of cross-purposes. Inside, here, at the Bauhaus after some two years of its existence, was confusion, too, I thought, but certainly no helplessness or aimlessness, rather exuberance with its own kind of confusion. But there seemed to be a gathering of efforts for some dim or distant purposes . . . [for] realizing sense and meaning in a world confused.[2]

Beyond that, there was Gropius. Anni always responded viscerally to confident, handsome men. When she was starting at the Bauhaus, she was in a state of uncertainty, with "a purpose I could not yet see and which I feared might remain perhaps forever hidden from me. Then Gropius spoke. It was a welcome to us, the new students. He spoke, I believe, of the ideas that brought the Bauhaus into being and of the work ahead."[3]

A quarter of a century after Gropius gave his talk, Anni could not recall the specifics, but she could vividly evoke the feeling inspired by the Bauhaus's founder. "What is still present in my mind is the experience of a gradual condensation." She moved from her state of "hoping and musing into a focal point, into a meaning, into some distant, stable objective." Following the hour in which Gropius explained the objectives of the Bauhaus, its emphasis on design based on function and the need to develop new materials, and the aim of spreading the new vision to all economic strata worldwide, Anni felt "purpose and direction from there on." It was, she concluded, "the experience of finding one's bearing."[4]

ANNI'S NEXT STEP, after hearing Gropius, was to choose a workshop. She wanted stained glass, but the Bauhaus masters said no. Gropius explained that one person was enough in this field; as it was, he and the other faculty members had questioned the value of glass as an independent discipline until Josef had, only recently, convinced them otherwise. Anni then tried for carpentry, then wall painting, and finally metalwork. For all three workshops, she was refused on the basis that the work was too strenuous.

Feminist revisionist history has, in recent years, maintained that the reason Anni finally went into weaving was that nothing else was open to women.[5] In fact, the other workshops had female students; the real issue is that Annelise Fleischmann was too frail for everything else. She never discussed her health issues, but the disability that had made it necessary for Josef to drag her up the mountaintop was Charcot-Marie-Tooth disease, an incurable genetic illness that causes muscular atrophy. Her difficulties, characteristic of the disease, were manifest primarily in her feet; she had unusually high arches as well as hammer toes, and diminished muscle function.

Many observers over the years would notice that Anni's legs resembled stilts, and that she walked with difficulty. But no one at the Bauhaus—or, later, at Black Mountain—knew exactly why. There were rumors of various causes, but everything was hypothesis. I was with Anni in the 1980s when her oncologist (by then she had developed and been successfully treated for lymphoma) discussed her inherited neurological disorder with her. She seemed totally bemused, as if she had never even known the name. She acknowledged her lifelong need for custom-made shoes, her inability to dance "while Josef was a very good dancer." She recalled that "people said I had had rickets, my legs were so thin, or that I had starved during the war, hardly the case." By the 1980s, it was also evident in a pronounced weakness and trembling in her arms, but Anni's response to these disabilities had been to utilize them in her art rather than to inquire about their cause or seek treatment (which would have been futile). She decided that instead of trying to draw straight lines, which she could no longer possibly do, she would let her tremor become a determining factor in the work. The inadvertent shaking caused a progression of small rises and dips in the shapes she was drawing, which were based on the typical Connecticut stone walls she saw out of her bedroom window, and the roughness of the contours was remarkably effective.

It was Charcot-Marie-Tooth, though not identified as such, that led her to weaving, as this allowed her to work seated. Although she had to operate the pedals on the looms, they did not require too much muscle. This was one of many occasions in which circumstances over which she had no control determined a major life decision for Anni, who, for all her insistence on mastering aspects of her own destiny, willingly accepted the things that were impossible to control.

The illness probably explained why Anni and Josef did not have children. Not only were they afraid of passing the malady on. Someone may have told Anni, correctly, that pregnancy can exacerbate the illness's symptoms; that was one risk she would not take. But Anni's sister-in-law, her brother Hans's wife, told me that "everyone in the family assumed that the reason Jupp and Anni did not have children was because they were too interested in other

things to focus on them. We always said that if Anni had had a baby, she would have put it away in a dresser drawer and forgotten where it was."[6]

ANNI WOULD QUICKLY come to accept the idea of making textiles, although initially, regardless of the necessity, she begrudged it. "I was not at all enthusiastic about going into the weaving workshop, because I wanted to do a real man's job and not something as sissy as working with threads."[7] She was willing, however, to be surprised. The medium she initially disdained immediately became the mainstay of her life, a source of fascination and, soon enough, of prodigious achievement.

In both her wall hangings and the functional materials she soon began to make, Anni became a pioneer. In time, her work would change the look of upholsteries and draperies all over the world, she would invent a new form of abstract art, and she would write articulate essays that have had great impact on textile design. Once she accepted a verdict about which she had no choice, she then went as far as possible with it.

ANNI ADMITTED THAT at that moment when she agreed to take up textile work "the freedom of painting was bewildering" to her. "There were worlds of styles and periods and cultures all open to you; I didn't know where I was." Her efforts with her private instructors and Brandenburg in her youth showed her that she liked the processes of making art, but she remained uncertain what direction to turn in. Necessity provided a solution. "I had to enter a workshop if I wanted to stay, and I wanted to stay. Weaving quickly became a kind of railing to me—the limitations that come with a craft, so long as you, at the same time, are concerned with breaking through it."[8]

Whether it was the possibilities as well as the frailties of thread, the reality of being Jewish in Nazi Germany, or the exigencies of a life where one could hardly afford string after having owned diamonds, this was how Anni lived: by responding to the givens and making the most of them. Once she was officially in the weaving workshop, she took filaments of jute, cotton, silk, gold leaf, and cellophane in previously unexplored directions and extracted a haunting beauty from them.

At first she made only swatches. The largest piece was a pillowcase. But she quickly discovered that the selection of thread and its manipulation to produce materials that served their future functions and added aesthetic pleasure to life both thrilled her and afforded her an inner harmony.

ANNI WAS SO EAGER to make the point that what is unexpected and undesirable can be beneficial that later in life she took to saying, "This Hitler business worked out rather well for us."[9] My wife eventually convinced her that the statement might offend others who had suffered more directly, but until

then Anni saw it only as indicating a harmless willingness to accept the unavoidable. This was the spirit with which, in 1941, after she and everyone else in her family had been forced to sell all of their expensive jewelry or use it for bribes, Anni used paper clips, sink strainers, bobby pins, and other staples of stationery and hardware stores to make and exhibit necklaces of astonishing originality and panache.

The only circumstances she ever seemed to find really difficult were when financial wealth and artistic status came her and Josef's way. Anni never could spend money comfortably, and prosperity troubled her. She continued to buy day-old bread and pastries at a bakery thrift shop (she considered both "Pepperidge" and "Entenmann's" modern marvels, examples of the Bauhaus ideal of mass production yielding uniformly impressive results), even after Lee Eastman told her, "Anni, you can eat caviar every day." She always acted as if Josef had never really had the success he merited, as if his solo show at the Met and the television documentaries and high prices his works garnered were an aberration, since there was no possibility that genius might be recognized in its own time. Suffering and limitation spurred you on; confidence, ease, or, worse yet, self-congratulation guaranteed disaster.

GIVEN HER NEVER-DISCUSSED and possibly undiagnosed medical disorder, Anni had no need to invent difficulties. But the main issue for both her and Josef was not so much what life presented them with as what they did with it. For Josef's sisters and most of the people with whom he grew up, working-class life in Bottrop was perfectly fine, suitable for the rest of their lives. For Anni's sister Lotte, only a year and a half younger, the plenitude of their childhood was a wonderful thing; the family was not merely rich, but they were immensely intelligent, and the idea of remaining in the milieu in which she had been raised was a happy one. Lotte married a Jewish judge, quite a bit older than herself, and although the realities imposed by the Third Reich brought the easy existence of both families to an abrupt halt (although without a single death), Lotte thought what they had was marvelous even as Anni despaired of it all.

The only luxury of her childhood about which I ever heard Anni enthuse was a gold cigarette holder one of her Ullstein uncles had received as a Christmas present. She liked that object because it ultimately saved her uncle's life when he used it to bribe a border guard.

The Bauhaus offered her a chance to grapple with reality, to replace fluff with toughness. The need to live simply and fight for a position invigorated her. How often she would say to me, "At least once in life, it's good to start at zero." When she had to do so for a second time, after the Bauhaus was closed, she mainly looked forward, without lament.

4

In her new life in Weimar, Anni was not yet among those who wore all white. She told me that then, as always, she "purposely avoided an arty look," and sewed her own dresses, which were mostly in a kimono style, with white collar and cuffs that may have been an unconscious reference to what she and Lotte wore to the Berlin opera as little girls. Tall and thin, with a large nose and fiercely intelligent face, she had thick long brown hair usually rolled up in a comb; she was, in vintage photographs, a striking beauty, but neither girlish nor pretty, as she claimed to wish she had been. Rather, even as others admired her appearance, which was that of an Egyptian deity, she was uncomfortable with it. Her greatest issue was that she felt that her coloring and nose revealed that she was Jewish, which, while she never tried to conceal it, made her self-conscious.

Anni called her Jewishness "that stone around my neck" and referred to other Jews as having "that dark side." It was never clear if she disliked being Jewish because she considered her Ashkenazi origins the source of her appearance, which she disliked aesthetically, or didn't like her nose because, in a world where antisemitism was so pervasive, it identified her as Jewish, but what is certain is that her own facial type and Jewishness were intertwined in her thoughts. And while she considered her husband a handsome man and attractive to ladies, she thought of herself as an ugly duckling.

Until she learned about it in the 1980s, Anni seemed unaware that a century earlier her mother's family, the Ullsteins—owners of the largest newspaper and magazine publishing firm in the world—had had a mass family baptism, in which some eighty-five of them became Protestant on the same day. Of course she knew she had been confirmed at Berlin's fashionable Karl Wilhelm Gedenkniskirche—she often referred to this—but, as she explained, she was "in the Hitler sense Jewish." She blamed herself for what that fact imposed on Josef in the 1930s; the Ullsteins' attempt to be thought of as Christian had been, like everything she associated with her mother, ineffectual.

It was only when I was researching this book that I learned that a census had been taken at the Bauhaus in 1923 to determine the percentage of Jews there, and hence to refute the charge of the Weimar citizenry that the school had too many "non-Germans." This knowledge helped me understand the

discomfort Anni had felt almost from the moment she had begun her new life. She had been more comfortable as an assimilated Berlin Jew, as she was in her childhood, than she was at the Bauhaus, where she was identified as Jewish.

Anni often told me with pride that being officially Protestant, and having produced her confirmation certificate, enabled her to secure burial plots in the oldest section of the town cemetery in Orange, Connecticut. She and Josef preferred this precinct of the cemetery, with its simple gravestones, to the newer part where Catholics were obliged to go, and where the marble monuments were too ornate. Anni had loved it when at this late stage of their lives, her background gave Josef something he wanted.

Yet her ambivalence about her background was clear. Anni's most magnificent artwork ever would be a memorial to the six million victims of the Nazi concentration camps. With interwoven threads, she succeeded in evoking swarms of humanity—a vast population of vibrant, connected lives—so that the mélange of black and white and gray fibers becomes audible. *Six Prayers,* like a Torah cover and ark curtain Anni also wove, has elements that resemble written Hebrew (see color plate 29). It is a deeply moving work, charged with life yet somber, inspiring hours of contemplation and deep emotional awareness.

Anni once tried to talk with me about Anne Frank, whom she resembled physically, and who was also born on June 12, exactly thirty years after Anni. Suddenly she could not go on. Anne Frank's fate was one of those subjects she was incapable of discussing—as unfathomable as the construction of the concentration camp at Buchenwald, only five miles from Weimar, where the gas chambers went into operation twelve years after the Bauhaus had moved on. When she told me of her parents' ship needing to dock in Mexico because U.S. ports were no longer open to these incursions of refugees from Nazism, she also had to stop speaking. When Anni learned, in the 1970s, that Marcel Breuer had totally concealed his Judaism at the Bauhaus, and officially had himself made un-Jewish in a government office in Weimar, she was as appalled as she was fascinated. After Josef's death, two Bottrop city officials came to Connecticut to propose building an Albers museum in his natal city. The smiling bureaucrats had been in the house for scarcely five minutes when she told them, "Sie wissen dass ich judishe bin [You know that I am Jewish]." It was possibly the only time in her life that she uttered these words with such clarity, instead of waffling by saying, "My family was, although only in the Hitler sense of the word, Jewish." The German officials told her that they already knew; she was too smart to be surprised.

She was rarely one to gloss over the truth, and she came from a world

where being Jewish was significant. However much she disparaged the idea, and reminded me and others that she had never in her life actually been inside a synagogue, even though she had executed textile commissions for two of them, Anni always acknowledged that she belonged to a Jewish family on her mother's side—even though they had converted and their money embarrassed her. She preferred her father's less wealthy but more stylish and aristocratic family, although their name, which was of course also hers—Fleischmann—appalled her, as much because it was a badge of Jewishness as because it meant "meat man," or butcher, but here, too, there was denial.

What she wanted in life, however, had nothing to do with any of that. She hoped, from the moment she got to the Bauhaus, to make art and design the central issues of her life and thus obliterate the issues of background. What mattered was devotion to art; her spiritual ancestors were the artisans of ancient Peru and the anonymous builders of Gothic cathedrals, and her current family of soulmates included other advocates of modernism and good design. For Annelise Else Frieda Fleischmann, even before she was Anni Albers, these were the real aristocracy of mankind. But, to her dismay, this new life she had chosen made her more, not less, aware of her background. There was no getting around it: to Gropius and Kandinsky, if not to Klee, and to the government authorities who founded the Bauhaus, and, eventually, to the bureaucrats who closed it, the distinction between being "Jewish" and being "German," whatever one's religious beliefs, was a pivotal issue.

For all of its idealism and emphasis on design for all of humanity, the Bauhaus, both because of the accusations that the German nation was funding "foreigners" and because of attitudes ingrained in German society, did not allow those attitudes of background to fade.

WHEN ANNI WAS in her early nineties, almost entirely bedridden, and reduced to very limited conversation, I once walked into her room and the first thing she said to me was "You're so lucky."

"Yes, I am, Anni, in many ways," I responded.

She continued, "They can't tell."

I pretended not to understand what she was saying, and asked, "They can't tell what?"

She explained that I did not seem obviously Jewish—either by appearance or by name. "No one would know you have that dark side." She knew I did not consider it anything to be ashamed of, but she had been lying in bed ruminating about her own Jewishness for hours, and what had come out were thoughts that had haunted her for a lifetime, and that her life in artistic milieus had intensified rather than diminished.

5

In spite of this ingrained awareness of race, part of what joined everyone at the Bauhaus, whether they were rich and Jewish like Anni, upper class and Aryan like Gropius, noble and Russian like Kandinsky, solidly burgherish and Swiss like Klee, or working class and Catholic like Josef, was both that they were not wed to their own backgrounds and that, in Anni's words, "We were impatient with the standards of the bourgeoisie."

They were joined in their will to replace outmoded values for everyone, rather than to retreat to alternative lives for themselves alone. They were not revolutionaries who wanted to topple the existing framework, but pioneers who sought to transform it. The Bauhauslers respected what was best in the existing German culture; they did not unilaterally disparage all its traditions. They wanted to forge connections, to see their ways accepted and integrated. "We were not violent, or rebellious in the present-day sense," Anni explained to me.

Gropius's original manifesto called for building "a new guild of craftsmen without the class distinctions that raise an arrogant barrier between craftsman and artist." The new unified spirit was to "rise toward heaven from the hands of a million workers like the crystal symbol of a new faith."

Anni and Josef, when I knew them, loved to go shopping at Sears, Roebuck; they marveled at their Polaroid Land Camera (an SX 70, the first to develop a picture in a minute); they extolled the products of Sony. These were examples of intelligent design flourishing within the system. The Alberses were thrilled that, in certain objects, a clear-headed aesthetic sensibility had assumed global dimensions. On the other hand, the notion of an artistic elite, apart from the world, was of no interest to them. Josef and Anni disparaged artists' colonies and places like Provincetown, Massachusetts, and East Hampton, Long Island, where people were cliquish and conspicuously bohemian. They abhorred fads and uttered the words "trend," "fashion," and "career" with contempt. They preferred watching Chinese acrobats on television to going to mediocre craft shows or confronting paintings they deemed sloppy or incompetent. What mattered was quality and seriousness.

While they loathed self-conscious artiness, they were fascinated by cultures where they observed that visual pleasure and good design were embraced by the majority of the people. About Mexico—where they fell in love with folk art in marketplaces as well as with the treasures of pre-

Columbian art, where serapes and earthenware all had intrinsic charm without pointing to the names of their makers—Anni declared that "art is everywhere." This was the ideal.

This was also the case in Weimar in 1922. Once she was settled in, Anni "was deeply involved in the Bauhaus and thought there was no more interesting place on earth. . . . There were things I didn't care for very much, but it was in my eyes *the* school at the time and *the* school for me."[10] Not that it was the well-organized teaching institution it appears to be in the many books that have since been published about it. The weavers were simply put in front of poorly set-up looms and left to their own devices. Anni told me about being instructed to weave a warp by combining inelastic linen with cotton, which is quite elastic. The task was impossible, an example of lack of understanding on the part of the instructor. But she was content to continue; she "expected other people to make mistakes, and took pleasure in being the one who occasionally had an answer." And even while those mistakes were made, here was a world in which everyone lived for the idea of improving what we see and touch.

ANNI WAS EAGER to have me realize that while the Bauhaus provided her with that exhilarating sense of possibility, the school was not a well-structured

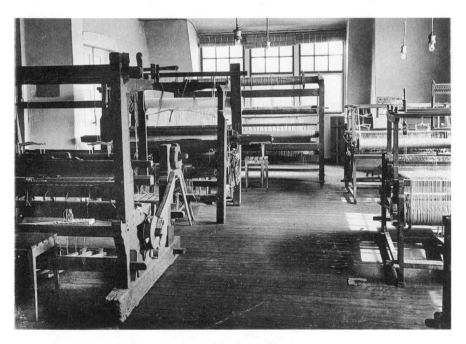

The weaving workshop at the Weimar Bauhaus. The equipment technically belonged to Helene Borner, who had taught art at the Weimar Academy.

and orderly institution. People were human, which in her eyes meant mostly indifferent or selfish. Kandinsky and Klee were, of course, geniuses, as hardworking and dedicated as they were gifted, but they held themselves apart from students and younger faculty. Gropius was alluring and charismatic; although not on their level creatively, he was a capable administrator and diplomat. Mies was unquestionably brilliant, but he was cold as well as too "fancy," and she never forgave him the "rich Jewish girls" remark. Josef was, of course, a more complicated subject, but she worshipped him when she wasn't enraged by him.

While most Bauhaus literature presents Helene Borner, the first director of the weaving workshop, as an expert, Anni described her as being better equipped to teach needlepoint than weaving, of which she lacked even basic knowledge. Beyond that, since Borner had been on the staff of Henry van de Welde's Arts and Crafts School and therefore had provided the looms— a coup, since many of the other Bauhaus workshops lacked basic equipment—she acted as if she owned them personally, with a possessiveness that was infuriating. The impact of Georg Muche, the form master, was "zero."

Even if this is the viewpoint of someone who needed to see herself as having triumphed against the odds, it rings true. This is in part because, however disparaging, Anni saw Borner's and Muche's inadequacies as inconsequential. She and those of her fellow students who became real friends thrived on the absence of methodical teaching. They were enchanted rather than frustrated by the sense of being on their own without much instruction. Anni told me:

> The importance of the Bauhaus in the early years was not the teaching, was not that great men were there, was not that educational ideas were later formulated there, or anything like that. It was what I now call a "creative vacuum." It was so unformalized, informulized, even contradictory in all its various areas, and we were so full of admiration for Klee and Kandinsky, who were experimenting on their own. You see: all of this went together; they too were finding their way. At that time they were not established as we now imagine, and they weren't "in" internationally. They were very much on the fringes of everything— the way we all were.
>
> It was as if one filled in the training later. At the beginning you knew nothing, and you really weren't taught anything. We all just dabbled around until something happened.

Anni and two older students, Gunta Stölzl and Benita Otte, tried to fill their gaps in technical knowledge. Even then, it took a while to progress

beyond swatches and the pillowcases that Anni remembered emerging by the dozen because their lack of tough technical requirements made them easy to do. The weavers were, after all, also there to enjoy life. Sitting on the bench of a big loom, having Josef come and position himself next to her to see what she was doing, just as the boyfriends of the other weavers did, made Anni feel more in the swing of life than she ever had before. Sometimes in the morning when they arrived at their workshop, she and the others would find flowers their young suitors had left on the looms; those moments gave her unprecedented joy, as important as the advances in design that get cited as the achievement of the Bauhaus.

FOLLOWING THAT FIRST CHRISTMAS, when Josef gave Anni the Giotto print, the romance took off. After going home for her twenty-third birthday the following June, she opened the door to a surprising delivery: a twelve-inch-high bronze replica of a thin, graceful Egyptian figurine from Berlin's Pergamon Museum. Only two copies of the figure existed, and the near-penniless Josef had secured this one for her.

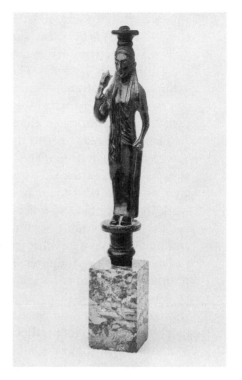

On Annelise Fleischmann's twenty-third birthday, which occurred shortly after she arrived at the Bauhaus, Josef Albers surprised her with this fine reproduction of a statue in Berlin's Pergamon Museum.

Again he had found the perfect gift to symbolize their shared love for art. The statuette epitomized equipoise and delicacy.

That gift would be at her bedside, standing on a shelf so as to be aligned with her pillows, for the rest of Anni's life: in her bedroom at the Dessau Bauhaus, at Black Mountain College, and in the austere, hospital-like bedroom in Connecticut where she lived a further eighteen years after Josef's death.

THOUGH SHE HAD BECOME involved with one of the most desirable and well-known men at the Bauhaus, Anni considered herself an outsider. She told me she felt most of the other people would not even remember her having been there. She and another student shared two rooms where they lived quietly, mostly separate from the other Bauhauslers, and completely apart from the very conspicuous Mazdaists. And she felt that her work was not noticed

any more than she was. Today books on the Bauhaus devote pages to her textiles; when she made them, she had no sense that they were being seen.

Yet Anni Albers's materials have an élan that make them unique amid all the Bauhaus textile work. They combine a soothing harmoniousness with a high charge of energy, restraint with enthusiasm. From the moment she completed her first woven wall hanging the year after she arrived, she revealed a rare ability to align dignity and verve (see color plate 24). The Bauhaus catalyzed in her, as if overnight, a pioneering and seductive vision. This first piece, a stunning essay in minimalism, shows how, from the very start, Anni was attracted by straight lines, by proportions and measures, and had the instinct to organize a surface into only a few sectors to create a work that was bold and quiet at the same time. Anni had been inspired by her passion for vitality within the rigorous rules of a well-ordered world, and by her craving for what exists only in art. Fully utilizing the possibilities of weaving, and suppressing personal concerns, she succeeded in juxtaposing serenity and order against the capriciousness of life.

Anni told me, half a century after making this piece, "Art is the one thing that keeps you in balance. You have the feeling that you are taking a part in something not parallel to creation, but something that adds in a way to a whole, that shows a wholeness that you can't find in nature because you can't understand nature as a whole." In her art, she was instinctively reaching for an accessible, microcosmic totality. Concentrating on technical and aesthetic problems, letting shapes and materials do all they could, attempting to think only visually and practically, she found her way to equilibrium and a sense of completeness.

Anni never expected this student effort to resurface. Then, in 1960, twenty-seven years after she and Josef had fled Nazi Germany, she was surprised to see the piece in Munich, in the home of Ludwig Grote, the former director of the Dessau and Nuremberg museums. Unbeknownst to the artist, Grote had bought it from the Bauhaus during his Dessau years. The school owned it; the issue of whether objects made at the Bauhaus belonged to their creators, and then to their creators' heirs, or to the institution remains unresolved to this day, as does the question of who is entitled to royalties for the designs of objects that have been mass-produced.

Looking at the wall hanging after all this time, Anni noted that in 1923 she had not yet developed her belief that asymmetry and a constant shifting of weight were necessary for movement and dynamism. But the careful placement of form showed that the seeds of the discipline and clearheadedness that have governed her entire life were already planted.

"I was really just one beginner in a group of others who were more advanced," Anni told me. Yet even if she had not yet fully explored issues of composition, and her work was in her own eyes initially somewhat imitative

or derivative, she unconsciously achieved qualities in her earliest work that distinguished it from that of anyone else at the Bauhaus. This first wall hanging is remarkable for its simplicity. It has less apparent complexity, more of a quiet, almost stoic quality, than the pieces of the better-known weavers at Weimar: Hedwig Jungnik, Ida Kerkovius, Benita Otte, and Gunta Stölzl. They shared Anni's delight in geometric forms, but none were as committed to a strict and rigorous order. Their work shows distinct patterns and rhythms, but not the same resolution and integrity of parts.

Anni's achievement is no accident; she divided the surface into a very few areas, minimizing form with a reductionism that for many artists is the culmination of a lengthy development, not the starting point. But as a twenty-three-year-old student struggling at the Bauhaus, dealing with a world of unknowns, having left a childhood that to others might have seemed idyllic but to her promised an unexciting future, in a Germany full of turmoil, Anni was enchanted by leanness and refinement. In this first work, she created a rich resting place, a clarity, an unanxious order—all achieved through balance, a paring down, and a precise modulation of tones.

THE FEW ABSTRACT COMPOSITIONS of this sort that Anni wove in Weimar were closer to her heart than the industrial materials with which Gropius was more concerned. His overriding interest was in the social implications of aesthetics and the power of the Bauhaus to awaken industry to good design; Anni, like Klee and Kandinsky, wanted first and foremost to make art.

Her wall hangings of the next couple of years were brave and beautiful forays into the realm of total abstraction that revealed more sophisticated ambitions than her first piece (titled simply *Wallhanging 1*). She still wanted art to be the attainable whole that nature never is, but she now tried to create an image of totality and clarity in a more subtle way, without exact symmetry. Anni and her fellow students were all exploring the rhythm of asymmetry; *Wallhanging 2* gives the viewer more surprises, less of an instantly readable formula, than the first hanging. With its title deliberately lacking in connotations, this second large piece has an intentional irregularity as well as balance. The dark and light bands at top and bottom are symmetrical against the horizontal middle. The white band at center is divided by a continuous black line and by two black lines that come from opposite directions and then halt at center, symmetrical along the vertical middle. The remaining sections of the hanging are unified because in both of them the top two bands are divided into the same sections of light and dark. But the other six bands are entirely different, related only by the artist's eye and not by any system of measuring. While the watercolors of Paul Klee, which Anni was studying closely at the time, work according to systems like those in classical music—two rectangles yielding to four, four to

eight—Anni eschewed such a clear pattern. *Wallhanging 2* gives the viewer a complex visual exercise.

Looking at it, we share with the artist the satisfaction of inventing order and then of letting go. We participate in the joyful manipulation of form and the careful relating of spatial areas, while never following a predictable path.

The texture of the piece is as cool and clear as the thinking behind it. Anni told me she had become intrigued by glazed Persian pottery in a Berlin museum, and developed the mixture of wool and silk to achieve the same subtly shimmering luster as those ancient ceramics. She used the identical material that appears at the top and bottom of the wall hanging to make two skirts, one short and one long, which could be worn with a single top that she also created. The crossover between art and everyday objects delighted her.

Some of the compositional elements of *Wallhanging 2* could apply to paintings, but other effects were possible only in weaving. The narrow black stripes appear to have been freshly peeled off to reveal a white layer behind them. This move, which seems to have happened only moments ago, excites the tactile sense. It reminds us that the stuff of the world is at times to do with what we will. Having had no wish to enter the domain of textiles, Anni now used it to evoke action and competence.

6

Anni made necklaces out of little beads and sold them in Weimar in order to earn some money beyond her modest allowance. She used her earnings to take Josef to a good tailor to have a conventional suit made. His typical outfit was a khaki corduroy jacket, with a hint of white scarf showing beneath it. She adored it, but observed that, in combination with his bangs, it made him look so bohemian that the waiters in Weimar restaurants invariably served him more slowly than other customers. The new suit was essential if she was to present the young man from Bottrop to her parents in such a way that they would not be put off. It was a success. This was the occasion they both loved recalling, when Anni's mother told Josef that the house would always be open to him.

LUXURIOUS AS THE ALBERSES' wedding lunch at the Adlon was, the only people there besides the bride and groom were Anni's parents and siblings and her sister's husband. Anni explained to me that big celebrations were for "peo-

ple who do things like that"—not individuals like her and Josef, who had other priorities.

She had enjoyed her involvement in Klee's fiftieth birthday celebration, and often referred to the large parties at the Bauhaus, but she and Josef never wanted to expend energy on events; any distraction from work was a waste. After they moved to America, they never attended celebrations given by family or friends, much to the annoyance of some of their relatives and acquaintances. They streamlined their existences to conserve their time and strength for making and writing about art, and getting their message and their creations out into the world.

The Alberses were extreme in their lack of sociability, but the Klees and the Kandinskys were certainly similar in the priority they accorded to work, such that any socializing they did was with colleagues whose goals were the same as theirs, or with museum curators or publishers or gallery owners; they had few friends with ordinary jobs, and they had no interest in "bourgeois" social life.

In the years I knew the Alberses, they never once left home in the evening; nothing justified the unnecessary disruption to their schedules. Nonetheless, in spring of 1975, when I became aware that their fiftieth wedding anniversary was approaching, I suggested to Anni that some of their relatives and work associates would like to celebrate. Perhaps she would let me organize a lunch?

"Out of the question," she said. She and Josef had not even acknowledged the upcoming date to each other. They did, however, agree—without saying why—that on the ninth of May they would drive to Litchfield, Connecticut, a colonial town where the grand wooden houses and churches are painted an identical regulation white. The drive was mostly on a numbered route and was therefore unconfusing. It took almost exactly an hour; Anni told me this last fact as if the roundness of the number were part of the suitability of the destination. And, very important, there was a good restaurant for lunch.

The following day, I asked how the outing had gone. Anni smiled and said that it had been exceedingly nice: "We didn't shout at each other once all day." This was the only way she and Josef acknowledged that it was their golden wedding anniversary. Anni knew, however, that Josef was aware of the significance of the date, because she had snuck a look at his desk calendar and seen that he had circled it.

WHEN THE NEWLY MARRIED Alberses moved to Dessau in 1925, they took, as their first home together, "a small, two-room apartment, neither sensible nor attractive." The crack under a door to the adjoining apartment was so gaping that Anni had to stuff it with a mixture of mothballs and crumpled newspa-

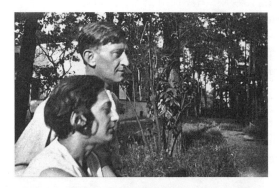

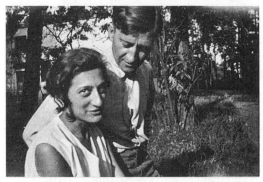

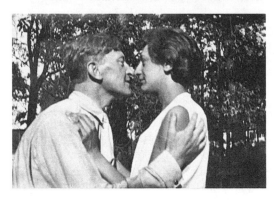

Josef and Anni Albers on the grounds of the future masters' houses in Dessau, ca. 1925. The Alberses were the only couple at the Bauhaus who were both esteemed artists. From totally different backgrounds, they were strikingly similar in some ways.

per. Then the main Bauhaus building was completed, at which point they moved into the only accommodations available: studios with sleeping alcoves, each for single occupancy, on separate floors. There was only one community bathroom on each hallway. Yet, even as she described this to me some fifty years later, Anni emphasized that to the townspeople of Dessau, who were suffering from a housing shortage, that dormitory was an enviable luxury. She did not mention the splendor she might have had in Berlin, if she had wanted— only how comfortable the dormitory rooms were compared to the way the local population lived.

The Alberses went to Florence together for a sort of wedding trip in the summer of 1925. They would never have used the term "late honeymoon," with its suggestion of the way more ordinary people celebrated their weddings, but that was the idea behind the journey to Italy. What Josef did in glass and Anni did in textiles after returning showed, in her opinion, the impact of the geometric façades of San Marco and Santa Croce and the stripes on the Duomo. When I mentioned this to Josef, thinking it would evoke fond recollections of the trip and of those early Renaissance buildings, he pooh-poohed the idea; as always, the concept of direct influence was unacceptable to him. Afterward, Anni confided to me that she was certain: they had both been so moved by the boldly

patterned buildings that they worked accordingly back in Dessau, which is why their art from about 1925 to 1928 is so remarkably similar in appearance.

The extant gouaches, as well as a rug and a tapestry lost in the war, all done in 1925, show the subtle effects of the trip to Florence. Anni was quick to admit to me that she was also influenced by the work of another student in the weaving workshop. If Josef refused, always, to acknowledge anyone else's influence on him, she made no bones about what she considered to be the wonderful exchange of ideas, the mutual give-and-take, that was essential to the Bauhaus community.

Still uncertain of her own direction, she followed her colleague in using a reverse mirror image. A tapestry in red, yellow, black, and gray silk follows this pattern: areas above and below the three central horizontal stripes are the same, only turned 180 degrees from one another. The result in each case is a satisfyingly crisp geometric composition, with distinct positive-negative relationships.

They were, however, Anni's last forays into panaceas for solving design problems. Again she ventured beyond symmetry, this time never to return. While her red and black rug of the same year has an overall equilibrium, it is a constantly dynamic whole in which no sequence is repeated, or even restated—thanks to an almost centrifugal force around the bold bars of red and black in the center (see color plate 17). Each visual phrase is allotted the precise amount of space Anni determined with a sense of scale she felt could never be explained. Anni pointed out to me that the rug gets narrower toward the top, an imperfection that shows her unfamiliarity with the ancient Smyrna knotting technique. Nonetheless, it has her trademark precision and boldness along with a new element of high-speed movement.

7

Anni said that there was one book she read in those years that made everything come together for her. It was Wilhelm Worringer's 1908 *Abstraction and Empathy,* the same small volume that was so vital to Klee and Kandinsky. Worringer made the drive toward abstraction and away from naturalism easy to grasp. He explained the motives behind the art Anni and the others were so desperate to create in a way that made complete sense to them.

Worringer wrote that "the reason for making art—whether abstract or figurative—was the maximum bestowal of happiness for the humanity that created it." More specifically, "the urge to abstraction finds its beauty in the

life-denying inorganic."[11] Anni's attraction to that "life-denying inorganic" was perfectly explained by Worringer's statement that "the simple line and its development in purely geometric regularity was bound to offer the greatest possibility of happiness to the man disquieted by the obscurity and entanglement of phenomena."[12]

As Anni clearly acknowledged when she was in her seventies, from the time she was a young woman, life itself was fraught for her. She felt that only through art could she find the necessary ballast to survive the vagaries of human existence. Forms of one's own imagining could, she was convinced, provide respite from illness, inflation, war, social discomfort, and the other realities beyond our control. The more that art enabled one to replace Worringer's "entanglement of phenomena" with something positive, the happier she was. This meant not only seeking the certainty offered by straight lines and right angles, but avoiding "space which, filled with atmospheric air . . . gives things their temporal value" and thus exacerbates the troublesome fleetingness of so much in life.[13]

Anni's wall hangings made no effort to reflect or solve the problems of the world; rather, they provided refreshment and strength to deal with the world's woes by offering both their maker and their viewers security, grace, and ease. They were the result of what Worringer calls "the urge—in the face of the bewildering and disquieting mutations of the phenomena of the outer world—to create resting-points, opportunities for repose."[14] Not only her textile work but her later graphics serve that purpose.

BUT EVEN AS she subscribed totally to Worringer's views, Anni, while guided primarily by her own imagination, was not averse to nature as a source of systematization and clarity. To serve its purpose as a stronghold of emotional uplift, geometric compositions, after all, needed to be possessed of rich systems. Anni deplored the sterile, vacuous abstractions she labeled "decorators' dreams." Even as she found the natural world impenetrable and mysterious, and its representation antithetical to her artistic goals, she had profound respect for the beauty and vitality of nature's structures.

She came to understand botanical organization through Goethe's *Metamorphosis of the Plants*. For her, from the time she was a child, Goethe "had a halo around him"; he was more to her taste than his Weimar counterpart, Schiller, whom she found "cold." But until she was at the Bauhaus, she knew only Goethe's literary work. Now she was riveted by his analysis of the single unit that, in various stages of transformation, is at the heart of plant life: "Everything is leaf. . . . None resembleth another, yet all their forms have a likeness; therefore a mystical law is by the chorus proclaimed."[15] Goethe analyzed the way that the outer details of flowers always relate in form and structure to the beginning of the plant. He pointed out that in a plant with

a triangular striation in the stem, variations of the number three recur in all that follows. Root structure determines the number of petals and of leaves.

Aware that a weaver is a builder, Anni identified textiles with plants. The first few rows, like plant roots, determine what comes afterward; the act of creation is a linear progression. The many parts are irrevocably interdependent—pull a few threads and the structure falls apart—so it is essential to maintain a system. Adhering to the aspect of nature that was dependable, she constructed textiles with a consistent integrity.

Threads are to Anni's yard materials what cells are to life. The individual units are combined in harmonious configurations. In the bulk of what Anni wove for upholstery and drapery fabrics, thread is not only the essential structural component, but it is the main visual element; whereas for centuries textiles had disguised their materials, using them to re-create pictorial imagery, in Anni's fabrics, the structure and the materials are the subject. She intended for the viewer to delight in the way in which strands of cotton or jute or hemp are as mutually dependent as parts of plants or organs of the human body. Nothing could be removed without detriment to the whole.

Had she covered the structure with a design, rather than used the structure as the design, this would have been obfuscated rather than celebrated.

WHAT WAS AS VITAL as the structure was the touch with which it was achieved, and the feeling for texture. Anni looped cellophane around wool as if she were making music. When she pulled one color mostly to the back of material, so that it remains a vibrant but subtle accent on the front, she was like a magician performing a sleight of hand. In this way she elevated textiles and the status of woven threads, putting the medium on equal footing with oil on canvas and watercolor on paper. Buckminster Fuller, himself an innovative devotee of design for the larger population, would later say, "Anni Albers, more than any other weaver, has succeeded in exciting mass realization of the complex structure of fabrics. She has brought the artist's intuitive sculpturing faculties and the age-long weaver's arts into a successful marriage."[16]

8

From the time she had started to look at paintings, the recent German art Anni liked the most had been by the Blue Rider group. But while she admired Macke, Marc, and Jawlensky (she showed no interest when I asked about Gabriele Münter and Marianne von Werefkin, dismissing them, it

seemed, because they were women), she had always considered Klee and Kandinsky "the two great ones of the group." Their presence at the Bauhaus thrilled her. "When Klee proposed taking a line for a walk, I took thread everywhere it could go."

One of the reasons for Klee's great impact was the way he built totalities out of components. Anni felt that she was uniquely receptive to this approach because of its applicability to weaving. She also admired the way he made use of the fundamental tools of the drawing and painting processes. Rather than disguise the brushstrokes in his attempts to conjure the surfaces of houses or boats or faces, he had the imprint the brush made on paper or canvas serve as a compositional element. In drawings, he used the scribbling of the pencil, or the little points he created with the point of his pen, to build entire organisms. Anni was attracted to the ways that Klee celebrated rather than disguised the physicality of art and technique.

"The technical makes you focus on what you are trying to do and forget introspection," Anni maintained. She enjoyed what she called "the stimulation of limitations" and applied Robert Frost's views on free verse to her deliberate subjugation to the dictates of the loom and thread. She quoted Frost saying that to work without preestablished laws is like playing tennis with the net down. Similarly, she followed Klee's self-imposed restriction to uniform components, declaring that "the work of any artist, if it's in music or writing or painting or whatever, is that of reduction of elements."

THERE WAS, HOWEVER, no pretending that Klee was accessible personally. At the Weimar Bauhaus, when Anni had initially tried to get into one of his classes, she was refused—with the advice that she develop her own work further. Anni recalled what happened when Klee became form master of the weaving workshop:

> Klee was our god, and my specific god, but he was remote as a god usually is. Although it sounds like blasphemy, I didn't think he was actually a teacher who could help those who were in their early stages trying to find their way. I remember his standing in front of a blackboard with us eight or ten students sitting behind him, and I can't remember that he turned around once to make contact with us students. He had this strange remoteness; besides, I really didn't understand what he was talking about. It was a disappointment, because I admired his work tremendously—and still think of him as *the* great genius.

Anni took a fiendish delight in saying this to me while Josef was in the house with us but safely out of earshot in his studio. He would have become

enraged with jealousy had he heard her put anyone else above him in the ranking of great artists.

Ise Bienert persuaded Klee to exhibit his watercolors on the corridor walls of the school. These occasional shows were "the great events of my time at the Bauhaus," recalled Anni. But, as was almost always the case, even with Klee her memories were of things working out less than perfectly. She asked him if she could buy a watercolor with "valuta"—money in a stable currency, a gift to her from an uncle. Klee was delighted, and showed her a portfolio of twenty recent works. "I'm still puzzled by this: that I hardly liked any of them," she said to me wistfully. "I thought he was not offering me his top works, they were all not quite in balance, but I chose one because I thought, 'If I don't do it today, tomorrow will be too late.' " Years later, when she and Josef were struggling financially in America, she would sell the watercolor through Josef's dealer Sidney Janis; if it had never been her favorite work, at least it helped financially.

Paul Klee, Zwei Kräfte [Two Forces], *1922–23.*
Annelise Fleischmann marveled at the spontaneous
exhibitions of Klee's watercolors, when the artist tacked
them on the corridor walls of the Weimar Bauhaus.
One of the rare students who could afford to buy one,
she opted for a particularly mysterious image —
although there was much about the transaction
that left her unsatisfied.

Even if she later disparaged the watercolor, one can see why Anni picked it. It is one of those Klees with a background that is undisguisedly paint applied to paper, with seemingly random brushwork almost like a child's finger painting, the paint so thin and watery that every grain of the textured paper is visible. On top of that surface that, by unabashedly presenting the processes and materials of art, resembles a sea of microscopic dots, there are forms that are more mysterious the longer we look at them. One is made of two bands joined at a right angle, like half of a mitered picture frame constructed out of wide strips of wood. That inanimate object stands on another band, which rests on a cloudlike blob. At the mitered corner, there is a large

arrow pointing down; three quarters of the way up, there is a small dark rectangle.

The other image on Anni's Klee is a form that resembles both a stone tablet standing at an angle and a ghost with a sheet over its head. Near the cap of this form with a domelike top, another large arrow, longer than the first one but not as dark, points off to the right. The only additional element is a cut triangle, like a ship's stern cut off by the right-hand side of the painting.

Everything suggests something, yet nothing is clear. There is a distinct narrative in these bold arrows, a sense of movement in many directions, but the reason for the hurry, or the purpose of the helter-skelter dashing, or their differences in proportion and tonality, are unknowable. What is without question, though, is that while life is enigmatic, the processes of making art have an irresistible fascination, and creativity enables one to celebrate, rather than shun, indecipherability.

THE COMPONENT OF DISAPPOINTMENT—or, alternatively, of disapproval—was inevitable in all of Anni's memories. When Klee was form master of the weaving workshop and the students hung their wall hangings for him, "he came in and judged all the various pieces, mostly smaller than my big hangings there, and he passed my pieces every time. My heart sank lower and lower. I thought, 'What on earth have I done?' " The complete lack of reaction from her hero was so devastating that, when she told me about it half a century later, she readily relived her misery.

Socially, the Alberses' age group was rarely included with the more established generation; they felt they "did not count." The one time Anni and Josef were invited to Klee's home, when they were all neighbors at the masters' houses in Dessau, Klee played a record of Haydn for them. When Anni passed Klee on the street, she always was so afraid of interrupting his reverie that she did not even try to say hello; nor did he.

But that sense of his remoteness is what had inspired her fellow weavers to conceive of the miraculous delivery of his presents for his fiftieth birthday, the event that proved, somehow, that in spite of all the vulnerability, all the challenges, the Bauhaus was a place unlike anywhere else. For there were no boundaries on human imagination.

9

When the sparkling and luxurious Bauhaus building opened in Dessau, the weaving workshop acquired new equipment. Naming the machines to me, Anni sounded like the ultimate gourmet reeling off a litany of

beloved delicacies: "a kontermarsch, a shaft machine, a jacquard loom, a carpet-knotting frame, and dyeing facilities." The machinery and the opportunity for more color variations inspired her to new work.

The first of these was a vibrant jacquard weaving. The composing units are straight bands, occasionally cut short into small blocks, elsewhere doubled when they are placed next to each other in twin lengths. Often Anni crossed stripes with other stripes to make a grid; sometimes she took most of a stripe to the back of the textile and allowed only tiny segments of it to appear; at other moments she matched it to itself, at right angles, to create a pure, unadulterated solid rectangle. Following Klee's playful suggestion to take a line for a walk, the inadvertent weaver put her compositional unit through a series of jumps and rest positions. While maintaining a visual integrity because of the use of a single core element—a circle or a diagonal would have been alien in this neatly unified world—she established the impression of ongoing motion.

The series of studies Anni made in advance reveal her appetite for resolution and balance. Knowing she would have to compose linearly once she was on the loom, she used graphics to work out, on a grid, the precise arrangement and proportions. In the drawings and gouaches, she moved toward simplicity. The jacquard loom, with its system of cards, is what pushed her toward this pattern that makes the wall hanging look like a close-up detail of a larger piece, and thus brings us in with a consuming engagement.

That the capacity of the mechanical loom, invented by Joseph Marie Jacquard more than a hundred years earlier, had facilitated this was something Anni celebrated. Jacquard looms depend on hooks that have two positions so that they raise or lower the harness, which carries and guides the warp thread so that the weft will lie either above or below it. The arrangement of raised and lowered threads is the source of the pattern.

That rich result required enormous patience and concentrated work. The threading of the Jacquard loom took a long time, as did the tying in of further warps to the existing one with a knotting robot that ties each new thread on individually. The process demanded day after day of repetitive work. But the woman who had loved watching the transformation of her parents' apartment and preferred the sounds of the orchestra tuning up to the final performance responded not just sensibly, but viscerally, to the dictates of the machinery. She gleaned satisfaction from the logic, the straightforward course of cause and effect, of the process.

THAT REVERENCE FOR MACHINERY, and the desire to be inspired by it, so vital to Bauhaus thought, became understandable to me in 1972, when Anni expressed an interest in making some prints at my family's printing company. Since it was a commercial shop, this was an unusual move on her part.

It had not occurred to me that Fox Press would offer anything to either of the artistic Alberses. The business, some forty-five minutes from their house, mostly churned out booklets and brochures for insurance and manufacturing companies; it was known for high-quality color-process printing, not for the sort of work that bears an artist's signature on each sheet in the tradition of limited-edition lithographs, etchings, and screen prints.

But Anni made her proposal with the same eagerness and openness with which she entered the vast domain of her local Sears, Roebuck (ten minutes from her house) and embarked on a course of what, with her lilting Berlin cadences, she enthusiastically called "tah-reasure hunting." At Sears she would extol the merits of plastic containers and polyester blouses, declaring that "all this emphasis on handmade" was nonsense, that machine processes were a wonderful thing and that synthetics were among the great achievements of the twentieth century. Now, with the unusual idea of grappling with the technology of photo-offset printing to produce artwork, she became a little girl eager to embark on a sublime adventure. The eyes of the sometimes dour septuagenarian lit up with expectation. She was entering her favorite realm: the unknown.

Discussing this process, this austere woman, dressed in her inevitable whites and pale beiges, her graying hair sensibly cut, her only makeup a hint of lipstick and maybe some powder, sparkled like an eight-year-old in a party dress.

Printing had been the starting point of my relationship with Josef Albers, and Anni's wish to do something at Fox Press was possibly also a way of entering his and my special territory and taking a more vital position. She was happy that Josef and I had this interest in common and talked about it animatedly, but by proposing that she take the step of making prints with me, she had in effect walked onto the playing field while he remained in the stands.

WANTING TO DISPOSE of certain objects that were burdening him as he approached the end of his life, Josef had given me books of typefaces. Since I shared his passion for typography and graphic design, he taught me that the initial reason serifs had appeared on letters was because, when they were carved into gravestones, the stone cutter invariably left little lines at the end of each chisel stroke. He was delighted by the way those additions had the unanticipated effect of enabling the eye to move along through the words while one was reading.

The way serifs came into existence, and their subsequent value, was for Josef a splendid example of how proper attention to a mechanical art could have an unintended by-product that significantly improved human exis-

tence. The issue of readability was vital. Albers deplored the use of sans serif type for long texts, for it impeded the act of reading and was therefore purposelessly arty. Helvetica Light was fine if used sparingly, but setting anything substantial in it was "too much *design*"—the last word being uttered disparagingly.

This was the sort of issue about which he liked to speak to me, and I was a respectful audience. But Anni put me in a very different role when she broached the prospect of her working in photo-offset and turned me into her collaborator and aide-de-camp.

BAUHAUS NORTH WAS unlike anywhere else in its richness as in its austerity. Josef's studio in the basement was a hotbed of artistic production. This was where he painted the *Homages.* He had more than a thousand tubes of paint, and he applied the color directly, with a painter's knife, to white Masonite panels that lay on two plywood worktables with sawhorse bases; it was over these identical surfaces that he had his varying installations of fluorescent bulbs. This arrangement, and the venetian blinds that made it possible to control any daylight that might seep in through the small windows, made the studio a perfect laboratory for the pursuit of color effects.

I was always fascinated to be with Josef in his studio and to hear him explain the alchemy of his painting—with the mysterious interaction that appears to occur whereby flat, unmodulated colors illusorily penetrate one another. He emanated a force that dominated the small house, but Anni, in her own quieter way, was even more captivating. With Josef, everything was out there, shining brilliantly; with Anni, one sensed that there were layers behind the layers, and a vast unopened treasure chest of observations and images. I treasured every morsel of her life story as well as her rigorous aesthetic belief system, and spent as much time with her as with him. Anni and I would sit side by side at the folding aluminum table in her workroom on the main floor, where she kept her few remaining textiles and, now that she no longer had a loom, worked on drawings and prints. Although I did not even know the difference between warp and weft, I was enchanted by the meandering threads in her framed weavings, feeling that they took abstract art in an unprecedented direction.

About six months after I met the Alberses, I earned some money by brokering the sale of an artwork; I used the commission to buy one of Anni's weavings. It was when I was looking at it and telling her why I enjoyed endlessly following the threads in the foreground, and why they resembled the solo violin in a Mozart concerto, with the background comparable to the full orchestra providing an infinity of experiences in counterpoint to the sin-

gle instrument, that she first allowed, in her measured and soft voice, "Kandinsky said, 'There is always an and.' " Anni rarely invoked the names of any of the people at the Bauhaus, so it was a great treat when she did. It was the beginning of my understanding of how the real geniuses in Weimar and Dessau profited from one another's presence.

Anni was fascinated by my love for her weaving as a pure artwork rather than a craft object—so much so that she suggested I write a book about her and her work. A small publisher gave me a modest advance, and I began to visit regularly in order to interview her. Those conversations were further impetus to her wanting to make the prints in my family's shop: she hoped to demonstrate the essence of the Bauhaus mentality, which we had come to discuss on a regular basis when considering her formation as a weaver.

EVERY VISIT to the Alberses' house—the address, 808 Birchwood Drive, delighted them both because of the way the numbers 8 and 0 are formed without endings, thus seeming eternal, and because "Birchwood" conjured their favorite white-barked trees—was an inestimably rich experience. Inside that house that greeted one like a loping, awkward carbuncle, there was more genius and courage palpable than within any place I had ever been before. What was most exciting was the vision and work of the Alberses themselves, but their extraordinary friends from the distant past added greatly to the luster. The conversations, and the life I witnessed and in which I began to play a minor role, made a mythic world—in which Walter Gropius, Wassily Kandinsky, Paul Klee, and Ludwig Mies van der Rohe were the other central figures—come into focus. I could always anticipate a rich nugget when either Josef or Anni began a sentence with the words "At the Bauhaus . . ."

The Alberses' nearly empty living room and an adjacent space that was intended as a dining area but was used to put up the occasional overnight guest, had only a few pieces of lean furniture of the sort one might have expected in a 1950s bank lobby. There was a complete absence of personal objects; the walls were blank except for four paintings by Josef. It was like a minimalist stage set, but the two Bauhauslers gave the scene Shakespearean magnitude.

This couple in their white and khaki clothing spoke with unparalleled clarity and intensity about the making of art. They emphasized the need for morality and modesty in painters, designers, and architects, as in everyone else who hoped to advance humanity. They both marveled at simple things—the form of an egg, the cleverness of egg cartons—just as they deplored pretense and corruption, of which they considered the New York art world a prime exemplar. These were just some of the ways in which they kept the true spirit of the Bauhaus alive.

Maximilian Schell delighted Anni by his saying that the house was *"nicht gemütlich"* (not cozy). She liked repeating those words with a wry smile. Schell was right. Anni was considered the foremost textile designer of the century, but in her own living room the simple 1950s sofas were covered in white Naugahyde rather than one of her own marvelous upholstery materials. There were the same thin-slat venetian blinds on the one large window in that room as in Josef's studio, and ordinary white rolling shades in the other rooms, ironic given that Anni's own drapery fabrics had been sold for years by Knoll International and other high-end purveyors. The living room rug was industrial, probably a leftover scrap that was marked down on the Post Road, the commercial strip nearby where the Alberses bought most of what was in the house. The cabinets in the bedrooms were metal office furniture meant for storing papers.

Yet not only was this monastic dwelling a hotbed of creation, with Josef working away on paintings and architectural commissions and print series, and Anni taking her geometric drawings into new realms and working on ideas for prints; it was also a place for exalted conversation. Most afternoons when I was there, at about four o'clock, Anni and Josef and I would have coffee and pastry in the kitchen. Josef's passion was for strudel from a particular baker in New York, Mrs. Herbst, which was occasionally brought by one visitor or another. Sitting on plastic-covered metal side chairs at the white Formica-topped table with wooden legs that screwed into it, surrounded by the whiteness of the kitchen appliances and the walls that were completely blank except for a large, plain clock and an ugly, dome-shaped, gold-colored thermostat, we would talk away. Once the Alberses had decided to take me to some degree into their world, they seemed to enjoy having an audience for stories of their youth and the Bauhaus, and I was thrilled to listen.

In the house itself, in the Alberses' unequivocal dedication to their work on multiple fronts, in the central role of the visual, I felt that I was beginning to understand what the Bauhaus was really about in a way that none of its published histories conveyed. And hearing Josef and Anni reminisce about conversations with the Klees and the Kandinskys when they were all neighbors at the masters' houses, learning about what bothered them as well as what gave them pleasure in the world where they had met and started new lives, but which they felt was oversimplified by its historians, I realized that the Bauhaus was both unique and like all other institutions for learning. At the same time that its dominant figures were some of the greatest geniuses of the twentieth century, they were also just people. They feuded; they had love affairs; they divided into factions. But a small handful of them were creative geniuses of the highest caliber, and that made everything very different.

For a weaver to decide to make subtle and sophisticated art using a com-

mercial printing method was a perfect example, although I did not yet see it as such, of that originality and imagination, as well as brilliance, that went hand in hand with the modest way of living.

EXPLORING THE IDEA of her doing a piece at Fox Press, I told Anni a bit about the technology of photo-offset. I gave a simple description of the process, trying to follow Anni's patient and generous lead when, a few months earlier, she had led me to understand weaving by taking a Lord & Taylor box top and stretching lines of string from one end to the other and then inserting Popsicle sticks at right angles to the string, with the sticks placed alternately above and below the taut fiber, in order to create a barebones loom that demonstrated warp and weft. She had told me then that she was delighted that someone so interested in her work knew nothing about textile technique, as she quite loathed "all that craft stuff" and wanted her work to be thought of as art first. I did not yet recognize the perverse aspects of her personality, but her wish to swim against the tide intrigued me, and since I thought that Anni's "pictorial weavings" had all the qualities of pure and great abstract art—that they belonged next to the paintings of her Bauhaus confreres Klee and Kandinsky, as well as Mondrian—and since I, too, had the arrogance to link most weaving with macramé and needlepoint and the like, I was amused and willing to go along.

When we began to discuss working with photo-offset, Anni proved to be a quick study. She decided that she would utilize the medium to make a print of two horizontal rectangular forms stacked one on top of the other. (See color plate 28.) Each of the rectangles would contain a triangulated pattern, in keeping with her recent geometric experiments, a design full of diversion and ins and outs but deliberately lacking in internal symmetry or repetition.

Anni emphasized that she was interested in art that was timeless and universal rather than art with specific links to a known locale or moment in history. As at the Bauhaus, her work embodied Worringer's idea of abstraction providing the opportunity to create "visual resting places" removed from the often painful realities of the natural world.

To keep the viewer engaged, the new creation, consistent with all of Anni's compositions, had to eschew easy resolution. Like Josef, Anni imbued abstraction with a certain tension, a perpetual in/out motion, an ongoing play between image and ground. The artist's own persona was to fade in deference to the sacred realm of art and to the comforts as well as the realities of the technical. Anni had no wish to reveal private emotions or the troubling fluctuations of her own mind and heart; she preferred, instead, to focus on the purely aesthetic and practical issues of printmaking, just as she

had for many years reveled in the construction of textiles. It is no wonder that she kept a volume of Lao-tzu in easy reach at her bedside. Her favorite dictum of the great philosopher was:

> *Grasp the simple, embrace the primitive,*
> *Diminish yourself, bridle your passions.*

PHOTO-OFFSET, Anni determined, would enable her to reproduce her own deliberately irregular pencil work, allow crystalline edges, and facilitate a reversed mirror image with the click of a switch. None of this could have been achieved with weaving. Anni made a sketch of a sequence of triangles. The meandering three-sided forms, ostensibly in the foreground, were to appear in flat red. With the side of a soft pencil, she created a field of mottled grays that would appear in the voids between them.

The photographic reproduction that would capture the irregularity of the grays had never been possible in the print mediums in which she had previously worked: lithography, etching, and screen printing. It enabled her to obtain a desirable randomness and suggest mysterious communication of the sort that fascinated her in hieroglyphics and other ancient forms of writing, where, for her, incomprehension was an asset, not a deficit. She liked undecipherable language.

The sequence of triangles she had drawn was enlarged by a simple mechanical process and cut on a rubylith—a plastic sheet with two layers, one bright red, one clear—in the stripping department of the print shop. Anni was fascinated by the rubylith itself, by the precision with which the top layer could be cut and removed from the bottom one.

Eventually, when she visited Fox Press to supervise the press work, she would be almost as enchanted by the man who cut it, a six-foot-eight deep-voiced "stripper" named Gary Thompson. She appreciated the irony of the term "stripper," admired his professionalism, adored his deference to her and wish to accommodate her desires, and, she told me, relished the Americanness of his name. When Anni had first given me the sketch for the pattern to be made in solid red, I had asked Gary to simulate her handwork exactly. My erroneous assumption was that she wanted the finished work to have the imprecision of her sketch; in fact, while she was seeking the hand-done look of the surface she had rendered in gray pencil strokes, she pictured those gray forms contained in triangles that were perfectly sharp and precise, unlike what she could have drawn herself. It had taken Gary days to cut a rubylith that perfectly resembled Anni's drawing—only to have her respond by saying that she hated the wobbly appearance. She had meant her drawing only as a guide to the final design; her goal was to have exact, crisp

lines and impeccable triangles, with the points just lightly touching. Gary then developed a grid from which he cut the triangles with the precision she desired.

ANNI BEGAN to use the word "miraculous" for Gary after I put her on the phone with him a couple of times so that she could explain what she wanted. She liked his deep voice and clear explanation of the technical possibilities in layman's terms almost as much as she thrilled to the capabilities of the photo-offset. After one of those conversations, Gary made a proof that achieved an instant reversal of Anni's design, so that what was in flat red on the top panel of this two-section print was a foamy gray below, and vice versa. Where there were solids above, there were pencil strokes below; where there was pencil on top, there was unmodulated red on the bottom. Anni's growing familiarity with the photomechanical process was what had led her to make the grand scheme of her print depend on her simply producing the wavering gray in two easily made panels, in her eyes a delicious economy of means.

The elusive fuzziness against the crisp purity of machined forms was, for her, the realization of a dream. And the idea that, with a flick of the wrist, she could make what was negative in one rectangle positive in the other permitted the sort of interplay with which she loved to divert the viewers of her art. Anni was grateful to the technology for having opened new visual possibilities—as if it, not she, were the responsible party. Now she could achieve the sort of contrast and unpredictability, the mixture of the personal and the impersonal, the coincidence of order and spontaneity, and the playfulness and elements of surprise intrinsic to her work. She told me that all of this was in keeping with the fundamental values of the Bauhaus, and with Gropius's goals. Art and industry functioned in tandem, not as adversaries. A creative person "listened to the voice of the materials and the process, and learned from the skilled laborer," rather than trying to impose all sorts of demands or ask the people executing the work to achieve something unreasonable.

At one of our meetings to discuss the print, I inadvertently placed a partially translucent negative of its image on top of a shiny, opaque proof. Anni was fascinated by the completely unexpected patterns that resulted. She made a slight adjustment to the position of the negative image on top, so that the forms were all off register in a consistent, well-measured way. She asked if this, too, could become a print: in dark brown and black. What could have occurred only through the photo-offset process, and could never have been achieved as a drawing, eventually became *Fox II* (see color plate 27).

ANNI FINALLY got to meet her heroic stripper in person. The occasion was a trip to Fox Press to watch the actual printing. She needed to be on the spot in order to determine the intensity of the gray as it rolled off the press and to make sure that the opaque red trapped it exactly, containing the pencil without any unwelcome white space around it.

For her Fox Press outing, Anni wore a simply cut, rather severe khaki skirt that ended just below the knee, a silky white crepe blouse, and a pure white cable-stitch sweater. Not yet knowing her well, I assumed that the sweater was expensive, handmade, and imported—that someone of Anni Albers's stature would wear nothing else—but, no, it was machine-made, synthetic, washable, and from a discount store. I was still to learn that Anni preferred the practical products of mass production to most luxury goods, and regularly instructed weavers championing the handmade and belittling machine-work to look at their own shirts.

After I drove Anni the forty-five minutes from her house to the printing plant, she gave her entrance there the quirky charm that she lent to the most simple actions. Proportioned like one of Alberto Giacometti's striding figures and walking with the aid of her plain stick, Anni was striking both for the dignity of her thick dark hair and her stately manner. Anni's plain, inexpensive clothes acquired a rare elegance on her, in part because of the way they fit and hung; her suits from Alexander's (a department store noted for its cheap merchandise) might have been Chanels. (When asked whom

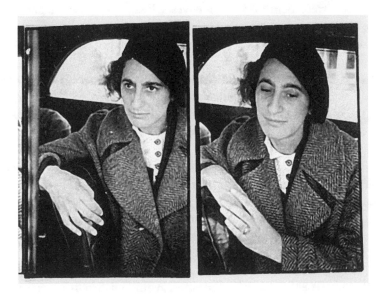

Anni Albers in the Dreiers' car in 1935. Photographs by Josef Albers

she considered to be the greatest artist of the twentieth century, she was inclined to answer "Coco Chanel.") Along with the whites and tans she wore that day, Anni had on a brown suede jacket, a shimmering brown silk scarf, and heavy brown suede shoes; the balances were of color as well as of texture.

When we walked into the pressroom, I told Anni that when my father had built Fox Press, he had considered buying *Standing Lithographer* by David Smith, a seven-and-a-half-foot-tall sculpture in which a steel type case suggested a man's chest. But the $10,000 needed to acquire it had ended up being required for a fire door. (The Smith had recently sold for $170,000, a detail I considered too vulgar to mention but of which I was keenly aware; even in 1972, art had begun to assume its current role as a commodity for investment.) Anni was unmoved by what I considered a misfortune. Without missing a beat, she simply pointed to a large Swiss two-color press in front of us and declared, "You see that machine? *That,* that is far more beautiful than anything David Smith ever touched."

ANNI POSITIONED HERSELF carefully on a wooden chair next to the thirty-two-inch single-color press where her print was to be run. She exuded a sense of importance and rectitude, as well as of grace—an honest worker trying to do her job as best she could. What was remarkable was her quiet brilliance, the humility that accompanied her originality. As the pressman adjusted the speed and the pressure with which the suction cups would pick up her prints—they were being done on Rives BFK paper, heavier and thicker than the usual stock—Anni spoke, as if she were experiencing an epiphany, of the wonder of the machine and of the artist's need to respond to the capabilities of the equipment.

Anni was curious about the flexible plate that was being locked onto a roller and wanted to know more about how it was made. The pressman fetched the platemaker, who suggested that we go into the prep department to see exactly how it was created. Observing the chemical processes and the fixing of the halftones, Anni marveled at the accuracy of mechanization. As she exulted in the technology, she made this printing plant in Connecticut seem an outgrowth of Bauhaus thinking and life. What she evoked of that great and pioneering art school was not the complicated politics or the rivalries that so often sullied its atmosphere—which she and Josef made sure I never forgot—but, rather, its crisp thinking and marriage of creativity and technology.

WHILE IMPRESSIVELY HUMBLE in her demeanor, Anni had also displayed a degree of manners that suggested true nobility. Shaking hands with the men at the plant, she smiled graciously and told them that she admired what they

did. "Craftspeople," Anni complained to me in an aside, suffer from their inability to use machines; again she reiterated her favorite point, that they should simply look at what they were wearing to understand the value of mechanization.

Watching the rollers get inked and clamped into position, and then seeing the first few prints roll off the press, which was usually used to fire off brochures by the thousand, Anni was riveted. Trial and error—the essence of process—never seemed to frustrate her. By the time of the visit, she had redone the handmade pencil part of her print three times before we discovered that these gray units had to be larger than she intended them to be in the final print so that they could be totally trapped, as Anni wished them to be, by the solid design on top. Now, as the first prints began to roll off the press, Anni saw that the gray of the upper half was darker than at the bottom. She insisted that this was her fault; she had done the two panels on separate occasions and had applied too little pressure the second time. As with her work in weaving, certain issues were paramount: the knowledge of materials, the degree of force or laxity, the wish for a balanced setting for irregularity, and the flexibility required to proceed from the initial concept to an end result that was still completely fresh.

The foreman joined the pressman in discussing the problem of the two different gray tones and Anni's wish to regulate them. They determined that a press adjustment would enable them to lighten the top gray. Anni was thrilled to use the machine to correct her mistake. She explained to all of us that the printing was as important to her artwork as was her initial design concept. The role of the equipment, she added, had been equally important when she started textile work at the age of twenty-two. She took comfort in tools that were meticulously fabricated and properly maintained. She respected sheets of paper as she had spools of thread: they did what they were supposed to do. The materials that performed so well, the jacquard cards and flexible steel printing plates, were not just dependable, unwavering in their charms, and therefore to be treasured as anchors in the storm of life; they also had souls.

She asked the two men if they had ever heard of an art school called "zuh Bauhaus." When they said they had not, she told them what it had been. She said that this was where she had learned to respect materials and mechanical technique, and that her admiration for, and compliance with, them had been a mainstay of her life ever since.

10

A silk wall hanging of 1926 that Anni wove shortly after the Bauhaus moved to Dessau shows what was made possible with triple weave (see color plate 25). The three-ply technique opened a new world of possibilities. The black forbidden by Martin Brandenburg could now be gloriously solid. On the back, the textile appears as separate fabrics pressed against one another, joined at the perimeters of the solid shapes on the front, each of these shapes a pocket with harness threads lying loosely in it, the appropriate threads picked up at each joining for the next form. The precision of that technique allowed Anni to produce, on the side we see, work as purely celebrative as a Handel trumpet concerto. It has nonstop movement, and the unequivocal exuberance art allowed even as life continued to be confusing. Juxtaposed rectangles all the same dimensions become louds against softs, a musical sequence of cause and effect.

This silk wall hanging is also an ode to the sort of number system Anni had uncovered in her reading of Goethe. Everything derives from the factors of twelve. Using inches in the world of centimeters, she made the overall dimensions forty-eight by seventy-two inches, both multiples of twelve. There are twelve vertical rectangles on each row, each of them divided into twelve horizontal stripes of equal thickness. There is, however, no pattern to the striping or repetition of any one arrangement. It was Anni's intent that, with the overarching order firmly established, the more we look, the more we are surprised by the unpredictable. Throughout the top six of the nine rows of vertical rectangles, Anni has kept the white horizontal stripes lined up, always on the same level; working our way down, we have been made to expect that rule to be maintained, only to discover that, on the bottom three rows (those she wove last), she has joggled the whites up and down and destabilized them.

Safely anchored to the requisites of weaving and the dictates of the loom, and to the system dictated by the mechanical givens, Anni then played. Her determination to do the unexpected bordered on the perverse. As our eyes move through the oscillating bands of this wall hanging, in the quiet mood induced by its muted greens and blacks and grays, colors that combine assuredness with subtlety, we can imagine the organizer of the sequence saying, "Here: I know what you are expecting, and I am going to do something very different."

SURPRISE EFFECTS were her specialty. Even as she invariably clad her lean body in subdued colors, when a student at Black Mountain College asked the deliberately plain former Bauhausler who she would most like to have been if she were someone else, she replied, "Mae West." And I remember once, when my wife and I were talking to her about a paintings conservator who had such an odd comb-over that we thought he maintained it with Toluene, the same varnish he used for Josef's paintings, Anni asked us, "Is he lesbian?"

One simply never knew what to expect. At the opening of Anni's major retrospective exhibition at the Smithsonian in 1985, a well-meaning admirer had made the trip from New Haven to Washington to attend the event. The woman, with a mixture of good-girl enthusiasm and intellectual shallowness that was not to Anni's liking, presented her with an enormous, meticulously arranged bouquet. The group of people surrounding Anni's wheelchair, assuming she would voice profuse appreciation, simply observed her scowling at the rigid assemblage of blossoms—there were too many chrysanthemums—and asking, "They are for my coffin?"

She did the same sort of thing in her art. She caught you off guard and startled you, although here it was always with the intention of providing delight as well as a form of awakening. There are moments in the Bauhaus wall hangings, as well as in the utilitarian materials, when a dash of color or a completely unexpected visual element appears for no reason whatsoever. As rigorous as the Bauhaus principles were, the lightness and the sense of play were essential to almost everyone at the school. That humor may be the element most neglected by its historians.

Not everyone responded to Anni's flippancy, though. Several months after Josef died, I took her to a local bank branch to set up an estate checking account. This meant driving to the Boston Post Road, where her and Josef's beloved Sears, Roebuck and Plank House were. Anni at this point was having considerable difficulty walking; she had grown noticeably weaker since Josef's death. I therefore parked very close to the entrance of the bank, and told her I wanted to go in ahead of her and organize things to make it easier for her to meet with the bank manager.

This was before the era of handicapped-only parking spaces or wheelchair access, which might have been just as well, for Anni had little use for the idea of special treatment. She was, in fact, incredibly unsympathetic about human disabilities, and oddly ashamed of her own. Fourteen years later, at the age of ninety, when she received the Gold Medal of the Royal College of Art in London, she made her first trip to London since a brief sojourn there during her Bauhaus years, I took her to the British Museum, which had no ramp or lift for wheelchairs, although many London cabs had special devices to accommodate them. Along with Anni and me that day were my seventy-

five-year-old father and Anni's nurse. When we arrived at the great institution on Bloomsbury Square, it became clear that we would have to carry Anni, in the wheelchair, up three steps. Instantly, a couple of museum guards appeared; they and my father and I each lifted a corner, and up we went. Anni smiled like a child at an amusement park as we transported her, with the chair wobbling, into the museum. After she landed, a museum official came out to greet her, and began apologizing profusely. "Oh, no," Anni said. "Don't be sorry. There is nothing I enjoy more than being carried by four men. And I don't approve of that handicap nonsense they have in America, anyway." Her delight in being carried that day was rivaled only by the Minoan art in the collection. Even more than the Elgin Marbles, which had been my reason for organizing the visit, this anonymous pottery from a civilization that used imaginative forms and geometric patterns to add luster to everyday living thrilled her. The exchange between objects and viewer was so powerful that, as she stared into the cabinets of Minoan pots from her wheelchair, I finally grasped Klee's idea that art could be looking at us as intensely as we look at it.

In the bank branch, I asked for the manager. An eager, young, on-his-way-up executive named Joe Maloney quickly appeared from a back office. I explained that I would be coming in with a woman whose husband had recently died, and that we were setting up an estate checking account, for which the first deposit would be about $170,000, although eventually there would be a great deal more money coming in. Maloney looked as if he might pass out. When I explained that Mrs. Albers had great difficulty walking and would need to sit the minute we got inside, since she refused to use a wheelchair, he rushed over to a desk right at the front of the bank branch and scurried to find chairs for Anni and me to face him there.

I went back to the car, and, grinning complicitously at Anni, told her we had "an eager one," a favorite term of hers. She knew enough about the reality of money, and was interested sufficiently in the human comedy (her favorite television show was *Merv Griffin,* of which she would say, "I love Mehrve"), to understand the excitement of the young executive about to open an account with so much money. She would play her part accordingly.

Joe Maloney, in his neatly pressed gray suit, held the door open as Anni, leaning on my arm and using her cane, made her way in. He then rushed ahead to hold her chair steady. Once she and I were seated facing the desk, he went to the other side and extended his arm for a handshake, saying, "Joe Maloney, ma'am."

The desk, which was generally occupied by the bank receptionist, had a nameplate on it that said "Carmen Rodriguez."

"No, you are Miss Rodriguez," Anni said, rolling her *r*'s. As she did so, she moved her eyes from his go-get-'em smile to the black Vinylite plaque

with its incised white lettering; the little sign assumed significance because it used the same materials and technique as Josef's *Structural Constellation* engravings.

"No, ma'am, Joe Maloney."

"Yes . . . Miss Rrrrrrrodriguez."

"Joe Maloney, ma'am."

"As you say, Miss Rodriguez."

I tried to stop the routine, even as he was muttering "Joe Maloney" yet again, and explain what we needed to do. But when I presented the document appointing Anni as Josef's executrix and tried to get down to business, Anni showed no interest whatsoever. She was too busy looking around the bank, taking in the furniture design, the bad art, and the appearance of the tellers, especially the hair and clothing of one of them who was rather conspicuously cheap-looking. (Anni and Josef adored a receptionist at the art storage warehouse who had a nameplate on her desk saying "sexretary," and whose shape lived up to her title.) Joe Maloney, meanwhile, looked like a hunting dog about to snatch its prey.

We filled out all the necessary paperwork and completed the transaction. Maloney spoke only with me, treating Anni as if she had dementia or was not present. But when we were all done, the deposit made, and a passbook created—it was the old-fashioned sort of savings account passbook, stapled on the spine, that fits into a plastic case—he turned to Anni and said, "Mrs. Albers, as you see from the poster on the wall, with every $5,000 deposited you are entitled to a five-piece place setting of Royal Doulton style dinnerware. With your deposit, that means thirty-four place settings."

Anni stared at him for what seemed like a long five seconds. "Do you know what the Bauhaus is, Miss Rodriguez?"

"Joe Maloney, ma'am. I'm sorry, I don't."

"Well, Miss Rodriguez, at the Bauhaus we don't like Royal Doulton, or any flower patterns, for that matter. On the other hand, there is something for which I would very much like to ask you."

"Joe Maloney, ma'am. Yes, of course."

"Do you know that little sleeve into which you placed the passbook just now?"

"Yes, of course."

"Do you have an extra? If so, I would like one."

"Right away, of course." He jumped up and was back with it in a moment.

"Zank you, Miss Rodriguez."

"Joe Maloney. You're welcome."

Once we were back in the car, I burst out laughing and told Anni she had been quite something with him. She grinned with mischievous satisfaction.

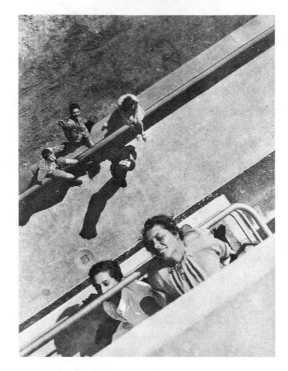

Anni Albers — as she was now known — and other Bauhauslers on the Preller house balconies at the Dessau Bauhaus, ca. 1927. Anni is the figure in the middle. She had never before been as happy as she was at the Bauhaus.

I then asked her what on earth she would do with the plastic passbook holder. "You never know, but plastics always come in handy."

11

Plastics, synthetics, new and useful practical materials, shaking up the bourgeoisie: these were everyday joys at the Bauhaus. The essential element of the 1926 wall hanging, as of all of Anni's work intended to be viewed purely as abstract art, is the way it wakes you up and keeps you on your toes. Anni was immensely satisfied when, following an exhibition of her work at the Hayden Gallery at MIT, a guard told her that the technol-

ogy students used to spend their lunchtimes sitting on the floor and eating sandwiches—she liked these details, and admired the practicality of sandwiches—as they tried to solve the puzzle of how this multi-ply weaving was done on a twelve-harness loom. What would have been easy on a Jacquard loom was much harder to achieve on the one she had used; to get the clearly defined, solid color areas she wanted, rather than the effect of interweaving indigenous to the process, Anni had trickily, and meticulously, calculated which threads to lift at which points. She enjoyed having baffled the technology students, just as she delighted in my surprise at the shifts in format and hence in tempo with the bottom three rows, a twist that had nothing to do with weaving technique, about which she realized I knew nothing, and was mainly aesthetic. Working within the rules, she dedicated herself to unpredictability.

ANNI WAS AGAIN EMPHATIC: there had been little response to this wall hanging when she made it. This was Bauhaus reality; while Klee and Kandinsky sold some work and had some attention from the outside world, they mainly worked away with little feedback, and the rest of the artists and designers were even more alone. Josef was respected, and had the occasional commission for a window, but he rarely received kudos. They all depended on their teaching salaries. What I and the people at the Busch-Reisinger Museum, the owner of Anni's wall hanging, and numerous experts had come to regard as a textile classic by the time that she and I were discussing it—and which, since Anni's lifetime, has become considered such a masterpiece that it is perpetually in demand for exhibitions all over the world, although Harvard rarely permits it to travel, or even be exhibited, because of both its fragility and their institutional capriciousness—was ignored when it came off the loom. It was only because Anni gave the hanging to her parents that it even survived the war; most of her best pieces did not. After her solo show at the Museum of Modern Art in 1949, when she hoped MoMA would buy the hanging at a very low price, they turned it down. The Busch-Reisinger acquired it shortly thereafter, thanks to one curator with an unusually adventurous vision.

"The parents didn't know what to make of it, either," Anni told me. "I gave it to them as a form of thanks. I thought it was the best thing I had done to date. They put it on the grand piano, as a sort of cover. And then they put a vase of flowers on top, with water in it so that the vase made a ring, which is still there."

When I visited the Busch-Reisinger to see the work in storage, the curator then in charge—not the one who had acquired it—told me that she and the conservator wondered how Anni had created the circular form. They

also remarked on the carefulness of its positioning, and when I told them it was the inadvertent result of a damp vase having been placed on the piece, they were initially incredulous. When I told Anni the story, she replied, "Yes, you see, museum people cannot see."

She then looked off into space before continuing: "They can't dress, either. Greta Daniel was curator of design at the Museum of Modern Art, yet she wore the most horrible dresses. I said to Arthur Drexler, 'How can she think she understands everyday design and wear those sacks?' "

ANNI'S SENSE of her own rightness, and her tactlessness, were not always easy to take. Fortunately, my wife had a better sense of humor than Joe Maloney. Katharine, who didn't care a lot about clothing when we first met, and generally was most comfortable in jeans and turtlenecks, had an elegant dress made for the opening of the Josef Albers retrospective at the Yale Art Gallery in 1977, the year after we were married. She was then twenty-one years old. When my very pretty wife and I arrived to pick Anni up to drive into New Haven for the opening, Anni looked her up and down and then asked, "Is that dress new?"

"Yes," replied Katharine, smiling. I had told her how becoming it was, and she had every reason to feel confident.

"Can you still return it?" asked Anni.

It was remarkably similar to an incident that had occurred during a 1962 exhibition of Josef Albers's work at the Pace Gallery, then still in Boston. At the opening, the gallery owner's mother said to Anni, "I have a hairbrush in my handbag, and you need it." It would be many years before Josef's work was again represented by the Pace Gallery.

If she never forgot, or forgave, these putdowns, no one could issue them more harshly than Anni herself.

THE PERSON who could be so difficult was as an artist immensely generous. Her goal was not just to find some form of satisfaction in her own troubled life, but to provide calm and diversion and pleasure for her fellow human beings. She really meant to serve humankind, whether by gracing their experience of going into the synagogue in Woonsocket, Rhode Island, with the richly soothing panels she wove for the Torah ark at the end of the sanctuary, or by using the saturated inks and engaging, intelligent designs of her prints to entertain people she would never meet. Abstract art was her music, and she wanted others to benefit from it.

At times, Anni reduced the components of her textiles to nothing but black and white thread, which she would use on their own or in combination to achieve a range of grays. She would pare her compositional elements

to squares exclusively. She embraced the limitations with which she countermanded the excess of choices, the too much of everything, of her previous world; from her few chosen givens she was able to build great beauty. This use of "minimal means for maximum effect"—a precept of Josef's—was intended to be both enjoyable and instructive for viewers.

Anni's 1927 *Black-White-Red* is a triumph of its three colors and regimented structure; she told me that it was also one of the works that clearly showed the great impression Florentine architecture had made on her. Vibrant, celebratory, invariably upbeat, this testimony to the possibilities of thread and to the emotional impact of abstraction is today regarded as one of the triumphant works of its era, for even though the original was thought to have been destroyed in the war, it was reproduced in 1964 by Anni's fellow Bauhaus weaver Gunta Stölzl. Stölzl did this with three of Anni's images of which it was assumed that only gouaches remained, and the new versions were purchased by the Bauhaus Archiv in Berlin, the Museum of Modern Art in New York, the Art Institute of Chicago, and the Victoria and Albert Museum in London, with all those institutions treating them as masterpieces. But when Anni made *Black-White-Red* in Dessau—and about this she was emphatic—"recognition was still distant." When an interviewer who was researching the Bauhaus asked her, in my presence, if she and Josef had foreseen their eventual eminence, she replied, irritably, "You can't think in those terms. Maybe the ambitious young ones today do, but we certainly never did."

The point of the artwork was simply to add to the world's beauty. Anni had no artistic grandiosity. She did not think her textiles were any more worthy than the anonymous blankets of the Navajos or the fragments of the pre-Columbian weaving from the Inca and Maya cultures she adored. She only hoped that she was adding a further voice of sanity, one more source of satisfaction, even pleasure, in a universal language that enabled it to be enjoyed anywhere in the world, at any time. This was what the Bauhaus had confirmed for her: that, in spite of all the weaknesses of humanity, everyday experience could be made better through the eyes. Purely visual events could provide a sense of logic and rightness.

SHE HAD EVERY REASON to believe that *Black-White-Red* had been destroyed after the closing of the Bauhaus and subsequent events in Germany. But in December 1989 the original work reemerged.

Anni and I were in Munich, where Maximilian Schell had organized a show of her and Josef's work at the Villa von Stuck, an institution named for the teacher Klee and Kandinsky and Albers had all disparaged. At that time in her life, Anni would do anything that Schell asked, and she had agreed to

the exhibition in spite of the inappropriateness of the setting; now it was the evening of the opening. Before the event, we were waiting in a back office of the museum, where, although she was the guest of honor, Anni was totally miserable. As usual, Schell had said he would be at her side at a certain time but was not there. I assured her it was only because he was making last-minute changes in the placement of the artworks, but she did not care; sitting in her wheelchair, looking at her watch every two minutes, she was inconsolable.

Anni and I had planned to meet, before the opening started, some collectors from Aachen who said they were eager to show Anni one of her original works thought to have been destroyed. In they walked, a pleasant couple, he an architect, she a teacher. The man explained that his father, also an architect, had bought Anni's wall hanging, the original *Black-White-Red*, directly from the Bauhaus in the 1920s and had always kept it safe.

One of her greatest pieces had not disappeared after all! I was overjoyed, and was sure she would be.

Anni continued to look at her watch and over the collectors' shoulders to see if Schell was coming. She also stared at the woman's pointed, white, stiletto-heel shoes, which she disliked intensely. She had no interest in this miraculous resurrection.

The collectors unrolled the original wall hanging. It was threadbare in many places, faded in others, but some sections had retained their brilliant colors. Compared to the 1964 edition, it was in terrible condition, but there was no question that this was the real thing.

Anni, however, gave it a shorter glance than she had the shoes. "No, no. Thank you for coming. But, no, I never made that. It doesn't count."

I argued, perhaps as emphatically as I ever had with Anni. The owners, who were polite and tactful, again reminded her of the history of the piece, and apologized for its condition. "Thank you for coming," Anni said, gesturing their dismissal with her right hand. They rolled the hanging and walked off.

I followed the couple out of the room and explained that Mrs. Albers was having a very difficult evening for personal reasons; of course this was her work. I assured them that I would talk with her about it. I did not allow that the woman's shoes had been the clincher.

At the opening, surrounded by her and Josef's work, receiving congratulations from an endless stream of people, Anni's only happy moments were when Maximilian was holding her hand and looking directly at her and not at anyone else. There were times when art simply could not provide the balance and serenity with which she hoped to counter the tumult of human emotions.

12

Anni enjoyed the Bauhaus festivals in much the same way as her parents' costume parties: as an observer of transformation more than a participant. For the White Festival of 1928, Josef used a curling iron to turn his straight blond hair into tight ringlets. "He looked absolutely appalling," she recalled with a joyful lilt in her voice. She helped him look all the worse by working on his eye gear: white ping-pong balls, cut in half, with little holes so he could see, and held in place by a rubber band that she had twisted in a series of knots so it attached to his ears. For the Metallic Festival on February 9, 1929, in response to the invitations sent on metal-colored cards, Anni prepared a costume for which she sewed little brass bells close together into a tight-fitting knitted cap that she pulled onto her head like a wig. "I think it looked quite good, a bit like an Indian goddess or Buddha." But there was nothing about the parties worth recalling other than how she and Josef looked.

TO OUTSIDERS, Anni was quiet and unknowable. But she was not reticent when she wanted something. Anni had made up her mind, she once told me, that if she wasn't married by the age of twenty-five (which she was, by barely a month), she would "have an affair"; given the mores of her milieu in that time period, this was as radical as her decision to go to the Bauhaus. She was equally determined to travel. Besides the trips to Val Gardena and Florence, she was the main instigator behind a junket she and Josef took to Paris with the Breuers in 1926. What she recalled of that first trip to France was a visit the four of them made to a bordello. Unfortunately, when Anni told me this, I did not know her well enough to ask for further details. And it was only in 2009 that it was discovered from a guestbook entry that while they were in Paris the Alberses, along with some other German artists, visited Le Corbusier's recently completed Villa La Roche. The Swiss banker Raoul La Roche had commissioned this innovative modernist pavilion to display his collection of paintings by Léger, Braque, Picasso, and the Purists Amadée Ozenfant and Charles-Édouard Jeanneret (Le Corbusier's real name, which he then used as a painter). It would have been wonderful to know what both Josef and Anni thought of Le Corbusier's curved ramps and the balconies around the luminous atrium, as well as the boldly geometric façade of that building.

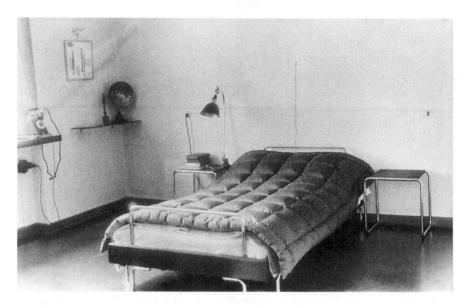

Anni Albers's bedroom in the masters' house in Dessau, ca. 1928. Anni always lived austerely, but she never failed to have Josef's art in her line of vision from her bed. For her entire life she kept the Egyptian statuette near where she slept.

Anni also engineered a trip in 1929 to Barcelona and San Sebastian in Spain, followed by a holiday near Biarritz. This is where Josef took his amazing photographs of people frolicking on the beach, of the Klees in resort wear, and of the tracks left in the sand by the water. It was Anni's instigating that got Josef to travel and hence to make this extraordinary visual record of how the Bauhauslers could enjoy themselves despite the constant onslaught of problems in their lives.

Anni planned trips for herself and Josef from Dessau to Belgium, to look at the masterpieces of Flemish art, and to England, where he photographed the houses of Parliament. But the gambol she liked above all was to Tenerife, in the Canary Islands, which they visited via banana boat in 1930. Anni felt the boat looked sufficiently substantial when she first saw it, but, she delighted in telling me, it had not yet been loaded. When she and Josef returned to the dock to get on board, the boat had sunk considerably, and suddenly looked very small. It took a lot of persuading to get Josef on board. But he ended up enjoying himself almost as much as she did. The passengers, twelve in all, ate with the captain every night of their five-week trip, and they visited two islands, journeying on muleback up to the high plateau of Tenerife. When she described that adventure in the Canary Islands, and a trip in 1953 to Machu Picchu and some less accessible Inca sites, she was aglow.

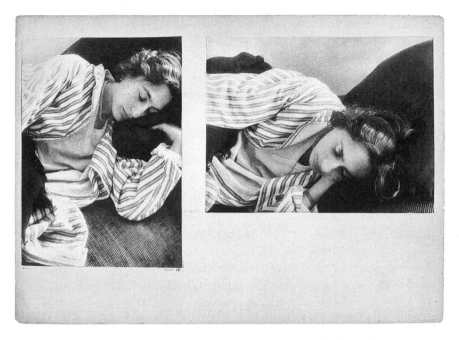

Josef Albers, Anni, Sommer '28, *1928. Josef Albers made this collage of two photos he took of his wife wearing an old jacket of his, which she remembered fondly when she rediscovered this work half a century after it was made.*

ANNI WAS EITHER impressed by important people or deemed them silly and worthless. Their position meant nothing to her; it was their attitude that was crucial.

When Josef participated in the symposium on the Bauhaus in Prague and they met Tomás Masaryk, she was deeply impressed by their host's "knowledge about art and education, which is very unusual for a head of state." Her other strong memory of Prague was that it was where she met Galka Scheyer, who also attended the symposium. What Anni most remembered was that Scheyer showed her how to put lipstick on. Using lipstick was almost as revolutionary as having an affair before marriage.

After their encounter with Masaryk, the attitude toward art, and details of physical appearance, generally determined the Alberses's taste in politicians. They both liked Nelson Rockefeller because of a description they had read of him wearing a flannel shirt and standing on a ladder in the governor's mansion when he was installing a Calder just before his inauguration, and because he was gracious when they met him at a dinner at the Museum of Modern Art, where most of the other trustees talked primarily to one another and to no one else. Gerald Ford was out of the question because "he had a face like a knee." I often visited the Alberses during the Watergate hearings,

with which Anni was obsessed, but more as if she were watching a soap opera than a tale of venality and corruption; she adored every appearance of Maureen Dean and regarded Martha Mitchell as a comedian. While Josef cared less about the whole procedure, he was enchanted by the name of John Ehrlichmann, wondering why no commentator pointed out that in German "*ehrlich*" means "honest." This was comparable to the green highway sign on the Merritt Parkway near the Alberses' house that said "This is Orange": a landmark he adored pointing out as an example of verbal treachery.

AS FOR THE USE of lipstick: Anni never lost her fascination with female contrivances. In 1982, I accompanied her to an annual meeting of the College Art Association, where she was on a panel with, among others, the sculptor Louise Nevelson. During the question-and-answer session, Anni was asked more than once if she felt that she had played second fiddle to Josef, and if she had suffered as the wife of a more famous artist. She simply answered, "No." Afterward, chatting with Nevelson, Anni said, "Now I have to ask you a question. Are those marvelous eyelashes your own, or did they come out of a jar?"

The exotic, Russian-born sculptor burst out laughing and answered, "Listen, darling, sometimes you have to give yourself what nature did not provide." At that, Nevelson pointed with both hands to her breasts, making clear that she wore falsies, and continued to laugh. Anni always maintained that this moment was the highlight of the event, "much better than all that feminist nonsense about Josef's and my marriage."

13

Anni felt that the Bauhaus, like all institutions, suffered from the way too many people tried to have the upper hand. The longing of certain individuals within the school to have power for its own sake was in her eyes more problematic even than all of the difficulties imposed from the outside by the bureaucracy that supported the school. Moreover, for all the good artists at the school, there were plenty of second-rate ones. The geniuses — like Klee and Kandinsky and Josef—changed your lives; the lower tier not only wasted your time, but, being more competitive than talented, disrupted the possibilities of equanimity.

Although Gropius had tried to prescribe a universal rapport in his "Principles of the Bauhaus," his stated goal of "encouragement of friendly relations between masters and students outside of work" and "cheerful ceremonial at

these gatherings" did not mitigate the caste system that was a reality of life in Weimar and Dessau. The older masters were the highest; the young instructors next; and then, lowest, came the students. "Kandinsky was the one who was closest in a way to Josef, although I couldn't say close, because none of the upper region of the Bauhaus ever felt close to the younger ones: Albers, Breuer, and Bayer." Mies van der Rohe was "a very difficult man who lived in a space of no-man's-land, very self-centered, self-contained. I liked him very much better when he came to this country, which had a good influence on him."

After George Muche resigned as form master of the weaving workshop in 1926, and Klee took his place, even though Anni considered him her "god" because of his work, she struggled with his lectures, which is perhaps why she remembered having attended fewer than was the case. She reiterated, "I couldn't understand them. They were beyond my grasp. They touched on form problems that pertained to his own investigations and were of no help to my own struggle, though some of the students profited greatly from his discussion. To me he did not seem to be the teacher whom you could easily approach with a personal question." It was, of course, as always, the vantage point of someone who specialized in seeing people's limitations, who reserved her 100 percent approval only for artworks.

One specific assignment served as a kind of railing for Anni in the confusing period just after Gropius resigned. The term "railing" was hers, and she said it in the most appreciative voice, savoring the idea of something firm to hold on to, a support against both her own unsteadiness and the vagaries of life. After Hannes Meyer came on board as the new Bauhaus director, he designed a school for union workers in Bernau. Meyer enlisted Bauhaus students to work on aspects of it and asked Anni to come up with a textile that could reduce what otherwise would have been an echo in its large auditorium.

The usual method of subduing reverberations was to put velvet on the wall, but velvet would have been impractical in a public place unless it was a dark color, which Meyer did not want. Anni therefore relegated the velvet quality to the back of the material and kept the front a light-reflecting surface that could be brushed and wiped off as needed. (See color plate 26.)

Hundreds of yards of the material were produced for the auditorium. Soft like a caterpillar's fur on the side hidden from view, it presented a subtly shimmering silver and black mixture on the auditorium wall. The juxtaposition of metallic and matte cotton fibers made a combination of exuberance and restraint that was the quintessence of elegance. Meyer decided that Anni merited her Bauhaus diploma on the basis of this textile, and so it was awarded.

Generally, Bauhaus graduates moved away and went out into the working world. Anni, however, was not going to be apart from Josef, who, in spite of his occasional whims to leave, now had an important position at the school. She remained in Dessau, briefly as head of the textile workshop, but mostly to work.

IT WAS A BIT more than fifty years after Anni received her diploma when I took her to the opening of the marvelous Paul Klee retrospective organized by Carolyn Lanchner at the Museum of Modern Art in New York. It was not easy to get Anni, who by then required full-time nursing care, into the city, but as I wheeled her around the show, her nurse tactfully out of view in the mob, it seemed totally worthwhile.

Few people in the crowd were looking at the art, and fewer still had any idea that the silver-haired lady in a wheelchair had been one of Klee's students and was at that time the last living member of the Bauhaus faculty. But Anni was content, for she was completely absorbed by the art. It was as if the crowd was not present, and she was communicating directly with the paintings before her just as she had when Klee tacked his watercolors to the Bauhaus corridor walls. The rhythmic forms, the visions of cats' faces and fishlike creatures and underwater plants and vibrating squares, seemed to penetrate Anni's being.

Suddenly Anni was startled out of her reverie. An elderly man had gently tapped her on the shoulder, and she had turned her wheelchair away from the art—she enjoyed her ability to execute that rotation—to face him. The man had long white hair, and a full beard and mustache, and although one could see little of his actual face, he was smiling. So was the woman next to him, who had straight white hair that matched his and was plainly dressed; she might have been a schoolteacher in a small town in Germany. Anni's rare, wholehearted smile betrayed a total sense of pleasure. *"Felix, ich kann dass nicht glauben!"* she exclaimed. "Felix, I don't believe it!"

It was Felix Klee. He and Anni at that moment were like any two people from the same small town: a woman who as a young bride had known a child when he gave his puppet shows and who has now, decades later, run into him. What made the small-town element all the stronger was when he presented his wife, Liva, and Anni instantly realized that this was Hannes Meyer's daughter, whom she had also known as a child. The daughter of the man who had had the confidence to assign her to cover the auditorium walls and then grant her the Bauhaus diploma had married the son of the man she admired above all other artists.

Anni was looking splendid that evening. She wore a simple short jacket—loose fitting, with three-quarter-length sleeves and a mandarin collar—which she had made out of Thai silk. For ceremonial occasions, she

forsook her usual look of reserve for this medley of bright squares, primarily pink and yellow. Years earlier, she had bought, on several occasions, bolts of this silk from a favorite supplier at an obscure location in Manhattan that required her to walk up several flights of stairs, a challenge she relished when the goal was worthwhile. With the splashy jacket, she had on a plain white blouse and long black skirt; the combination gave her panache. But nothing was more arresting than the aliveness of her face as she told Liva that it was her father who had awarded her her certificate for having completed her training at the Bauhaus. Anni admitted that, although she normally disparaged ceremonial documents, this one meant something.

Felix and Liva, even with their white hair, beamed like young newlyweds. And Anni delighted at seeing them, in her mind's eye, as children, at the same time that she recognized them as the elderly pair they had become.

IN THOSE FERTILE YEARS when, diploma in hand, Anni had a new confidence, she made a curtain for a theater café in Dessau that had a soigné flair in the same way as Marlene Dietrich's singing did, and a children's rug that was a checkerboard of brightly colored washable fabric (see color plate 22). She designed and wove a mercerized cotton tablecloth using narrow vertical and horizontal stripes that vibrate at their intersections. While it was never produced commercially, this animated covering could bring exuberance into any household where it was deployed.

In Florence, Anni had bought a cap crocheted out of strawlike cellophane, one of the earliest synthetics. She unraveled the cap and tried weaving with the clear fiber. She found it so useful that she bought longer lengths in Germany and then made a wall covering with a linen warp and two strands of raffia, one tan and one white, for every strand of cellophane, in a plain weave—using a simple technique to accentuate the imaginative juxtaposition of materials—and went on to create further variations of the same idea.

For wall coverings, she liked materials that could be cleaned easily and brushed off, and that would not show nail holes; for upholsteries, she wanted fabrics that were pliable. Everything had to be as practical as it was visually potent.

ON ONE OCCASION when I was with the Alberses in Connecticut, Josef, Anni, and I were looking at a photo of one of Josef's fruit bowls. Josef explained that a couple of institutions—the Museum of Modern Art in New York, the Bauhaus-Archiv in Berlin—had originals, but that he no longer owned one. This suited him, he said, because his ideal, and that of the Bauhaus in general, had been to get clean and effective designs out into the world, not to hoard possessions. I quoted back to him one of his short poems, published

in various places—"To distribute material possessions is to divide them; to distribute spiritual possessions is to multiply them"—and he was pleased.

Anni, however, said she now wished they had not given so much to MoMA. Following her 1949 exhibition, she had donated to it a number of textile samples and study gouaches. "No tax deduction, by the way," she commented. "Our accountant said the value for tax purposes was only the cost of materials, paper or thread. But now when someone else organizes a show of my work, the Modern charges a fee per object, for each little swatch a charge, even though they hardly ever show what I gave them and mostly keep it in storage."

We came back to the subject of the fruit bowl. I marveled at the use of the three bearing balls, a perfectly folded rim of stainless steel, and a flat sphere of glass, nothing more, composing an object that was elegant as well as machined and functional. As I waxed rhapsodic, Anni's only comment was "Yes, but think of what happens with blueberries."

It was true that there was a gap between the glass base and the rim to support the fruit, which suited the bowl for bananas and apples but nothing smaller. But Josef was annoyed. I wondered whether Anni was simply being truer than he was to the Bauhaus's insistence on impeccable functionality, or whether she was just being perverse and acting out of her usual need to debunk.

Describing the masters' house at Dessau, Anni likewise had to point out the silliness. The roof garden "of course was nonsense because the house was under the trees anyway." She clearly took pleasure in implying that the lack of direct sunlight negated the value of that location for a real garden, without allowing the possible pleasure of a private, elevated space in the woods. Once she had that satisfaction, however, she was enthusiastic. "It was marvelous to live in a house that was so clean-cut and light." Everything about the place was "a great luxury." And she again spoke of the miracle of the Bauhaus receiving funds from the city of Dessau for the masters' houses in such difficult times, with so many people in need.

She was determined as usual to treat money as a necessary part of reality. Anni had grown up in a household where anything having to do with finances was a forbidden topic at the dinner table, and she still agreed that it was a good idea to stay off the subject when eating, but what things cost, and how they were paid for, was as essential to her as the pliability of a particular thread or the functions of the human body. At the same time, preferring the art of impoverished Mexicans in their marketplaces to that of aggressive careerists focused on trends and auction values, she made a complete separation between artistic value and economic interests.

Money had been a central determinant for her family. Her parents and siblings' way of life had been shaped by a fortune that allowed them to

devote their days to sports and eating well and outfitting themselves with the clothing in which to attend the opera. The loss of that fortune had the effect of forcing her father, ultimately, to spend his days working on the loading dock of a warehouse in the Bronx, and her mother and sister to wait tables.

The idea of economic well-being as the main goal of life was anathema to her, but the role of economics was, at the Bauhaus and in the stages of her and Josef's life that followed, to be addressed squarely.

14

All the Bauhaus books say that Anni was the director of the weaving workshop in Dessau after Gunta Stölzl left in 1930. When I first asked Anni about this, in the early 1970s, she said that if she had not read it, she would have had no memory of having headed the workshop. "My main function was the continuation of my own work."

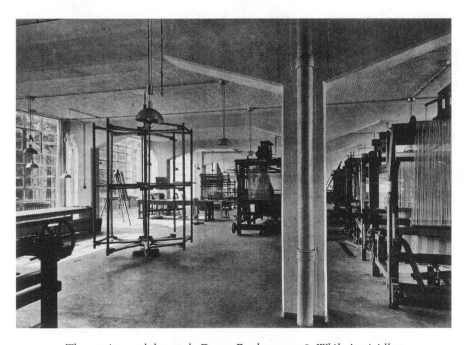

The weaving workshop at the Dessau Bauhaus, 1928. While Anni Albers eventually became its director, she minimized the significance of the position and even pretended that she did not remember having held it.

What did this mean? Was it a slight game, to make clear that titles and official status meant nothing to the Alberses, that she and Josef were above such things? Or was it a reflection of the truth—that what she really cared about most was her own art? She then explained that the point of the Bauhaus was to leave students "largely on their own," and that she was "simply an acting director who tried to interfere only when necessary." So she remembered after all.

She had been toying with the facts to make her point. Anni manipulated the telling of her story, and that of the Bauhaus, as carefully as she interlaced threads. Her goal was to belittle titles, and to make clear how much more important official designations sounded than they actually were. This was of vital importance to both Alberses, who felt that designations like "Dr." before the name of someone who had a PhD, or a medal on one's lapel or framed certificates on the wall, had little to do with real intelligence or skill. Consistent with that belief, when an honorary doctorate was conferred

Nicholas Fox Weber and Anni Albers at the Royal College of Art graduation ceremony, London, June 29, 1990. Anni enjoyed going to London to receive the college's Gold Medal, its highest level of honorary doctorate, but considered the ceremony "completely boring" and much preferred her visit to the British Museum, where she appeared to communicate directly with the Minoan art.

upon Anni by the Royal College of Art, amid much fanfare in a long ceremony at the Royal Albert Hall—during which Sir Jocelyn Stevens, the director of the Royal College, said it should now be renamed "Royal Albers Hall"—she told me, after I wheeled her out while the attendees applauded her in a standing ovation, that it had been "three of the most boring hours" she had ever spent. On the other hand, after Maximilian Schell introduced her to H.R.H. Duke Franz of Bavaria at a social event in Munich, her face lit up with a smile as she told me about it—but part of her delight was that she was among those who were invited to call him "Franzy," and because he knew about modern art and asked her about her work.

Once she had her diploma, Anni was, apart from this stint as director, not connected officially with the Bauhaus, although she attended

many activities as Josef's wife. With her large loom at home, spending time there rather than in the weaving workshop, she was not as taxed by the move to Berlin as were people more directly connected to the school. And she did not have a salary to lose, as Josef did.

This was when her family helped pay the rent in an apartment that delighted her and Josef in one of the recently developed Berlin neighborhoods. If others felt the pain of exile after the brief idyll in Dessau, and were sad to leave behind the school building and the masters' houses, Anni was excited to be back in the capital and to put white linoleum on the floor.

Otti Berger, 1927–28. Photograph by Lucia Moholy-Nagy. Berger was a favorite of Anni's among her fellow weavers; they often went to Berlin together. Berger's death in a concentration camp marked Anni forever after.

Berlin, she told me, was the way it appears in *Cabaret*. Although she had seen only vignettes from the live and film versions, she had read Christopher Isherwood's stories on which it was based and thought them a perfect vision of the world that fascinated and appalled her in a society falling apart. Anni, however, could not bear most books or films set in the Nazi period. She found the sound of German military marches intolerable. Anne Frank's *Diary of a Young Girl,* she explained, was simply too painful to read.

THEN, ONE DAY, Anni began to talk to me about Otti Berger. Berger was among her favorites of the other weavers. Before Anni was married, she often took Berger to Berlin for weekends with her family, and since Josef liked her as well, the three of them occasionally did things together.

Berger, Anni said, lost her life at Auschwitz. Anni managed to tell me this without using the word "Jewish," which never came to her lips easily, but she didn't need to. I had never seen her look so sad.

She then told me that Berger had given her a jacket that was true folk art, made of traditional material from Berger's native Yugoslavia. Anni had saved it. One day she would have the strength to show it to me, she said, but at the moment she could not face it.

15

On August 31, 1933, the twenty-four-year-old Edward M. M. Warburg, the rich young New Yorker who had bought two oils from Klee in Dessau, wrote the following letter to Alfred Barr:

Dear Alfred,

I want to tell you about another project that I have been playing with during the last few weeks.

One Mr. Rice came into my office several weeks ago and told me he had formerly been connected with Rollins College in Florida and that due to a disagreement with Dr. Holt, the president, he and several other professors resigned (9 to be exact) from Rollins College. And some twenty students resigned with them. The argument, it seems, concerned itself with progressive education. . . .

Rather than wait around for jobs that might be offered from more conservative organizations, they banded together. They found a place in North Carolina that is used by a conference centre in the Summer by the Young Men's Christian Association, and which, with very little change, could be turned into a college during the Winter months. They decided to rent this place and with a $20,000 guarantee which they have collected, and thirty students, they are opening up this Fall.

The members of the faculty will receive no salary for the first year and are pooling their own personal libraries for the benefit of the students. . . .

Mr. Rice came in to see me about finding a man to head their Fine Arts Department, and both Phil [Johnson] and I immediately thought of Albers. We have written him a letter to find out whether he and his wife would come over here, and we received a cable to the affirmative.

The problem now is how to get them into this country. Phil, Mr. Rice and I went down to see Mr. Duggan of the International Institute for Education, and he informed us that the Immigration Authorities demand that the invitation for any professor who has taught for a minimum of two years prior to application, must come from an accredited institution. As Black Mountain College (the proposed name for their college) is not yet on the list as an accredited institution, this does not apply to them. However, Mr. Duggan felt that if it were possible to guarantee a salary of $1500. to Albers, and his wife as well, that Col.

McCormick, the head of the Immigration Bureau, would be perfectly willing to let him in. And we are now trying to figure out where we can get $3,000. . . .

Unfortunately, Albers's not being a Jew, my usual contacts are fairly useless as my friends are only interested in helping Jewish scholars. The Christian people who might be interested, have given towards foundations and the foundations are usually a bit scared of new organizations.

I would like to know from you whether you think it would be diplomatic and right for me to place this whole matter before Mrs. Rockefeller.

I cannot help but feel that getting Albers into this country would be a great feather in the cap of the Museum of Modern Art. . . .

With Albers over here we have the nucleus for an American Bauhaus!

What do you think of the whole scheme?

As ever,
Eddie[17]

A couple of months before "Eddie" Warburg wrote Alfred Barr, Philip Johnson had run into Anni Albers on a street in Berlin. Anni invited Johnson to tea, in part because she rightly sensed he would be intrigued by the apartment she and Josef had recently stripped to the barest white and furnished with their own art and the leanest chairs and tables they could find, and where they served water from chemists' flasks in order to avoid ornate decanters. Anni was also alert to any possibility that might lead to her husband's finding a new job.

When Johnson was in the Alberses' new flat, however, he was as intrigued by Anni's personality and work as by Josef's. He told me about this on a couple of occasions in the 1980s and 1990s. Josef was too doctrinaire for Johnson, and, although Johnson did not say it, probably also too homophobic. He was more drawn to Anni, with her subtle humor; beyond that, Johnson could not get over the strength and serenity of her textiles.

Josef Albers, Anni Albers, *ca. 1940. When Josef photographed Anni, he captured her intensity and her sensuousness to rare effect.*

Johnson was also intrigued by a bit of deception of which he became aware on that summer afternoon. He saw several fabric samples that, a few months earlier, Mies van der Rohe's mistress, Lilly Reich, had represented to him as having been hers. But these were Anni's. Johnson told me that it was not simply that Reich's work resembled Anni's, it was that Reich had represented Anni's work as being her own. Johnson realized that Anni Albers was not only exceptionally talented on the basis of what he knew she had done, but also on the basis of what he had been led to believe someone else had done.

JOHNSON HAD his visit with the Alberses in mind when, shortly after his return from Berlin, Warburg invited him to join the meeting with John Andrew Rice at the offices of the Museum of Modern Art. Rice had gone to see Warburg at the suggestion of Margaret Lewisohn. Lewisohn was especially aware of what Eddie Warburg, who was a relative, was up to because her husband, Sam Lewisohn, was then secretary of the Museum of Modern Art's board. Rice had approached Margaret Lewisohn on the advice of Ethel Dreier, the mother of a young man named Theodore Dreier.

Ted Dreier, who had been seven years ahead of Warburg and Johnson at Harvard, was the nephew of Katherine Sophie Dreier, a pioneering collector of avant-garde art. His father, Henry, was the only one of Katherine's four siblings to bear children. Ted had grown up with an especially close connection to his childless Aunt Kate. He saw her often and heard her discussed all the time. It wasn't just her art collecting that gave the family plenty to talk about. At one formal Sunday dinner, Katherine made a particularly strong impression on the children by scratching her back with her knife. Her explanation was that the conversation was getting a bit dull. She also made a point of challenging the usual way of doing things out in the world.

Ted Dreier's own interests were outside the art field. What impressed him most in the family legacy was the idea of rebellion and the spirit of good works. Another of his aunts headed the Women's Trade Union League. His mother was chairman of the Women's Suffrage Party of Brooklyn and the Women's Committee for Mayor La Guardia's Re-election, and she had politicized the Women's City Club of New York City. What moved Ted above all were causes to better humanity.

Although Aunt Kate had made Ted more cognizant of surrealism and other modern art developments than were most Harvard undergraduates of the day, Ted's world was different from that of Warburg and Johnson. At Harvard he majored in geology, before studying electrical engineering at Engineering School. At Rollins he was teaching physics when he met Rice, who was a classics professor. Then, as Eddie Warburg had intimated to

Alfred Barr, Rice was fired by Rollins's president, Dr. Holt. Holt claimed that, among other things, Rice had "called a chisel one of the world's most beautiful objects, has whispered in chapel, . . . had an 'indolent' walk, has left fish scales in the sink after using the college's beach cottage, and . . . wore a jockstrap on the beach." Two other faculty members were fired shortly after Rice. Ted Dreier had resigned in sympathy with their cause.

Almost immediately, this group of outcasts set about forming Black Mountain College, with Rice at the helm. Their progressive coeducational institution stressed free inquiry, gave faculty the control of educational policy, eliminated grades, emphasized participation in community life, and elevated the arts as the focal point of the curriculum. Rice was particularly glad to have Ted join him in the new venture. In his eyes the young Harvard graduate was "a sweet person, a very endearing dreamer—one of those strange creatures that the rich families produce every now and then; they want to repudiate the whole thing." His coming from a wealthy family would do the new school no harm. Not only did his relatives have money, they had friends with money. Of the fifteen thousand dollars in contributions required to get Black Mountain off the ground, Ted's friends Mr. and Mrs. J. Malcolm Forbes had anonymously provided ten thousand and his parents had given two thousand.

When Ethel Dreier told Ted some of the things she had learned from Margaret Lewisohn about what the people at the Museum of Modern Art were up to, it was only natural for him to go knock on the door. If art had never before been his main interest, that quietly changed. In little time Ted and John Rice were looking at photos of the folded-paper experiments done in Josef Albers's introductory course at the Bauhaus. They both immediately felt that it was precisely what they were looking for. The Black Mountain founders were especially eager "to break the tradition of the idea that it was effeminate to be in the arts," and felt that this sort of work would only help advance that point.

Philip Johnson had various reasons for wanting to help Black Mountain get the Alberses. He thought that Anni was "the best textile designer [he'd] ever met."[18] He admired the honesty and rigor of her work. In his own designing, he was advocating the aesthetic of exposed radiator pipes and linoleum for clients who previously would have had ornate carpets. He believed in acknowledging the truth of things: that's where heat comes from; that's the material from which the object is made. It was time to stop disguising. Johnson believed that Anni Albers's presence in the United States would improve textile design in general, and that she and Josef would help the Museum of Modern Art. Shortly after Eddie Warburg wrote to Alfred Barr, so did Johnson:

Eddie is writing to you about Albers. . . . But I know he is thinking of paying his way himself if he has to. He also got $500 from Mrs. R. for him. Personally I wish no responsibility for him, but I can't think better [*sic*] person could be got from the lot of ex Bauhaeusler [*sic*] than Albers. He could be very useful in all the industrial arts and in typography.[19]

Barr, who had met Josef at the Dessau Bauhaus, and had written him a long letter (in German) four years earlier, was sympathetic.

When Eddie Warburg wrote Barr about his scrambling for the funds to bring the Alberses over from Germany, Black Mountain College was still $500 short of the minimum needed to get started. Rice may have told Warburg that they had received a $20,000 guarantee and were opening in the fall, but in truth they weren't there yet. Moreover, although Warburg was able to wangle things with the immigration authorities and Johnson was able to negotiate with Albers so that all that was needed to get the Alberses to America was a guarantee of $1,500—for Josef's salary for one year ($1,000) as well as his and Anni's steamship fare ($500 for both in first class)—no one was coming up with the necessary money. While Warburg did indeed go to Mrs. Rockefeller and get $500 from her, he gave the rest himself.

According to Ted Dreier, without that gift from Eddie Warburg, "Black Mountain College would never have started."[20] Dreier had promised the Forbeses that he would abandon the whole venture unless he received $5,000 in addition to their $10,000. He had managed to scrape together $4,500, but had reached his deadline without seeing how he could possibly raise another penny. Warburg's own contribution, along with the one he solicited from Mrs. Rockefeller, entitled the school to receive the Forbes money, in addition to guaranteeing that Josef Albers—whose salary would be the only wage paid to a Black Mountain faculty member that first year— could come to the United States.

It was as Anni had said about the Bauhaus and everything else in her life: money was secondary in importance to art or love or the spiritual aspects of existence, but it mattered more than many people wanted to admit.

IN NOVEMBER 1933, Anni and Josef Albers arrived in New York on the S.S. *Europa.* Anni was excited about their new adventure, and had astonishingly few regrets about having left Germany and the world in which her family had had such prominence, but she still felt guilty that her being Jewish, even more than the closing of the Bauhaus, was the main reason that Josef had to leave his homeland. I often argued that her guilt was preposterous, but she insisted that she felt it, and she blamed herself for being "that stone around his neck, like a weight."

Once the *Europa* had docked, press photographers began to shoot pictures of the Bauhaus professor who was being imported to teach in the United States. Then someone called out, "Let's get the wife, too." Anni was utterly delighted. She did not for a minute mind her position as the famous man's wife; rather, she considered the wish to include her in a picture, and the way the journalist called out, to be marks of American friendliness. In the shot taken of her in her sealskin coat, next to Josef in his perfect top hat and overcoat, she doesn't look cheerful, though. But she does look dignified, with the elegant reserve that also pervades many of her textiles.

Philip Johnson was waiting at the docks. The following day, he and Eddie Warburg took the Alberses to Warburg's parents' house at 1109 Fifth Avenue—today it is the Jewish Museum and houses Anni's *Six Prayers*—for a tour of the collection of Rembrandt and Dürer etchings. Then they crossed the street and walked downtown a few blocks to the Metropolitan Museum, where the Alberses marveled at the eager crowd, as they had at the energy and dynamism on the city streets.

Two days later, Anni and Josef were at Black Mountain College. At first things were hard to get used to. A thumbtack attached a notice to an Ionic column at the school's Robert E. Lee Hall; this was impossible in Germany, where columns were made of marble. There were no notions of aristocracy. Back home, people of the Dreiers' social and economic class might have spent their holidays taking the waters at Baden-Baden; Ted and his wife, Bobbie, preferred to go backpacking. Where their German counterparts might have whiled away the hours playing baccarat, Ted and Bobbie joined the road crew. But Anni and Josef Albers fit in soon enough, and Anni in particular warmed to the more relaxed attitudes.

On Thursday, March 18, 1937, the day before Josef's forty-ninth birthday, thirty-seven-year-old Anni wrote a letter, in German, to Ted Dreier from New York. The metropolis scared her in some ways. If Weimar had been her haven from Berlin, Black Mountain was her haven from Manhattan. She wrote Ted—with whom she may well have been having a love affair, just as Josef was probably having one with Bobbie Dreier; based on the photos Josef took of Anni and Bobbie together in the nude, the chemistry between the two couples was powerful and extensive—a vivid account: "Dearest: Here in the great wide world it is not nearly as agreeable as at Black Mountain. Something is terribly wrong here in the big city, and as always, I don't know how I can become a communist and a Nazi at the same time, and so I am quite confused."[21]

The day had already been packed with events; Anni was a player on the scene of modernism in her new country, even as she maintained that she thought of herself as an outsider. She had gone to the house of a "Miss Post" for breakfast, and at noontime she went to the remarkable house of the mod-

ernist architect William Lescaze for a cocktail reception. It's unlikely that Anni had anything more than a glass of water as she stood, for an hour and a half, surrounded by expanses of unadorned white plaster and curved glass and talked with people she had never before met—no easier for her physically than psychologically, given the absence of arches in her feet and the malformation of her legs, as well as her social malaise. She wrote Ted, "I think I was terribly awkward."[22] But Joseph Hudnut, who was dean of the Graduate School of Design at Harvard and had invited Gropius to take a position there, was present and was very nice, as was Lawrence Kocher, managing editor of *Architectural Record,* who had, the previous September, included an article on Black Mountain, which had interested him from its start, in an issue of the magazine devoted to the education of architects. Kocher would advocate future collaborations among Anni and Josef and Breuer and Gropius.

Anni also had a good conversation with Philip Youtz, the director of the Brooklyn Museum, who was creating textile and industrial arts departments there and invited her to visit the museum the next day. But a "Mrs. Swan" was "not nice"—Anni had no idea who she was—while Mr. Swan was "very nice." Anni was greatly troubled that Mrs. Swan had acted so strangely toward her; perhaps this was the person who appeared to regard her as either a communist or a Nazi, or both.

The major event of that day, to us if not to Anni, is that, at dawn, she had met Walter Gropius's boat. We don't know any of the details of that reunion on the docks of New York; all that Anni wrote is that she got up before 6 a.m. to be present when Walter and Ise arrived in America with the plan to make it their new homeland. When Anni was twenty-two years old, Gropius had changed her life with his few paragraphs describing the Bauhaus and then with his greeting to the new students. Now she was the one who welcomed him.

THE ALBERSES STAYED at Black Mountain College for sixteen years, and although it had financial and personality problems similar to those at the Bauhaus, it had a conviviality the Bauhaus had merely proclaimed. The United States was a splendid new homeland for the Alberses. In 1939, they both became citizens. They didn't celebrate the way they had with the Kandinskys eleven years earlier in Dessau, when the Kandinskys became German citizens, but they were overwhelmed with joy.

On her American passport, for her profession, Anni put "housewife." Perversity? A secret wish? In an odd way, this was probably above all an expression of the Bauhaus wish to focus on everyday domesticity. Anni could have written "artist" or "weaver" had she wanted to, but the first struck her as pretentious (she would never use the word for herself) and the second as

"too artsy-craftsy, like one of those little ones making shoulder bags." The term "those little ones" was one Anni regularly applied to women "still trying to find themselves," which in her eyes included most of the female sex.

President Roosevelt felt to Anni and Josef like "our savior, or a beloved uncle." Anni's family lost everything materially—but she was able to get them and a number of friends visas for the United States.

Anni often said that "at least once in life, it's good to start at zero." She rarely voiced nostalgia for anything her family had given up. In fact, perverse though it sounds, she spoke of their difficulties not as a tragedy but as a cleansing ritual that reduced life to its essentials and facilitated a fresh start.

The idea of "start[ing] at zero" was consonant with Anni's instructions to her students when she taught the principles of weaving at the Museum of Modern Art at the same time as she had her exhibition there in 1949. She advised the class members to imagine themselves on the coast of Peru, centuries ago, without any machine power. They were to consider how they might weave textiles. To assemble a primitive loom, they might place some twigs parallel to each other, spaced at equal intervals, and then connect them with perpendicular bands made from strips cut from leaves. The materials they would create could be comprised of anything from animal skins or bird feathers to vegetable matter: shredded tree bark, wildflower petals, seaweed. Anni told me that the student who most impressed her was one who made a miniature loom using matches taken from an ordinary matchbook.

In her own life, clearly, the starting at zero was not theoretical. She did it twice: once by choice, once because it was imposed on her. The first occasion had been her going to the Bauhaus; this flight to America was the second. But now she had Josef, and they both had their overwhelming wish to keep making art.

ANNI TOLD ME that on the single occasion when she and Josef returned to Germany together, on the trip back to America, they saw, for the first time, the Statue of Liberty. "It had been night when we arrived in 1933, so we had missed it. Now, in 1962, we saw that arm raised high, as if she was welcoming us.

"And Josef and I said to each other, 'This is one time when abstract art does not work.'"

America afforded them the opportunity to continue making art, and to keep the Bauhaus spirit alive, which they did, continuously, for the rest of their lives.

Ludwig Mies van der Rohe

1

As director of the Bauhaus, Ludwig Mies van der Rohe summed up in one sentence the achievement of his main predecessor at the job: "The best thing Gropius has done was to invent the name Bauhaus."[1] He made the slight not just because Gropius left the Bauhaus without adequate financing. Mies was a fighter, and few people brought on his pugilistic instincts more than Gropius. Mies had first encountered the man whose job he eventually assumed well before the Bauhaus was founded. Back then, Gropius was a well-heeled play-boy, versed in horsemanship and good clothing and the other privileges of upper-class life, while Mies himself was still suffering as a complete outsider who didn't have a mark more than his meager earnings at the Berlin architecture office where he slaved away after hours and Gropius left work early. Not only did Mies harbor a life-long resentment of his colleague who grew up on easy street, but he also never considered Gropius a top-level architect.

Sergius Ruegenberg, Caricature of Mies with Model of Glass Skyscraper, *ca. 1925. Mies was a man of few words. He labored over every detail and nuance of his buildings and expected his students to do the same. The student who drew this was the same person whom Mies asked to burn the papers showing his pre-modernist past.*

The man who started his life as Maria Ludwig Michael Mies dressed up his background as best he could. Whereas Josef Albers embraced his humble origins and made them central to his identity, Mies invented a new self. Born in Aachen in 1886, he was the son of Amalie Rohe—there was no "van" or "der"—and Michael Mies; Mies van der Rohe's name, which he assumed when the Bauhaus was in Weimar, was one of his most elegant artistic creations.

Ludwig's father was eight years younger than his mother. They were both Catholic, and he was their fifth and last child; he had two older brothers and two older sisters. Ludwig's paternal grandfather was a marble carver, and his father was a stonemason. It was an upbringing with few luxuries.

Michael Mies put the children to work at a young age. This was a necessity. Early in Ludwig's childhood, Michael's business, which had briefly flourished in the early 1890s, suffered financial reverses and went into such a sharp decline that it became impossible to pay workers' wages. For All Saints' Day, when people wanted grave monuments, Ludwig was given the task of carving the letters on them. He would in time develop a keen instinct for the finer things in life, but he learned the tough truths of stone first.

His mother, meanwhile, took him to mass almost every Sunday in the impressively grand but splendidly simple Palatine Chapel, built by Charlemagne around A.D. 800, when he made Aachen the capital of his growing empire. The clarity of its design impressed Ludwig; so did the power of balanced forms and harmonious proportions to suggest a totally different universe from the one he knew at home. He needed that domain of mental escape, for family life only got tougher as he approached adolescence. At age fifteen, Ludwig had to drop out of school to become an unpaid apprentice in construction work. His main jobs were to lay bricks and deliver coffee to the other workers. The idea was for him to get sufficient training so he could earn money, but when his parents stopped supporting him when he was sixteen, the builders still would not pay him for his work.

Forced to look elsewhere, Ludwig landed himself a job as a draftsman in a stucco factory. He quickly discovered that he had only just begun to harden himself to life's difficulties. His boss, annoyed because of an error the sixteen-year-old had made in a drawing, threatened him physically. Ludwig told his employer, "Don't try that again," and walked out.[2] The employer sent for the police, who agreed that such behavior was intolerable for a youth and went to apprehend the ruffian at his parents' home. Ludwig's brother met the uniformed officers at the door and argued that Ludwig had no obligation to return. Members of the Mies family put up strong arguments, and the police retreated, but shortly thereafter, Ludwig had a second encounter with the law. Inebriated, he mounted a large monument of Kaiser Wilhelm I and hopped into the saddle next to the emperor. This time when

a policeman came he charged Ludwig. But the young man was too drunk to get down and be taken to jail. Again, Ludwig's brother, who was on the scene and somewhat more sober, came to his rescue. He persuaded the policeman to go with him to get a ladder. By the time they returned, Ludwig had managed to scramble down and flee.

He remained in Aachen a bit longer, without further encounters with the law, and took odd jobs with some local architects, for whom he did whatever was asked of him. Then he made an even greater escape than his flight from the emperor's saddle: he took a train to Berlin. It was 1905; he was nineteen.

LIKE ALBERS, who would be born two years later in nearby Bottrop, Mies was magnetically attracted to the sophisticated world of the capital. But while Albers would go to Berlin to advance his education and then return to his birthplace to work, Mies never went home again. Once he had tasted the pleasures of cosmopolitan life, he would not forsake them. And while both of these men from working-class backgrounds would marry sophisticated and wealthy Berliners, for Mies the marriage was merely a stepping-stone into a milieu he craved, while Albers's alliance would be lifelong, enduring even after Anni's family lost everything after the rise of the Nazis.

The first thing Mies did in forging his new life was to go to work for the architect Bruno Paul. He also took up printmaking. One day he was in the process of chiseling a woodcut when an elegant young woman approached his supervisor in the print workshop and said she hoped she might find a young artist who could design a birdbath for her.[3] The supervisor did not suggest Mies, who might have executed as well as designed it, but the project for her garden was so successful that the woman came back to the supervisor saying that she and her husband were now looking for a young architect whom they could hire to design a house for them in the wealthy suburb of Neubabelsberg. The printmaker, knowing that nineteen-year-old Mies worked for Bruno Paul as well as in the print shop, recommended him. The woman, Frau Riehl, invited Ludwig Mies to dinner that evening.

Mies's colleagues instructed him that he would be expected to dress formally. He rushed frantically "to all the desks in Paul's office, borrowing money from anyone I could find so that I might buy a frock coat." He also bought a cravat, which he later decided was completely wrong: "some wild yellow thing, totally out of place."[4]

Mies van der Rohe later described that first encounter with the haut monde. He saw himself as having been a total rube, the ultimate provincial lad in the big city. He felt like a clumsy intruder as he observed the man ahead of him, in tails and covered with medals, gliding gracefully across the parquet. Mies had the impression that, as the host smoothly greeted one guest after another, he stuck out as a bumpkin.

In the following days, however, he showed no lack of mettle. Herr Riehl was enthusiastic about the neophyte, but Frau Riehl was not. Mies managed to convince her of his merits. Then, once he had secured the job, and Bruno Paul suggested he do it in the office under Paul's guidance, Mies vetoed the idea. That decision cost him his day job, but allowed him to complete his first architectural commission on his own.

The house was not remarkable, but it was a decent start. By the time the twenty-six-year-old Ludwig Mies was photographed on the Riehl house veranda, his attire was impeccable, his wing collar and understated cravat and pinstripe trousers as correct as his cutaway. It did no harm that he had the face of a young prince. Mies was one of those people whose handsomeness opened doors, and who knew how to put his assets to good use.

2

In 1908, four years before that photograph was taken of the dashing and impeccably attired young architect with his first clients, Mies's transformation had been given a jolt forward, when he went to work for Peter Behrens. For young designers interested in a new approach, Behrens was Berlin's leading architect. Walter Gropius, three years Mies's senior, was also employed by him. Gropius and Mies first met in Behrens's office.

It might have been a scene in a Balzac novel. When the young workman's son from one of the toughest neighborhoods in Aachen met Gropius, he was instantly aware that, unlike him, this well-connected young man had everything a rising architect could have wanted. Gropius's father served in the city administration as a building councilor; his great-uncle had been a distinguished architect in the tradition of Schinkel. Besides having designed important public buildings and private villas, Martin Gropius had headed the Berlin School of Arts and Crafts, where Mies had briefly been a student. Walter Gropius had gone to the finest schools and served in the Wandsbeck Hussars—among the most glamorous of Germany's cavalry regiments— whereas poor Mies had been nothing but a low-level soldier, and only for a brief period. When he went to work for Behrens, Gropius had just returned to his native Berlin from a thrilling year in Spain; Mies had never enjoyed a day without obligations. Mies assumed that the well-born, confident Gropius was not even paid by Behrens, even though he had a high-level job. Mies himself received a pittance.

Then, in 1910, Gropius, who was more bent on industrial streamlined form than was Mies, went off to work on his own. Mies, who did not even

have an architecture degree, certainly could not afford to do the same. The groundwork was laid for a competitiveness and antipathy that would only intensify with time.

AFTER A YEAR in Behrens's office, tensions between Mies and another young architect escalated to such a point that the two could no longer remain in the same place; since the other man had seniority, Mies had to leave. Following a hiatus of about a year, he returned. By then, his new social circumstances were forcing him to comport himself in such a way that his rough edges were concealed from everyone except for his intimates. His

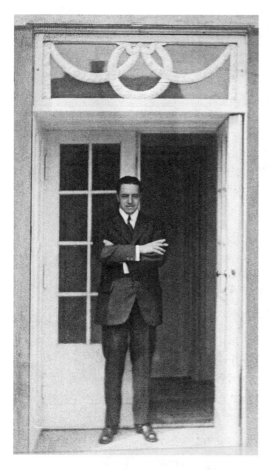

first clients, the Riehls, had some friends, the Bruhns, also a worldly and prosperous family, and the Bruhns had a daughter, Ada. The prospect of an alliance with an affluent, well-connected woman from Berlin was very much to Mies's liking, and he began to pursue Ada Bruhn.

His improved social position had in the meantime gained him entry into a milieu that would enable him to forge into new territory with his architectural work. Mies was taken along one evening to the home of a second important client for a private house, Hugo Perls, a successful lawyer and collector of contemporary art. Perls, who regularly hosted soirées for the leading intellectuals of the day, was pleased to meet a young architect who was so different from others in the strength and clarity of his passion for clear and elegant design. The young architect explained to Perls in few words why he eschewed ornament and would avoid the usual vestiges of classical motifs most rich people expected on their houses. Mies was not blind to the past—he revered the strength of the nineteenth-century designer

Ludwig Mies in the doorway of the Riehl house, ca. 1912. It was hard to believe that the impeccably dressed young man who had ascended to the upper echelons of Berlin society had, only a few years earlier, been running from the police in the town where he was doing construction work.

Schinkel, whose bold structures dotted Berlin—but he craved a simplicity that no one else dared imagine.

Hugo Perls's unpublished reminiscence of his first encounter and subsequent meetings with Mies provides a vivid portrait:

> After many experiences in old, more recent, and new art we returned to Berlin in the hot summer. Our small apartment under the roof, in the midst of the forest, had been furnished by mother and sister. We had only to unpack the cases with our treasures from Paris and to hang Picasso's paintings on the wall. In the exhibition of the Secession we quickly bought Munch's *Bathing Men.*
>
> Soon there was activity in our attic. Artists came, one introduced another. One evening Ludwig Mies van der Rohe appeared. . . . Van der Rohe did not talk much; the few things he said, however, seemed right and were easily understood. Something like a new era had come about in building. Better architects were already trying to keep away from façades, useless ornaments, angles, bay windows, and all the glue-on romanticism. A new classicism came into existence, and there was much talk about "decency" in building after Henry van de Velde had introduced morals into construction. What was being built was already less horrid than the usual, boastful architecture under William II. Van der Rohe's convictions were sharp. If I remember correctly he explained the way of building a new house about so: "The architect has to become acquainted with the people who will live in the future house. All the major factors are easily derived from their wishes. Situation, direction, and the terrain, of course, play an important part in the final outcome of the blueprint. If all these are taken into account, the 'how' of the exterior follows organically." We spoke about the functions of the parts of the house, although the rather dogmatic word "functionalism" perhaps did not exist. . . .
>
> Deep in the forest, near the "Krumme Lanke," he built our house. My too conservative mind led to many a friendly fight. The house could have been still better, for Mies van der Rohe was one of the founders of the new architecture.[5]

The blocklike house Mies made in Grunewald for the Perlses paid subtle homage to the past, but with its plaster facing devoid of decoration and its simple symmetrical plan, it was on the way to an unprecedented minimalism.

WENDING HIS WAY in the world of architecture, Mies was aided by the charm he worked on women. Peter Behrens was designing a large house in Holland for A. G. Kröller, a wealthy man who left most of the decisions about any-

*Ludwig Mies, Perls house, Berlin, 1912. While he had not yet broken free
from tradition, in his first houses for wealthy clients, Mies was already
simplifying form and avoiding gratuitous details.*

thing to do with art, which he collected in great quantity, and architecture
to his wife, Helene E. L. J. Müller. Behrens had made Mies his main liaison
to Kröller-Müller, as she was known. It wasn't long before the rich and dis-
cerning Kröller-Müller began to prefer the young architect's ideas to
Behrens's. One of Mies's suggestions was that it would be worthwhile to
consult with the Dutch architect Hendrik Petrus Berlage. He raised this
idea to Behrens, who disagreed. The acid-tongued Mies responded by sug-
gesting that Behrens was deceiving himself. Again, Mies seemed on the
verge of physical battle with an employer. A furious Behrens "would have
liked nothing better than to give me one in the face," he later observed.[6]

Mies was again out of a job. But following his abrupt departure from
Behrens's office, Kröller-Müller put him in charge of her house. She gave
him an office in The Hague, where he worked surrounded by some fifty
major paintings by Van Gogh. It was unlike anything he had ever imagined.

Having previously championed Berlage, Mies now wanted the project
entirely for himself. The Dutch architect, however, was already on board
because of Mies's earlier intervention. Mies's previous choice now became
his main rival.

Mies made a design that combined elements of a Greek temple with the
details of a modern factory. It was classical in its configuration and entry por-
tico of parallel perpendicular columns, but industrial in its flat roof and
unadorned surfaces. Mies immediately realized he would have to work as

hard promoting his concept as he had creating it. Seeking effective endorsement, he went to Paris to show it to the critic Julius Meier-Graefe. Meier-Graefe's views had great sway, and he wrote the letter of Mies's dreams. If only it had arrived at A. G. Müller's office sooner, it might have secured the young man the commission. But before Meier-Graefe's letter was on Müller's desk, H. P. Bremmer, a critic Müller had hired to help him make the best decision, had prevailed on Berlage's behalf. Mrs. Kröller-Müller implored her husband to use Mies, however.

The result was a stalemate. For the time being, nothing came of either proposal. The Kröller-Müllers were so incapable of making a mutually agreeable decision that it was not until 1938 that they had their villa, from a different design.

Mies would make sure that nothing of the sort ever happened again.

3

Friedrich Wilhelm Gustav Bruhn was a successful manufacturer and inventor. He owned factories all over Europe, as far away as London, and had invented both the meters that were used in Berlin's taxis and an altimeter that became standard in airplanes used by the German air force. He was known to bear down hard on his children yet also to spoil them in the extreme, and when Mies met Bruhn's daughter Ada, she was a highly complicated individual, given to episodes of neurotic illness. Tall, with long brown hair she wore in a chignon, Ada was also striking in appearance. Already a dignified upper-class lady, Mies's future wife was more than a year older than he was.

Ada was a student in a Dresden suburb, Hellerau, where she was studying eurhythmics with the composer and musicologist Émile Jaques-Dalcroze. Jaques-Dalcroze had a profound influence on many of the most advanced proponents of modern dance and music, among them Le Corbusier's brother, Albert Jeanneret. Ada may have belonged to the upper stratum of Berlin society, but she was also an adventuress. She lived with the modern dancer Mary Wigman and another woman, Erna Hoffmann, who would marry Hans Prinzhorn, a well-known psychiatrist who would write *The Art of Psychotics.*

From the start, Bruhn and Mies made a fascinating pair. He came from a completely different rung of society, but he exuded the confidence and savoir faire she lacked. With his strong square jaw, chiseled nose, and bright hazel-green eyes, he also had movie-actor good looks. His shock of silky

black hair, combed straight back to make his forehead look as precisely geometric as the forms he advocated for building design, added to his impact. Ada was also striking, but the impression she gave was of deep thoughtfulness tinged with uneasiness.

Ada had already been engaged, to the great art historian Heinrich Wölfflin, who was twenty-one years older than she was. She was attracted to intelligence and originality in men as in music and dance. What lured Mies to her was a different matter. Dorothea, the second of the three daughters born to Mies and Ada told me, many years ago, "My father was nothing but a social climber, nothing whatsoever." Ada offered not only wealth, but also further entrée into the world Mies had already begun to penetrate although he was still an outsider.

Ada was sufficiently neurotic that her family was pleased enough that she was ending up with someone who worked hard and was clearly motivated and industrious. The only aspect of Mies her parents disliked was his name. "Mies" on its own had an unfortunate sound, and in German slang translates, roughly, as "crummy" or "rotten." But for the time being the Bruhns kept their protests quiet.

The bride's parents gave the pair a proper Lutheran wedding and set them up in a nice house in one of Berlin's most affluent suburbs. The year was 1913, and Mies, who had started his own office the previous year, now had more prospects for clients in need of fancy houses. But then the young architect was again drafted into the army. Because he did not have a university degree, he became a noncommissioned soldier of low rank, and went off to fight in Romania.

DURING THE WAR YEARS and immediately afterward, Mies and Ada produced three daughters. Mies, however, wanted a son. He therefore used boys' nicknames, complete with the masculine pronoun, for two of the girls. Dorothea became "der Muck," and Marianne became "der Fritz." Only Waltraut got off easy—as "Traudl."

Once he returned from his military service, Mies again enjoyed the benefits of being married to a rich woman. Ada, assisted by a governess, freed him of any obligations of fatherhood. He designed large and luxurious private houses, with Ada's parents' circle of friends as his clients. The bulk of the money that supported his way of life came from his wife's father, but as the man in the family, he was in charge of it. There was enough so that Mies could practice architecture independently and take up skiing and horseback riding in his spare time.

He was not yet as committed to modernism as he would later have people believe. The houses he designed were less ornate than many being built in Berlin's wealthy suburbs, but even if they lacked ornate façades and

crenellated parapets, they were not out of keeping with the style of other rich people's mansions. Later in life, hoping to redesign history and keep people from realizing how traditional he had once been, Mies would instruct a subordinate in his office, Sergius Ruegenburg, to burn his papers from this period.[7] That revisionism, which began in the mid-1920s, would continue, but in the years right after the world war, even as the Bauhaus was being founded, Mies was very content to fit into his new milieu and to live and design according to its rules.

4

The change began when Ludwig Mies became even more fascinated with the new and radical ways of seeing that he had first experienced with Mrs. Kröller-Müller. "De Stijl," "constructivism," and "dada" were all in the air in Berlin, and Mies met some of their practitioners. Hans Richter, an abstract artist who was two years younger than Mies, was the catalyst in getting a number of the leading artistic adventurers to meet one another. Richter, who came from a wealthy Berlin family, had joined the dada movement in Zurich. He made experimental films, and believed that artists should actively oppose war and support revolution. Through him, Mies came to know Theo van Doesburg, Hans Arp, Tristan Tzara, Naum Gabo, and El Lissitzky, and began to see them regularly.

Mies was drawn primarily to the wish of those artists to purify and simplify visual experience and to get to the essence of things. Their approach was the opposite of expressionism, the other dominant trend of the time, with its deliberate revelation of personal emotion. The young architect enjoyed the artistic cross-pollination that occurred through his exposure to other brilliant people; even if their styles were by no means identical, a lot of mutual learning was possible. For the first time, he was discovering that it was not just pleasant to be with like-minded souls, but that it was deeply informative. Part of what would lure him to the Bauhaus, which he would frequently visit before becoming its third director, was another version of the creative camaraderie that Hans Richter had helped him discover in Berlin.

IN THIS PERIOD when he was listening eagerly to dadaists and constructivists with their attitudes ranging from nihilism to positivism, Mies's own views were reflected in the writing of Oswald Spengler, whom he read with the sense that he was facing his own truth. In his book *The Decline of the West,*

Spengler proffered the theory that European civilization was in its "early winter."[8] Rather than deceive ourselves about the painful reality of that approaching demise, it was necessary to face it squarely.

Mies also confronted the hard truth of his home life. At the end of 1921, Ada and the three girls, all under the age of seven, moved to a separate apartment, in Bornstedt, another Berlin suburb. Ada was in a deep depression. She remained devoted to her husband, but they felt they could no longer be together all the time.

At first, Mies spent most weekends with her and their daughters. Given the unusual circumstances, they were surprisingly like a traditional family during those visits. But soon he began to show up with less frequency, and started to restructure his life. He turned the dining room of the former family home into his workspace, while moving his bed into the capacious master bathroom—the actual toilet was behind a door—and using what had been his and Ada's room for guests. It was no longer a space to which his wife and children could return.

Then Maria Michael Ludwig Mies engineered a new name for himself. In May 1922, a reference to his work in an important architectural review said it was by Ludwig Mies van der Rohe. The son of Michael Mies and the former Amalie Rohe had dropped Maria Michael and, while he could not entirely shake off the discordant Mies, had softened its impact by following it with his mother's maiden name and dressing it up with the sonorous, and seemingly grand, "van der." He even added an umlaut over the *e* of Mies, in an effort to shake off its grimy connotations, but that maneuver did not stick. "Roh" means "pure," a nice antidote to the nastiness of the "Mies" he hoped to vitiate with the umlaut, and the ensemble had a pleasing flow. In addition, the new appellation seemed Dutch, because of the choice of "van" rather than "von," in keeping with the tastes he had developed in working with Mrs. Kröller-Müller.

He would, regardless, be referred to and known as Mies. That practice is followed in this book, even though Dorothea, who was calling herself Georgia van der Rohe when I met her, instructed me, her finger waving, "Never ever just say 'Mies,' which means something quite wretched; my father's name was 'Mies van der Rohe,' always with all of it."

Ada put their three daughters in a new academy that Isadora Duncan had just launched in Berlin, but it soon became clear to her that their old way of life would never be restored, and in 1923, she took off with the girls for Switzerland. It was the final break in their family life. The mother and the three children would move from place to place for over a decade; Mies would live his life apart from them, although never divorcing—in part because he could not afford to do so financially.

LUDWIG MIES VAN DER ROHE also took on a new identity as an architect. He made a design for a triangular skyscraper, sheathed entirely in glass, that soared like a crystal prism. While it resembled an imaginary edifice in a science-fiction movie, it was very real in the clear exposure of its structure. It invited a new way of seeing that disguised nothing and celebrated recent technological advances. The focus was on up-to-date materials and construction methods, and unprecedented ideas of how things might look, with a scrupulous avoidance of anything personal. Mies was already rallying to many of the same principles that were being celebrated and explored at the Bauhaus. While he had no real connection to the school as yet, he was well aware of what Walter Gropius, the elegant and well-heeled young man he had encountered in Peter Behrens's office, had recently started in Weimar.

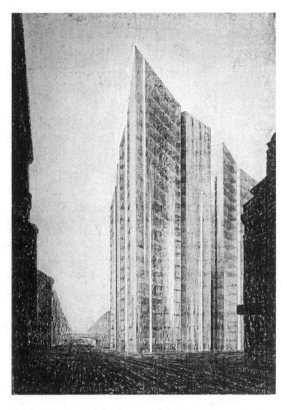

Ludwig Mies, Friedrichstrasse skyscraper, perspective view from the north, ca. 1921. Mies's skyscraper designs looked like cinematic versions of the future.

He then conceived a second skyscraper, also made in shimmering glass, but this time the thirty stories were translucent columns. The overall impact of the scheme is of undulating curves that resemble an updated, space-age version of the portico of the Parthenon—as if the noble form of the temple on the Acropolis has now gone organic. The plan of each floor looks like a marvelous butterfly with fluttering wings; a minimal, delicate core housing two circular elevators with stairs twisted around them is the linchpin of the amorphous form.

There was no doubt that Mies, however frosty or contrived his persona, was someone of incredible imagination as well as tenacity. The designer of this second glass skyscraper clearly believed that anything was possible in the realm of building. His spectacular inventiveness, which he skillfully paired with the advances of modern engineering, opened a new world. Mies

as a man began to soar and expand like his building designs. In 1919, he had joined the Novembergruppe, named for the month when the Weimar Revolution occurred. That radical organization had goals similar to those of the Bauhaus: a new closeness between artists and laborers; and the unity of art, architecture, city planning, and the crafts. One of its intentions was to open the common man to the groundbreaking modernity that was in the air after the war. The other members included Lissitzky, László Moholy-Nagy, the composers Paul Hindemith and Kurt Weill, and the dramatist Bertolt Brecht. Unsatisfied, ever, to be merely a member of an organization, in 1923 Mies became the Novembergruppe's president.

At this time, he was also spending more time with Kurt Schwitters and Hannah Hoch. These brilliant "dada" artists were an inspired choice as friends, for they endowed their groundbreaking, seemingly random, abstract compositions with sublime artistry. Even if Mies could not fully embrace Schwitters's and Hoch's emphasis on spontaneity and chance, he, too, envisioned a form of liberation. His mission was "to free the practice of building from the control of aesthetic speculators and restore it to what it should exclusively be: Building."[9]

Mies was adamant that the purpose of a structure must govern all decisions; any preconceived notion of what something should look like was a folly that had to be avoided scrupulously. "We refuse to recognize problems of form, but only problems of building. Form is not the aim of our work, but only the result. Form, by itself, does not exist."[10] He made this declaration in the new magazine *G,* started in 1923 by Richter, Lissitzky, and Werner Graeff. Mies's bold design for a concrete office building—it resembles a modern multilevel car park of the type that proliferates today in cities all over the world—was also in the magazine. It was tough and absolute, and as didactic as his words.

THEN THE NEW Herr Mies van der Rohe began to demonstrate the quiet elegance that would be his forte. When he applied his strict approach to private residences, the complete absence of adornment, and the crisp right angles and bold forms, led to ineffably graceful results. Mies's idea of building from the inside out, reversing the traditions of domestic architecture that had ruled the western world ever since the Renaissance, inspired designs of balletic grace.

Mies had a gift that went far beyond all of his theories and statements: he had a guiding eye that was the equivalent of perfect pitch in music. He infused his assemblages of concrete or brick blocks with a rhythmic motion and overarching grace that made them come alive.

The young architect transformed weighty materials by combining them in such a way that they miraculously produced a fluid movement within a

Ludwig Mies van der Rohe, concrete country house project (view of model), 1923.
In the same year that he dropped his given first names and added the soigné
"van der Rohe," Mies invented completely original forms of human habitation.

balanced whole. He was like a master musician who uses an instrument that is primarily wood or metal to create flawless sequences of mellifluous sounds. Mies's concrete country house of 1923 and his brick country house of 1924, while never realized, remain, in their drawings and models and plans, creations of breathtaking beauty. Based on no architectural precedent, deriving only from Mies's own ideas of how to align walls and juggle rooftops and use the most straightforward modern materials to create magical spaces, they are both splendidly animated and imbued with a look of tranquillity. In other hands, similar concepts might have been harsh; in his, they are refined. In the concrete villa, the few openings and occasional short flights of exterior steps in the otherwise bunkerish whole invite a sense of dreamlike events. In the residence in brick, with its long retaining walls and massing of blocks at the core, the marvelous placement of translucent walls amid the solidity of the rest provides sheer delight.

The man himself was cold, forbidding, and ambitious; his architecture was warm and welcoming. What the building designs have in common with the person who made them is that they prove that refinement is not a matter of the elements with which one starts out, but of what one does with them. They show that structural materials can be as elegant as they are rough.

The brick in country houses went back to Georgian architecture in eighteenth-century England, but in that instance the desire was to minimize the rawness of the material and encase it in ornament. Mies's brick country house is the opposite. It is simply a sequence of freestanding brick walls, of various heights and lengths and thicknesses, some of them meeting

Ludwig Mies van der Rohe, brick country house project, 1924.
In elevation and plan, his brick country house had rhythmic
interlocking forms and extraordinary spatial flow.

at T-junctions, others joined at right-angled corners. With no doors, it is one continuous flowing space. Full of surprises, with a concentration on the human experience, the conglomerate alternates nooks and crannies with larger spaces. It accommodates the human need for both coziness and generosity of scale. It and the concrete country house, with their exquisitely refined designs based on ordinary materials, presented a new notion of a suitable shell for human existence. With their open plans, they would have lasting influence on domestic architecture worldwide.

5

While Mies was making these groundbreaking designs, one of the hottest topics in Berlin was the Bauhaus. But for Mies, there was the Gropius problem. The stonecutter's son from Aachen had not gotten over

the way the former hussar had made him feel when they were both in Behrens's office.

Mies's antipathy to Gropius had grown all the stronger at the start of 1919, when Mies submitted his Kröller-Müller design to an exhibition Gropius was organizing that was to open at the end of March. Gropius's show, which had the catchy title "Exhibition of Unknown Architects," was to be the first exhibition of architecture following the armistice. Nearly fifty years later, Mies would still recall Gropius's response to his submission, as if it had been said only the day before: "We can't exhibit it; we are looking for something entirely different."[11]

In 1921, Theo van Doesburg, a friend of Mies's who was the leader of the Dutch de Stijl movement and one of the founders of *G,* had gone to Weimar in hopes of being hired to teach at the Bauhaus. When Gropius failed to appoint him, he stayed in the new German capital anyway, and taught privately. Meanwhile, Mies's friend Werner Graeff, who at age nineteen had become a Bauhaus student, was making remarkable graphite and tempera drawings in Itten's course—they look like a combination of Zen calligraphy and the paintings Franz Kline would make in America thirty years later—but Itten did not approve of his approach. Graeff left the school unhappily and studied with Van Doesburg instead. Hans Richter was also among Van Doesburg's group of Bauhaus outsiders, and even if Mies did not subscribe to Richter's political agenda, he considered the former dadaist a colleague. In the period when Van Doesburg was teaching at home in Weimar rather than at the Bauhaus, Mies, Graeff, Richter, and Van Doesburg often communicated about what they considered to be Gropius's aesthetic fickleness.

Everything changed in 1923, however. That year, Gropius asked Mies to show some of his recent work in the great Bauhaus Exhibition. Mies could not resist the invitation. Models of the glass skyscraper and concrete office building, and a drawing of the concrete country house, went off to Weimar, where they were handsomely installed in the section of the show devoted to international architecture. Given their long if unspoken rivalry, the alliance between Gropius and Mies still felt tentative, but their relationship was improving.

THE PROJECTS MIES actually realized in the early 1920s were not nearly as radical in concept as his skyscrapers and brick and concrete country houses. But the houses he designed for his parents-in-law's circle of friends had a bit of the spareness and boldness that were his ideal, even as these residences retained enough of a traditional tone so that their owners did not risk being socially ostracized. And a monument Mies built in Berlin's Friedrichsfelde cemetery in honor of Karl Liebknecht and Rosa Luxemburg, the martyrs to

the German Communist party who had been killed in an uprising in 1919, was revolutionary in design in a way appropriate to Liebknecht and Luxemburg's politics. Composed entirely of coarse bricks, their jagged edges bespeaking unmitigated toughness, this abstract sequence of blocks was like a resonant shout. Adorned with hammer and sickle emblazoned on a five-pointed star, the monument had a stridency that was unmistakable. We know it, however, only from photos; Mies's brave reminder of Liebknecht's and Luxemburg's courage was destroyed by the Nazis in 1933.

While Mies's client base still consisted mainly of the Bruhns' friends, he was living as if he were a bachelor. Ada and Dorothea, Marianne, and Waltraut moved around in Switzerland, although the girls would on occasion visit their father in Berlin. Sometimes their mother went along, sometimes the three sisters were on their own. And on his rare holidays, Mies would go to see them, initially in the French-speaking Swiss mountain town of Montana, and after that in the Swiss Engadine.

Then Ada, who loved the mountains but had to give up hiking because she developed a crippling anxiety about heights, finally moved them near Bozen, in the Italian part of the Tyrol. This became their home for long enough for her to undertake psychoanalysis. Her estranged husband had little patience for Freud and his methods, however. Mies himself appeared to avoid introspection; he just kept designing flawless buildings.

He was beginning to command important projects. As vice president of yet another important organization of modern architects and artists, the Deutscher Werkbund, Mies became, in the mid-1920s, artistic director of the Weissenhofsiedlung. This energetic undertaking on the outskirts of Stuttgart was to present the latest in residential architecture. There were to be houses by Le Corbusier, Bruno Taut, J. J. P. Oud, and another half dozen or so of the most interesting European architects. Now it became Mies's turn to do a favor for Gropius. As if in exchange for his own participation in the 1923 Bauhaus show, he not only included his former rival in the list of world-class architects who would create houses for Weissenhof, but gave Gropius one of the best building lots on which to do so. Not that Gropius was elevated to the top; Mies himself and their tough old boss Peter Behrens were doing entire apartment buildings.

This remarkable group of modern residences in a Stuttgart suburb remains to this day a pilgrimage spot for architecture enthusiasts, and Mies's layout of the array of dwellings is part of the fascination. He had a difficult task; the overall site was narrow, irregular, and full of steep rises and drops. Mies did a spectacular job. He awarded Le Corbusier corner lots so that the Swiss architect's two stunning villas command the site and announce the thrill of modernism to the approaching visitor. Their glistening white streamlined forms are endowed with lively rhythms and possessed

by bravura without arrogance; Mies did well to place them like a signpost. And by locating Le Corbusier where he did, Mies also provided the Swiss with the chance to give the people inside the two villas a sweeping view of vineyards and fields and the distant horizon, fulfilling Le Corbusier's dream of access to the sky and the forces of the universe.

Besides Gropius, who submitted a prefabricated house, there were other designers whom a lesser person would have excluded as rivals. But Mies showed professionalism and generosity in his approach. He organized the myriad buildings on that difficult spot of land with impressive concord. Their unifying factor was that every house had to be white and have a flat roof; otherwise, the individual designers were given great liberty. The buildings were meant to display both homogeneity and variety.

THE WAY MIES went about the Weissenhof project did not please everyone, however. He was notoriously slow—some would say passive-aggressive— about everything he did. He spent days laboring over the single paragraph he wrote for the exhibition catalogue, greatly irritating the editor. He waited until October 5, 1926, to invite Le Corbusier to participate in this undertaking for which the two villas needed to be completed by July 23 of the following year, which was strangely at odds with the way he then sited them in the premium position. It was Mies's laboriousness that enabled him to perfect his work, but when its price imposed hardship on everyone in his orbit, there was a lot of displeasure.

Yet few people disagreed with the opinion that at Weissenhof Mies had organized something marvelous, with first-rate work. What might have been cold, with a stultified appearance of having emerged from the same mold, was full of variety. This was very much Mies's intention; in the fore-word over which he labored so long, he wrote, "I held it imperative to keep the atmosphere at Stuttgart free of one-sided and doctrinaire viewpoints."[12] As a group of buildings, Weissenhof, when it was completed, was without precedent. Everything was pared down, related by its whiteness and those planar roofs, and by its crispness and functionalism, yet the structures all maintained the particularities of their architects, and were jaunty and pos-sessed of remarkable élan.

Mies's own work at Weissenhoff had the authority and grandeur that were his alone. His four-story-high apartment house, a long rectangular slab dominating Weissenhof from its highest ridge, is magisterial. Mies had in common with some of his future colleagues at the Bauhaus a wish for his work not only to be effective in fulfilling its purpose, but also to demon-strate an understanding of materials. Yet what was even "more important" to him was for it to have a "spiritual quality."[13] He achieved this through visual tempo and the grace of the proportions.

The west façade of that large building is punctuated by an elegant grid of windows that is, the longer we study it, ever more astonishing. With each vertical rectangle of glass framed in black steel—and with a very subtle and judicious arrangement achieved by using, as an organizational tool, narrow vertical strips of the smooth white plaster—he establishes a precise beat. From left to right, the façade reads three/stop/one. Then there is a full break for the stairwell, followed by one/stop/three/stop/three/stop/four/stop/one. Then there is another stairwell; then comes one/stop/four/stop/three. At that point, following a brief halt, begins the mirror image of what the viewer has just seen.

One is left transfixed by this visual orchestration with its classical beat and tempo. The east façade, which sports balconies and openings for the roof gardens, is equally mesmerizing in its boldness. Klee's hero was Mozart; Mies's work conjures Beethoven.

Inside of Mies's buildings, the apartments look both east and west, so the rooms are flooded with light. That luminosity animates the space so that for all of the balance, Mies's architecture is always alive with movement. The turns of the stair rails have the grace of flawlessly executed ballet steps, adding further fluidity to the minimalism and inducing the "spiritual" effect Mies desired. As in a Zen rock garden, the visual becomes inexplicably religious.

6

While Mies was in Stuttgart working on Weissenhof, he lived in a small apartment with Lilly Reich. Reich, who was, like Ada, one year older than he was, designed textiles and women's clothing. In 1914, she had run a fashion show put on by the Werkbund; it had been one of the last activities of the avant-garde design group in Berlin before the war ground things to a halt.

Reich's own appearance conformed to the styles she put into that fashion show. She was always impeccably groomed, in a modern, manly way that was startling to many people, completely counter to the usual style of bourgeois women and the expectations of most men. She assiduously avoided the soft and frilly,[14] not only in her appearance but also in her behavior.

While Weissenhof was open to the public, Reich was responsible for a concurrent exhibition in downtown Stuttgart that showed contemporary furniture and household objects. This was where Mies introduced his cantilevered "MR" side chair, a breakthrough in elegant minimalism. The

skeleton of the "MR" is a continuous form of tubular steel that is like a drawing made in three-dimensional space. Everything necessary for a chair has been reduced to the bare essentials. The single line of steel establishes the base, legs (of which there are only two, through a feat of equilibrium), seat, and back. Mies calibrated each angle and proportion with utter precision. On the impeccable frame, two expanses of material—either leather or painted caning, depending on the customer's preference—are stretched tautly to complete the seat and back.

In the history of armchairs, this was among the visually lightest to date. Mies's sense of line and scale seem to have come from the angels. The curve that creates the base, the seat, and the back is scrolled as if with a magical wand; its opposite number, which further cradles the back, turns for arms, and flows downward until it attaches itself at the perfect point on the legs for effective bracing, completes the exquisite assemblage in a way that guarantees visual pleasure as well as the physical well-being of the sitter. Not only

had Mies van der Rohe revolutionized the concept of armchair, but he had transformed the possibilities of matter, making strong substances ethereal.

By offering this chair for sale at the pivotal moment when enthusiasts of modern design from all over the world were descending on Stuttgart, Reich proved herself the perfect colleague. She and Mies had the same taste in design, and they both ascribed utmost importance to the presentation of one's self— in comportment, speaking manner, and appearance. When they continued to live together back in Berlin, they reinforced each other's stridency on these issues. Mies's daughters came from the Swiss mountains to visit, and Reich immediately let the girls know in no uncertain terms that the clothing in which their mother had dressed them would not do. While using their mother's family's money, to which Mies still had limited access even as its buying

Lilly Reich and Ludwig Mies van der Rohe. Although he never divorced his wife, who was the mother of his three daughters, Mies lived openly with the opinionated and imperious Lilly Reich, who shared his views on how people should present themselves.

power dwindled with inflation, Reich clad them according to her own preference for what was more austere in style and considerably more expensive than anything they had ever owned before.

The girls quickly came to feel as if their father's mistress was a cold and disapproving stepmother. They were well brought up and polite, but they disliked her intensely. Mies's reaction was to put even more distance between himself and his children.

To outside observers, the relationship between Mies and Reich depended on her slavish devotion to him. Reich fit in perfectly with the world Mies was designing. Her smart dresses, streamlined hair, and assured speaking manner epitomized rationalism and control while eschewing sentiment. Each of the geniuses at the Bauhaus had a companion who provided vital support, but Mies's was the only one who offered the flattery of which imitation is said to be the highest form. Everything she did was done in a disciplined, authoritarian way.

IN JULY 1928, Mies van der Rohe was commissioned to design the German Pavilion for a great international exhibition opening in Barcelona. Having forced Le Corbusier to rush his houses for Weissenhof, now he was in the same predicament; the structure needed to be completely ready for the opening of the exhibition by the king and queen of Spain the following May. If it had taken him half a year to write a paragraph, now he had to create and completely construct a major building in ten months.

The result of that breakneck process had rare grace and equipoise. And it had the highest degree of finish imaginable.

The lithe, elegant façade of the Barcelona Pavilion was nothing but a thin rectangular wall of travertine marble blocks aligned so that the graining of the marble achieves a musical flow. A flat white roof was perched lightly on top with an overhang that was like a long continuous eyebrow. Those two forms dominated the structure, yet there was nothing "dominant" here; rather, there was a sense of perfectly related elements juxtaposed in total harmony. The thin and graceful chromed entrance columns, which in cross-section were X-shaped, and the refined half flight of entrance steps incised at a right angle into the sloping terrain, had the same elegance and quiet strength as the marble façade and lithe roof. Inside, Mies had inserted a nonbearing wall between two bearing walls; this breakthrough in building design gave birth to the open plan he had developed but not executed in his country house designs. As Mies explained late in his life, "One evening as I was working late on that building I made a sketch of a free standing wall, and I got a shock. I knew that it was a new principle."[15]

The components, inside and out, were delicately interwoven so that there was a balance of mass and lightness. The furniture was powerful, but it was

*Ludwig Mies van der Rohe, view of principal façade of German
Pavilion, Barcelona, 1928–29. With its unprecedented grace
and eloquent use of fine materials, the Barcelona Pavilion
was well-known and admired at the Bauhaus.*

installed sparely and with ample space around it. White and black, vertical
and horizontal: the contrasts played off one another with perfect equilib-
rium. Yet there was no suggestion whatsoever of an underlying formula; if
the system had been visible, it might have diminished the viewer's response.
Rather, the flawless proportions seemed to have grown as naturally as those
of a rosebush.

Working on the Barcelona Pavilion, Mies willingly responded to the exi-
gencies of the situation, letting them determine the end results, just as
Anni Albers let the capabilities as well as the limitations of the medium of
thread guide her design of textiles. He had very little time to construct the
building, and he was constrained by the season; he knew he could not move
the large pieces of marble he desired from the quarry "in the winter because
it is still wet inside and it would freeze to bits."[16] Yet he did not want to use
brick, the most likely alternative. So he went to a marble depot, where he
found onyx blocks that he used as a module, making the pavilion double the
height of a single block.

Even when seen only in vintage photographs, the Barcelona Pavilion fills
viewers with the sense of well-being that occurs when something has such
perfect grace that its ambient rightness enters us. The rich quietude, the
clarity without pomp, directly affect our breathing. A sculpture of a female
nude by Georg Kolbe, rising gracefully from a shallow pool in front, adds
both the perfect humanistic touch and a welcome resting point for the eye
amid all the reflections in glass and chrome. Refined to the nth degree yet

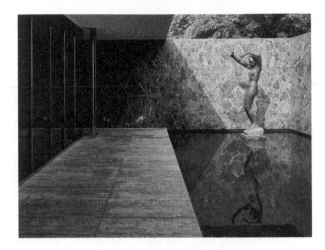

Mies used light as an element at the Barcelona Pavilion; shadows and reflections played a major role in the visitor's experience. With the Kolbe sculpture installed near the entrance, the structure also had a completely human element along with its machined perfection.

totally robust, this new form of beauty that Mies invented induces true tranquillity at the same time that it energizes us.

IT WAS FOR the flowing reception space in the Barcelona Pavilion that Mies designed the lounge chairs and accompanying ottomans that today proliferate worldwide. The capacious seats now exist in reproductions that range from costly authorized renditions of the originals to poorly made rip-offs, and they are seen in building lobbies, offices, and private residences over much of the globe. They became known quickly, and whereas most of the designs of the Bauhaus furniture workshop were seen by, at best, a dozen people, what Mies made for a large public exhibition in Barcelona received international publicity right away. That success was proof to people at the Bauhaus that the larger world was ready for modernism.

Yet even as the streamlined form of Mies's elegant Barcelona chairs was admired at the Bauhaus and fulfilled the goals of being ornament-free and using current technology, these pieces of furniture did not represent the values of every Bauhausler. Anni Albers summed up the problem in a word when she said, grimacing, that Mies furniture was "fancy." The leather and chrome were too much the materials of her uncle's Hispano-Suiza, and there was the problem of weight. Mies's chairs were very heavy. This meant that they were awkward to move and costly to ship, which was contrary to the ideals of a lot of Bauhaus design. They were also expensive. And, beyond all that, they were built for royalty, not for the population at large.

The Barcelona chairs were meant to serve as thrones for King Alfonso XIII and Queen Victoria Eugenie when the pavilion opened. As such, they put an ancient idea, laden with tradition, into a totally new form. They may have been intended for monarchical ceremonials, but they threw away every notion of ornament. Where once there might have been brocade or damask, now there was white leather, quilted to hold its position; because of its whiteness, the leather seemed to be more pure and less animal-like than it would have in its natural color. Where the support structure might previously have been laden with carving and gilded to excess, now it was lean and refined, dependent on the tensile strength of metal and the reflective qualities of chrome, formed impeccably into graceful, sloping X's.

But for all those breakthroughs, this furniture was not meant for the people of every societal rank who were the Bauhaus's intended clients. The other drawback of the chairs was one they shared with their designer: they presented themselves with great finesse, but had a certain coldness.

Nonetheless, when he became director of the Bauhaus the year after many of its luminaries visited Barcelona to study his work, Mies would give the school a much-needed stability in dire circumstances. Behind his façade, there was considerable humanity, and the strength to uphold important values.

7

Ludwig Mies van der Rohe had been offered the directorship of the Bauhaus when Gropius resigned in the spring of 1928. It was only after Mies declined the invitation to go to Dessau that Gropius replaced himself with Hannes Meyer.

Meyer's directorship wreaked havoc on the school. Moholy-Nagy, Marcel Breuer, and Herbert Bayer all quickly resigned in frustration with this man who opposed individual experimentation in deference to his Marxist agenda. Meyer's main interest was functional architecture achieved by group consensus. In 1929, Schlemmer also quit the faculty, and while Albers, Kandinsky, and Klee stayed on, they all felt that the art they most cared about, painting, was becoming less and less significant at the Bauhaus.

In the summer of 1930, the City Council of Dessau notified Meyer that they were terminating his contract. According to the court proceedings, the reason was the city administration's "concern for a situation brought on by the abuse of the intellectually political aims of Mr. Meyer for party-political agitation, which would have endangered the continued existence of the

Bauhaus." Meyer graciously submitted his resignation prior to the end of the period for which he was contractually allowed to remain, so that Mayor Hesse could appoint his successor, but he published an open letter to Hesse that appeared in the Berlin magazine *Das Tagebuch,* where he wrote:

> Herr Oberbürgmeister! You are attempting to rid the Bauhaus, so heavily infected by me, of the spirit of Marxism. Morality, property, manners, and order are now to return once more hand in hand with the Muses. As my successor you have had Mies van der Rohe prescribed for you and not—according to the statutes—on the advice of the Masters. My colleague, poor fellow, is now expected to take his pickax and demolish my work. . . . It looks as if this atrocious materialism is to be fought with the sharpest weapons and hence the very life to be beaten out of the innocently white Bauhaus box. . . . I see through it all."[17]

When Mayor Hesse approached Mies, he was intentionally choosing a Bauhaus director who had the strength of character to cope with the maelstrom. Aligned with no political party and focused on abstract design, coming from the outside, used to holding his ground in taxing conditions, Mies was the best possible choice.

Mies's achievement in Barcelona had already made him well-known at the Bauhaus. I know that Anni and Josef Albers went to Barcelona on their trip to Biarritz and San Sebastian, and were deeply impressed. It seems likely that Klee and Bayer, with whom the Alberses met up in the Basque country, also detoured at the international exposition that summer; besides being of great interest, Barcelona was one of the places where they might have changed trains on their way to the Atlantic coast at the juncture of southern France and northern Spain. Even those Bauhaus masters and students who had not seen the actual building were enthralled by the newspaper and magazine photos. Mies was a regular visitor to Dessau; some of the masters knew him personally, and all were inspired by his work. Whatever Mies's drawbacks were, most of the students and faculty in Dessau were delighted when, following the troubled stewardship of Hannes Meyer, one of the most accomplished and widely recognized architects in the world took the helm of the school.

That its new director epitomized the acceptance of modernism in the halls of power could only help in the Bauhaus's perpetual struggle to garner government support and forge connections with industry. Those people who had flocked through the exhibition in Barcelona had, for the most part, responded favorably to Mies's elegant juxtaposition of sheer planes of marble and glass, and to his use of shimmering chrome. Mies's work might be more costly and blatantly luxurious than most Bauhaus design, but he knew

what it took to expand the audience for unadorned form and for technically advanced design.

Hesse was content to replace the Meyer regime with someone who not only functioned so effectively in the world but was the image of propriety and order. Occasionally Mies switched from a bowler to a homburg, and he could be a dandy, donning spats and a monocle, but, given the tense cross-currents of German society in 1930, it seemed better to have the face of the Bauhaus be a director who flaunted his elegance than one who was conspicuously left-wing.

LIKE MANY PROSPEROUS BERLINERS of the time, Mies had become overweight. This was true to such a degree that one Bauhaus student observed, "When you see from the distance two men approaching, and nearer to you there is only one man, you will be sure it is Mies."[18] The impression of his size was accentuated by his imposing personality.

But the man who was so large in physique and myth, and who had designed new thrones for the even larger king and queen of Spain, had other sides. Confident people did not find him intimidating, and he restored a degree of calm to the Bauhaus, to the extent possible given the political turmoil outside the school. In March 1932, well into Mies's reign, Josef Albers wrote his friends Franz and Friedel Perdekamp, "The new director, Mies van der Rohe, that is, he's been here almost two years, is a splendid chap. He has time, is not loud, and has made work the first principle again." Albers acknowledged, nonetheless, that the spirit of Weimar was gone. "However," he continued, "the pleasant neighborliness we had has disappeared, though that is not his fault."[19]

Albers greatly enjoyed the nightly walks he took with Mies and Kandinsky. He and Mies were just about the same age, and came from similar backgrounds and the same part of the world. The students and younger faculty, however, had a harder time with the new Bauhaus director. The cold eyes beneath the rigid brim of his bowler stared in a way that discomfited some. Mies's jaw, which seemed to be made of the same steel that supported his architecture, was locked in a set position; his conversational manner was fairly tense.

As for his family, by the time he was directing the Bauhaus, Mies visited his three daughters only once a year. In 1931, they and Ada relocated from the Bavarian Alps—she had completed her psychoanalysis—to Frankfurt. Even though the move put them nearer to Dessau, the physical proximity did not compensate for the father's increased emotional distance.

WHILE THE POLITICIANS and senior faculty were pleased, younger people were not. Shortly after Mies arrived, the students took over the school cafeteria to

show their discontent over Meyer's dismissal. They demanded that Mies, who was staying aloof in his office, meet with them. Mies's response was to have the Dessau police evict the students, after which the mayor closed the school and Mies took the further step of having the entire student body, not just the radicals, expelled.

The students all had to reapply to the Bauhaus, and agree to his new rules once they were readmitted. In the eyes of the administration, the draconian measures succeeded: all but twenty of the two hundred former pupils compliantly came on board. Nonetheless, the Bauhaus was clearly losing its utopian aura. This was when Paul Klee resigned.

Mies's work, however, had a favorable impact on those students and faculty who remained at the school. At this time he designed a house in Guben, a historic market town in what was then East Brandenburg and is today southwestern Poland, right at the German border. It showed a softer, immensely appealing side of his architecture. In a garden that is a precise composition of brick walkways and terraces framing the regularized verdure, Mies had incorporated the qualities of the Dutch painter Pieter de Hooch into modern architectural design. This house, for Erich Wolf, made clear the architect's eye for domestic scale. He manipulated the bricks with the care that would have been accorded them in a bourgeois courtyard, even as he organized them with the clean brush of modernism.

The more one looks at the Wolf house garden, the more one sees its benefits. The depths of the shallow steps invite slow entrances and exits: the modest low balconies prompt meditation. One feels a call for motion and also for full stops. Art is a Zen-like experience: serene and calm while remaining active, and deeply felt. Architecture here inspires slow and steady breathing in and breathing out, and invites the viewer to imbibe the light and shadows gradually. Where Mies has turned a course of bricks, he has done so with utmost precision and care; nothing is left to chance.

This poetry, and the opting for control as well as maximum avoidance of hazard and risk, was a significant issue for the Bauhauslers. Josef Albers, for example, despised a lot of what had occurred in the art of the time because of Marcel Duchamp's influence; he and most of his Bauhaus colleagues thought it was the artist's task to impose order, not to embrace disorder or chance. Yet they were not control freaks. They let the rain weather the bricks, and treated the movement of the leaves, even the occasional drip of paint, as valuable determinants of the end results. The true representatives of the Bauhaus ideals were master organizers, and they carefully orchestrated what they did, all the while remaining completely open to playfulness—to the pizzicato. Albers used to say that he worked and worked and worked on his color choices, then threw his hands up in the air and thanked

God; Mies's garden for the Wolfs has that same openness to events beyond human control.

While he was running the Bauhaus, Mies also made a number of plans for sunken courtyards. Intended only for moments of gentle socializing or repose, these were places without immense usefulness or practical function. The architect was deliberately reviving a tradition that has existed in various cultures, and that in China goes back to the Han dynasty (third century B.C. to the third century A.D.). His designs followed the idea of the Hu-t'ung Avenue houses in Beijing in which the courtyard, rather than being at the center of a residence, is closer to the street, from which it is separated by a wall that is a continuation of an external wall of the house.

There is a brazen honesty to this architecture in which the support structure, with its load-bearing elements, is distinct from the curtain walls. There is also a clear affection for nature in the way that inside and outside penetrate and the raw elements and shelter coexist in happy tandem. Everything is rendered beautiful, however, whether it serves to support the building or is an embellishment. Mies believed that nothing in life needed to be ugly to look at. This embodied the essential attitudes of the greatest of the Bauhauslers. Everything—a pair of socks, an extension cord—could exert its magic.

ONCE MIES WAS in Dessau, he and Lilly Reich lived together in an apartment, and she took the helm of the weaving workshop. Ludwig Hilbersheimer, second in command under Mies, also had a wife who was far away, while his mistress, Otti Berger, served as Reich's assistant. Reich and Mies were at the Bauhaus only three days a week; otherwise, they lived in Berlin, and he ruled in absentia. But he was having such an impact on world architecture, and was so effective in Dessau, that he was given the leeway.

Adding to Mies's luster in the world, the year he became the Bauhaus director he completed, for a sophisticated couple in Czechoslovakia, a sleek modern palace that redefined luxury. Like Le Corbusier in France, Mies was proving that opulence could not merely have a contemporary look, but could even suggest the future. This was a change from the usual practice of having mansions for the rich invoke the past. Most luxurious residences deliberately echoed Versailles and the *schloss* of the eighteenth century, or Tudor and Georgian country houses; the goal of their design was not so much aesthetic refinement as an implicit link to landed gentry and to a sense of entitlement and social superiority. Le Corbusier and Mies not only transformed the aesthetics with which privileged people would live; they invoked a radically different value system.

Like the Barcelona Pavilion, the house Mies designed for Fritz and Grete

Tugendhat on the outskirts of Brno gave unprecedented voice to the beauty of functional forms—undisguised radiator pipes, frankly welded joints—and evoked a richness in unadorned materials previously considered beyond the pale. This was the place for which Mies designed what would become the best-known coffee table of the twentieth century: a simple X-shaped base made from four bar angles and an unframed glass top.

Almost as familiar today is the dining room chair, known as the Brno chair, that Mies put into the house. At the Bauhaus, and to the audience that was growing for his work worldwide, Mies's name was identified with a philosophy of "less is more." It is impossible to imagine how a seat, chair back, and arms could be arranged more minimally or more eloquently then in the Brno chair.

PHILIP JOHNSON was a dinner guest at the Tugendhat house shortly after it was built. While not yet an architect, the American visitor was an unpaid director of the Department of Architecture and Design at the recently formed Museum of Modern Art and hence one of the key figures involved in disseminating information about the Bauhaus in America. Because people from all over the world went to New York City to discover what was happening in culture internationally, Johnson's admiration for the Bauhaus would have vital echoes. Describing the Tugendhat house, he praised "the exquisite perfection of details" and "a scrupulousness unparalleled in our day."[20]

The Tugendhat house was constructed at the edge of a fairy-tale landscape of crenellated castles perched on jagged mountains, and old churches that are all curve and fantasy. Its apparent severity was not unknown to the Bauhauslers; Gropius's villas, as well as a lot of other housing by the architects whose work was included at Weissenhof, were in the same vein. But it still presented a startling and powerful alternative to the Baroque and Jugendstil styles that dominated contemporary domestic architecture.

Fritz Tugendhat had grown up in houses where antimacassars were the order of the day, but Grete Tugendhat said her husband had "a horror of the doilies and knickknacks that overloaded every room" of his childhood homes. They both craved "clear and simple forms."[21] By picking Mies as their architect, not only did they get chairs of unadorned leather and steel, but the ornament in their house was nil, the sight lines uncluttered. The Tugendhats endorsed Mies's pioneering notions of beauty, reevaluating what was appropriate as a source of household materials and what it took to make a home elegant. The young Czech couple were delighted to inhabit a setting as efficient and unembellished as the latest manufacturing machine. At the same time, they created a residence for themselves and their children as refined, as poetic, as rich in certain elements, as the palaces of earlier eras.

THEIR HOUSE was a wedding present from Grete Tugendhat's father, among the richest men in Brno in the 1920s. He had given her the sloping site over-looking Brno, with a commanding view of cathedral steeples and the turrets of Spielberg castle. She had admired the open spaces, as well as the large glass doors that separated the living room from the garden, in the house of Edward Fuchs in Berlin, and had asked the name of the architect. Learning it was Mies van der Rohe, she arranged a meeting.

From the start, according to Grete Tugendhat, the Tugendhats knew they "were in the same room with an artist." Mies and the people in his Berlin office, from which he commuted to Dessau, had one radical idea after another, and the Tugendhats accepted them all. Years later, Mies would recall that the Tugendhats—Fritz more than Grete—gave him a hard time and initially resisted each new concept, but those reminiscences are considered largely inaccurate, intended mainly to enhance his own glory.

In keeping with the site, Mies put the top floor, which contained the bedrooms and nursery, at street level. The court in front of it leads to a wraparound balcony, which in turn connects on both ends with a terrace on the other side facing the view. Inside the entrance hall are steps that lead down to the lower level—a vast open space in which all that separates the living room, dining room, and library are two freestanding walls, one curved and one flat. These rooms, mostly sheathed in glass, open to the lawn and the city.

That large, continuous living/dining area, fifty by eighty feet, is punctu-ated by cross-shaped columns made by the joining of four L-beams encased in chrome. Similar to those Mies used in the Barcelona Pavilion, they help support the building. What gives the house its structure is also a source of beauty. Plainly visible horizontal slats are handsome evidence of one of the first air-conditioning systems in Europe, for which the air was initially blown from ice stored in the basement. Heat comes through straight-forward steel tubing. Modern technology is at the fore; the floor of the living/dining area is an expanse of white linoleum.

THERE WAS, however, no rule that everything had to be machine-made. The carpets, of natural wool, were woven by hand. Some of the materials are quite fine and exotic. The flat wall was tawny gold and white onyx from Algeria; draperies were Swedish linen and black and beige raw silk. White velvet and Macassar ebony were abundant. The cantilevered chairs had lean lines that reflected the latest engineering advances and eschewed all decora-tion, but their coverings were of the finest pigskin and cowhide.

For these details, the past tense applies, for while the house still stands, it has mostly been gutted. But when the Tugendhats moved in, just as Mies

became the director of the Bauhaus, the mix of natural abundance, human handwork, and modern technology was remarkable.

This respect for natural elements and the creation of exquisite and original objects, many of them one of a kind, was embraced at the Bauhaus. Even as Gropius had worked for the global spread of good design, artists like Klee, Kandinsky, and the Alberses were, first and foremost, in pursuit of sources of beauty and a feeling of wonder. Theory, concepts, and an aesthetic philosophy to be promulgated worldwide were less of an issue; a recapitulation of life's marvels was the primary focus. Mies was the right person to forge ahead with that agenda of celebration.

Beauty might come in an expensive package—the Alberses would, at the end of their lives, love the leather upholstery of their Mercedes-Benz 240 SL—or it could be free and easy to find, as in the seashells Klee collected, the beach pebbles Josef Albers admired, and the tree bark Anni Albers cherished as one of the finest designs she had ever seen. Or beauty could be the result of mechanical effectiveness, as with Kandinsky's beloved racing bicycle, which he was pleased to have Gabriele Münter return to him when he was in Dessau. It could be natural and readily accessible, like the trees Klee studied every day during his strolls in the parks of Weimar and Dessau, or exotic like the tropical fish Klee kept in his aquarium. It could be sensuous in its impact, as it was for Gropius from the moment he began to fall sway to the allure of women as a young man in Spain, and to develop a connoisseur's attraction to the opposite sex. Beauty might also be new and experimental, like Kandinsky's paintings and Stravinsky's music, or ancient and in a humble peasant style, like the folk art furniture Kandinsky adored.

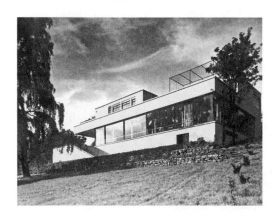

Ludwig Mies van der Rohe, Tugendhat house, 1928–30. The house Mies created for adventurous young patrons in the recently formed Czechoslovakia offered beautiful and unprecedented sights from every angle, inside and out.

As at the Tugendhat house, the only requisite for visible form was that it be wonderful.

IN BRNO, Mies personally designed every detail: the heating pipes, the drapery track holders, the door handles, the wooden-slatted venetian blinds, the lighting fixtures. For the living and dining areas, he built large glass walls overlooking the city; they could be electrically raised and lowered in increments, allowing them to disappear completely if so desired. He arranged the furniture meticulously. There was a black pearwood dining table supported by a single X-sectioned column. Without its leaf, it allowed intimate dining for the Tugendhats and their three children; with the leaf in, up to twenty-four people could be seated in those Brno chairs.

Brno had an ancient past, but in 1930 it was also a thriving modern city. The head of the Czechoslovakian republic then was Tomás Masaryk, whose broad cultural viewpoint was the reason Josef Albers had been summoned to speak at a conference in Prague. In 1918, Masaryk had been elected the first president of the recently formed republic. He had attended grammar school in Brno, where he earned money by tutoring the family of a police chief. Early on, Masaryk had advocated the eight-hour workday and education for women. Having led Czechoslovakia to liberation from the Habsburg monarchy, he condemned oppression in any form, opposed outmoded relics of the past, and was sympathetic to all new ways of thinking, including the most recent developments in art and architecture. The Tugendhat house was built in a hospitable environment.

But the world soon changed. In 1931, the German magazine *Die Form* declared the Tugendhat house unlivable, an ostentatious showpiece more than a home. The Tugendhats defended their choices in a subsequent issue of the magazine, saying that the spaces gave them a new freedom, and that even if it was impossible to rearrange the furniture or hang pictures in the main living area, the wood graining and marble patterns offered great aesthetic richness and diversity.

They made this statement in an article titled "Can One Live in the Tugendhat House?" The participants in the discussion, besides Franz and Grete Tugendhat, included Ludwig Hilbersheimer and several writers on architecture. One critic, Justus Bier, attacked the open plan of the house, saying that it made privacy impossible, and protested the bold wood grain and powerful stone pattern of the walls and floors, insisting that they not only made it impossible to hang art, but also caused the architect's presence to dominate that of the clients. Another critic, Roger Ginsburger, a Marxist, referred to "immoral luxury."[22]

Grete Tugendhat said the house provided "an important feeling of exis-

tence." The "large and austerely simple" rooms, she said, were "liberating" and had the effect of making one see "every flower in a different light" and causing people to "stand out more clearly against such a background."[23]

This was the unifying Bauhaus wish: to intensify seeing. Alertness mattered in multiple realms; it was vital to *see* the possibilities of color and line, of thread, of the working of the psyche, of the visual aspects of sound, or of the impact of design on our lives.

Grete Tugendhat also credited the house with rhythms that provided "a very particular tranquility."[24] Visual occurrences were the source of emotional well-being.

IT WOULD TAKE MORE than words, however, to defend the Tugendhats' way of life. What would happen in Brno, in the surprisingly near future, was to be the fate of so much of the physical legacy of the Bauhaus. The couple, who were Jewish, left Czechoslovakia in 1938, the year before the Third Reich entered. Soon thereafter, Albert Messerschmitt, the aircraft manufacturer, moved into the house. In 1944, as the Wehrmacht was falling apart on the eastern front, the Red Army took over. Mies van der Rohe's biographer Franz Schulze writes: "The Russians rode their horses up and down the travertine garden staircase and roasted oxen on a spit in front of the onyx wall."[25] The curved ebony dining room wall was destroyed.

In postwar Czechoslovakia, the house fell into further disrepair. When I visited about twenty years ago, when it was still a challenge just to get a visa to an eastern bloc country, Brno had generally deteriorated after decades of bureaucratic Communist rule. Grim apartment blocks proliferated alongside remnants of Baroque glory. Although a new spirit was in the air, the city looked down-at-the-heels, as did the house. Between 1952 and 1985, local authorities had restored Mies's masterpiece at a cost of six million crowns for the building and one million for the garden, but not all for the better.

The Tugendhats' family home had become a guest house for official visitors to Brno, and parts of it were open to the public for guided tours on Saturday and Sunday. The building still had some of its old power, but the differences from photographs of the house in its original state were shocking. Not a stick of the original furniture remained. Recent Czechoslovakian art in low-priced frames hung here and there, and televisions were everywhere. An antenna on the roof of the house did no kindness to Mies's pure and perfect form. A notice was taped to the curved entrance wall, now made of opaque plastic panels rather than the original milk glass, and leaks were visible in the ceiling. The only way to enter the garden was to jump the padlocked fence.

But it is no surprise that it was not possible, or desirable, for the Communist government to re-create the atmosphere of a private residence where seventeen servants once worked. Indeed, the idea of an onyx panel worth three million crowns is troublesome in a country where there has been such suffering. And even if it had not entirely honored the aesthetic of the Tugendhat house, the city of Brno had at least kept it alive. In spite of its deterioration, the onyx wall, and many other elements of the original house, made thrilling viewing.

Unable to reconstruct the floor-to-ceiling glass walls to their original appearance, the authorities in Brno had still managed to redo them with a seam, and they had the curved dining room wall rebuilt. The lawn needed seeding, and one longed for the garden on which Mies had carefully consulted, but at least the garden façade was intact and was still an exceptionally harmonic abstract composition. The intersection of machined planes at right angles — whether in outside details or in the travertine marble slabs over the radiators — remained a powerful form of modern beauty. The trees had grown higher than Mies might have wished, but visitors could still walk on a sweep of balcony and gaze at the castles and church towers.

I particularly relished the chance to sit on an extraordinary semicircular bench that typifies Mies's eye and his imagination with materials. The bench, which echoes the shape of the dining room wall, is made of wood on cinder blocks with backing of stovepipe. The materials are rough, but the form is gentle. At his best, Mies van der Rohe could be exceedingly generous in his understanding of the need for grace and pleasantness in everyday life.

Moreover, the chrome-plated X-columns were still sculptural and functional at the same time, noble yet lighthearted. And given that the Barcelona Pavilion no longer stands, except in a reproduction, they provide an opportunity to relish one of the pavilion's key features. Other original details — the wooden blinds, the frankly functional heating and air-conditioning systems — were also in evidence. And the onyx wall reflected and absorbed the setting sun with the bravura it had sixty years earlier. The travertine marble was still in the entrance hall. Few of Mies's lighting fixtures remained, but one of his designs for a ceiling lamp had been reproduced in a number of rooms. Throughout the house, the ebony was remarkable. The bedroom doors, each almost eleven and a half feet high, dazzled with both their warmth and their scale.

What a unique and salubrious house this once was. There was still an enclosed winter garden. The library needed additional restoration and the correct furnishings, but at least its dramatic shelving was unchanged, and I could glimpse an adjoining space that gave great insight into the Tugendhats' way of life: a small cubicle in which Fritz Tugendhat kept his business

papers. He felt that such papers were unattractive in a home and should be out of sight. A library was for loftier purposes, and children should not concern themselves with money matters.

That degree of cultivation, and deference to a seamless style of everyday living, reflected the attitude that made Mies van de Rohe's taste so ideal for his patrons. Refinement, dignity, and the mix of careful understatement with consummate luxury reached their apogee in the Tugendhat dwelling, where a young and forward-thinking couple gave an architect of such exceptional vision and courage the opportunity to have his full voice.

IN 1933, during a period when Mies was visiting the Gestapo headquarters in Berlin every other day in an effort to determine the fate of the Bauhaus, he was pleased that Kandinsky had raved to Galka Scheyer about the Tugendhat house to such an extent that he was asked to send photos of it to her in Hollywood, California. She, in turn, planned to show the images to an American collector, who presumably might want a similar dwelling.

Later in his life, however, Mies would not consider the Tugendhat house that important. In 1965, when the distinguished art critic Katharine Kuh interviewed him for the *Saturday Review* in his Chicago office, he remarked that "the Tugendhat House was considered outstanding, but I think only because it was the first modern house to use rich materials, to have great elegance. . . . I personally don't consider the Tugendhat House more important than other works that I designed considerably earlier."[26]

This was part of his attempt to rewrite history, to suggest that he had been a breakthrough modernist in the early 1920s, when in truth he was still designing relatively traditional houses for his clients at that time. The word "considerably" was part of a deliberate effort to put himself at the forefront. He shared with many other architects the wish to say "I did it first." In fact, it took some of the inroads made thanks to the Bauhaus, and the acceptance accorded the pioneering villas constructed by Le Corbusier well in advance of Mies actually building (as opposed to just designing) truly modern structures, before Mies could do anything as bold as the Tugendhat house.

Nonetheless, this confident, optimistic, rhythmic assemblage of concrete, glass, and steel was a masterpiece of visual effects and rhythmic and textural richness. That Mies got to certain things a few years after other people, and even as the great era of modernism in Germany was already coming to an end, is important to our understanding of architectural history, but the quality of his achievement is unique. The timing of his stint at the Bauhaus, similarly, made him someone who furthered something that others had developed rather than that he initiated, but he did so with verve.

8

As a teacher at the Dessau Bauhaus, Mies worked only with advanced students. He started them out with the seemingly simple task of designing "a single-bedroom house facing a walled garden."[27] Then he had them try to perfect their schemes, repeatedly telling them to go back to their drawing boards to improve their work.

This class for half a dozen students was the first teaching Mies had done anywhere. He was far from gentle. Two of the students, Hermann Blomeier and Willi Heyerhoff, who had attended architecture school together in Holzminder, where both had been highly successful, showed Mies some plans they had made there. Howard Dearstyne, another of the group of six, reported that "Mies rode roughshod over them, marking them up with a black pencil to indicate how they should have been done."[28] The two students were so upset that they did not return to the class for a month.

Mies's general response to whatever the students did was "try it again."[29] He spoke in a quiet voice, but he was emphatic. On that first simple project, he had the future architects work and rework the details for months before allowing them to proceed to the larger structure they were dreaming of.

Mies articulated his own goals as an educator. "You can teach students how to work; you can teach them technique—how to use reason; you can even give them a sense of proportions—of order." That teaching, he believed, would enable the student "to reach their potential, and this differs, of course, for each student." On this last point he was adamant: "But the different potentials are not the teacher's problem. . . . Some students you simply cannot teach."[30] He did not care about people as much as about architecture; he had decided that only a few good students were needed to make good architecture everywhere, and therefore his only concern was to develop the most gifted pupils.

"I thought a lot and I controlled my thoughts in my work—and I controlled my work through my thoughts," he declared of his own approach.[31] This gave him license to speak as little as he wanted. One of his former students said that when one asked Mies a question, "he simply would not respond. If you pressed him he was likely to get quite ill-tempered about it. . . . I'm not talking about questions that were asked spitefully, but serious questions. He simply would brush them aside."[32]

That same abruptness came through in an interview Mies granted late in

his life to six college students. "Some people think our problem is the human situation today, but that is a general problem. That is not an architectural problem." Mies was deliberately taking a stand opposite to that of Le Corbusier, with whom he felt a rivalry, and who maintained that architecture was "in the service of mankind." Crusty to the point of nastiness, Mies was emphatic about his belief that rationalism and intelligence could be applied to all problems, and were more important than personal responses. He amplified on the idea that "the human situation" was not the concern of architecture: "You can prove something logical by reason. You cannot prove feelings. Everyone has emotions and this is the hell of our time. Everyone says they have a right to their opinion, but they really only have the right to express their opinion."[33]

He believed he could construct every element not just of his buildings but of his personal existence with rigor and perpetual fine-tuning. What was vital was to take time and think things through, rather than to rush or to succumb to emotions. He told the six students, "I had 3,000 books in Germany. I spent a fortune to buy these books and I spent a fortune to read them, to study them. I brought 300 books with me to America and I can now send 270 books back and I would lose nothing. But I would not have these 30 left if I would not have read the 3,000."[34]

That emphasis on reason went hand in hand with his belief in aesthetic judgment; Mies had strict criteria for appearance in which there were definite standards for beauty. He said to one of his first students, "Come now, Selman, if you meet twin sisters who are equally healthy, intelligent, and wealthy and both can bear children, but one is ugly, the other beautiful, which one would you marry?"[35]

It was because of his unwavering conviction about what looked good and what did not that Mies lambasted Gropius's architectural work in front of his students, and felt free to remark that the name "Bauhaus" was Gropius's greatest achievement. Movements, causes, and institutional loyalty were all secondary to quality; visual perfection was what counted. Mies wasn't one for teamwork. Once, in a conversation with Gropius in Chicago, long after the closing of the Bauhaus, when Gropius was extolling the merits of group efforts and collaborative architecture, Mies asked, "Gropius: If you decide to have a baby, do you call in the neighbors?"[36] Mies pushed his own art to its maximum; he expected nothing less from others. The only way to push ahead was in solitude.

ON DECEMBER 20, 1931, Dearstyne, who was American and had attended Columbia University before going to the Bauhaus, wrote home to his parents from Dessau:

One of the uncomfortable sides of associating with an architect of the first rank is that he ruins your taste for about all but one-half of one percent of all other architecture that's being done the world over. Mies van der Rohe not only comes down hard on the American architects (for which he has, without a shadow of a doubt, the most perfect justification) but holds that one doesn't need the fingers of one hand to count the German architects who are doing good work. . . . It's much easier to work under less critical men and content yourself with middle-rate work. That's what I was doing at Columbia and what most of the students in America (and here) are doing. But I thank my stars I landed where I did.[37]

Josef Albers, Ludwig Mies van der Rohe, *ca. 1930. Albers, who described Mies as "a great guy," hoped that as director of the Bauhaus the elegant architect would be able to save the school, in spite of opposition from within and without.*

That emphasis on perfection is one of the contradictions of the Bauhaus. A dozen years earlier, Gropius had founded a school where the primary goal was to improve design for the masses. But the greatest of the faculty he attracted to Weimar and Dessau believed mainly in their own work, and in the development of artistic excellence and consciousness of true quality, more than the issue of audience. It was the nurturing of the design and the making of the paintings that mattered more than the promulgation of the idea. They would be delighted if quality became widespread, and if what was good and true made an impact on the lives of viewers and users, but they knew they could not change the way the masses responded to art and design. What they could do was develop and support the vision of a very small number of gifted people. They readily excluded second-rate practitioners.

Mies believed in Albers and Klee and Kandinsky, but not in the second tier of painters. Albers didn't believe in Mies, or Gropius, or Breuer, as architects. Kandinsky admired Klee; Klee mainly admired the artists of ancient Egypt and the chefs who had created a perfect "spaghetti a la sugo." Anni Albers mostly liked the work of Klee and Coco Chanel. They all abhorred the idea of blind enthusiasm for "the arts" without quality judgment, and loathed a blanket fondness for the idea of creativity as promul-

gated by well-intentioned but undiscerning "culture" lovers. They preferred the contents of good hardware stores to what was found at craft fairs, and would rather watch sports well played than see a sloppy dance performance.

The idea that just being in a "creative" field conferred some sort of distinction was anathema to the true Bauhauslers. They had the highest standards for excellence and were the most discerning of connoisseurs. They were, in short, aesthetic snobs.

9

With his reverence for greatness, Mies embodied the attitude to the past as it was endorsed by most of the leading Bauhauslers. When he had a supporting column stand on the outside of a building, he was proud to have adhered to one of the primary principles of Gothic construction. When he put the column under the roof slab, he was aware that he had followed a norm of the Renaissance. His interest in monumentality, derived from the great Romanesque structures in his native Aachen, had been reinforced by his exposure to the architecture of Schinkel in Berlin; he acknowledged the influence openly. He gladly credited his more immediate predecessors as well as the historical ones. Mies let the students know, for example, how much he admired Berlage, the architect he had recommended to Helene Kröller-Müller, even if he then became furiously competitive when Herr Müller opted for Berlage's design over his own. Mies said of Berlage's De Beurs building in Amsterdam, "The idea of clear construction came to me there, as one of the fundamentals we should accept. We can talk about that easily, but to do it is not easy."[38]

Like so many of his Bauhaus colleagues, Mies was greatly excited by number systems—in art and architecture as in nature. This is another reason that Charlemagne's chapel at Aachen, the building that had been his introduction to the emotional power of visible form, remained a point of reference throughout his life. The thirty-three-meter-high chapel was an octagon, encased by a sixteen-sided polygon. The building is based on a single unit of measurement that was carefully doubled or halved throughout.

When Albrecht Dürer visited Aachen, he recognized the ways in which the chapel exemplified the architectural principles elucidated by Vitruvius in the Roman era and that subsequently had such influence on Leon Battista Alberti and Andrea Palladio in the Renaissance. Vitruvius believed that the requisites of a good building were functionalism, firmness, and an ability to

bring a sense of pleasure. This came not just from qualities of measure and proportion, but also from the choice of materials. Odo of Metz, the architect who began work on the chapel in Aachen in 792, had demanded the demolition of Roman ruins to acquire just the right stone, and had scavenged fine materials at various locations to enrich the chapel. As a young boy, Ludwig Mies had feasted his eyes on its rich mosaics, marble columns, and bronze parapets.

With the Barcelona Pavilion, the minutest measurements and the deployment of beautiful materials were pivotal. The shallow reflecting pool gains its breathtaking beauty because of the thickness and extension of the overhang that surrounds it. We feel a Beethovenesque perfection here: were those slabs of travertine a centimeter thicker or thinner, we would not be nearly as moved. And the deep gray travertine, one of nature's most marvelous stones with its ever-changing network of veins, is like the sound of a Stradivarius perfectly bowed: a splendid object deftly employed.

BUT MIES'S DETAILS were pricey, and not everyone had the fortunes of the Spanish government or of Grete Tugendhat's parents. Shortly after he became director of the Bauhaus, Mies designed a house for the painter Emil Nolde. It did not get built because it was too expensive, and Mies was unwilling to make the changes that might have made it work with Nolde's budget.

He then designed an apartment in New York for his admirer and champion Philip Johnson. In this case, the client had the money. Not only was Johnson, a rich young man whose father had bequeathed him a lot of stock in the Aluminum Company of America (Alcoa), able to serve in his position at the recently founded Museum of Modern Art without a salary, but he could afford the bachelor digs of a prince. When Johnson was touring Europe to study modern architecture in the summer of 1930, he called on Mies in Berlin and commissioned the apartment. They discussed the project while the young American millionaire drove Mies around in his Cord, one of the fanciest automobiles of the era, and over lavish meals with fine wines in the city's most expensive restaurants.

Johnson complained that Mies put as much work into the apartment "as if it were six skyscrapers."[39] Nevertheless, he was proud of the apartment that resulted. The Bauhaus director, in his first project in America, had created, in a building at 424 East Fifty-second Street, just around the corner from New York's elegant Sutton Place, a space with spare and elegant lines and an assertively modern atmosphere. Lilly Reich executed it, and she, like Johnson, delighted in the effrontery to the other inhabitants in the building who could not imagine living with anything other than flower-patterned chintz and Chippendale-style armchairs. Reich installed Mies's Barcelona

chairs—it was the American debut of this three-year-old design—as well as solid, raw silk curtains and Chinese floor matting. Johnson enjoyed embracing a style that shocked his Harvard classmates and the other wealthy people in his circle. It wasn't just that he liked Mies van der Rohe's aesthetics; what appealed to him above all was the feeling that adhering to them made him different, and better, than other people.

I talked with Philip Johnson quite a lot about this project a number of years ago. Johnson was in his office in the Seagram Building, Mies's greatest New York project, and one for which Johnson had found Mies the client and on which Johnson had worked.

Johnson, impeccably dressed as always in a Savile Row suit that honored every dimension of his lean body, sneered when he told me that the apartment had "a lamp which was as bad as any lighting fixture you could imagine. It threw a miserable cold light, but Mies only cared about it as an object."[40]

Philip Johnson delighted in denigrating his former hero. For many years after that initial collaboration, Johnson imitated Mies shamelessly in his own work, borrowing the master's overall forms as well as his choices of Macassar ebony and travertine marble, putting Mies's furniture into almost all of his own architectural projects. But he came to dislike Mies, and while Johnson made an art of accommodating his clients, of befriending them and making them feel that his architecture served their needs, he was intent that I see Mies's selfishness and coldness.

IN RESEARCHING THIS BOOK, I acquired new perspective on Johnson's antipathy. The apartment on East Fifty-second Street, I learned from letters that passed between Johnson and Mies, had caused the first of many disputes between them. In 1934, Mies was "provoked" (Johnson's word) that Johnson had apparently copied Mies's furniture "without proper credit." Johnson blamed the misunderstanding on *House & Garden* magazine; he told Mies that the magazine, which featured the apartment, had failed to use information Johnson had provided that named Mies as the designer of furniture Johnson had had made for the apartment. Johnson went on the defensive. Referring to an apartment he, Johnson, had designed for his friend Edward M. M. Warburg—the same person who had gone to the Bauhaus to buy work by Klee and who had funded the Alberses' steamship tickets to America—he wrote Mies, "I have in no way, by intention or deed, done anything to take credit for your designs. I have used, it is true, the drawings which you sold me to make furniture for my own apartment and for Mr. Warburg. Everyone has been fully aware, so far as I knew, that the designs are yours"[41]

Johnson went on to tell Mies that he was including in a show at the Modern one of Mies's Brno chairs, "which I'm proud to attribute to you."

From there, the Alcoa heir turned positively obsequious, while also self-aggrandizing, in what he wrote to Mies. He seemed to fear and admire the Bauhaus's last director in equal measure. Johnson wrote, "I am not sure to what extent you realize how well-known you have become in the United States and in what great honor all modern architects hold you and your work, nor do I believe I am immodest in saying this is in a great measure due to my efforts on your behalf through exhibitions, articles and lectures. May I congratulate you on the magnificent installation of the Exhibition in Berlin this summer, and assure you once more of my never diminishing respect for you and your work."[42]

MIES WROTE JOHNSON back promptly. The post took about two weeks by ship, and the architect, in Berlin, answered his worshipper's entreaty shortly after receiving it:

Dear Johnson,
Thank you for your letter of 2nd November of this year. I gather that you are considering an exhibition of works by my former pupils. I am not sure exactly who you are thinking of. It is out of the question to regard somebody as my pupil who only worked with me for a short time at the Bauhaus. So if you really do intend to follow through with this idea I must ask you to send me precise details of your plans. I take my work and the modern architecture movement far too seriously to accept responsibility for events or works with which I am not familiar; all the more so as recently there have come to my attention more and more American claims that the modern architecture movement is just a fad. That is very dangerous and gives us all the more reason to consider future public appearances very carefully and apply the strictest standards. I am happy that all is well with you and remain
With best wishes, Yours[43]

Philip Johnson responded immediately, in a huff:

My dear Mies van der Rohe,
Thank you for your letter of November 23.
I must say that I am surprised at the tone of your letter.
You know from my writings I have always had the highest respect for you and for the purity of the architecture for which you stand. I am not at all interested in modes or fashions in various kinds of modern.
I am leaving the Museum of Modern Art and the world of architecture in New York and so will have no opportunity to carry out my plan of showing the work of your students. The Museum of Modern Art

will have no more architectural exhibitions so you need fear no further publicity in America.

Yours very sincerely.[44]

Johnson's prediction, or threat, did not prove true. After World War II, not only would Mies van der Rohe live and build in America, but he would count Philip Johnson among his greatest supporters.

IN 1986, AT A SYMPOSIUM at the Museum of Modern Art in honor of the hundredth anniversary of Mies's birth, Philip Johnson would proclaim to the large and attentive audience, "No other architect in history has ever produced so much original work in such a few years." He credited Mies with having "invented the international style with the office building"; and he said that the brick and concrete country houses and the curved skyscraper were all without equal.[45] This was consistent with the views of Mies's grandson, Dirk Lohan, who said that in the late twenties Mies was at his creative apogee. Lohan told the audience that after the Nazis rose to power, Mies was out of work; he mainly read and lived off royalties from his furniture designs. And while he produced some exquisite buildings after he went to the United States in 1938, when he was fifty-two, nothing was ever again as purely inventive as what he had done when the Bauhaus flourished.

Philip Johnson's encomium for Mies's work at the centenary symposium did not result from an improvement in their relationship. Their last encounter had been at Johnson's Glass House in New Canaan, Connecticut, a building that made unquestionable reference to Mies's work in a myriad of ways. On that occasion, Johnson asked Mies what he thought of Berlage. "He got up and walked out," Johnson recounted at the symposium. It was about 11 p.m., and Johnson had to phone friends to come pick Mies up outside the house so he could spend the night with them, since he refused to return to Johnson's, which is where he was meant to stay. As Johnson told his startled listeners, "You don't use the word truth around Mies because he had his own idea of what it was. . . . He broke any of his rules anytime he wanted to. But woe be to you if you broke them or if he didn't like the way you broke them."[46]

10

When he was sixty-two years old, Ludwig Mies van der Rohe told a small group of design students about his experience at the Bauhaus. Al-

though it was an informal talk rather than a lecture, it was recorded and transcribed:

I became director of the Bauhaus only because Gropius came one morning with the Mayor of Dessau and told me: "the school will break to pieces if you don't take it." He said that if I would take it over it would go ahead. And later in 1932, the Nazis came. Nobody's position was strong enough for that. In 1933 I closed the Bauhaus. Maybe that is interesting to you.

You know the rise of the Nazi movement was not so sudden. It began at Dessau. That was the first state that became by election Nazi. After the Nazis came to power, the mayor told me they wanted to see what the Bauhaus was doing and so on. They wanted an exhibition for criticism, and he said, "I know you would like a vacation for two weeks. I am delighted to give you a vacation," and I said, "No. I'd like to stay here. I'd like to see these people." And I did.

Then they came. It was a long talk. There was one man; his name was Schulz-Naumburg, and he wrote early, you know, about 1900, works on cultural tendencies in general, about old buildings and about the factories ruining the country—sentimental, aesthetic, typical of the misunderstanding of his day. [Mies was referring to the series of books called *Deutsche Kulturarbeiten.*] He wanted to change. He wanted to save wonderful towns. You cannot save wonderful towns. You can only save wonderful towns by building new ones.

That's all you can do. He was a man in the Nazi movement, very old with a gold medal. [Here Mies was referring to the Nazis' gold party badge.] There were only about ninety that had these gold medals. He was one of these men. And he came, and we gave an exhibition at the Bauhaus. I tried everything, to keep that in order. And we made a wonderful exhibition, and I had a heck of a time you know, with Kandinsky. Kandinsky had his constructions of old pictures, these geometric analyses. I said, "Do we have to show these?" And he had a fit. So I said, "Keep it." And we put it on the table that was in the center of a huge room. Everything was around and this analysis was on the table. When these people came we had a talk, and then I showed them what we were doing. I moved them, you know, around the walls. They never saw the table.

It was then I knew it was absolutely hopeless. It was a political movement. It has nothing to do with reality and nothing to do with art. I had nothing to lose, nothing to win, you know. I didn't want to win. But now we talk about what really happened in the end.

The city of Dessau decided to close the Bauhaus. They stopped us

and they said, "You have to go." The mayor, who loved the Bauhaus and wanted to help us, said, "Take all the machinery, all the weaving looms, and just leave."

So I rented a factory in Berlin. I did that on my own. It cost me 27,000 marks for three years. It cost 9,000 marks a year. That was a lot of money in Germany, nothing in America. So I rented this factory that was terrible, black. We started to work—all of us—every student. Many Americans who were with us will remember that we cleaned it all up and painted everything white. This was a solid, simple factory painted clean, wonderful, you know. And just on the outside, on the street, there was a broken down wooden fence, closed. You couldn't see the building. And I can assure you there were a lot of people when they came there and they saw this fence and went home. But the good ones, they came through and stayed. They didn't care about the fence. We had a wonderful group of students.

One morning, I had to come from Berlin in the streetcar and walk a little, and I had to pass over the bridge from which you could see our building, I nearly died. It was so wrong. Our wonderful building was surrounded by Gestapo—black uniforms, with bayonets. It was really surrounded. I ran to be there. And a sentry said, "Stop here." I said, "What? This is my factory. I rented it. I have the right to see it."

"You are the owner? Come in. Come in." He knew I never would come out if they didn't want me to. Then I went and talked to the officer. I said, "I am the director of this school," and he said, "Oh, come in," and we talked some more and he said, "You know there was an affair against the mayor of Dessau and we are just investigating the documents of the founding of the Bauhaus." I said, "Come in." I called all the people and said, "Open everything for inspection, open everything." I was certain there was nothing there that could be misinterpreted.

The investigation took hours. In the end the Gestapo became so tired and hungry that they called their headquarters and said, "What should we do? Should we work here forever? We are hungry and so on." And they were told, "Lock it and forget it."

Then I called up Alfred Rosenberg. He was the party philosopher of the Nazi culture, and he was the head of the movement. It was called Bund Deutsche Culture. I called him up and said, "I want to talk with you." He said, "I am very busy."

"I understand that, but even so, at any time you tell me I will be there."

"Could you be here at eleven o'clock tonight?"

"Certainly."

My friends, Hilberseimer and Lilly Reich and some other people said, "You will not be so stupid as to go there at eleven o'clock?" They were afraid, you know, that they would just kill me or do something. "I am not afraid. I have nothing. I'd like to talk with this man."

So I went that night and we really talked, you know, for an hour. And my friends Hilberseimer and Lilly Reich were sitting across the street in a café window so they could see when I came out, if alone, or under guards, or what.

I told Rosenberg the Gestapo had closed the Bauhaus and I wanted to have it open again. I said, "You know, the Bauhaus has a certain idea and I think that it is important. It has nothing to do with politics or anything. It has something to do with technology." And then, for the first time he told me about himself. He said, "I am a trained architect from the Baltic States, from Riga." He had a diploma as an architect from Riga. I said, "Then we certainly will understand each other." And he said, "Never! What do you expect me to do? You know the Bauhaus is supported by forces that are fighting our forces. It is only one army against another, only in the spiritual field." And I said, "No, I really don't think it is like that." And he said, "Why didn't you change the name, for heaven's sake, when you moved the Bauhaus from Dessau to Berlin?" I said, "Don't you think the Bauhaus is a wonderful name? You cannot find a better one." He said, "I don't like what the Bauhaus is doing. I hope you can suspend, you can cantilever something, but my feeling demands a support." I said, "Even if it is cantilevered?" And he said, "Yes." He wanted to know, "What is it you want to do at the Bauhaus?" I said, "Listen, you are sitting here in an important position. And look at your writing table, this shabby writing table. Do you like it? I would throw it out of the window. That is what we want to do. We want to have good objects that we have not to throw out of the window." And he said, "I will see what I can do for you." I said, "Don't wait too long."

Then from there on I went every second day for three months to the headquarters of the Gestapo. I had the feeling I had the right. That was my school. It was a private school. I signed the contract. It was 27,000 marks—a lot of money. And when they closed it I said, "I will not give up that thing." And it took me three months, exactly three months, to get to the head of the Gestapo. He must have had a back-door somewhere, you know. And he had a bench in the waiting room not wider than four inches, to make you tired so that you would go home again. But one day I got him. He was young, very young, about your age, and he said, "Come in. What do you want?" I said, "I would like to talk to you about the Bauhaus. What is going on? You have

closed the Bauhaus. It is a private property, and I want to know for what reason. We didn't steal anything. We didn't make a revolution. I'd like to know how can that be."

"Oh," he said, "I know you perfectly, and I am very interested in the movement, the Bauhaus movement, and so on, but we don't know what is with Kandinsky." I said, "I make all the guarantees about Kandinsky." He said, "You have to, but be careful. We don't know anything about him, but if you want to have him it is O.K. with us. But if something happens, we pick up you." He was very clear about that. I said, "That is all right. Do that." And then he said, "I will talk with Goering, because I am really interested in this school." And I really believe he was. He was a young man, about your age.

This was before Hitler made a clear statement. Hitler made this statement in 1933 at the opening of the House Der Deutschen Kunst, the House of German Art, in his speech about the culture policy of the Nazi movement. Before, everybody had an idea. Goebbels had an idea; Goering had an idea. You know, nothing was clear. After Hitler's speech the Bauhaus was out. But the head of the Gestapo told me he would talk with Goering about it and I told him, "Do it soon." We were just living from the money we still got from Dessau. Nothing else came to us.

Finally I got a letter saying we could open the Bauhaus again. When I got this letter I called Lilly Reich. I said, "I got a letter. We can open the school again. Order champagne." She said, "What for? We don't have money." I said, "Order champagne." I called the faculty together. Albers, Kandinsky . . . they were still around us, you know, and some other people: Hilberseimer, Peterhans, and I said, "Here is the letter from the Gestapo that we can open the Bauhaus again." They said, "That is wonderful." I said, "Now I went there for three months every second day just to get this letter. I was anxious to get this letter. I wanted to have the permission to go ahead. And now I make a proposition, and I hope you will agree with me. I will write them a letter back: 'Thank you very much for the permission to open the school again, but the faculty has decided to close it!' "

I had worked on it for this moment. It was the reason I ordered champagne. Everybody accepted it, was delighted. Then we stopped.

That is the real end of the Bauhaus. Nobody else knows it, you know. We know it. Albers knows it. He was there. But the talk about it is absolute nonsense. They don't know. I know.[47]

The Bauhaus Lives

1

I was with Anni Albers in September 1980 when she received a phone call saying that Nina Kandinsky had just been murdered.

The person on the other end of the line was Tut Schlemmer. All three of these women—Nina, Tut, and Anni—were now widows. Anni had had nothing to do with Nina since Kandinsky's death; there was no feud, but she and Josef felt no real connection with her. A letter they had received from the Kandinskys in 1935 summed up the problem. Wassily had complained for fourteen handwritten pages about the hardships of making his way in Paris: "Neither the public at large nor the beautiful people show the least interest in art."[1] At the bottom, Nina had scrawled an ecstatic addendum. At a ball given by a Russian grand duke, she had worn a magnificent gold lamé gown and danced a Viennese waltz with a prince: "I would have loved, dear Albers, to have danced with you."[2]

Anni had often cited that letter as an example of who Nina really was. Regardless, the news of Nina's violent death flabbergasted her.

TUT EXPLAINED to Anni that she had gone to Nina's villa in Gstaad, the Esmeralda, for a dinner date, and that no one had answered the door. She rang and knocked for nearly five solid minutes. Finally, she went to the nearest telephone and summoned the police. When they broke in, they discovered that Nina had been strangled.

Tut, who had been in Nina's chalet a number of times, was pretty certain that none of Kandinsky's paintings were missing. Everything was where it

was supposed to be. And she knew that Nina kept most of her jewelry in the bank vault. But eventually it was discovered that Nina's latest diamond necklace, valued at almost a million dollars at the time, was gone, as were some other items.

Anni, who favored Mexican clay beads, was fascinated with Nina's taste in jewelry. A couple of years earlier, a curator from the Guggenheim Museum had described Nina at the Carlyle Hotel getting ready to go to the opening of a Kandinsky show. Anni, remembering how broke most everyone in Weimar and Dessau was in the 1920s, and having personally considered the Bauhaus an escape from the ostentation that prevailed in the Berlin of her childhood, was intrigued as she heard about Kandinsky's widow going through a jewelry box that was like a treasure chest trying to decide whether to wear emeralds or diamonds or rubies around her neck that evening, and then addressing the question of which earrings to wear, and which bracelet and how many rings of precious stones. After Kandinsky's death, the price of just one of his paintings had skyrocketed to a higher value than all that the artist had earned during his lifetime. With her new fortune, Nina had become so well-known for her million-dollar jewelry habit that Van Cleef & Arpels and Cartier vied for her patronage.

When the Bauhaus was in Weimar and Dessau and Berlin, the main issue had been survival; Kandinsky had been excited when he could finally buy new shoes. And those conditions had been an improvement over the earlier period when the Kandinskys' toddler son died from malnutrition. No one could have imagined that there would someday be a group of Bauhaus widows who would be among the most powerful figures in a money-driven art world, or that Kandinsky's former housekeeper would be a millionaire. But all this *had* come to pass. After Kandinsky's death, the Paris-based art dealer Aime Maeght had "no problem worming his way into [Nina's] confidence" and had encouraged her to spend freely—to enjoy herself for a change. This was observed by the pithiest of commentators on the worldly side of artists, John Richardson, who wrote:

> The more she splurged, the more art she was obliged to sell, and the more Maeght profited. After all those years of hardship, why shouldn't she treat herself to a car and driver and clothes from Balenciaga? Since she was Russian, why shouldn't she play lady Bountiful with the vodka and caviar and wear a sable coat? And why, above all, shouldn't she indulge her as yet unindulged passion for jewelry? Rubies, sapphires, above all emeralds reminded her of Kandinsky's resplendent sense of color. . . . "Van Cleef & Arpels are my family," Nina would declare.[3]

Anni and Tut chatted briefly about their new lives as managers of important artists' estates. "We have something called 'a foundation,' " Anni explained, as they discussed the irony that, having once been nearly destitute, they now spent so much time with lawyers and accountants and tax experts trying to manage the good fortune that had come their way in recent years. She also told Tut about recent and upcoming exhibitions of Josef's and her work, although she was not boastful, and still acted as if the recognition that was Josef's due had not fully arrived.

She and Tut agreed to stay in closer touch, and Tut promised that if anything more was discovered about the circumstances of Nina's death, she would let Anni know.

THE MURDER OF EIGHTY-FOUR-YEAR-OLD Nina Kandinsky has never been solved. But I was with Anni a month or so after the call from Tut Schlemmer—who never phoned again, because there was nothing substantial to report—when she had a conversation about the crime that fascinated her. John Elderfield, who was then curator of drawings at the Museum of Modern Art in New York and was working with me on what was to be an interdepartmental Josef Albers retrospective there, had come to Connecticut so we could look at Josef's unknown work together. Anni, however, was not so interested in Josef's show as in what she might learn further about the strangling in Gstaad.

Elderfield, in his buttermilk voice and North-of-England accent, smiled mischievously and told her, "There's a rumor that Felix Klee did it."

"Nein!" Anni answered. But she was excited at the prospect, even as she and John Elderfield concurred that of course it was impossible.

FROM TIME TO TIME, Anni would mull over these events in her head. Could Felix have done it? Of course not, but there had been a lot of animosity when he remained in Germany after all the Bauhaus masters had left. Felix as a little boy had been so close to Kandinsky, even before Nina was on the scene, and then the two families had shared that house next door to the Alberses' on Burgkuhnauer Allee in Dessau; could there have been something that went on that no one knew about?

After the Bauhaus closed, the Alberses had grown apart from most of these people. They had exchanged warm letters with Klee, but he died before the war was over. Josef and Kandinsky had stayed in close touch throughout the 1930s—Albers had even tried to get him to Black Mountain, and Kandinsky had organized and written about a show of Josef's work in Milan in 1934—but Kandinsky, too, had died before there was any possibility of the Alberses visiting Europe again. They saw Mies a couple of

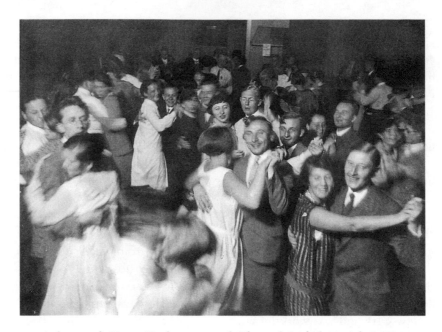

A dance at the Dessau Bauhaus ca. 1926. The couple in the lower right is Nina Kandinsky and Josef Albers. In 1935, when the Kandinskys were in exile in Paris and the Alberses were in the United States, Nina wrote, after a fancy dress ball, "I would have loved, dear Albers, to have danced with you."

times in Chicago, in spite of Josef's views of the cigars and gin fumes, but Mies was never someone to whom one could be close anyway. When he died in 1969, the Alberses were aware that there was no one to whom they could write a condolence note.

Gropius, who died the same year as Mies, was the only one with whom they maintained a professional connection. The Alberses had both worked with him in 1950 on the Harvard graduate center. Josef designed a brick fireplace for one of the public spaces there; it has a subtle abstract pattern made through the various angles at which white bricks were set in mortar. Anni created woven room dividers and bedspreads in bold abstract patterns— they bear a remarkable resemblance to what would become the trademark lining material of Burberry raincoats—that added considerable panache to the students' lives. Josef also made a mural in the early 1960s for the Pan Am Building; called *Manhattan,* it was installed over the escalators that took 25,000 people a day to and from Grand Central Terminal. It was based on one of his Bauhaus glass constructions, yet it conveyed the liveliness and energy he and Anni discerned in New York the moment they arrived there after leaving Nazi Germany.

Except for the time when Ise had embarrassed Anni about the pearls, the

Alberses had not seen the Gropiuses socially. And while Josef maintained a connection with Marcel Breuer, the friendship ended completely after a feud erupted because Josef felt that Breuer had taken one of his designs— for an abbey in Minnesota of which Breuer was architect—without giving him proper credit. Josef often broke off from people definitively, even as Anni tried to be the diplomat and work with mutual friends to achieve a rapprochement.

With their savior Philip Johnson, however, neither of the Alberses cared about maintaining the connection, even after Johnson gave Anni her exhibition at MoMA; they were too appalled by his betrayal of modernism and his embrace of historical forms. Equally important, the Alberses considered Johnson a socialite, not a dedicated artist of the sort they had known at the Bauhaus. He may have been the person who engineered their getting out of Germany at the best possible moment, but his affinity for rich and chic friends was more than they could tolerate. This was most apparent when he invited them to the Glass House in New Canaan for Sunday lunch and served them leftover meatloaf from a dinner party for "more important people" the night before: an offense they never forgave.

After Josef died, and when Anni was suffering too much from dementia to understand more than the simplest ideas, I had a moment with Philip that made it easy for me to understand the rift. Philip was graciously showing me his art collection, which was in storage in a gallery space on the grounds of the Glass House. First of all, the style of the building would have set Josef's hair on end. Then, when Philip was pointing out a large painting by Jasper Johns, I said to him, far more politely than Josef would have, that while I recognized that many people considered Johns a major artist and that the early painting Philip was showing me on a storage rack was of particular interest to people who prized his work, I simply did not like Johns's art. Philip smiled and quickly responded, "Oh, neither do I. It's just that Alfred told us we all had to buy them, and we did whatever Alfred recommended."

Philip looked very pleased as he said this. He took a cynical delight in pointing out that the reasons for which rich people acquired expensive art rarely had to do with their own taste. On another occasion, he was delighted to tell me that Eddie Warburg had bought an important 1905 Picasso portrait of a young boy because the youth was so good-looking: "We all had such a crush on that boy, Lincoln [Kirstein] and Eddie and I."

Philip Johnson's quips were antithetical to the Bauhaus spirit. People like the Alberses and Klee and Kandinsky never let anyone else dictate their taste; they held artistic quality to be the supreme issue. And for Josef Albers, the idea of Alfred Barr—Philip's "Alfred"—as the voice of authority was an impossibility. Josef told me that he felt that Barr had never forgiven him for being part of a group of artists who, in the mid-1930s, stood in front of the

Modern to protest its lack of attention to purely abstract artists. Josef was among the few people who questioned Barr's criteria for what great art was, and who was willing to say so. Philip, in letting himself be swayed—and, beyond that, in his Oscar Wilde–like embrace of his own fickleness—took pleasure in what he considered his moral corruption (his favorite line about himself as an architect was "I'm a whore"), while the Alberses, Kandinsky, Klee, Gropius, Mies, and a number of other people at the Bauhaus considered aesthetic standards inviolable.

EVEN THOUGH ANNI had not stayed in touch with Nina Kandinsky, she still thought of her as part of the extended family. Silly as Nina was, she had made it possible for a genius to live and to paint with far more ease and comfort than he would have known without her. And Nina belonged to the golden age. Anni was always fascinated to learn the latest gossip about this woman who had amused her and Josef and their more serious colleagues in Weimar and Dessau. Hearing about Nina was like reading a magazine at the hairdresser's. She was well aware of the contrast between Kandinsky's marriage and Josef's, and knew full well that, while Josef would not have married a coquette who knew little about art, he still had a hankering for some of Nina's frivolity.

Josef Albers and Nina and Wassily Kandinsky, ca. 1930–31. For all the seriousness of their devotion to making great art, the Bauhauslers also applied their imagination to having a good time.

Anni was intrigued when she learned that Van Cleef had made Nina a parure that consisted of a necklace with a 20-carat diamond pendant, a bracelet, earrings, and ring. It had different colored diamonds that resembled a variety of colored drinks: Remy Martin, chartreuse, Lillet, and Dubonnet among them. Nina was so scared of crime that she used a code number rather than her name in dealing with the jewelers, yet she was photographed wearing the parure when she was given a Legion d'Honneur by the French minister of culture, the same year that Josef died, and she had called her chalet Esmeralda after her favorite stone. Anni also enjoyed hearing about

Nina's flirting with young men, in part because she felt superior because she had Maximilian and therefore did not have to do the same.

Nina had written a gossipy memoir that no one bothered to read; Anni had been given a copy, but did not make it past the first page. The most entertaining detail, which in Anni's eyes summed up the whole silly undertaking, was that Nina had wanted to call it *I and Kandinsky* until Heinz Berggruen persuaded her to go with *Kandinsky and I*.

QUITE SOME TIME AFTER Tut Schlemmer's phone call and John Elderfield's visit, Anni was particularly interested by some details she learned about the connection between Felix Klee and Nina in the last days of Nina's life. Felix had dined with Nina on September 1, 1980, the night before she died, an occasion at which Tut Schlemmer was also present. There was so much borscht and beef Stroganoff left over that Nina had invited them back the following evening.

That was the evening when the police found Nina's tiny corpse on the bathroom floor. "She had been strangled by bare hands."[4] If there were fingerprints, they were never discussed in any accounts of the crime. There was no sign of anyone having broken into the apartment. A package of the powder florists include with bouquets was sitting on a table, but there were no flowers; this may or may not have indicated that someone arrived with a bouquet and then left with it, perhaps because it would have been a clue to the crime. Jewelry worth more than two million dollars was gone.

There were only fourteen people at Nina's funeral when it took place a few days later in Paris. None of them, it seems, felt it necessary to push the case to a conclusion.

Kandinsky had always said that it was impossible to solve the mysteries of life. The few characters on the upper tier of the pyramid he describes in *On the Spiritual in Art* are the rare human beings who accept that the fortress of knowledge is impregnable. Could he have imagined that his wife's death would require that same resignation?

2

Anni's descriptions of the key players at the Bauhaus—and the anecdotes she told with a good novelist's feel for the details that matter most—made me see life in Weimar and Dessau as if I had lived there. In addition, both of the Alberses exemplified the unusual world that had lasted for little more than a decade but had such a powerful effect on the appearance of

buildings and objects, and on attitudes toward design, all over the world—
an impact that is still growing. Knowing them, I saw firsthand the true
spirit of rebellion, as well as the consuming love for beauty, that were fun-
damental to the Bauhaus. I witnessed the energy fueled by passion, and the
rigor, that united the school's reigning figures. I also saw the enthusiasm for
a way of life outside the norm, and the concomitant irreverence for the usual
hierarchies, of these aficionados of everyday living.

With the passion for what he loved, Josef deplored everything he consid-
ered fraudulent. He particularly loathed self-importance. One day, when he
joined us in the kitchen at the end of an afternoon when I was working with
Anni, he was consumed by rage. His pale skin turned lobster red as he
explained why. In *The New York Times* that morning, there had been an
interview with Robert Motherwell. "And do you know what Motherwell
said he achieved in his work, Nick?" Albers asked me in a rant. Raising
both hands in disbelief, he answered: " 'Eternity!' Eternity! Motherwell
dares to think he has achieved eternity. Not even Michelangelo, not even
Leonardo, would claim that! Who says it? Motherwell!"

Josef suddenly rose from his seat at the kitchen table and charged over to

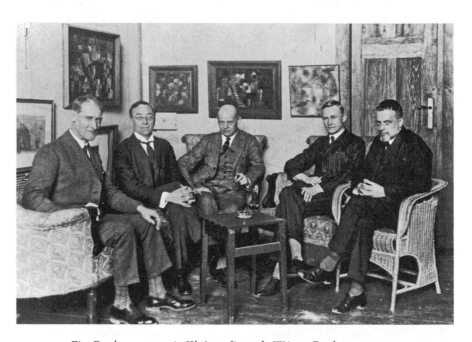

*Five Bauhaus masters in Klee's studio at the Weimar Bauhaus, ca. 1925
(from left: Lyonel Feininger, Wassily Kandinsky, Oskar Schlemmer, Georg Muche,
and Paul Klee). When the great artists of the Bauhaus assembled for social occasions
other than costume parties, they looked like bankers or schoolteachers;
they deliberately avoided self-conscious bohemianism.*

the sink. From the windowsill behind it, he picked up a small, hand-painted clay bird. "You see this bird, Nick? Anni and I bought it in a market in Mexico. For only a few pesos. There are birds like it in markets all over Mexico. We don't know who the artist is—of this or any other of those birds. But look at the color. Look at the joy, the wish to celebrate, the nice form. There's more of eternity in this bird than anything that Motherwell, or that crowd of Clement Greenberg and all those critics, ever dreamed of."

He then sat down, somewhat calmer, and ate his strudel.

WHAT BOTHERED JOSEF about Robert Motherwell was both his work and his jockeying for power within the art world. Josef considered Motherwell's collages derivative of better French art, mainly Matisse's, and the large canvases too personally expressive, while lacking in visual merit. He deplored what he deemed an attitude toward life that perpetually called for figuring out who was important for the future. "Career," Anni often said, "is one of the ugliest words there is. It has nothing to do with art."

The Alberses' views seem harsh to many people, but they were fundamental to the credo that unified the cast of characters of this book. Gropius had created the Bauhaus with the idea that the purpose of art and design is the improvement of human life. That goal was what counted; the personal advancement of individual creators did not. And strong opinions were a given. Art was too serious a matter for people to be polite if they didn't like what someone had done, or for people to accept popular notions of what was important. Passion allowed no compromise.

JOSEF'S DISDAIN for self-aggrandizement was particularly vivid one day in 1974 when I drove him and Anni to New York. They had chosen the location of their house in Orange in part because it was less than a mile from an entrance to the Merritt Parkway, thus making such trips as easy as possible both for them and for visitors, but they had reached the age where they could not contend with New York parking on their own, and I was delighted to be asked to be their chauffeur for the day. Any chance just to listen to Josef and Anni together was full of promise.

The Alberses had meetings scheduled at the Metropolitan Museum of Art. I now realize that these were to discuss a substantial gift to the museum, which included two of the assemblages of glass bottle fragments Josef had made from detritus from the local dump when he was still an impoverished student at the Weimar Bauhaus. But at the time all that I knew was that they had been invited for lunch in the museum's executive dining room, and while they could easily have proposed that I go off for lunch in a coffee shop and meet them afterward, they had instead nicely arranged for me to be included.

We were a small group at lunch. Josef enjoyed Henry Geldzahler, who had curated the Met's Albers exhibition, but they disagreed completely about artists like Ellsworth Kelly and Frank Stella—Josef liked the work of neither—and the conversation was lively. This was also the occasion when, during an especially heated moment in the debate about the New York School, Josef interrupted his own discourse on the evils of too much self-expression in painting to taunt Geldzahler about his rings; it was as if the issues of real masculinity and artistic integrity were related.

Shortly after the quips about Geldzahler's jewelry, Josef lowered his head suddenly, as if something dreadful had happened to him. I was sitting next to him, on his left, and thought that he might be choking on a bone from the trout, a food he adored, that he was having for lunch. My panic was palpable when I asked, "Mr. Albers, are you all right?"

He tilted his head, which was still practically in his plate, and made a mischievous smile. His eyes sparkling, he said, "Yes, I'm fine. It's only that that *schwein* Hoving has just come in, and if he sees me he will come over and give himself credit for everything I have ever done."

Once Thomas Hoving, the Met's renowned director, was seated, Josef sat up and continued with his lunch and the conversation. Geldzahler, who had taken in the incident, simply grinned.

On the way home, as we were driving up the West Side Highway, Josef in the front passenger seat, Anni in the back, I said, "Mr. Albers, I have to say, I was really alarmed when I saw you lower your head when Thomas Hoving came into the dining room."

He smiled like a little boy who had gotten away with something. He had, after all, succeeded in his goal of avoiding the director. But then Josef grew serious. "Just remember, all museum directors are *SCHWEIN!*"

AT THE DESSAU BAUHAUS, in fact, one museum director—Ludwig Grote, director of the local public art gallery—had been a great friend and supporter. Josef's attitude, however, was another essential element of what the Bauhaus was all about. Politicians, officials who knew how to jockey within the power structure, and people in the art world who were more concerned with money and administrative matters than with the ultimate significance of art, were not to be trusted.

I thought of his "schwein" remark six years later in relation to the exhibition at the Museum of Modern Art I was trying to organize with John Elderfield. I had been delighted when the exhibition was put on MoMA's schedule and the plans confirmed with a handshake between Richard Oldenburg, MoMA's director, and me. Then the show was rescheduled when a trustee insisted on an exhibition of an artist in whose work he had invested heavily. After that, as other priorities came to the fore, this exhibition that

would have been groundbreaking for being interdepartmental was pushed so far ahead on the calendar that it no longer existed. Elderfield told me that this prompted him to say to Oldenburg, "But I was there when you assured Nick Weber the Albers show would take place." Oldenburg, according to Elderfield, replied, " 'The agreement wasn't on paper, it was only a handshake.' "

Josef described the administrators and bureaucrats associated with the Bauhaus as being no more dependable than these American museum directors, even if there were exceptions like Redslob, Hesse, Masaryk, and Grote. He made clear that at the Bauhaus it was a given that artists and museum people were, by definition, foes. To think that "the authorities" might have the same interests as creative geniuses was naïve. I thought of this again in 1988 when, thrilled as I was to curate a centenary retrospective of Josef's work at the Guggenheim Museum in New York, shortly before it opened, I was coerced into including a painting belonging to a museum trustee even though it had to be shown under Plexiglas, making it essentially impossible to see.

IN NOVEMBER 1975, I drove the Alberses to New York a second time. They had a morning meeting with a dealer in pre-Columbian art—they were swapping an *Homage to the Square* for a particularly fine Inca pot—and had, yet again, asked me to join them for lunch in the exclusive precincts of the Metropolitan Museum. Following lunch, Anni and I were to look at a group of her textile samples from the Bauhaus workshops in Weimar and Dessau—she had given these to the Met many years earlier.

With her frail, emaciated hands, Anni picked up, one after another, swatches of materials she had made at the Bauhaus. In her parents' apartment, she said, the materials had been mostly silk and velvet. Their appearance masked rather than celebrated their structure; instead of letting yarn and its construction into fabric be patently visible, the everyday fabrics of pre-Bauhaus Germany were covered with ornamental flower patterns, images of women on swings, and decorative motifs that had nothing to do with process or function. Disguise and embellishment had been the goal not just of the living room curtains and tablecloths and armchair coverings in her parents' universe, but of everything else in their way of life. At the Bauhaus, however, she had, blessedly, learned that there were other people who, like her, wanted to face the truth squarely—and who even thought that the truth could be beautiful.

While she was holding an evening dress material in which shimmering metallic thread was intertwined with a matte black linen, Anni suddenly shifted subjects. She told me that Josef had had an attack of dizziness in the morning. She thought he was now fine, but she wanted me to know about it.

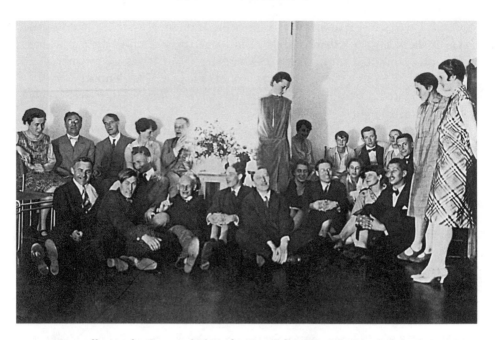

Farewell party for Georg and El Muche, Haus Scheper, Dessau, February 7, 1927.
Wassily Kandinsky, Paul Klee, Oskar Schlemmer, Josef Albers, Anni Albers, and Walter Gropius
are among those in the group. The Bauhauslers always celebrated events with great style.

Later in the afternoon, we met Josef in the lobby of the museum at the appointed time. We were about to head toward the car when he suddenly felt very faint. He sat down on a bench in the lobby, and Anni, who positioned herself next to him, had him rest his head on her shoulder. I went to bring the Alberses' dark green (Josef loved the idea that the color was called "British racing green") Mercedes around to the front of the building. A Met staff member watched the car while Anni and I slowly helped Josef down the steps of the museum, Anni supporting him on one side while I took the other.

As I drove this chivalrous elderly couple out of the city, Josef looked pale in the seat next to me. He was, in fact, suffering from the undiagnosed heart ailment that would, five months later, kill him. But as we drove up the West Side Highway, going past the Cloisters, with the windows open and the air over the Hudson replacing the pollution of the city, the eighty-seven-year-old began to perk up. He started to talk about Romanesque architecture and sculpture, which he loved, and then to discuss aspects of the current art scene and the "museum world," which he detested.

From there the conversation shifted to Giotto, about whom I asked him some questions relating to what he said he admired in the Romanesque. I knew, of course, that when he had given Annelise Fleischmann, shortly after

they met at the Weimar Bauhaus, a reproduction of Giotto's *Flight into Egypt,* it embodied the grace and equilibrium they both considered vital to all great art and design.

Josef began to gesture animatedly with his right forefinger. "You know, Nick, finally I prefer Duccio. There is a tension in his line—an excitement—an *energy.*" He outlined a Duccio Virgin Mary with his finger. He was flushed, and his eyes sparkled. Discussing line, making shapes with his finger, he was alive again.

3

The true spirit of the Bauhaus had as much to do with Giotto and Duccio, and with ancient Egyptian and pre-Columbian art, as with modernism. What counted were the aspects of vision that are universal and timeless. Issues of precise location, or epoque, or the personal history of the individual artist were all secondary to something far more essential in the artists' and designers' works.

Everyone at the Bauhaus was, of course, very different from one another. Klee, Kandinsky, Gropius, Mies: each was as independent and strong-willed as the other. The Alberses' sharp opinions were mild by comparison. But with Anni and Josef as my way in, I came to see the shared values of these powerful individuals and the reasons for their mutual respect. What became clear was the passion for artistic excellence, the love for life itself, and the reverence for nature that unified the best of the Bauhauslers.

But their personal quirks and the realities of their circumstances and their families were also immensely significant. This was apparent to me because of my good fortune in having a link to the last living Bauhauslers. In focusing on six of the people at the school who went far beyond the issues of one period or place, and were geniuses for all time, and in trying to sketch them as human beings, I have attempted to show how they created and lived out a dream that was never equaled before or since.

ANNI ALBERS died in May 1994, just shy of her ninety-fifth birthday.

With the death of Nina Kandinsky fourteen years earlier, Anni was the last major Bauhaus figure still alive. At times, that position conferred a certain stature on her, but on other occasions, given what a major artist she was, the lack of recognition was equally remarkable.

To her delight, Maximilian Schell filmed her for a scene in his documentary about Marlene Dietrich. Anni, at age ninety-one, went to Berlin so he

could do this, and she was fascinated to hear her beloved Maximilian direct the cameramen and instruct her on what to do. He had the authority and artistic definiteness that she adored, and she relished complying with his instructions. She showed no interest in Berlin itself, no apparent nostalgia for her colorful and luxurious childhood; she cared only about her new adventure.

In the documentary, Anni is shown going through lots of discarded 32-millimeter film, running it between her fingers as she might have once handled thread. She is the perfect foil to Dietrich, for while Dietrich appears to be a vain prima donna, Anni is seen with little makeup and with uncolored white hair, and her intellectual curiosity is made manifest as she studies the celluloid.

Yet after the documentary appeared, Gabrielle Annan, in her review for *The New York Review of Books,* while pointing out that "the name Anni Albers appears on the cast list," asks of Anni, "Who is Schell's dark lady? . . . Can she be the widow of the irresistible Hans Albers, a German cross between Gérard Depardieu and Maurice Chevalier, the raffish darling of the Berlin public before the war? . . . Whoever the old lady is, we can read her as a symbol of the last years of the Weimar Republic, when Dietrich was in her prime. Her look of displacement haunts and disturbs." Annan describes the mysterious Anni as "a small old German-Jewish lady, bewildered and bewildering"—all in contrast to Dietrich.[5]

When I read this, I took a fit. I immediately fired off a snippy letter to the editors of *The New York Review of Books,* identifying the world's foremost textile artist and saying that the Albers to whom she had been married was not Hans but Josef, the renowned painter and color theorist. I also pointed out that Anni stood five-foot-seven, which is not normally considered short for a woman, and asked if Annan had determined Anni's religion because of the shape of her nose. There was no other reason for declaring Anni Jewish, since no reference is made to this in the film.

Annan replied in a letter that was forwarded to me. She said that she now realized that Anni Albers was her cousin and godmother, whom she "had last seen at the baptismal font." She offered no further explanation.

I HAD DETERMINEDLY KEPT all of this—the review, my response, Annan's letter—from Anni, since I felt that the "small old German-Jewish" description would have greatly upset her. But then Maximilian sent her Annan's piece, along with some other reviews.

I phoned him and asked why he had done so. He said he thought Anni would not be bothered by Annan's description of her—after all, Annan's overall take on his film was very positive—and that Anni was used to bizarre criticism and was even excited by it.

In this last statement, he was right. But she was, of course, irked by what Annan had written. Once I knew she had read it, I showed her my letter to the *Review*'s editor and Annan's subsequent response. Anni thought for a moment and said, "Of course, her father was Louis Ullstein, the youngest brother. But she was Lotte's godchild, not mine." It made sense to both Anni and me that Annan had reconstructed history to have her godmother be the Fleischmann sister who ended up being famous and important in the eyes of the world. This, Anni reminded me, was the way that people falsified the past. "Anyone who was at the Bauhaus or Black Mountain, and then read all the nonsense, should understand."

OTHER PEOPLE, however, knew exactly who Anni was.

In 1978, my wife brought Jacqueline Onassis to meet Anni. Katharine and Jackie had spent the day looking at American country antiques, mainly in a barn and former chicken coop in South Windsor, Connecticut, and were ending their outing at the Alberses' house, from which Jackie's driver would continue with her back to New York, while Katharine would go home with me.

Jackie, in an old baggy sweater with small holes in it and well-worn corduroys, looked unbelievably beautiful that afternoon. Her hair was big and somewhat messy, and if she had makeup on, it was the type someone like me could not see; she had a magnificent vitality, and exuded energy and alertness that were almost savage.

As the former first lady walked up the half flight of stairs, Anni awaited her in her wheelchair on the landing. Jackie acted like a well-brought-up Miss Porter's School girl being presented to royalty. In a tremulous voice, she told Anni what a great honor it was to meet her. And then, after just a few seconds of observing the living room with its walls bare except for the four *Homages to the Square*, Jackie said, without hesitation, "Just like Matisse's chapel in Vence: all the white, and then the color."

No one could have scripted the line for her, and rarely had anyone said anything as appropriate about the Alberses' vision.

The two women began to discuss design, and the need for open space. Anni started a sentence with the words, "At zuh Bauhaus . . . ," and then interrupted herself to ask, "Have you heard of zuh Bauhaus, Mrs. Onassis?"

"Oh, Mrs. Albers, I *have,* and you just can't possibly imagine what an honor it is to meet you!"

WHEN ANNI DIED, I phoned Maximilian right away. He expressed sadness, but we agreed that she had outlived herself. He would not be able to attend the funeral scheduled two days hence, he told me.

I knew, but he did not, that he was not mentioned in Anni's will. Except

for some of Josef's paintings that she left to her brother and to the children of her late sister—a gesture she decided on in spite of their having nothing more than polite interest in the art she and Josef made, but that was meaningful now that Josef's art had significant financial currency—she left everything to the foundation that was to continue their legacy. Besides, had she included Maximilian in her will, it would have suggested that her material wealth mattered to him. It was vital for her to maintain the idea that the intense love between her and the younger actor/director was based on purer, less worldly concerns.

As the executor of Anni Albers's estate, I decided to send Maximilian two personal objects. One was a black cashmere scarf, very much his style, which I found among her possessions. Another was her gray Parker fountain pen, which was at her bedside, and which she had used for years, even when her hand trembled so severely that she needed me to hold it to guide her to make important signatures.

I wrote him a slightly smarmy, sanctimonious letter explaining the meaning of the objects and what they acknowledged about his and Anni's personal connection. My secretary, who always suspected Maximilian of the worst, was delighted to send the package.

A few days later, Maximilian phoned, sounding irate. "Is this *it*? Is this all I get from Anni?"

"Yes, Maximilian." I followed Anni's cue in being among the only people close to him not to call him "Max." "I thought you would be touched to have them."

"Is there nothing more? She left me nothing more?"

I explained that Anni had left everything to the Albers Foundation, and I reminded him of how generous she had been to him in the past, giving him such wonderful paintings, even giving a splendid oil on paper to his stepson after he married Natasha, the lovely woman he met when he was shooting a film in Moscow a few years earlier.

"A foundation! A foundation! Motherwell had a foundation too, and Renate [Ponsold, Motherwell's widow] was saying what a problem it could be. What about people? What about friends?"

He then calmed down, and told me, with the most ironic laugh, that the scarf was something he had given Josef many years earlier.

A FEW DAYS LATER, Maximilian's sister, the actress Maria Schell, phoned. I had met her on various occasions with Anni, and, except for the time when Maria had insisted on deferential treatment at the opening of the Josef Albers Museum in his hometown of Bottrop in 1983, we had always gotten along well. In Bottrop, my issues with Maria had made Maximilian so furious, that, in front of Anni in her elegant room at the Schlosshugenpoet,

a luxurious small country house hotel where we were all staying in nearby Essen, he and I nearly came to blows. What I remember most about the occasion is that as Maximilian and I were boiling over and looked as if we might start throwing right hooks, Anni looked more engaged than at any time during the inaugural festivities. In fact, I had rarely seen her as excited.

I was remembering that episode when I heard Maria on the phone after Anni's death. For, as she had when she explained why she needed the mayor's car at her beck and call in Bottrop, she again delivered a tremendous performance. She consoled me with incredible warmth, saying she knew how close Anni and I had been, and how much I must be feeling, and how wonderful I had been to her, adding, "But of course, dear Nick, she is now in another world, and must be serene there."

Then, suddenly, Maria's voice changed completely. Normally very deep, it went up an octave, and she had a new animation. "Did she really leave Maxy nothing? Nothing more?"

I explained to her, as I had to him.

"But he was so devoted to her. For so long. And you know, he has had financial setbacks. Even a great actor cannot always afford to direct his own films."

The call quickly wound its way to conclusion, once Maria recognized that Anni's will was inviolate.

IN WEIMAR OR DESSAU, who would ever have imagined any of this?

4

What the Bauhauslers did was for all times, but the world in which they did it was unlike any other one in history.

In 1939, Sebastian Haffner—a pseudonym used by the writer whose real name was Raimund Pretzel—completed a memoir that serves as a contemporaneous account of German life as viewed by someone who suffered no direct threat from the Third Reich. He was not a Jew, a homosexual, a Gypsy, a modernist, a Communist, a Socialist, or a member of any other minority at risk, but he still recognized the total transition of German culture during the years when the Bauhaus flourished and then ceased to exist.

When Haffner's son, Oliver Pretzel, translated and published this unknown memoir shortly after his father's death in 1999, he opened it with a quotation from Goethe, Weimar's most heroic figure, its guiding light even

when the Bauhaus was started there a century after the poet's heyday: "Germany is nothing, each individual German is everything."[6] The Bauhaus was conceived with the intention not only of making that statement true, but of expanding it to include non-Germans who were present at a school funded by the German state—much as the Bauhaus's foes opposed that idea of allowing students and faculty of other nationalities to be there.

What was happening in Germany, however, can hardly be called "nothing" in its impact on the Bauhaus. The extremes to which civilization had moved, the economic situation and the zeitgeist, sparked and fueled the school at the beginning, then caused its demise.

The conditions Haffner describes as being prevalent in the early 1920s give a sense of the world of which Gropius was in some ways a part, and against which, in other ways, he reacted. Haffner characterizes the Germans of that epoque as having

> those characteristics that are so strange and incomprehensible in the eyes of the world, and so different from what used to be thought of as the German character: the uncurbed, cynical imagination, the nihilistic pleasure in the impossible for its own sake, and the energy that has become an end in itself. . . .
>
> No other nation has experienced anything comparable to the events of 1923 in Germany. All nations went through the Great War, and most of them have also experienced revolutions, social crises, strikes, redistribution of wealth, and currency devaluation.
>
> None but Germany has undergone the fantastic, grotesque extreme of all of these together; none has experienced the gigantic, carnival dance of death, the unending, bloody Saturnalia, in which not only money but all standards lost their value. The year 1923 prepared Germany not specifically for Nazism, but for any fantastic adventure.[7]

The Bauhaus was one such adventure. It took place, however, in the context of another societal change that would have far greater impact—Nazism—which, although its roots went back in time, gained steam the same year of Gropius's great Bauhaus Exhibition. As Haffner recorded, "That year gave birth to its lunatic aspects: the cool madness, the arrogant, unscrupulous, blind resolve to achieve the impossible, the principle that 'might is right' and ' "impossible" is not in our vocabulary.' "[8]

SEBASTIAN HAFFNER describes the spring of 1933 in Berlin. The conditions under which Mies and the other remaining faculty members chose to close the Bauhaus, as the school struggled to keep going in its final shell, were such that most people were

permanently occupied and distracted by an unending sequence of cel-
ebrations, ceremonies, and national festivities. It started with a huge
victory celebration before the elections on March 4. . . . There were
mass parades, fireworks, drums, bands, and flags all over Germany,
Hitler's voice over thousands of loudspeakers, oaths and vows. . . .

A week later Hindenburg abolished the Weimar national flag,
which was replaced by the swastika banner and a black, white, and red
"temporary national flag." . . .

The colossal emptiness and lack of meaning of these never-ending
events was by no means unintentional. The population should become
used to cheering and jubilation, even when there was no visible reason
for it. It was reason enough that people who distanced themselves too
obviously—sshh!—were daily and nightly tortured to death with
steel whips and electric drills. Better to celebrate, howl with the
wolves, *"Heil, Heil!"* Besides, people began to enjoy doing so. The
weather in March 1933 was glorious. Was it not wonderful to cele-
brate in the spring sunshine, in squares decked with flags?[9]

The Bauhauslers who chose not to be part of this were exceptionally for-
tunate. Almost all of them made it out of Germany.

THE CLASS ISSUES and the economic situation were part of the picture for all of
these artists.

This came to mind when, while I was working on this text, I encoun-
tered, on the platform of a train station, the brother of a friend of mine from
college. I had not seen him since my friend's twenty-first birthday party, but
I was delighted to recognize the person I will rename "Ashton Somerset."
Among other things, he was a perfect exemplar of a patrician American type
that fascinated Anni, with whom I had a quick mental dialogue. I was also
glad to see him because I had a vivid memory of Ashton's father having been
one of those rare people who responded heart and soul to Paul Klee's work.

Ashton now had distinguished white hair. In his elegant, long, black
cashmere Chesterfield topcoat and paisley silk scarf tied like an ascot, he
resembled a character in a J. P. Marquand novel, which seemed just right for
someone to run into waiting for the train from New Haven to Boston. I
asked what he was now doing, and he explained that he was an investment
banker. I then jumped to tell him something I thought he would enjoy
hearing, which was that in 1967 his brother had arranged for me to go with
their father to the Klee retrospective at the Guggenheim Museum in New
York, and that it had been an incredible pleasure for me at age nineteen. His
father was as alive to Klee's work as anyone I knew at the time.

I also told him how much I had enjoyed going to their family house in

Washington and seeing the many Klees his father had acquired over the years. His father, I said, was the rare thing. He had pointed out to me details in the work that only a true aficionado would recognize, and spoke with me about the work with infectious enthusiasm. Klee's world was unlike anyone else's, and Ashton's father was clearly among the rare people who ventured into its depths.

I knew that Mr. Somerset had since died, because I had seen that some of these Klees had been sold from his estate, in 2007, at Christie's. "Yes," Ashton said with a grin, "he had a lot of Klees. And we did very well with several of them at auction."

"You know, your father was different from other collectors. He had such passion, and because, if I remember correctly, he collected only two things — Klee paintings and Rembrandt etchings — he had an unparalleled eye."

"Yes, he was a wise collector, because the ones we sold fetched, well, you know, between three and four times their reserve price. There are twelve grandchildren, so this is a very good thing in our lives."

"It's all so strange," I said. I tried to sound lighthearted, not to pontificate, but could not help continuing. "I have just been writing about Klee, at a moment in 1923 when he and Kandinsky went to a café in Weimar, each to have a cup of coffee, nothing more, but then went home without having ordered, because they could not afford the two cups."

"Yes, we were very happy with what Christie's did with the work, and the timing was just right — before the current downturn."

In a way, this could have been the 1920s.

5

Toward the end of September 2008, I was riding my bicycle on the Avenue Gabriel in Paris one morning when a movement on the other side of the road caught my eye. The sun was bright, but the air crisp and cool; it was one of those days when every sight sparkled. A powerfully built black man, about age forty, was unloading cargo from the back of a large truck. To shoulder his load, he had his torso twisted, with his forward shoulder lowered. His knees were bent, and his weight was clearly concentrated in his legs rather than his back. The way he was managing the large, and presumably heavy, wooden box showed a complete knowledge of his methods, a consummate grace and professionalism.

As I pedaled along the tree-lined avenue, past the spectacular and ornate

structures that line it, I realized that this was what the Bauhaus intended. The goal of its guiding lights was to get us to see things, to notice what is allegedly ordinary but is in fact totally extraordinary. My mind flashed to an occasion thirty-three years earlier when I was driving Josef and Anni Albers to New York. Josef was obsessed with a structure then going up alongside the Cross County Parkway, because of the way it was being sheathed from the top down once the scaffolding was in place. Other people I knew would have focused on the traffic jam we were entering, or might have had their minds far from where we were; he was riveted to what was right there, and to what many people would not have perceived.

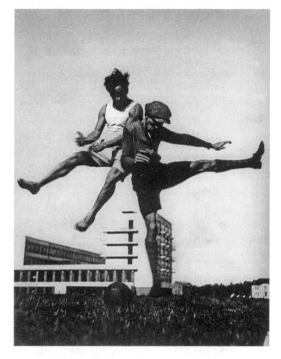

Sport at the Bauhaus, ca. 1928. Photograph by T. Lux Feininger. Skill and pleasure were revered at the school.

Anni, too, was very excited about the way the walls were going on to this building, and explained, in her soft voice, "You see, I always love the process; it's more exciting now, with the bricks getting placed, than it will be when it's finished."

The man unloading the box on the Avenue Gabriel recalled Josef's drawing of electrical workers—a sketch he made before going to the Bauhaus, and that I had found in his basement storage in New Haven. What had intrigued him was the way those workers high on a pole had angled their bodies, the act of balancing, the know-how and the coordination.

The sight of the trucker managing his cargo also made me remember one of the last times I had seen Josef, on a bitter January day in 1976. When I turned into the driveway of the Alberses' house—where, every time I went there, I was struck anew by how nondescript it was, as if I still could not reconcile the blandness of the contractor's design with the power within— Josef was standing in front of the open garage door with a snow shovel in his hand. He had on a Viyella tattersall shirt, the neck button closed, and khakis. Looking rugged yet boyish, and somehow innocent, the handsome eighty-seven-year-old came to greet me, transferring the wooden handle of

the shovel from the right hand to the left. With a smile, as if he enjoyed the problem he was solving with the icy driveway, Josef explained that the northern exposure and the angles of the asphalt caused ice to melt into puddles that then refroze.

He was about to break up some sheets of ice when I tried to persuade him to let me take the shovel. He protested, but I prevailed and began to attack the ice. Not wanting to be rude by leaving me on my own, he stood at the open garage door and watched. Josef's presence had the impact on me it had had on generations of students; it always made people want to do their very best. I knew that here was a man who preferred good shoveling to bad painting, and I shoveled as if my life depended on it.

"Marvelous . . . *wunderbar,*" he told me. Smiling and animated, he went on, "You know, Nick, you have very mature shoveling strokes. The little schoolboys who usually shovel here are half your height." He indicated this with his hands. "And their shovel throws go only half as far as yours. They have young boys' strokes. You have a man's."

The exaggeration and the symmetry of his comparison belonged to the side of Albers that invested ordinary reality with poetry. Beyond that, what was especially striking was the way Josef was a connoisseur of daily moments. He cared about effective methods and pertinent details, whether the slope of a driveway, the reach of a shovel stroke, or the thickness and texture of a pen nib; it all fascinated him. Above all, he observed things astutely and responded to what he saw in unexpected, original ways.

The Bauhaus was so much more than a place or an artistic movement. Yes, there were the realities of its history and of the individuals who were there, but the heart of the school, for its truest practitioners, had to do with the most universal and timeless issues. Above all, the teachers implored their students to look at things, to observe carefully, to proceed from investigating with the eyes to seeing. With keen observation comes a sense of the miracle of existence.

As I continued to ride along the Parisian street, I thought of Josef's obsession with bicycles. He did drawings of them and wrote about them; to his mind, a bicycle, with the simple functioning of the pedals, the chains, and the wheels with their many spokes, was a perfect example of form following function. That issue has become a cliché in discussions of design, but its familiarity does not make it any less significant. The architecture along the Avenue Gabriel represents exactly the opposite values, with the profusion of ornament, the unnecessary flourishes on each façade, the emphasis on décor. The Bauhauslers did not oppose that past with all of its filigree and add-ons, but they exulted more in objects like bicycles. It was the use of tubular steel in a bike that led Marcel Breuer to many of his most innovative designs in strong, lightweight furniture.

I was also aware of the leaves that had fallen on the street, and of nature's seasons. As I delved into the lives of my six Bauhaus characters, one of the elements I found the most striking was the way Klee took daily walks in the great parks of Weimar and Dessau and focused on natural growth. Botany as a source of knowledge was a fundamental of the school. The respect for nature was of paramount importance.

THE DESTINATION of my bike ride was a sports facility that is part of a club in what was once a very grand house. The garden at its entrance was, on this early autumn day, rich in orange and yellow flowers. I thought for a moment of the way that Le Corbusier—among the people most admired at the Bauhaus, and the subject of one of the school's finest publications as well as a participant in its exhibitions—was more concerned with the choice of trees and flowers in the courtyards of his houses than with many other elements (including some that would have benefited from more attention, like the issue of leaking roofs). The form of those flowers made me think of Klee, and the vibrant colors conjured Kandinsky. I was reminded of their love for the bounty and inventiveness of nature, and their awareness that visual pleasure—color on its own, abstract shapes—can directly impart intense emotional pleasure.

I entered my club, and my thoughts were sent in a totally different direction when I signed in the register and saw that the person ahead of me had put down his name as "Comte de Rochefoucault." As I wrote my name underneath, I was aware that this, too, had to do strongly with the Bauhaus. The grandson of a glasscutter whose parents immigrated to America, I have very little interest in titles and the concept of nobility, and as an American I am largely ignorant on the subject, but I am intrigued by the way in which those distinctions do and don't matter to many people. The Bauhaus was established thanks to the interest of a prince, and its first home had once been a royal academy, but it was a place where Jews and Catholics and Protestants, some from aristocratic families and others from humble working-class backgrounds, were engaged side by side in the same effort. The issues of background and family were by no means erased—they were too embedded in German history—but the passion for seeing and for making art, the wish to establish design standards of universal application, rendered them relatively unimportant.

In a bike ride in Paris in 2008, one could readily fathom the real meaning of the Bauhaus. It was a place where life was celebrated, where the visual was accorded supreme importance, where people from any world whatsoever were given the chance to explore and savor the wonders of life and art. Its legacy is not the perpetuation of one particular style; it is, rather, the extension of those larger values all over the world.

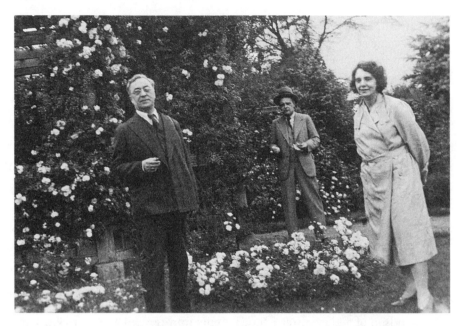

*Wassily Kandinsky, Paul Klee, and Nina Kandinsky in Wörlitzer Park, Dessau,
1932. The park in Dessau was a favorite haunt of Kandinsky and Klee.*

Acknowledgments

Anni Albers had two favorite words: "Thank you."

On ceremonial occasions, when she might have been expected to make a long speech—the inauguration of the Josef Albers Museum in Germany; the events where she received prestigious medals or honorary doctorates—in her soft but deep voice, a sort of powerful whisper, she would tell her attentive listeners, "There is just one thing I have to say: 'Thank you.'" (Her pronunciation of "thank" as "tzank" was in this instance the only trace of an accent.) Her use of those two words gave them rich meaning: one felt she was saying, from the bottom of her heart, that she was indescribably grateful to be alive, to be able to practice her art, to have received the help of others.

I am happy to echo her sentiment. I often wonder what it would have been like to have lived before recent times, and therefore never to have known the paintings of Klee, the Barcelona Pavilion, the compositions of Kandinsky, or many of the other miraculous inventions for which we use the rubric "modernism." I am beholden to all the true proponents of this breakthrough art and architecture, to everyone who made the Bauhaus feasible, and, of course, to the six principal characters of this book for their devotion to vision and to change. I owe heartfelt thanks to every teacher, librarian, and archivist—and a range of other kind people—who have enabled me to delve into these marvels of the twentieth century. In particular, I feel inestimable gratefulness to the Alberses: for having been, unfailingly, who they were, and for their constant wish to contribute to everyone's experience of seeing.

My parents, first and foremost, taught me that life is a gift and that vision is a miracle. They insisted, equally, on a sense of reality about the world's evils. That combination was essential to any grasp I might have of the Bauhaus.

Then Josef and Anni showed me in a new way that the exploration and celebration of beauty in various forms could be one's raison d'être as well as one's personal anchor.

This book would not have been possible without Ruth Agoos Villalovos. She introduced me to Anni and Josef Albers and changed my life forever on that autumn afternoon nearly forty years ago. She is someone of rare warmth and sharp instincts, a specialist in human connection, and she was right in sensing that the meeting she organized that day (or, at least, organized with me, for she took the Alberses by surprise) would have great meaning for all parties involved. I am inestimably grateful to her.

Her husband at the time, Herbert Montwid Agoos, was, in addition to being a man of remarkable charm and exquisite taste, as splendid an observer of the human comedy as he was a connoisseur of art and architecture. He chose and arranged paintings and furniture, and anemones, with an eye I have never seen equaled, and he saw past people's veneers. He died in 1992, but I still have mental conversations with him all the time, and I love imagining his voice—that wonderful Bostonian accent inflected with sharp enthusiasm—and recalling his wisdom. At one point

or another, Herb and I discussed each of the six people in this book, and thanks to him I learned and saw as never before.

Herb and Ruth produced four exceptional children. They were directly affected by their parents' passion for the spirit of the Bauhaus, and each abounds in rare personal qualities. In particular I thank Ted for his wit and uncompromising eye, Kathy for her clarity as well as for her splendid blend of realism and humor, Peter both for his fantastic imagination and for the companionship he offered on a particularly memorable day with Anni Albers in 1972, and Julie for the staggering beauty of her poetic vision and depth and warmth.

Having published several tomes within the past few years, I have in their acknowledgments done my best to thank the various people who are the mainstays of my life. I feel that it would be repetitive, and boring for my readers, if I named them all again here. But I have to make a couple of exceptions:

Victoria Wilson has outdone herself in providing understanding and encouragement and support that have been the lifeblood of my ability to write. No words properly evoke my luck in knowing and working with this woman of extraordinary courage and integrity. She is bright and independent and funny and kind, and she maintains the long view; these qualities are as splendid as they are rare.

Gloria Loomis is one of those people who simply gets more energetic and astute and warm as time goes on; without her, my life would be like a building without foundation or framing. One does not need to have gone to the Bauhaus to understand the meaning of that idea. Her first name suits how I would like to sing her praise.

As before, but now more than ever, Carmen Johnson at Knopf has epitomized patience, professionalism, and personal grace; Ellen Feldman has worked on this text with an eye and ear for language of the highest order; Peter Mendelsund has, yet again, demonstrated his genius as a designer and the passion to get things just right; Oliver Barker has been the essence of energy and helpfulness, applying himself with fantastic zeal and perpetual good spirits to a range of complex tasks concerning the illustrations for this book; Brenda Danilowitz has demonstrated daunting intelligence and acuity; and Philippe Corfa has manifested phenomenal organizational skill while providing generous personal support. Laura Mattioli, during a visit to a Kandinsky exhibition we made together, led me to new understanding; Daphne Warburg Astor added to my vision in particular of the art of Klee and both the Alberses; Nancy Lewis, vivacious and generous as ever, encouraged my way of seeing; Mickey Cartin has proved himself the most extraordinary of friends, for his knowing vision of vital matters in life as in art; and Brigitte Lozerec'h offered precious council on issues of language. There are, in addition, some newcomers to my list of allies: Barry Bergdoll, the most generous and warmhearted of colleagues; Martin Filler, a source of unequaled camaraderie made all the better by his rare wit; Sophie de Closets, a brilliant editor at Fayard in Paris, who offered encouragement that has been nothing short of magnificent; Sir Nicholas Serota, one of the world's rare visionaries, who gave me the sort of feedback that is a writer's dream; and Andres Garces, a master of patience and thoroughness in dealing with vital details. Christian Wolsdorff, at the Bauhaus-Archiv in Berlin, one of the great specialists in the field of Bauhaus studies, prompted me to look at the economic realities of the institution and its faculty; his perspective had a powerful effect on my research. I also thank, for their generous help: Annemarie Jaeggi at the Bauhaus-Archiv in Berlin; Stefan Frey, an independent Klee specialist in Bern;

Michael Baumgartner, chief curator of the Zentrum Paul Klee in Bern; and Christian Derouet, secretaire et tresorier de la Société Kandinsky of the Centre Georges Pompidou in Paris. Oliver Pretzel, in translating, in little time and with true understanding as well as poetry, some highly idiosyncratic German (Paul Klee's recipes, Josef Albers's letters written while drunk) for this book, has given its readers, as well as me personally, a real gift.

There are many people no longer alive who led me to greater understanding, in particular, of the ever fascinating Anni. I am especially grateful to Fritz and Anno Moellenhoff for their perspective on the woman who was Fritz's girlfriend when they were both in a sanatorium at age eighteen ("However you find Anni now is how she has always been," Fritz told my wife in 1978), and to Hans Farman for grasping his older sister's nature with such grace. And Jacqueline Onassis provided an outside vision of remarkable authority when, after their one meeting, she turned to me and said, "There's a lot of power emanating from that wheelchair."

The rest of you—friends, coworkers, family—who have been there for my work with such generosity and efficaciousness: you know who you are, and please accept my deepest thanks.

When I was a senior at Columbia College in 1968–69, I took a semester-long course in the Bloomsbury group, which was then far less well-known than it has since become. Naturally, we read Woolf and Forster and Strachey and others, and discussed a large cast of characters and their work. At the end of term, when we sat down for our three-hour exam, with our blue books in front of us, we expected the usual two or three mimeographed pages with a combination of short multiple-choice questions and complex essay topics. Instead, the brilliant young professor, Michael Rosenthal, went to the blackboard, picked up a piece of chalk, and wrote, in large letters, "What is Bloomsbury?" He then faced the dozen or so students and said, "That's the exam question. You have three hours."

I have never gotten over the brilliance of Professor Rosenthal and his directive. There was no right or wrong answer; what counted was our understanding of the underlying passions and goals of an artistic movement led by very different individuals. Forty years later, I remain extremely grateful to a teacher who encouraged us to see the broad picture while also knowing each genius for who he or she was. My goal in this book has been to capture the true spirit of the Bauhaus while, I hope, evoking the marvelous particularities of the people I consider its stars.

My fellow directors of the Josef & Anni Albers Foundation were selected by the Alberses with good reason. They are not only consummate legal professionals and individuals of immense good heart, but they have a rare understanding of the Alberses' priorities, artistic as well as human. John Eastman and Charles Kingsley are, in addition, two of the finest friends one could hope for.

John's intense aliveness, his penetrating intellect, and his rare élan add unparalleled pleasure to my existence. Among many other things, he is one of the few people whose companionship I enjoy in museums, for in front of great art he looks more than he speaks, and when he speaks, he reveals the depths with which he has seen. He is as kind as he is droll, which is saying a lot. That his radiant wife, Jodie, is always so warm and supportive is a further boon.

Charlie Kingsley, who was the Alberses' Connecticut lawyer (while Lee Eastman, John's father, represented them in the New York art world), is simply one of the finest human beings who ever existed. I will never forget the impact of a condolence letter he wrote Anni, thirty-three years ago, just after Josef died. It revealed

the qualities I have always found in this man: a depth of understanding and a warmth, and a wish to improve the lives of others. And Anni didn't even know what a joy it is to play tennis and squash with him. But she did know his energetic and insightful wife, Gretchen, and that was her good fortune as it is mine.

My wife, Katharine, put up patiently with Anni's more difficult sides while helping in countless ways, in the early years of my Albers work, with everything from the saving of Josef's photographic film and organizing of rare contact sheets to taking Anni on interminable outings to the kitchenware department of Sears, Roebuck. She also gracefully became part of the Alberses' circle, which included so many wonderful people who are no longer alive, among them Lee and Monique Eastman, Ted and Bobbie Dreier, Hans and Betty Farman, and Lotte Benfey. Kathy is the truest of partners, and together we speak of this cast of characters as one does of family.

We have two exceptional daughters. When Lucy Swift Weber and Charlotte Fox Weber were younger, I dedicated two books to both of them, in ways that befit their ages at the time (*The Art of Babar* when they were little; *Balthus: A Biography* when they were adolescents). Now they are mature women and can no longer be paired as "the girls." It's time for each to be the sole dedicatee of her own book.

Lucy, the older sister, approved this policy in advance of anyone else learning about the dedication of *The Bauhaus Group*—while knowing the next one will be hers. Having looked at Paul Klee's work with me first when she was a two-year-old in a backpack, and then when she was eight and she and Charlotte and I went to Bern and the girls stood dazzled before Felix's puppets, Lucy is someone of immense visual gifts. As with the subjects of this book, this initially became apparent in early childhood; Lucy made remarkable drawings after work by Carpaccio, Ingres, and Balthus. Having been held at the age of three weeks in Anni Albers's arms, she had Anni, as well as the Alberses' friends and family, as part of her own upbringing—and she carries their spirit as well as a flair for art and design in her. She is a human being of rare heart.

Charlotte, in her spark and imagination, and in her subsuming aliveness, has a magic all her own. She is one of the greatest joys of her father's existence, and has an alertness and understanding that never fail to stagger me. More specifically, this radiant and beautiful woman has found and then passed on to me a lot of the richest material in *The Bauhaus Group*. While pursing her graduate studies in psychoanalytic training at the same time that I was writing about Klee, she undertook intense research on my behalf and came up with rare and thrilling texts that provided unique insight into the complexities of this wonderful artist. She also located and annotated invaluable narratives about Sigmund Freud's work with Gustav Mahler. Charlotte understands my mind and interests in a way that is a parent's dream, and read copious material in order to highlight exactly the sort of points for which I longed. She enlarged my vision considerably. Not only for that phenomenal help, but because of a love beyond expression, I dedicate this book to her.

NFW
Paris
June 2009

Notes

WALTER GROPIUS

1. Reginald Isaacs, *Gropius: An Illustrated Biography of the Creator of the Bauhaus* (Boston: Bulfinch Press, 1991), p. 3.
2. Ibid., p. 13.
3. Ibid.
4. Ibid., p. 17.
5. Ibid., p. 18.
6. Hans M. Wingler, *The Bauhaus: Weimar, Dessau, Berlin, Chicago*, ed. Joseph Stein, trans. Wolfgang Jabs and Basil Gilbert (Cambridge, Mass.: MIT Press, 1969), p. 20.
7. Ibid, p. 21.
8. Francoise Giroud, *Alma Mahler; or The Art of Being Loved,* trans. R. M. Stock (Oxford: Oxford University Press, 1991), p. 16.
9. Ibid., p. 17.
10. Ibid, p. 20.
11. Ibid, p. 23.
12. Ibid, p. 79.
13. Alma Mahler Werfel, *And the Bridge Is Love* (New York: Harcourt, Brace and Company, 1958), p. 50.
14. Ibid, p. 51.
15. Giroud, *Alma Mahler,* p. 81.
16. Isaacs, *Gropius,* p. 83.
17. Giroud, *Alma Mahler,* p. 82.
18. Mahler Werfel, *And the Bridge,* p. 51.
19. Ibid.
20. Isaacs, *Gropius,* p. 34.
21. Giroud, *Alma Mahler,* p. 83.
22. Mahler Werfel, *And the Bridge,* p. 52.
23. Isaacs, *Gropius,* p. 34, undated letter from Alma Mahler (AM) to Walter Gropius (WG), Vienna, probably June 1910.
24. Isaacs, *Gropius,* p. 35.
25. Mahler Werfel, *And the Bridge,* p. 53.
26. Giroud, *Alma Mahler,* p. 88.
27. Ibid.
28. Isaacs, *Gropius,* p. 35.
29. Ibid.
30. Ibid.
31. Ibid., quoting letters of September 19 and 21, 1910.
32. Ibid., quoting letter of September 21, 1910.
33. Giroud, *Alma Mahler,* p. 90.
34. Isaacs, *Gropius,* p. 35; AM to WG, late October 1910, from New York.
35. Ibid., p. 36; Anna Moll to WG, November 12, 1910, sent from Vienna.
36. Ibid.
37. Ibid.
38. Ibid., WG to AM, late May 1911.
39. Ibid., pp. 36–37; WG to AM, mid-August 1911.
40. Ibid., p. 37; WG to AM, September 18, 1911.
41. Ibid., WG to AM, December 15, 1911.
42. Ibid., p. 38; WG to AM, November 21, 1912.
43. Mahler Werfel, *And the Bridge,* p. 78.
44. Ibid., p. 72.
45. Ibid., p. 73.
46. Isaacs, *Gropius,* p. 30.
47. Ibid., p. 38; AM to WG, May 6, 1914.
48. Mahler Werfel, *And the Bridge,* p. 84.
49. Isaacs, *Gropius,* p. 41. The date of the letter is incorrect in Isaacs's footnote; it can't be November, since it refers to New Year's.
50. Mahler Werfel, *And the Bridge,* p. 85.
51. Ibid., pp. 85–86.
52. Isaacs, *Gropius,* p. 43; AM to WG, probably June 1915.
53. Mahler Werfel, *And the Bridge,* p. 87.
54. Wingler, *Bauhaus,* p. 21; Henry van de Velde to WG, April 11, 1915.
55. Ibid.; Van de Velde to WG, July 8, 1915.
56. Ibid., p. 45; F. Mackensen to WG, October 2, 1915.
57. Ibid.; WG to F. Mackensen, October 19, 1915.
58. Ibid.; AM to WG, late fall 1919.
59. Isaacs, *Gropius,* p. 46.
60. Ibid.; WG to MG, September 1915.

61. Ibid., pp. 47–48; AM to WG, September 1915.
62. Ibid., p. 48; WG to Manon Gropius (MG), December 1915.
63. Ibid.
64. Ibid.; AG to WG, January 1916.
65. Wingler, *Bauhaus,* manuscript of January 25, 1916, p. 23.
66. Ibid.
67. Ibid., pp. 23–24.
68. Ibid., p. 24.
69. Ibid., pp. 24, 23.
70. Isaacs, *Gropius,* p. 49; AG to WG, March 1916.
71. Ibid.
72. Ibid., p. 77; AG to WG, Summer 1916.
73. Ibid., p. 51.
74. Ibid.; AG to WG, August 1916.
75. http://thenonist.com/index.php/ thenonist/permalink/oscar_and_the_ alma_doll/.
76. Ibid.
77. Isaacs, *Gropius,* p. 52.
78. Ibid., p. 52; WG to MG, October 16, 1916.
79. Mahler Werfel, *And the Bridge,* p. 89.
80. Ibid., pp. 89–90.
81. Ibid., p. 91.
82. Ibid., p. 96.
83. Ibid., pp. 97–98.
84. Ibid., p. 98.
85. Isaacs, *Gropius,* p. 15; WG to MG, March 26, 1917.
86. Ibid.; WG to MG, Schloss Flawinne near Nemurs, June 17, 1917.
87. Ibid.; WG to MG, August 1917.
88. Ibid., p. 54; WG to Karl Ernst Osthaus (KEO), December 19, 1917.
89. Ibid.; WG to MG, January 7, 1918.
90. Ibid.
91. Ibid., pp. 55–56; WG to MG, June 11, 1918.
92. Ibid., p. 57; WG to Richard Meyer, July 6, 1918.
93. Ibid., p. 58; WG to MG, August 17, 1918.
94. Mahler Werfel, *And the Bridge,* pp. 120–21.
95. Ibid., p. 122; Giroud, *Alma Mahler,* p. 124.
96. Giroud, *Alma Mahler,* p. 125.
97. Isaacs, *Gropius,* p. 63; WG to KEO, December 29, 1918.
98. Ibid.; WG to MG, Berlin, January 1919.
99. Ibid., p. 64.
100. Wingler, *Bauhaus,* p. 26.
101. Ibid.
102. Isaacs, *Gropius,* p. 67; WG to MG, March 31, 1919.
103. Wingler, *Bauhaus,* p. 31.
104. Ibid.
105. Giroud, *Alma Mahler,* p. 127.
106. Mahler Werfel, *And the Bridge,* p. 133.
107. Isaacs, *Gropius,* p. 319 n. 48.
108. Ibid., p. 79; Lyonel Feininger to his wife, May 30, 1919.
109. Feininger letters, The Lyonel Feininger Archive, Harvard Art Museum Archives, Morgan Center, Harvard Art Museum/ Busch-Reisinger Museum.
110. Julia Feininger to Lyonel Feininger, May 26, 1919, Feininger Archive.
111. Lyonel Feininger to Julia Feininger, May 20 and May 28, 1919, Feininger Archive.
112. Julia Feininger to Lyonel Feininger, May 31, 1919, Feininger Archive.
113. Mahler Werfel, *And the Bridge,* p. 134.
114. Lyonel Feininger to Julia Feininger, June 7, 1919, Feininger Archive.
115. Isaacs, *Gropius,* p. 81; WG to MG, June 14, 1919.
116. Ibid.; WG to AM, July 12, 1919.
117. Ibid.
118. Ibid.
119. Ibid., p. 82; WG to AM, July 18, 1919.
120. Ibid.
121. Ibid.
122. Wingler, *Bauhaus,* p. 36.
123. Ibid.
124. Ibid.
125. Isaacs, *Gropius,* p. 82; FW to WG, August 29, 1919.
126. Ibid.; AMG to WG, September 1919.
127. Ibid., p. 83; WG to Lily Hildebrandt (LH), October 14, 1919.
128. Ibid.; WG to LH, October 15, 1919.
129. Ibid., p. 85; WG to LH, November 1919.
130. Ibid.; WG to LH, December 13, 1919.
131. Ibid., p. 86; WG to LH, December 1919.
132. Ibid.; WG to MG, undated, probably 1919, just after Christmas.
133. Ibid.; WG to LH, February 1, 1920.
134. Wingler, *Bauhaus,* p. 37.

135. Isaacs, *Gropius,* p. 87; AMG to WG, undated, from Vienna, probably early December 1919.
136. Ibid., p. 88; WG to unnamed "young widow," April 19, 1920.
137. Ibid.
138. Ibid., p. 90; WG to LH, undated.
139. Tut Schlemmer, ed., *The Letters and Diaries of Oskar Schlemmer* (Evanston, Ill.: Northwestern University Press, 1990), p. 90.
140. Mahler Werfel, *And the Bridge,* p. 142.
141. Ibid., p. 143.
142. Isaacs, *Gropius,* pp. 92–93; WG to LH, late spring 1921.
143. Wingler, *Bauhaus,* pp. 51–52.
144. AM to the Feiningers, July 3, 1922, Houghton Library, Harvard University, 6MS Ger 146 (1423).
145. Lyonel Feininger to Julia Feininger, September 7, 1922, Feininger Archive.
146. Mahler Werfel, *And the Bridge,* p. 142.
147. Wingler, *Bauhaus,* p. 64.
148. Isaacs, *Gropius,* p. 105; WG to Ilse Frank, undated.
149. Ibid.
150. Walter Gropius, "Statement on Haus on Horn," 1923.
151. Ibid.
152. Herbert Bayer, Walter Gropius, and Ise Gropius, eds., *Bauhaus, 1919–1928* (Boston: C. T. Branford, 1952), p. 93.
153. Igor Stravinsky, *An Autobiography* (New York: M & S Steven, 1958), p. 107.
154. Ibid., p. 108.
155. Ibid.
156. Stephen Walsh, *Stravinsky: A Creative Spring* (New York: Knopf, 1999), p. 370.
157. Ibid.
158. Bayer, Gropius, and Gropius, *Bauhaus,* p. 91.
159. Ibid.
160. Isaacs, *Gropius,* p. 109.
161. Wingler, *Bauhaus,* p. 76.
162. Ibid.
163. Isaacs, *Gropius,* p. 111.
164. Wingler, *Bauhaus,* p. 84.
165. Ibid., p. 86.
166. Isaacs, *Gropius,* p. 113.
167. Ibid., p. 115.
168. Ibid., p. 116.
169. Wingler, *Bauhaus,* p. 89.
170. Isaacs, *Gropius,* p. 117.
171. Wingler, *Bauhaus,* p. 109.
172. Ibid., p. 110.
173. Ibid.
174. Ibid., p. 125.
175. Ibid.
176. Ibid.
177. Ibid., p. 127.
178. Isaacs, *Gropius,* p. 135; WG to Wassily Kandinsky, February 1927.
179. Ibid., p. 137.
180. Ibid., p. 139.
181. Ibid.
182. Christian Walsdorf, at the Bauhaus-Archiv in Berlin, generously supplied this information.
183. Isaacs, *Gropius,* p. 141.
184. Wingler, *Bauhaus,* p. 136.
185. Ibid.
186. Isaacs, *Gropius,* p. 141.
187. Ibid., p. 145.
188. Ibid., pp. 148–49.
189. Ibid., p. 321.
190. Malcolm Ticknor, introduction to the Huntington Gallery project, Huntington, WV, 1967, in *The Walter Gropius Archive: An Illustrated Catalogue of the Drawings, Prints, and Photographs in the Walter Gropius Archive at the Busch-Reisinger Museum, Harvard University,* Vol. 4: *1945–1969: The Works of The Architects Collaborative,* ed. John C. Harness (New York and London: Garland Publishing, 1991), p. 479.

PAUL KLEE

1. *The Diaries of Paul Klee,* ed. and intro. Felix Klee (Berkeley: University of California Press, 1964), p. 419.
2. Ibid., p. 377.
3. Jankel Adler, "Memories of Paul Klee," in *The Golden Horizon,* ed. Cyril Connolly (London: Weidenfeld & Nicolson, 1953), p. 38.
4. Ibid.
5. Prince Myshkin speaking in Fyodor Dostoyevsky's *The Idiot,* trans. David McDuff (London: Penguin Classics, 2004), p. 639.
6. Ibid., p. 645.
7. *Diaries of Paul Klee,* p. 4.
8. Marta Schneider Brody, "Paul Klee in

the Wizard's Kitchen," *Psychoanalytic Review* 91 (2004): 487.

9. Marta Schneider Brody, "Who Is Anna Wenne? Gender Play Within Art's Potential Space," *Psychoanalytic Review* 89 (2002): 486.

10. Ibid., p. 410.

11. *Diaries of Paul Klee*, p. 4.

12. Ibid., pp. 4–5.

13. Ibid., pp. 10–11.

14. Ibid., pp. 23–24.

15. Ibid., p. 33.

16. Ibid., p. 34.

17. Ibid., p. 35.

18. Ibid., p. 36.

19. Ibid.

20. Ibid., p. 38.

21. Ibid.

22. Ibid., p. 39.

23. Ibid., pp. 40–41.

24. Ibid., p. 41.

25. Ibid., p. 43.

26. Ibid.

27. Ibid., p. 45.

28. Will Grohmann, *Paul Klee* (New York: Harry N. Abrams, 1967), p. 31.

29. John Richardson, "A Cache of Klee," *Vanity Fair,* February 1987, p. 83.

30. Grohmann, *Klee,* p. 53.

31. Ibid., p. 57.

32. Tut Schlemmer, ed., *The Letters and Diaries of Oskar Schlemmer* (Evanston, Ill.: Northwestern University Press, 1990), p. 41.

33. Ibid.

34. Ibid., p. 96.

35. Marcel Franciscono, *Paul Klee: His Work and Thought* (Chicago: University of Chicago Press, 1991), p. 242.

36. Ibid., p. 241.

37. Adler, "Memories," p. 266.

38. Ibid.

39. Ibid.

40. Franciscono, *Paul Klee,* p. 241.

41. Ibid.

42. O. K. Werckmeister, *The Making of Paul Klee's Career, 1914–1920* (Chicago: University of Chicago Press, 1989), p. 226.

43. Grohmann, *Klee,* pp. 62–63.

44. Stefan Tolksdorf, *Der Klang der Dinge: Paul Klee–Ein Leben* (Freiburg: Herder, 2004), p. 140; translation by Jessica Csoma.

45. Paul Klee, *Lettres du Bauhaus,* trans. into French by Anne-Sophie Petit-Emptaz (Tours: Farrago, 2004), p. 22.

46. Frank Whitford, ed., *The Bauhaus: Master and Students by Themselves* (Woodstock, N.Y.: Overlook Press, 1993), p. 54.

47. Klee, *Lettres,* p. 27.

48. Transcript of Felix Klee's interview with Ludwig Grote, March 26, 1972, Klee Archive, Bern.

49. Ibid.

50. Klee, *Lettres,* p. 29.

51. Ibid., p. 34.

52. Ibid.

53. *Rainer Maria Rilke et Merline: Correspondance, 1920–1926,* ed. Dieter Bassermann (Zurich: Insel Verlag, 1954), p. 224.

54. Klee, *Lettres,* p. 38.

55. Whitford, *Bauhaus,* p. 62.

56. Klee, *Lettres,* p. 35.

57. Whitford, *Bauhaus,* p. 70.

58. Ibid.

59. Ibid.

60. Ibid.

61. Ibid., pp. 70–71.

62. Ibid., p. 71.

63. Ibid., p. 72.

64. Grohmann, *Klee,* p. 68.

65. Ibid.

66. Klee, *Lettres,* p. 39.

67. Richardson, "Cache of Klee," p. 83.

68. Klee, *Lettres,* p. 40.

69. Ibid., pp. 40–41.

70. Ibid.

71. Grohmann, *Klee,* p. 69.

72. *Tagebücher von Paul Klee, 1898–1918* (Cologne: M. Dumont Schauberg, 1957), p. 416; translation by Oliver Pretzel.

73. Felix Klee, *Reflections on My Father, Klee,* catalogue for exhibition at Foundation Pierre Gianadda Martigny, 1985.

74. Ibid.

75. Ibid.

76. Klee, *Lettres,* p. 489.

77. Ibid., p 253.

78. Felix Klee, introduction to Pierre von Allmen, *Paul Klee: Puppets, Sculptures, Reliefs, Masks, Theatre* (Neuchâtel: Editions Galeries Suisse de Paris, 1979), p. 19.

79. Grohmann, *Klee,* p. 54.

80. Lothar Schreyer, quoted in Whitford, *Bauhaus,* p. 120.

81. Felix Klee, introduction to Allmen, *Paul Klee,* pp. 19–21.
82. Klee, *Lettres,* p. 49.
83. Grohmann, *Klee,* p. 64.
84. Hans M. Wingler, *The Bauhaus: Weimar, Dessau, Berlin, Chicago,* ed. Joseph Stein, trans. Wolfgang Jabs and Basil Gilbert (Cambridge, Mass.: MIT Press, 1969), p. 54.
85. Whitford, *Bauhaus,* p. 121.
86. Brody, "Who Is Anna Wenne?," p. 497.
87. Ibid., p. 496.
88. Ibid., p. 489.
89. Ibid., p. 493.
90. Ibid., p. 494.
91. Ibid., pp. 494–95.
92. Ibid., p. 499.
93. Grohmann, *Klee,* p. 377.
94. Brody, "Who Is Anna Wenne?," p. 499.
95. Tolksdorf, *Der Klang der Dinge,* p. 164; translation by Jessica Csoma.
96. Marta Schneider Brody, "Paul Klee: Art, Potential Space and the Transitional Process," *The Psychoanalytic Review* 88 (2001): 369.
97. Wilhelm Uhde, "Quelques opinions sur Klee," in *Les Arts Plastiques,* vol. 7 (1930); translation by Philippe Corfa.
98. Klee, *Lettres,* p. 65.
99. Jürg Spiller, ed., *Paul Klee Notebooks,* vol. 2: *The Nature of Nature* (London: Lund Humphries, 1973), p. 6.
100. Ibid., p. 25.
101. Ibid., p. 29.
102. Ibid.
103. Ibid., p. 31.
104. Ibid.
105. Ibid.
106. Ibid., p. 35.
107. Ibid., p. 43.
108. Ibid.
109. Ibid., p. 44.
110. Ibid.
111. Ibid., p. 45.
112. Ibid., p. 51.
113. Ibid., p. 53.
114. Ibid., p. 63.
115. Ibid.
116. Ibid., p. 66.
117. Ibid.
118. Ibid.
119. Ibid., p. 67.
120. Ibid.

121. Marianne Ahlfeld Heymann, "Erinnerungen an Paul Klee," in *Und trotzdem überlebt* (Konstanz: Hartung-Gorre Verlag, 1994), p. 78; translation by Oliver Pretzel.
122. Ibid., p. 80.
123. Ibid., p. 82.
124. Ibid., p. 83.
125. Ibid.
126. Paul Klee, *Briefe an die Familie,* Vol. 2: 1907–1940 (Cologne: Dumont, 1979), p. 768; July 30, 1911.
127. Ibid., p. 789; March 14, 1916.
128. Ibid., p. 813; May 9, 1916.
129. Ibid., p. 831; November 9, 1916.
130. Ibid., p. 838; December 2, 1916.
131. Ibid., p. 889; December 5, 1917.
132. Ibid., p. 861; April 1, 1917.
133. Ibid., p. 930; August 5, 1918.
134. Ibid., p. 935; August 29, 1918.
135. Ibid., p. 1177; February 15, 1932.
136. Ibid., pp. 1178–79.
137. Ibid., p. 1183; March 15, 1932.
138. Ibid., p.1231; translation by Oliver Pretzel.
139. Spiller, *Nature of Nature,* p. 125.
140. "Taschenkasender Paul Klee," in Klee, *Briefe an die Familie,* Vol. 2: 1907–1940, entry for January 3, 1935, p. 1257; translation by Oliver Pretzel.
141. Ibid., entries for January 20 and 22, 1935, pp. 1258–59; translation by Oliver Pretzel.
142. Ibid., entry for January 9, 1935, p. 1259; translation by Oliver Pretzel.
143. Spiller, *Nature of Nature,* p. 69.
144. Ibid.
145. Ibid., p. 72.
146. Ibid., p. 79.
147. Ibid.
148. Ibid., p. 101.
149. Ibid., p. 103.
150. Ibid., p. 105.
151. Ibid., p. 107.
152. Ibid.
153. Reproduced ibid., p. 170.
154. Brody, "Paul Klee in the Wizard's Kitchen," p. 398.
155. Ibid., p. 400.
156. Ibid., p. 415.
157. Ibid., p. 403.
158. Ibid., p. 412.
159. Ibid., pp. 416–17.

160. Ibid., p. 255.
161. Ibid.
162. Grohmann, *Klee,* p. 365.
163. Ibid., p. 366.
164. Howard Dearstyne, *Inside the Bauhaus* (New York: Rizzoli, 1986), p. 264.
165. Whitford, *Bauhaus,* p. 130.
166. Ibid.
167. See Isabel Wünsche, *Galka E. Scheyer and the Blue Four* (Bern: Benteli Verlag, 2006), p. 180, for picture.
168. Ibid., p. 7.
169. Ibid., pp. 37–38.
170. Ibid., p. 47.
171. Ibid., p. 46.
172. Klee, *Lettres,* pp. 67–68; translation by Oliver Pretzel.
173. Interview with Felix Klee in *Paul Klee: Aquarelle und Zeichnungen,* ed. Dieter Honisch, exh. cat., Museum Folkwang, Essen, August 22–October 12, 1969, p. 15.
174. Wünsche, *Galka E. Scheyer,* p. 76.
175. Ibid., p. 78.
176. Ibid., p. 77.
177. Klee, *Lettres,* p. 69.
178. Ibid., p. 71.
179. Ibid., p. 68.
180. John Willet, *Art and Politics in the Weimar Period: The New Sobriety, 1917–1933* (New York: Pantheon Books, 1978), p. 49.
181. Schlemmer, *Letters and Diaries,* p. 137.
182. Wingler, *Bauhaus,* p. 93.
183. Ibid.
184. Feininger's letter cited ibid., p. 96.
185. Ibid., p. 97.
186. Ibid.
187. Felix Klee, *Aquarell und Zeichungen,* p. 17.
188. Feininger's letter in Wingler, *Bauhaus,* p. 97.
189. Grohmann, *Klee,* p. 200.
190. Ibid.
191. Klee, *Lettres,* p. 77; September 16, 1925.
192. Ibid., p. 78; September 16, 1925.
193. Ibid., p. 79; October 25, 1925.
194. Ibid., p. 88; January 24, 1926.
195. Wünsche, *Galka E. Scheyer,* p. 134; April 9, 1926.
196. Klee, *Lettres,* p. 96; May 8, 1926.
197. Ibid.
198. Wingler, *Bauhaus,* p. 519.
199. Helen Nonne Schmidt quoted ibid., p. 524.
200. See Eberhard Rotters, *Painters of the Bauhaus* (New York: Frederick A. Praeger, 1969), pp. 94–206.
201. Klee, *Lettres,* p. 112; May 11, 1926.
202. Whitford, *Bauhaus,* p. 215.
203. Ibid.
204. See Wingler, *Bauhaus,* p. 158, for original article.
205. Grohmann, *Klee,* p. 58.
206. Ibid.
207. Wingler, *Bauhaus,* p. 120.
208. Klee, *Lettres,* p. 104; November 1926.
209. Gerhard Kadow, quoted in Dearstyne, *Inside the Bauhaus,* p. 139.
210. Ibid.
211. Dearstyne, *Inside the Bauhaus,* pp. 137–38.
212. Gerhard Kadow, "Paul Klee and Dessau in 1929" (translated by Lazlo Hetenyi, from the catalogue of an exhibition of Klee's late work held in Düsseldorf, November–December 1948), *College Art Journal* 9, no. 1 (Autumn 1949): 35.
213. Dearstyne, *Inside the Bauhaus,* p. 133.
214. Kadow quoted ibid., p. 139.
215. Christof Hertel, quoted in Dearstyne, *Inside the Bauhaus,* p. 140.
216. Dearstyne, *Inside the Bauhaus,* pp. 141–43.
217. This and the following quotes from interview with Hans Fischli by Sabine Altdorfer, "Mich faszinierte der Musiker, Renker, Träumer," *Berner Zeitung,* September 8, 1987.
218. Grohmann, *Klee,* p. 70.
219. Ibid., p. 74.
220. Ibid., p. 55.
221. Schlemmer, *Letters and Diaries,* pp. 202, 199.
222. Klee, *Lettres,* p. 120; June 28, 1927; translation by Oliver Pretzel.
223. Ibid.; July 2, 1927.
224. Ibid.
225. Ibid., p. 122.
226. Ibid., p. 123; July 6, 1927.
227. Grohmann, *Klee,* p. 76.
228. Klee, *Lettres,* p. 137, August 6, 1927.
229. Brief an Lily Klee, from *Brief an die Familie,* Vol. 2: 1907–1940, p. 1058; August 10, 1927; translation by Oliver Pretzel.
230. Grohmann, *Klee,* p. 76.
231. Ibid., p. 77.

232. Ibid., p. 159; translation by Oliver Pretzel.
233. Ibid., pp. 162–63.
234. Ibid., p. 186; January 13, 1929.
235. Ibid., p. 268.
236. Ibid., p. 205.
237. Klee, *Lettres,* p. 189.
238. Ibid., p. 192; translation by Oliver Pretzel.
239. Grohmann, *Klee,* p. 64.
240. Schlemmer, *Letters and Diaries,* p. 265.
241. Grohmann, *Klee,* p. 78.
242. Klee, *Lettres,* p. 214; April 3, 1930.
243. Ibid., pp. 223–24; April 18, 1930.
244. Ibid., p. 238; May 22, 1930.
245. Ibid., p. 249; June 1, 1930.
246. Ibid., January 26, 1931.
247. Edward M. M. Warburg, *As I Recall* (Westport, Conn.: privately published, 1977).
248. Wünsche, *Galka E. Scheyer,* p. 241.
249. Richardson, "Cache of Klee," p. 102.
250. Gunter Wolf, "Endure! How Paul Klee's Illness Influenced His Art," *The Lancet,* May 1, 1999.
251. Schlemmer, *Letters and Diaries,* p. 382.
252. "Fish of the Heart," *Time,* October 21, 1940.
253. Ibid.
254. Ibid.

WASSILY KANDINSKY

1. *Berner Kunstmitteilungen 234–236,* letter 16, Wassily Kandinsky (Dessau) to Lily Klee (Weimar), December 7, 1925, courtesy of Paul Klee Stiftung, Bern; translation by Oliver Pretzel.
2. Will Grohmann, *Wassily Kandinsky: Life and Work* (New York: Harry N. Abrams, 1958), p. 9.
3. Ibid.
4. John Richardson, "Kandinsky's Merry Widow," *Vanity Fair,* February 1998, p. 130.
5. Grohmann, *Wassily Kandinsky,* p. 10.
6. Ibid.
7. Ibid., p. 9.
8. Kenneth Lindsay and Peter Vergo, eds., *Kandinsky: Complete Writings on Art* (Boston: Da Capo Press, 1994), pp. 357–58.
9. Ibid., p. 358.
10. Ibid., p. 365.
11. Grohmann, *Wassily Kandinsky,* p. 16.
12. Ibid., p. 14.
13. Ibid., p. 29.
14. Lindsay and Vergo, *Kandinsky,* pp. 371–72.
15. Ibid., p. 343.
16. Ibid., p. 363.
17. Grohmann, *Wassily Kandinsky,* p. 31.
18. Lindsay and Vergo, *Kandinsky,* p. 360.
19. Ibid.
20. Ibid.
21. Ibid.
22. Ibid., p. 361.
23. Ibid.
24. Ibid., p. 366.
25. Ibid., p. 364.
26. Ibid.
27. Ibid., p. 363.
28. Ibid., p. 343.
29. Grohmann, *Wassily Kandinsky,* pp. 33–34.
30. Ibid., p. 77.
31. Ibid., p. 83.
32. Ibid., pp. 84–85.
33. Ibid., p. 87.
34. Ibid.
35. Ibid.
36. Ibid., p. 88.
37. Lindsay and Vergo, *Kandinsky,* p. 346.
38. Richardson, "Kandinsky's Merry Widow," p. 130.
39. Nina Kandinsky, *Kandinsky und Ich* (Munich: Knaur Nachf, 1999), p. 192.
40. Tut Schlemmer, ed., *The Letters and Diaries of Oskar Schlemmer* (Evanston, Ill.: Northwestern University Press, 1990), p. 140; June 23, 1922.
41. Hans Wingler, *The Bauhaus: Weimar, Dessau, Berlin, Chicago,* ed. Joseph Stein, trans. Wolfgang Jabs and Basil Gilbert (Cambridge, Mass.: MIT Press, 1969), p. 56.
42. Grohmann, *Wassily Kandinsky,* p. 175.
43. Wolfgang Venzmer, "Hölzel and Kandinsky as Teachers: An Interview with Vincent Weber," *Art Journal* 43, no. 1 (Spring 1983): 29.
44. Ibid.
45. Jelena Hahl-Koch, *Kandinsky* (New York: Rizzoli, 1993), p. 292.
46. Venzmer, "Hölzel and Kandinsky as Teachers," p. 29.
47. Ibid., p. 30.

48. Grohmann, *Wassily Kandinsky,* p. 178.
49. Lindsay and Vergo, *Kandinsky,* pp. 486–87.
50. Hahl-Koch, *Kandinsky,* p. 294.
51. Schlemmer, *Letters and Diaries,* p. 188.
52. Jelena Hahl-Koch, ed., *Arnold Schoenberg–Wassily Kandinsky: Letters, Pictures, and Documents* (London: Faber and Faber, 1984), p. 73.
53. Ibid., p. 21.
54. Ibid.
55. Ibid., pp. 22–24.
56. Ibid., p. 75.
57. Ibid.
58. Ibid.
59. Ibid.
60. Dore Ashton, "No More Than an Accident?" *Critical Inquiry* 3, no. 2 (Winter 1976): 238.
61. Hahl-Koch, *Arnold Schoenberg–Wassily Kandinsky,* p. 77.
62. Ibid.
63. Ibid.
64. Ibid., p. 78.
65. Ibid., p. 79.
66. Ibid., p. 82.
67. Ibid.
68. Nina Kandinsky, *Kandinsky und Ich,* p. 196.
69. Ibid.
70. Grohmann, *Wassily Kandinsky,* p. 188.
71. Ibid., p. 190.
72. Lindsay and Vergo, *Kandinsky,* p. 218.
73. Grohmann, *Wassily Kandinsky,* pp. 187–88.
74. Ibid., p. 188.
75. Isabel Wünsche, *Galka E. Scheyer and the Blue Four* (Bern: Benteli Verlag, 2006), p. 43.
76. Grohmann, *Wassily Kandinsky,* p. 174.
77. Ibid., p. 175.
78. Ibid., p. 174; October 2, 1924.
79. Schlemmer, *Letters and Diaries,* p. 187.
80. Grohmann, *Wassily Kandinsky,* p. 179.
81. Ibid.
82. Ibid.
83. Ibid., p. 182.
84. Wünsche, *Galka E. Scheyer,* p. 101; September 1, 1925.
85. Ibid.
86. Ibid., p. 102.
87. Ibid.
88. Ibid., p. 103.
89. Ibid., p. 119.
90. Grohmann, *Wassily Kandinsky,* p. 199.
91. Ibid., p. 200.
92. Wünsche, *Galka E. Scheyer,* p. 140; July 18, 1926.
93. Ibid.
94. Hahl-Koch, *Kandinsky,* p. 294.
95. Grohmann, *Wassily Kandinsky,* p. 171.
96. Ibid., p. 200.
97. Ibid., p. 201.
98. Schlemmer, *Letters and Diaries,* p. 191.
99. Wünsche, *Galka E. Scheyer,* p. 154.
100. Grohmann, *Wassily Kandinsky,* p. 203.
101. Ibid.
102. Schlemmer, *Letters and Diaries,* p. 230.
103. Paul Klee, *Lettres du Bauhaus,* trans. into French by Anne-Sophie Petit-Emptaz (Tours: Farrago, 2004), p. 154.
104. Grohmann, *Wassily Kandinsky,* p. 202.
105. Alfred H. Barr Jr., *Defining Modern Art: Selected Writings of Alfred H. Barr Jr.* (New York: Harry N. Abrams, 1986), pp. 57–61.
106. Ibid., pp. 124–25.
107. Alice Goldfarb Marquis, *Alfred H. Barr Jr.: Missionary for the Modern* (Chicago: Contemporary Books, 1989), p. 50.
108. From the unpublished manuscripts of Hugo Perls, "Why Is Camilla Beautiful?/Warum ist Kamilla schön?" in the archive of the Leo Baeck Institute, New York.
109. Wünsche, *Galka E. Scheyer,* p. 164; May 10, 1929.
110. Schlemmer, *Letters and Diaries,* p. 248.
111. Grohmann, *Wassily Kandinsky,* p. 202.
112. Ibid., p. 195.
113. Wünsche, *Galka E. Scheyer,* p. 174.
114. Grohmann, *Wassily Kandinsky,* p. 86.
115. Giorgio Cortenova, *Vasilij Kandinskij* (Milan: Edizioni Gabriele Mazzotta, 1993), p. 168.
116. Grohmann, *Wassily Kandinsky.*
117. Schlemmer, *Letters and Diaries,* p. 265; August 23, 1930.
118. Wünsche, *Galka E. Scheyer,* pp. 199–200.
119. Eckhard Neumann, *Bauhaus and Bauhaus People* (New York: Van Nostrand Reinhold, 1970), p. 161.
120. Ibid., p. 162.
121. Wünsche, *Galka E. Scheyer,* p. 209.
122. Ibid.
123. Ibid., p. 210.
124. Ibid., p. 214.

125. Ibid., pp. 218–19.
126. Schlemmer, *Letters and Diaries*, p. 312.

JOSEF ALBERS

1. Quoted in Nicholas Fox Weber, *The Drawings of Josef Albers* (New Haven, Conn.: Yale University Press, 1983), p. 2.
2. Ibid.
3. Ibid.
4. Ibid.
5. Ibid., p. 3.
6. Philipp Franck, *Ein Leben für die Kunst* (Berlin: Im Rembrandt Verlag, 1944), p. 30; translation by Brenda Danilowitz.
7. Weber, *Drawings of Josef Albers*, p. 7.
8. Letter from Josef Albers (JA) to Franz Perdekamp (FP), February 14, 1916; translation by Oliver Pretzel. All letters from Josef Albers to Franz Perdekamp are in a private collection in Germany, with copies at the Josef & Anni Albers Foundation, Bethany, Conn.
9. Letter from JA to FP, March 1, 1916.
10. Ibid.; translation by Oliver Pretzel.
11. Ibid.; translation by Oliver Pretzel.
12. Margit Rowell, "On Albers' Color," *Artforum* 10 (January 1972): 30.
13. Weber, *Drawings of Josef Albers*, p. 21.
14. Letter from JA to FP, November 19, 1916; translation by Oliver Pretzel.
15. Letter from JA to FP, April 14, 1917; translation by Oliver Pretzel.
16. Ibid.
17. Ibid.
18. Ibid.
19. Letter from JA to FP, April 25, 1917; translation by Oliver Pretzel.
20. Brenda Danilowitz, "Teaching Design: A Short History of Josef Albers," in Frederick A. Horowitz and Brenda Danilowitz, *Josef Albers: To Open Eyes: The Bauhaus, Black Mountain College, and Yale* (London and New York: Phaidon Press, 2006), p. 14.
21. Letter from JA to FP, June 20, 1917; translation by Oliver Pretzel.
22. Ibid.
23. Letter from JA to FP, June 22, 1917; translation by Oliver Pretzel.
24. Letter from JA to FP, March 26, 1918; translation by Oliver Pretzel.
25. Weber, *Drawings of Josef Albers*, p. 30.
26. Ibid.
27. Letter from JA to FP, November 30, 1919; translation by Oliver Pretzel.
28. Letter from JA to FP, December 11, 1919; translation by Oliver Pretzel.
29. Letter from JA to FP, Easter Sunday 1920; translation by Oliver Pretzel.
30. Letter from JA to FP, July 5, 1920; translation by Oliver Pretzel.
31. Weber, *Drawings of Josef Albers*, p. 33.
32. This and all following quotations from Marcel Breuer interviewed by Robert Osborn, November 22, 1976, Marcel Breuer Papers, 1920–1986, Archives of American Art, Smithsonian Institution, Washington, D.C.
33. Letter from JA to FP, January 10, 1921; translation by Oliver Pretzel.
34. Danilowitz, "Teaching Design," p. 16.
35. Nicholas Fox Weber, "The Artist as Alchemist," in *Josef Albers: A Retrospective*, exh. cat. (New York: The Solomon R. Guggenheim Foundation and Harry N. Abrams, 1988), p. 21.
36. Ibid., pp. 21–22.
37. Letter from JA to FP, March 22, 1922; translation by Oliver Pretzel.
38. Anni Albers, conversation with Nicholas Fox Weber, undated.
39. Ibid.
40. Danilowitz, "Teaching Design," p. 21; citing Josef and Anni Albers interview by Martin Duberman, November 11, 1967.
41. Ibid., p. 19.
42. Ibid., p. 21.
43. George Baird, interview with Josef Albers, produced by Jane Nice, 2007; LTMCD 2472, LTM Recordings, 2007 (Track 8).
44. Hans M. Wingler, *The Bauhaus: Weimar, Dessau, Berlin, Chicago*, ed. Joseph Stein, trans. Wolfgang Jabs and Basil Gilbert (Cambridge, Mass.: MIT Press, 1969), p. 293.
45. Danilowitz, "Teaching Design," p. 22.
46. Letter from JA to FP, October 22, 1924; translation by Oliver Pretzel.
47. Josef Albers, *Historical or Present*, Archive of the Josef & Anni Albers Foundation.
48. Ibid.
49. Ibid.
50. Letter from JA to FP, October 22, 1924; translation by Oliver Pretzel.

51. Ibid.
52. Letter from JA to FP, December 5, 1924; translation by Oliver Pretzel.
53. Letter from JA to FP, May 12, 1925; translation by Ingrid Eulmann.
54. George Baird interview with Josef Albers, produced by Jane Nice, 2007; LTMCD 2472, LTM Recordings, 2007 (Track 9).
55. Weber, "The Artist as Alchemist," p. 23.
56. Ibid., p. 24.
57. Erwin Panofsky, *Early Netherlandish Painting: Its Origins and Character* (Cambridge, Mass.: Harvard University Press, 1953), p. 144.
58. Weber, "The Artist as Alchemist," p. 24.
59. Ibid.
60. Letter from JA to FP, January 1, 1928; translation by Oliver Pretzel.
61. Ibid.
62. Letter from JA to FP, February 9, 1928; translation by Oliver Pretzel.
63. Ibid.
64. Josef Albers, conversation with Nicholas Fox Weber, undated.
65. Undated document in archives of the Josef & Anni Albers Foundation.
66. Letter from JA to FP, April 22, 1928; translation by Oliver Pretzel.
67. Letter from JA to FP, December 10, 1928; translation by Oliver Pretzel.
68. Ibid.
69. Letter from JA to FP, January 17, 1929; translation by Oliver Pretzel.
70. Ibid.
71. Letter from JA to FP, February 22, 1930.
72. Letter from JA to FP, June 21, 1930; translation by Oliver Pretzel.
73. Letter from JA to FP, March 29, 1932; translation by Oliver Pretzel.
74. Wingler, *The Bauhaus,* p. 188.
75. Ibid.
76. Letter from JA to FP, June 10, 1933; translation by Oliver Pretzel.
77. Wingler, *The Bauhaus,* p. 188.
78. Weber, *Drawings of Josef Albers,* p. 44.
79. Ibid., p. 46.
80. Ibid., pp. 46–47.
81. Rudolf Arnheim, *The Power of the Center* (Berkeley and Los Angeles: University of California Press, 1982), p. 146.
82. Ibid.

83. George Eliot, *Middlemarch* (Harmondsworth, U.K., and New York: Penguin Books, 1985), p. 35.
84. Josef Albers, *Interaction of Color* (New Haven, Conn.: Yale University Press, 1963), p. 44.

ANNI ALBERS

1. Josef Albers to Franz Perdekamp, July 31, 1925; translation by Oliver Pretzel.
2. Anni Albers, *On Designing* (Middletown, Conn.: Wesleyan University Press, 1979), p. 36.
3. Ibid.
4. Ibid.
5. Sigrid Weltge-Wortmann, *Bauhaus Textiles: Women Artists and the Weaving Workshop* (London: Thames and Hudson, 1993), p. 42, and Anja Baumhoff, "Weberen Intern: Autorriät und Geschlecht am Bauhaus," in Magdalena Droste and Manfred Ludewig, *Das Baushaus Webt: Die Textilwerkstatt am Bauhaus* (Berlin: G+H Verlag, 1998), p. 53.
6. Elizabeth (Betty) Farman, conversation with Nicholas Fox Weber, undated.
7. Anni Albers, conversation with Nicholas Fox Weber, 1974.
8. Ibid.
9. Anni Albers, in conversation with Nicholas Fox Weber, 1974–80. Subsequent unattributed quotations from Anni Albers also come from these conversations.
10. Anni Albers, conversation with Nicholas Fox Weber, 1973.
11. Wilhelm Worringer, *Abstraction and Empathy: A Contribution to the Psychology of Style,* trans. Michael Bullock (London: Routledge and Kegan Paul, 1963), p. 4.
12. Ibid., p. 14.
13. Ibid., p. 20.
14. Ibid.
15. Johann Wolfgang von Goethe, *Metamorphosis of the Plants,* (1790); translation provided by Anni Albers to Nicholas Fox Weber, 1973.
16. Buckminster Fuller, back cover of Albers, *On Designing.*
17. Letter from Edward M. M. Warburg to Alfred Barr, August 31, 1933, Alfred H. Barr Jr. Papers, Museum of Modern Art Archives, New York, quoted in Nicholas

Fox Weber, *Patron Saints: Five Rebels Who Opened America to a New Art, 1928–1943* (New York: Alfred A. Knopf, 1992), p. 203.

18. Philip Johnson, conversation with Nicholas Fox Weber, 1977.

19. Quoted in Weber, *Patron Saints,* p. 203.

20. Letter from Ted Dreier to Nicholas Fox Weber, March 6, 1989, quoted ibid., p. 409.

21. Letter from Anni Albers to Ted Dreier, March 18, 1937, The Albers-Dreier Correspondence Collection, The Josef & Anni Albers Foundation Archives; translation by Oliver Pretzel.

22. Ibid.

LUDWIG MIES VAN DER ROHE

1. Franz Schulze, *Mies van der Rohe: A Critical Biography* (Chicago: Univerisity of Chicago Press, 1985), p. 177.

2. Ibid., p. 16.

3. Ibid., p. 23.

4. Ibid.

5. Hugo Perls, unpublished memoir, Leo Baeck Institute, undated, n.p.

6. Schulze, *Mies van der Rohe,* p. 61.

7. Ibid., p. 83.

8. Ibid., p. 92.

9. Ibid., p. 106.

10. Ibid.

11. Barry Bergdoll and Terence Riley, *Mies in Berlin* (New York: The Museum of Modern Art, 2001), p. 107.

12. Ibid., p. 137.

13. Ibid., p. 214.

14. Ibid., p. 139.

15. "6 Students Talk with Mies" (interview of Mies van der Rohe by students of the School of Design, North Carolina State College), *LINE* magazine, vol. 2, no. 1 (February 1952).

16. John Peter, interview with Mies van der Rohe, ms., 1956, Mies van der Rohe Archive, Museum of Modern Art, New York.

17. Hans M. Wingler, *The Bauhaus: Weimar, Dessau, Berlin, Chicago,* ed. Joseph Stein, trans. Wolfgang Jabs and Basil Gilbert (Cambridge, Mass.: MIT Press, 1969), p. 165.

18. Schulze, *Mies van der Rohe,* p. 175.

19. Josef Albers to Franz and Friedel Perdekamp, Dessau, March 29, 1932; translation by Oliver Pretzel.

20. Nicholas Fox Weber, "Historic Architecture: Mies van der Rohe, Revisiting the Landmark Tugendhat House," *Architectural Digest,* October 1990, pp. 74–86.

21. Ibid.

22. Bergdoll and Riley, *Mies in Berlin,* p. 99.

23. Ibid.

24. Ibid.

25. Schulze, *Mies van der Rohe,* p. 170.

26. *Saturday Review,* January 23, 1965.

27. Schulze, *Mies van der Rohe,* p. 176.

28. Howard Dearstyne, *Inside the Bauhaus* (New York: Rizzoli International, 1986), p. 223.

29. Transcript of interview with Dirk Lohan, p. 37, Mies van der Rohe Archive, Museum of Modern Art.

30. *Saturday Review,* January 23, 1965.

31. Ibid.

32. Unidentified voice from February 26, 1986, Mies van der Rohe Archive, Museum of Modern Art.

33. North Carolina State College in 1952; reprinted in *LINE* magazine, vol. 2, no. 1.

34. Ibid.

35. Schulze, *Mies van der Rohe,* p. 177.

36. Ibid., p. 338.

37. Lohan interview, p. 39.

38. Werner Blaser, *Mies van der Rohe* (New York: Praeger, 1972), p. 14.

39. Schulze, *Mies van der Rohe,* p. 179.

40. Nicholas Fox Weber, "Revolution on Beekman Place," *House & Garden,* August 1986, p. 58.

41. Letter from Philip Johnson to Mies van der Rohe, November 2, 1934, Mies van der Rohe Archive, Museum of Modern Art.

42. Ibid.

43. Mies van der Rohe to Philip Johnson, Berlin, November 23, 1934, Mies van der Rohe Archive, Museum of Modern Art; translation by Oliver Pretzel.

44. Philip Johnson to Mies van der Rohe, December 5, 1934, Mies van der Rohe Archive, Museum of Modern Art.

45. "Mies at 100" symposium, moderated by Franz Schulze, Museum of Modern Art, New York, February 25, 1986,

p. 47 of transcript, in Mies van der Rohe Archive, Museum of Modern Art.

46. Ibid.

47. Transcript in Mies van der Rohe Archive, Museum of Modern Art.

THE BAUHAUS LIVES

1. Wassily Kandinsky to Josef Albers, December 19, 1935, in Jessica Boissel, ed., *Une Correspondence des Kandinsky–Albers années trente* (Paris: Éditions du Centre Pompidou, 1998), p. 71.

2. Ibid., p. 73.

3. John Richardson, "Kandinsky's Merry Widow," *Vanity Fair,* February 1995, p. 131.

4. Ibid., p. 135.

5. Gabrielle Annan, "Girl from Berlin," *The New York Review of Books,* February 14, 1985.

6. Sebastian Haffner, *Defying Hitler,* trans. Oliver Pretzel (New York: Picador, 2000), p. 26.

7. Ibid., p. 52.

8. Ibid., p. 53.

9. Ibid., pp. 128–29.

Index

Page numbers in *italics* refer to illustrations.

ILLUSTRATION CREDITS

2009 Artists Rights Society (ARS), New York/VG Bild-Kunst, Bonn: color plates 2, 11, 15
AKG-Images: page 470
Art Resource, NY, photograph by Erich Lessing: page 438
Oliver Barker: page 141
Bauhaus-Archiv Berlin, © Bauhaus-Archiv, Berlin: page 3 (right), 8
Bauhaus-Archiv, Berlin (Dr. Stephan Consemüller [photo]), VG Bild-Kunst, Bonn: page 405
Bauhaus-Archiv, Berlin/2009 Artists Rights Society (ARS), New York/VG Bild-Kunst, Bonn: pages 58 (Paula Stockman [photo]), 226, 293, 294, 392, 407; color plate 12
Courtesy Bauhaus-Archiv, Berlin/2009 T. Lux Feininger/Artists Rights Society (ARS), New York: page 483
Bauhaus-Universität Weimar, Archiv der Moderne, photograph by Hüttich-Oemler: page 65
Berlinische Galerie, Landesmuseum für Moderne Kunst, Fotografie und Architektur: page 416
Bildarchiv Preussischer Kulturbesitz/Art Resource, NY/2009 Artists Rights Society (ARS), New York/VG Bild-Kunst, Bonn: page 375
Centre Pompidou/Mnam—Cci/Bibliothèque Kandinsky: pages 140, 179, 194, 218, 232, 242, 243, 248, 249, 466
CNAC/MNAM/Dis. Réunion des Musées Nationaux/Art Resource, NY/2009 Artists Rights Society (ARS), New York/ ADAGP, Paris: pages 224, 247; color plates 9, 10, 13
Courtesy of Fondazione Mazzotta, Milan/2009 Artists Rights Society (ARS), New York/ ADAGP, Paris: color plate 14
Courtesy René Guerra, photograph by René Guerra: page 233
Harvard Art Museum: page 9
Harvard Art Museum, Busch-Reisinger Museum, Gift of Josef Albers/2009 The Josef & Anni Albers Foundation/Artists Rights Society (ARS), New York/VG Bild-Kunst, Bonn: page 453; color plate 25
Courtesy of Historic New England, photograph by Wanda von Debschitz-Kunowski: page 64
The Jewish Museum/Art Resource, NY/© The Josef & Anni Albers Foundation/Artists Rights Society (ARS), New York/VG Bild-Kunst, Bonn: color plate 29
Courtesy The Josef & Anni Albers Foundation/2009 Artists Rights Society (ARS), New York/ VG Bild-Kunst, Bonn: pages 45, 342; color plate 8
Courtesy and copyright The Josef & Anni Albers Foundation/2009 Artists Rights Society (ARS), New York/VG Bild-Kunst, Bonn: pages xiv, xv, xvii, 83, 195, 259, 260, 317 (left), 321, 322 (both images), 323, 332, 347, 365, 370, 385, 398, 399, 406, 409, 468; color plates 18, 19, 20, 21, 23, 24, 26, 27, 28
Klassik Stiftung Weimar, Herzogin Anna Amalia Bibliothek: page 363
Klee-Nachlassverwaltung, Bern: pages xii, 96, 97, 126 (Helene Mieth [photo]) , 164, 187
Courtesy Kunstmuseum Basel, photograph by Martin P. Bühler/2009 Artists Rights Society (ARS), New York/VG Bild-Kunst, Bonn: page 21; color plate 4
Courtesy of Library of Congress: page 36
Mahler-Werfel Papers, Rare Books & Manuscript Library, University of Pennsylvania: pages 3 (left), 14
Merzbacher Kunststiftung/2009 Artists Rights Society (ARS), New York/VG Bild-Kunst, Bonn: page 191
The Metropolitan Museum of Art, The Berggruen Klee Collection, 1984: page 135